RUSSIAN ARCHITECTURE
AND THE WEST

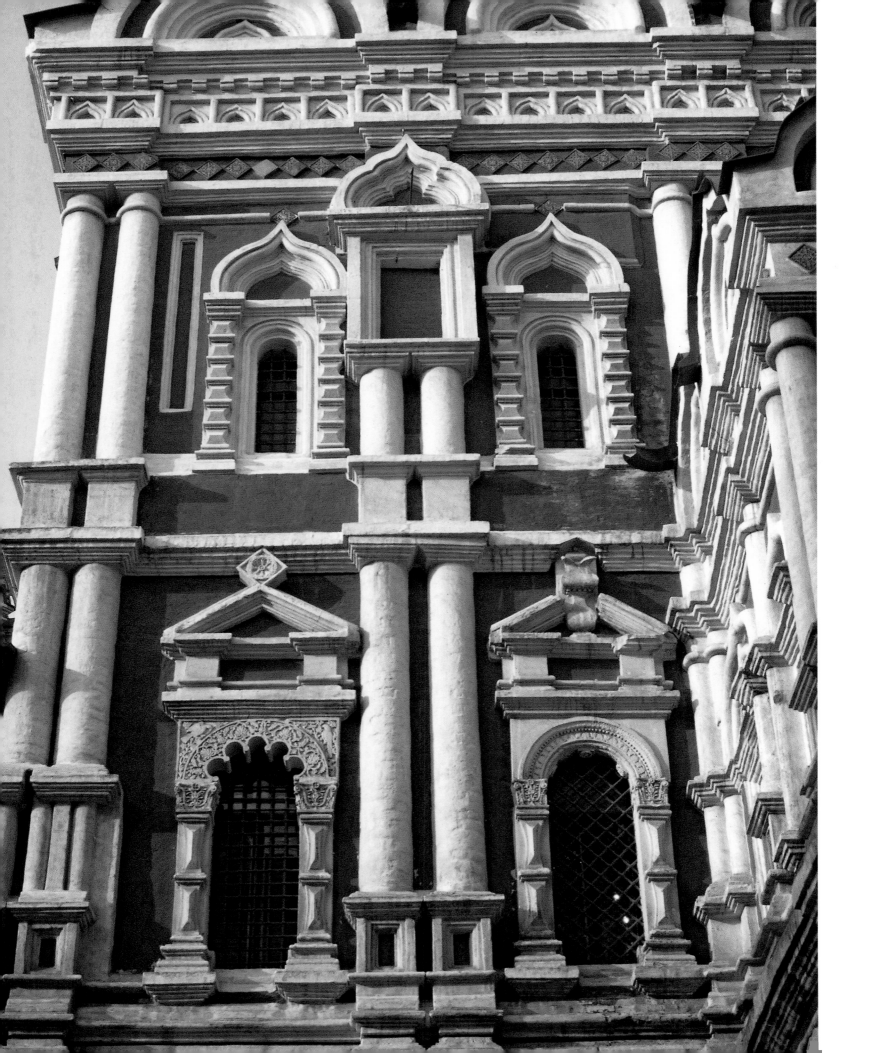

RUSSIAN ARCHITECTURE AND THE WEST

DMITRY SHVIDKOVSKY

Photographs by

YEKATERINA SHORBAN

Translated from the Russian by

ANTONY WOOD

YALE UNIVERSITY PRESS

NEW HAVEN & LONDON

PUBLISHED WITH THE ASSISTANCE OF

THE GRAHAM FOUNDATION FOR ADVANCED STUDIES IN THE FINE ARTS

Designed by Gillian Malpass

Printed in Singapore

Library of Congress Cataloging-in-Publication Data

Shvidkovskii, D. O. (Dmitrii Olegovich)

Russian architecture and the West / Dmitry Shvidkovskiy.

p. cm.

Includes bibliographical references and index.

ISBN 978-0-300-10912-2 (cl : alk. paper)

1. Architecture–Russia. 2. Architecture–Russia–European influences. I. Title.

NA1181.S53 2007

720.947–dc22

2006100424

A catalogue record for this book is available from the British Library

Frontispiece Detail of the south front of the church of the Holy Trinity in Nikitniki,
Moscow, 1631–50s.

Contents

Acknowledgements

FOR THE OPPORTUNITY TO WRITE THIS BOOK I am very grateful to a great number of individuals and institutions. The manuscript was begun in Oxford a dozen years ago while I was a visiting researcher at Corpus Christi College and was finished when I was a visiting fellow of All Souls College. Without the most generous help of these colleges and their fellows, I could have done nothing. The former librarian of the Codrington Library, the late Dr John Simmons, was the person who introduced me to the "Oxford world" and looked after my studies for a long time.

In between the two periods in Oxford I worked on the book in the Institute of Art History at the Russian Academy of Art, where the director, Professor Viktor Vanslov, and my other colleagues helped me greatly by offering their expertise and advice, as did my colleagues in the Department of History of Architecture at the Moscow Architectural Institute, especially my teacher, Professor Tatyana Savarenskaya. I thank my colleagues Dr Uliya Klimenko and Dr Sergey Klimenko for their kind help in the preparation of plans.

Many institutions were vital for my research: I am very pleased to thank the Centre of Advanced Studies of the Renaissance in Tours (France) and especially Professor Jean Guillaume; the Andrea Palladio Foundation for the Study of Architecture, Vicenza, and the president of its academic council, Professor Howard Burns; the Kennan Institute of Advanced Russian Studies and its director, Dr Blair Ruble; the Department of Architectural History of the University of Illinois in Champain-Urbana and Professor Robert Ousterhaut; the Institute of Art History at the University of Bern and Professor Norberto Gramaccini.

Of significant help for work on the book was the financial support from the Paul Mellon Centre for Studies in British Art and the Graham Foundation, Chicago.

I am especially grateful for the extremely valuable advice and support for this research that I received over many years from scholars of various countries: Professor James Ackerman, Professor Andrey Batalov, Mrs Mavis Batey (former president of the Garden History Society), Ambassador Bruno Bottai, the late Dr Catherine Cooke, Professor Anthony Cross, Dr Alexander Currie, Professor Hélène Carrère d'Encausse, Dr Larisa Haskell, Peter Hayden, Dr Jeremy Howard, Dr James Howard-Johnston, Professor Elisabeth Kievan, Professor Henry Mellon, Professor Robin Middleton, Professor Jean-Marie Pérouse de Montclos and Dr Brigitte Péruse de Montclos, Professor Nicolette Mout, Ambassador Pierre Morel and his wife, Ambassador Olga Morel, Professor Priscilla Roosevelt, Professor Andrew Saint, Professor Vladimir Sedov, Dr Gavin Stamp, Professor Sir Keith Thomas, and Dr Werner Zambien.

My understanding of Russian architecture as part of a larger, European tradition was of course developed and elaborated during my research, but I owe this idea to my father and mother, both architectural historians, Professor Oleg Shvidkovsky and Professor Vera Kalmykova, who lived the greater part of their life in the Soviet era, behind the Iron Curtain, but were willing, in spite of every circumstance, to consider themselves Europeans.

I thank also Antony Wood, who translated this book from the Russian – a very difficult task.

My most profound gratitude is to my editor, Gillian Malpass, without whose constant support, understanding and hard work the book would not have been accomplished.

From the beginning, Dr Yekaterina Shorban has been my partner in this enterprise, and her wonderful photographs, which illuminate, enhance and decorate the text, are testimony to our co-authorship of this book.

facing page View of the courtyard of Peter Palace, Moscow, 1775–1782, from the main entrance.

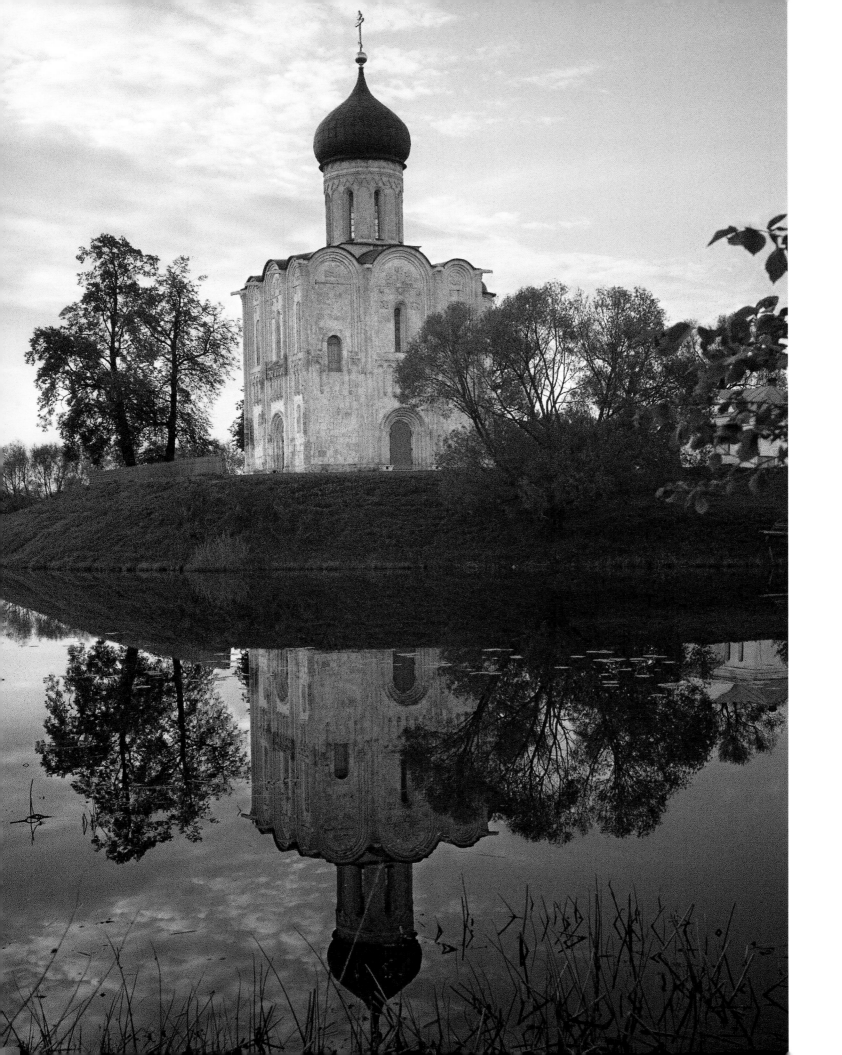

Glossary

Asnova Association of New Architects, one of the first Soviet architects' groups of the 1920s

chetverik four-sided compartment of a building

Early Russian concerning the period before the reign of Peter the Great (1682–1725)

izba Russian peasant's single-storey wooden house

kokoshnik blind gable, an ornamental element in Moscow churches, arranged in one or more tiers

kolokol'nya bell-tower

kremlin citadel at the centre of a medieval Russian town

kreshchatyy vault vaulting taking the form of a cross-shaped intersection of two cylindrical vaults

lemekh wooden tile

lopatka pilaster without a capital, used in Early Russian architecture

nalichnik ornamental surround to a door or window

Paleologue dynasty the last Byzantine imperial dynasty, in power from 1261 to 1453; the period saw an artistic flowering known as the "Paleologue Renaissance"

pereulok narrow street linking two major streets

OSA Society of Contemporary Architects, an early Soviet architects' group whose aim was the transformation of the environment of everyday life by architectural means. The Constructivist movement was founded mainly by its architects

plinfa long thin brick used in Byzantine and Early Russian architecture

pogost country churchyard, with a church or chapel attached

posad trading and craftsmen's quarter of a medieval Russian town, usually outside the town wall; in later use the term came to mean "suburb"

posadskiy khram church in a suburb

pridel side-chapel

pritvor outer narthex or vestibule built onto the exterior of a church

sandrik decoration above a window in the form of a cornice or pediment

sloboda suburb of a medieval Russian town with a defined degree of administrative independence; the term continued to be used in later times

strelka spit of land mostly surrounded by water

tyaga thin protruding strip, horizontal or vertical, on a façade

Wimperg sharply pointed triangular pediment, usually above a window or door

zakomara semi-circular gable finishing a division of the façade of an Early Russian church, as marked off by *lopatki* or by a *lopatka* and the edge of the façade, the latter usually being divided into three parts, each finishing in a *zakomara*

Translator's Note

The so-called British system of transliteration from Cyrillic – as fixed by W. K. Matthews, "The Latinisation of Cyrillic characters", *The Slavonic Review*, xxx/75, June 1952 – has been adopted in this book in preference to the slghtly more exact Library of Congress system, being felt to be more assimilable to the reader without a knowledge of Russian. The endings *-iy* and *-yy* in names of persons are simplified to *-y*.

facing page Church of the Intercession on the Nerl', 1165.

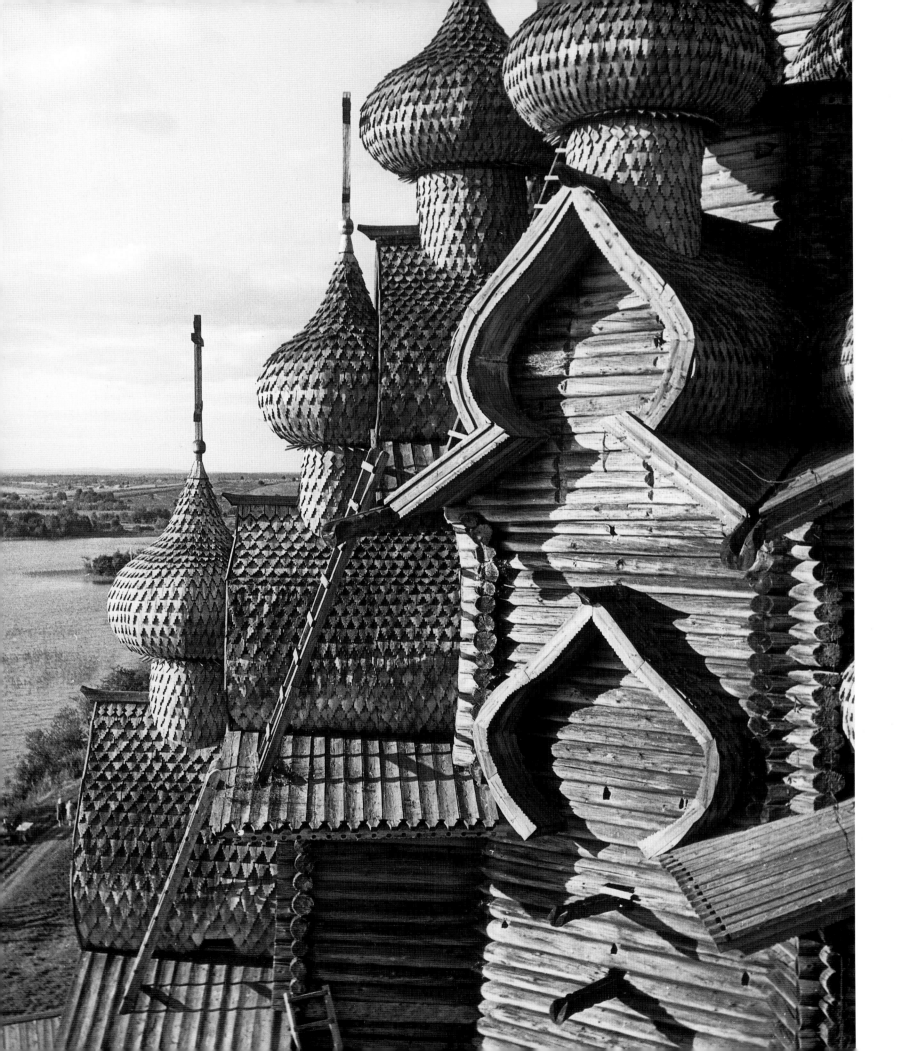

Introduction

I HAPPENED TO SEE ONCE, at the home of a British friend near Oxford, a map of Russia engraved in Paris in 1692.[2] Peter the Great was then twenty. However, the map showed Russia as it had been a century and a half earlier, at the beginning of the reign of Ivan the Terrible. But what surprised me most of all was that the tiny semi-independent principalities that existed at the beginning of the sixteenth century on the border between Lithuania and Muscovy were shown as huge. Their territories were depicted on the map as equal in size to those of the great principalities of Tver' and Ryazan', which in reality were hundreds of times bigger. The lands bordering Muscovy were exaggerated out of all proportion on this map, as if shown on quite another scale.

This seemed to me symbolic. It was as if something similar happened to the perception of Russian cultural history over a long period of time. For centuries the significance, the solidity, the impenetrability of the frontiers between Russia and the West were exaggerated, and this perspective became the traditional Russian and Western perception of Russian culture. If, however, this approach is discarded in favour of one that fore-grounds contact rather than confrontation with the West, then the picture of Russian culture changes, at least in the domain of architecture.

The idea of writing this book, however, would not appear to have been an entirely reasonable one. It is difficult to grasp ten centuries, the entire architectural history of one's country, as a whole. Hundreds if not thousands of specific questions arise which need to be resolved either afresh or in accordance with a generally accepted view. Furthermore, Russian architecture is still insufficiently understood both outside and inside Russia. Every year, specialists in the preservation of ancient monuments discover and record ever more remarkable buildings. Many of the discoveries of recent years have altered prevailing ideas of particular periods, styles or individual architects. At the same time, the study of Russian architectural history has been continuous for some three centuries, its beginnings dating back to the reign of Catherine the Great. Throughout this time, many conceptions have accumulated and hardened into accepted tradition, and whether any particular conception is true or not is often undiscussed.

1 (*facing page*) Church of the Transfiguration, Kizhi, 1714.

In Russia, research on architectural history has unfortunately seen a sharp quantitative decrease in recent years, with falling numbers of scholars engaged in it. In the West, on the other hand, especially in the United States, more and more high-quality monographs on Russian architectural monuments, with copious photographic illustrations, have appeared.

Nevertheless, I could not help writing this book. I felt an urgent inner need to respond to the changes that the last decade has seen in Russia in terms of the discipline that I practise, architectural history. However strange it may seem, this discipline, remote from the political and economic realities of the present time, has turned out to be affected by the changes in Russian thinking produced by the new order. The collapse of the Soviet Union, the disappearance of so-called socialism, the lifting of the Iron Curtain, have led to much greater attention being paid to the part played in the development of Russian architecture by contacts with other countries. In the Soviet era it was understood that Russians in their homeland were "Soviet", and this sufficiently determined the features of national identity in the totalitarian system under which Russians lived, with the enforced isolation of their country from the West. The situation affected Russians' view of their past as well as of their present. Now there is a return to the long-standing problems of Russian history, to the search for the determining factors in its special character, including the question of the "identity" of Russian architecture.

Who are the Russians? Does Russian culture belong to Europe? Or to one of the Eastern traditions, its closeness to the Western world being only a matter of geography? Or perhaps, as has often seemed to be the case, Russia is without analogue and has its own destiny, belonging neither to East nor to West?

In this book I wanted to look at Russian architectural history from a European viewpoint. I have tried to discern in it characteristics that the West might regard as close to Western culture, or perhaps even as its own. In other words, I have aimed at bringing out cultural phenomena common to both Russian architecture and to individual architectural traditions of various European countries during specific historical periods. I am thinking in the first instance of numerous direct and indirect influences, the contribution of foreigners to Russian architecture, for example, but not only this. I was interested in the continuing life in Russian architecture of models taken from the West, in the metamorphoses of European styles, manners and motifs. It seemed to me that, while undergoing change in the Russian environment or coexisting in it, these elements might show Russian architecture in a new light – as that part of European tradition situated furthest east. It seemed to me important to interpret international cultural exchange as a set of

factors that has played a prime part in shaping Russian architectural history.

I realize that an assertion such as this will be seen as provocative, but I make it in full awareness. For too long, for centuries, Russian architectural history has been exhibited to visitors to the country and seen by architectural historians as lying outside European architectural evolution. This has affected, for example, terminology. For a long time the terms Romanesque, Renaissance and Mannerism were little used in Russian architectural historiography, and even where they were, it was not always in a European context. Stylistic designations commonly applied to Western European architecture, however, have begun to be applied comparatively recently to Russian architecture from the Baroque to the Avant-Garde of the 1920s, albeit qualified as "Russian Baroque", "Russian avant-garde", and so on.

I wanted not only to apply Western architectural historical terms to Russia but also to try to show that the Romanesque, Renaissance and Mannerist styles had their reflections in Russian architectural history and, furthermore, that Baroque, Neoclassicism, Historicism, Art Nouveau and the other international movements, in principle all those belonging to "normal" European national architectural traditions, also reached Russia.

It is certainly the case that each of the principal European architectural styles found its special form in Russia, sometimes being only partially assimilated, and frequently undergoing the most astonishing transformation. Still, in my view the main movements in the history of European art not only had an influence on Russian architecture but also played a direct part in its development, even if this often took an unusual form, associated with specific borrowings from one or more than one West European country, not always the most internationally fashionable. On the contrary, alongside widely known architectural models, others were adopted to which today's architectural historians attach little significance, but which attracted the attention of Russian builders in past centuries.

I am by no means sure that my approach is a legitimate one. Nevertheless, the temptation to try to break free from the traditional separation of Russian architectural history from the mainstream European story was too great for me to resist, and this is what I have set out to do.

It must be said at once that this enterprise has produced a book which selects just one from other possible versions of Russian architectural history; it is by no means an encyclopedic account. Although all ten centuries of masonry building in Russia will pass before the reader, not all major monuments or even regional schools will be covered. It has, unfortunately, proved impossible to discuss even the schools of Novgorod, Pskov, Smolensk, Galich or Vladimir-Volynsky in much detail.

Surprising as it may seem, it was not in these regions bordering Poland and the Baltic states but in those further to the east, Vladimir and Moscow, that the events in Russian architectural history took place that were most closely linked with the adoption and assimilation of West European ideas. The main and most detailed discussion will be devoted to those buildings of various periods, beginning with Kievan Rus' and concluding with the last years of the past millennium, that have shaped the history of Russian architecture in a European context. The history of towns, fortifications and gardens in Russia will be touched on only in passing, for adequate treatment of their relationship with the West would require separate volumes. This book focuses on the evolution and meanings of Russian architectural styles.

Russian architectural history is traditionally divided into broad periods of evolution with reference to internal and external cultural factors: for example, Russia's conversion to Christianity and at the same time Byzantine, especially Constantinopolitan, building practice during the second half of the tenth century. Or the founding of the Russian Empire as a result of the reforms of Peter the Great and its orientation towards various national schools of West European architecture at a moment that saw the coexistence of Baroque, seventeenth-century Classicism and a residue of late northern Mannerism. Or the October 1917 Revolution, which brought together in architecture nineteenth-century Western thinkers' utopian ideas about the living environment and the aesthetic radicalism of the Russian Avant-Garde.

Each turning-point in Russian architectural evolution was determined by demands arising from the foundation of a new type of state and a new ideology. Out of the latter came architectural ideals that played an essential part in the creation of a visible image of the new power. Often these ideal forms arose not from within the home culture but from outside it, so that what was "foreign" was made into "our own". Each time this happened, central authority would lay down a style, following Byzantine or West European models, that established a new direction for Russian architecture.

It is often said that Western architecture first made its appearance in Russia under Peter the Great. This is far from the truth. The Petrine myth of the "window cut through to Europe" to this day obscures long historical processes that led to a watershed in Russian culture at the turn of the seventeenth and eighteenth centuries. The Petrine reforms were made possible by at least three centuries of preparation. It would be too simple to consider them without exploring both the means by which the Russian people handled the new experiment so comparatively easily and rapidly and the causes of the continuing survival of certain Byzantine traditions in Russian culture

after Peter's reforms. The speed of Russia's assimilation of European concepts, at least in the sphere of architecture, might be ascribed purely to the resolute character of the reformer. In fact, however, equally important was the fact that Russian architecture had already gone through a prolonged period of preparation for the ingestion of new ideas. By Peter the Great's reign, Russian culture was already well accustomed to preserving its characteristic features in transformative conditions. It was this factor that made possible such a wholesale new orientation towards the European experience under Peter the Great. Traditional Russian culture would have been totally destroyed if it had not far earlier acquired methods of accommodating to Western ideas.

It must be said at the outset of this study of the international aspects of Russian architecture that the subject concerns stone and brick building exclusively, which had its beginnings at the same time as the first centralized state in the country, Kievan Rus', in the late tenth century. Before this, the fortresses, domestic dwellings and pagan shrines that covered the vast East European plain had been built of wood. The paucity of proof that for a thousand years the tradition of timber building had any significant influence on masonry building in Russia is striking, particularly since throughout this lengthy period wooden building coexisted with stone and brick, and was even predominant up to the eighteenth century.[3]

It is in fact the case that an entire culture based on timber building has always existed in Russia (pl. 1). However, why this tradition evolved separately from the evolution of masonry architecture is one of the chief unsolved problems of Russian architectural history. The wooden building tradition underwent changes in the course of time, but significantly less so than masonry architecture. It preserved many of its forms from the earliest times up to the reign of Catherine the Great; some symbolic pagan ornamental motifs have survived in peasant houses up to the twentieth century.

Masonry architecture, on the other hand, was always linked with fashions and discoveries that entered Russia from abroad. It was not, however, the case that brick-built churches or palaces were perceived by Russians as "foreign" intrusions. Such buildings, whether in Byzantine, French or Italian tradition, were seen, rather, as indications of a common Russian and European cultural community, and in particular as showing that Russia belonged to the latter. It was for this reason that such architecture was highly valued by the state authorities, for whom it took on a political meaning.

It was successive changes in masonry architectural forms that most clearly displayed Russian cultural changes brought about by changes in the international position of the Russian state; that revealed, in other words, those features of national con-

sciousness that could be identified not only as Russian but also as belonging to a wider community – the Byzantine "commonwealth", the Christian world or, later, Europe, the West.

In his celebrated essay "Russia's Byzantine Heritage" Dimitri Obolensky observed:

> Professor Toynbee has convincingly argued that the national state is not "an intelligible field of historical study" [. . .] In his opinion, the history of an individual nation becomes fully intelligible only if studied as part of a larger whole [. . .] Now it seems to me that to illustrate the truth of Professor Toynbee's thesis, Russian history is an equally good test case [. . .] It should not be difficult to show that each of these chapters [i.e. the main periods of Russian history] illustrates Russia's close dependence on the outside world; for none of them is fully intelligible unless we view it against the background of one or several civilisations more extensive than Russia herself.[4]

John Simmons makes the same point in relation to the history of Russian printing:

> [. . .] the most interesting and fruitful periods in the history of Russian printing are those when her artists and craftsmen have been in contact with the West – we think of Ivan Fyodorov's *Typographus Slavonicus et Graecus*, of Israhel van Meckenem's engravings, of the developments under Aleksei Mikhailovich, of Peter the Great, and so on, down to the World of Art movement at the end of the nineteenth century. This is not to undervalue the Russian element – in each case Russia took what she needed from the West, transmuted it, and added it to her native stock to make a synthesis that is essentially Russian.[5]

The present book applies these ideas to architecture.

Russian architecture and the self-image of Russian architects have been unique in their perception of the surrounding world, practically without any serious conflicts between the national and the universal. For most of the millennium of Russian history, at least in the domain of architecture, choices were Russian, and Russia, proceeding from its own image of its place in the world, consciously constructed its own special culture. At the heart of this process lay centuries of aspiration towards association with Western civilization.

The beginning of masonry architecture in Russia was directly linked with the country's conversion to Christianity in 989. Most early Russian stone buildings that have survived to the present day are churches or cathedrals. Despite all later stylistic influences and changes, the type of interior designed for the Orthodox liturgy has always been preserved, and this remains perhaps the chief distinguishing feature of Russian architecture. The Byzantine builders, however, stayed only about three-quarters of a century in Russia; after they had departed, Byzantine influence was indirect, reaching Russia via the Balkans or Mount Athos rather than Constantinople.

From the third quarter of the twelfth century onwards, Russian architecture was not unresponsive to the artistic movements of Western Europe. The weakening of the Byzantine Empire under the attacks of Arabs and Crusaders, the increased political power of the Roman Catholic Church and the eastward expansion of the Holy Roman Empire were reflected in the innovative character of the architecture of the Vladimir region – the territory out of which Greater Russia grew. While the sacred spatial layout typical of Byzantine churches was preserved, in Vladimir the form of the Russian church evolved in a Western direction. It will be seen how, at the same time as the Crusaders were consolidating their Latin empire in Constantinople, north-eastern Rus' experienced a flourishing union of Byzantine spatial layout with – rare in the Orthodox world – exterior monumental sculpture. The latter had clear Romanesque and especially Lombard origins.

At this moment, the first of the great turning-points in Russian architectural history occurred. Native response to the emergence of the Romanesque, first of the great international post-Antique styles of the West, was vigorous and decisive (pl. 2). It marked a swing away from the general predominance of the Byzantine heritage and towards the adoption of West European aesthetic concepts. To this period the first chapter of this book is devoted.

One of the principal differences between Russian architecture and Western European tradition lies in the absence of Gothic. Only occasionally are ornamental motifs in the Gothic north German brick style to be found on the exteriors of certain buildings in Novgorod and Pskov, which traded with the Hanseatic towns. The Tatar invasion of the thirteenth century, which cut Russia off from the Gothic world, contributed to the consolidation of its earlier architectural forms. In the course of the fourteenth and first half of the fifteenth centuries, separation from the West on the one hand and the importance of tradition as a means of resistance to the dominant power in the eastern steppe on the other strengthened the Byzantine roots of Russian architecture – although no craftsmen from Constantinople were working in Rus' during this period.

It was at this time that forms of spatial organization that had evolved in Russian church architecture by the first third of the thirteenth century became canonical, to remain fundamental through all subsequent evolution, consolidating a permanent

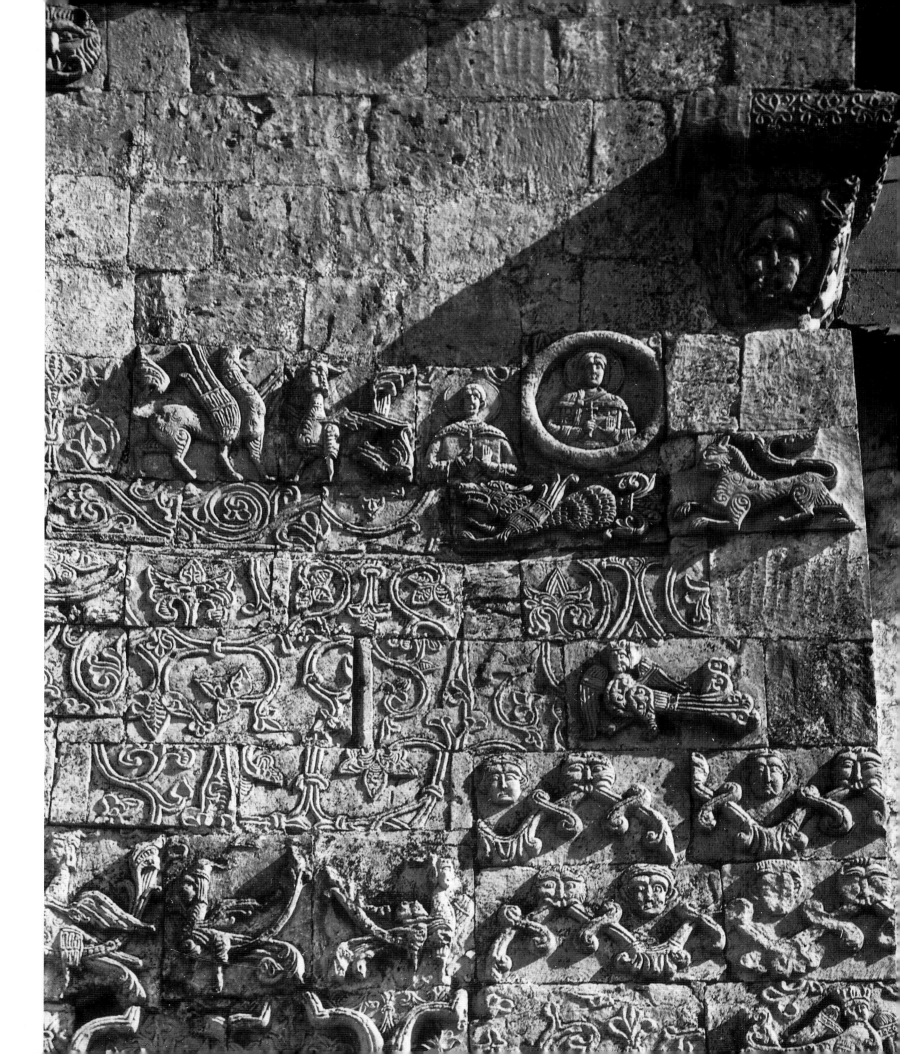

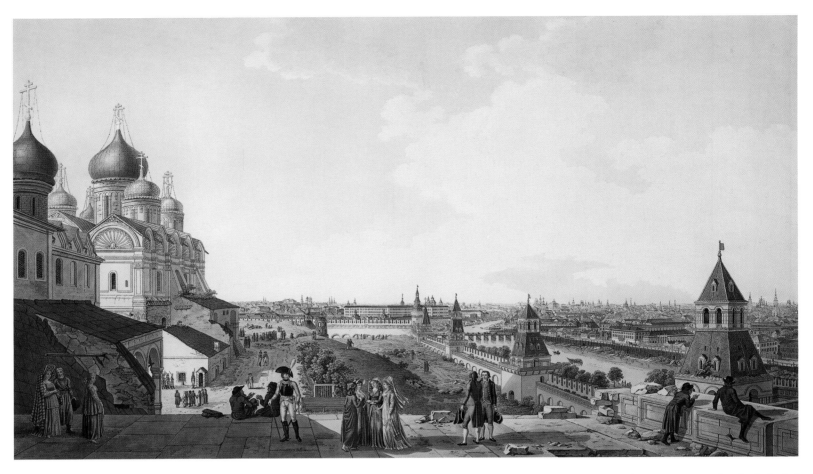

3 *View of the Kremlin and Zamoskvorech'e* (Moscow), engraving after the drawing by Alexandre de la Barte, late eighteenth century. St Michael's Cathedral and the Kremlin wall can be seen in the foreground.

link between the liturgical form of the Byzantine Church and Russian church architecture. The formula promulgated in the mid-fifteenth century by St Iona, the metropolitan of Rus', that Russians should follow "the piety of the early Greek Church laid down by God", contributed much to this process. But the architectural experiment carried out in Vladimir also had its consequences. It was the buildings of the princes of Vladimir, dating from the eve of the Tatar invasion, that provided the basis of the Moscow school, which preserved elements of the synthesis of the Byzantine heritage and the Romanesque style that had been attained in Russia.

It is not customary to speak of the Renaissance in Russian architectural history, in contrast not only to Western art history but also to that of a number of East European lands, such as those represented today by Poland, Hungary and the Czech and Slovak republics. In Chapter 2, which carries what is probably the central argument of this book, an attempt is made to show that, albeit over a long process of time and in its own special way, Moscow architecture contained not only reflections of the Renaissance but the Renaissance itself. It might

have been better to follow Irwin Panofsky in calling this phenomenon one of the "renascences", with a small *r*, to bring out its place in the context of late medieval tradition.[6] In any case, this period saw decisive change in the character of Russian architecture along with increased contacts with the West (pl. 3). From 1474 to 1539 large groups of Italian craftsmen worked uninterruptedly on the tsar's buildings in Moscow. At the same time, after the fall of Constantinople in 1453, many "latter-day Byzantines" settled in Moscow and Venice. In 1472 the marriage took place between Ivan III, grand prince of Moscow, and Sophia Paleologa, niece of the last Byzantine emperor.

Thanks to this couple, a Byzantine-Italian Palaeologue renascence took place, nourished by the dream, if not of a Byzantine recovery, then of the establishment of a new Orthodox empire – a Third Rome. The forms of "early Byzantine piety", perceived in Moscow as an ancient ideal preserved, fused with a Renaissance idea of Rome itself, introduced by craftsmen from Bologna and Milan, Venice and Florence. This produced a mechanism for the assimilation of Renaissance forms executed in Moscow by Italian architects.

These forms were then adapted to the creation of an *architecture parlante* expressing the ideology of the Muscovite state. A new architectural language now sprang up from the use of late fifteenth-century Milanese and Venetian motifs and their combination with early Musvovite elements, which underwent complex transformations in both form and substance (pl. 4). From this process completely improbable buildings resulted, like the church of the Ascension at Kolomenskoye (tserkov' Vozneseniya v Kolomenskom), now on the outskirts of Moscow, or the cathedral of the Intercession by the Moat (sobor Pokrova na Rvu), also known as the cathedral of St Basil (Vasily) the Blessed (sobor Vasiliya Blazhennogo), on Red Square in Moscow (pl. 6). James Billington comments on the meaning of these buildings: "[. . .] during this early period of Western contact, Russians were fatefully conditioned to look to the West not for piecemeal ideas and techniques, but for a

key to the inner secrets of the universe [. . .]"[7] Chapter 2, "The Moscow Paleologue Renaissance", demonstrates how Russian architecture under Vasily III and Ivan the Terrible was bound up with ideas of Russia's place not only in the world but also in the non-Catholic model of the universe. In the seventeenth century, with the incoming Romanov dynasty, the use of *architecture parlante* continuing from the reigns of Vasily III and Ivan the Terrible was accompanied by an ornamental approach based on a striking handling of motifs that went back to Italian models (pl. 5).

From a stylistic point of view, such a handling of Classical forms and their combination with Gothic and Early Russian forms seems to me comparable with Mannerism, and such a comparison is made in Chapter 3, "Post-Byzantine 'Mannerism' in the Muscovite State", which covers the reigns of Ivan the Terrible, his son Fyodor, Boris Godunov and the first three

4 Circle of Fyodor Alekseyev, *View of the Terem Palace* (Kremlin, Moscow), watercolour, late eighteenth century.

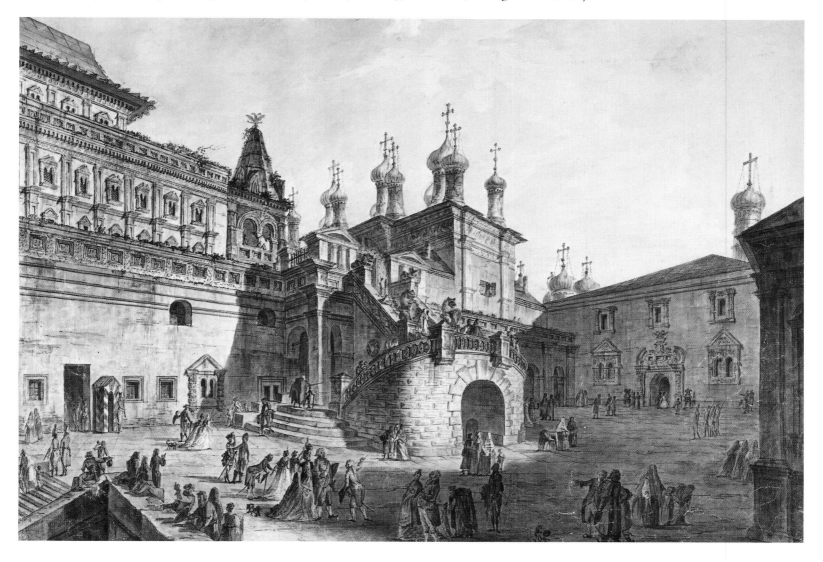

5　Detail of the façade of the church of the Trinity, Nikitniki, 1631–34, in the 1640s–50s.

Romanovs up to the beginning of the Petrine reforms. The complexities of the exuberantly ornamental Russian architecture of the seventeenth century harboured a quest for a new "style", and behind this also lay the persistent attempts under Ivan the Terrible and the early Romanovs to grasp and make use of the engineering and artistic architectural technology then to be found in many West European countries. Russian interest in foreign architecture grew throughout the seventeenth century, and at the same time Mannerist-like motifs gradually gave way to Baroque. To a large extent this can be explained by the "Polish fashion" at the court of Tsar Alexis Mikhaylovich, father of Peter the Great. The Baroque style appeared in Poland a century earlier than in Russia, reaching Moscow via the Ukraine and Belorussia.

In its first manifestations, however, Russian Baroque was not a pure style. Its sources were very diverse – Dutch, Polish, Ukrainian, Saxon, Prussian, Italian. The result was a mixture of Baroque "manners", each of which followed the tastes of the tsar and of those closest to him, of one or another aristocratic clan. Following the death of Peter the Great, a common "Russian imperial Baroque" for all types of building emerged from the achievements of the great architects Pyotr Yeropkin, planner of Baroque St Petersburg, and Francesco Bartolomeo Rastrelli, who gave such grandeur to the principal buildings of Russia's new capital. To this first, unabashedly Western European style in Russian architecture Chapter 4 is devoted, dealing with the architectural reforms of Peter the Great and their consolidation during the second quarter of the eighteenth century.

Chapter 5 covers the architecture of the Age of Enlightenment and the reign of Catherine the Great, whose court included a large circle of foreign and Russian architects. Catherine's artistic policy ensured that Russian architecture

6 Detail of a flanking tower of the cathedral of St Basil the Blessed, Moscow (?Barma), 1555–61.

was connected with the European mainstream, and this was to be seen both in Russia's absorption of various Neoclassical trends and in the emergence of stylistic pluralism in the adoption of Chinoiserie, *turquerie*, Gothic Revival and other stylistic tastes of the Age of Enlightenment. Consolidating what had been done in the eighteenth century, Russian architecture made the nineteenth century well and truly "the European age". So extensive were Russian architecture's international links during this century that it has been impossible to trace all of them in the present account. Chapter 6, "The European Century", is concerned with the general character of Russian architecture from Paul I's short reign to the tragic era of Nicholas II.

The "Europeanization" of Russian architecture was checked not so much by the October Revolution as by first Stalin's totalitarianism and then the gentler version of Khrushchev and Brezhnev. The brilliance of the Russian Avant-Garde led to the establishment of active contacts with the Bauhaus and the school of Le Corbusier, and mutual relations were those of equal partners (pl. 8) before they were brutally broken off by the official adoption of Neoclassicism in the 1930s. The Soviet period, while not bringing the total destruction of contact with Western architecture, can scarcely be called a "European age". At the same time it is practically impossible to consider Soviet architecture outside an international context.

In view of the amount already written on the period by others, I have covered the decades from the October Revolution to the present day by way of a general conclusion, without the extent of detail in the six main chapters.

At the present time Russian architecture once more, as in the tenth, fifteenth and seventeenth centuries, faces the problem of choosing its direction of development. Despite the

9

undoubted necessity of following the path laid down by international developments in architecture, the problem of Russian architectural identity remains a subject of debate. Architectural freedom of choice can be provided today probably only through technological improvement. Such, however, has been the case for ten centuries, during which Russia needed first Byzantine building technology and subsequently the skills of Romanesque masons, Dutch engineers, Italian, French and German architects and urban planners, and English landscape architects. At the beginning of the new millennium, Russian architecture is rapidly renewing its contact with the West.

Notwithstanding its special character, the historical path of Russian architecture has always been linked with that of European architecture as a whole. And it has always responded, in its own way and at times belatedly, but always vigorously, to new Western architectural movements, styles and ideas. It is probable that this tradition will continue, and I personally hope that it will indeed carry over into Russian architecture of the future. Architectural historians will at once see that this book is primarily addressed to the broad public interested in Russian cultural history. It is nevertheless to be hoped that the historical account and comments on individual monuments that it contains might lead to a new, not entirely traditional view of the evolution of Russian architecture and its place in the built environment of Europe.

8 Detail of the Mel'nikov house, Moscow (Konstantin Mel'nikov), 1927–29.

7 (*facing page*) Detail of the main portico of the Pashkov house, Moscow (Vasily Bazhenov), 1784–88.

I

Between Byzantine and Romanesque

1 A Choice of Faith and a Choice of Architecture

Sir Dimitri Obolensky, in whom the blood of his remote Varangian ancestors, tracing their line from Russia's first ruler, Ryurik, mingled with that of the Byzantine emperors, had this to say of what the Byzantine heritage means to Russia.

"Russia's Byzantine heritage" might [. . .] mean either a quasi-permanent, and still existing ingredient of Russian civilization, or a set of influences formerly exerted upon Russia by Byzantium which can no longer be detected at the present time [. . .] The heritage of East Rome was not, as it is sometimes suggested, Russia's "mark of the beast" that isolated her from medieval Europe: it was the main channel through which she became a European nation. Byzantium was not a wall, erected between Russia and the West: she was Russia's gateway to Europe.[1]

Russian architecture was born at the moment when Europe emerged from the Dark Ages. The Byzantine Empire was being attacked by Arabs from the south, by Slavs, Bulgars and Hungarians from Eastern Europe and by Varangians from the seas washing its shores. The new, Second Rome, Constantinople, still had its great churches, Hagia Sophia and the rest, its palaces, forums and aqueducts. The city amazed the barbarians by its size and magnificence, its huge population, the splendour of its church services and court ceremonial. Here the imperial idea was combined with the Christian religion. The union of church and state, the *symphonia*, as the Byzantines called it, continued to exist. Perhaps it was this that drew the founders of the first Russian state to Byzantine culture. At any rate, the role of ruling princes in church-building was to be paramount in Early Russian architecture.

The Roman Catholic tradition at this time could scarcely answer the political ambitions of the Kievan princes. The ancient city was still the holy centre of Italy and the whole western world, but it had lost its lustre as the seat of the supreme secular power. In the tenth century the Eternal City greeted pilgrims with emptiness and vast expanses of majestic ruins, and pervasive undergrowth covered the basilicas that had been built at the end of the Classical era on the outskirts of the city as it had been at that time. Although the German ruler Otto I was confirmed as Holy Roman Emperor, the heartland of the empire of the Germans was far away from the Tiber. Furthermore, in the last quarter of the tenth century neither German nor northern Italian architecture was ready to transmit mature and traditional models to other nations. The West needed time for the creation of the Romanesque style if it was to compete with the architectural splendours of the Byzantine imperial court. At their first contact with the Mediterranean world, the Russians were magnetically drawn to Byzantine culture. However, the first contact was far from friendly.

What is this? What is this evil and terrible power and fury? Why has this dreadful, thunderous blow fallen on us from the far north? Woe to me when I see a wild and savage tribe which, not knowing fear, [. . .] destroys everything; fields, houses, herds, pack-animals, women, children, old men [. . .]. O city that rules over almost all the universe, what uncontrollable army, equipped like slaves, mocks you as if you were a slave [. . .]?

Thus the Constantinopolitan Patriarch Photius, in one of his homilies, described the first appearance of the warriors of "Rus'" before the walls of the Byzantine capital in 860.[2] This was one of the unpleasant consequences of the opening up of the permanent route "from the Varangians to the Greeks [i.e. Constantinople]", from Scandinavia to the Black Sea and on to the shores of the Bosporus, running through the lands which were to become Russia, the Ukraine and Belorussia. For the people of Rus' this route was a means of creating a new state and culture. The Varangian princes and their armed forces

9 (*facing page*) Ornamental carving on the north façade of St George's Cathedral, Yur'yev-Pol'sky, 1230–34.

opened up the surrounding world for the eastern Slavs. However, they brought with them, to Novgorod and Kiev, military skills, not a model of settled life, and they left no trace in architectural history. In scarcely over a century, the charms of Byzantine civilization had conquered the aggression of the "northern barbarians", the success of some Byzantine generals also contributing to the process. Constant pressure on Kievan Rus' from the east, from the Khazars and Pechenegs, also prevented the pagan Varangian princes of Kiev from devoting full attention to the imperial forces, despite the prospects of incomparable booty from military success against them. It was, however, internal factors connected with the creation of the first Russian state that played the crucial role in the entry of Kievan Rus' into the Byzantine cultural orbit.

The new state born on the east European plains needed to choose its cultural model. Existing pagan ideas of the world were inadequate to the complexities of the internal and external political situation of the state that had developed so rapidly, and that had a natural urge to use, among available models, the one that appeared to be the most highly developed at this historical moment. This was especially the case with architecture. The very fact of an initial "choice" seems to reveal one of the key general features of Russian architectural history. Throughout the next millennium the forces and individuals shaping the development of Russian architecture would be confronted with the problem of choosing a type of architectural culture. On each occasion this choice would be made thanks to the historical mechanism that was characteristic of its particular epoch, in all its political, economic, cultural and religious circumstances. In the complex of factors determining choice, most often one single factor would prevail. In the tenth century, in the reign of Grand Prince Vladimir of Kiev, this factor was the problem of the adoption of a state religion, or at least, that was how the early chronicles of Rus' interpeted the situation.

The legendary account of the visits of exegetists of Islam, Judaism, Catholicism and Orthodoxy to Kiev is found in the earliest preserved chronicle, the Primary Chronicle, and also in the chronicles of other peoples of Eastern Europe.[3] In the words of Metropolitan Makary, one of the earliest historians of the Russian Church:

In 960 [. . .] envoys from the Bolgars of the Volga came to Vladimir, proposing that he should embrace the Mohammedan faith. The Grand Prince [. . .] listened to them, not without pleasure [. . .]. But when the envoys said that Mahomet instructed them to practise circumcision and forbade them wine and pork, Vladimir was highly displeased [. . .]. Soon afterwards emissaries from Rome arrived, and

told Vladimir of their principle of "fasting according to one's strength". But Vladimir [. . .] said to them: "Depart hence; our fathers accepted no such principle." Then came the Khazars' envoys [. . .] Vladimir suddenly asked them: "What is your home land?", and they replied: "Jerusalem . . . God was angered by the sins of our forefathers, and banished us from our home land, and scattered us about the earth." "[. . .] If God loved you and your faith, you would not be thus dispersed in foreign lands. Surely you do not expect us to accept that fate also?" At last, the Greeks sent a scholar [. . .]. This scholar showed the Prince a picture of the Last Judgement, and pointed to the righteous ones on the right hand side, going with joy to their eternal home, and to the sinners on the left hand side, being dragged to eternal torment [. . .]. "If you too wish to be among the righteous," the scholar told him, "be baptised. [. . .]" Vladimir replied: "I shall wait a little."[4]

In 989 the Grand Prince chose to be baptised, and ordered his subjects to follow his example. Soon after this, Byzantine architecture made its appearance in Kiev in consequence of the adoption of Christianity as the state religion. In this case, choice of faith signified choice of architecture too.

Russian art and architecture first come into contact with Byzantine culture during the Macedonian dynasty.[5] Byzantine architecture of this period has none of the magnificence of the buildings of Justinian I. Nothing like Hagia Sophia, with its extraordinary boldness and precision of execution, was possible in tenth-century Constantinople, which lacked aspiration towards the monumental symbolism of the huge spatial designs that was so characteristic of early Byzantine architecture. However, the interiors of secular buildings of the Macedonian dynasty, in their variety of marbles, abundance of mosaic, and murals of astonishing quality, were in no way inferior to the achievements of the Justinian era. The exquisite splendours of late Antique floor, wall and vaulting decoration and the heritage of early imperial buildings were preserved at the Constantinopolitan court, and it was this that most impressed West European and Russian travellers, including Princess Olga, mother of Vladimir I, who is said to have been converted to Christianity on a visit to Constantinople.

The main feature that Russian architecture took from the Byzantine was the so-called cross-domed or cross-in-square system, which was fairly simple to execute and was soon in universal use. This layout, of square general outline, was divided in its interior by four supports into nine "cells" (in the simplest case, if the number of supports increased, so the number of cells increased also). These supports, in Constantinople most often columns, in Russia usually simple pillars, made it possi-

ble for vaulting underneath a central dome to bear on a drum. The remaining eight cells had small vaulted ceilings. Whatever the overall dimensions, this system practically always remained identical. During the Macedonian dynasty it became the standard Byzantine church design. Theologians of the "empire of the Romans on the Bosforus" gave a symbolic sacred interpretation to each part of the cross-domed system. This type of spatial design reached Russian architecture in Kiev immediately after the conversion of Rus' to Christianity, and once mastered, it remained in use for many centuries and was the basis for the persistence of Byzantine basic principles in Russian architecture.

In his classic *Byzantine Architecture* Cyril Mango observes:

[. . .] Byzantium gave to Russia basically one, all-purpose church, namely, the cross-in-square, which could be used in a number of variants. At its simplest, it had three aisles, four piers, and one dome; by fusing the nave with the narthex, a more oblong, six-pier plan could be obtained; or else the core of the church could be surrounded on three sides by an ambulatory, thus producing the effect of a five-aisled church.

It is interesting to observe that Russia did not borrow from Byzantium either the triconch plan, which was certainly coming into vogue in the tenth century, or the octagon on squinches, which was introduced in the early eleventh. Indeed, one may say that there was only one major infusion of Byzantine architectural concepts into Russia, namely, in the period 990–1070, and that this infusion was confined to the cross-in-square type [. . .].[6]

Mango's observations are entirely correct. The centuries-long attachment to a single main architectural church type and its derivatives may be taken as perhaps the leading unsolved problem of Russian architectural history. It is not the case that Russian architects saw no other Byzantine types of church; they abounded throughout the empire, and the craftsmen who came from that city to Kievan Rus' over a period of eighty years were unquestionably familiar with them. In other Slavonic countries in the Balkans possessing a Byzantine heritage there was no such universal preference for one type of church only. What was it that brought about the continued use of the cross-in-square system in Russia? What is it that constitutes "the Byzantine heritage" in Russian architectural history?

Conceptions of Russia's Byzantine heritage were to change in the course of the centuries. At first, at the end of the tenth century and for most of the eleventh, they sprang directly from the creative and technical projects of Byzantine builders. Then within a century, the Byzantine idea was differently interpreted in numerous lands and principalities throughout Early Rus'. Despite striking differences in their approach to decoration,

what was common to all these styles was their adoption of a single type of liturgical space, and this continued to be the case up to the Renaissance period. In the second half of the fifteenth and beginning of the sixteenth centuries, another model of the Byzantine heritage appeared, combining Renaissance with Early Russian forms. In the Orthodox world the image of Byzantine culture as that of a Second Rome gave way to that of a Third Rome, a Second Constantinople and a New Jerusalem – Moscow. These ideas outlasted both the era of Petrine reforms and the age of Neoclassicism. Constancy of spatial organization continued in Russian church architecture, emphasized in nineteenth-century buildings in Byzantine-Russian style and even surviving into Soviet times. This consistency was the basis on which Russian architectural traditions were maintained for a thousand years, from the absorption of the Byzantine heritage which began with the conversion to Christianity up to the present day. It is time to consider how this tradition began.

2 The Architecture of Kievan Rus': The Emergence of a Model for Sacred Buildings

Work on the construction of the first well-known masonry building in Rus' began soon after the country's conversion to Christianity in 989, and was completed in 996, its relatively lengthy period of construction probably being due to the unusual richness of its decoration. Vladimir, grand prince of Kiev (956–1015; later canonized), the chronicler records, "living in accordance with the Christian code, conceived the idea of founding a church dedicated to the Most Holy Mother of God." The chronicler emphasizes that this church was built by Byzantine master builders who had been specially sought: "and having sent for them, he brought over masters from the Greeks."[7] Here is another motif which continues throughout the entire history of Russian architecture – the search for master builders and craftsmen. The question always immediately arises as to who was sent to look for them and where. Another very important question is the identity of those who were invited to Russia. On the basis of later similar cases it may be said that Russian sovereigns usually gave precise prescriptions for the capacities they sought in the craftsmen they required, and their envoys tried to find craftsmen for the execution of specific tasks. This would seem to be how Vladimir proceeded, as in fact has been indicated by excavations of the first masonry buildings in Kiev, the grand prince's palace and the Desyatinnaya church, destroyed by the Tatars in 1240 (pl. 10).

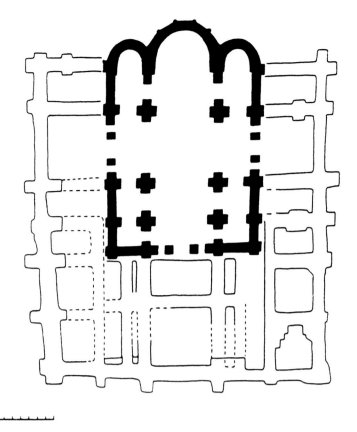

10 Plan of the Desyatinnaya church, Kiev, 989–96.

Archaeological research has produced a number of different interpretations of this complex of buildings,[8] but the consensus of conclusions may be summarized as follows. The church and a series of palace buildings almost entirely surrounding it were built at the same time.[9] Remains of these buildings have been found to the north, south, east and also west of the church, i. e. to either side of the main entrance. The southernmost of these buildings was huge in comparison with the church, while that to the west almost abutted it. Before it was rebuilt at the beginning of the eleventh century, the church was very small, the diameter of its main dome being no more than six metres. Its plan was typical of a Byzantine church of the Macedonian dynasty, indicating the cross-domed system with three aisles, six cluster piers dividing the aisled area and three apses on the eastern side.

It is true that this plan has some typical features of *architecture parlante*. The central aisle is almost three times as wide as the other two. The pair of piers nearest to the west entrance is placed almost against the wall. The second pair is not far away from the first, while the third, easternmost pair is placed close to the corresponding apse. Thus a square space is created at the centre of the building, linked to the main apse, which is also significantly larger than the side apses, and the periphery of the

interior is drastically curtailed. With great ingenuity, space has been found for grand ceremonial services intended for a small number of participants. This church, without doubt, would have served the prince's court, not the city. Furthermore, there were similar, unusually wide ceremonial triple entrances from south, north and west, possibly designed for processions of some kind connected with the surrounding palace buildings, as was customary in the Byzantine capital.[10]

It is also to be noted that in this church traces of the most sumptuous architectural decoration of all Russian medieval churches from the tenth to the fifteenth century have been found: marble wall finishing, porphyry inlay, choir parapets of red slate with marble fretwork mountings. Among finds on this site are traces of green and white marble, porphyry of various hues, and ceramic tiles of many different colours. The chronicle records that St Vladimir donated to this church the whole hoard of precious ware taken in the storming of Kherson, and appointed priests from that town to serve in it.[11] Perhaps the most striking fact of all is that among ornamentation found on this earliest known site of a building complex in Kiev executed by Constantinopolitan masters, sculpture from antiquity has been found. Behind the church a bronze quadriga and two female statues were placed, "like women in form, being made of marble", presumably also taken at Kherson.[12]

All this together gives a surprising picture. The Constantinopolitan builders constructed not so much a complex of religious buildings as a palace complex containing a church, using the same forms and materials as those found in the Byzantine capital and some items that even in Constantinople rated as "relics of Antiquity" – probably late Roman sculptural fragments. Here in fact was an attempt to transport to Kiev not only an architectural model but also, as far as was possible, the aesthetic milieu of Constantinopolitan court life. For the execution of this task, the services of master builders from the Byzantine capital were essential.

In this process a clear-cut programme is discernible – the use of an established Byzantine architectural vocabulary to express the prestige and special character of a supreme power, with a splendour unseen before in Rus'. The divinely sanctioned authority of this power was indicated by the fact that this first stone Orthodox church in Kiev was the centre of a whole palace complex. The project shows the application of the Byzantine method of architectural expression to the idea of the centralized state. It was in full accordance with St Vladimir's determination to marry the sister of the Byzantine Emperor, one of those born to the purple and reared in the porphyry-decorated rooms of the palaces of Constantinople to join the elite of European monarchs. The exactness with which Constantinopolitan palace layouts were reproduced could be

checked and corrected by Vladimir's wife Anna and the retinue who accompanied this Byzantine princess to a country newly converted to Christianity.

In order to achieve all this, craftsmen taken prisoner at Kherson were scarcely adequate, and so, as mentioned in the chronicle, envoys were required to travel to Constantinople in search of master builders and craftsmen of various specialities, and of materials that were scarce or unavailable in Eastern Europe. The funding of the church's construction also took an unusual form – the grand prince contributed one-tenth of his revenue towards its cost, and it entered history by the name of the Desyatinnaya, or Tithe, church.

Building activity in Rus' was interrupted by the death of Vladimir in 1015 and the internecine strife between his sons that ceased only when the country was divided into two parts. Prince Yaroslav Vladimirovich – subsequently called "the Wise" in the chronicles – established his domain in the west, with Kiev as his capital. The eastern lands, centred on Chernigov, passed to his brother Mstislav. The latter began a major building programme earlier than Yaroslav. Among the churches he commissioned was the cathedral church of Chernigov, the cathedral of the Transfiguration (Spaso-Preobrazhenskiy sobor). This is the oldest surviving Russian church (pl. 11). Also of the cross-domed type, with six piers and three apses, in many of its features it resembles the Desyatinnaya church, but it makes a more strictly Byzantine impression than the latter.[13] As is frequently the case in the churches of Constantinople, between the piers round columns are placed, probably of marble, which is extremely rarely found in medieval Russian churches. In contrast to the Desyatinnaya church, there is nothing regal about it, neither prominent central ceremonial space nor unusual tripartite entrances. There is, however, as is customary in the churches of Constantinople, a "narthex" (vestibule) on the west side.

The choir tribunes above the narthex and side aisles are of unusually elaborate construction, as are the staircase towers on either side of the narthex which give access to them. And particularly unusual for a Byzantine church is the hypertrophic development of the upper storey of the interior. It is possible that this signifies a separation into an upper, aristocratic part of the church and a lower part for the common people. Apportionment of space for persons of princely standing was to become one of the most important aspects of Russian church architecture, testifying, however, more to social concerns regarding the separation of groups of the congregation according to their status than to the expression of ideas of the state such as those seen in the Desyatinnaya church. In this matter Mstislav's architectural ideas differed from those of both St Vladimir and Yaroslav the Wise.

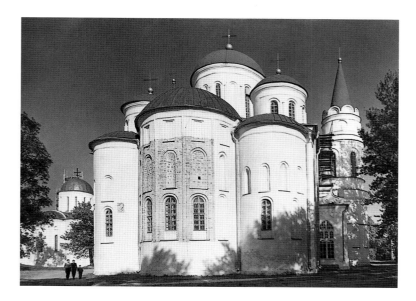

11 The cathedral of the Transfiguration, Chernigov, pre-1036.

Yaroslav, who survived his brother Mstislav to become the sovereign prince of Rus', was renowned for his intellectual interests and achievements. These were fully reflected in the new interpretations of the Byzantine architectural models that emerged during his reign. In his plans for the extension and improvement of Kiev, the aim of imitating Constantinople was not limited to bringing to Kiev a fragment of the residence of the Byzantine emperor that was imposing in its splendour, but also included a desire to reproduce all the basic landmarks of Byzantine religious architecture in Constantinople.

The chronicle for 1037 records: "Yaroslav founded a great city, and this city has a Golden Gate; he also founded the metropolitan church [cathedral] of Saint Sophia, and then, on the Golden Gate, the church of the Annunciation to the Holy Mother of God, and then the monastery of Saint George and the church of Saint Irina."[14] The monastery was so named because St George was Yaroslav's patron saint; he had kept his Slavonic name as his princely name but had been baptized Georgy. The other dedications here – to St Sophia and St Irina, as well as the name of the Golden Gate – indicated the most important buildings of Constantinople as direct models.

The essential element in the ideology of Yaroslav the Wise was the introduction to Russia of the symbol of *Sophia*, Holy Wisdom. This had far-reaching consequences, revealing the prince's high ambition and his concept of the role of Rus' in the Christian world. The cathedral of St Sophia (sobor Sofii) was built at a time when the international links of Kievan Rus' were being vigorously extended. The marriage of Yaroslav's daughter Anna to a king of France was the most brilliant of several international marriages made in Yaroslav's immediate

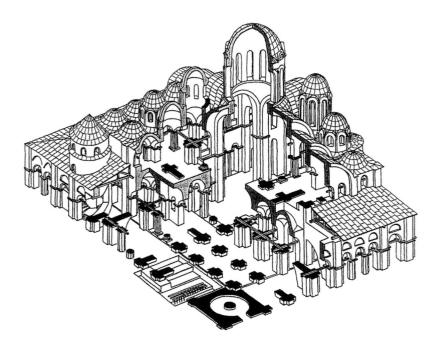

12 Reconstruction by Yu. Aseyev and A. Ikonnikov of the cathedral of St Sophia, Kiev, begun before 1037.

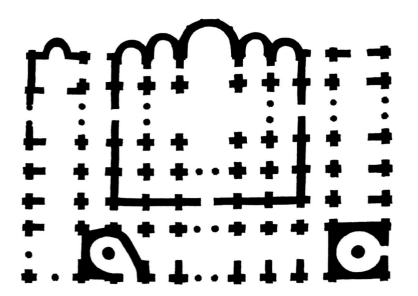

13 Plan of the cathedral of St Sophia, Kiev, begun before 1037.

family. Yaroslav saw his capital as one of the focal points of the Christian world and sought to give expression to this vision in a number of major buildings.

Up to the end of the fifteenth century, St Sophia in Kiev (pls 12–15) was the largest cathedral in Rus'. With its galleries, its main façade measured 54.6 metres; the main dome, which had a diameter of 7.6 metres, was surrounded by twelve smaller domes. Unfortunately, the building has suffered much destruc-

tion and rebuilding in the nine centuries of its existence. Its appearance was especially altered in the seventeenth century, when Ukrainian Baroque features were grafted onto it. Nevertheless, the substantial degree of preservation of the interior and painstaking research by architectural historians over more than one and a half centuries make it possible to imagine how it must have looked at the time of Yaroslav the Wise.[15]

Various opinions have been expressed as to the sources of the architectural forms of St Sophia, not infrequently connected with national feeling or political causes.[16] Without entering into detail on this vast subject, the present writer is in agreement with Cyril Mango:

> For my part, I fail to see any feature of St Sophia that is not Byzantine: the masonry technique, the plan, the pyramidal arrangement of the domes, the recessed arches, the discreet use of meander patterns on the exterior, and every detail of the interior decoration are not only Byzantine but specifically Constantinopolitan. In saying this I do not wish to imply that Constantinople can provide a carbon copy of the Kievan St Sophia.[17]

Pavel Rapoport, concurring with this statement, considered that it would have been impossible to complete such a huge project in such a short time (if the chronicle is to be believed, the cathedral was built in four years – half the time it took to build the Desyatinnaya church) without the involvement of local craftsmen.[18]

Whoever the builders of this great cathedral were, two facts are clear and irrefutable. First, it belongs to the Byzantine building tradition. Secondly, it is the largest and, from an art-historical point of view, most important eleventh-century building in that tradition, and moreover, not only in Rus'. And there is a further important factor. The Byzantine architectural language of the first half of the eleventh century is used here to express an ideology originating not in Constantinople but in Kiev, at the court of Yaroslav the Wise.

The main task confronting the Constantinopolitan builders must have been how to construct a cathedral of exceptionally large size, the largest size they possibly could. Here Yaroslav took the model of Hagia Sophia in Constantinople as his keynote in a purely theological sense. No attempt was made at formal citation of the Hagia Sophia. This could scarcely have been due to a lack of boldness or of technical means; some token conveying the concrete appearance of the principal church of the "Empire of the Romans on the Bosforus" could perfectly well have been devised. This negative fact is fundamental to an understanding of Yaroslav's whole architectural approach. He did not set out to copy his model. He sought to reflect, by the means of his own time, an ancient symbol that

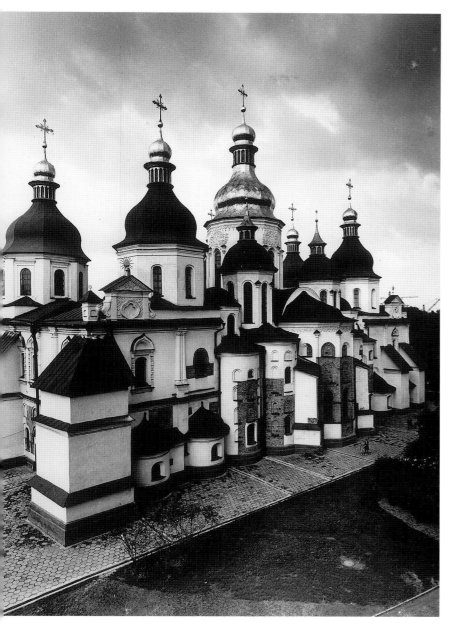

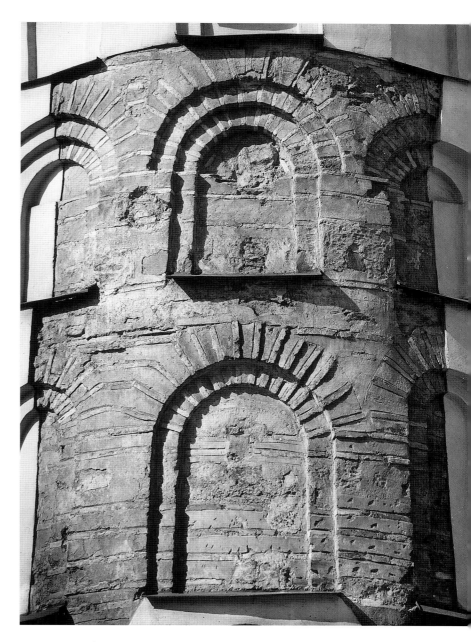

14 East front of the cathedral of St Sophia, Kiev, begun before 1037.

15 Section of original masonry of the cathedral of St Sophia, Kiev, begun before 1037.

was fundamental to both the Empire and the Orthodox Church. The dedication of the huge cathedral to Sophia, Holy Wisdom, as in Constantinople, transformed his state into an Orthodox, right-thinking realm. This must have been how the grand prince understood his political act, which he repeated in buildings in key centres of his territories – Novgorod in the north and Polotsk in the north-west.

All three of Yaroslav's cathedrals dedicated to St Sophia have a five-aisle cross-domed plan. The fact that the main body of these buildings takes such similar form points to a single conclusion as to what must have been the special function com-

mon to all of them: that of a church in which the grandest possible form of service could take place in the presence of the prince.

The central area of St Sophia in Kiev stands out especially clearly as a cross-in-square under the main dome. Around the five-aisled cathedral with its five apses, to south, north and west are first narrow two-tier galleries and then wide and narrow single-tier galleries.[19] The second tier of narrow galleries served as a continuation of the choir tribunes, which also surrounded the central area of the aisles on three sides (pls 16, 17). The two staircase towers giving access to the choir tribunes are asym-

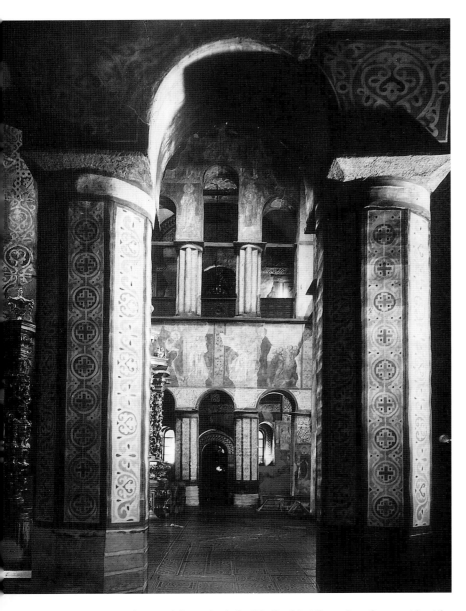

16 Central area of the cathedral of St Sophia, Kiev: view from a side aisle.

structure is far more developed in St Sophia in Kiev than in any other church built in Rus' over the next five hundred years.

If the Desyatinnaya church was part of a palace complex, the cathedral of St Sophia fulfilled the role of centre of the city and, above all, symbol of Russian Orthodoxy as a whole. Its structure was duplicated in Novgorod, and to a lesser extent in Polotsk. The lesser complexity of these two cathedrals is a function of the political significance of their cities.

Scholars have repeatedly emphasized the special nature of the silhouette of the cathedral of St Sophia in Kiev; that its mass rises stepwise up to the central cupola, giving the whole the character of a pyramid. In this Nikolay Brunov has even seen a connection with conical burial mounds.[21] Andrey Ikonnikov considers this an exaggeration, however, [22] at the same time rejecting Aleksey Komech's interpretation of the design of the cathedral in purely constructional terms, outside the realm of ideas.[23] Ikonnikov sees in St Sophia an expression of the idea of universal harmony, heavenly hierarchy, which the church must communicate visually on earth. It is hard to say how far such ideas, difficult to express through the architecture of a single building, could have occurred to Prince Yaroslav.[24]

The ideology of the cathedral of St Sophia in Kiev would seem to rest on quantitative features and clearly expressible symbols. First of all, the idea of the power of the grand prince of Kiev among Christian, and indeed all neighbouring rulers. Hilarion, metropolitan of Kiev, one of the most outstanding figures of the Russian Orthodox Church of the eleventh century, who witnessed the building of the cathedral, stated in his *Discourse on Law and Grace* that the church that was built was "wondrous and glorious to all surrounding countries [. . .] from east to west".[25] This was the effect of its huge size and the magnificent workmanship of its interior, the breathtaking mosaics and marble work brought from Constantinople, the frescos and sumptuous plate. Yaroslav the Wise adorned the new cathedral, as Hilarion emphasized, "with every kind of beauty, with gold and silver and precious stone".[26]

Another idea contained in the building of the cathedral concerned its role as protector of the city and guardian of its sanctity. "A house of God in the great sanctity of Divine Wisdom [. . .]" was built "to the sanctity and sanctification of Thy city [. . .]. And to the city it can be said: rejoice, faithful city, God is with you."[27] It may be seen from this that the purpose of St Sophia was to be the centre of the sacred topography of Kiev. Hilarion even compared Yaroslav with Solomon, builder of the great Temple. St Sophia contained, further, New Testament symbolism: the main dome and the twelve smaller ones inevitably suggested Christ and the Apostles. All these

metrically positioned (the one to the south was actually built later). The interior of St Sophia contains a combination of several clearly defined spatial plans.[20] First of all there is the high central cell, undivided into tiers, beneath the main dome. Three rows of round columns leading off this make a striking impression, an altogether fitting architectural setting for solemn processions. A significant proportion of the aisled area, that is, the areas beneath the choir tribunes, is low-ceilinged, creating a sharp contrast between the centre and the periphery of the cathedral. The upper storey of broad galleries could play an independent role, as could the spacious exterior galleries which were added later; here various events of either a religious or a political nature could be accommodated. This complex spatial

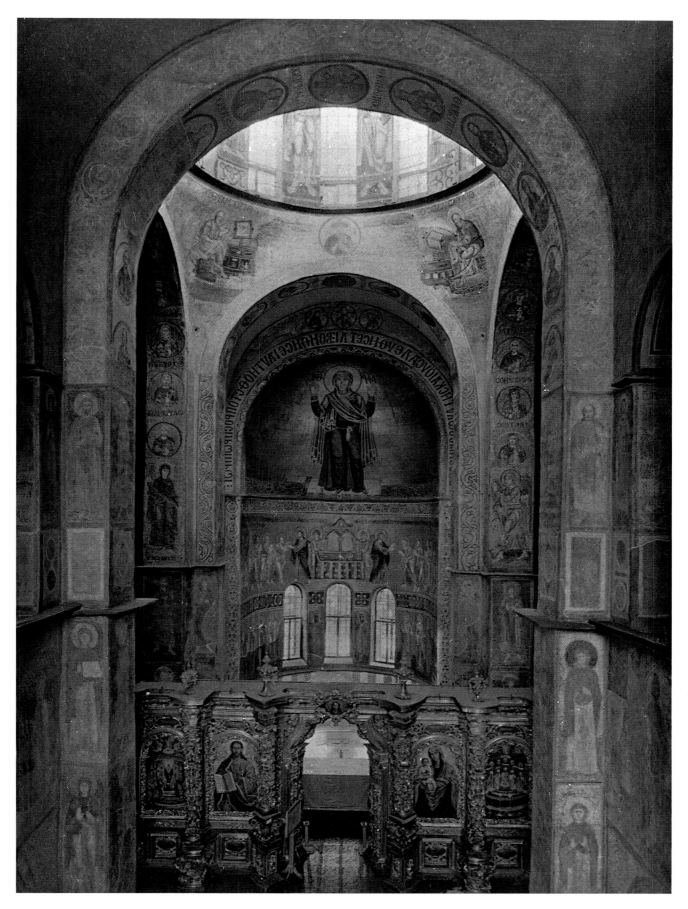

17 Central apse of the interior of the cathedral of St Sophia, Kiev, begun before 1037.

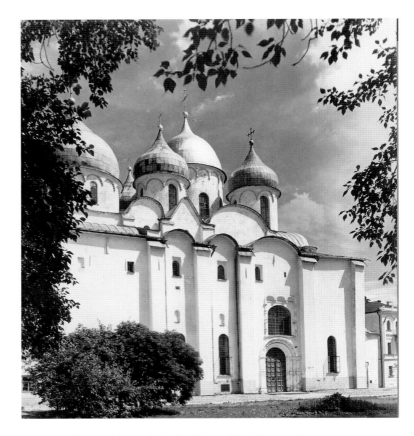

18 Plan of the cathedral of St Sophia, Novgorod, 1045–50.

19 West front of the cathedral of St Sophia, Novgorod, 1045–50.

themes, only touched on here, were to emerge with increasing distinctness in Russian architecture in the course of the following centuries.

The cathedral of St Sophia, Novgorod, built in 1045–50 in the second most important city of Rus' at the time, clearly departs from the Kiev model (pls 18, 19).[28] The central area is smaller. Of the five aisles, only the three middle ones have an apse. There is only one wide tribune, with one tower staircase, placed, as in St Sophia in Kiev, asymmetrically. The number of cupolas is reduced to five. There was also a change of building technique: Pavel Rapoport has suggested that for lack of locally produced Byzantine-style narrow bricks (*plinfy*), thin limestone slabs were extensively used instead in the building of this cathedral,[29] which brought a difference in the wall surfaces but not in overall aspect. This was a question of imitation of unavailable materials rather than conscious adoption of a new technique – the deliberate forsaking of Constantinople-style brick for stone would have been a great innovation.

The Novgorod St Sophia is also very different from the Kiev cathedral in the nature of its imagery. In the latter building both the exterior and the interior are far more complex, varied and pictorial. The Novgorod cathedral makes a more severe, monolithic impression, the court-oriented features of Constantinople giving way to laconic monumentalism.

The third of the St Sophia cathedrals, built in Polotsk in the mid-eleventh century, is the least well preserved. Its form, apparent only from reconstruction based on its plan and from archaeologically discovered fragments, develops the features of the Novgorod cathedral still further in the same direction.[30] After this third great early cathedral was completed, building activity in Kievan Rus' returned to Kiev.[31]

It was in this city that the building of monastic churches evolved. In general, masonry churches were built in the seats of princes of the ruling line. But monastic churches had a completely different character from the mighty St Sophia cathedrals designed with state purposes in mind. Of more modest proportions, they exercised a major influence on the development of Russian architecture until at least the fifteenth century. A large number of monastic churches was built, leading to the emergence of a well-defined architectural canon. The foremost examples in Kiev were the cathedrals in the Demetrius monastery (Dmitriyesvkiy monastyr', 1060s) and in the Old Vydubitsky monastery (Staro-Vydubitskiy monastyr', 1070s), the cathedral of the Dormition in the Monastery of the Caves (Uspenskiy sobor Kievo-Pechorskogo monastyr, 1073–78, and the cathedral of St Michael's monastery "with the golden roofs" (sobor Mikhaylovskogo Zlatoverkhogo monastyrya), begun in the second half of the eleventh century and probably completed at the beginning of the twelfth. All these churches had three aisles, three apses, a choir-gallery at the west end and six pillars. They were of fairly small size, the west front not exceeding 15 metres, and had a single cupola. In most cases a baptistry was built next to the church in the form of a small chapel with a dome surmounted by a cross.

The most important of these buildings was the cathedral of the Dormition in the most renowned of the Kiev monasteries, the Monastery of the Caves (Kievo-Pechorskaya lavra).[32] The site of the monastery was the dwelling-cave of the hermit St Antony Pechorsky who settled there around 1051; the monastery was then established in a chain of caves excavated by monks in the high bank of the River Dnieper. Permission to build the church and further monastery buildings above the caves was granted by the grand prince Izyaslav in 1062. Under the abbot Theodosius, the monastery adopted the rule of the Studion monastery in Constantinople, received directly from the Patriarch of Constantinople[33] and based on the *kinoviya* system – a monastic community and shared economy, a strict regimen and hierarchy.[34] The Kiev Monastery of the Caves acquired immense significance in Russia as a model that was adopted by monastic communities throughout the country.

In 1073, in the reign of Prince Svyatoslav Yaroslavich, "four men, master church builders" were sent for from Constantinople to build a cathedral in the Monastery of the Caves.[35] They completed it in five years. The chosen model was not from Constantinople but from Kiev itself. The general form of the Desyatinnaya church was adopted, perhaps with deliberate reference to its significance as the first Russian masonry church to be built after the country's conversion to Christianity. This is a most interesting indication that even in this early period Russian patrons showed a preference for the oldest available local model. And, the Desyatinnaya church being anyway wholly Byzantine, its choice as a model could scarcely have presented the architects from Constantinople with any problems or grounds for objection.

The cathedral, of short-rectangular plan (pl. 20), has three aisles and four pillars supporting the vaulted ceiling, a single cupola with long narrow lights, a narthex at the west end within the main perimeter of the plan, and a baptistery which is slightly detached from the south wall. The façades are divided by shallow pilasters without capitals (*lopatki*) corresponding to the positions of the pillars of the interior and crowned by semi-circular arches; the flat recesses between them have narrow windows, some of which, probably to conserve heat, are blind. The apses are faceted, their corners extending into elongated fasciae (*tyagi*).

Such, in its main features, was to be the typical church form in Rus' for the next five centuries. Even considering the fame of the Kiev Monastery of the Caves and the veneration in which the complex has always been held by Russians, it is nevertheless surprising that a monastic church should have been a model for many later secular buildings in major cities and appanage principalities of north-eastern Rus'.

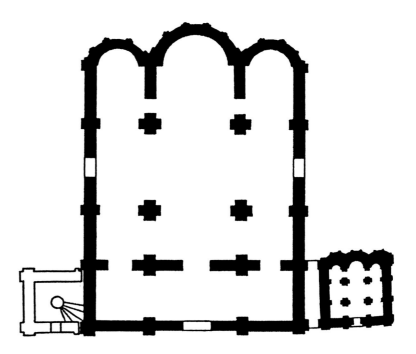

20 Plan of the cathedral of the Dormition in the Monastery of the Caves, Kiev, 1073–78.

It is to be noted that the cathedral in the Monastery of the Caves, like the principal cathedrals of Vladimir and Moscow, was dedicated to the Dormition of the Virgin. Though all commentators have noted that the model for this monastic church was a court building, the Desyatinnaya church, it is all too often forgotten that that church too was dedicated to the Dormition of the Virgin.[36] When the cathedral of the Dormition was built in Vladimir as the cathedral church of north-east Rus', the Desyatinnaya church still existed; it was destroyed by the Tatars a century later. Most probably this first church to be built after the conversion of Rus' and associated with the memory of the first Christian ruler of Rus', St Vladimir, also served as a symbolic prototype for the cathedral church of Vladimir, just as it had a century earlier for the cathedral in the Monastery of the Caves. The idea content of the successive cathedrals dedicated to the Dormition would appear essentially different from that of the three St Sophia cathedrals. The latter were oriented towards the principal sacred building of Constantinople and associated with the whole Orthodox world; the appeal of the former was to local tradition, illumined by a model of the true Christian life, the monastic regime, and the special patronage of the Virgin. It is possible that the Blachernai monastery in Constantinople, which already had associations with the Kiev Monastery of the Caves, and was the site of the miracle of the Protective Veil of the Mother of God, was also a significant influence. Overall, in the churches dedicated to the Dormition

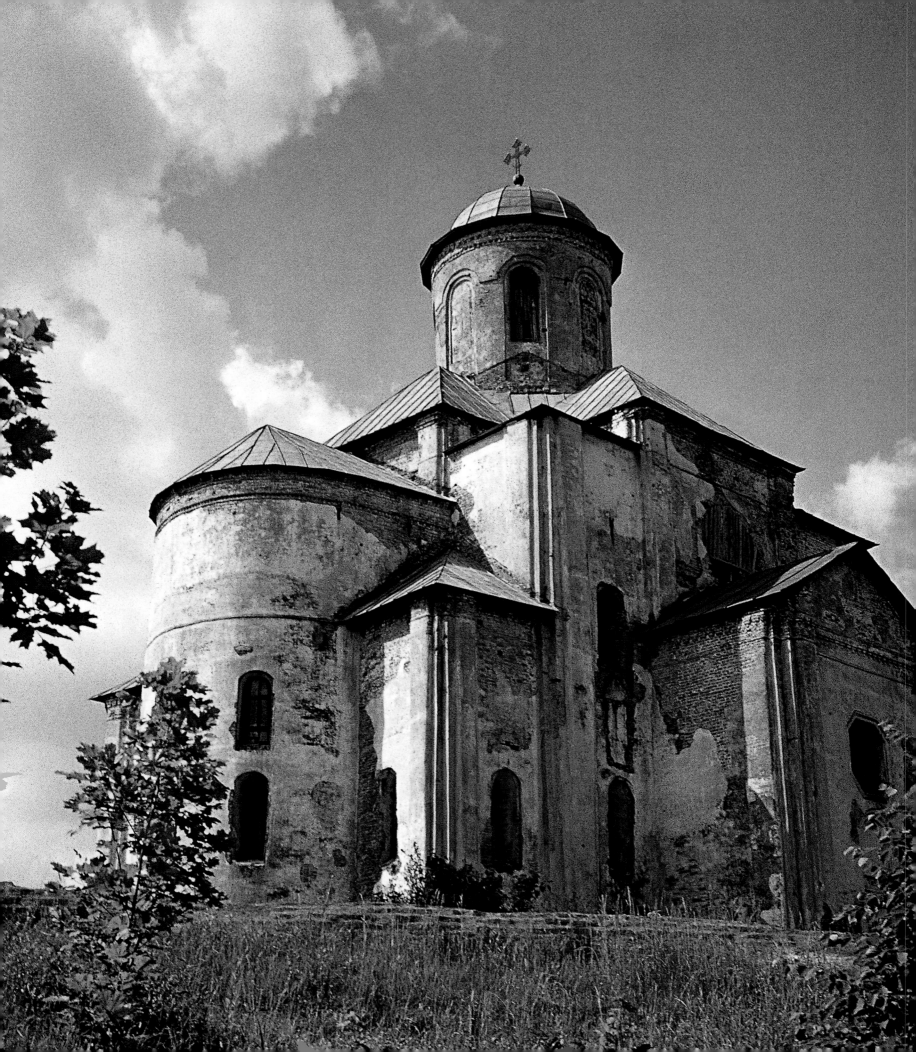

the type of the monumental, complex St Sophia cathedrals was replaced by simpler architectural forms.

By the twelfth century the political situation in Rus' had significantly changed. This time is usually called the period of "feudal fragmentation"; two mutually opposed trends were uppermost. Individual principalities had gained independence – Chernigov on the east bank of the Dnieper, joined by lands further east as far as Ryazan'; Polotsk and Smolensk in the west, Volynsk and Galich in the south-west, Novgorod and Pskov, which had rapidly developed into aristocratic republics, in the north-west. In the second half of the century, these principalities in turn began to split into smaller territories under various members of the Ryurik dynasty. It was in the larger principalities that architectural schools sprang up in the twelfth century.

At the same time, the idea of the unity of the land of Rus', the state of Vladimir and Yaroslav the Wise, was very strong, and it was strengthened by the existence of a hierarchy of principalities and the custom whereby a prince, after the death of an elder relative, would move his dwelling to a more important town. This system, as often as not, did not work well, and in the course of the twelfth century it was less and less practised. However, the notion of a ranking order of principalities, and of Kiev as the established centre of all Rus', definitely remained in both political and architectural thinking. This trend predominated in the first half and middle of the twelfth century, architecturally evident in the Kiev school, within which Pavel Rapoport is inclined to place not only Kiev itself but also Chernigov, Ryazan' and Smolensk.[37] Rapoport has shown, furthermore, that buildings in these cities were the work of interlinked groups of masters, sometimes belonging to one and the same itinerant artel, often following a prince when he moved to a more prestigious capital. An artel would split into separate units when several commissions came at once. If the buildings of Kiev bore the stylistic mark of the previous century, those of Chernigov began to display new features.[38]

Strict adherence to the plan that grew from the models of the Desyatinnaya church and the cathedral of the Kiev Monastery of the Caves became a long-lived tradition in Russian architecture. It was at this moment that the short-rectangular plan with three apses and six pillars, with the pillars supporting the cupola more widely spaced and picking out the main area where divine service took place, became the standard model of the Russian Orthodox church. This model, however, became more and more laconic, as seen in the growing massiveness of each part of the structure and the precisely articulated interior and exterior rhythms. Preserved façade detail shows restraint in ornament. During excavations at the monastery of SS Boris and Gleb in Chernigov, however, carved white stone capitals of clearly Romanesque style were found, the earliest example of contact between Byzantine and Romanesque architecture on Russian soil. The origin of these capitals, unfortunately, is completely unknown, though it is evident that they are the work of craftsmen who were familiar with Romanesque forms.

When Prince Vsevolod of Chernigov finally became grand prince of Kiev in 1078, his builders constructed the church of St Kirill, and the same artel probably next worked in Pereslavl'-Yuzhny, Smolensk and Vladimir-Volynsky. Churches built at this time in all these cities have predominant features of one and the same school.[39] Smolensk, especially the church of SS Peter and Paul, stands out for its heightened ornamental element, with *lopatki* bearing decorative string-courses and the drum small arches, cross-shaped reliefs and inset ceramics. These features look forward to the birth of an independent west Russian school in the last quarter of the twelfth century in Smolensk and Polotsk.[40]

Major building activity took place throughout the twelfth century in the wealthy cities of northern Rus', which sent their own products to north-west Europe via the Baltic and were important shipping ports for goods from the East and furs from the Far North. Novgorod churches of the twelfth century displayed no special characteristics of their own, having four pillars and a narthex or six pillars without a narthex, usually with a gallery accessed by a spiral staircase.[41] The number of cupolas of Novgorod churches varied from five (cathedral of St Nicholas / Nikol'skiy sobor, 1113) in the Yaroslav palace complex, to two (church of St George's monastery / Yur'yevyy monastyr', 1119). The chief ornamental features of the façades were the two-tiered niches which sometimes contained windows. These churches, without ornament apart from modest features on the drum supporting the cupola, were even more severe and monumental than the churches of the Kiev school. The appearance of the churches of Novgorod built in the first half of the twelfth century shows a growing distance from the earliest churches constructed in Rus' by builders commissioned from Constantinople.[42]

By the end of the twelfth century, the architectural situation in both Novgorod and Smolensk had changed.[43] The process began in Polotsk, the most north-westerly of the principalities of Rus', which had been conquered by Kievan Rus' later than other principalities but before this had led an independent existence earlier than the rest. The builders who led architecture in Chernigov, Kiev and Novgorod in a more laconic, restrained and simplified direction did not work in Polotsk, where the intricate, elegant and ornate architectural style of the period of Yaroslav the Wise was preserved. From Polotsk this style reached nearby Smolensk, finding especially striking

21 (*facing page*) Church of the Archangel Michael, Smolensk, 1191–94.

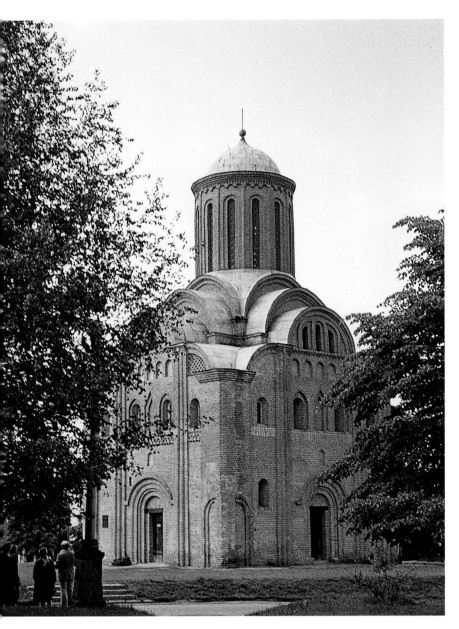

22 The Paraskeva Good Friday Church, Chernigov, beginning of the thirteenth century

in itself, but was raised on a special triple-arched pedestal. All *lopatki*, at corners and in recessed parts of the façades, were in the form of vertical fasciae (*tyagi*). All these features gave this church a new, upward impulse. Its type spread throughout Smolensk, where it would appear that five or six similar churches were built which have not, unfortunately, survived.[44] This type was introduced to Novgorod, and laid the foundations for the church architecture of that city in the thirteenth and fourteenth centuries. The Paraskeva Good Friday church in the Market Place (tserkov' Paraskevy Pyatnitsy na Torgu) was built at the beginning of the thirteenth century in this new style, which established itself in the southern environs of Kiev, Vyshgorod and Ovruch and especially in Chernigov.[45] At the same time, the more traditional form of church continued to be built in Novgorod, an example of which is the well-known church of the Saviour on Nereditsa (tserkov' Spasa na Nereditse). The new-style Paraskeva Good Friday Church in Chernigov was built before the Tatar invasion of the early thirteenth century, and was converted into a tower-shaped church of complex, stepped outline (pl. 22).

The new upward impulse, with strongly emphasized verticals, stepped silhouette, variety of spatial form in niches and stepped arcades, and contrasting brickwork courses, dominated Russian architectural evolution through the first third of the thirteenth century, only to be abruptly cut off in the devastation wrought by the Tatar invasion of 1239–40. Revival began in north-eastern Rus', where by that time an independent architectural school had evolved.

3 Romanesque in North-eastern Rus': The Architecture of Vladimir – Historical Context

In the twelfth century events occurred that not only influenced the course of Early Russian history, but laid the foundations for the future Russian state. Over three centuries the migratory movement from the southern parts of the East European plain to north-eastern Rus', which had begun even before the conversion of 989, had brought tangible results. Between Slavs and the Finno-Ugrian tribes that had inhabited these territories since time immemorial, a new community had gradually been forged which was to form the basis of the Great Russian people.

It is necessary to stress at the outset the special geographical, ethnic and cultural circumstances that obtained in these north-eastern lands, too far from the Black Sea and Danube regions to experience such a strong Byzantine influence as did Kievan Rus'. Only echoes reached here of what happened on the great north-south route "from the Varangians to the Greeks",

expression in the church of the Archangel Michael (1180–90) (pl. 21). The plan of this church was more complex than its predecessors': to the basic three-aisle design, low-ceilinged *pritvory* (vestibules) with their own apses were added to north and south, with yet another at the west end. At the east end of the church, only the central apse had a high ceiling; those flanking it were low-ceilinged and of square plan. The appearance of this building was entirely new; its height exceeded that of its predecessors. In the middle of each façade was a high semi-circular gable (*zakomara*), below and to either side of which similar features abutted in halves. The drum was not only high

between Novgorod on the Volkhov and Kiev on the Dnieper and further south towards Constantinople. Scandinavian impact on the north-eastern territories of Rus' was no less weak than Byzantine, and for a long time amounted to no more than the periodic collection of tribute.

However, the lands of the Volga and Oka basins were by no means isolated from the processes of cultural interaction taking place at this time in the east of Europe. Besides maintaining contacts with Kievan Rus', their peoples had also long belonged to a system of international contacts via other routes, not north-south but east-west. Perhaps as early as the seventh or eighth century, along the Volga to the Caspian Sea or by caravan routes along its western shore, contacts were established between the people of the Volga and Transcaucasia, Persia, and the Arabian caliphate. From the territories of the Great Perm tribal group in the middle Ural region, the legendary "Biarmia" of the medieval geographers,[46] whose peoples settled along the Volga's north-eastern tributaries, the furs of the north found their way to Isfahan and Baghdad.

These contacts were strengthened with the emergence of the Khazar kaganate on the Lower Volga.[47] After its demise in the tenth century under the attacks of Slav and Turkic tribes, a Turkic people, the Volga Bolgars, became dominant in this region.[48] Whilst the Khazars had adopted Judaism as their state religion, the Volga Bolgars chose Islam. Religious contacts played a leading part in the cultural relations between these peoples. With Slavs established on the Upper Volga, the trade routes which opened the way to cultural interaction were extended along the whole of the Volga and even beyond, as far as Novgorod, as has been proved by substantial findings of eastern coins there.[49] Such was one ancient geographical axis along which the territories of the north-eastern principalities of Rus' were threaded, and it secured closer links for them with the great eastern powers than the axis with Kievan Rus'.

The Volga axis was intersected by another, the route from the middle Volga to Smolensk on the Dnieper and the towns of western Rus', then on to Cracow, Prague, Regensburg on the Danube and still further beyond into the territories of the Holy Roman Empire.[50] Apart from the routes used in the fur trade, this was the most northerly of the branches of the Silk Road. When at the end of the eleventh century the nomadic Polovtsians (Kumany) not only destroyed the southern routes between the Volga, the Don and the Dnieper but made access to the Black Sea via the Dnieper problematic, this overland route to the west acquired greater importance as an alternative geographical axis that was to play a major part in Russian history and culture.[51]

The architecture of the principality of Vladimir is the most striking testimony of contact between north-eastern Rus' and the West. The results of this contact became evident in architecture only after a strong state had come into being on this territory. The new state soon won a leading position among the numerous principalities into which Kievan Rus' broke up.

The long-lasting internecine struggle in southern Rus' in the twelfth century between different factions of the disintegrating and ramifying dynasty of Ryurik caused comparatively little disturbance in the north-east, with its ancient centres of Suzdal', Rostov and Murom, which had long been ruled by descendants of one of the most celebrated of Kievan grand princes, Vladimir Monomakh, who had himself ruled these territories at a young age during the transition between the eleventh and twelfth centuries, when he had founded a number of new cities. The names of two of these, Vladimir and Pereslavl'-Zalessky, speak for themselves. Cities as renowned as these had existed for a long time in Kievan Rus'; the father of Vladimir Monomakh, Vsevolod, had long reigned as prince of Pereslavl'-Yuzhny. Vladimir-Volynsky was one of the most famous cities of south-western Rus'. In play was undoubtedly a bid to transfer the centre of Rus' from the south to the north, and rivers, whole regions, towns, gates and, of course, churches were correspondingly named.[52] The resonant name of St Vladimir was also associated with the founding father of the state of Rus', Vladimir Monomakh, and could be interpreted as the proud name of a new capital now intent on domininating the surrounding world.

For Vladimir Monomakh, however, these territories were peripheral; his interests were concentrated in Kievan Rus'. His son Yury Dolgoruky had already made the north-east his chief and powerful fulcrum in the struggle with his rivals for the throne of the grand principality of Kiev, and he continued with the founding of new towns, including, around 1147, Moscow. But even this prince left the north-east in order to rule in the south. It was at this moment that the developing territories of Suzdal' and Rostov reached critical mass, each having enough inhabitants of fortified settlements to acquire independence.

The older and senior towns in this part of Rus', departing from tradition, themselves chose and invited a prince to rule over them – Andrey, son of Yury Dolgoruky, who was at this time grand prince of Kiev. This was done, however, against the will of his father. Andrey has entered history with the sobriquet Bogolyubsky, after his favourite residence of Bogolyubovo near Vladimir and also with the wider meaning of "chosen, or loved, by God".

Prince Andrey left Kiev secretly in order to hide from his father. His conduct in north-eastern Rus' was to be quite different from that of the other ruling princes in the area at this time. Selecting Vladimir as his capital, he set out to form a new

type of state based on absolutism. He broke with the tradition of power shared with the whole princely ruling clan so well established throughout Rus' and adopted the principle of autocracy on the model of the Byzantine emperors. His intention of being the first "tsar" of the north-east was in part successful. Vladimir-Suzdal' became the strongest of all the principalities of Rus', possessing a more clearly defined ideology than the rest, and this was demonstrated in Andrey Bogolyubsky's attempts to found a metropolitanate in Vladimir independent of Kiev.[53]

Andrey Bogolyubsky and subsequent rulers of Vladimir succeeded in giving expression to their political programme in architecture of a kind hitherto unknown in Rus'. It combined Byzantine canons and motifs with Romanesque forms taken from Western Europe, certain elements being drawn from the ornamental traditions of the East, with which, as has been indicated, these north-eastern territories, through the Volga trade route, were in closer contact than the rest of Rus'. The artistic traditions of the Finno-Ugrian tribes long established in the region also contributed to this new architecture, in which diverse elements of the art of East and West gradually combined and cohered.

4 The Earliest Cathedrals of North-eastern Rus'

The leading specialist in the architectural history of north-eastern Rus', Nikolay Voronin, has correctly pointed out that the appearance of masonry building in this region was preceded by "a prolonged period of local building in timber, about which much remains unclear to us".[54] Apart from some remains of dwellings discovered by archaeologists, either free-standing timber or half-excavated structures, and several mentions in chronicles of the existence of wooden churches in Suzdal', Rostov and Murom in the eleventh century, available data on early wooden architecture in these cities are non-existent. That, however, large-scale and imposing structures were built there in timber is clear from the chronicle description of one of the earliest wooden churches in Rostov, built soon after the conversion to Christianity, as "great and wondrous".[55] There was clearly a well developed tradition of wooden architecture in the north-eastern territories, which must have had input not only on the Slav side but also from the Finno-Ugrian tribes which had intermixed with Slavs in this region.

The earliest masonry buildings that appeared in the northeast, after models from Kiev, belong to the reign of Vladimir Monomakh; on his initiative a cathedral was built in the oldest city of the region, Rostov. In the Kiev Monastery of the Caves, important testimony of the building of this church has been preserved: "[. . .] Vladimir, follower of Christ, took the dimensions of this sacred Pechorsky church [the cathedral of the Dormition], and built a church in the city of Rostov to the same height, width and length. And he recorded in a charter the spot where each holy festival was observed [depicted in murals in the cathedral of the Dormition in the Monastery of the Caves], and all was performed as was the practice in this great church."[56] It is further recorded that "the son of that prince [Vladimir Monomakh], Prince Georgy [Yury Dolgoruky, founder of Moscow] [. . .] also built a church in his principality, in the city of Suzdal', of the same dimensions."[57]

Some chronicles contradict this last statement and attribute the building of Suzdal's first cathedral to the initiative of Vladimir Monomakh. More significant, however, is the fact that sources on both sides of the testimony indicate exact as possible imitation of the architecture of southern Kievan Rus', the starting-point of north-eastern architecture. This is wholly to be explained by the still dependent status of these territories lying on the outskirts of the state of Rus'. As the military and political power of this part of the country, customarily called the principality of Vladimir-Suzdal', increased, the more significant grew the distinctions between the churches built here and those of other schools of eleventh- and twelfth-century Rus'.

Approximately ten masonry churches were built during the reign of Yury Dolgoruky. Although they are all dated to the same year, 1152, in the chronicles, they were probably built earlier. Only two of them have survived, the cathedral of the Transfiguration (Spaso-Preobrazhenskiy sobor) in Pereslavl'-Zalessky and the church of SS Boris and Gleb in Kideksha (Suzdal'). Archaeological excavations have revealed further churches of the same type that have not survived, for example the church of St George in Vladimir, the first cathedral of St George in Yur'yev-Pol'sky (rebuilt at the beginning of the thirteenth century) and the cathedral of the Saviour or Transfiguration (tserkov' Spasa / Preobrazheniya) in Suzdal'. All these used the cross-domed system in its simple form. Four central pillars, which supported arches bearing the drum carrying a single cupola, also served as supports, together with the strict rectangle of the walls, for a semicircular vaulted ceiling. The west end was divided into two tiers, with a choir-gallery extending as far as the first pair of pillars. Both interiors and exteriors of these churches were without ornament; neither ornamentation nor decoration was any concern of their builders.

However, these buildings have together provided one of the most enduring models in Russian architectural history. They seem "Russian" in the all-embracing modern sense of this term, perhaps because their chief qualities, solidity and unity,

correspond to the serenely consistent landscape of the territory of Vladimir, which is completely lacking in dramatic effects. The chaste but self-confident strength of these churches seems to spring from the earth on which they stand. Their overall shape resembles a cube shallowly embedded in the ground. The three solid semi-cylindrical apses adjoin the east end of the main building. Flat *lopatki* giving a three-part division of each façade, a ledge below the bottom line of the windows where the wall is thinnest, a single semi-circular-arched door and three slit windows make a strictly rational, not to say laconic architectural scheme. Nothing is superfluous, everything emphasizes the overall mass of the building, the strength that is capable of supporting the heavy dome which rests on a wide, high drum.

To contemplate these earliest masonry churches in north-eastern Rus' today is to experience a sense of perfect peace. This architecture seems to contain no thought of rivalry or of comparison with any other building. On the contrary, it communicates a feeling of new power in free, unlimited space. In the time of Yury Dolgoruky, when the cathedral of the Transfiguration in Pereslavl'-Zalessky was contained within a large fortress with its earth ramparts and wooden fortifications, wooden palace and humbler dwellings, it must have merged with numerous other buildings that surrounded it, although these could in no way have diminished its ascendancy over them all (pls 23, 24).

The church of SS Boris and Gleb, Kideksha, near Suzdal', makes an even more powerful impression. It was built not in the town itself but on a comparatively small estate belonging to Yury Dolgoruky, on a high river bank, and its severe outline dominates the gentle landscape surrounding it (pl. 25).

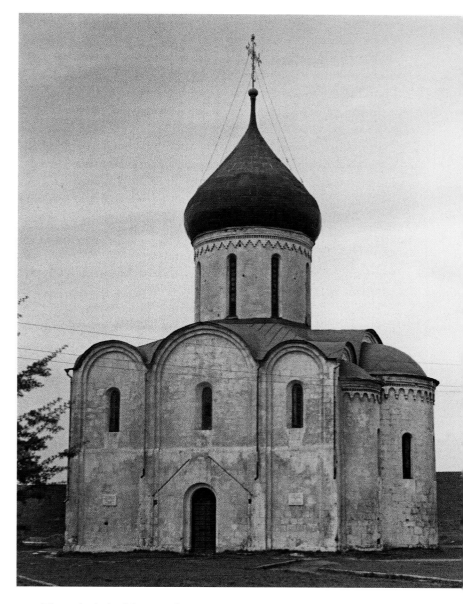

23 Plan of the cathedral of the Transfiguration, Pereslavl'-Zalessky, 1152–57.

24 The cathedral of the Transfiguration, Pereslavl'-Zalessky, 1152–57.

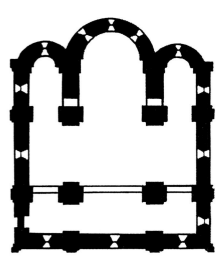

These mid-twelfth-century churches are distinguished by a special building method which seems to have definitive significance in the historical classification of the churches built in north-eastern Rus' during the reign of Prince Yury Dolgoruky. In contrast to the earlier buildings of the period of Vladimir Monomakh, and indeed to most architectural monuments of Kievan Rus' in general, they were built of exquisitely cut blocks of local "white stone", i.e. limestone. Fitting perfectly, almost seamlessly together, these blocks form a smooth, even surface which enhances the effect of unity and power. In the almost complete absence of ornamental detail, extended bands of blind arcading command attention. In twelfth-century Rus' nothing of the kind had been seen before outside Galich and

29

Volynia in the extreme west, where Byzantine and Romanesque motifs coincided. The wall surfaces of the earliest cathedrals on the territory of Vladimir may be compared with German churches of the Ottonian period, or with early Czech churches, however different these might be in plan.

In the churches of the era of Yury Dolgoruky, features began to develop which, scarcely discernible as yet, were to be of major importance in Russian architectural history. While adherence to the Byzantine system of liturgical space, absolute fidelity to the canons of the Othodox Church, and the constructional logic of the crossed-dome system that had arisen in the hellenistic east continued, materials, proportions, and treatment of wall surfaces began to change. In consequence, the basic form of the early churches of north-eastern Rus' diverges from the Byzantine heritage – in the brick-built tenth/eleventh-century Constantinopolitan version, at any rate. It is still too early to speak of serious links with Syrian or Caucasian masonry architecture. The leading compositional role of the stone mass is one of the essential features of this model, bringing it close to the Romanesque. The heavy preponderance of the stone mass is one of the features that display a link with the early Romanesque architecture of westernmost eastern Europe. Here in Vladimir, the future birthplace of Russia, two major architectural cultures met, the late Byzantine and the Romanesque, resulting in the emergence of new forms which are quite distinct from the architecture of Kievan Rus'.

5 The Churches of Andrey Bogolyubsky and the Lombard Masters

The next stage in the architectural history of Vladimir-Suzdal' occurred very quickly. The chronicles' first mention of churches built by Yury Dolgoruky is in 1152, and building activity associated with his son Andrey Bogolyubsky is evident only six years later. The latter has quite a different character, which continues after the death of this outstanding prince in 1174, and is to shape the main features of Vladimir architecture up to the Mongol invasion.

Lack of historical sources precludes an adequate understanding of Andrey Bogolyubsky's architectural programme in the political context of his move from the south to the north-east of Rus' and separation from his father, grand prince of Kiev. Certain facts are clear, however. Prince Andrey enlarged and strengthened Vladimir as his capital and, like other princes, ordered the construction of monumental stone gates which he called "golden", "silver" and "bronze". This was a clear reference to similarly named structures in Kiev and Constantinople. The cathedral that he built in Vladimir was dedicated to the

Dormition of the Mother of God (Uspenskiy sobor), not, like the cathedral in Kiev, to St Sophia or Holy Wisdom. And he bestowed "one-tenth of his livestock and one-tenth of tithes" on the building.[58] In both these respects he did as Prince Vladimir had done in Kiev, using the same means to secure the support of the Desyatinnaya church, which, incidentally, was also dedicated to the Dormition of the Mother of God.[59]

Scholars have devoted much attention to Andrey Bogolyubsky's attempts to establish a second Russian metropolitan see in Vladimir ranking with that of Kiev, that is, directly subordinate to the Constantinopolitan church, bypassing Kiev. The result of prolonged and complex negotiations, intrigues and even acts of force, in which representatives of Kiev, the metropolitan, and princes, envoys and clergy from southern and north-eastern cities of Rus' took part, was, however, that the status quo was maintained. In Constantinople neither the patriarch nor the emperor supported Andrey Bogolyubsky.[60]

Important, nevertheless, for the ideology of mid-twelfth-century Vladimir was not only a correlation with Kievan models, but also the acquisition of Byzantine sacred objects. A key symbolic act by Prince Andrey was the transportation from Vyshgorod, near Kiev, of the Byzantine icon of the Mother of God of Odigitriya (ikona Bogoroditsy Odigitrii), which is known in Russian history by the name of the Miracle-Working Vladimir Icon of the Mother of God (Chudotvornaya Vladimirskaya ikona Bogomateri) and remains to this day one of the most important relics of the Russian State.[61] No less important for Rus' as a whole was the establishment, probably in Vladimir itself at this time, of the Feast of the Miracle of the Intercession of the Mother of God (prazdnik vo imya chuda Pokrova Bogoroditsy).[62]

The origin of this feast relates to the fifth-century ascetic St Andrey. It is recorded that he visited the church of the Mother of God in Blachernai in Constantinople, in which the Emperor Leo the Great had placed a garment worn by the Virgin Mary found in Jerusalem, and there had a vision. He saw the Virgin Mary pass through the church, go to the pulpit and take off her "omophorion" (in this case meaning "veil"). The veil rose into the air above the congregation, and all were under the Protection of the Virgin. "For as long as the Most Holy Mother of God was present, it was seen; but when she went, it was no longer seen [. . .] there she left grace."[63] In early Rus' St Andrey was considered a Slav from Constantinople.[64] What is most significant for present purposes is the coincidence of his name with that of Andrey Bogolyubsky. It is not known whether he was a spiritual patron of the prince; that would explain much about the emergence of the cult of the Veil in Vladimir and the building, in association with the Feast

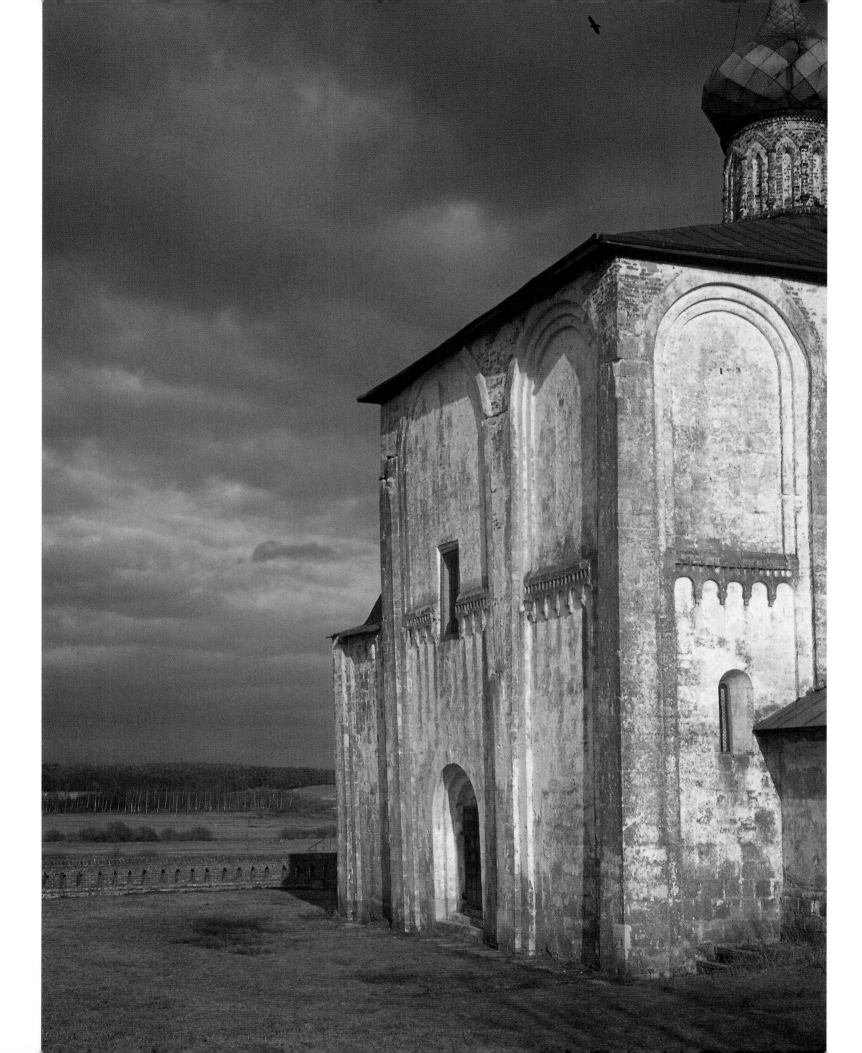

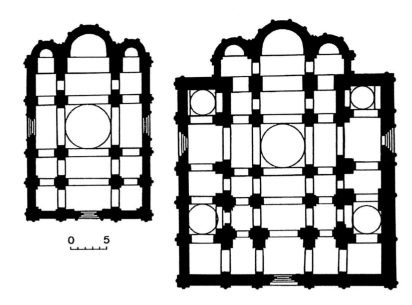

26 Plans of 1158 and 1189 of the cathedral of the Dormition, Vladimir, 1158–89.

of the Intercession, of one of the most important Russian medieval churches, the church of the Intercession on the River Nerl' (tserkov' Pokrova na reke Nerli).

The cathedral of the Dormition (Uspenskiy sobor) in Vladimir did not retain its original appearance after it was rebuilt in the 1180s (pl. 26) – more will be said on this subject later – and furthermore, only traces of Prince Bogolyubov's suburban palace buildings have survived. A good idea of the architectural style of the new leading power of north-eastern Rus', however, may be obtained from the church of the Intercession on the Nerl', built *c*. 1165, even though, without its original stair-towers and the wooden buildings that once surrounded it, it must now make a quite different impression from when it was built. Today the church looks out over a wide expanse of water-meadows alongside the river Nerl', a tributary of the Klyaz'ma (see illustration on page x), and its distinguishing features mark it off sharply from the churches of the era of Yury Dolgoruky.

Like the churches in Pereslavl'-Zalessky and Kideksha, the church on the Nerl' has four pillars, a single cupola and three apses, triply divided fronts, each part having a semi-circular gable (*zakomara*) corresponding to the semi-circular vaulting of the interior, monumental entrance portals and lancet windows. All three churches are of identical structure, but the appearance of each of them is quite different. The church on the Nerl' was built thirteen years later than the churches commissioned by Yury Dolgoruky. It is striking how quickly architectural taste changed while liturgical treatment of space remained constant.

The impression of a great cube embedded in the ground has vanished (pl. 27 and p. x above). There is no hint of massive weight, might and power. Exquisite lightness of proportions, outlines and detail are the hallmarks of Andrey Bogolyubsky's craftsmen. An upward striving is emphasized by the numerous verticals composed of densely superimposed arches and by long, slender columns extending to the full height of the

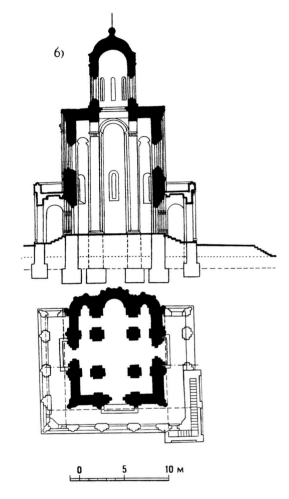

27 Plan and section of the church of the Intercession on the Nerl', 1165.

church (pl. 28). Laconicism has been replaced by refined and strictly organized ornamentation. Although all essential features of the plan of Dolgoruky's churches are preserved, a completely new impression is made, apart from the question of ornamentation, as regards the mass of the building. Every part of the church, wherever one looks – the apses, the drum – is harmonious in the highest degree. In the interior, which is very small in proportion to the overall dimensions of the church, one has no feeling of oppressive confinement, but an urge to look upwards. The tall though narrow windows of the fronts and the drum fill the upper part of the church with light. Even the

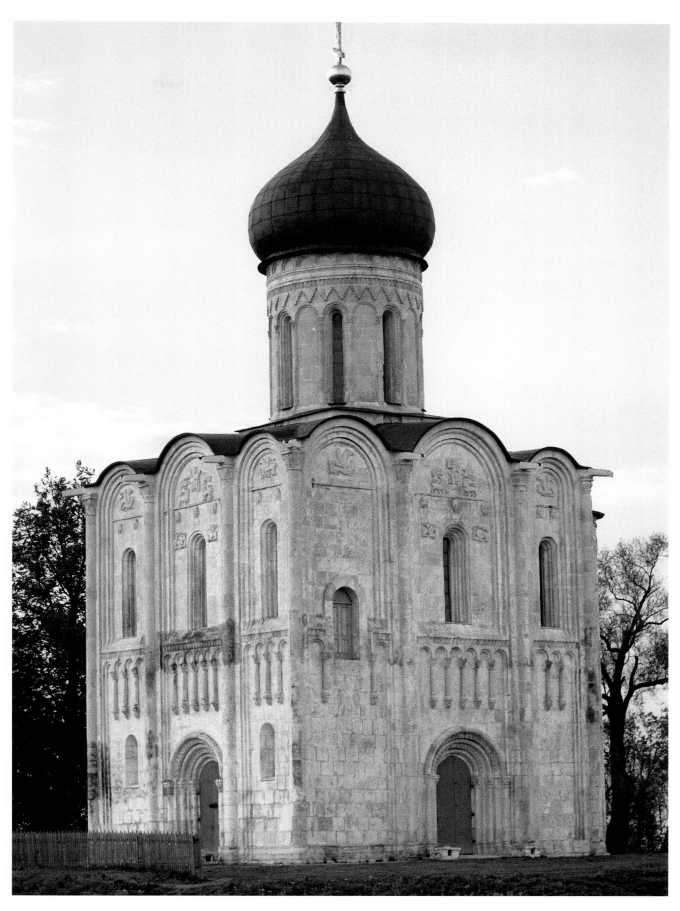

28 Church of the Intercession on the Nerl', 1165.

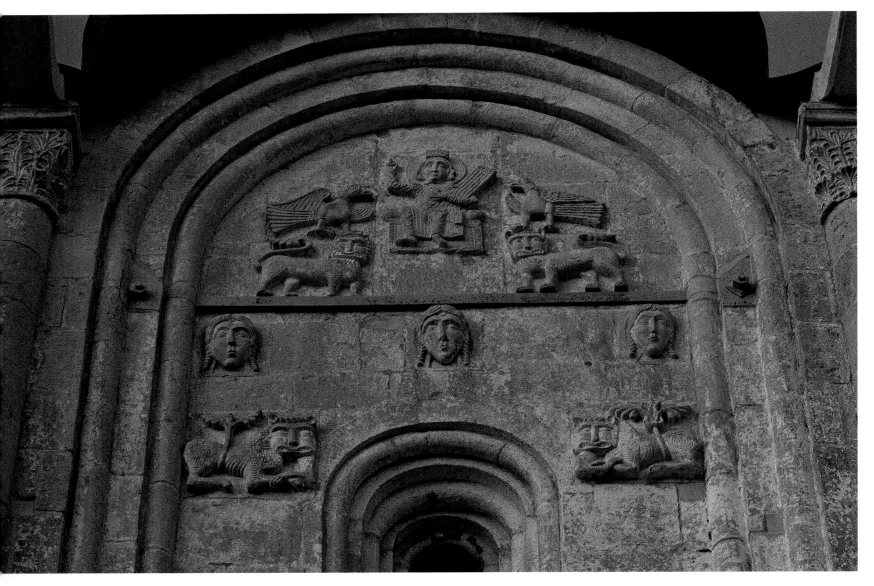

29 Sculptural detail showing King David on the façade of the church of the Intercession on the Nerl', 1165.

closeness of the pillars to each other and the narrowness of the arches that link them emphasize the expansive proportions of this interior.

The ornamental scheme of the church of the Intercession on the Nerl' is of great interest. Here the transformation of external stone surfaces into an overall envelope covered with ornamental forms is first seen in Russian architecture. In this church, as in all other surviving churches built under Andrey Bogolyubsky, the ornamental "covering" has an architectonic strictness that will soon undergo radical change in Vladimir.

Sculptural elements appear in the ornamentation of the church of the Intercession on the Nerl'. In the middle of all three fronts there is a depiction of King David surrounded by wild animals. The king bears a psaltery. Eagles fly above the heads of the group, and below them are three large heads, presumably representing angels. Lower still, flanking the top of the lancet window, are flying lions with tails transformed into palms (pl. 29). In the other parts of the fronts the same motif is repeated six times – a griffon holding a deer in its claws, with a pair of angel's heads below.

Before consideration of the subject matter of these sculptural motifs, it must be emphasized that they play a subordinate role in the overall structure of the church, in which architectural elements have far greater significance and make a much stronger impact. It is architectural form that conveys the sense of a well-built, clearly structured world. On the three fronts consoles in the form of heads support a row of columns on which the arches of blind arcading rest, above which the line

34

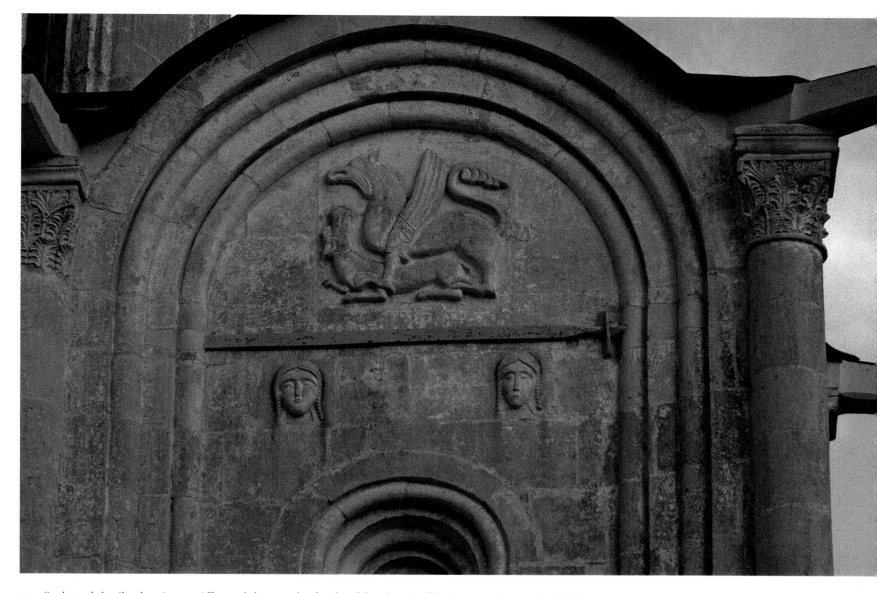

30 Sculptural details showing a griffon and deer on the façade of the church of the Intercession on the Nerl', 1165.

of a ribbed frieze forms a horizontal affording a base for windows and monumental arches. Four columns rise uninterruptedly to unite all zones of each graceful façade.[65]

The ornamental programme reveals a good deal about the ambitions of the ruler of Vladimir. His conception of statehood decidedly exceeded the bounds usual in early Rus'. Without doubt, his aspirations went beyond his status as a member of the princely line that ruled the country, and even beyond his moving up the family hierarchy from ruler of a minor to that of a major city. Prince Andrey conducted himself like an autocrat, playing the role of an emperor, as far as this was possible in the political situation of Rus' in the 1160s. It was for this that he died at the hands of assassins bent on revenge for the abolition of time-honoured customs and old families' loss of power.

Given such aspirations, it was natural for Bogolyubsky to collect diverse artistic models from all available sources, and from as many different countries as possible. In this process stylistic prototypes were welded together into a general architecural programme based on a specific ideological conception. It would seem that Prince Andrey justified the flight from his father and repudiation of his southern heritage by his special devotion to God and to the Virgin. The naming of his residence Bogolyubovo (a place loved by God or devoted to love of God), the adoption of the Blachernai church in Constantinople, where the miracle of the Intercession had taken place, as the model for the cathedral of the Dormition in Vladimir, the dedication of the church of the court monastery near Bogolyubovo on the Nerl' to the same Miracle of the

Intercession – all is indicative of a particular ideological programme.

In the evolution of court architecture in Russia, preconditions for the emergence of *architecture parlante*, a set of symbolic forms in architecture and architectural sculpture, have always arisen in such circumstances. And this occurred in the era of Andrey Bogolyubsky. The architectural language that emerged at this time was to undergo further evolution, but it is already recognizable in the church of the Intercession on the Nerl'.

The placing of King David in the centre of the composition as the image of a ruler chosen by God, the singer of psalms possessing the art of praising God, wholly corresponds to what can be reconstructed of the ideology of Andrey Bogolyubsky. The struggle between griffons and deer, symbolizing the battle between good and evil, and the defensive role of the lions are symbolic motifs widespread throughout Europe, East and West. Here they emphasize the main concept – the ruler to whom everyone else in the region is subordinate and who himself serves and hymns God. This new architectural language, especially in its use of sculpted forms, presupposes the availability of craftsmen capable of executing the prince's programme (pl. 30). It has been suggested that two types of carving may be distinguished in the sculptural ornamentation of this church.[66] According to this view, the depictions of King David and of the deer-rending griffons are the work of Russian craftsmen, and they have been linked to wood-carving tradition; while the columns with markedly Classical capitals in the bands of blind arcading and the consoles in the form of heads on which they rest are considered to be the work of foreign masters. On the basis of this allocation of roles, the conclusion has been reached, especially by mid-twentieth-century scholars, that Russian craftsmen played a leading part in this work.[67]

It is important to note the high probability that Andrey Bogolyubsky commissioned Western craftsmen, for the first time in Russian architectural history. The documentary evidence of this is second-hand, consisting of copies made by the eighteenth-century Russian historian Vasily Tatishchev of passages from a manuscript that was subsequently lost. Master craftsmen referred to as "*nemetskiye*" – which at that time in Rus' meant Western in general, not necessarily German – are there mentioned as being sent to Prince Andrey Bogolyubsky by the Holy Roman Emperor Friedrich I (Barbarossa).[68] The surviving first-hand documentary evidence reveals another point of view: "God sent masters [to Prince Andrey Bogolyubsky] from all lands".[69]

Strict adherence to Orthodox church forms in the planning and organization of liturgical space on the one hand and the use of Romanesque sculpture on the other have led scholars to take the craftsmen who worked on the exterior of the church of the Intercession on the Nerl' to have been from western Russia, most likely those who built the church of St Panteleymon in Galich.[70] However, the surviving remains of that church and the little known about it provide no basis for worthwhile comparison beyond the fact that its portals are distinctly more Romanesque in character than those of the Church on the Nerl'.[71]

In the 1920s it was suggested that the churches built by Andrey Bogolyubov might have links with German Romanesque, in particular with the style of the cathedrals of Rhenish cities such as Worms, Speier and Mainz and the monastery church in Quedlinburg.[72] Some coincidence in architectural detail, besides a treatment of similar topics in sculptural ornament, is indeed to be found, but no great similarities: scale, compositional principles, style of stone-carving are all different. The similarities that do exist would seem rather to be explained by elements present in both imperial German Romanesque cathedrals and in the churches of Andrey Bogolyubsky that draw on common influences. The Holy Roman Emperors brought craftsmen to Germany from northern Italy, giving rise to the surmise that their artel could have travelled further east as far as western or eventually north-eastern Rus'.[73]

This is possible, and would be consistent with the chronicler's mention of Prince Andrey's craftsmen as coming "from all lands". It may also be the case that an "international" architectural artel was formed in Vladimir at this time. At any rate, in recent times it has become inceasingly accepted that northern Italian masters must have predominated in this artel. Tatishchev's testimony that master craftsmen were sent to Vladimir by the Emperor Friedrich Barbarossa would still seem likely to be the most accurate statement of the case. In the late 1150s and early 1160s Barbarossa was giving primary attention to his possessions in Italy. He was crowned king of Italy in Pavia. That so many coincidences exist between the architecture of Lombard churches and those of Vladimir can hardly be coincidental.

The Romanesque school of Lombardy emerged, indeed, earlier than the school of Vladimir, at the turn of the eleventh and twelfth centuries. Just at the moment when Barbarossa is said to have sent master-craftsmen to Rus', churches were built in Romanesque style in Como (San Fidele, San Abbondio) (pl. 33), Pavia (San Michele (pls 34, 35), San Teodoro, San Pietro), and numerous other northern Italian towns. The Lombard Romanesque tradition, already fully established, could well have passed on to Germany and thence to Rus'. The craftsmen who worked on Andrey Bogolyubsky's churches are most likely to have come from the artel that created the ornamental sculpture of Modena cathedral (pls 31, 32) or the church of San Michele in Pavia.[74]

31 Sculpture on a pediment on the west front of Modena cathedral, built between 1099 and 1184.

32 Detail of sculpture on the south front of Modena cathedral, built between 1099 and 1184.

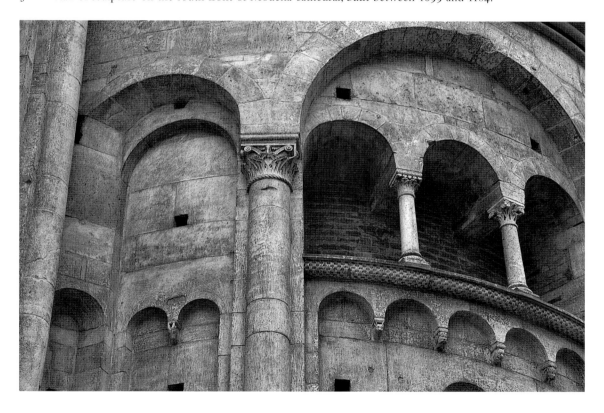

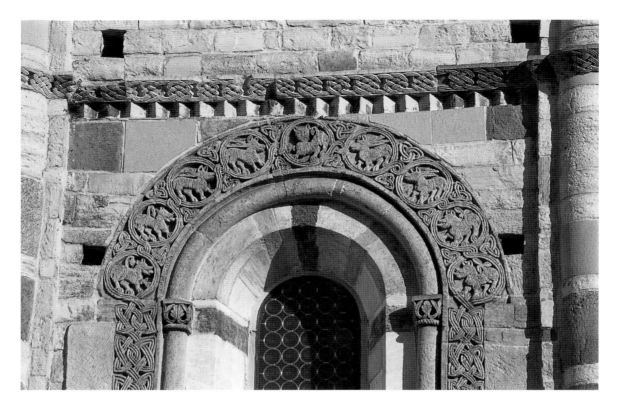

33 Detail of the south front of the church of San'Abbondio, Como, mid-twelfth century.

34 Detail of the west front of the church of San Michele, Pavia, built between 1004 and 1155. In 1155 the coronation of Friedrich Barbarossa took place in this church.

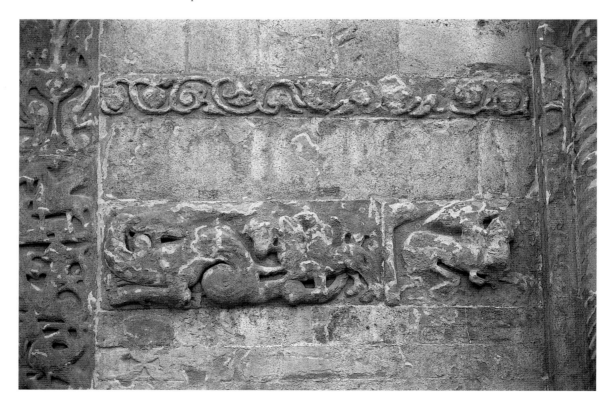

As Oleg Ionnisyan has noted, Modena cathedral and Andrey Bogolyubsky's churches in Vladimir display similarities in the spatial treatment of their façades, which are divided by *lopatki* (lesenes) with thin pilasters, their capitals being identical in form.[75] Furthermore, both in Modena cathedral and in the church of the Intercession on the Nerl', columns are placed at the corners of the building. It is, however, the extraordinary similarity between the two churches in the composition of the King David scene – in the centre of the western façade of Modena cathedral and of each façade of the church on the Nerl' – that most convinces the present writer of the Italian origins of Andrey Bogolyubsky's master-craftsmen. It is not only the formal similarity that is striking, but also the leading role of the subject matter in both artistic composition and ideological construction of the sculptural programme in these two churches.

The significance of the appearance of the masters from Lombardy in north-eastern Rus' in the 1160s is hard to exaggerate. They founded a whole architectural school there, and must have instructed Russian building craftsmen and stone-carvers. The contribution of the latter, as well as the requirements of local patrons, was gradually to develop the distinctive character of Vladimirian architectural style. Nevertheless, literal coincidences with Lombard tradition in sculptural elements would continue to occur up to the demise of this school with the Mongol invasion.

In two decades Prince Andrey Bogolyubsky founded a new architectural school in Vladimir and the surrounding region. The city took on the aspect of a capital, with a magnificent cathedral, of which more will be said later in the context of its rapid reconstruction. Outside Vladimir a major citadel was built in Bogolyubovo. One of the towers of the palace within it survives, and here archaeologists have discovered remains of the stone walls of the church of the Nativity of the Mother of God (tserkov' Rozhdestva Bogoroditsy). These fragments and the information we have about them in no way contradict the image of Vladimir's new architectural school to be gained from the church of the Intercession on the Nerl'. Vladimir's subsequent architectural history, during the last quarter of the twelfth century and the first third of the thirteenth, offers one of the most striking demonstrations in medieval Europe of the encounter between the Byzantine heritage and the Romanesque.

The cathedral of the Dormition in Vladimir, said to have been built by Prince Vladimir Monomakh, founder of the city, was completely rebuilt in 1158–61, during the reign of Andrey Bogolyubsky, and then, after a fire, rebuilt once again in the reign of his brother Vsevolod (nicknamed "Big-Nest" on account of his numerous progeny) in 1185–89. Andrey

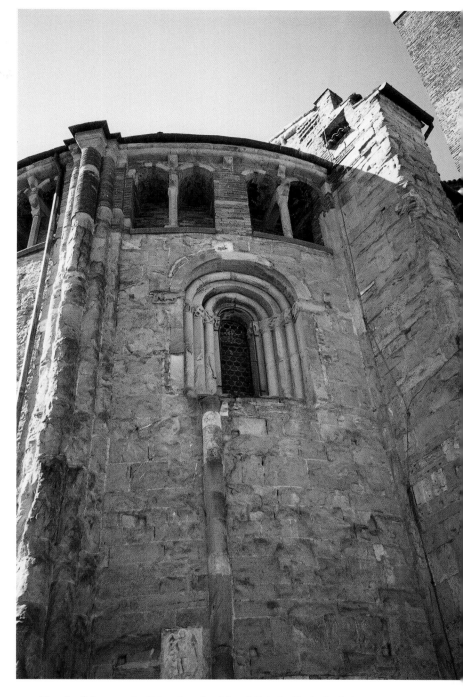

35 Detail of the portal of the church of San Michele, Pavia, built between 1004 and 1155.

Bogolyubsky's building displayed the outline of a typical city cathedral of its time. Under the necessity of increased space, the four-pillar plan was extended to six pillars, which permitted the placing of the choir further to the west and a clearer demarcation of the domed space. Important features of the building were a lightening of its mass and an increased decorative element (pls 36, 37).

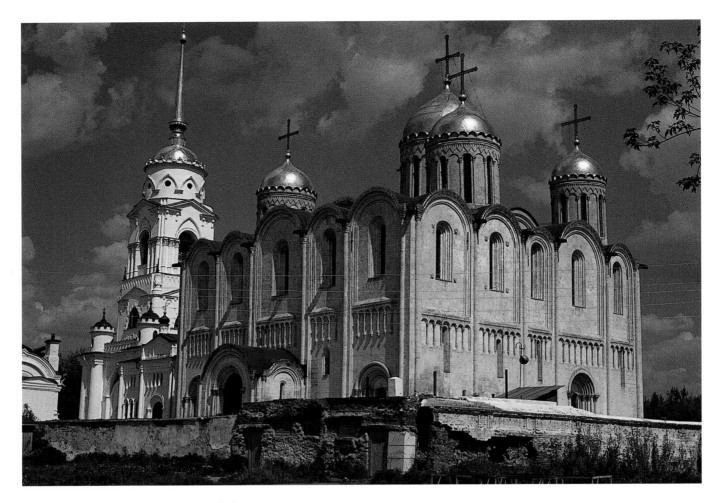

36 The cathedral of the Dormition, Vladimir, 1158–89.

The interior of the cathedral was highly painted and gilded, with an abundance of costly cloth. There were multicoloured frescos and yellow and green majolica floor tiles, doors covered with gilt-bronze, silver-gilt candle-holders and, especially interesting, three large gold representations of Mount Sion, probably including the Tomb of the Saviour. The chronicle compared the cathedral thus rebuilt to Solomon's Temple,[76] confirming that their ruler's ambition to create an all-Russian shrine in Vladimir was known to people at the time.

Elements of the interior decoration were transposed to the façades of the cathedral. Not only was the cupola gilded, but the arches of the *zakomary* were covered in gilt-bronze. According to the chronicle, the prince "had the church girt with gold, and decorated the stone surfaces and columns."[77] What was referred to here was most likely a carved and gilded stone string-course on the façades. The columns too, or at least their capitals, were gilded. Figures of saints were set in the niches between them. The exterior of the church was also decorated with frescos. The upper part of the church, the tops of

the *zakomary* and the corners of the building were adorned with carved gilded figures.

Besides all this, the exterior was ornamented with lively stone carvings, the Romanesque character of which has never been in doubt, playing a modest role, probably with protective symbolism – masked lions' or angels' heads set round windows. In the central sections of three façades thematic groups were placed: "Three youths in a burning furnace", "Forty martyrs from the town of Sevastiya" and "The ascent of Alexander of Macedon [the Great] to Heaven".[78] The first two of these depicted God's defence of true believers through fearful tortures. Significantly, the first related to the Old Testament, to the Book of Isaiah, and the second to the Christian martyrs of the New Testament. The third carving was an attempt to sacralize pre-Christian symbols of power. These depictions conveyed the idea of universal unity embracing all times, the periods of Old and New Testaments and of Antiquity. This once more brings out the ambitious scale of Andrey Bogolyubsky's architectural policy, his attempt to "construct" in the ideology of the prin-

cipal church of his newly established power a complete and perfected image of the world, filled with the sense of God.

Although the Romanesque style of these stone carvings is generally ackowledged by scholars, it is difficult to regard their subjects as Western, universal as they are in the Christian world. They had long been widespread in Byzantine decorative art. The theme of the three youths was familiar from its appearance in a Byzantine treatise on the symbolism of images, *The Physiologist*, which was widely disseminated at this period both in its Latin versions and in commentaries. "The Ascent of Alexander of Macedon" came from the medieval *Roman d'Alexandre*, well-known throughout the Christian world.

Sculpture was systematically employed in the architectural policy of the princes of Vladimir in the second half of the twelfth century, and it became the chief stylistic hallmark of the architectural school of Vladimir from this time up to the end of the first third of the thirteenth century. There is evidence that the sculpture of the churches of the Vladimir region related to ideas originating with princes rather than church leaders. When the cathedral of the Dormition rebuilt by Andrey Bogolyubsky burned down and his brother Vsevolod rebuilt it, no new sculpture appeared in this significantly enlarged episcopal cathedral. On the other hand, the new princely cathedral nearby, dedicated to the patron saint of the current ruler, St Dmitry Solunsky, displayed massed ornamental sculpture.

The cathedral of the Dormition in Vladimir, when rebuilt in 1185–89, was given still more majestic aspect by purely architectural means. New walls were added on three sides, the structures of the old ones being retained. In other words, the building was surrounded on the west, south and north sides by three galleries, while the east side was widened. The galleries were connected with the main structure of the former building by additional doorways. The principal new feature was the addition of four supplementary cupolas at the corners of the galleries. The five-cupola pattern of the new cathedral would subsequently become one of the hallmarks of Russian architecture.

6 The Cathedral of St Demetrius and the Depiction of Paradise

The cathedral of St Demetrius (Dmitrovskiy sobor) in Vladimir was built in 1191–97 (pls 38, 39).[79] Genrikh Popov expressed the opinion that it "marks a transition to a new stage in the religious and cultural life of the principality", a judgement that was based on the fact that "massive and complex efforts were made in 1196–97 to acquire relics in Thessalonika and bring them to Rus'".[80] Among such relics was probably a silver ark, a copy of a ciborium found on the site of the martyrdom of

St Dmitry of Thessalonika and a reproduction of a graveside icon from his shrine. Prince Vsevolod (whose given name was Dmitry) undoubtedly took careful measures to ensure that these holy relics associated with his patron saint found their way to Vladimir. There is little novelty in this, rather the logical development of an independent Vladimirian ideology. It is not by chance that this ideology had begun to form at the

37 Detail of the west front of the cathedral of the Dormition, Vladimir, 1158–89.

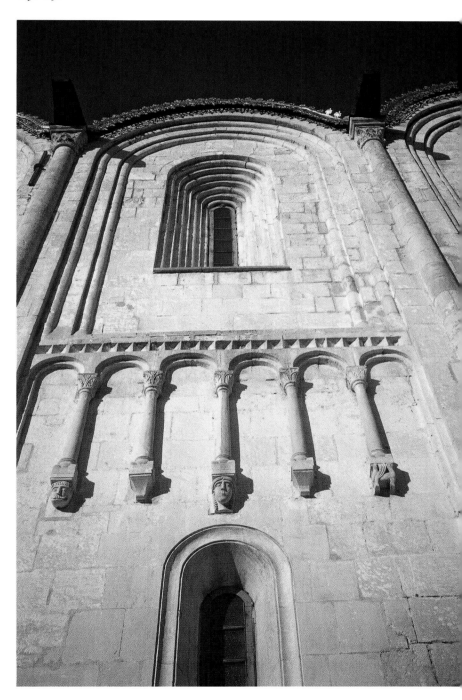

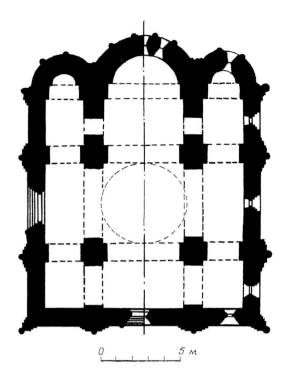

of characteristic forms of monumental sculpture, unheard-of in Byzantine culture. In its artistic logic it is comparable with the most developed and mature Romanesque sculptured ensembles (pls 40, 41, 44).

Not only the bands of blind arcading with their miniature engaged columns but the whole upper zone of the church is carpeted with relief carving, as are the portals and their capitals. Sculpture, however, is still subordinate to architectural structures and limited by them; it is still architecture that introduces order into a world composed of ornamental elements so

39 The cathedral of St Demetrius, Vladimir, 1191–97.

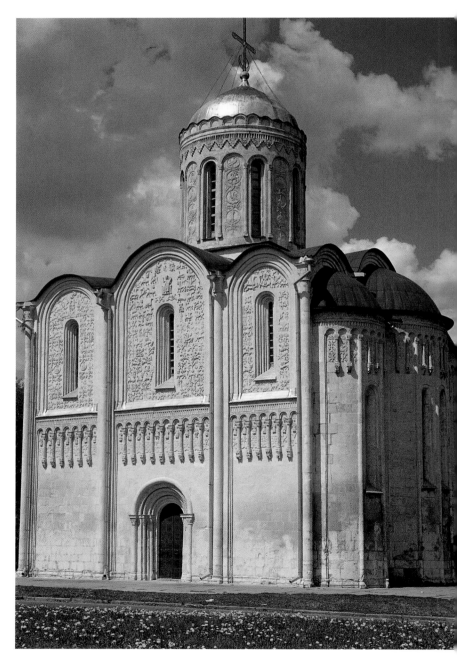

38 Plan of the cathedral of St Demetrius, Vladimir, 1191–97.

moment when Prince Andrey Bogolyubsky had had the famous Byzantine icon that became known as the Virgin of Vladimir brought from the south to the north-east of Rus'. It is indeed the case, as Genrikh Popov observes, that "Vsevolod III completed Andrey Bogolyubsky's life's work [. . .] taking Vladimir into the international circle of Orthodox imperial capitals".[81]

A similar political process was to mould the distinctive features of Vladimirian architecture. The characteristics already noted in the cases of the church of the Intercession on the Nerl' and the cathedral of the Dormition were developed still further in the vast ornamental programme of the palace church of Vsevolod III. The ornamental envelope of a building of traditional form (returning to a single cupola, four pillars and three naves) is on an incomparably greater scale than in the case of any other church hitherto. The strict architectural organization of the church on the Nerl' is retained, but not completely, as was soon be the case with the cathedral of St George (Georgiyevskiy sobor) in Yur'yev-Pol'sky. Vsvevolod III's church, nevertheless, is only a step away from a completely new, un-Byzantine approach to the appearance of a church exterior. Byzantine features, it should be stressed once more, remain, in the structure of its interior, its decorative style and wall-paintings of the late Komneny period.[82] However, its architectural orientation towards the outside world, *parlant* and even loquacious, is achieved by large-scale and systematic use

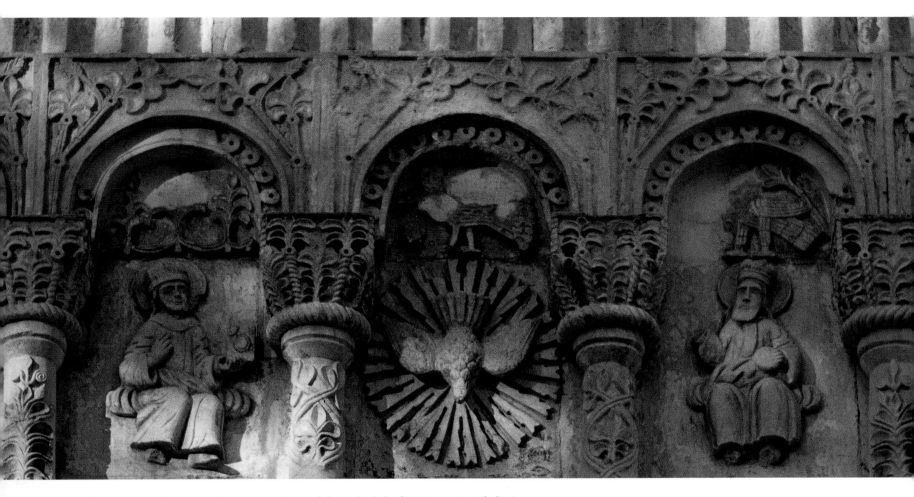

40 Ornamental sculpture on the southern front of the cathedral of St Demetrius, Vladimir, 1191–97.

manifold that only the shape of the cathedral can set a limit to them. Architecture and sculpture, in contest with each other, seem to be in balance. From the point of view of content, however, it is sculpture that has the upper hand.

Commentators have singled out secular and even pagan characteristics in the ornamental sculpture of the cathedral of St Demetrius.[83] This comment would seem more apt to the case: "images of a Christian character [. . .] although not greatest in number, occupy the principal place in the exterior ornamentation."[84] Depictions of the subjects already familiar to us take a central place in the ornamental scheme of each front: King David playing his harp, Alexander the Great's ascent to Heaven. A novelty is the scene portraying the prince, builder of the church, with his five sons.

At the time when this last group was being sculpted, two or at least one of Prince Vsevolod's sons had died,[85] but all five sons are depicted on the wall of the cathedral. This reveals the meaning of the whole scheme. It lies outside historical time, and depicts a realm of the future, Heaven. The whole is a vast representation of Paradise, inhabited by strange animals and birds, fabulous beasts and plant forms, amongst which figures of saints emerge in greater relief. Heroes of antiquity are also to be found – by virtue of their exploits, like Alexander the Great, or biblical figures – for their special love of God, like King David; and also contemporary individuals – for building a church of unprecedented splendour to the glory of God, like Prince Vsevolod III. In the symbolic scheme of the blind arcades the figures of the saints are placed between the engaged columns, as if forming a spiritual "fence" marking off the higher, heavenly zone. There are numerous specific ornamental motifs analagous to those found on the exterior of the church of San Michele in Pavia (pls 42, 43).

These ideas and architectural features are developed still further in the cathedral of St George (Georgiyevskiy sobor) in Yur'yev-Pol'sky, the last great cathedral to be built in Rus' before the Mongol invasions which changed the course of its culture.

★ ★ ★

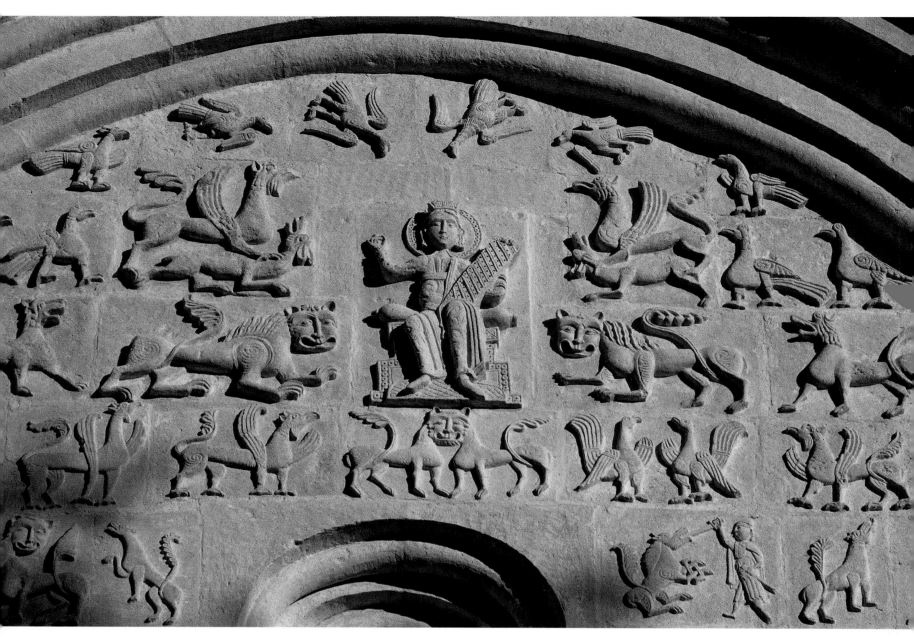

41 Ornamental sculpture, cathedral of St Demetrius, Vladimir, 1191–97.

7 St George's Cathedral in Yur'yev-Pol'sky: An Encyclopedia of Russian Romanesque

This cathedral is one of the most important architectural monuments of Russia. It sets more unsolved riddles and problems than any other building, despite the fact that it has been the intense focus of scholarship for more than a century.[86]

It was built in 1230–34 on the site of a church raised by Prince Yury Dolgoruky less than a century previously and dedicated to St George, his patron saint. The builder of the new church was Yury's grandson Prince Svyatoslav Vsevolodovich.

At that time the principality of Vladimir was divided into several smaller principalities, and the town of Yur'yev-Pol'sky was allotted to Prince Svyatoslav. Chroniclers of the time noted the extraordinary features of the church. "And Svyatoslav built a wonder, carved in stone."[87] "The church was far more abundantly ornamented than other churches [. . .] stone carvings of saints and fabulous creatures covered the entire church."[88] No church or cathedral in Rus' or Russia has ever exceeded this one in the number of its carvings – over 450 separate reliefs.[89]

Unfortunately, it is impossible today to be certain of the original sequence of the reliefs on the exterior of the cathedral,

which collapsed in 1471. The building was considered unique even then. A fifteenth-century chronicler confirms that it "was all of carved stone",[90] and he mentions that Prince Ivan III of Muscovy sent an experienced building contractor, Vasily Yermolin, to "rebuild the church as it had been before".[91] This was one of the earliest attempts made in Russia deliberately to conserve, to best later understanding, the historical appearance of an earlier building.

However, the fifteenth-century restorers encountered insuperable difficulties. Much of the culture of Vladimir had been destroyed in the Mongol invasion, including all record of the scheme of the reliefs on the exterior of St George's Cathedral. The Muscovites of the epoch of Ivan III had no idea of the meaning of most of the reliefs, and none of the purpose of the series as a whole. In their work of restoration they placed the fragmented reliefs in new positions next to each other accord-

42 and 43 Ornamental sculpture on the western (*below*) and main (*bottom*) portals of the church of San Michele, Pavia, built between 1004 and 1155.

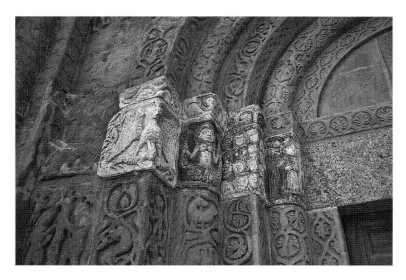

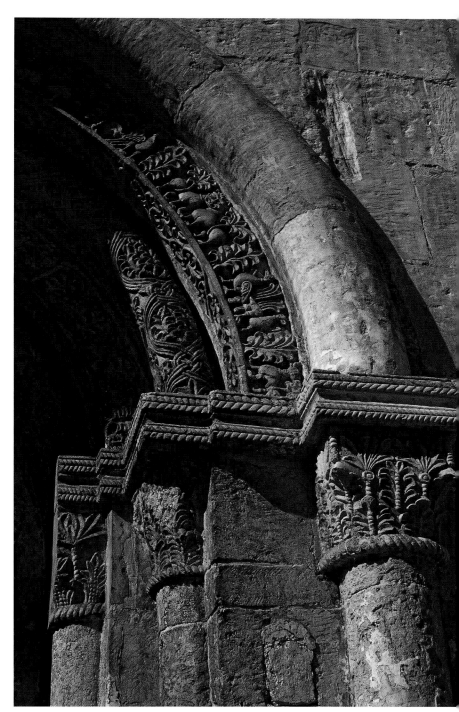

44 Capitals of the south portal of the cathedral of St Demetrius, Vladimir, 1191–97.

ing to subject, sometimes according to size. Some reliefs had been carved on the interior walls. The undestroyed north-western part of the church was fortunately left unchanged by the restorers, and thanks to this some idea may be gained of the original arrangement of what is now a magnificent mosaic of relief carvings of the most diverse character.

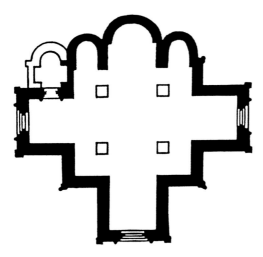

45 Plan of St George's Cathedral, Yur'yev-Pol'sky, 1230–34.

The cathedral has a squat, somewhat clumsy and ponderous appearance (pls 45, 46). Originally, it most likely made the opposite impression. This building was a landmark in the history of church architecture in Vladimir, from a structural as well as ornamental point of view. The plan was based on a well-defined square. To the east were the three traditional apses, thrown further out than in earlier churches. On the other three sides the space of the interior was increased by three low-ceilinged vestibules open to the inner square. There would appear to have been no choir. There were four pillars, set widely apart. The central area was more than twice as large as the rest. The interior space was clearly centralized and hall-like. Judging from the distance between the pillars, the drum and cupola must also have been of extensive proportions.

The cathedral is thought to have had two tiers of windows. If this was the case, it was a highly distinctive feature. There were windows too in the drum. Light would thus have entered the interior at three levels, providing excellent illumination. It is probable that before the Mongol invasion there was a small side-chapel on the south-east side, in the form of a single-cupola church and containing a burial-chamber in which Prince Svyatoslav Vsevolodovich is said to have been buried. All this testifies to the perfection to which the cathedral of St George in Yur'yev-Pol'sky was built and the point reached in the architectural development of Vladimir on the eve of the Mongol invasion.

Nevertheless, the importance of the sculptural ornamentation of this church in Russian cultural history unquestionably exceeds that of its architectural merits. In consequence of the annihilating Mongol invasions of the thirteenth century, very little of the pre-Mongolian culture of the grand principality of Vladimir has survived. No important literary works from north-eastern Rus' have come down to us, none, at least, that bears comparison with those of Kievan or Novgorodian Rus'. Fresco fragments and a small quantity of icons are evidence of an independent school of painting, but give a very incomplete idea of Vladimirian culture.

The reliefs of St George's Cathedral in Yur'yev-Pol'sky constitute nothing less than a surviving "encyclopedia" of pre-Mongolian Vladimirian culture, large-scale, rich and varied, whose significance in Russian cultural history has been undervalued. It is the view of the present writer that the sheer wealth of ideas and images contained in this magnificent complex places it on a level with a literary masterpiece such as the twelfth-century *Lay of Igor's Campaign* (*Slovo o polku Igoreve*). It is one of the chief sources for the pre-Mongolian culture of Rus', difficult to appreciate fully in the absence of any comment on the sculptural programme in the chronicles. Understanding is particularly hindered by the absence of any explanatory written "key" to the images and their overall scheme, even belonging to a later period. Interpretation must rely entirely on present-day analysis, carrying the danger of modernizing the content of these reliefs.

Aiming to avoid this danger, and drawing no conclusions, I shall try to establish the subjects and motifs present in the original parts of St George's Cathedral dating from the first third of the thirteenth century and in the reliefs restored in the fifteenth century.

Bold assumptions have often been made about these reliefs, among them identifications of individual saints, although almost none of the images has features that allow the depiction to be named.[92] Instead of adopting this approach, I shall look for themes, motifs and concrete subject-matter, and moreover, only those definitely established to the satisfaction of the majority of scholars. In this way, a basis on which to discuss the message expressed in the ornamental sculpture and architecture of St George's Cathedral may be obtained.

Three subjects from the New Testament undoubtedly play a leading role in the overall scheme, the Transfiguration, the Crucifixion and the Ascension,[93] presumably originally placed in the tympana of the *zakomary*. These subjects here appear for the first time in the monumental sculpture of Vladimir. Gospel scenes are prominent in the sculptural programme of St George's, as are individual depictions of Christ and the Virgin. These may be correlated with the icons of the type of the Saviour Not Made by Hands (Spas Nerukotvornyy) and the Mother of God of Odigitriya (the Sign) (Bogomater' Odigitrii Znamen'ye; pl. 47). The depiction of the Virgin in St George's has sometimes been interpreted as the Intercession of the Mother of God (Pokrov Bogoroditsy), evidently because of the cult of this miracle popular in the Vladimir region.[94] However,

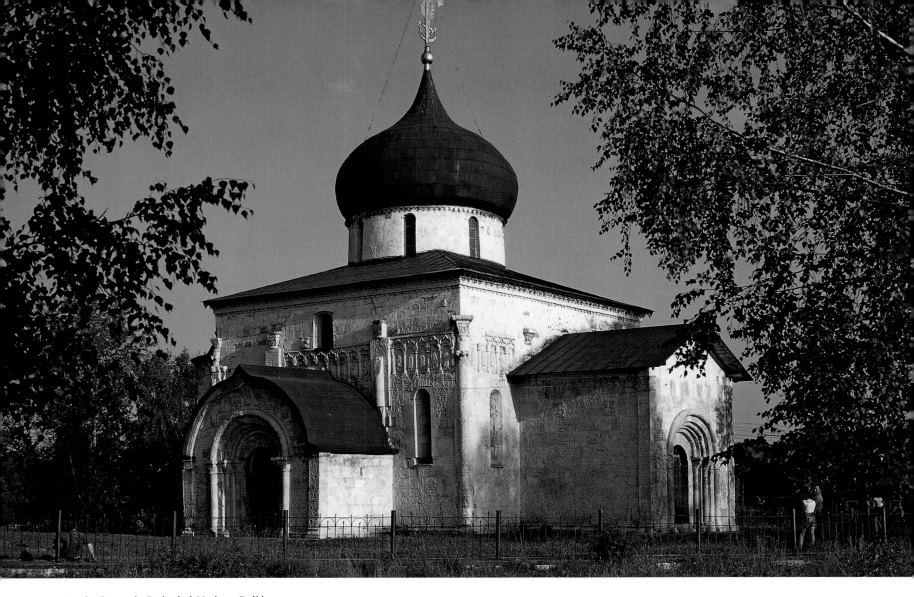

46 St George's Cathedral, Yur'yev-Pol'sky, 1230–34.

the attributes necessary for such an interpretation are absent. What is important is that among the reliefs on the walls of St George's is a representation of the Trinity in Old Testament form, that of the three angels that came to Abraham and received hospitality from him (pl. 48).

It is also to be noted that the sculptural plan for this cathedral includes a number of scenes from the Old Testament. The motif of three youths in a burning furnace had been treated in earlier sculpture found in Vladimir, as had that of the Prophet Daniel in the lion's den. Besides these, further subjects may be identified concerning the miracles of the martyrs from early church history: the depiction, for example, of seven sleeping Ephesian youths, symbolizing the true believers who took refuge in a cave at a time of persecution, slept for centuries, and awoke after the triumph of Christian belief.

Among the reliefs of St George's Cathedral, a significant place is occupied by depictions of saints and prophets. Only

one of these, the figure to whom the cathedral is dedicated, St George, is accompanied by an inscription. Scholars have claimed to identify a number of other saints among these images, but only by conjecture and by comparison with the traditional placing of icons in iconastases of a later date, and also with reference to the patron saints of princes standing in some degree of family relationship to the builder of the cathedral. Rather than adding to these conjectures, it will be worth noting simply that the sculptural ensemble of St George's includes many and repeated genre images of saints.

These include large, full-length images of saints and saint-like figures placed in the niches of the blind arcading (pls 50, 51); smaller figures (pl. 49); and two types of busts – both in the interior and lacking round medallions (pl. 52). Among them healing saints, holding a medicine spoon in the right hand, and holy warriors, carrying weapons, may be clearly distinguished; and almost certainly also saintly kings and princes in formal

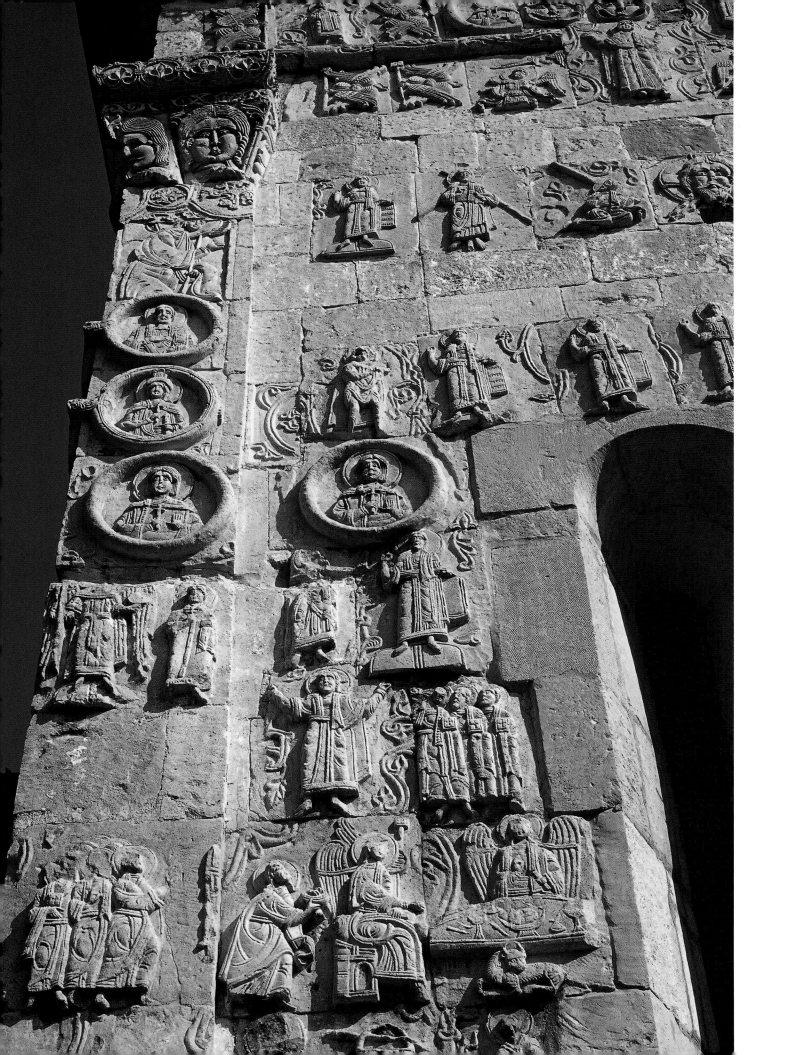

heads above them. In Romanesque art this motif denotes defence against evil.[95]

Another large group of images is composed of mythological and fantastic beasts and also wild animals with specific symbolic significance – griffons, centaurs, sirens, dragons (although some scholars have preferred to see these as characters of Iranian fable), numerous lions taking various forms, and a host of birds; among the last, it is unclear whether the depictions are of phoenix, eagle, pelican, dove or any other particular avian species popular in thirteenth-century Russian art.

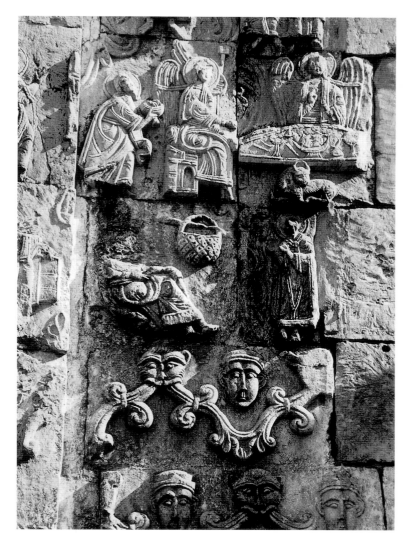

48 (*above*) Detail of "The Trinity" with large figures, St George's Cathedral, Yur'yev-Pol'sky, 1230–34.

47 (*facing page*) Detail of ornamental sculpture on the south front of St George's Cathedral, Yur'yev-Pol'sky, 1230–34, showing parts of "the Sign of the Mother of God", "The Trinity" and "The Ascension".

headdress, penitents holding a cross in both hands, and prelates also holding a cross, but in one hand only, or giving blessing. There are also many images of Old Testament prophets holding long handwritten scrolls. In the absence of written sources, no attempt will be made here to identify these numerous figures, whose range embraces practically all degrees of sanctity, making up a complete and powerful panorama of those leading the Church on Earth, represented as glorified in Heaven.

The heavenly powers are represented on the walls of St George's Cathedral in the form of seraphim, cherubim and large figures of angels. There are also some reliefs depicting lions' mouths out of which protrude garlands, with angels'

49 Detail of ornamental sculpture with figures of saints of smaller size, St George's Cathedral, Yur'yev-Pol'sky, 1230–34.

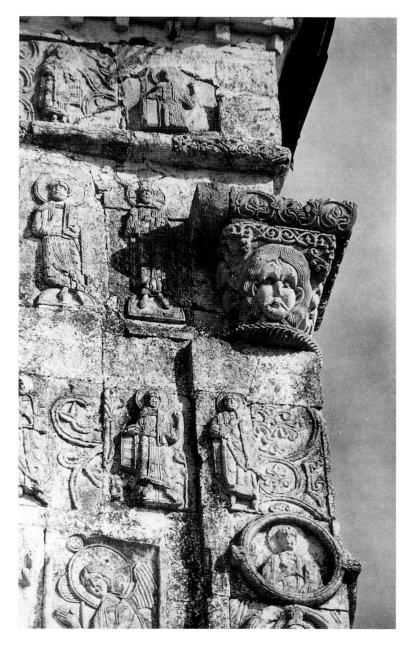

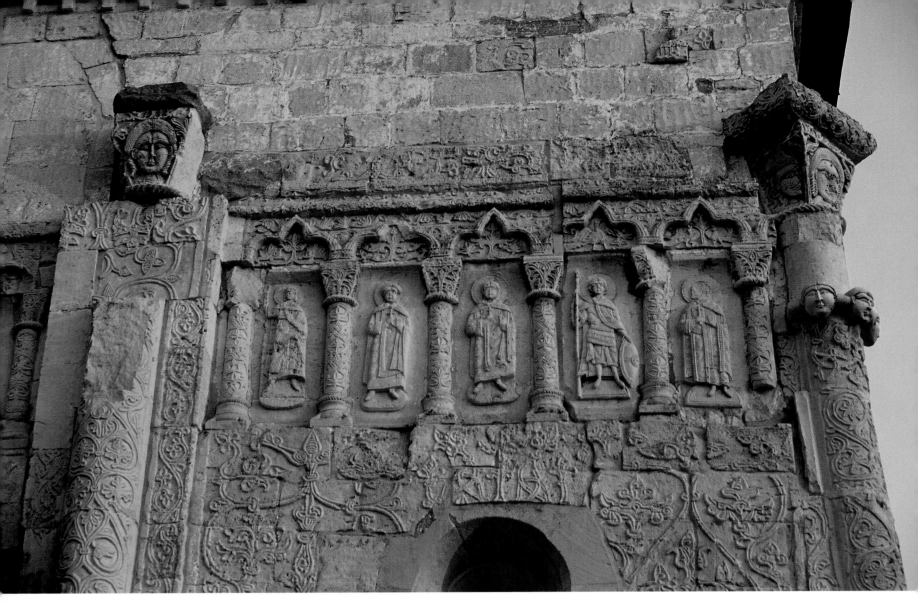

50 Blind arcading with columns and figures of saints at St George's Cathedral, Yur'yev–Pol'sky, 1230–34.

On this subject practically all scholars refer to the Byzantine treatise *Physiologus*, probably written in the ninth or tenth century and widely familiar throughout Europe in the following centuries up to the Renaissance.[96] This medieval "dictionary" of symbolic meanings of various beasts may well have been in widespread use in the thirteenth century. If, however, it was known to the creators of St George's, they certainly made little use of it in their work there, drawing on no more than four or five of the treatise's 49 chapters in the Alexandrian edition. Most of the animals, plants and stones described in the *Physiologus* are absent from the reliefs of St George's, which are more likely to have drawn on other sources.

The first consideration must be the models used by the craftsmen who executed the reliefs. The architectural link between Vladimir and certain Lombard churches of the end of the eleventh and the twelfth centuries has already been men-

tioned in the fifth section of this chapter, and in those churches almost all the subject-matter found in the ornamental sculpture of St George's is also present. Furthermore, images of saints, mythical beasts and wild animals take virtually identical forms in both regions, and there is also close similarity in technical execution.

The images of beasts in the reliefs of St George's may have both positive and negative meanings. The lions undoubtedly have positive,[97] and the centaurs and sirens negative significance; in the *Physiologus*, at least, the latter denote the people's break with the church.[98] No mention of griffons has been found in the treatise, while dragons are not identified as such and merge with beasts that may have both a positive and a negative significance, as symbols of wisdom or of temptation.

It was established some time ago that the ornamentation of St George's Cathedral was executed in two stages.[99] First

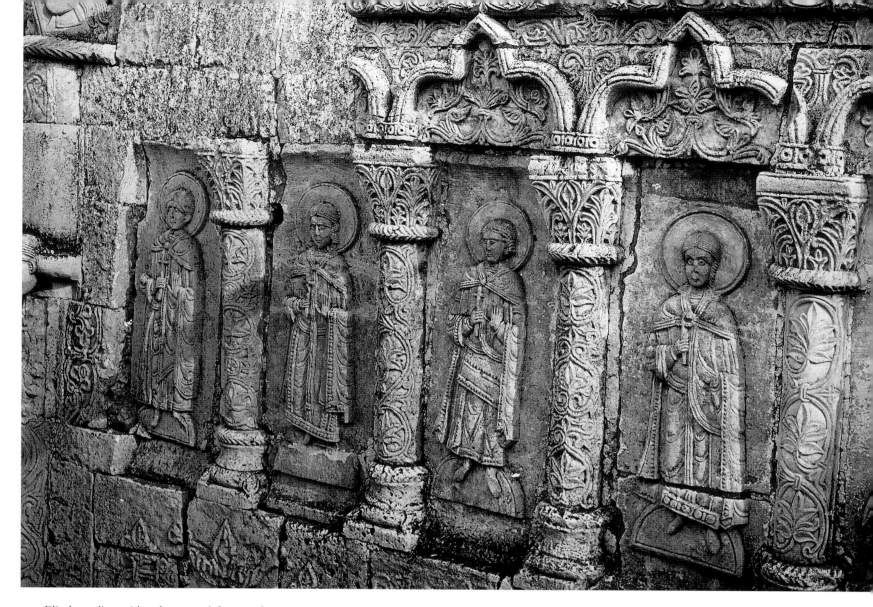

51 Blind arcading with columns and figures of saints at St George's Cathedral, Yur'yev-Pol'sky, 1230–34.

carved were all the high-relief figures already described, and also those on the blind arcading and their capitals and on the long columns extending up to the bases of the arches of the *zakomary* and on their capitals and elsewhere. Then the free surfaces of the walls were carpeted with plant motifs in considerably lower relief (pl. 56), with dove-like birds among them as well as occasional "evil" beasts such as the two centaurs on the south wall of the west vestibule.

This carved scheme may be considered purely ornamental. However, here the *Physiologus* beckons once more. The treatise includes a chapter on the Peridexia tree. "In the land of India there is a tree called the Peridexia. It has the sweetest of all fruits, pleasant to the taste and most wholesome. Doves are fond of feeding from the top of it [. . .] and if we too, guided by the Wisdom of God, should taste the fruits of the spirit [. . .] then we shall be preserved beneath the Tree of Life."[100] It

has been suggested that the sentiment expressed here contains "echoes of the idea of the Tree of Life" and the general scheme of the universe.[101]

Full-length columns play a very important part in the ornamental scheme of the exterior of the cathedral of St George. Those at the corners are almost fully detached; the others are half-columns, dividing each front into three sections. The capitals make a striking effect. Not all are in their original state; some have been altered and even doubled, probably in the restoration of the fifteenth century. Those of the columns near the corner are three-sided: on the front is a noble face *en face*, looking like that of Christ; on either side is a strange face in profile, wearing a tall cap and a large ear-ring. In a lower position are three heads on a single neck in the form of a ring. The capitals of the columns in the middle of the façades bear only the image of the noble face, here suggestive of Christ the

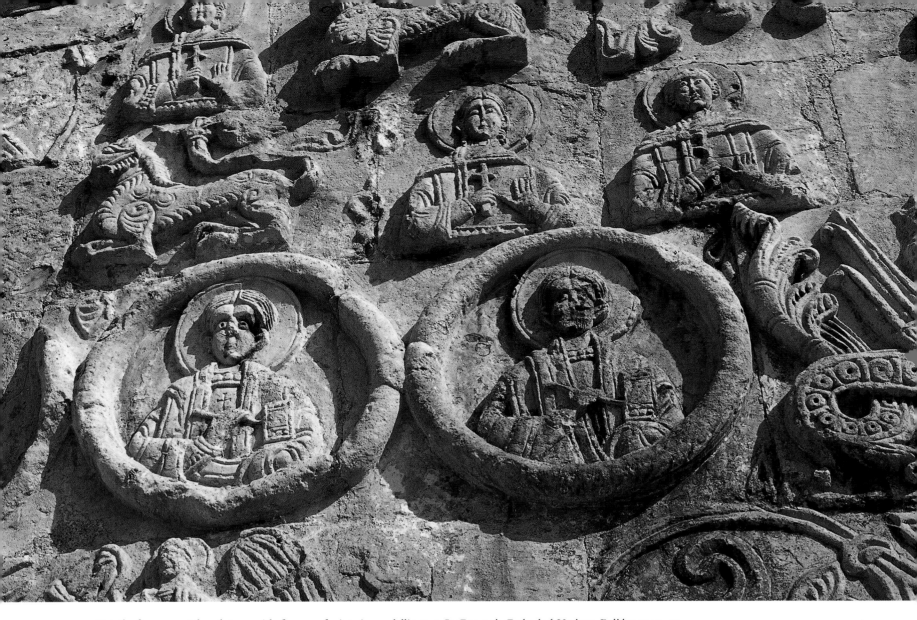

52 Detail of ornamental sculpture with figures of saints in medallions at St George's Cathedral, Yur'yev–Pol'sky, 1230–34.

53 Detail of ornamental sculpture with a lion at St George's Cathedral, Yur'yev–Pol'sky, 1230–34.

54 Detail of ornamental sculpture with an elephant at St George's Cathedral, Yur'yev–Pol'sky, 1230–34.

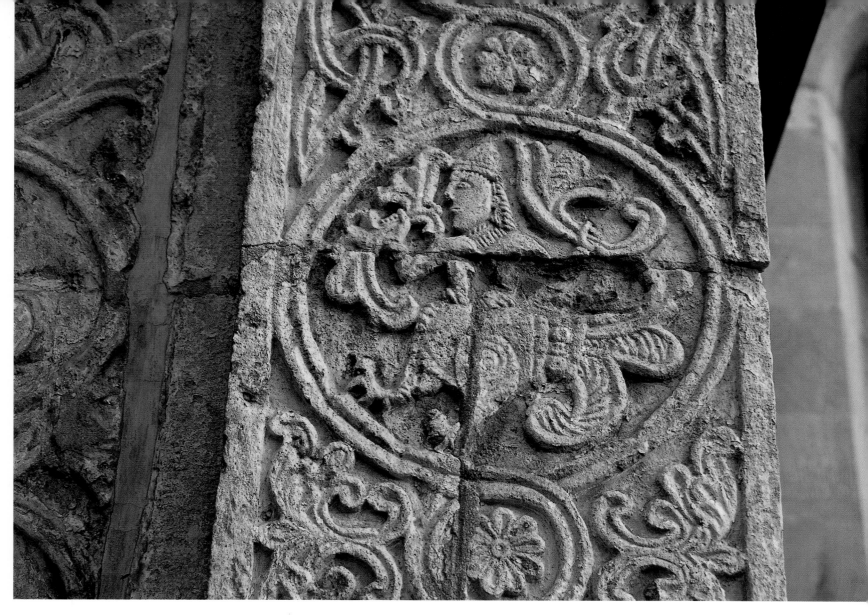

55 Detail of ornamental sculpture with a representation of the Sirin bird (Sirena of Greek myth) at St George's Cathedral, Yur'yev-Pol'sky, 1230–34.

Saviour. In Romanesque art this motif is termed "Christ on a column", and may here symbolize the Crucifixion; the strange faces may represent the thieves crucified with him, and the three heads on the single neck Hell Conquered and Beelzebub (the Romanesque ornamentation of Payerne Abbey in Switzerland includes a similar image).

In general, such a wealth of ornament presents great difficulties in interpretation. First, however, it must be said that despite its altogether exceptional nature, this sculpture represents an entirely logical continuation of the architectural development of the Vladimirian period, which, through the second half of the twelfth and beginning of the thirteenth century, saw an increased role for monumental art. While the ornamental sculpture here provides a dense, sumptuous and variegated envelope for the exterior of the building, the architectural ele-

ments of the composition, as in the case of the cathedral of St Demetrius in Vladimir, continue to play their structural role. Columns divide each front into three parts, crowned, as always, by the fin-like arches of the *zakomary*. The upper horizontal of the girdle of triple blind arcading divides each façade vertically into two zones of approximately equal height. The composition is of course complicated by the protruding vestibules (pl. 57). It would seem that completion of the cathedral turned out to be a more complex process than in the case of any previous church, and legend has it that this is what caused the building to collapse.[102]

The architectural elements, very much present as they are, vie with the powerful impact made by the ornamental scheme. The line between architectural form and its sculptural treatment all but disappears, to an even greater extent than in the

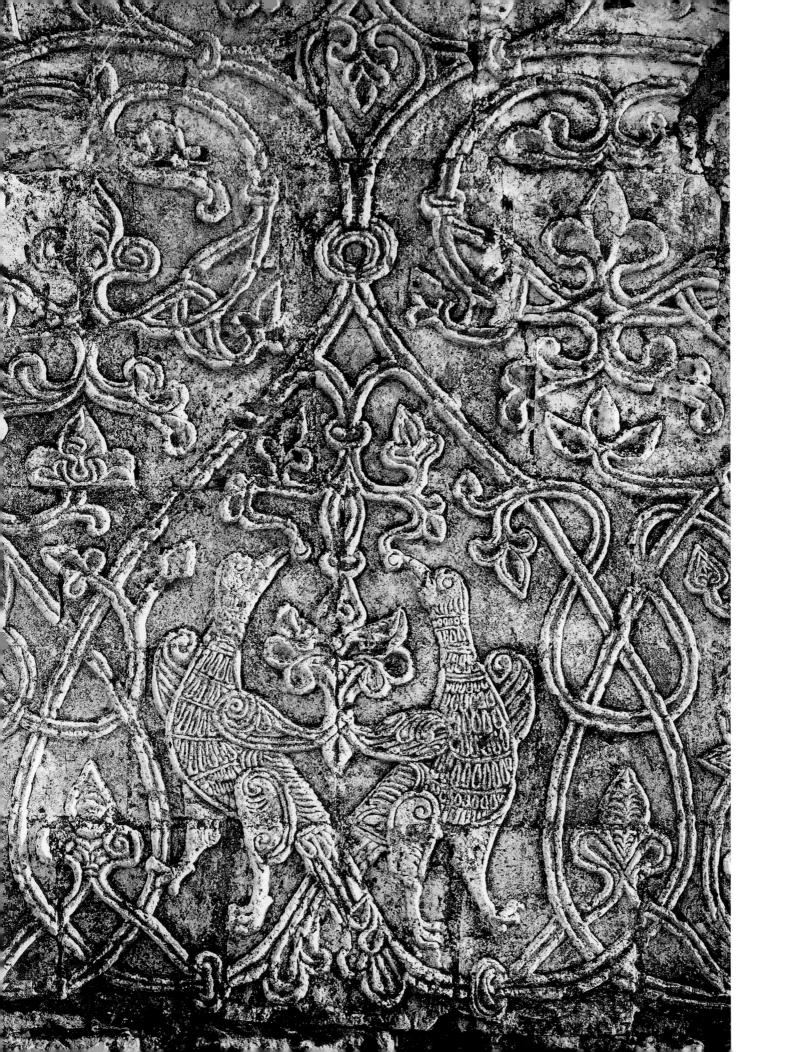

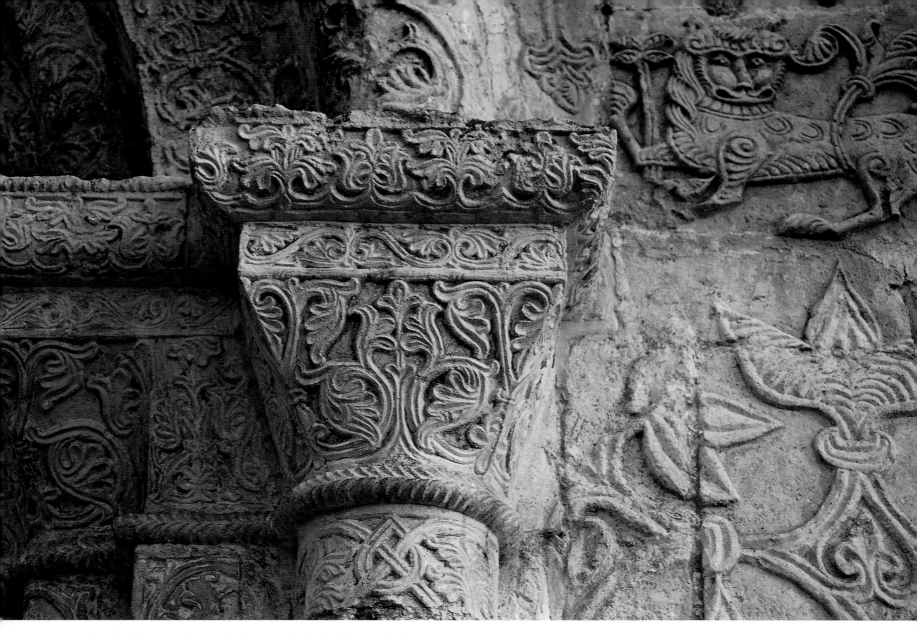

57 Detail of the north front of St George's Cathedral, Yur'yev-Pol'sky, 1230–34.

case of the cathedral of St Demetrius. The reliefs cover the exterior so abundantly that they almost smother it. The form of the building is no longer defined by its architectural features, as it was in the case of the church of the Intercession on the Nerl'. It must have been the sculpture, and the *parlant* artistic language of the entirely symbolic ornamental programme, that dominated in the impact made by this cathedral at the beginning of the thirteenth century.

It was the meaning of the overall sculptural scheme that determined the placing of individual reliefs on the façades and their relation to architectural structures and elements. Once the ideas of the builders of the cathedral had been to a large extent deciphered, the intellectual content of its form came to shape interpretation of its artistic features.

As research on St George's Cathedral has progressed, scholars have advanced more and more complex hypotheses about the meaning of its ornamental programme. In the early 1950s Viktor Lazarev justly observed that the religious basis of this programme was strongly evident. At the same time he emphasized the role of the depictions of patron saints, and noted magical elements that seemed to him to lie behind the Christian content of some motifs.[103] A decade later Nikolay Voronin wrote that "in the ornamental sculpture of St George's Cathedral not only do we see the predominance of vitally important ideological and political themes that shape the whole composition made up of symbolic Christian motifs, but also a strong contribution of features of Russian popular culture."[104] This comment from one of the leading modern schol-

56 (facing page) Plant-form surface ornamentation at St George's Cathedral, Yur'yev-Pol'sky, 1230–34.

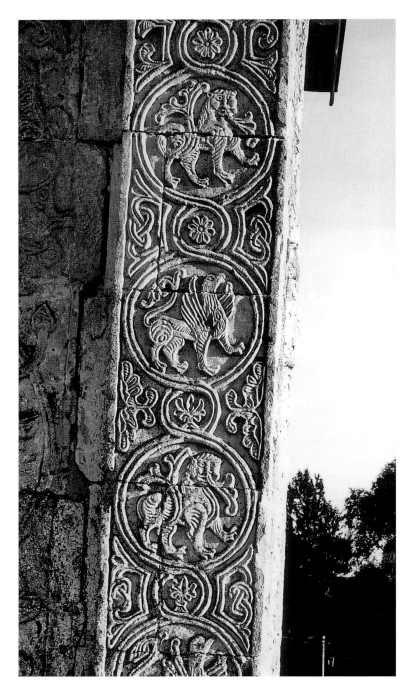

58 Detail of ornamental sculpture with lions and griffons at St George's Cathedral, Yur'yev-Pol'sky, 1230–34.

ars of the architectural history of north-eastern Rus' cannot be taken out of the context of its period, the 1960s, which saw intensified hostility to religion on the part of the Soviet authorities. The tendency of the time was to approach medieval art from a political or popular-cultural viewpoint. It is very difficult, however, to associate a depiction of an elephant, unseen and unheard of in Rus' at the time, or figures of classical Greek mythology, both of which appear among the

reliefs at St George's, with early thirteenth-century popular art in Rus'. It is equally difficult to find grand political ideas in the seat of a little-known appanage prince with no aspiration to the throne of a grand principality at the time when the cathedral was built. Svyatoslav Vsevolodovich assumed the throne of Vladimir fifteen years after the Mongol invasion, and then for only a few months (1247–48). No evidence has come to light of his earlier political ambitions. And anyway, the leading role played in the sculpture of St George's Cathedral by purely religious themes is in general hard to interpret in a political sense – the Crucifixion, the Resurrection and the Transfiguration – would appear indisputable.

Not long after Voronin's work was published, it began to be suggested, notably by G. K. Wagner, that the ornamental scheme of St George's was connected with the glorification of the princes of Vladimir-Suzdal', especially Grand Prince Georgy Vsevolodovich, elder brother of Svyatoslav Vsevolodovich, builder of the cathedral, and of the latter's personal entourage. Wagner took the various "masks" as portrayals of warriors in the armed force of the prince of Yur'yev-Pol'sky, with their heads taking the place of capitals,[105] and interpreted much of the content of the cathedral's ornamental scheme in socio-political light. "The whole of the lower zone [of the ornamental scheme of the exterior] was intended as a depiction of the fertile Earth. Perhaps the region of Vladimir-Suzdal' itself was seen as the foundation, if not of the universe [. . .] then of Rus'."[106]

If these hypotheses are accepted, the religious meaning of the reliefs is considerably reduced. In the present writer's view, to introduce political ideas into the discussion is to put too modern a gloss on the given historical conditions.

Wagner performed a service in that he took account of Byzantine treatises to include theological ideas in his interpretation. He took the ornamental scheme of St George's Cathedral to be a representation of the universe, as conveyed in the "Christian topography" of Cosmas Indicopleustes.[107] Accordingly, "the reliefs on the base of the drum [. . .] signified 'Upper Heaven', as presented [by] Indicopleustes [. . .], while 'Lower Heaven' was assigned to the *zakomary*. Here the principal scenes of the Christian cycle were placed."[108] To the zone of Lower Heaven Wagner also assigned biblical scenes and motifs associated with miracles of saints and the Ascent of Alexander the Great. "All the groups mentioned were accompanied by [. . .] symbols of the various forces of nature: birds, sirens, griffons, dragons and lions" (pls 53, 54, 58).[109] The "Heavenly zone", in Wagner's scheme, was separated by heads of warriors belonging to Prince Svyatoslav Vsevolodovich's bodyguard from the "lower zone", which "in its turn was divided into two parts. The upper one of these was devoted to

the theme of the Church on Earth."[110] Here Wagner placed the reliefs depicting the Virgin Orant, the four patron saints of the princes of Vladimir-Suzdal', the Old Testament prophets, and the healing and miracle-working saints. The lower part of the "lower zone" was taken to represent the fertile earth of the principality on which the cathedral stood.[111] Wagner was at pains to draw attention, as he put it, to "secular images [. . .]. Depictions of *druzhinniki* [warriors in the princely armed forces] occupy not only capitals but even the drum of the cupola", which he signalled as being "quite unprecedented".[112]

The above interpretation of the ornamental scheme of St George's Cathedral provides one of the most striking examples it is possible to find of the influence of Soviet ideology on problems of medieval architectural history. It would not have been worth setting out these ideas in such detail if they did not continue to have such a hold on present-day thinking.

It is typical that the attachment of great significance to social motifs on the part of the feudal hierarchy appeared "quite unprecedented" to this scholar. The placing of "portraits" of *druzhinniki* in a higher position than scenes in the Christian cycle seems inconceivable today. But even if this author's general conception of zones of Heaven and Earth in the scheme of the reliefs is accepted, the prince's warriors would have been in "Upper Heaven", that is, at the summit of the universe, the sphere of God. This by itself would seem to the present writer sufficient grounds for rejection of the whole "social theme" of such a conception. The true case must surely be that there never was a "social theme" in the plan of these reliefs.

It is also impossible to accept the other "theological" side of Wagner's interpretation. First, it is hard to find proof that the work of Cosmas Indicopleustes was known in Yur'yev-Pol'sky or in Vladimir at the beginning of the thirteenth century. It is, further, incomprehensible why the builders of a cathedral should have turned to a geographical treatise, even if it was a Christian one. Doubt also arises as to why depictions of wild animals and fantastic beasts should be taken as denoting the forces of nature rather than as concrete Christian allegories, as they are in the above-mentioned Byzantine treatise *Physiologus* and in bestiaries of Western European origin.[113]

Nevertheless, Wagner made a substantial contribution to our knowledge of the artistic form of the sculptural scheme of St George's. His most important idea concerned the structuring of the numerous subjects, the need to find a system for their correlation. Without this, any discussion of the appearance of the exterior of the cathedral or of its significance in Russian cultural history on the eve of the Mongol invasion would be impossible.

It would seem rational to start any new interpretation of the sculptural programme with what is already well known from earlier buildings in Vladimir, and next to try to see the differences and novelties achieved by the master craftsmen working there and their client. Most of the subjects that appear among the reliefs of St George's Cathedral, Yur'yev-Pol'sky, also appeared in earlier churches, a significant proportion of them in the cathedral of St Demetrius, Vladimir.

It will be fruitful to start with broader aspects. The carved blind arcading round the façades occurs in both buildings, images of saints being placed between its columns. These images, like almost all others, are much larger in the reliefs of St George's. On wall surfaces covered predominantly with images of plant forms, depictions of fantastic beasts and, from time to time, saints also occur. In the case of the cathedral of St Demetrius these images are placed in the higher zone of the façades, but at St George's they start at ground level. In both cathedrals the composition was probably intended as a depiction of Paradise, of the Heavenly Jerusalem.[114]

A crucial new characteristic of St George's Cathedral lies in its particular Christian orientation. At the church of the Intercession on the Nerl', and at the cathedrals of St Demetrius and the Dormition in Vladimir, a leading role is played by images of King David, and in the last of these buildings, also by the Ascent of Alexander the Great to Heaven and a portrayal of the princely family. None of this is found at St George's. Finally, depictions of New Testament themes occur uniquely in the latter, the most important from the theological point of view being Christ's Transfiguration, Crucifixion and Ascension, the leading events of the Christian story, affirming the presence of God in the New Testament. No less significant is the presence of the Trinity in its Old Testament form (three angels eating at Abraham's table), Christ in the customary iconic form of the Saviour, and the Mother of God of Odigitriya. The basic subjects treated by the sculpture convey the essential tenets of Orthodoxy; the cathedral may be called, in a sense, a "monumental catechism". It is here, in the present writer's opinion, that the principal meaning of its ornamental scheme lies.

And indeed, Christ is the leading figure among the reliefs (pls 59–61). It is he, and not warriors from the princely bodyguard, who is depicted on the capitals of columns; and here, in fact, is the familiar Romanesque iconographic type of image of "Christ on a column" already mentioned. The reliefs of St George's possess no military attributes; and most of them are concerned with Christ. These sculptures were most likely originally placed in the upper parts of the exterior, in the middle area of each façade. The representations of events from the life of Christ were probably accompanied in the flanking parts of each façade by Old Testament scenes foretelling the New Testament and by depictions of miracles of saints performed in the name of Christ.

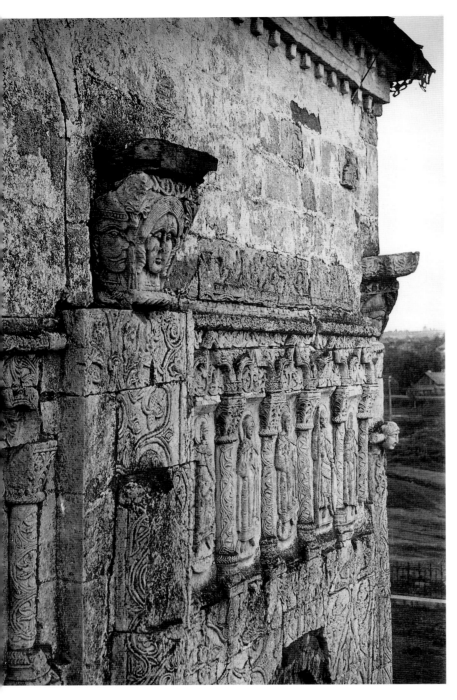

59 Ornamental detail on the north front, with capitals and blind arcading with columns, St George's Cathedral, Yur'yev-Pol'sky, 1230–34.

The filigree ornamentation with foliage forms entirely carpeting the lower parts of the exterior would not seem to have been intended to represent the Earth in flower. On the contrary, this foliage was paradisal, intended to mark off the world of the cathedral from the reality of the everyday world, separating the latter from the "fence" of blind arcading which guarded the entrance to that part of the Heavenly Jerusalem inhabited by saints and prophets, who do not appear below the blind arcading. Most of the figures making up the Heavenly Church Triumphant, therefore, were placed above the level of the blind arcading but lower than the scenes from the life of Christ. The depictions of wild animals and fabled beasts must also have been placed on this level, serving in customary manner as various Christian allegories.

Three images would seem to have been combined in the reliefs of St George's: the usual one for any Christian cathedral, but expressed here with astonishing art, that of the Heavenly Jerusalem, immortal life and salvation in the next world; that of the Church Triumphant, conveyed by saints and prophets; and finally, an image of Christ of a power and vividness unprecedented in the monumental art of the Vladimir region.

Many scholars, of whom V. N. Lazarev was one, have arrived at this conclusion: "the most interesting thing, but also the hardest to grasp, about the sculptural ornamentation of St George's is that it remains a conundrum as regards the next stage in stylistic evolution. If sculpture in Italy at the end of the twelfth century was followed by the Early Renaissance style, and sculpture in southern Germany at the beginning of the thirteenth century by Gothic, where was sculpture in Vladimir-Suzdal' at the beginning of the thirteenth century to lead to?"[115]

This is a surprising question, or at least it surely was fifty years ago, before counterfactuals were taken seriously. What followed, alas, was the rapid destruction of the culture of Rus', especially in the north-east, and even the memory of much of it. Two centuries later, the Muscovites who restored the cathedral no longer remembered its sculptural programme. If Lazarev's question, which has exercised many Russian scholars, is nevertheless to receive a reply, the following one might seem paradoxical. The stylistic stage reached in Yur'yev-Pol'sky could lead nowhere. To move on, it was possible only to move backwards. The sculpture of St George's Cathedral marks the highest point in the evolution of Russian Romanesque. Under favourable historical conditions, this style might have spread more widely. However, it would have encountered other architectural schools in Rus' untouched by the Romanesque. The question as to which school would have prevailed is impossible to answer (pls 62, 63).

Rus' was not completely cut off from Europe by the Mongol invasion. For a time, of course, trade declined as a consequence of the widespread destruction and poverty. However, contacts between the West and the Golden Horde began during the reign of the first Mongol khan, Batu, conqueror of Rus', grandson of Genghis Khan. And indeed, in the mid-thirteenth century contacts between Vladimir and western Rus', which had suffered less destruction than the rest of the

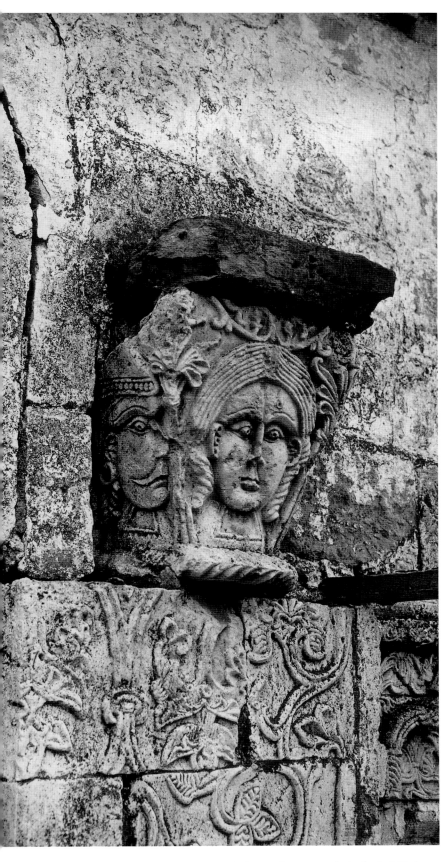

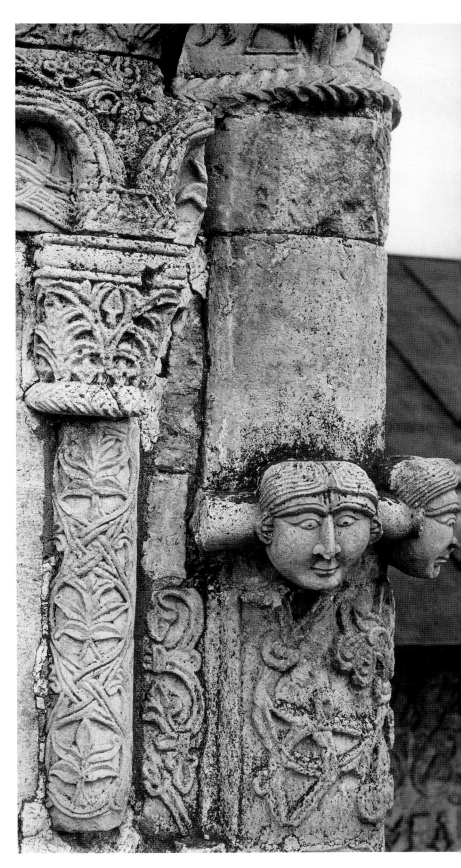

60 Capital fragment on the north front of St George's Cathedral, Yur'yev-Pol'sky, 1230–34.

61 Base fragment of a column on the north front of St George's Cathedral, Yur'yev-Pol'sky, 1230–34.

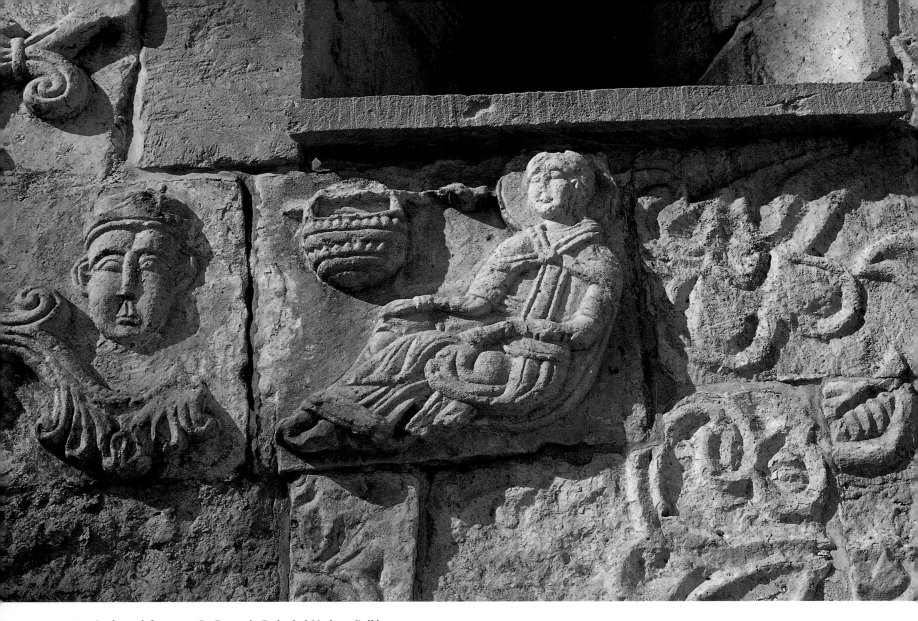

62 Sculptural fragment, St George's Cathedral, Yur'yev-Pol'sky, 1230–34.

country, grew stronger.[116] The way was open to Romanesque master craftsmen, as it had been earlier. It is important to note that the architecture of western Rus', which had rapidly been absorbed into a new Lithuanian-Russian state, knew neither Romanesque nor Gothic. It would be hard to imagine the like of the architectural history of Vladimir, far away on the other side of the country.

In St George's Cathedral we see the apogee of the "sculptural" period in the architectural history of north-eastern Rus', the moment when it was most Romanesque. It sometimes seems as if the Romanesque features "introduced" to the domains of Andrey Bogolyubsky by master craftsmen sent by the Holy Roman Emperor Friedrich Barbarossa were soon "diluted" in the architectural style of Vladimir. This is only partly true. In fact, in so far as architectural forms are con-cerned, it was the Romanesque style that to an incomparably greater extent "diluted" the Byzantine appearance of the churches of Vladimir.

The Romanesque style might itself be called the principle of the use of sculpture to adorn façades. This was infrequent in East Christendom. The use of sculpture in architecture, sometimes seen in Syria and from there passed on to the Caucasus, was not usually of a systematic kind. The rare examples of large-scale use of architectural sculpture in early Eastern Christendom are nearly always connected with specif-ic political undertakings, as in the case of the celebrated Armenian church at Akhtamar dating from much earlier than the churches of Vladimir, or in the slightly later case of the use of ornamental sculpture at St Sophia in Trebizond, which could have been the result of Western or Caucasian influence.

63 (*facing page*) Sculptural fragment, St George's Cathedral, Yur'yev-Pol'sky, 1230–34.

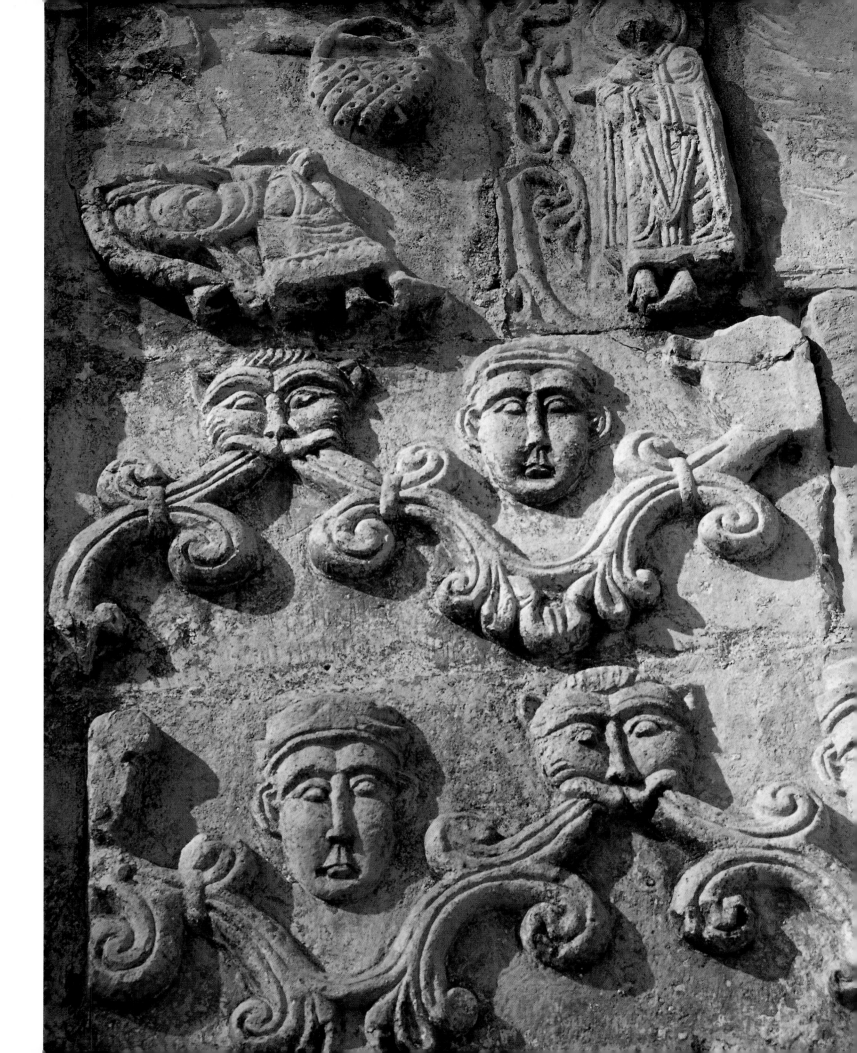

The principle of the combination of church architecture and monumental sculpture on a practically equal footing seen in the Vladimir region was undoubtedly a Western trend based on memories of Antiquity and revived in a new form in the Romanesque period.

In the second half of the twelfth century the trend was taken up in other parts of Rus' and fully exploited at the beginning of the next. On this principle an artistic language was created in which, centred round Russian Orthodox thought of the time, elements of the most diverse origins were employed. Motifs were borrowed from Western jewellery, Byzantine ivory-carving, Byzantine manuscript miniatures, patterns from Constantinopolitan and Spanish cloths; the burial shroud of Andrey Bogolyubsky was made from the latter. Russian and Finno-Ugrian wood-carving also exercised its influence.

All this indicates the aspiration towards universalism in the arts and architecture of the Vladimir region, out of which Russia emerged, a universalism founded by Andrey Bogolyubsky when, as the chronicler records, he gathered in master craftsmen from different lands. Prince Svyatoslav Vsevolodovich too, perhaps, played his part in this process at Yur'yev-Pol'sky. Scholars concur that such a large-scale project must have been executed by a large number of craftsmen and that they must have come from many places. Legend has it that during the campaign against the Bolgars of the Volga, the prince captured some stone-carvers sent to the region from Baghdad. But an overall coordinator of these craftsmen was needed, who would define the programme and control the course of the work and stylistic consistency. There is a fragmentary chronicle record of this: "Prince Svyatoslav Vsevolodovich himself was the master-builder."[117]

The Romanesque features that enter the architectural history of Vladimir in the twelfth and early thirteenth century had all but disappeared after the Mongol invasion. However, they had not been entirely stamped out. Their impact is clearly felt in the early architectural history of Moscow in the fourteenth and early fifteenth centuries.

8 The Mongol Invasion and the Absence of Gothic

"In the splendour of Mongol swords Rus' heard a wondrous tale of the East," wrote Nikolay Roerich in 1939, idealizing Mongol influence on Russian culture.[118] In the nineteenth century the poet Aleksey Tolstoy made a monster from the ancient past, a character in one of his historical poems, the serpent Tugarin, utter the prophecy: "After you have swallowed the whole character of the Tatars, you will call it Russia."[119] A leading present-day proponent of the idea that the Mongols imposed an alien, Eastern way of thought and civilization on thirteenth-century Rus' is Lev Gumilev.[120] The dictum of the celebrated historian Vasily Osipovich Klyuchevsky that the Russian spring and autumn, making the roads impassable, gave the Russians a respite from the Mongol onslaught, should not be forgotten either.

Before considering the later conflicting conclusions of those who have studied the place of the Mongol invasion in Russian cultural history, it will be as well to remind ourselves of its successive phases. A huge stretch of Russian history is involved. The period of the so-called Tatar yoke, taken as beginning in 1238, the year of the beginning of the invasion of the armies of Genghis Khan's grandson Batu, and continuing up to the confrontation of Ivan III with Khan Ahmad on the River Ugra in 1480 and renunciation of allegiance to the Golden Horde, amounts to some two and a half centuries. However, relations with the East established by the Mongol rulers of Rus' played a dominant or at least a crucial role in Russian history up to the steppe campaigns of Prince Vasily Vasilevich Golitsyn during the regency of Sofia Alekseyevna in the years of Peter the Great's minority. That is to say, the central importance of relations with the East in Russian history lasted from the mid-thirteenth to the end of the seventeenth century – almost half the millennium of the Russian state's history.

Batu Khan's first invasion and the savage onslaughts of his commanders in the mid-thirteenth century are undoubtedly a tragic landmark in Russian history. For present purposes it is important to note not only the enormous human and material losses, the destruction of towns, villages and monasteries, but also the results of these losses in terms of the general character, content and forms of Russian art and architecture.

It was the oldest and the most recent layers of Russian culture that suffered most. Among the regions laid waste were those from which the earliest contacts with the Byzantine Empire had been made, where what was left of the heritage of Kievan Rus' up to the middle of the thirteenth century was concentrated – Kiev itself, Chernigov, Pereslavl'-Yuzhny. It took these regions many centuries to recover from the devastation wrought by the Mongols. This whole area had in fact experienced decline at an even earlier date, from the second half of the twelfth century, though it is impossible to tell whether this might not have been a temporary situation linked with the depression throughout the Byzantine world contemporaneous with the Latin Empire of the Crusaders based in Constantinople. It is possible that with the recovery of the Byzantine Empire under the dynasty founded by Michael Palaeologus in 1261, the situation in southern Rus' might have improved too, at least as far as art history is concerned, had the Mongol invasion not occurred. What is clear is that the latter

hastened the disintegration of the heritage of Kievan Rus', and much that had been borrowed from Byzantine culture – mosaic art, for example – was not to be revived in Russia until the eighteenth century.

The Vladimir region and neighbouring principalities suffered no less. This was the area where new cultural movements had sprung up and, as seen, a new art had flourished that was balanced on the border between the Byzantine heritage and the Romanesque school. During the difficult years of the second half of the thirteenth century and most of the fourteenth, the whole architectural spirit and tradition of the great cathedrals of Vladimir, Suzdal' and Yur'yev-Pol'sky, of Bogolyubovo, was lost. Like Kievan mosaic art, the new mastery of exterior monumental sculpture disappeared from Russia for many centuries.

Political developments at this time also had their impact. The aim of the Mongol invasions was not the destruction of states, but their subjugation and incorporation into the Mongol empire, which aspired to suzerainty over all lands as far as "the furthest sea". The unity of this empire – from the Pacific to the territories on the Black Sea, from Rus' to Arabia, taking in much of Eastern Europe and great and ancient states including China, Khorezm and Persia – lasted for no more than about a century. Individual Mongol dynasties, however, retained power in their respective territories for considerably longer. These Mongol states crushed the more developed local cultures and everywhere left their traces in historical memory, drastically accelerating the "Eurasianization" of Russia and changing its relationship with the West, in architecture as in all else.

Not all of Rus' formally became part of the Mongol empire. The principal regions that did so were the grand principality of Vladimir and the smaller principalities grouped around it – Ryazan', Tver', Nizhny Novgorod and Moscow. These not only paid tribute to the khans of the Golden Horde, but their rulers had to be confirmed on their thrones by their overlords, even when a son succeeded a father. The region of the former Kievan Rus', even though it had been laid waste and then been subjected to intense military pressure by the Mongols, freed itself from political dependency fairly rapidly. However, to achieve this it was compelled, in the fourteenth century, to unite with Lithuania to form what historians often call a "Russian-Lithuanian" state, which remained outside the Mongol empire. Formally, Rus' was divided into two parts by the Mongolian border. Vladimir and the nascent power of Moscow were on the Mongolian side. The north-western regions, Novgorod and Pskov, never encountered the horse-borne armies of their neighbours' overlords, but were nevertheless in a compromised position; they paid tribute to the khans and therefore found themselves affiliated to the region that was under Mongol suzerainty.

The Mongol subjugation of Rus' differed in kind from the conquest of China, Khorezm and Persia. The conquering khans, with their retinues, armed forces and families, settled in all the latter three countries. A few of the Mongols, a very small number by comparison with the local population, came under the influence of a higher civilization and adapted to urban life, which they had never previously known. The result was the rapid assimilation of the conquerors and a revival of former state and cultural traditions among the conquered peoples. In Rus', however, conditions in a cold, heavily forested country were not to Mongol taste, and the conquerors left behind them only administrators, *baskaki*, who monitored the payment of tribute and the progress of princely policies. This significantly limited the infiltration of Eastern elements into Russian culture.

Of crucial import was the fact that the Mongols conquered Rus' half a century before their conversion to Islam. Before this the attitude of the khans towards the Orthodox Church had already formed; at that time the Yasa laws of Genghis Khan proclaiming religious tolerance, with the requirement that representatives of all faiths in the huge empire should pray for the welfare of their supreme ruler, were in full force. In the thirteenth century the Mongol army even included a number of Eastern Christians of the Nestorian persuasion. Until the end of the fourteenth or early fifteenth century, with the exception of isolated tragic incidents, relations between Rus' and the Golden Horde did not include religious confrontation. The culture of the church and its architecture suffered destruction in the course of military action, but did not undergo enforced change. The Orthodox foundations of church architecture were fully preserved in the form that they took at the beginning of the thirteenth century. This cannot be said of secular culture. The princes of eastern Rus' learned the Tatar language and acquired the skills of horsemanship and hunting in the steppe; domestic articles from the East came into daily use.

Positive Eastern influence on Russian architecture throughout the Mongol period, however, appears to amount to strikingly little. Virtually no Eastern features are to be seen in building technique, architecture, ornament or decoration in Rus' from the thirteenth to the fifteenth century, and this despite the employment of master craftsmen from first China and then Central Asia in the khans' residences on the Volga.

In a negative sense, however, the architectural impact of the absorption of Rus' into the Mongol empire was profound. The widespread destruction and the obligation of tribute curtailed new building activity to an enormous extent. Besides this, the mechanism of cultural survival played its part. The circum-

stances stimulated the conservation of celebrated monuments and tended to fix established forms. Russian architecture, at least in the east of the country, withdrew into itself and became distanced from foreign influences of any kind.

In any event, the centuries of Mongol hegemony were the period when Rus' responded least in its history, if at all, to architectural movements occurring in the West. This is the period of the greatest difference between the general course of Russia's architectural evolution and that of Western Europe — seen above all in the almost complete absence of Gothic in Rus', despite the dissemination of elements of the Romanesque style in the preceding period and the powerful influence of the Renaissance in the next. The absence of the Gothic component from Russian culture has contributed to the formation of many of its distinguishing features compared with the rest of Europe, and in this it has a similarity with Byzantine culture. The Russian distance from Gothic may be seen particularly in the unchanged use of traditional church plans drawing on Byzantine models and of Romanesque ornamental and decorative features such as semi-circular monumental portals up to the Renaissance. Only in thirteenth-century Novgorod, which conducted an active Baltic trade, did certain ornamental features in brick Gothic appear, in the style of the Hanseatic cities.[121] These features, however, were of local significance, and did not essentially alter the typology of churches in plan or construction, being concerned with ornamental enrichment, as for example with triangular-headed niches or variegated brick string-courses. Gothic influence grew slowly in Novgorod up to the mid-fifteenth century, when it began to reach Moscow together with masters from north Russia on the eve of the first stirrings of the Moscow Renaissance. It is especially to be seen in the church of the Holy Spirit in the monastery of the Trinity and St Sergey (tserkov' Sv. Dukha v Troitse-Sergiyevoy lavre), built in 1476–78, after the first Italian master craftsmen had arrived in Moscow. Nevertheless, Gothic made far less impact on Russian architecture than the Lombard Romanesque or northern Italian Renaissance styles.

During this period the principal architectural events in Rus', as history so often shows, were linked with political processes. Unobtrusively and little by little, the Muscovite princes began to bring eastern Rus' together. In the buildings they commissioned in the fourteenth and first half of the fifteenth century, gradually and at first uncertainly, the features of a national style emerged.

★　★　★

9 The Beginnings of Moscow Architecture

The beginnings of Moscow architecture have been the subject of scholarly debate for one and a half centuries. Nikolay Sultanov, at the end of the nineteenth century, suggested that after the Mongol invasion, building was revived in the east of Rus' by masters from Pskov and Novgorod.[122] In the 1930s, Aleksey Nekrasov wrote of building craftsmen coming to Moscow from the territory of present-day Belarus.[123] A number of early twentieth-century scholars were of the opinion that the Vladimir-Suzdal' architectural tradition did not die out in the thirteenth century.[124] Nikolay Voronin showed that a central role in the territories of the grand prince of Vladimir was played by surviving local masters, in particular those belonging to the circle of "churchmen" who were in part protected by the Mongol laws,[125] and a document from the time of Mengu-Temir (1267) has been discovered which supports this.[126] The argument is generally accepted by Pavel Rapoport, who concludes that the masters from Novgorod worked not in Moscow but further north, in Tver'.[127]

In Vladimir and the older cities of the north-east, Suzdal' and Rostov, almost no new architectural development took place, only restoration of ruined buildings. The area that from now on saw the most historic development was further west, the Upper Volga, the Upper Oka, and tributaries of the latter, in particular the River Moskva. Vladimir was never to resume its former role, retaining simply formal status as capital of a grand principality. The leading figures of the princely families and the church lived in other towns. A struggle for supremacy between Tver' and Moscow continued through the early decades of the fourteenth century. At first Tver' was in the ascendant, but then Moscow, under Prince Ivan I (nicknamed Kalita, or Money-bags), prevailed. The situation was reflected in the architectural history of the two cities.

Masonry building was revived in Tver' almost half a century earlier than in Moscow. The cathedral of the Saviour and Transfiguration (sobor Spasa-Preobrazheniya) was built there as the city's principal cathedral in 1285.[128] Rebuilt a number of times, it was demolished in the seventeenth century and this time replanned. It is impossible to tell to which Early Russian architectural school the original building belonged, especially from early depictions, which are unreliable. It has been assigned to the Vladimir tradition.[129] A later, unusually well preserved church in Gorodnya on the Volga, however, gives a more convincing indication that this cathedral belongs specifically to the Tverian tradition.[130]

On 4 August 1326, on the day of the Feast of the Dormition of the Mother of God, as the chronicler records: "the foundations of the first stone church in Moscow were laid in the

square in the name of the Dormition [. . .] of the Holy Mother of God by the Most Reverend Metropolitan Pyotr and the Most Noble Prince Ivan Kalita."[131] This event is one of the key landmarks in Russian history. For a full understanding of its significance, it is necessary to take some account of the political circumstances of the time.

The struggle between Tver' and Moscow for the rights and title of grand principality was at its height. When the Mongol khan awarded these to the prince of Tver', Ivan Kalita used all possible means (including helping the Mongols to sack Tver' in 1327) to get the decision reversed in favour of Moscow. Metropolitan Pyotr, who supported Moscow, was an old man. Officially the see and residence of the head of the Russian church was supposed to be not in Vladimir but in Kiev, now totally eclipsed and politically insignificant. In 1326 Prince Ivan and the metropolitan took an unexpected decision.[132] In order to establish a precedent for the head of the Russian Church to reside in Moscow, for which there was no basis in law or tradition, the very aged metropolitan willed that he should be buried in Moscow. The prince's capital city lacked not only a church sufficiently important for this purpose, but also had not a single masonry building. To carry out this plan and provide a fit church for the important burial expected shortly, the foundations were laid of the first cathedral of the Dormition (Uspenskiy sobor) in the Moscow Kremlin. The death of Metropolitan Pyotr indeed occurred very soon afterwards, and he was buried in the unfinished cathedral, which was completed in 1327. In the following year, 1328, the khan granted the throne of the grand principality to the princes of Moscow. The new metropolitan, Theognostes, invited from Constantinople, chose Moscow as his see. The combined presence of supreme secular and church authorities in the same city was to be decisive for the future course of Russian history.

The dedication of the cathedral of the Dormition points to this. The principal cathedral of Vladimir bore the same name, giving an unmistakable symbolic significance underlining continuity in relation both to the see where metropolitans had served immediately before the Mongol invasion and to the cathedral of the capital city of the grand princes. The cathedral of the Dormition in the Moscow Kremlin has been radically rebuilt four times over the centuries.[133] Scant information from chronicles and depictions on icons are all the graphic indication we have of the appearance of the original building on the site. Archaeology has produced more precise data, which turn out to be surprising.[134]

In form and scale, the plan of the original cathedral of the Dormition in Moscow repeated not the principal cathedral of the capital of the grand principality of Vladimir, but St George's Cathedral in the minor appanage city of Yur'yev-Pol'sky. The plan of each building is the same: relatively small dimensions, widely spaced pillars, three apses and vestibules giving straight onto the central square of the interior. Even the side-chapel is situated in exactly the same place, in the north-eastern corner, and this fact, for the present writer, is of cardinal significance.

Masonry architecture in Moscow does not start with the model of a politically important older building, but takes up the Vladimir tradition at the point where it was stopped by the Mongol invasion, unconcerned by the political insignificance of the tiny appanage principality where the model church is situated. It is no less revealing that the builders of the Moscow cathedral should have thought of copying the plan and probably the basic form of their model, but with no hint whatsoever of any intention of reproducing its sculptural ornamentation. It is as if the complex series of reliefs covering the exterior of St George's Cathedral in Yur'yev-Pol'sky went unnoticed by those who built Moscow's first masonry church.

The same thing is seen at a somewhat later date in Nizhny Novgorod – in the rebuilding of the cathedral of the Saviour there in 1350–52 and the building of a new church of the Archangel Michael on the same spot in 1359.[135] St George's Cathedral, Yur'yev-Pol'sky was most probably imitated in both Moscow and Nizhny Novgorod for practical reasons. The capacity of the interior was increased by the vestibules. To have achieved this by other means, with a more complex plan or enlargement of overall proportions, would not have been possible given the reduced conditions of building at the time.

Further masonry building soon took place in Moscow: the church of St John Lestvichnik "under bells" (tserkov'-kolokol'nya vo imya Sv. Ioanna-Lestvichnika) was completed in 1329 and the church of the Saviour on the Bor (khram Spasa na Boru) was begun in 1330. When the latter was destroyed in the Soviet era, stone fragments carved with foliage forms dating from one of the numerous previous rebuildings were found in wall masonry; such ornament was popular in Moscow in the late fourteenth and early fifteenth centuries.[136] Here is an important continuity, linking the origins of ornamental carving in Moscow with the Vladimir tradition which was based, as seen above, on Romanesque. The Moscow architectural school, extending to the smaller annexed principalities such as Kolomna, Serpukhov and Mozhaysk, evolved steadily in the course of the fifteenth century, and in these smaller towns a more distinct type of church emerged, clearly returning to Vladimirian style. Its plan was a short rectangle; it had three apses of which the central one was slightly more extended, and four pillars on which rested arcades supporting the drum and cupola. Occasionally the party walls of the apses would have a supporting function. Although the proportions are

somewhat different, this was the form taken by the first cathedral of the Archangel Michael (sobor Mikhaila Arkhangela) in the Kremlin (1365) and the church of the Resurrection (Voskresenskaya tserkov') and cathedral of the Dormition (Uspenskiy sobor) in Kolomna;[137] the last was surrounded by an open arcaded gallery, with one or even three stairways.[138] The second cathedral of the Dormition in Moscow, standing on the same site as the first, would seem to have been similar in form; it was completed in 1380, a few weeks before Moscow's grand prince, Dmitry Donskoy, destroyed the Mongol reputation for invincibility with his decisive victory over Mamai, warlord of the Golden Horde, at Kulikovo.

A group of cathedrals dating from the end of the fourteenth/beginning of the fifteenth centuries exemplifies the "early Moscow style" preceding the arrival of Renaissance master craftsmen in the city: the cathedral of the Dormition (Uspenskiy sobor) in Zvenigorod (1396–98), the cathedral of the Nativity of the Virgin (sobor Rozhdestva Bogoroditsy) in the Storozhevsky Monastery of St Savva (Savvino-Storozhevskiy monastyr', 1405–08), and the cathedral of the Trinity (Troitskiy sobor) in the Troitse-Sergeveva Monastery (c. 1422). The least rebuilt and restored of these buildings (and unfortunately, restoration work in all these cases is inadequate) is the cathedral of the Dormition in the kremlin in Zvenigorod, an ancient town which was the centre of an appanage principality belonging to the Moscow dynasty. Here the style of Moscow architecture of the time is especially clearly on view.

Of course, this cathedral has undergone various alterations through the six centuries of its existence, especially during the seventeenth and the nineteenth. Its walls have been resurfaced, the *zakomary* removed, the central windows of the south and north fronts and those of the apses widened. The portals were probably restored in the nineteenth century, though there is incomplete record of this. Fortunately, however, in the building as it is today, original fourteenth/fifteenth-century features predominate, and it is entirely possible to mentally reconstruct the original appearance of this outstanding monument, the artistic quality of which, in the present writer's view, is comparable with that of the church of the Intercession on the Nerl'.

The cathedral of the Dormition in Zvenigorod bears characteristics of the time when Moscow was still seeking to raise its status among other eastern Russian principalities. Though its paramountcy was already secured, it was by no means the only centre of power in the lands of Rus'; there were also the independent principalities of Tver' and Ryazan', and the huge territory of Great Novgorod. In due course Moscow would unite all of them into a monolithic Russia.

Historians often write of the political manoeuvrings of the princes of Moscow, of their deft use of the effect of the Mongol invasion to suit their own ends, and there is a widespread notion of the powerful economic and financial interests of the Moscow dynasty. The Moscow princes in general tend to be thought of as skilful, obstinate mediocrities. This image has come to be applied to the whole period of early Moscow, which is wholly inappropriate.

In the second half of the fourteenth century, the territories of Muscovy unquestionably became central to Russian culture. It will be sufficient proof of this to name only two leading historical figures active in the territories ruled by the princes of Moscow and who had direct links with them: St Sergey of Radonezh, who inspired the growth of monastic life in Russia, and Andrey Rublev, greatest of Russian painters. To the culture represented by these two men, the creators of the cathedral of the Dormition in Zvenigorod, so rich and subtle in all its traditional simplicity, must surely be said to belong. Only a few fragments of Rublev's frescos and a very small number of his icons are preserved. The cathedral dates from a time when its builder, Prince Yury Dmitriyevich, was very close to a follower of St Sergey of Radonezh, St Savva, who at this time founded the Storozhevsky Monastery of St Savva, soon to become famous, near Zvenigorod.

The cathedral of the Dormition stands at the south end of the old kremlin of Zvenigorod on a hill rising above the River Moskva (pls 64–66), which in the fourteenth century was wider than it is today. When it was built, the cathedral stood on a smooth stretch of river looking out over a wide expanse of water meadows.[139] It is extremely simple in plan, thick-walled and nearly square, not counting the apses. Four cluster-piers stand at the centre of the square, with the choir to the west. Only the middle apse extends outside the square of the plan. The two side apses, unusually, are turned on a diagonal, having the effect of "smoothing out" the corners and enhancing the unity of the whole structure. If the high iconostasis, installed later, is mentally replaced with the original lower one which exposed the upper half of the presbytery to view, the interior makes another impression. Thanks to the low-ceilinged entrance area, beneath the choir, the eye naturally moves forward and upwards into the generous central space below the high drum and cupola, and straight on to the furthest point of the semicircle of the middle apse (pls 64–66).

The exterior of the cathedral also makes an unexpected impression. Its plan suggests a cube-shaped building. But the effect is quite to the contrary – it has a vertical harmony reminiscent of the church of the Intercession on the Nerl'. The cathedral of the Dormition, however, is much bigger, a grand city building, and yet graceful, despite the traditional design of its fronts, which are divided by shallow pilasters into three parts, each crowned with a narrow arch. Up the middle two

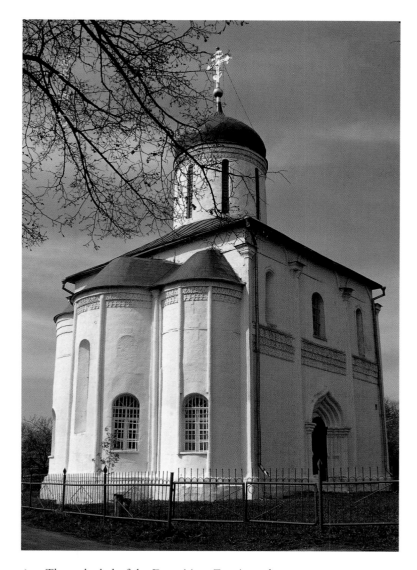

64 The cathedral of the Dormition, Zvenigorod, 1399–1400.

65 Detail of the south front of the cathedral of the Dormition, Zvenigorod, 1399–1400.

pilasters and at the corners of each front run long, slender columns. The windows, now partially rebuilt, were originally slit-shaped and placed in the upper part of the façade only, at the level of the choir. Below them is an ornamental band carved with foliage forms. At the centre of each front is a monumental entrance portal.

These features are found in any church of the Vladimir school. However, this Zvenigorod church of the end of the fourteenth century has a new aspect. It is shorn of figurative sculpture, of the ornamental covering of the last pre-Mongol-period buildings. At the same time, the finest architectural qualities of that moment are preserved in the feeling conveyed of balanced proportions, of grace and peace, and no less importantly, in a reminder of the carved tradition associated with Romanesque influence.

This last quality is seen in the exceptional sensitivity of the handling of detail in "white stone" (limestone) – in the capitals of the superbly elegant columns extending to the full height of the building, the slender mouldings of the windows, the carved band round the façades which, although flat, preserves and concentrates within itself the former abundance of ideas found in the Vladimir school, along with the memory of a vanished sculptural art. On the other hand, this ornamentation speaks of a new, stricter era, of artistic thinking that strives for clarity and purity of structure alongside the capacity for exuberance.

From the late Vladimir heritage, when sculpture dominated architectural form, this building in Zvenigorod also preserves exterior tectonic freedom. The *lopatki* with their accompanying columns on the exterior are not linked to the interior pillars, as they usually were in Byzantine and the earliest Russian

66 Detail of ornamental frieze, cathedral of the Dormition, Zvenigorod, 1399–1400.

churches. The façades of the cathedral of the Dormition are freely designed, which gives the whole exterior lightness and poise.

It was with this building that a new Russian architectural culture began, led by Moscow, in process of regeneration after the shock of the Mongol invasion. The cathedral in Zvenigorod did not belong to the grand princes. Prince Yury Dmitriyevich of Zvenigorod was a son of Dmitry Donskoy, victor of Kulikovo. After the latter's death Yury Dmitriyevich became a pretender to the throne of Moscow during the minority of Vasily I, heir to Dmitry Donskoy. More than half of the fifteenth century passed in a struggle between two branches of the Moscow dynasty, with first Prince Yury in the ascendant and then his sons. The throne of the grand principality and of Moscow itself passed into their hands more than once,

but in the end the senior branch of the family prevailed, establishing its power once and for all with the accession of Grand Prince Ivan III (the Great), one of the most gifted and successful of all rulers of Russia, in 1462.

Yury Dmitriyevich built the cathedral of the Dormition in his appanage capital just before the beginning of the internecine family struggle, and the building conveys his political programme. Apart from the question of who was to take the throne, this programme corresponded in many ways to the general aspirations of all branches of the Moscow dynasty, and in the buildings of Yury Dmitriyevich its main points were expressed, perhaps, with particular clarity, because the younger branch of the family was more in need of monumental propaganda than the elder, who held in their hands the sacred places and relics of the Moscow Kremlin. The dedication of the cathedral to the Dormition of the Virgin linked it, characteristically, with the principal cathedrals of Vladimir and Moscow. Vladimirian features were emphasized in its very plan and in the slender columns on the façades and the carved frieze, and all this testified to a continued architectural orientation towards the Vladimirian school, allied with a memory of the greatness of the rulers of north-eastern Rus' before the Mongol invasion.

As has already been mentioned, further buildings in the same spirit were the cathedrals of the Nativity of the Virgin in the Storozhevsky Monastery of St Savva (pl. 69)[140] and of the Trinity in the Troitse-Sergiyev Monastery.[141] Although these buildings stylistically resemble the cathedral of the Dormition, they lack the supreme grace of the cathedral that served as the princely church of Zvenigorod (pls 67, 68). Nevertheless, the stylistic integrity of all these churches makes it possible to speak of the establishment of a Moscow architectural school.

Scholars of Moscow's architectural history in the early and mid-fifteenth century have stressed that the traditions of a number of Russian principalities made it into a single unified system. The cathedral of the Saviour (Spasskiy sobor, pl. 70) in

67 and 68 Plans for the cathedrals of the Dormition and of the Nativity of the Virgin, Zvenigorod.

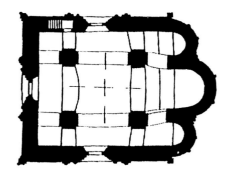
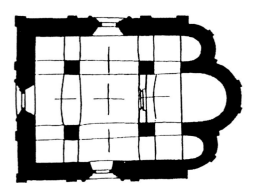

69 View from the east of the cathedral of the Nativity of the Virgin in the Storozhevsky Monastery of St Savva, 1405–25.

the Andronikov monastery, the oldest preserved monument in present-day Moscow, is usually taken as a supreme example of this.[142] In comparison with earlier buildings, it has an upward thrust that begins to suggest the form of a tower. Its plan is traditional, but the main structure of the building is not. The middle aisles have higher ceilings and the corner cells lower; the cupola at the centre is placed on a base surrounded by the arches of ornamental blind gables (*kokoshniki* and *zakomary*). Scholars have considered that the aspiration to a dynamic vertical design derived from south Russian architecture, and in particular from the thirteenth-century Paraskeva Pyatnitsa

church in Chernigov, which displays similar features. This is not surprising: both secular and church authorities at that time were making every effort to unite past traditions, and turned to building models belonging to a time of greatness for both southern and north-eastern principalities. The features noted above may have derived from southern architecture, but the important factor is that in this cathedral in the Andronikov monastery they were made to serve the principles of the earlier Vladimirian style. Here, as in Vladimir, the walls of the interior are divided by *lopatki*, the pillars are of cluster form, and the drum is covered, as in Vladimir churches, with orna-

mental arcading. This cathedral displays features typical of the styles of the north-west, Novgorod and Pskov, where many churches were built cross-shaped and with lower flanking parts.

The large-scale borrowing to be seen in the cathedral of the Saviour in the Andronikov monastery notwithstanding, the attempt was made here to create an entirely new form of church. The synthesis of different traditions, the simultaneous adoption of the attainments of the chief architectural schools of Russia, seen in both earlier and contemporary cathedrals, is an event of cardinal importance and novelty, and testifies to the aspiration to universalism typical of Moscow of that period, when the grand principality was gathering in the Russian lands to form a unified state.

No less important is the emotional content of this building. It has a palpable aspiration towards a single, unified structural system, complex and indivisible, with an upward-surging movement culminating in a combination, typical of the new Moscow style, of crowning elements – first the *zakomary*, and then the *kokoshniki* surrounding the base of the drum. And although the cathedral is on a comparatively small scale, it achieves a monumentality that is linked with its tendency to ornament. These features displayed in the cathedral in the Andronikov Monastery in the first quarter of the fifteenth century were to be the basis for the further development of the Moscow architectural school.

The second quarter of the fifteenth century was another fallow period for masonry architecture in Moscow. Only after the return of political stability in the third quarter of the century did numerous masonry buildings appear, in the Kremlin and in other parts of the city, few of which, unfortunately, survive today.[143] It may be said, however, that these vanished buildings changed the face of Moscow between 1450 and the mid-1470s. In the Kremlin alone during this period, eight new churches were built, as many as in the city's entire history hitherto.

There was also a new material development. Earlier buildings in Moscow had been built of "white stone", limestone; now brick began to be employed as well. Brick had already been used as a building material in Novgorod and Pskov, probably under the influence of brick architecture in the North German seaboard towns with which Novgorod had active trading links. It is thought that in the third quarter of the fifteenth century an artel of Novgorod masters worked in Moscow and brought new techniques with them. Traditional Moscow techniques continued to be used by local craftsmen working at the same time. In addition, in 1474 a group of masters was brought from Pskov. Such a concentration of all the building skills in the country in the capital city of the grand principality of Moscow was stimulated by the need to execute a new architectural programme related to the changing internal and external position of Muscovite Russia, which was at a new stage of self-identity.

The end of the fourteenth and first half of the fifteenth century were grievous times for Moscow. Soon after the Russian victory at Kulikovo, the Mongols came back with a vengeance and took and sacked Moscow, and the Tatar yoke was reimposed. One of Dmitry Donskoy's sons, Grand Prince Vasily Dmitriyevich (Vasily or Basil I), was for a time a hostage of the Mongols. In 1445 Muscovite forces again suffered defeat, and their ruling prince, Vasily I's son, Vasily II, was also taken prisoner. This prompted the younger branch of the Muscovite dynasty to make a new bid for power. Ransomed back from captivity, Vasily II was seized and blinded by his cousins. But Moscow remained faithful to the elder branch, and Vasily the Dark (Blind), as he was henceforth called, was confirmed on the throne.

Vasily's eldest son Ivan became co-ruler of Muscovy. After his father's death in 1462, as Ivan III he ruled for over 40 years. It is no exaggeration to call this outstanding monarch the creator of Russia. Over the previous two centuries his predecessors had acquired the territories of the neighbouring minor principalities one by one; in his reign, the process was taken further to engage all other major centres of power in Rus'. Ivan III annnexed the northern Russian territories, those of Great Novgorod, significantly more extensive than Muscovy. He won dominion over Tver' and gained control of Ryazan', strongest and most dangerous rivals of Muscovy. A victorious war with Lithuania brought some of the southern lands of Rus' into the Muscovite state. At this point the territories ruled by Ivan extended from the Arctic Ocean to the southern steppes, from Lithuania in the west to the Northern Urals in the east. This was now Russia. In 1480, with the Mongol retreat after the long confrontation on the Ugra, Mongol rule was at last ended. Having become the independent ruler of a huge country, Ivan III set about giving his authority a new ideological stamp. During this period Russian architectural style was transformed.

70 (*facing page*) The cathedral of the Saviour in the Andronikov monastery, Moscow, 1425–27.

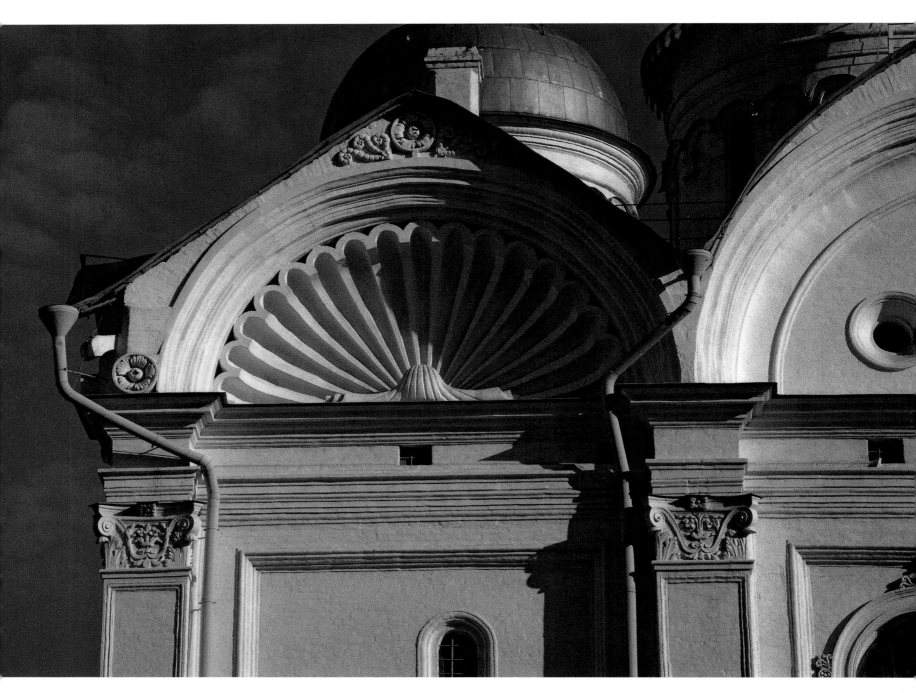

71　Scallop ornamentation on the façade of the cathedral of the Archangel Michael, Kremlin, Moscow (Alevisio Lamberti da Montagna), 1505–09.

II

The Moscow Renaissance

1 Byzantine Masters in Renaissance Italy and Moscow

"An observer of the year 1500 might well have supposed that Muscovy was about to be drawn into the cultural orbit of Western Europe and would adopt Renaissance architecture," mused Cyril Mango in his history of Byzantine architecture.[1] The Renaissance period, when contacts were restored between the State of Muscovy and a number of Italian cities, introduced new features to Russian architecture which were preserved throughout the following centuries. The changes that took place in the architecture and artistic language of Moscow during the last quarter of the fifteenth century and first third of the sixteenth were on a scale to be compared with only two events in Russian architectural history up to that time: the adoption of Byzantine models after the conversion of Rus' to Christianity at the end of the tenth century, and the appearance of Romanesque in Vladimir after the arrival of the Lombard masters there in the second half of the twelfth century.

The radical new directions in Russian architecture at the turn of the fifteenth and sixteenth centuries were the result not so much of internal artistic developments as of external causes, in particular, the emergence of new building programmes. The last, in turn, were brought into being by a chain of political events occurring on a vast scale throughout Europe from Constantinople to Paris, from Rome to Saray, capital of the Golden Horde on the Lower Volga, which transformed the Russian state's international position and self-image. The main part in this process was played by the advent of the Ottoman Empire which took the place of the Byzantine – the last great movement of the East towards the West, shifting the frontiers of the civilized world. At the same time, Tamerlane's defeat of the Golden Horde on the Volga and the conqueror's retreat into Central Asia facilitated Russia's liberation from Mongol rule and contributed to its rapprochement with the West.

At the beginning of the fifteenth century, Muscovite Rus' still belonged to the East in two ways: politically, it belonged to the Mongol empire of the steppes; in ecclesiastical jurisdiction and in cultural terms, it belonged to the Mediterranean Byzantine world. During the chronological period that coincided with the Italian Renaissance, both these European power centres, Saray on the Volga and Constantinople, were lost; the Golden Horde disintegrated and the Byzantine Empire was swallowed up by the new Ottoman Empire. Muscovite Rus' gained both political independence and ecclesiastical autocephaly. The Russian state's new role in Europe was the logical outcome of the new East-West frontier. At the critical moment of Ottoman expansion and the fall of the Byzantine Empire, the West, led by the Papacy and the Venetian Senate, made attempts to include Muscovy in its political system. This moment gave Russian architecture the opportunity to fix its future course, and it always afterwards preserved the memory of the rapprochement between Muscovy and the West that took place at the turn of the fifteenth and sixteenth centuries.

Fortunately, this development occurred at a propitious time, and Russian contact was with the vanguard of the West, Renaissance Italy. This was not by chance: Venice, Florence and Rome on the one hand, and the Orthodox cities of Eastern Europe on the other, were havens for Byzantine thinkers and craftsmen unable to accommodate to the Ottoman regime. In their own lifetime and that of the next generation, they helped to link Italy with Muscovite Rus'.

These East-West relations had begun to be established before the fall of Constantinople to the Turks in 1453. Byzantine culture on the Mediterranean had been absorbing aspects of Western culture for three centuries. The "Latin Empire" set up after the seizure of Constantinople by the knights of the Fourth Crusade in 1204 survived in the heart of the Byzantine Empire for more than half a century. Only in 1261 was the power of the Paleologue dynasty, after a counter-

attack on the Crusaders mounted from Nicaea (modern Iznik), reestablished in the New Rome on the Bosporus. Byzantine trading supremacy, however, had now disappeared forever. Around 1290 the Genoese occupied the ancient Crimean port of Kaffa (present-day Kerch); a century later a Venetian trading settlement began to flourish on the estuary of the Don at La Tana, and further Italian trading stations crept up to the Russian frontier.[2]

In the middle of the fifteenth century, the dying Byzantine world found itself under the prevailing Italian, above all Venetian, influence. Before the capture of Constantinople by Ottoman forces, the Venetian Senate had expressed its desire to help defend the city, which, so ran its resolution, "belongs, we may say, to our state".[3] Byzantine hopes, in turn, were directed towards the West. Events now took place the like of which had not been witnessed for many centuries: the Emperor John Paleologus II visited Italy, accompanied by the patriarch of Constantinople Iosif with twenty-two Byzantine metropolitans and bishops who participated in an ecclesiastical council.

The Council of Florence (1439) played, perhaps, just as important a role in Russian as in Byzantine history. Its proclamation of the union of the Orthodox and Roman Catholic churches afforded Constantinople neither political nor military help. The crusade against the Turks promised by the papacy failed to materialize. The Council's most significant outcome was the division of the Byzantine world into two camps, those who accepted and those who rejected the union of churches. Muscovite Rus' was vehemently opposed to union.

The papacy responded with a succession of attempts to reach an accord with eastern Rus' (the western part of the country still being joined with Lithuania). Had it not been for this, Grand Prince Ivan III would scarcely have married, in 1472, Zoë Paleologa, niece of the last Byzantine emperor, Constantine Paleologus, and presented as his dynastic heir. Sophia, as she was rechristened, had been brought up in Italy in the circle of Byzantine émigrés who accepted union with the West. Her entourage was an unusual and short-lived cultural group, a Greek-Italian circle which included Orthodox prelates who accepted the union with Rome and had joined the Vatican court, Byzantine humanists fleeing the Ottoman regime, and Italians with close cultural or commercial Greek connections. The central figure in this circle was indisputably Vissarion, metropolitan of Nicaea, who had come to Italy to take part in the Council of Florence and played a leading role in the resolution for union between the churches of East and West. He was first appointed a cardinal, then legate to Bologna, and at the end of his life, after the fall of the Empire, nominal patriarch of Constantinople in exile.[4] He bequeathed his remarkable library together with a number of relics to the State

of Venice, in which he placed hopes for the liberation of Constantinople. He formulated a plan for the education of young members of the imperial family who had escaped from the Turks.[5]

The marriage of the grand prince of Muscovy to Princess Zoë was very likely Cardinal Vissarion's project. In any case, it is generally accepted that it was Vissarion who most clearly articulated the idea of "Byzantine reconquest",[6] and indeed, throughout the rest of his life he attempted to get a new crusade underway to liberate Constantinople. Amongst this circle that cherished the memory of the Byzantine Empire and considered itself that empire's true heir, the idea arose of the establishment of a new Orthodox *oikumene* which would be a source of strength even if "Byzantine reconquest" as such were never to take place. The fewer expectations the exiles from Constantinople had of help from the West, the more illusions they built up about the most distant of the Orthodox states, Muscovy. The "Byzantine dream", which persisted for several decades in the exiled community of Greek and Italian humanists and politicians, was transferred to Moscow by the last representatives of the Paleologue dynasty and their Italian-Greek retinue.

It is possible that the notion of Moscow as heir to Byzantium did not originate with Russian statesmen but arose in Venice, the chief centre of the Italian-Greek world at the end of the fifteenth century. In any case, at the very moment that the grand prince's envoy, Semyon Tolbuzin, sent a group of Italian master builders to Moscow, the Venetian Senate sent a message to Ivan III stating that "the Eastern Empire, seized by the Ottomans in expectation of the extinction of the male imperial line, should be subject to your resplendent power by virtue of your propitious marriage".[7]

The seeds of the ideology of Moscow as a Second Constantinople and consequently a Third Rome fell on fruitful soil in Russia. The fast-growing State of Muscovy was in need of political ideology and court ceremonial, and also of artistic forms, which would express its new international status.

As the activities of Cardinal Vissarion, and especially his educational programme for the younger members of the Paleologue family indicate, the Byzantine émigré circle living in Italy believed in a genuine conjunction of Byzantine with Latin ecclesiastical authority. For those fifteenth-century Greek thinkers who had emigrated to Italy it had to do, besides, with a synthesis of the heritages of Christian Byzantine Hellenism and of imperial Rome. In both cases, such an ideology presupposed a simultaneous turning towards Roman and Byzantine Antiquity. In this circle, Antiquity must have been understood in a rather different sense from that in which the native Italian Humanists understood it. For the Greek émigré circle in Italy,

the art of the late Roman Empire, the imperial buildings of the early Christian era, the Byzantine churches dating from the time when Constantinople had been at the zenith of its power and possessed a number of Italian colonies, converged into a single group of prototypes which could conjure up ideas of the resurrection of the Eastern Empire, an Orthodox "reconquest" and the foundation of a Third Rome, that ideal kingdom which would triumph over non-Christians and last for ever.

Zoë (Sophia) Paleologa, her brothers and their retinues, Cardinal Vissarion – all of them lived in Italy when the Renaissance was at its zenith. Of course, they understood the latter in their own way, in the light of their own political ideas and Byzantine tradition. But it was from this source that the "Moscow Paleologue Renaissance" sprang, transforming the architecture of the capital city, resetting the whole course of Russian architectural history, and leaving a bold mark on Muscovite political ideology. Is this phenomenon, however, strictly speaking, to be called a "renaissance"?

2 The Prospects of a Moscow "Renaissance"

If a combination of four basic factors was probably necessary for the Renaissance to occur in the architecture of any European country besides Italy, the first of them must have been the existence of a number of like-minded groups of men receptive to ideas and forms related in one way or another to Antiquity.

The first such group would have consisted of an adequate number of master craftsmen – architects, stone-masons and wood-carvers familiar with and capable of recreating the forms of Classical Antiquity that were typical of the buildings of the Italian Renaissance. In the fifteenth century, of course, these forms varied considerably from one Italian city to another. But it was not, at first, important which particular variant of the quest for the Classical ideal influenced the architecture of any European country, whether it came from Milan, Venice, Florence, Rome or any other Italian city. For the time being, all that was necessary for an architect was a general knowledge of the new art that aspired to revive the heritage of ancient Rome, in whatever Italian form it was manifested. And of course, no project could be realized without craftsmen.

A second essential group of like-minded men with an active interest in Antiquity, consisting of powerful patrons with their own political motivation to embrace the new architecture, was outside customary medieval tradition. Most often, the emergence of this new kind of patron in Eastern and Central Europe – in Hungary, Poland, Lithuania, Russia and even in Turkey in the second half of the fifteenth century – was connected with the formation of nation states, for whom the imperial idea, ever alive in images of Ancient Rome, was ideologically important. The rulers of these countries and their courts sought architectural expression for the universality and legitimacy of their power, linking the novelty of the artistic forms appearing in Italy with the authority of the tradition of the greatest power known to history, the Roman Empire.

A third group without whom national varieties of the Renaissance would scarcely have been possible was constituted by theorists who either had a grasp of Italian humanist philosophy, or Byzantine in the Russian case, or were able to create an ideology, above all one of statehood, in which associations with the Roman Empire played a significant role. For formulation of the new ideas and the creation of a system uniting political requirements with artistic development, specialized knowledge of the culture of Antiquity was essential, if only in forms transmitted by available sources. Wholesale exclusion of the use of Byzantine sources would not have suited the needs of the time. Where, therefore, the ideologues, in particular religious figures, turned away from direct references to Antiquity, and where a later body of moral and political tradition was dominant, the influence of the Renaissance was limited.

In fifteenth-century Turkey where, as in Rus', a new state was being formed, there were numerous powerful patrons eager for the creation of a new artistic language capable of expressing the imperial idea. Many Italians had settled there who maintained contact with famous Milanese and Venetian master craftsmen, and even sought to have them placed in the service of the sultan. And yet no "renaissance" took place in Turkey, despite attempts made there at imitation of Byzantine buildings of the Justinian period.

In this enumeration of the enabling conditions for the Renaissance to enter the architectural history of nations geographically remote from Italy, the role of specific persons has been emphasized; the part played, not by generalized phenomena, but by particular individuals – master builders and their patrons, commentators and theorists who influenced the ideological character of architectural commissions. The same idea, however, could be expressed in a different way – that the essential conditions for the Renaissance to occur in any given country were: knowledge of the new architectural language that had emerged in Italy in the fifteenth century; favourable political circumstances; and the dissemination of Italian humanist philosophy, or the formation of a system of ideas capable of taking the place of that philosophy and demonstrating the necessity of adopting artistic forms based directly or indirectly on Antiquity.

There is one further, no less essential condition to add to these. It was vital that all the above factors operated simultaneously in any given country. Without the appearance of all the above-mentioned groups together, and without their ability to speak to each other in the same language, that is, without a unity of ideas, however relative, amongst architects, theorists and political leaders, the new architecture would not have come into being.

The essential conditions for the assimilation of the Italian Renaissance tradition of architectural ideas existed in Russia at the end of the fifteenth century. Furthermore, the impact of the new movement that had originated in the cities of Italy was so powerful in Moscow at this time that it is appropriate to speak of more than simply the dissemination of Italian ideas in Russian architecture. The Italian Renaissance revolutionized Russian architecture, transformed the ideology of the State of Muscovy, and created new styles and forms.

Russian historical conditions at the time of the Renaissance were unusual and complex. In Muscovite Russia, Renaissance ideas were never free from medieval aspects, remaining at the same stage of combination of old and new that was typical of the architecture of many Italian cities in the middle of the fifteenth century – Milan, Venice and Genoa, for example. A style closely imitative of Antique models never emerged in Moscow. It was a long time before the Roman discoveries of Donato Bramante and later Italian Renaissance architects made their impact in Russia.

Nevertheless, the innovatory ideas that appeared in the evolution of Muscovite architecture when it was closest to the Italian Renaissance of the fifteenth century continued to determine the course of its development for a long time afterwards. The Italian concepts introduced in Moscow at the turn of the fifteenth and sixteenth centuries continued in active use throughout the following centuries, up to the reign of Peter the Great. The impact of the Renaissance follows an uneven line through two centuries of Russian architectural history, with Renaissance-style decorativeness sometimes predominant in surprising degree. Architectural historians speak of a "belated Russian Renaissance", placing it in the seventeenth or even eighteenth century. If this judgement is to gain assent, it must be recognized that where the Renaissance is concerned, in Russian architectural history everything took place just as it did in Europe, but more slowly and later. Be that as it may, for Russia, the Renaissance has the nature of an abstract phenomenon, occurring at no specific moment in history.

At the same time, it must be remembered that Renaissance features appeared in Russian architecture just when the Renaissance was taking place in Italy, thus giving Russian architecture specific contemporaneous links with that of Western Europe. However, it is not the whole of the Italian Renaissance that is in question here, but only that period of it – the last quarter of the fifteenth century – that saw the most intensive contacts between Moscow and Italy. So it was that the "Moscow Paleologue Renaissance" possessed a strongly marked local character.

However, this was not so very much more the case than with other national schools of Renaissance architecture, especially at the first stage of their development. In most European countries, sixteenth- and seventeenth-century architectural history seemed to consist of two intersecting courses, in which the development of a national formal "vision" or style, transforming medieval tradition, took place simultaneously with the infiltration of Italianisms. Both these processes proceeded in each country in a particular way determined by particular circumstances, at a differing rate of development and distance from Italy, with differing interpretation and choice of Italian models, and local traditions surviving in their own ways. An important part was played, too, by each country's conception of the past and of what was understood by "Antiquity". Russia's national take on the Renaissance in principle unfolded in accordance with this general pattern, allowing for the peculiar character of its history and the special significance possessed for it by the Byzantine heritage.

Masters from Renaissance Italy worked in Russia from 1475 to 1539. This was a key period in Russian history, during which, following the break-up of medieval Rus', the foundations of modern Russia and a unified Russian nation were laid with the formation of a centralized state and completion of the process of subordination to Muscovy of the principalities and appanages that had been independent from the twelfth to the fourteenth centuries.

The new Russian state needed both an ideology to justify its independence and importance, and architecture to express this ideology. The moment had come for a rethinking of the architectural tradition of ancient Vladimir and a radically new approach. Through the mediation of the Italian masters, the concepts of the Italian Renaissance were employed in this process.

The pace of development of the new ideology, in both matters of state and in architecture, increased after Ivan III's marriage to Zoë Paleologa in 1472, one of the most decisive moments in Russian cultural history. Russia had received its first historic Byzantine impulse with the adoption of Christianity in 988, and this was the second. Of crucial importance was that it had come not directly from Constantinople, but through the agency of Italian statesmen and master craftsmen. It was also important that in both Rome and Venice the ideology of the Greek émigrés on which the heiress of the

Paleologues had been brought up remained an ideology of empire. At any rate, at the Moscow court at the end of the reign of Ivan III and especially during that of his son Vasily III (1505–33), there was a general awareness of the historic path that was already leading from the emerging Russian kingdom to the Orthodox empire of the future, the Third Rome. Such was the context in which Renaissance ideas entered Russian architectural history. It would be more accurate to say that ideas about the future of Russia entertained in Moscow at this time coincided with the assimilation of Renaissance architectural ideas.

The conditions for a new state building programme and the demand for architectural expression of a new conception of the Muscovite state were in place in the early 1470s, at the same time as the launch of Ivan III's programme with his marriage to Zoë (Sophia) Paleologa. The patron of the new architecture, from this time until his death, was Ivan himself. The invitation to the foreign masters, however, was a project conceived some time after his second marriage had taken place and after the Byzantine princess and her retinue had familiarized themselves with the situation in Moscow and were playing a full part in court life. It is thus evident that the ideologues of the new culture came from Sophia's circle. It can hardly have been coincidental that the first master invited to Moscow had close links with the Greek émigrés in Italy who belonged to Cardinal Vissarion's circle – Aristotele Fioravanti from Bologna, where Cardinal Vissarion was a papal legate.

The influence of the Italian Renaissance on Russian architecture began from the moment when three groups of men came together: Ivan III as patron, the Greek and Italian members of his new wife's retinue, and the group of architects headed by the master from Bologna who had been invited to Russia through their offices. This occurred in 1475. The end of the Renaissance in Russian architecture may be dated just as precisely. After the death of Ivan's son, Grand Prince Vasily III, followed by that of his wife, Yelena Glinskaya, the heir to the throne was the minor Ivan IV, the future Ivan the Terrible. During his childhood and the power struggle between rival boyar families, the state ceased to commission new buildings. Although the clergy and the aristocracy included men who contemplated a Third Rome and the destiny of the Byzantine heritage, the necessary conditions for the further development of the "Moscow Paleologue Renaissance" had disappeared. The last Italian master known to have been in the service of the grand princes of Moscow, the Florentine Pietro Annibale, fled from Russia after 1539 at the time of the troubles during Ivan IV's minority. Evidence survives of Italian craftsmen in Moscow even during the latter's reign, but no architects were among them. They were most likely second generation, born

in Russia to the craftsmen who had originally come to the country. The year 1539 may be taken as the date when direct influence of the Italian Renaissance on Russian architecture ceased.

I shall now turn to the work of successive groups of Italian craftsmen who came to Moscow around the turn of the fifteenth and sixteenth centuries, and examine their contributions to Russian architectural history and the influence of Renaissance ideas on the formation of a distinctive national architecture. First of all, however, it must be shown that these Italian craftsmen recognized the new architecture emerging in Moscow as "their own". Were it not for that, it would be difficult to call the new buildings in any way "Renaissance" in character.

3 Foreigners' Accounts of New Buildings in Moscow at the Turn of the Fifteenth and Sixteenth Centuries

On 26 September 1476 Ambroggio Contarini, ambassador of the Republic of Venice at the Persian court, arrived in Moscow and stayed with his compatriot, known in Russia as Mark Fryazin.[8] Ivan III had sent the latter to Venice, where he had met Contarini and promised to help him when he came to Moscow. Among his fellow-countrymen whom he knew to be living in the Russian capital at that time, the ambassador later remembered "Master Trifon, a jeweller from Kotari, who made [. . .] all kinds of pots and other ware for the grand prince [. . .] Also Master Aristotele from Bologna, a builder who was building a church on the square at that time [the cathedral of the Dormition in the Kremlin] [. . .]". Contarini also recalls that "through the good offices of the same Mark I obtained rooms in the house where [. . .] Master Artistotle lived. This house was situated almost next door to the Grand Prince's palace and was a very fine one. But after a few days I was ordered, in the Grand Prince's name, to leave this house: I do not know from whence this order originated."[9] The reason for the order was probably Ivan III's suspicious nature; like later Russian rulers, he thought that visitors might assist foreign master craftsmen to flee the country. Every attempt was made to protect the famous architect from such influences. At any rate, Ambroggio Contarini was the first to leave eye-witness testimony on the work of the Italian masters in Moscow during the last quarter of the fifteenth century, and he revealed that these craftsmen were treated "like precious jewels".

Some ten years later, on 28 June 1486, Duke Galeazzo Sforza of Milan commissioned a report on Russia by the Muscovite envoy, Georg Perkamot, a Greek by origin,[10] "who had arrived some time before from Constantinople", bringing with him an

official document and "four score excellent sables, two gerfalcons and some live martens" as a gift from Ivan III to the ruler of Lombardy.[11] Of Moscow he reported that "all houses in those parts are built of wood, except for a few which have been built for prelates and princes and some of the nobility, construction of which has commenced in stone and brick, in the Italian manner"; and he adds that "this manner has been introduced by Italian master craftsmen and engineers".[12]

Thirty years later still, in 1516, Sigismund Herberstein, envoy of the Holy Roman Emperor, newly arrived in Moscow, found a citadel there "large enough to accommodate, besides the extensive and magnificent stone palace of the sovereign, the headquarters of the metropolitan as well [. . .] and [the citadel was] of a scale reminiscent of a small town". He too went on to comment that "the walls and towers of this citadel and the royal palace are built of brick in the Italian style by Italian masters from Italy, commissioned by the sovereign at great expense".[13]

Descriptions of Italian buildings in Moscow began to circulate in Europe early in the sixteenth century. In his *Treatise on two Sarmatias* completed in 1523, the Polish bishop Matfey Mechofski praised the fortifications of the Kremlin but thought the palace of the grand princes mean and cramped, for all his emphasis that it was built "on the Italian model".[14] In his book *On the Muscovite Mission to Pope Clement VII* (c. 1525), Paolo Giovio, bishop of Como, described how, on the peninsula formed by two branches of the river, "an astonishingly beautiful citadel with towers with slit-windows had been built by Italian masters [. . .] where there were many bronze cannon to be seen, exquisitely cast by Italian craftsmen [. . .]".[15] He also commented that "on a prominent spot there is a cathedral dedicated to the Virgin Mary, wonderful in its composition and grandeur, built sixty years ago by Aristotele Bolonsky, a great artist and famous master [. . .]".[16] In the seventeenth century too, Western commentators wrote of defensive structures and royal palaces in Moscow "in the Italian taste".[17]

Of especial interest is a comment by the Venetian envoy Marco Foscarini, who visited Moscow in 1557. In his *Historical Sketch of the State of Muscovy* he writes: "Each quarter has its own church, nobly built and of corresponding size; such churches didn't exist here in earlier times, but about sixty years ago they were given astonishingly beautiful form by some architect from Bologna."[18] Whether these words express simply an envoy's pride in a compatriot's work, or the impact made on him by a number of Italian-built Moscow churches that have not survived, is hard to say. But in any case, this is the earliest specific historical confirmation there is of the influence of "the Italian manner" on Russian architecture as a whole at the turn of the fifteenth and sixteenth centuries. Typically, the statement was made at a moment when Moscow had begun to forget the masters invited to the capital by Ivan III and Vasily III. The name of Aristotele Fioravanti had already vanished from public memory, so that he could be referred to as "some architect from Bologna". The papal legate Antonio Possevino, looking at the walls of the Kremlin in 1581, also spoke of the builders as "a Milanese architect" and "Italian master builders", not mentioning their names.[19] To the numerous English, Livonian and Polish visitors and merchants in Moscow during the second half of the sixteenth century, such names could be of no great interest, or even traceable, since the programme of new buildings and rebuilding under Ivan the Terrible had changed the face of Moscow.

Nevertheless, it is extremely significant that for three-quarters of the sixteenth century, foreigners felt "an Italian spirit" in the principal new buildings of the Russian state. Italians of the Renaissance period recognized this architecture as "their own", one of the surest signs of its Renaissance character.

The large groups of Italian architects and craftsmen who worked permanently in Moscow between 1474 and 1539 consisted by no means only of adventurers and those unable to find work in their own country. Both these categories, of course, were represented, but masters already celebrated in Italy led a number of the parties of Italians whom history cast on Russian shores. When they set off for Russia, they did not reckon to stay there forever. However, they were to discover that although they were honoured persons in Moscow, they were not given the freedom to return home. Many attempted to do so, but the only one to succeed was Pietro Annibale, builder of the renowned church of the Ascension at Kolomenskoye. When the Italian diplomat Giovanni Tebaldi asked Ivan the Terrible "why he would not let foreign craftsmen leave Moscow [. . .] especially the Italians, whom he called 'his Europeans' and held captive for the sake of art, and, in his own words, loved them for it [. . .], he replied that it was because otherwise they would never return to Moscow [. . .]".[20]

4 Aristotele Fioravanti and Filarete

The career of Aristotele Fioravanti is the best proof that Moscow attracted leading masters from Renaissance Italy and that at the end of the fifteenth century in particular, prominent Italian practitioners of the building arts settled in Moscow. It will be useful to begin consideration of this great engineer from Bologna not in real-life biographical terms but as a figure of literature.

He features prominently in the celebrated *Trattato d'architettura* (1461–64) by the Florentine sculptor and architect Antonio

di Pietro Averlino, better known by his pseudonym, Filarete, "Lover of Virtue". The *Trattato* takes the form of a hellenistic novel or utopian treatise. Building technology and landscape design provide a vehicle for the utopian depiction of an ideal country.[21] The main theme of this outstanding literary work is the building of a new life, embracing the whole Renaissance programme, not only in terms of restoration of the artistic achievements of Antiquity, but also in a life-developing sense. The author sets out to establish a heaven on earth, in the exquisite decorative features of the Italian landscape – chains of hills, blooming valleys, fast-flowing rivers and seashores – and in architecture "in the manner of Antiquity".

It is probable that Filarete wrote his treatise in Milan, where he served as an architect at the ducal court.[22] The *Trattato* reflects the initial phase of the Renaissance, in which creative thought predominated over the pursuit of the Antique ideal. Filarete was a brilliant and widely popular mid-Quattrocento representative of this trend in Renaissance architecture. It wasn't only Italian ruling princes who invited him to join their service; evidence has survived that the Turks tried to acquire his services for building programmes in Constantinople, which had recently fallen into their hands.[23] Here contacts were established through the agency of Byzantine humanists, some of them settled in Italy, others remaining in the former Byzantine capital.

Fiorovanti's close association with a figure like Filarete is highly significant. It provides an authentic basis for a definition of the type of culture to which the intellectual associates of the author of the famous treatise belonged, especially those who feature in it as extensively as Fioravanti. The established fact of his link with Filarete is of fundamental importance for a detailed understanding of the influence of the Renaissance on Moscow architectural history at the turn of the fifteenth and sixteenth centuries, and so it will be worth examining it in some detail. Filarete wrote a whole series of episodes in this treatise, it seems, "from life", and they directly illuminate relations between the two men.

> We rode a dozen miles [. . .] past a variety of cornfields and vinyards [. . .] We reached [a castle] not long before Phoebe began to send down her rays [. . .] we looked around and, since we liked the look of the spot, explored the vicinity [. . .]. My companion and I went down to the brook [. . .] and gathered herbs for a salad. We returned to the castle and took the herbs that we had gathered to the stream flowing beneath its walls [. . .]. My companion Aristotele and I sat down there [. . .] and we washed them [. . .]. Sister Phoebe was now plainly visible [. . .].[24]

This scene comes in Books XV and XVI of Filarete's treatise.

His travelling companion, with whom he peacefully strolls and gathers herbs for a salad on the bank of a brook, is instantly recognizable as Aristotele Fioravanti.

Filarete gives a detailed account of the work of the master from Bologna and of his origins, and the master himself turns up among a handful of the author's contemporaries whom he introduces into his text as live persons. Mostly he codes the name of Aristotele as Letistoria. Occasionally, as in the excerpt quoted above, he calls him by his real name.

Other passages in which the master from Bologna appears concern the transportation of loads from the quarry supplying stone for the building of the city of Sforzinda, capital of the ideal country. In one of them the sovereign asks the author how he proposes to transport columns hewn as single pieces of stone. The author replies: "'We must make barges to transport them, and wooden machinery that can drag them to the river [. . .].'"[25] The author then adds: "'My lord, the master from Bologna has just arrived, the one I spoke to you about a few days ago, who is a great expert in the transportation of loads.' 'Send for him. What is his name?' 'Maestro Aristotele.'"[26]

The character of Filarete's relations with Fioravanti is revealed in the words that he puts into the mouth of another of the rare characters whom he calls by his real name, Tommazo Cappellari di Rieti, councillor to Duke Francesco Sforza. Filarete writes: "[. . .] he told me everything. He was preparing to leave for his estate to build a castle there. I offered my services for this task [. . .] and he replied: 'Believe me, I had been intending to ask you, and I should like Master Letistoria to come too, because I want to build a beautiful castle. In this way, he can help plan it.' I was very happy about this."[27] Thus it becomes clear that Filarete thought it possible that he might work in collaboration with Fioravanti.

In the section of the treatise on the building of a monument in the capital of the ideal country in honour of the sovereign, Filarete also mentions Fioravanti, and here he places him among the most remarkable Italian masters of the mid-Quattrocento.

> Three masters were commissioned to undertake this work. They followed the plans and my instructions and executed all the work in the most gracious fashion. Their names were: Donatello, a sculptor in marble who also did bronze figures; Desiderio, a mason who worked in marble and other kinds of stone; and the third was Christòfano Geremia from Cremona. All three were excellent masters, and worked in both marble and bronze [. . .]. However, setting up the columns was a difficult task, and in this they were joined by the master from Bologna whom they called Letistoria. He was extremely experienced in the science of transporting loads.[28]

This collaboration was, of course, fictional. However, Filarete's description of the creation of a monument in Sforzinda is one of the most important passages in the treatise. The monument was dedicated to the "old king", a sobriquet of Duke Francesco Sforza, Filarete's patron. This emblematic project designed by Filarete must actually have been built by Donatello in collaboration with Fioravanti.[29]

The passage in which Filarete and Fioravanti gather a salad together indicates the close personal relations between the two in actuality. It also indicates that the founder of the Lombard Renaissance architectural style considered the method of the master from Bologna sufficient indication that he would be a suitable figure to work with. And finally, he placed him alongside Donatello among those with a capacity for noble art "in the spirit of Antiquity". All this allows us to conclude that Fioravanti was close to the humanist circle that formed between 1450 and the early 1460s at Sforza's court, a circle in which Filarete played an important role. The first stage in the formation of this group came to an end around 1464–65, when Filarete ceased active work and Fioravanti returned to Bologna.[30]

5 Aristotele Fioravanti in Italy

The life of Aristotele Fioravanti began to be studied in detail by Italian scholars in the nineteenth century,[31] and was the subject of monographs and special numbers of journals throughout the twentieth.[32] For present purposes it will be sufficient to trace the broad outline of the Italian period of his life, an understanding of which is vital to the appreciation of his work in Russia. He was born probably around the year 1415 in Bologna, of a family of builders. His grandfather is known to have been employed in the rebuilding of the Palazzo Accursio in Bologna, and his father was responsible for the alteration of the Palazzo Communale in 1425–30. Aristotele first worked with his father, and then, after the latter's death in 1447, with his uncle, serving the usual period of apprenticeship, laid down by the medieval building guilds, up to the age of thirty. The fact that Fioravanti belonged to an established building family is of great significance. Italian master builders of his time were usually capable of working in different styles, either using the traditional methods and motifs of their own town, or, if their client so desired, working in the "Antique" style, all'antica.

Fioravanti's life changed in the year 1451. Working in Rome, he began to develop the speciality that would make him famous throughout Italy. He transported the monolithic columns of the Temple of Minerva for incorporation in a new ceremonial entrance to the Basilica of St Peter's. He accomplished this task with great success and papal approval, and soon began to receive commissions for a variety of engineering projects all over Italy demanding a high degree of experience and expertise. However, the wide esteem in which he was held led to his return to his home city when he was elected head of the guild of freemasons there.[33] His work at this time, above all in the strengthening of old or unsafe constructions and fortifications, made him more and more famous.

In 1458 the duke of Milan asked the city council of Bologna to release Fioravanti to him to strengthen some palace walls (presumably those of the Castello Sforza), and the master went to his court and stayed there for some six years.[34] Admittedly, he was frequently enticed from his main duties by commissions from other Italian dukes. In 1459 Sforza was persuaded to allow his master to correct a leaning gateway tower at the Gonzaga residence in Mantua and the drawbridge in front of it. "Since His Holiness [Pope Pius II] will ride through this gate, and it is in danger of collapsing, we should like to rectify it [. . .] in any way possible," the marquis of Mantua wrote to his envoy in Milan, insisting that the latter should meet the duke and "inquire in our name about this Master Aristotele, who can move walls. And should he not be too occupied with His Grace's affairs, ask whether he might not be displeased to come here for a week [. . .]."[35] Fioravanti did go to Mantua and finished the work in a month, March 1459: "Today at 23 hours I completed the work of restoring My Lord Marquis's tower to a level; it leaned [sic] three ells from the vertical, which could not be corrected by My Lord's engineers."[36]

From 1460 to 1464 Fioravanti worked in Milan and other towns in Lombardy, where he strengthened the fortifications of a number of castles, repaired bridges and constructed canals. One nineteenth-century scholar even considered that Fioravanti was responsible for much that came to be attributed to Leonardo da Vinci, who two decades later performed similar tasks for the duke of Milan. One of Fioravanti's most important achievements, and indisputably his own, was his contribution to the construction of the Ospedale Maggiore, the magnificent hospital and almshouse that was Filarete's principal building project in Milan. This building is one of the major architectural monuments of the Quattrocento in Lombardy and expresses the principles of the new architecture promoted by Filarete, although many other masters, including his opponents, contributed to its construction and, after the death of the initiator of the project, its completion. Nevertheless, the lucidity of its composition, the rationality of its plan, its simplicity contrasting with Gothic complexities – all these new qualities of the Quattrocento are on full view in the Ospedale Maggiore. The brickwork style, the vaulting, the unusual masonry detail, in particular in consoles and keystones, are

strikingly similar to findings on surviving fragments of the grand ducal palace in the Moscow Kremlin which was the work of Italian masters. In the Ospedale the new rationalist spirit of the Renaissance and advances in building technology are to be seen side by side with architectural solutions belonging to an earlier age.

Fioravanti returned to Bologna around 1464, but once again he was not to remain there for long, despite his appointment as city engineer in December of that year. The king of Hungary, Matthias Corvinus, wrote to the city council of Bologna at the end of 1465: "We are informed that you have a certain Master Aristotele in your service [. . .]. Having to wage constant war against false believers, we have great need of such a man."[37] The king's letter does not speak of "the master who moves towers"; the "need" for him was evidently in another capacity, above all as a military engineer. Fioravanti's whole time in Hungary, however, including his stay in Buda, amounted to little more than six months.[38]

He worked in Bologna for the next eight years, completing many and various projects, which would seem to have included little to challenge such an experienced architect and builder. One of his projects may have included the making of a model for the city's principal public building, the Palazzo del Podestà. The tradition that this was built after Fioravanti's model has, however, been called into question, it would seem justifiably, by many scholars.[39]

At the same time as fulfilling commissions in the small port of Recanati, Fioravanti appeared at the court of Naples.[40] Above all, however, he was attracted to Rome, where he hoped to obtain a commission to move an Antique obelisk on St Peter's Square. Negotiations on this were proceeding with some success when he came up against a dangerous intrigue. He was accused of complicity in forgery. Considering the method of execution for forgery in the Quattrocento – molten tin poured down the throat – this was a serious matter. He proved his innocence, but despite the fact that at sixty he was an old man by the yardstick of the time, he apparently still considered it unsafe to remain in Italy. At this moment the embassy from Ivan III arrived, headed by Semyon Tolbuzin, and Fioravanti was invited to enter the grand prince's service in Moscow.[41]

6 Fioravanti, Cardinal Vissarion and Semyon Tolbuzin

In 1453, in Bologna, Fioravanti was commissioned to raise a heavy bell, cast as a gift to the city from the papal legate then representing the Holy See in Bologna. In itself this task would have held no particular interest for us had it not been for the identity of Fioravanti's client, famous throughout the Mediterranean world, the previously mentioned Cardinal Vissarion.[42]

Aristotele Fioravanti executed various commissions for the prelate, even rebuilding his personal apartments.[43] Fioravanti's talents would undoubtedly have produced a strong impression on Vissarion. In 1455, also in Bologna, he succeeded in moving the 25-metre bell-tower of the church of Santa Maria Maggiore a distance of thirteen metres, for which Cardinal Vissarion paid the liberal sum of 50 gold ducats.[44]

It would be tempting to take the close personal contact between Fioravanti and one of the chief advocates of the union of Orthodox and Catholic churches who in exile had remained faithful to the last representatives of the Paleologue dynasty, and had participated in the education of Princess Zoë/Sophia, as sufficient explanation for the master's trip to Moscow. Vissarion died, however, before the embassy which invited Fioravanti to join the grand prince's service in Moscow reached Italy. Nevertheless, the undoubtedly cordial relationship between the two men was of crucial importance for Russian architectural history. In Cardinal Vissarion, the great engineer from Bologna encountered Orthodox thinking in the person of one of its foremost representatives in Quattrocento Italy. In any event and above all, Fioravanti was linked via Vissarion to "the last Byzantines" in Italy. If evidence came to light of how he thought of himself, and of what kind of Byzantine architecture had survived in his homeland, it might conceivably indicate that he presented himself as a master versed in the Byzantine tradition to the Russians who greeted him in Moscow.

In June 1474 Semyon Tolbuzin was sent from Moscow to Venice. The pretext for this was Ivan III's desire to inform the Doge that his envoy Trevizan, with whom there had been many misunderstandings in Rus', was being sent home "with fair compensation, more than seven hundred roubles' worth of silver".[45] Besides financial dealings with the Venetians, the grand prince's envoy had another mission of no less importance. A chronicle records that Tolbuzin was to "try out a master builder of churches".[46] This wording would seem to indicate that his task was not only to find an architect who could come to Rus', but also to "put him to the test" to find out whether he would be appropriate to the grand prince's aims.

The task in question was undoubtedly the restoration of the new cathedral of the Dormition (Uspenskiy sobor) in the Kremlin, which had recently collapsed when nearing completion. It was hoped in Moscow that the building could be repaired rather than completely rebuilt. A master was required who specialized in the restoration of large-scale buildings with serious structural damage. The best-known such specialist in

Italy was unquestionably Aristotele Fioravanti. The Russian envoy travelled to Rome to meet him and made inquiries about him. In the chronicler's words: "Semeon [Tolbuzin] said that there were many masters there [. . .] but that he had chosen Master Aristotele [. . .], praising the rare breadth of his knowledge."[47] And this rumour had its effect: "It was also said that the Turkish Sultan had sent for him from Tsaregrad [Constantinople]."[48] Such a renowned master would be highly suitable to bring before the grand prince.

The most striking episode in the course of the Moscow envoy's discussions with the master from Bologna occurred when they both went to Venice, where Fioravanti astounded the Russian with his domestic inventions. The master "took him to his house, for he had a fine house [. . .] and ordered a plate to be fetched, and this plate was made of copper, supported on four copper apples, and also a pitcher, and out of this pitcher you could pour water or wine or mead, whatever you wished".[49]

The most interesting thing about Tolbuzin's visit to Venice with Fioravanti is the latter's reference to St Mark's. The chronicle records that he told the Russian envoy that "he had built St Mark's [. . .], a very fine and wondrous building", and took him to see it.[50] Here an obvious error has crept into the chronicle; it is inconceivable that Fioravanti would have passed off such an important church as his own work, in the undoubted presence of the Venetians accompanying the Russian party during their stay, and especially considering his leading reputation.

The reference must be interpreted otherwise. Fioravanti did not take the Russians to see his own work. He wanted to show them his conception of a church in the "Greek" Orthodox, that is to say Byzantine, tradition which, as he could hardly fail to appreciate, would have predominated in Rus' in view of the orientation of the national faith. In other words, the Moscow envoys, and Fioravanti himself, well understood what architectural style to be found in Italy corresponded closest to the "early Greek piety" that they wanted to see resurrected in Moscow. They must have explained to him very precisely the reasons for the invitation to Rus', and especially, in general outline, the project for the cathedral of the Dormition based on architectural models of Orthodoxy belonging to an earlier period. In this event, it becomes understandable that when he arrived in Rus', Fioravanti should have "recognized", as the Russian chronicler put it, the style that he soon saw in the architecture of Vladimir, a style familar in his country, for it had been created by his fellow-countrymen (as shown in the previous chapter). It was with such thoughts that he must have set out for Moscow, taking with him "his son, named Andrey, and a boy called Petrushka".[51]

Fioravanti spent the last ten years of his life in Moscow, from 1475 to c. 1485/86, and never returned to Italy. During his time in Moscow he improved the grand prince's artillery and systematized the production of cannon and coinage;[52] he was present at the siege of Novgorod[53] and the Tver' campaign.[54] It has been suggested that he prepared a plan to rebuild the fortifications of the Moscow Kremlin, but there is no firm evidence of this. Fioravanti's main achievement in Rus' is the cathedral of the Dormition in the Kremlin, newly built as the principal shrine of the Russian Orthodox Church, and also the church for coronations of Russian sovereigns.[55]

This cathedral, of supreme importance ideologically, is the first building in Moscow which was the work of a master from Renaissance Italy. It does not resemble an Italian Renaissance church, but its creation is linked with the formation of a new architectural system in Moscow.

7 The Architectural Programme of the Cathedral of the Dormition in the Moscow Kremlin and the "early Greek piety laid down by God"

The building of the new cathedral of the Dormition in the Moscow Kremlin was one of the most decisive acts by the Moscow-based metropolitanate in the struggle to unify the Russian church,[56] a struggle caused by the division of the Russian Orthodox world into those eparchies that lay in territories under Lithuanian rule and those in lands under the control of the ruler of Muscovy and other Russian princes. Officially, the all-Russian metropolitan see under the patriarchate of Constantinople was based in Kiev, which was subject to the grand princes of Lithuania. In reality, however, the metropolitanate had abandoned it for Vladimir in the thirteenth century. A further complicating factor was that since the early fourteenth century, under Metropolitan Pyotr, the head of the Russian Church had resided in Moscow, while retaining the official title of Metropolitan of Kiev. Through the rest of the fourteenth century and much of the fifteenth, the struggle continued as to whether the head of the Russian Church should reside on territory belonging to Lithuania or in the State of Muscovy, whether the metropolitanate should be single and united or divided as a result of political frontiers.

The situation became more sharply focused and took on radically new aspects in the aftermath of the Council of Florence. First of all, once the former universal arbiter of the Orthodox Church, the patriarchate of Constantinople, had agreed, if only temporarily, to union with the Rome, it lost much of its authority in the eyes of the secular and spiritual ruling powers of the State of Muscovy and, after the fall of Constantinople to the Turks in 1453, its significance diminished

still further. To meet the urgent need to fill the vacuum that now arose in the ideology of the Muscovite State and the Russian Church, new formulae were evolved. These were ultimately expressed in the architectural programme of the cathedral of the Dormition.

On 5 July 1439 the representative of Rus' at the Council of Florence, Metropolitan Isidore, a Greek who had recently arrived in Moscow from Constantinople, signed the agreement of union with Rome. He returned to Rus' a legate of the Holy See. In Vilnius and Kiev there was an attempt to play down the new situation, but in Moscow things took a different turn. On 19 March 1441 Isidore entered the city "as a papal legate [. . .], processed with the Latin cross, went to the cathedral of the Dormition for holy service, and told the archdeacon to read out the proclamation of union from the pulpit".[57] The Russian bishops, the grand prince and the boyars, however, *declared themselves for the Greek rite as before* [emphasis: DS], and called Isidore a heretic".[58] The latter fled to Lithuania and thence to Rome before returning to Constantinople, hoping in vain that the emperor and the patriarch might prevail upon the Russians.

The authorities in Moscow, well aware that Emperor John Paleologus and the patriarch in Constantinople favoured union, decided to depart from tradition and choose a head of the Russian Church themselves, and not, as before, to send their chosen candidate to Constantinople for official confirmation in the post; this was, in effect, a declaration of autocephaly for the Russian Church. On 15 December 1448 Bishop Iona was installed as "Metropolitan of all Russia", which he remained up to his death in 1460, when he was succeeded by Feodosy. In 1464 Filipp I succeeded as Russian metropolitan – both these last, again, without confirmation by the hierarchy in Constantinople.

All this led to serious diplomatic problems. When Moscow rejected union and dismissed its Greek metropolitan who agreed with the decisions of the Council of Florence, the patriarchate of Constantinople excommunicated the Russian territories.[59] In 1470 Grand Prince Ivan III entered into correspondence with Rome. This was the moment when Ivan's offer of marriage to Zoë Paleologa, Byzantine heir, was made. In order fully to understand the situation it needs to be remembered what was happening in western Rus', which was under the control of Lithuania. The head of the Orthodox Church there, Metropolitan Grigory, appointed by Rome, understood that his congregation would not accept union and returned to Orthodoxy as previously constituted. At the same time, the patriarch in Constantinople, Dionisy I, also rejected union, and confirmed Grigory as having sole authority to rule over the spiritual life of the whole of Rus', including Moscow.

In no circumstances would Ivan III accept as head of the Russian Church a man who had lived in Lithuania for ten years and had the closest of links with its ruler. Moscow was thus obliged to assert its own ecclesiastical independence.

It would be difficult to overstate the importance of this moment in the development of the identity of the Russian state and church which marked the beginning of the idea of Russia's exclusiveness, its special spirituality, its divinely appointed destiny. Semyon of Suzdal', one of the Russians at the Council of Florence, wrote in an account of his journey to Italy and of the decision on the union of churches: "In Rus', Orthodox Christianity is superior to that in any other country."[60] The author of *A Description of the Composition of the Eighth Council [of Florence]* goes further, putting into the mouth of the Byzantine Emperor John Paleologus the comment that "There is more Orthodoxy and a higher level of Christianity in the eastern lands – in White Rus' [the term by which the Russian territories in Eastern Europe were then known]".[61]

At this same time, Metropolitan Iona, the first head of the autocephalous Russian Church, composed a formula on which not only the leading ideas of the Church but also, to a large extent, the aesthetic of Russian architecture, would be based for centuries to come. In a message to the bishops of Lithuania he wrote that "our Holy Church of God, the great church of the Russian faith, contains the Holy law and Godly principles of the Holy Apostles and the rulings of the holy fathers – the great Orthodoxy of the *early Greek piety laid down by God* [emphasis: DS]".[62] These words define the cardinal postulates of Russian thought in the second half of the fifteenth century – the recognition of Russia's originality ("Russian faith") as established by the Byzantines ("Greek piety") at an earlier time, and of a church tradition of divine inspiration ("laid down by God").

These ideas were already finding architectural form in the mid-fifteenth century. According to the above-mentioned *Description of the Composition of the Eighth Council*, the land of Rus' "has God's protection [. . .] and by the radiant Grace of God holy churches have been created, like stars shining in the Heavens, sacred, magnificently decorated churches".[63]

Metropolitan Iona's message to the bishops of Lithuania is of exceptional interest in connection with Russian architectural ideas between the second half of the fifteenth century and the first three decades of the sixteenth. He was turning away from the practice of the contemporary church and towards that of the early Byzantine church, giving it the features of an incontestable ideal – "piety laid down by God". In the long history of the Byzantine Church, such a retrospective ideal could be focused on a period belonging either to the recent or to the

distant past. Metropolitan Iona evidently considered that it was "Russian piety" that preserved the features of the "early" ideal "laid down by God". Consequently, attention came to be turned towards the history of the Russian Church itself, towards churches that were testimony of times when the Church had been inseparably linked with "early Greek law", so that this retrospective ideal contained both Byzantine and national spiritual history and preserved universal features.

Paradoxical as it may seem, this thinking is not so very different from Renaissance ideas of a revival of the Roman imperial ideal. Iona, of course, approaches the past as a source of truth not in secular but in spiritual and ecclesiastical terms, and is concerned with "Greek" rather than Roman revival, based on Constantinople as a Second Rome. To the present author, nevertheless, the two sets of ideas do seem to exhibit similarities – in their retrospection and in their aspiration towards a God-created and therefore universal ideal.

The imperial idea merely had to make an appearance in Rus' and the symbols of Ancient Rome and the Second Rome, the secular and the spiritual, the imperial and the ecclesiastical, fused together. The spiritual image of the Byzantine Second Rome was to prevail over the secular imperial image in Russia for some time to come, a point to be noted when it comes to analysis of architectural programmes of the early sixteenth century, during which period the concept of Moscow as a Third Rome arose. For the moment, what needs to be emphasized is that this famous Muscovite imperial formula was preceded by Iona's.

In the course of the last quarter of the fifteenth century, the ideal of "early Greek piety" took on many features of the ideal of the Third Rome, and this process may be traced in the architectural history of the Moscow Kremlin. It began with the building of the cathedral of the Dormition in 1475–79.

8 The Building of Fioravanti's Cathedral of the Dormition

The dedication of this cathedral and its predecessor on the same site provides a symbolic link with Vladimir, capital of the grand principality of Vladimir in north-eastern Rus'. It must be remembered, however, that officially, up to the sixteenth century the see of the metropolitan of the Russian Church was Kiev. It was at the suggestion of Metropolitan Pyotr that in 1326 Grand Prince Ivan Kalita ("Moneybags") had built the first cathedral on the Kremlin site, the earliest masonry church in Moscow; its dedication imitated that of the principal cathedral of Vladimir. In the case of this first cathedral of the Dormition in the Moscow Kremlin, only its name was significant; the architectural form of the Vladimir cathedral was not reproduced. The same could also be said of the second building.

In 1471 Metropolitan Filipp I proclaimed an entirely new approach to cathedral-building. As the chronicler describes, the desire was to build on this site "just *as large* a church [emphasis: DS] dedicated to the Most Holy Virgin as the cathedral in Vladimir".[64] The first intention was an exact reproduction of the model, in its appearance and all essential features. The chronicler emphasizes the magnitude of this demand of the metropolitan's: "With most ardent spirit and triumphant will we desire to see a church of the same dimensions [. . .]."[65] With this task in mind, the metropolitan commissioned the masters Krivtsov and Myshkin to build the cathedral and sent them to Vladimir.[66] "And they saw the church to the Most Holy, and wondered greatly at the beauty of the building [. . .] and, having measured its width and height and the altar, returned to Moscow."[67] It was subsequently decided to increase the length and breadth of the building by one and a half sazhens or about 9 feet (3.20 metres).[68] This was a symbolic gesture: Moscow was aiming not merely to follow the model, but to surpass it.

In September 1472, inside the new cathedral in process of construction, a temporary wooden church was put up for the wedding of Ivan III and Zoë Paleologa. After the ceremony, construction work continued as before. When the vaulting had been completed and the drum of the main cupola was being set in place, the building collapsed.[69] Such was the general shock that the chronicler even suggested an earthquake might have occurred, which was scarcely likely in Moscow.[70] Ivan III summoned masters from Pskov, who "came from abroad [from the Baltic region], where they had learned the art of masonry".[71] They praised the masonry work but explained the disaster as the result of the poor quality of the lime used. After this, the initiative in the building of the new principal cathedral of Muscovy passed to the sovereign, and his envoy Semyon Tolbuzin invited Aristotele Fioravanti to Rus' to perform the task. The payment offered was typically generous, a monthly amount of ten roubles, an enormous sum for the time, and payment by instalments was also unusual. The master was no doubt quite unaware of the long years he would spend in Rus'.

Fioravanti corroborated the findings of the masons from Pskov, and insisted that the cathedral should be entirely rebuilt from the foundations. The aim of the commission remained as before – to reproduce the old principal cathedral of north-eastern Rus' in the new capital. Soon after his arrival in Moscow, Fioravanti was taken to Vladimir. There is a tradition, based on a preserved chronicle manuscript, that on seeing the twelfth-century buildings in Vladimir, he commented: "This is the work of our masters."[72] In these early buildings on Russian soil, the fifteenth-century Italian master recognized the hand of

the Romanesque masons sent to Andrey Bogolyubsky by Emperor Friedrich Barbarossa, as described in Chapter 1.[73]

Here lies one of the strangest problems to do with the building of the cathedral of the Dormition in the Moscow Kremlin. It can scarcely be doubted that Fioravanti was given precise instructions, in one form or another, as to the desired appearance of the new cathedral, and it is surely likely that the grand prince would have explained to him the ideas of the late Metropolitan Iona, who had long been his spiritual mentor. The idea that "Russian piety" should be based on "early Greek piety laid down by God" had an unmistakable historical, retrospective nuance. Neither was the adoption of a local model of an earlier period foreign to the urge to follow Antiquity. Fioravanti recognized the latter in the creators of the buildings of northern Italy, Lombardy and even Bologna belonging to the same period as the churches of Vladimir. A master coming from a country aspiring to restore Antiquity – which at that time was taken to include early Christianity – would have been quick to perceive his own kind of "historicism" in architectural thinking in Moscow.

Of course, Moscow's choice of models of an earlier period, Russian or Byzantine, should not be fully equated with the Renaissance quest for the Antique ideal. But the aspiration to express "early Greek piety laid down by God" in the art and architecture of churches simply transfers the problem of an ancient ideal to the theological plane. In this sense the renaissance in Moscow of "early Greek piety" was a serious movement, soon to crystallize into one of the main themes of Russian thought. The form taken by Fioravanti's cathedral of the Dormition is to be interpreted in this context.

9 Russian, Italian and Byzantine Features of the Cathedral of the Dormition

The cathedral of the Dormition has always stood on a fairly crowded spot in the Kremlin, with the metropolitan's residence on the north side and the grand princes' palace and the modest-sized church of the Deposition of the Robe (tserkov' Rizopolozheniya) on the west. At the time of its completion as now, the cathedral as a whole could be viewed from the south, from Cathedral Square – formerly called Red Square. From this viewpoint, the building makes its most "Vladimirian" impression and appears similar to its twelfth-century prototype. Its tranquillity, deliberate simplicity and monumentality are immediately felt. The wall surface is divided by broad *lopatki* into four bays, and the wide semi-circular arches surmounting them emphasize the overall impression. The band of blind arcading with slender, rather longer columns than on the

Vladimir façades is placed lower than usual, and the tall, narrow windows, similar to those typical of twelfth-century Russian churches, higher. The group of five cupolas that typifies the Vladimir cathedral appears here for the first time in Moscow; it is to become one of the chief stylistic features of later churches of the tsars.

No considerations of detail can alter the overall impression made by this building: that of a church entirely in the spirit of early Vladimir, a symbol, straight from that period, of the heart and centre of the Russian Church transported to the new capital of the grand principality. Actually, however, the new cathedral is not an exact copy, but a brilliantly successful composite effect. Plan, structural basis, the handling of interior space are connected in the most tenuous of ways with the Vladimirian prototype, or even wholly in contradiction to it.

Fioravanti completely changed the proportions of the plan from almost a square to a long rectangle (pl. 72). This was picked up at once by contemporaries, the chronicler noting: "He gave the church an elongated plan, after the style of a

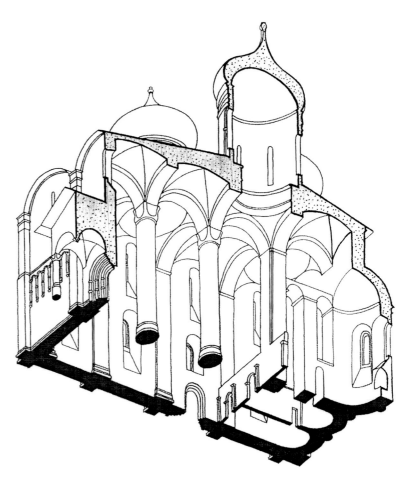

72 Axonometric projection of the cathedral of the Dormition, Kremlin, Moscow (Aristotele Fioravanti), 1475–79, by Sergey Pod"yapol'sky.

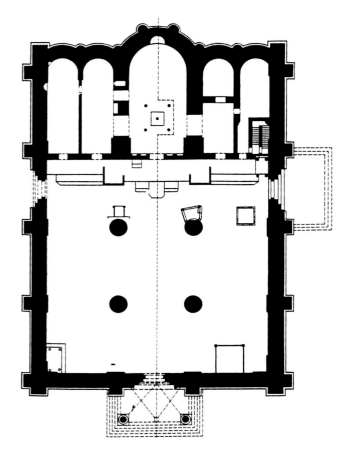

73 Plan of the cathedral of the Dormition, Kremlin, Moscow (Aristotele Fioravanti), 1475–79.

palace hall" (pl. 73).[74] At that time, Russians were used to a more compact plan for a church.

The main difference between the new cathedral and its model in Vladimir lies in the undivided spaciousness of its high-ceilinged interior. The ceiling is on one level throughout, with quadripartite vaulted bays. The part of the interior visible from the entrance, up to the chancel, is an almost exact square, with four corresponding round pillars supporting the ceiling. The Muscovites were astonished by the geometrical precision of everything that the master from Bologna did: "everything is done by rule and compass," wrote the chronicler.[75]

In this part of the cathedral above all, designed for the congregation, a new handling of space enters Moscow architecture, and its novelty was immediately felt: "this church is wondrous for its magnitude, its height, its abundance of light and space, its sonority, such as have never before been witnessed in Rus' [. . .]."[76] The grand scale, the distance between the supporting pillars, the penetrating light, the exact geometry of the proportions based on a strict square grid – these features can be traced to the great Italian cathedrals of the late Middle Ages, up to Santa Maria del Fiore in Florence; neither they nor

Fioravanti's cathedral of the Dormition bear any trace of Gothic – the origins of these interiors are rather to be found in Romanesque. The handling of space here seems Renaissance *avant la lettre*.

Returning to the chronicler's mention of Fioravanti's new cathedral as being "after the style of a palace hall", we may relate these words directly to the system of arches and barrel vaulting supported by pillars and interior *lopatki*. Such vast "salons" did not, of course, exist in Rus' at the time, but the "palatial" impression made by this part of the cathedral is palpable. Fioravanti was certainly aware that he was building a coronation church, which would have influenced the nature of his design. He was concerned to enhance the visual and acoustic aspects of the interior by every possible means.

With the different tasks set by the chancel, Fioravanti proceeded otherwise. It was necessary to emphasize the sanctity of this part of the cathedral and its rituals, and above all to accommodate the tombs of the metropolitans and the chapels of their patron saints, traditionally located here.[77] This was a sacred spot for Muscovites, and it made the cathedral the centre of the metropolitan see. There was no such aspect to the cathedral in Vladimir. Fioravanti therefore made the eastern part of his cathedral quite different, with five not three apses as in Vladimir, and each of them two-tiered.

Fioravanti's handling of the cupolas was especially bold for an Italian master of the mid-Quattrocento. The geometrically and constructionally logical placing of the five cupolas, appearing to describe a square, would have been above the lower square of the interior (pl. 74). In fact, he moved the upper square of the cupolas to the east by one-quarter of the length of the whole front. Furthermore, his modular system of equal-sized cells demanded that all the cupolas should be of equal size. Their bases are indeed all of equal size. In the centre, however, Fioravanti departed from this scheme, making the drum of the main cupola wider than its base. All this was done, as already mentioned, for the sake of appearances, with the object of making the exterior resemble that of its model, the hallowed cathedral of the Dormition in Vladimir (pl. 75).

A number of features of the new cathedral, however, are surprising in their sharp divergence from the style of the Vladimir school (pl. 76). The latter, as has been described, is vividly decorative and ornamental, whereas in Fioravanti's cathedral a pronounced monumentality is dominant (pl. 77). Let us take, for example, the bands of blind arcading in the two cathedrals of the Dormition. Fioravanti's are entirely without ornament, while consoles support phantasmagorical creatures or allegorical wild animals on the façades of the Vladimir building. The capitals on the latter are a Romanesque variant of Corinthian capitals, with more developed foliage ornament. Capitals and

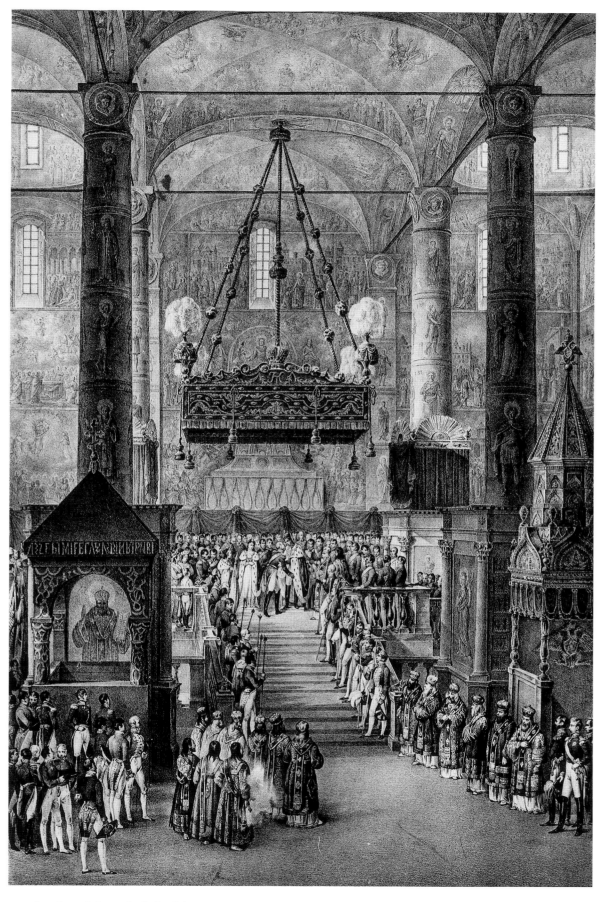

74 Interior of the cathedral of the Dormition, Kremlin, Moscow (Aristotele Fioravanti), 1475–79: coronation of
Nicholas I, 1826; lithograph, 1828.

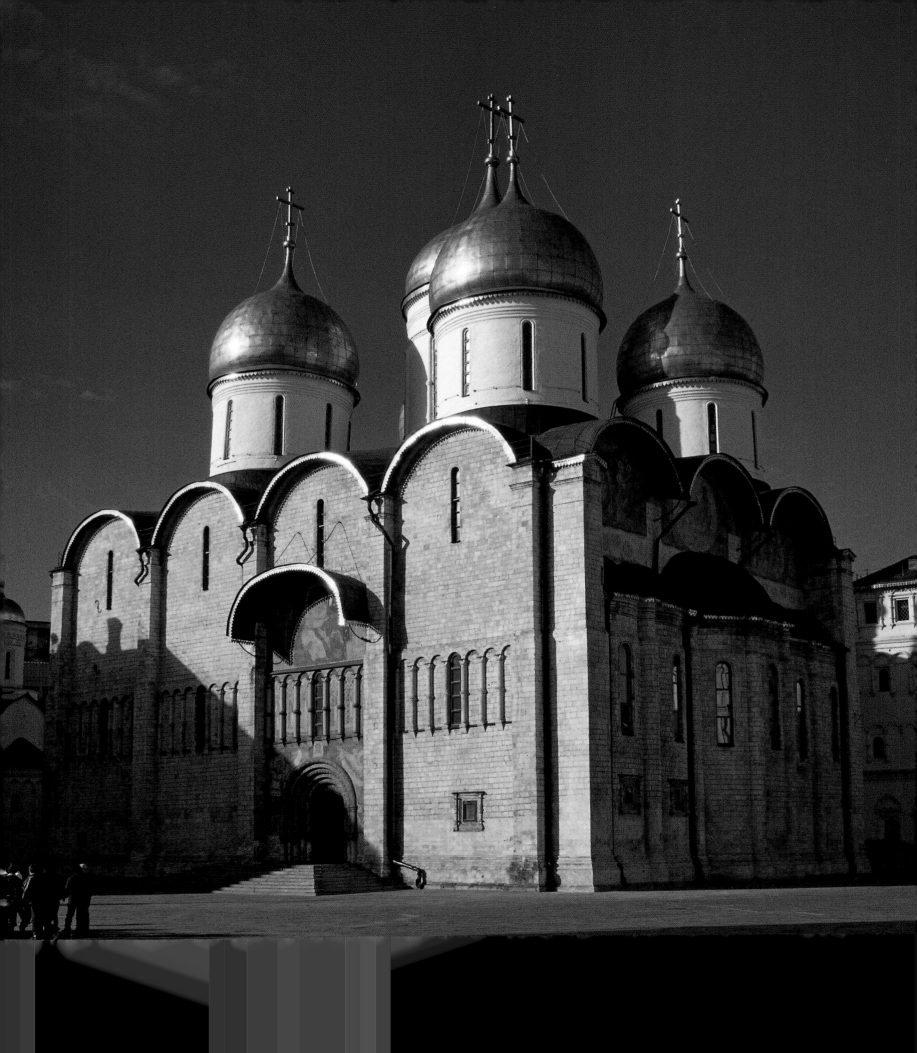

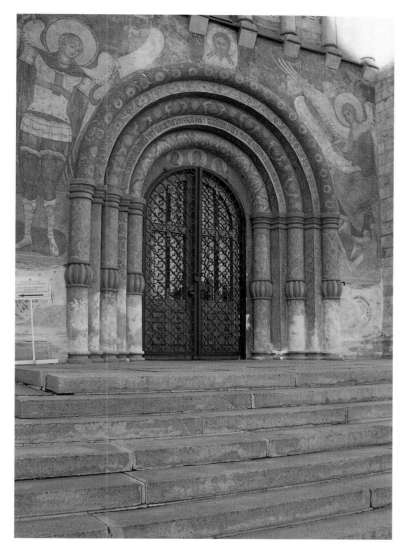

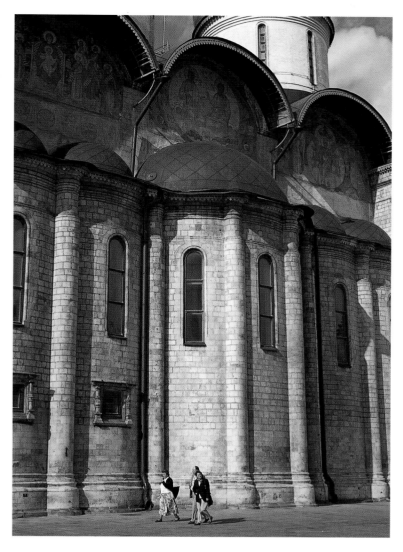

76 The south portal of the cathedral of the Dormition, Kremlin, Moscow (Aristotele Fioravanti), 1475–79.

77 East front of the cathedral of the Dormition, Kremlin, Moscow (Aristotele Fioravanti), 1475–79.

bases of Fioravanti's columns are far removed from Antique models, even by comparison with the work of Russian architects of the twelfth century. His capitals are generalized to an extreme, and transformed into heavy, abstract geometrical blocks. In this building he uses them in the same way in all contexts, whether on the small columns of the blind arcading or on the great pillars of the interior (pl. 78). Even the Moscow chronicler was struck by "this wondrous spectacle: on each of the four pillars a great stone has been set [. . .] each opposite the other".[78] The chronicler goes on to comment: "The stone is carved as if it were wood."[79] These words have caused scholars to suppose that originally the supporting pillars in this cathedral had Corinthian capitals. Thorough investigations in the course of restoration work have not confirmed this, but one substantial piece of evidence suggests that Fioravanti may

78 Blind arcading with small columns, south façade of the cathedral of the Dormition, Kremlin, Moscow (Aristotele Fioravanti), 1475–79.

75 (facing page) View from south-east of the cathedral of the Dormition, Kremlin, Moscow (Aristotele Fioravanti), 1475–79.

that architects of the Quattrocento, especially those like Fioravanti who belonged to craft building families, always had great respect for the Romanesque style, as distinct from Gothic which aroused their ire. To them, Gothic was an outlandish style from the other side of the Alps and contrary to the spirit of architecture *all'antica*, which was oriented towards the national past, the heritage of Rome. In his work on the cathedral of the Dormition Fioravanti used motifs which had long been in continuous use throughout northern Italy, including Bologna, up to the Quattrocento; these did not, however, belong to the Renaissance.

The Muscovites were struck by a number of innovations in Fioravanti's work. He introduced a more durable brick than the kind used in Rus' hitherto, longer and narrower in form. He mixed lime as thickly as possible, so that it hardened quickly and firmly. He introduced the use of iron ties in masonry, and a complex system of winches and pulleys for construction work which particularly impressed contemporaries.[81]

Two architectural strata may be distinguished in his cathedral of the Dormition: "one going back to the Italian tradition, and the other connected with Russian architectural forms and building methods", as Andrey Ikonnikov quotes Sergey Pod"yapol'sky.[82] This is wholly in accordance with the sources of the architectural language of the cathedral.

Created both to represent the national church and to be a venue for the coronation of the rulers of Muscovy, the building is completely successful as an original and unusual expression of both religious and secular concepts. In its composition Fioravanti would seem to have aimed at comprehensiveness and consummation, from the general impression made by the building down to the smallest detail; "it seems to be made with a single piece of stone", as the chronicler put it.[83]

As is amply demonstrated by his reputation in Italy and his important role in mid-Quattrocento Italian architecture, Fioravanti was a very experienced master, well able to grasp and execute his client's commission. A glimpse of the latter may be gained from Metropolitan Iona's message to his bishops. Although Iona died before the cathedral was designed, there is reliable evidence that he shared his thoughts with Grand Prince Ivan III. We may take it that Fioravanti's cathedral of the Dormition was built as a church of "Russian piety", understood as "early Greek piety laid down by God" and brought to Rus'. The adoption of the cathedral of the Dormition in Vladimir as a model indicated that Greek piety was flourishing in north-eastern Rus', which was particularly important to Ivan III, as is evident from *The Story of the Princes of Vladimir*, popular at the Moscow court of the time.[84]

These ideas were born in Rus', but in all probability through the agency of the Greek-Italian circle that was fairly numerous

79 Detail of the apse with column, cathedral of the Dormition, Kremlin, Moscow (Aristotele Fioravanti), 1475–79.

have used the Corinthian Order, which was widespread in both Bologna and in some Lombard towns. Sergey Sergeyevich Pod"yapol'sky is right, in this regard, to suggest comparison between the Moscow cathedral and the churches of Santo Stefano in Bologna and San Michele in Pavia.[80] The similarity in the use of architectural motifs in these Italian twelfth-century churches on the one hand and in the Moscow cathedral built in the last quarter of the fifteenth century on the other is almost exact (pl. 79).

All the same, it would at first sight seem hard to explain today how a figure whom Filarete placed alongside Donatello, and especially such a gifted engineer as Fioravanti, could in 1475, without attaching any particular significance to the matter, employ twelfth-century Romanesque motifs; and furthermore, how he could have passed over the newer *all'antica* style for more traditional forms. It must be remembered, however,

80 Interior of the cathedral of the Dormition, Kremlin, Moscow (Aristotele Fioravanti), 1475–79.

Aristotele Fioravanti died in Moscow in 1486 without having returned home. Shortly after his death, Ivan III dispatched another mission to Italy headed by two Greeks who had emigrated to Rus', Dmitry and Manuil Ralev.[86] One of the aims of the mission was to find a new architect to take charge of the Kremlin building programme. A master was found who occupied a high position but had been ill treated by his patron: Pietro Antonio Solari, third-generation architect to the duke of Milan. His grandfather Giovanni and father Guiniforte had occupied the same post at the Lombard court.[87] Giovanni Solari was a colleague and rival of Filarete. Guiniforte took over not only his father's work but also Filarete's unfinished buildings when the latter left Milan in 1465, and for the next fifteen years he was one of the leading architects of Lombardy.[88] With his father he began work on Milan Cathedral; from 1462 to 1480 he was *capomagistro*, superintendent of works, at the famous Carthusian monastery of Certosa di Pavia, and from 1465 he worked on the completion of the Ospedale Maggiore in Milan. He was appointed chief architect to the duke in 1471.

Among Guiniforte Solari's best known work is the nave of the church in the monastery of Santa Maria delle Grazie, Milan, celebrated for Leonardo's *Last Supper* in the refectory and also for the cupola built above the eastern part of the church by Donato Bramante. The contrast between Solari's work and Bramante's here strikingly marks off the dividing line between Lombard Gothic, which was nearing the end of its time, and the High Renaissance style which, a decade later, Bramante would establish in definitive form in his Roman buildings. Guiniforte Solari's rib-vaulted nave, low-ceilinged and dark, overlooked by the wide west front with a central rose-window, tall narrow windows and plain buttresses, is far removed from Gothic virtuosity. However, its marked regularity of rhythm, strict simplicity of outline and absence of Gothic pointed elements are scarcely incidental. Here the deep spirituality and ornamental exuberance of late Gothic are replaced by Renaissance rationalism; a new atmosphere is created by simple proportions and rectangular forms, those aspects characteristic of Filarete's Ospedale Maggiore or Fioravanti's cathedral of the Dormition.

There are even some indications here of Guiniforte's conscious simplification of forms in imitation of pre-Gothic Lombard churches. It is stated in a history of the monastery of Santa Maria delle Grazie written in the seventeenth century that when the church was being built, the monks wanted the ceiling to be flat, as in early Christian basilicas, but ribbed vaulting was used on the insistence of the donor, Count

in Moscow when the cathedral of the Dormition was being built (1475–79), shortly after Ivan III's marriage to Zoë Paleologa. It was not by chance that at this time the Venetian ambassador, Ambroggio Contarini, not only met Fioravanti in Moscow but also found there "many Greeks from Constantinople who had come to Moscow with the princess" and "became very friendly with them, as with everyone".[85] The circle of former figures of the Byzantine court and Italian masters who had been invited to Rus' through Greek intermediaries, formed at the Muscovite court in the 1470s, played a leading part in the formation of the new ideology which was to produce the idea of "The Third Rome". In Fioravanti's work a new artistic language was born, which combined rational elements of the Italian Renaissance with forms associated with early Orthodox architecture. Here, on the foreign soil of the Muscovite State, the last renascence of Byzantium took place, the last rally of those true to the ideal of the fallen empire.

Aristotele Fioravanti laid the foundations for a new architecture in Rus'. He introduced Russians to new skills and techniques essential for the creation and construction of new architectural forms. Through him, Moscow came into direct contact with early Italian Renaissance rationalism. The new expanse of well-lit space that he created in the interior of the cathedral of the Dormition was the first manifestation of the Renaissance conception to be seen in Moscow. His work radiates an upsurge of "new life", notwithstanding his use, so precise and thoughtful, of ancient Russian architectural forms – his kind of "antiquity" in Ivan III's Moscow (pl. 80).

★ ★ ★

Gasparo Vimerchanti. Another source maintains that Guiniforte Solari was imitating the earliest Lombard church in which ribbed vaulting was used, the already wholly Romanesque church in the abbey of Viboldone.[89] "It is amply evident," James Ackerman has commented, "that whether or not the architect was concerned with the employment of Romanesque forms, he was certainly intent on reaching back to a distant past [. . .] in a search for the ultimate roots of the Gothic style."[90] The same is true of that part of the monastery of Certosa di Pavia built by the Solari family. The point takes on particular importance in the present context in light of the fact that from the mid-1470s Pietro Antonio Solari worked with his father, and in the last years of his life and after his father's death was in charge of the completion of all his projects – the Ospedale Maggiore, Certosa di Pavia, Santa Maria delle Grazie, and Milan Cathedral; in the last, the figure of the Virgin Mary (1485) is attributed to him.[91]

Pietro Antonio Solari belonged to the building dynasty that played a key part in the formation of the architectural language of Milan from 1460 to 1480. Among its features were a striving for overall clarity of plan, a distinct compositional horizontalism combined with an almost mechanistically precise rhythm in vertical articulation, the use of dark-red brick with carved simplified Classical detail in white stone (keystones, capitals and consoles) for wall surfaces, the use of Gothic detail, especially in the treatment of apertures; and at the same time technical perfection in the execution of stonework and vaulting and a distinct relish for the engineering side of the building process.

Donato Bramante brought the evolution of this kind of architecture in Milan to an end when in 1488 he completed the well-lit, magically spacious choir of the church of Santa Maria delle Grazie. It was now clear to all that a new architectural era had arrived. At this moment Pietro Antonio Solari was dismissed by the duke and, affronted, left Lombardy, taking with him the Milanese architectural achievements of the third quarter of the fifteenth century. Reaching Moscow, he began to call himself *architectus generalis Moscoviensis*, chief architect of the Russian capital, which he indeed remained up to his death in 1493.

11 The Late Fifteenth-century Lombard Fortifications and Grand Princes' Palace in the Kremlin

In Moscow Pietro Antonio Solari found two other Italian masters, known in Rus' as Marco and Onton Fryazin, who had probably arrived soon after Fioravante's death around 1486.[92] They were given the task of constructing new walls and tow-

ers for the Kremlin (Kreml'). In 1485–88 Onton Fryazin built a new south entrance overlooking the river – the Taynitskaya Tower, with gates and containing a well for use in times of siege; and also the Vodovzvodnaya Tower at the south-west corner on the river. Marco Fryazin built the Beklemishevskaya Tower at the south-east corner.[93] The last two towers were strategic defence points, and the latest artillery, for the production of which Fioravanti was responsible, was probably installed there.

It is obvious why construction of the new citadel began with these three towers. The river side of the Kremlin, to the south, was that most vulnerable to attack by invaders, such as the Mongols, and so was the first part of the perimeter to be fortified.

Pietro Antonio Solari was put in charge of this work. In 1490 he built two key gate-towers, the Borovitskaya and the Konstantin-Yelena. A year later he built the Saviour (Spasskaya) and Nikol'skaya gate-towers, both giving onto Red Square (Krasnaya ploshchad'). With the construction of the tall, multifaceted Arsenal Tower a year later still, the Kremlin's northeastern corner was secured, and all entrances to the Kremlin were now fortified. At the same time, Antonio Solari linked these principal fortified elements with walls in which smaller towers were set at intervals. The perimeter along the River Neglinka was the only stretch he did not manage to fortify, but this was considered easily defensible by virtue of the steep bank there.

These fortifications were only completed after Solari's death by other Italian masters led by the Milanese architect Alevisio or Luigi da Carcano, known in Rus' as Aleviz the Elder. He was invited to Moscow in 1493 immediately after the death of Pietro Antonio Solari through the offices of the husband of the sister of the architect and sculptor Giovanni Antonio Amadeo.[94] Alevisio da Carcano was close to the Solari family. With his father Giovanni, nicknamed Zanino, he worked under the direction of Boniforte Solari and Antonio Amadeo, and he was active in Moscow for probably at least ten years; he died in Lublin c.1512. When he left Rus' and what he built in Poland is unknown. In any case, his Lombard origins explain the stylistic unity of the Kremlin fortifications (pls 81–85).

The building of the fortifications of the Kremlin was one of the most important events in Russian architectural history. They not only changed the face of the Kremlin, and the entire centre of Moscow, but became the model for new fortifications throughout the country. Through them, the culture of fortifications as it existed in Italy in the fifteenth century was passed on to Russia. Like other technological innovations, the architectural style was taken over by the Muscovite State lock, stock and barrel, with its characteristic features of round or multi-

faceted towers and instantly recognizable swallowtail merlons. The Moscow Kremlin fortifications, in the typical Lombard style of the second half of the Quattrocento, were of unusual extent; this was almost certainly the largest Renaissance citadel in Europe at the end of the fifteenth century. It has to be said that these fortifications did not represent the very latest thinking in Italian fortification theory, which at this time was rapidly finding engineering solutions to new means of waging warfare, especially the growing role of artillery. In Russia too, the design of fortifications was to evolve in this direction, but those of the Moscow Kremlin not only had a lasting importance for their military qualities, they also became elements of an architectural language conferring a sacral character on royal power.

In the course of time, these fortifications lost much of their specific Italian character. In the seventeenth century, ornamental spires were added to the towers, and there was much reconstruction in the eighteenth and nineteenth centuries. However, the lower parts of the walls and the rest of the towers have preserved their late fifteenth-century Milanese character up to the present day.

During this same period, Pietro Antonio Solari and Marco Ruffo began to build a palace for Ivan III in the middle of the new citadel, later called the Terem Palace (Teremnoy dvorets), which was subsequently rebuilt a number of times (pls 86, 87). In its original form, this building probably consisted of three two-storey rectangular blocks with a flat roof set off by a prominent cornice, its ornamental style reminiscent of the well-known drawing of the Medici bank in Filarete's treatise. Between the blocks was a courtyard with a uniform pattern of

81 Detail of the Corner Arsenal Tower, Kremlin, Moscow.

82 Stretch of wall with the Orugeynaya Tower, Kremlin, Moscow.

Tuscan pilasters on the surrounding walls and a brick balustrade surmounting the second storey. It is difficult to tell what remained of Solari's original structure following the disastrous fire of 1493 and the architect's death soon afterwards. Rebuilding did not begin until 1499, under the direction of Alevisio da Carcano. After the rebuilding that took place in the sixteenth and seventeenth centuries and the Romantic restora-

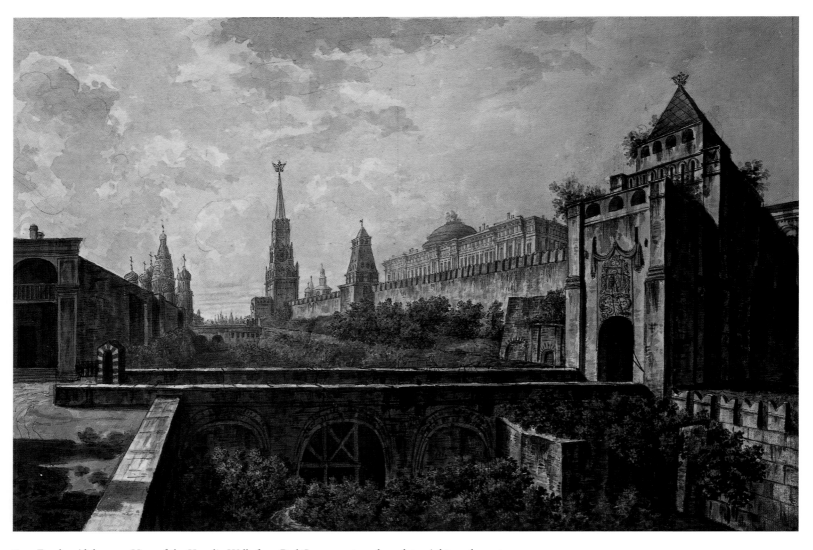

83 Fyodor Alekseyev, *View of the Kremlin Walls from Red Square*, watercolour, late eighteenth century.

tion of the nineteenth, only a part of the ground floor of the original building, with altered ornamentation, remained.

As a result of extensive investigations carried out during restoration work at the Great Kremlin Palace (Bol'shoy Kremlyovskiy dvorets) in 1995–98 under the direction of Sergey Pod"yapol'sky, a large quantity of ornamental architectural fragments dating from the turn of the fifteenth and sixteenth centuries was found.[95] These revealed that in the origi-

84 (*left*) Fyodor Alekseyev, *View of the Kremlin and the Kamennyy Bridge*, late eighteenth century.

85 (*facing page*) Lower part of the Corner Arsenal Tower, Kremlin, Moscow.

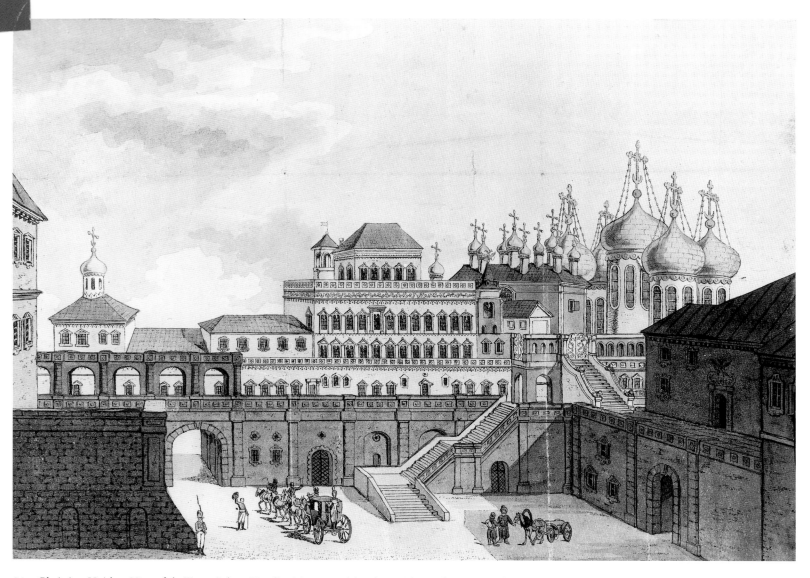

86 Christian Heisler, *View of the Terem Palace, Kremlin, Moscow*, etching, late eighteenth century. The ground floor is fifteenth/early sixteenth century.

nal building the Milanese masters used detail – in consoles, capitals and doorway and window mouldings – very similar to that used by Guiniforte and Pietro Antonio Solari in the final stages of work on the Ospedale Maggiore.[96] Here is material proof of the introduction to Moscow of the typical pre-Bramante style of Lombard palace buildings, marking the moment in the evolution of Lombard Renaissance architecture when, on the eve of the High Renaissance, the quest for innovation was replaced for a time by a preference for more traditional forms associated with older customs that still had their place in master builders' workshops. Such features are of course frequently found in buildings in Milan and its environs dating from the second half of the fifteenth century – for example, in ornamentation executed at this time in parts of Pavia Cathedral and the Palazzo Botticelli also in Pavia; and in Milan itself sim-

ilar ornamental elements may be seen on the exterior of the church of Santa Maria presso San Satiro.[97]

The only part of the original structure of the Great Kremlin Palace that remains materially unchanged today is the Faceted Palace (Granitovaya palata), built in 1487–91 in Pietro Antonio Solari's lifetime (pl. 88). Its interior is wholly in Russian tradition, consisting mainly of a large square hall with a massive central pillar supporting four groin vaults (pl. 90). It used to be entered via a narrow lobby, with the so-called Red Staircase leading up to it.

The façades of the Faceted Palace have an appearance that was completely new in Russian architecture when it was built. At ground floor level the wall is left plain; and each façade is finished with a simple Classical cornice. The main part of the wall of each of the three façades is ornamented with diamond-

pointed rustication; windows are placed in two symmetrical groups on two levels, with two large windows on the lower level and a small one between them on the upper level. This unusual rusticated surface occurs in Italy in the Quattrocento, in the Palazzo Diamanti in Urbino[98] and the Ca del Duca in Venice[99] (pl. 89). In the case of the latter, only a small part of the building was completed. In Urbino this feature had heraldic significance, a cut diamond being included in the coat of arms of the d'Este family.

The jambs and lintels of the windows of the Faceted Palace originally took Classical forms. The existing windows date from the seventeenth century; the original ones consisted of two semi-circular arches with central slender columns covered with foliate ornament. The overall composition of this façade, displaying typical Renaissance detail and constructional principles, was unprecedented in late fifteenth-century Rus'. Its rich ornamentation and especially the defining role of the complex rustication are remarkable for its time. Renaissance forms emerged at this moment in Rus' like ornamental clothing covering buildings of traditional construction and interior design.

It was not until the reign of Vasily III, son of Ivan III and Zoë Paleologa, that the Great Kremlin Palace was finally completed. This is a somewhat shadowy period of Russian history, with a dearth of written records that reveal the ruler's personality. Vasily III received a mixed Muscovite and Greek-Italian upbringing. He was the only grand prince of Moscow who grew up in a circle with personal knowledge of the life and culture of the late Byzantine Empire, and which could influence his architectural tastes and especially the ideology expressed in the design and ornamental schemes of the buildings he commissioned.

★ ★ ★

87 Marie-François Damam de Marte, *View of the Terem Palace, Kremlin, Moscow*, coloured engraving, 1810. The church of the Saviour in the Wood is in the foreground.

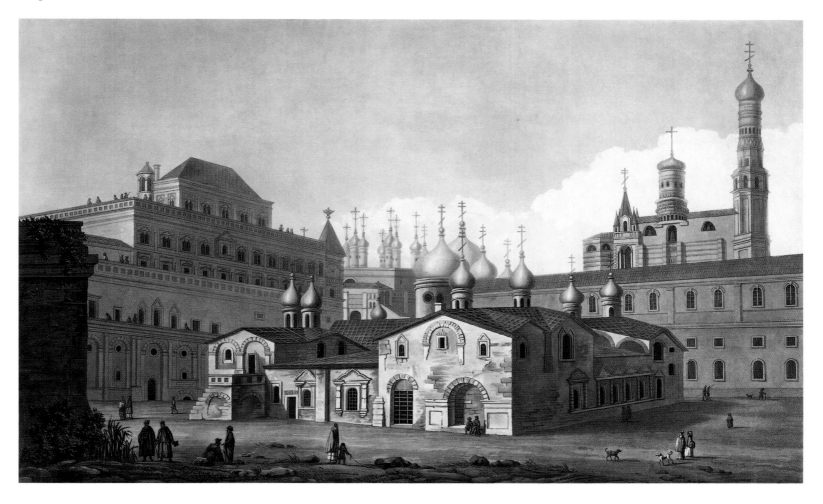

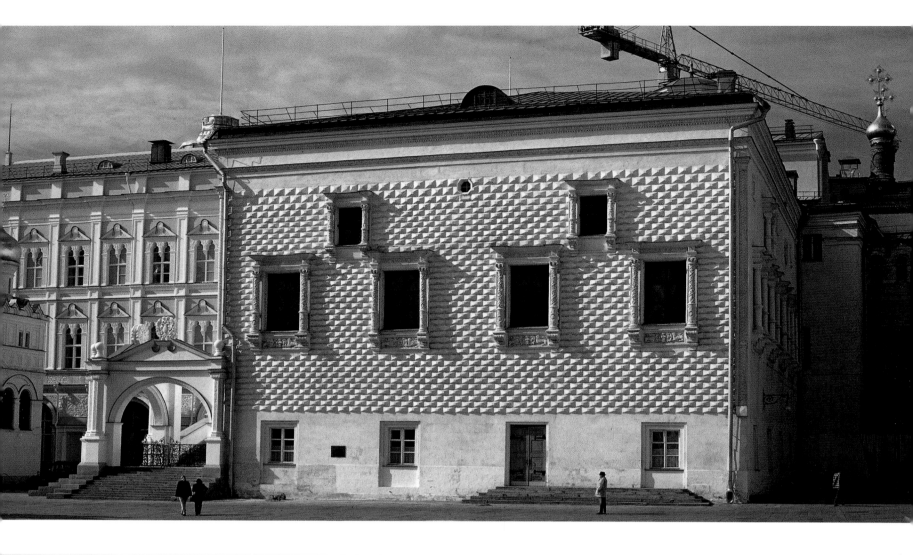

88 (*above*) The Faceted Palace, Kremlin, Moscow (Mark Fryazin and Pietro Antonio Solari), 1487–91.

90 (*facing page*) Interior of the Faceted Palace, Kremlin, Moscow (Mark Fryazin and Pietro Antonio Solari), 1487–91.

89 (*left*) Detail of the façade of Palazzo Ca' del Duca, with "diamond" rustication, Venice, late fifteenth century.

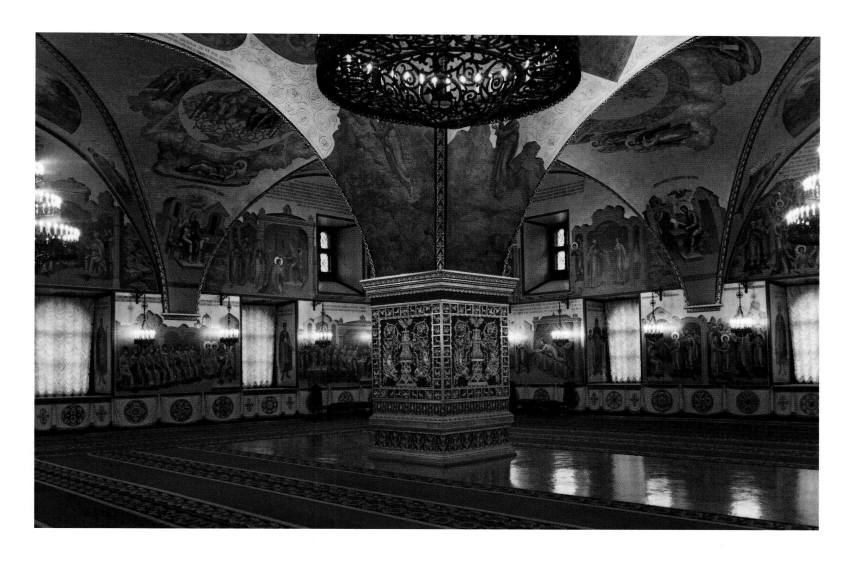

12 *Alevisio Lamberti da Montagnana and the Burial-place of the Princes of Moscow*

In 1504 the Crimean khan Mengli-Girey, then an ally of Moscow, wrote to Grand Prince Ivan III that he was sending him back his envoys Dmitry Palev and Mitrofan Karacharov, and with them an Italian master. The khan emphasized how very special was his gift: " [. . .] a most excellent master, not like others, a very great master. And now I ask you, my own brother, I myself ask you, do not look upon other masters as the equal of this Alevisio [. . .]."[100] What had made such an impression on the ruler of the Crimea was the "iron gate" constructed by Alevisio Lamberti da Montagnana in his palace in Bakhchisaray. This master came to be known in Moscow as Alevisio Novy, "the new Alevisio", as distinct from the other Alevisio who had already worked in the Kremlin, the above-mentioned Alevisio da Carcano.[101]

The name of Alevisio Lamberti da Montagnana was only discovered in the 1940s in the course of research in Venetian archives by Sebastiano Bettini, who established that this master went to Moscow in 1503.[102] He is first mentioned as a stone-mason in the team that carved the lower part of the façade of the Scuola di San Marco in Venice.[103] Some small-scale buildings in Pavia and a number of other towns in the Veneto have been attributed to him,[104] not entirely convincingly, by comparison with some of his motifs executed in Moscow and not on documentary evidence.[105] On this basis, it would be possible to attribute many other buildings in Venice and its environs to Alevisio. More likely work of his is to be seen at Montagnana cathedral (pls 91–93), completed *c*.1502. This building preserves traces of Venetian Gothic, but motifs *all'antica* also enter its ornamental scheme, balanced on the verge between rich Late Gothic ornament and imitation of Antique forms. Especially striking features of the interior are the giant "scallop-shell" motifs at the end of each transept-aisle, used by Alevisio in his most important work in Moscow. The only thoroughly attested example of individual work by him in his homeland is the Gruamonte memorial in Ferrara Cathedral,[106]

91 Montagnana cathedral, completed in 1502.

92 Detail of the south chapel of Montagnana cathedral, completed in 1502.

93 Detail of the cornice of the façade of the south chapel of Montagnana cathedral, completed in 1502.

showing him as a sculptor only, possessing true Renaissance qualities in his handling of figures. Northern Italian in character as they are, these images, dating from 1498, seem to belong to the High rather than Early Renaissance. Only in the modelling of folds in drapery is the spirit of Gothic felt, and the strictly geometric design is a reminder of its time – we are still in the Quattrocento.

Whether Alevisio Lamberti da Montagnana was primarily an ornamental sculptor or an architect has long been a matter of dispute.[107] Relying purely on documentary evidence, one might agree with Irina Buseva-Davydova that "in his native Venice he could hardly assume the role of architect. However, [in Moscow] the Italian did not fall down"[108] in his execution of large-scale architectural tasks, notably the building of the cathedral of the Archangel Michael in the Kremlin (pls 94, 95).

There are two particularly significant and well-documented aspects of Alevisio's Italian career. He unquestionably collaborated in the execution of the remarkable, and most extensively ornamented, façade that stands out among the others dating from the end of the fifteenth century in Venice – that of the

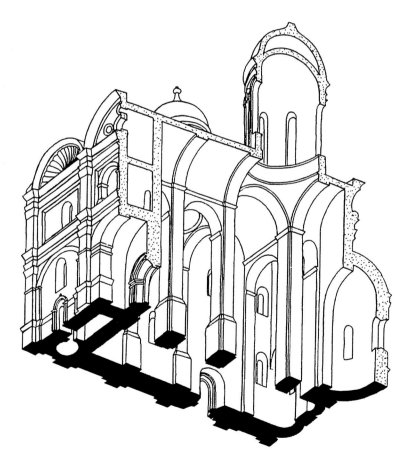

94 Axonometric projection of the cathedral of the Archangel Michael, Kremlin, Moscow (Alevisio Lamberti da Montagnana), 1505–09, by Sergey Pod"yapol'sky .

95 View from the north-west of the cathedral of the Archangel Michael, Kremlin, Moscow (Alevisio Lamberti da Montagnana), 1505–09.

Scuola da San Marco (pl. 105). And at the moment of Ivan III's mission to Italy led by Dmitry Ralev, he happened to have become celebrated as a tomb architect. These were the very two qualifications most sought after in Moscow at this time.

Knowing that he was at the end of his life, Ivan could not avoid thinking about his final resting-place. The cathedral of the Archangel Michael (sobor Mikhaila Arkhangela) in the Kremlin, the traditional burial-place of Moscow's ruling princes,

looked old-fashioned and dilapidated beside its new neighbours, the cathedral of the Dormition and the Faceted Palace. The new Venetian master, with his special abilities and achievements, seemed to the Russian envoys well qualified for the task of transforming the burial-place of the princes of Muscovy.

It was characteristic that Alevisio Lamberti da Montagnana was a Venetian, and that he travelled to Moscow via Constantinople and the Crimea, the traditional sea route used by Italian merchants trading with Moscow, who established links with Rus' through their trading stations north of the Black Sea. Alevisio's choice of route indicates not only its commercial but also its cultural significance. Over the next few decades, with the Turks increasingly hindering the maritime movement of the Venetians and the Genoese, the situation in the region changed radically. Venice was to cease to play a major role in Russian cultural history, but for a limited time, following Ivan's marriage to Zoë Paleologa and through the turn of the fifteenth and sixteenth centuries, it continued to maintain close contacts with Moscow, counting on dividends from its Eastern policy. Alevisio's work in the Kremlin was the most striking memorial to Venetian-Muscovite contacts at the beginning of the sixteenth century.

As the most "Renaissance" building in the Moscow Kremlin, the cathedral of the Archangel Michael has long aroused scholarly dispute as to the relationship between its traditional Russian features and the new architectural order introduced from Venice. The main difficulty in the way of understanding the building lies in the fact that, in comparison with Fioravanti's cathedral of the Dormition, it is not only still more markedly Renaissance in character, but also more closely linked with Early Russian architectural tradition. It contains two opposed architectural tendencies in practically equal measure.

One possible way of reaching an understanding of this cathedral is to grasp the programme that lay behind its construction. This was entirely different from the purpose of the cathedral of the Dormition, and also bound up with the changing ideology of the Muscovite court. Fioravanti's cathedral, the principal shrine of Russian Orthodoxy, was built as a focal point, in Moscow, for the idea of "the early Greek piety laid down by God". The cathedral of the Archangel, which for centuries had been the burial-place for the rulers of Muscovy, had to represent the character of their rule. The native burial-place of the heirs of Ivan Kalita most certainly had to possess traditional Muscovite features.

At the same time, it was hardly fortuitous that it should have been Ivan III who at the end of his life decided to give a new appearance to the church that had existed on the spot since 1333. The opinion has been expressed that the reconstruction was simply due to lack of space after a high number of burials. This, however, would explain the enlargement of the building only, and not the innovatory features of its appearance. An ancestral burial-place for monarchs, as an architectural type, had to express the idea of the continuity of power, and there had to be good reason for its reconstruction in a new spirit.

During the last years of his reign, Ivan III was tormented by doubt as to his choice of successor – whether Dmitry, son of his elder son from his first marriage to the Princess of Tver', or Vasily, son of Sophie Paleologa. A struggle over this arose at court. The faction supporting Vasily was truly Byzantine, quick to take up new ideas, including Italian. The duality of the architecture of the cathedral of Michael the Archangel fitted the contradictory situation at Ivan's court to an astonishing degree. It has been held that Ivan III's will, with his aspiration to divide the State once more into appanage territories settled on his sons, indicates the strong hold that old Muscovite customs must have had on the grand prince's thinking.[109] At the same time, the final choice of his son by Sophie Paleologa as heir to the throne reveals his passionate desire to raise his dynasty to a higher status among the rulers of the known world. In his heir Vasily flowed not only his own blood but also that of the last rulers of the Byzantine Empire. In order to create new architecture in the hallowed burial-place that would appropriately reflect the raised status of his dynasty, Ivan III would most especially seem to have required a master from Venice, where Byzantium was best remembered.

Work on the new Archangel cathedral began in 1505 in the last months of the life of Ivan III, and without doubt, to a plan that met with his approval: a large church with six pillars, of traditional cross-domed structure, but enlarged on the west side. On the second storey there was to be a gallery for distinguished women attending services. Even at this stage, the plan obviously corresponded with the cathedral of the Dormition; the new cathedral was actually somewhat smaller. The design of the presbytery was borrowed from that of the Dormition, with the side apses being divided into two. Of central importance was that once again, as in the case of the Dormition, there were five domes.[110] The new building clearly followed the architectural line that Fioravanti had laid down in Moscow. It was completed in 1508, when Grand Prince Vasily III had been on the throne for three years, in the course of which his rival Dmitry had died in close confinement. It is possible that the bold features of the exterior had been approved by Vasily, brought up by his mother and her circle in a different spirit from that of his father, in Venetian-Byzantine style (pl. 99).

The cathedral of the Archangel is the first church in Muscovite Russia in which the Renaissance Orders are used. Its

96 The lowest tier of the west front of the cathedral of the Archangel Michael, Kremlin, Moscow (Alevisio Lamberti da Montagnana), 1505–09.

façades are divided into two tiers with a cornice and finished with another which supports semicircular *zakomary*, the outer ones being ornamented in the Venetian manner as huge scallop shapes. The lower tier consists of arches resting on pilasters. Each tier has its own pilasters, which together make the façade into an overall structure based on the Orders. Especially in Venetian style is the loggia on the west front with round windows above it (pls 96–97).

The white stone portals, although their general form belongs to the Moscow architectural school, are carved with ornamental motifs drawn from the Renaissance models, an innovatory feature in Russian architecture. Classical acanthine ornament, voluted capitals, and urns decorated with plant forms appear here for the first time in Muscovite church architecture, making a decidedly stronger impact than the restrained

Lombard-style ornamental carving of the grand prince's palace, and rivalled only by the sumptuous façades of the Faceted Palace. This scheme must have made a more Venetian impression before the Gothic pinnacles[111] beneath the *zako-mary*, the gilding of detail and the red wall colour were lost.[112] The scalloped ornamentation finishing the façades, however, preserves a further Venetian note.

The interior of the cathedral is in traditional Moscow style. It lacks the Dormition's spaciousness and abundance of light. The most interesting thing about it is that the vault-supporting pillars customary in Early Russian church architecture are transformed into gigantic square piers on pedestals. This feature is also seen in late fifteenth-century Venice in churches on a smaller scale, such as Santa Maria Formosa built by Mauro Codussi in the early 1490s.[113]

97 Side portal of the west front of the cathedral of the Archangel Michael, Kremlin, Moscow (Alevisio Lamberti da Montagnana), 1505–09.

The Archangel cathedral marks a change in the architectural orientation of the "Russian Renaissance" at the transition of the reigns of Ivan III and Vasily III, when Venice was replacing Milan as a source of new ideas. As already seen, from the very beginning of intensive Russian-Italian contacts during the fifteenth century this city had served as an important staging-post between Moscow and the West. Thanks to the work of Alevisio Lamberti da Montagnana, Venetian influence can be more easily traced in Rus' in forms of architectural decoration and ornamentation. It has long been a commonplace among architectural historians that the basis of the architectural links between Moscow and Venice was the contact that each school had with the Byzantine heritage.[114] The similarity of the Archangel Cathedral to Venetian buildings by Mauro Codussi and Pietro Lombardo has been especially remarked.[115] Sergey Pod"yapol'sky even goes so far as to say that in studying the

Archangel, "the similarity of the approaches to church architecture in Venice and Rus' sometimes makes it almost impossible to distinguish between them."[116]

Late fifteenth-century Venetian churches such as Santa Maria Formosa (begun in 1492) and San Giovanni Crisòstomo (begun in 1497) built by Mauro Codussi combine features of basilica and cross-domed church. This was not the case in Moscow. The interior of the Archangel cathedral preserves the features of the traditional Russian cross-domed structure, but when it comes to the exterior, Alevisio uses the same architectural language as Mauro Codussi. He does not copy any of Codussi's specific buildings, but gathers elements of various Venetian buildings, especially those of Codussi, into his own composition, unconcerned as to whether they come from an interior or an exterior. In their wealth of ornamental detail, the façades of the Archangel cathedral perhaps most closely resemble San Zaccaria church, Codussi's most large-scale building (pls 100–04).

The Archangel cathedral is the most important example of Renaissance-style ornamental architecture in Russia, that is, of an integrated architectural scheme defining a whole exterior, while traditional features of the interior are preserved. A similar example of this principle, as seen above, is the Faceted Palace. This preservation of traditional spatial design in an interior along with an absolutely new, Renaissance-style appearance of the exterior marks a new stage in the impact of Renaissance ideas on Russian architecture at the turn of the fifteenth/sixteenth centuries. Another example is to be seen in the lower part of the Ivan the Great Bell-Tower (kolokol'nya "Ivan Velikiy") in the Kremlin (1505–08), the work of Italian masters led by a figure as yet unidentified in his homeland, known in Moscow as Bon Fryazin (pl. 107). Here the traditional Russian type of bell-tower church acquires the appearance of a late fifteenth-century Lombard-style campanile. And indeed, Bon Fryazin belonged to a group of Milanese masters working in Moscow, where he remained after the death of Pietro Antonio Solari in 1493 and the departure of Alevisio da Carcano for Poland some ten years later.

It is hard to say how long this tendency in Alevisio's work continued. In 1514–17, according to the chronicles, he collaborated in the construction of eleven churches in Moscow.[117] The only one of these possibly to have been preserved is St Peter the Metropolitan in the Upper Monastery of St Peter (tserkov' Petra-mitropolitana v Vysoko-Petrovskom monastyre; pl. 106), but even here, the only certainty is that it was originally a centralized building.[118] Alevisio ceased to work in Russia in the 1520s, although there is evidence dating from 1531 of a house belonging to him.

98 (*facing page*)　Detail of the lowest tier of the north front of the cathedral of the Archangel Michael, Kremlin, Moscow (Alevisio Lamberti da Montagnana), 1505–09.

100 Detail of the façade of Santa Maria dei Miracoli, Venice, 1520s.

101 Detail of the Order on the façade of the Palazzo dei Camerlenghi, Venice, 1525.

102 West front of the church of San Zaccaria, Venice (Mauro Codussi), 1510s.

103 Blind arcading of the west front of the church of San Zaccaria, Venice (Mauro Codussi), 1510s.

100 (*facing page*) Interior of the cathedral of the Archangel Michael, Kremlin, Moscow (Alevisio Lamberti da Montagnana), 1505–09.

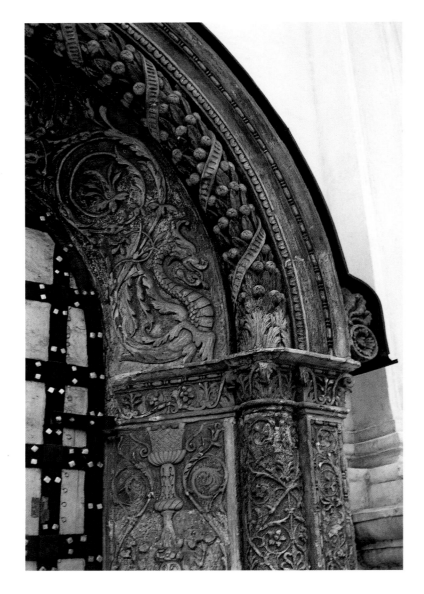

106 (*above*) Church of St Peter the Metropolitan, early sixteenth century; restoration.

13 Moscow Traditional Architecture in the Renaissance Period

There was another evolutionary stratum in Moscow architecture at the turn of the fifteenth and sixteenth centuries, a logical development of those types of church buildings that had been constructed in Moscow before the arrival of the Italian masters. In this category, Moscow architectural traditions of the fourteenth and first half of the fifteenth century were preserved and the typical buildings of the capital enriched by architectural discoveries and new techniques that reached Moscow from other parts of the country, above all the northwest, Novgorod and especially Pskov.

First and foremost among buildings belonging to this strand is the cathedral of the Annunciation (Blagoveshchenskiy sobor), which served as the private chapel of the grand princes. It was built in 1484–89, postdating Fioravanti's Dormition, though its builders were not noticeably influenced by the latter. They came from Pskov and had been active in Moscow for ten years before beginning work on the new cathedral – it was they who had been consulted about the collapse of the cathedral of the Dormition in 1474.

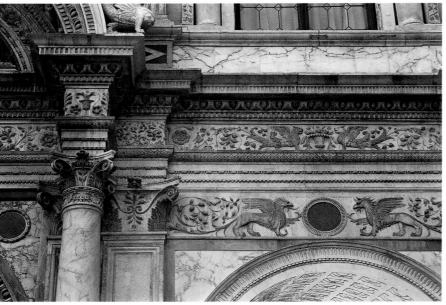

104 (*above left*) Detail of the north portal of the cathedral of the Archangel Michael, Kremlin, Moscow (Alevisio Lamberti da Montagnana), 1505–09.

105 (*left*) Ornamental detail, exterior decoration of the Scuola di San Marco, Venice.

107 (*facing page*) The Ivan the Great bell-tower (church of St John Lestvichnik) (Bon Fryazin), 1505–08.

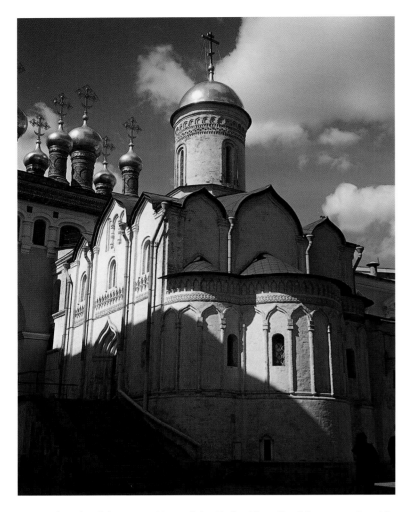

108 Church of the Deposition of the Robe, Kremlin, Moscow, 1484–88.

Another church was begun in the Kremlin in 1484, the Deposition of the Robe (tserkov' Rizopolozheniya), probably the work of the same Pskov masters who built the cathedral of the Annunciation (pl. 108). This smaller church was executed in the same traditional Early Russian forms, and here too there is a noticeable tendency towards more elevated proportions, the overall structure being extended by being placed on raised foundations, and the drum supporting the single dome also being raised. The building displays a further key element in Moscow and Russian architectural evolution, a heightened ornamental and decorative development, and in this it is not incidental that, as in the cathedral of the Annunciation, elements from early Moscow, Vladimir and Pskov are combined. In this church the architects from Pskov refined favourite motifs they had used in their home cities. These two tendencies, the upward striving of the mass of the building and the enrichment of the interior with increasingly varied architectural detail, foreshadow Moscow's future architectural evolution.

The little cathedral of the Nativity of the Mother of God in the convent of the same name (Rozhdenstvenskiy monastyr') was built in 1501–05. Its form is markedly retrospective, the pyramidal silhhouette going back to the early fifteenth century and recalling the cathedral in the Andronikov Monastery of the Saviour. The construction of the later building is more finished: the lower corner cells are roofed with groin vaults, rarely used by Russian architects, and four pillars carry stepped arches supporting the central dome which admits an abundance of light. The constructional boldness might be evidence of the work of an Italian engineer, but the architectural forms clearly indicate the client's wish to follow Russian tradition.

At the turn of the fifteenth and sixteenth centuries, alongside the major cathedrals in the Kremlin, the monasteries and convents, another type of church was evolving, the small parish church (posadskiy khram). An example of this type is the church of St Triphon in Naprudnoye (pl. 109), of great interest for its new pillarless constructional principle, which had probably just reached Moscow from Pskov. This system supported the weight of the drum and cupola and freed up the interior of the small church; it was to be influential in Moscow architectural evolution (compare the church of St Anna in the Corner/tserkov' Sv. Anny v uglu; pl. 110).

The exterior of the church of St Triphon preserves traditional Moscow features: a pyramidal silhouette, façades divided into three parts by lopatki, monumental portals, and kokoshniki around the base of the drum. However, the impact of the work of the Italians in the Kremlin is felt here; the lopatki have taken the form of pilasters, and the cornices are more complex.

Similarly, the crowning of the façades of these small parish churches in central semi-circular arches flanked by lower

The cathedral of the Annunciation, a small building of slightly rectangular plan, four pillars and three apses, was built on to the high white stone cellar storey of the earlier church on the site; crowned with three finely proportioned domes, it had a majestically elevated appearance. In the structure of the ceilings the Pskov system of stepped corbelled arches was used. In the decorative/ornamental scheme three strands can be discerned, representing different Russian architectural schools. The bands of blind arcading on the apse walls and further decorative arcading on the drums supporting the three original domes are typical of the churches of Vladimir. The kokoshniki around the base of the central drum are early Muscovite features. And the in-depth geometrical decoration of the apse walls and domes is clearly in Pskovian tradition. The building soon changed its original appearance. Under Ivan the Terrible open galleries were added on three sides, then these were built over with side-chapels, and six domes were added. The Italian masters' carving in Antique style on the portals influenced later ornamentation in Kremlin palaces.

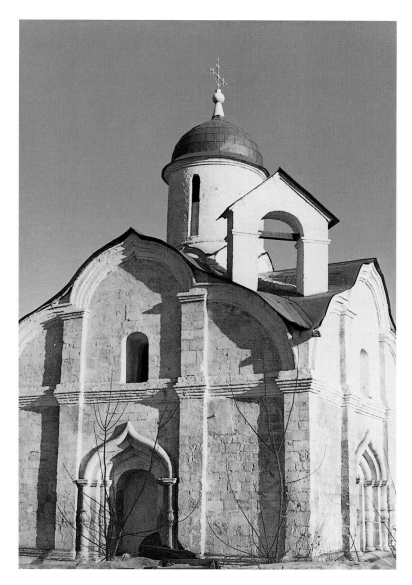

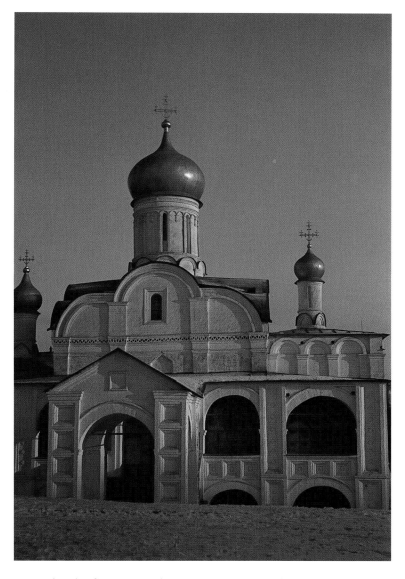

109 Church of St Triphon in Naprudnoye, Moscow, late fifteenth/early sixteenth century.

110 Church of St Anna in the Corner, Moscow, early sixteenth century.

quarter-arches indicates that the architects belonged to the circle of Alevisio Lamberti da Montagnana. This kind of composition is not found earlier in Rus', but was a favourite of Mauro Codussi (church of San Michele, Venice, one of this architect's earliest buildings), and of Vicenzan architects (church of the Annunciation, Brendola).[119] It was perhaps this correspondence that prompted the Italian envoys to speak of their fellow countrymen's transformation of the appearance of the parish churches of Moscow.[120]

• • •

14 The Symbolism of the Third Rome: Vasily III and the Church of the Ascension in Kolomenskoye

In 1492 the Orthodox Church was expecting the end of the world. According to the calculations of the annals, which started with the supposed date of the creation of the world and continued up to the present, the seventh millennium ended in this year, and the general mood was eschatological. When the year 7000 had passed uneventfully, expectations of universal catastrophe were replaced by a desire to establish a long historical perspective into the future.

Metropolitan Zosima in Moscow produced a new calendar of the principal festivals of the Church, the paschal cycle. In his calculation of this "to the eighth millennium [. . .] the hour

[. . .] of the [second] coming of Christ", he developed the ideas of Metropolitan Iona regarding the Russian Church as the focal point of "the early Greek piety laid down by God". Zosima now spoke of the transfer of the righteous Christian empire to Russian soil. "And now [. . .] God has glorified [. . .] the true believer and lover of Christ, the Grand Prince Ivan Vasilevich, ruler and autocrat of all Rus', the new Emperor Constantine whose seat is Constantine's new city, Moscow."[121] Earlier Russian sovereigns had often been compared in the chronicles to the Emperor Constantine. However, Zosima's statement contained a radically new element. For him, Moscow was not simply "a new Constantinople", not only the centre of the Orthodox world, but the world's last capital, which would last until the Second Coming.

These ideas, emerging at the end of the reign of Ivan III, became the foundation for the political concepts that prevailed during the reign of Vasily III and determined the manner in which Renaissance ideas were taken up in Russian architecture. In the course of the first third of the sixteenth century, a variety of literary works appeared in which a new image of the Russian State was presented. Among these were a number that treated the theme of continuity of sovereign power: *The Story of the Kingdom of Babylon*, *The Epistle of Spiridon-Savva on the Crown of Monomakh*, *The Story of the Grand Princes of Vladimir*. Linking all these texts is the idea of the transmission of symbols of royal virtue, symbols of the transference of a righteous kingdom pleasing to God, one which would be taken as "passing consecutively from the kingdom of Babylon to Egypt, and from there to Rome, Byzantium, and at last Rus'."[122] *The Story of the Grand Princes of Vladimir* even refers directly to the descent of ruling Russian princes from the Emperor Augustus via his supposed brother Prus, an ancestor of Ryurik, founder of the reigning dynasty.[123]

During the reign of Vasily III a wide-ranging and virulent debate was waged on the theme of Moscow as a Third Rome, a new world imperial capital that would "last to the end of time", and the outcome affected the course of Russian architectural history. In 1508 Nicolas Bulow, a specialist in medicine and astrology and "well grounded in all sciences", arrived in Moscow from Germany.[124] He was soon appointed court physician and became one of the grand prince's closest companions. The German scholar was an adherent of the First Rome, and his viewpoint combined the imperial idea with that of the primacy of Rome in the Christian world. Like many Germans, he believed in the prediction that the world would come to an end in 1524.[125] This completely contradicted the dream cherished by the last Byzantines and their Moscow allies of a last Orthodox empire to be established in Rus'. Opposition to Bulow's ideas came from various quarters.

The humanist Maxim the Greek, after emigrating to Italy and working there with John Lascaris and Giovanni Francesco Pico della Mirandola, settled in Moscow in 1516 and soon entered into dispute with the German doctor, endeavouring to prove the superiority of the Byzantine Orthodox tradition.[126] On the eve of what German astrologers expected to be the end of the world, in 1523 or 1524, the monk Philotheus, from the Pskov district, supported Maxim in his celebrated epistle *Against Astrologers*. This tract by the *starets* of a remote monastery[127] was so in tune with Moscow court thinking that it would seem to have incited those figures in the entourage of Vasily III who embraced the idea of the transformation of Moscow into the new centre of the Orthodox world.

Philotheus's formulation of this doctine was to take a classic place in Russian culture: "It is said that all the Christian empires have come to an end and come together in our own State [. . .] that is, the Russian State. Rome has fallen twice [Ancient Rome and Constantinople], but the Third Rome [Moscow] is standing, and there will be no Fourth [. . .] It will behove our sovereign to observe this with great piety and turn to God."[128] He looked upon Vasily III as "[. . .] our most radiant [. . .] monarch, who is the only Christian ruler in the whole world, and the builder and protector of the holy universal angelic churches of God's holy thrones". To a striking degree, the monk from a monastery near Pskov pinpoints, in pure Byzantine terms, as if he were writing in Constantinople, the emperor's role within the church.[129] And he emphasizes Moscow's superiority, in the matter of religion, over both Rome and Constantinople, taking the true Orthodox Church to be represented a particular building, of which a detailed account has already been given: "In the blessed city of Moscow, instead of the churches of Rome and Constantinople, there is the sacred and glorious [cathedral of the] Dormition of the Most Holy Mother of God."[130]

The church built by Fioravanti has thus become the centre of the only true church, a symbol of the new empire. However, as already seen, the ideal embodied in its architecture was a generalization of the past, based on the prototype of "early Greek piety". At the same time, the concept of Moscow as the Third Rome was distinctly futuristic, extending from the present moment to the end of time. These ideas needed to be given new symbolic expression, in palace architecture as well as cathedrals, and this process took place during the second half of the reign of Vasily III.

The period divides into two parts: first, 1505–25 and Vasily's marriage to his first wife Solomoniya, who came from a distinguished boyar family, the Saburovs. The second part, 1526–33, begins after the dissolution of Vasily's first marriage and his marriage to Yelena Glinskaya, from the princely

Glinsky family which had recently emigrated to Moscow from Lithuania, where some of its members had been among the highest-ranking courtiers of Grand Prince Alexander. Yelena's father and uncle had been educated in Europe; there is some evidence of periods spent in Italy and Germany.[131] When the family came to Moscow, especially after Vasily III's marriage to Princess Yelena, the links between Rus' and the West were renewed. In 1527–28 another mission, headed by Trussov and Lodygin, was sent to Rome; it returned with a new architect.

At this time Vasily III was continuing to consolidate his power and develop the ideology that aimed to give the Russian state a new character. And it was at this moment that the idea of Moscow as the Third Rome received its final expression. The new ideology fed into the radical change that took place in the appearance of the buildings commissioned by Vasily III, ushering in a third period during which Renaissance ideas made a direct impact on Russian architecture.

Striking testimony of this is the most important monument of the time, the church of the Ascension (tserkov' Vozneseniya) in the grand princes' residence in the village of Kolomenskoye near Moscow. Its date of completion, 1532, is documented. The identity of the architect used to be the subject of long debate, but today it is accepted that he was Pietro Annibale, known in Moscow as Little Petrok (Petrok Maly).[132] He fled from Rus' in 1539, caught up in the turbulence after the death of Vasily III, whose young son Ivan IV, the future Ivan the Terrible, and widow Yelena Glinskaya, whose connection with the Moscow aristocracy was tenuous, were unable to hold on to power. The Italian master, deprived of his principal patron and protector, fled to Livonia, where he related his life-story to the bishop of Derpt.[133] After the fall of Rome in 1527 to Charles V, there were many unemployed architects in the city. What was needed in Rus' at this time, however, was a combination of architectural and military engineering skills, and on the advice of the pope, the choice fell on the Florentine Pietro Annibale, who had formerly been employed at the Vatican.[134] His biographical details are particularly important to know, because it was he who took a major new step in the adoption of Italian architectural ideas in Rus'. He and his patron decided to break with the age-old cross-domed tradition and create a completely new type of church.

The church of the Ascension at Kolomenskoye (pl. 111) changed the whole course of architectural evolution in Russia in the sixteenth and seventeenth centuries. Its forms, above all the tall, tent-shaped roof, had little to do with earlier churches. Nineteenth- and twentieth-century scholars made many attempts to explain the architectural sources for this church, claiming to find structural precedents in Italy, Georgia, Armenia and Poland, and linked it with the type of church "under bells" that was built in Moscow in the fourteenth and fifteenth centuries, that is, crowned with a bell-tower.[135] These explanations and comparisons, however, were unconvincing because they relied purely on earlier general examples of vertical composition or on details that did not help to define the overall design of the church.

The church at Kolomenskoye is specifically designed to include the function of a lookout tower; it is 62 metres in height. Its plan is strictly central, a Greek cross. The interior is very small, no more than one hundred square metres (pl. 111). A gallery runs round the church, with three staircases, repeating the basic plan. All corners on the exterior are marked off with plain protruding pilasters with flat capitals. Between the pilasters are Gothic canopies whose sharp points come up to the level of the capitals. Upon the basic structure of the church an octahedron is set, surmounted with tiers of large keel-shaped arches in traditional Moscow style. Above these rises the octahedron with a double-faced Classical pilaster at each corner and a window at the centre of each face. The octahedron is surmounted with a tall tent-shaped roof with ribs picked out in limestone from the overall brick (pls 112–15).

Everything about the building breaks with Russian tradition – the vertical composition on such a scale, the centralized plan without apses, the style of its detail. But most important of all

111 Plan of the church of the Ascension, Kolomenskoye (Pietro Annibale/ Little Petrok), 1532.

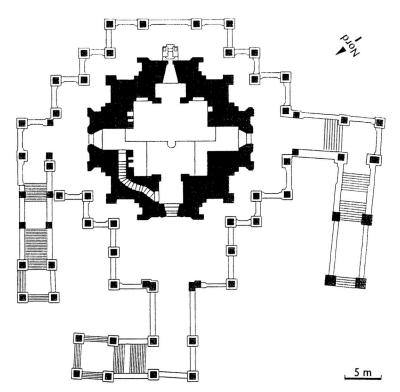

112 Interior of the tent roof of the church of the Ascension, Kolomenskoye (Pietro Annibale/Little Petrok), 1532.

113 Pylon capitals in the church of the Ascension, Kolomenskoye (Pietro Annibale/Little Petrok), 1532.

from the historical point of view is the strong impact of monumentality and the limited capacity of this church, which can accommodate only a small congregation, quite out of proportion with the mighty scale of the building. This is an indication that the architectural composition serves a specific ideological conception rather than a functional purpose.

Striking also in this church is the combination of Italian Renaissance elements, Gothic motifs and traditional Moscow features (pls 116, 118–21). But the compositional principles typical of the Italian Renaissance are most important of all. Pietro Annibale selected what was considered the ideal church plan in Italy at the beginning of the sixteenth century, the Greek cross form. Rudolph Wittkower has commented that the combination of the symbol of the cross with the symbolic values of centralized geometric form reflected the ideas of the time.[136] Pietro Annibale used the kind of plan for the church of the Ascension that would have been used by many Italian architects in the early sixteenth century for such an "ideal" or "ideologized" building. And it was just as normal to put an open gallery around the interior.

Two innovatory features distinguish the church at Kolomenskoye from Italian churches with plans in the form of a Greek cross. First, the tent-shaped, pyramidal roof taking the place of a dome. And secondly and less prominently, the monumental throne on the east gallery, behind and with its back turned towards the altar (pl. 117). The origin and meaning of the tent-shaped roof and throne belong to a number of intriguing mysteries in early sixteenth-century Russian architectural history. It will be worthwhile to seek to answer both these questions at the same time, in other words, to try to find a link between the design of this completely new kind of roof and the highly unusual positioning of a throne facing away from the altar.

The dedication of the church to the Ascension of Christ will help to solve the mystery. The pyramidal tent form is reminiscent of the ciborium or canopy above a reliquary or altar familiar to Russians for several centuries. Artistic representations of pyramidal ciboria are found in Rus' as early as the eleventh century, and the form was used up to the sixteenth century. Two decades after the completion of the church at Kolomenskoye, a prayer throne with a similar canopy was made for Ivan the Terrible, the "Tsar's seat" in the cathedral of the Dormition in the Kremlin.[137] The aspiration of Vasily III and his Greek-Muscovite court to effect a symbolic transfer of the sacred centre of Orthodoxy from Constantinople to Rus' looks like being of central significance here, and the Hagia Sophia could have served as a symbolic model. There had always been a tradition in Rus' of dedicating leading cathedrals to St Sophia, but it had never involved concrete architectural allu-

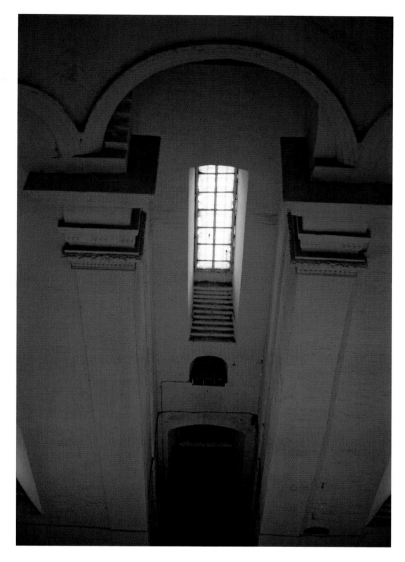

114 Pylons in the church of the Ascension, Kolomenskoye (Pietro Annibale/Little Petrok), 1532.

sions to Hagia Sophia, perhaps because of the extreme technological difficulty and therefore unthinkability of reproducing the huge, complex structure and features of the renowned building. To the sixteenth century, however, with its acute desire for models, a concrete, reproducible image was essential.

In this connection, there is a remarkable coincidence between the design of the church at Kolomenskoye and the huge ciborium above the altar in Hagia Sophia. A detailed description of this feature by St Hermann of Constantinople, dating from the eighth century, has long been familiar in Russia from Simeon Solunsky's early fifteenth-century text: "[. . .] the ciborium," according to St Hermann, " [symbolic] site of the Crucifixion, takes the place of the spot on which Christ was crucified [. . .] it also represents God's promises in the Old Testament." St[138] Hermann's description of the ciborium runs:

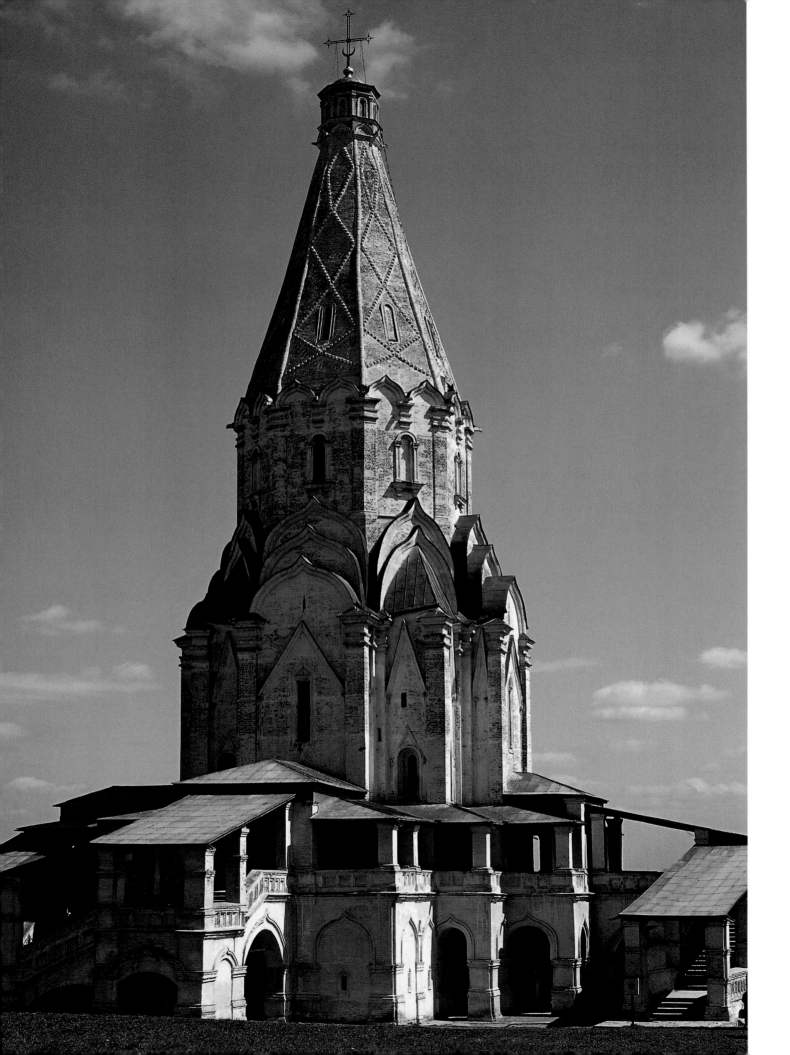

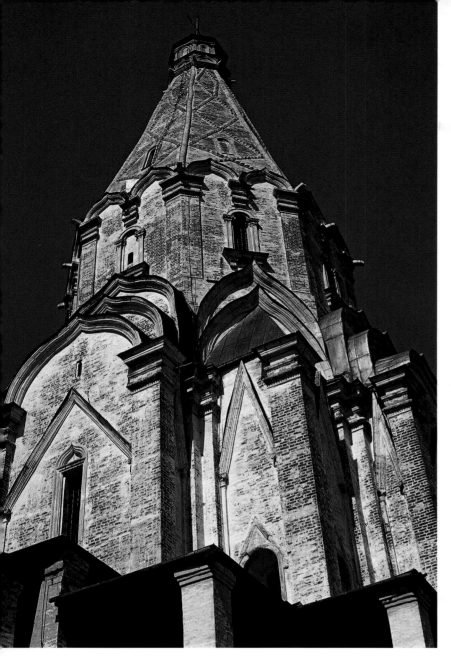

116 Tent roof of the church of the Ascension, Kolomenskoye (Pietro Annibale/Little Petrok), 1532, as a ciborium.

117 The throne in the gallery of the church of the Ascension, Kolomenskoye (Pietro Annibale/Little Petrok), 1532, in readiness for the Second Coming of Christ.

[. . .] above the altar, an immeasurably tall tower rises into the vast aerial expanse, supported on four sides by silver arches [. . .] The structure above the arches resembles a cone in form, but not completely so, for its base is not truly spherical in outline, but rather octagonal, and as the structure rises [. . .] displaying long facets [. . .] it gradually narrows until it ends in a sharp point [. . .]. These facets, in the shape of long thin triangles, finally join together in a single point, upon which a chalice is depicted [. . .]. Just above the arches, a decorative band of pointed volutes frames the lowest level of the base of the cone.[139]

It would be hard to imagine a more precise description of the innovatory pyramidal roof of the church of the Ascension at Kolomenskoye.

At Kolomenskoye the huge ciborium was built over the whole church to glorify its dedication to Christ's Ascension and form an architectural image of this central Christian event (pl. 116). It is important that Christ's Ascension is directly linked to his Second Coming; the very moment of the Ascension marks the beginning of the expectation of God's return to Earth. The Second Coming, however, is to be prepared for by the triumph of the Christian Kingdom on Earth.

115 (facing page) View from the south-west of the church of the Ascension, Kolomenskoye (Pietro Annibale/Little Petrok), 1532.

118 Capital of a pylon on the façade of the church of the Ascension, Kolomenskoye (Pietro Annibale/Little Petrok), 1532.

119 Arcade in the lower part of the gallery of the church of the Ascension, Kolomenskoye (Pietro Annibale/Little Petrok), 1532.

Early sixteenth-century Russian theologians called this latter "kingdom awaiting the end of time", in the concept already described, the "Third Rome", and identified it with the Muscovite State. In this context, the positioning of the throne with its back to the altar and away from the "ciborium" which has become the roof of the church becomes clearer.

The roof-ciborium glorifies an event that has already passed, Christ's Ascension. The throne is a symbolic one awaiting the Second Coming. Its placing east of the altar, behind it, would appear to transfer it symbolically to the future, to the "new world" that will come about following the Second Coming. The combination of, on the one hand, the glorification of Christ's Ascension and its symbolic representation in the form

of a "ciborium" above the shape of a Greek cross, and on the other, an expression of eschatological expectations in the form of a throne awaiting Christ's return to Earth, indicates that the church at Kolomenskoye embodies the establishment of the mystic centre of the Orthodox Kingdom on the soil of Rus'. This church is an architectural symbol which will exist "until the end of time", throughout the era of the Third Rome – after which, in the opinion of the sixteenth-century monk Philotheus, "there will be no Fourth".

Thus Pietro Annibale would seem to have combined the architectural ideas exemplified by the central-plan Italian churches of the early sixteenth century with the eschatological programme of Vasily III's court. The latter expressed both the

120 (*facing page*) Capitals of the lower pylons of the interior gallery of the church of the Ascension, Kolomenskoye (Pietro Annibale/Little Petrok), 1532.

shock at the fall of Constantinople to the infidel experienced by the "last Byzantines", the court and family of Vasily III, and Moscow's reaction to this event – the desire for the transfer of the symbolic centre of the Orthodox world to Rus'. Political aspirations too, typical of fifteenth- and sixteenth-century Rus', colour the ecclesiastical symbolism. The emerging centralized State, the Muscovite Empire, needed concrete expression of its ideology which would assert its ruler's legitimacy and God-sanctioned authority. The essential need was for a visible new image of this authority, an image of persuasive grandeur.

A new image of the power of the Muscovite ruling princes, placing them on a level with the rulers of Byzantium, had already been displayed by the innovatory styles of the walls and towers of the Kremlin, its principal palace and most important cathedrals. The symbolism of the church of the Ascension at Kolomenskoye, setting out to interpret the nature of the new state and to communicate its ideal, marks a further step in the development of the architectural ideology of the Russian state. The architecture of the church at Kolomenskoye, expressing the new ideology of the Third Rome, contributes to the debate on the ideal state.

The innovations of this period, when masters from Renaissance Italy were working in Moscow, were to provide the foundations for all further architectural evolution in Russia up to the end of the seventeenth century. Alongside these innovations, a purely Russian, very distinctive type of architectural ideology evolved, expressed in forms associated with the Italian Renaissance and at the same time boldly including both references to early buildings in Rus' and forms born of memories of Byzantium. A kind of architectural thinking now arose in Rus' which might be defined as that of an "eschatological renaissance" or "renaissance of the last empire, to last until the end of time". It is important to note that despite their religious application, these ideas belonged essentially to the state. They built up an architectural symbolism that glorified the power of the ruling prince in a context of *symphonium* with the life of the church, and this pervades princely buildings of the sixteenth and seventeenth centuries. Of course, motifs introduced by Italian masters at the beginning of the Renaissance underwent substantial change in Rus' during this period; all the same, they recognizably survived up to the age of Peter the Great (pls 118–21).

A simpler use of Italian forms is shown by the small church of St George "under bells" at Kolomenskoye (pl. 122), a graceful two-storey rotunda with serene, Classical ornamentation. If this building were half its present height, we should see before us the small round Italian Renaissance church type in its ideal form. However, the urge to build upwards which became per-

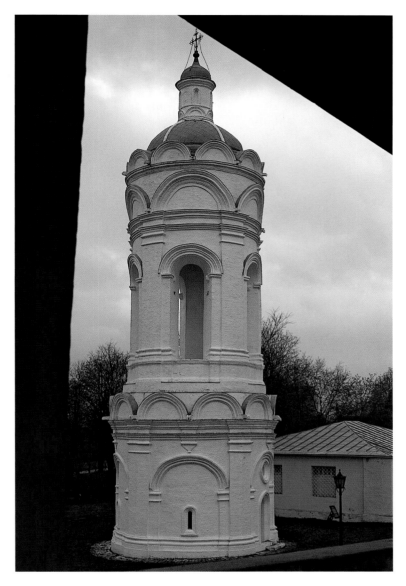

122 Church of St George "under bells", Kolomenskoye, first third of sixteenth century.

vasive in Moscow in the 1530s gave the church quite a different shape, one of unexpectedly Gothic verticality.

The church of the Ascension at Kolomenskoye is a prime example of the secular power's predilection for an architectural system using elements of assorted origins. This new Russian architectural style, based on a combination of principles brought to Rus' by Italian masters and late medieval aspiration towards heightened expressiveness, verticality and the boldly ornamental, is the last significant architectural development of the final period of Italian activity in Russia at the end of the reign of Grand Prince Vasily III. After the flight of Pietro Annibale, creator of the church at Kolomenskoye, to Livonia in 1539, Italian architects were long absent from Moscow.

121 (*facing page*) Detail of the base of the tent roof of the church of the Ascension, Kolomenskoye (Pietro Annibale/Little Petrok), 1532.

III

Post-Byzantine "Mannerism" in the Muscovite State

1 Post-Byzantine "Mannerism"? The Stylistic Features of Sixteenth- and Seventeenth-century Russian Architecture

The chronological framework of this chapter is determined by major historical events linked to the emergence of a new self-image on the part of the ruler of Russia. The opening date is 1547, when Ivan IV was crowned, no longer grand prince of Muscovy, but tsar. Earlier Russian rulers had used this title mainly with reference to the Byzantine emperors and the Tatar khans, and fifteenth-century grand princes of Moscow had only occasionally used it of themselves. Its adoption by Russia's ruler now signified national unity and autocracy. The period ends with the year 1689, which saw the de facto coming to power of Peter the Great and the beginnings of the formation of the Russian Empire and of reforms in practically all domains of state. It was a period marked by many dramatic events and far-reaching changes.

It began with the long, cruel, contradictory reign of Ivan IV, known as Ivan the Terrible (1533–84), founder of Russian autocracy. Russian hegemony expanded rapidly eastwards. The conquest of the Tatar khanates of Kazan' and Astrakhan' in the 1550s secured control of the whole of the Volga region as far as the Caspian Sea, and at the end of Ivan's reign the colonization of Siberia began. The end of the reign of Ivan's son, the feeble-minded and childless Fyodor (1584–98), brought the end of the Muscovite dynasty. The Russian Church won new status as a result of the establishment of the Moscow patriarchate in 1589 and its recognition by the existing patriarchates of the Orthodox Church. Brief attempts by Fyodor's wife's brother Boris Godunov and by Prince Vasily Shuysky to found a new dynasty were unsuccessful.

The "Time of Troubles" (1605–13) is usually taken as dividing the history of the Muscovite State into two halves, and during this interregnum the evolution of the Russian state was indeed interrupted by a series of dramatic events. Not one but a number of False Dmitrys successively appeared, each claiming to be Ivan the Terrible's son and to have escaped the would-be assassins hired by Boris Godunov. After the offer of the Russian throne to the fifteen-year-old Prince Wladyslaw, son of King Sigismund III of Poland, the intervention of Swedish and Polish forces and the latter's capture of Moscow brought the breakdown of the Russian state and the devastation of much of the country.

After the liberation of Moscow by provincial militia led by Prince Dmitry Pozharsky and Kuzma Minin, Mikhail Romanov was crowned tsar in 1613, and the restoration of the Russian state began. Under the second Romanov, Alexis Mikhaylovich (1645–76), westward expansion took place, including the annexation of the eastern Ukraine, Kiev and eastern Belorussia. Despite all the economic difficulties experienced by Russia during this period, under Alexis Mikhaylovich the eastward expansion of Russia reached as far as the River Amur, and clashes with China took place, ending in the division of spheres of influence in the Far East.

The five-year reign of Alexis's elder son by his first marriage, the sickly Fyodor Alekseyevich (1676–82), was followed by a long power struggle, in which the faction supporting Alexis's only son by his second marriage, Peter, eventually prevailed. In April 1682 Peter was proclaimed tsar at the age of ten, with his able and strong-willed half-sister Sofya as regent. His acknowledgement as effective ruler of Russia in 1689 marks the beginning of a new epoch.

A rehearsal of only the chief events of this hundred-and-fifty-year period indicates the richness and dynamism of the history of the Muscovite State. The fact that the Time of Troubles comes between the end of one dynasty and the foundation of another makes it tempting to consider the second half of the sixteenth century and the first three-quarters of the seventeenth as quite separate periods, and this is the view commonly taken, especially by Russian art historians. The fore-

123 (facing page) Detail of flanking towers of the cathedral of St Basil the Blessed, Moscow (?Barma), 1555–61.

shortened perspective of the present investigation, however, in which Russian architectural evolution is considered in the relative context of Byzantine, Western European and Russian traditions, presents the Muscovite period as an integral whole. Despite the rapidity of their evolution, Russian art and architecture of this time maintain the balance between the traditions created by the Moscow "Paleologue renaissance".

Along with a unified and centralized Muscovite State, a whole national architectural school arose. Local centres, such as Yaroslavl' from the middle of the seventeenth century, acquired various degrees of importance, but the overall logic of evolution, the basic line of development, was common to the whole of Russian architecture.

The most important aspect of Russian architecture during the period of the Muscovite State is its post-Byzantine character. The fall of the Byzantine Empire not only disrupted architectural contacts with Constantinople, but led to a wholesale reappraisal of the Byzantine heritage. The horror of witnessing the destruction of the great, thousand-year Orthodox power gave rise to the idea, in Russian minds, of Byzantine "sinfulness", for which the Byzantines had been punished by Providence. This notion dating from the fifteenth century has had a long life in Russian cultural history. Nevertheless, church-building remained the most vital concern of Russian architecture throughout the sixteenth and seventeenth centuries, and Byzantine Orthodox features, especially Byzantine forms of treatment of liturgical space, retained their prominence.

From the mid-sixteenth century, however, until the second half of the seventeenth, Jerusalem replaced Constantinople in the minds of Russian rulers and higher clergy as the centre of the Orthodox world. In the ideology of this time, Moscow stood not only for the Third Rome but also for the New Jerusalem. But the church of the Holy Sepulchre in Jerusalem remained the most sacred of shrines, unique in that it was permitted to be represented symbolically in architecture only in exceptional circumstances, such as occurred in Moscow in the reign of Boris Godunov, when it was proposed to build a "Holy of Holies" in the Kremlin, and later in the time of Alexis Mikhaylovich and Patriarch Nikon, when the New Jerusalem Monastery was built outside Moscow. It is possible that the onion form of church dome, which became widespread at this time, originally bore symbolic reference to Jerusalem. Of the many theories of the origin of this form, the one most likely to be true is that at the turn of the sixteenth and seventeenth centuries Russians associated it with the church of the Holy Sepulchre, either with the cupola of that church or with the canopy above the spot where the body of Jesus is said to have been laid. Its meaning was subsequently lost, and it became the typical form of Russian church dome.

Another major characteristic of Russian architectural history during the period of the Muscovite State, in the present writer's opinion, was that it included contradictory processes. The end of the medieval Moscow tradition was simultaneous with new architectural developments founded on the attainments of the Moscow Paleologue Renaissance. The contributions of the Italian Renaissance masters were not only not forgotten, but took on representative significance at this time.

The architectural ideal of the period of the Muscovite State was largely embodied in those buildings directly associated with the power of its rulers – the Moscow Kremlin with its fortifications, the cathedral of the Dormition used for coronations, the royal burial-place in the cathedral of the Archangel Michael, the fifteenth-century grand-princely palace with its sumptuous chambers, the cathedral of the Annunciation. The forms of these buildings and their characteristic ornamental and decorative elements came to symbolize the power of true Orthodox tsardom. These seminal buildings raised in the Moscow Kremlin at the end of the fifteenth and beginning of the sixteenth centuries, as described in the previous chapter, were the work of masters invited to the country from various Italian Renaissance cities. For Russians who lived several generations later, the Italian origins of their architectural forms would seem to have been entirely insignificant; these buildings had become "their own", and more than that, were intimately associated with the idea of nationhood expressed in tsardom.

Objectively speaking, the pilasters of the cathedral of the Archangel and the carving of the portals of the Annunciation remained clearly Western and Renaissance in style, but later generations forgot who had built them. As a result, new waves of "Italianisms" were seen in Russian architecture throughout the sixteenth century and frequently in the seventeenth. Any use of motifs from the Kremlin as symbols of tsardom brought to new buildings ornamental and decorative elements first used by the Renaissance masters employed by Ivan III and Vasily III. The innovations introduced into Russian architecture by the Italian masters continued to influence changes in both typology and architectural forms of buildings raised in the Muscovite State. The church of the Ascension in Kolomenskoye was followed by numerous, often very bold new spatial compositions, free from any connection with Byzantine or Early Russian prototypes. Foremost among these were the tent-roof churches built from the middle of the sixteenth century onwards.

For most of the sixteenth century direct contacts with Western architects were much less intensive than at its beginning or at the end of the preceding century. It has only recently been discovered that a group of English masters sent to Ivan the Terrible by Elizabeth I worked in Moscow between 1567 and 1571, though the style of their work is unknown. In the

next century, following the Time of Troubles, Moscow developed close relations with Scotland and then with the Netherlands, and master craftsmen and engravings connected with northern Mannerism appeared in the Russian capital. At the same time Baroque influences reached Russia from the territories of the Kingdom of Poland and from the recently annexed parts of the Ukraine and Belorussia. All these contacts, both in the second half of the sixteenth and in the seventeeth centuries, were with countries which had already been exposed to the impact of the Italian Renaissance, and they introduced typical Mannerist and Baroque motifs to Russian architecture, thus strengthening its post-Renaissance character.

It is important, and the point must be stressed once more, to abandon any ideas of a belated and prolonged Renaissance in Russian architecture lasting continuously from the period of Ivan III almost into the reign of Catherine the Great. Renaissance elements entered Moscow architecture during the Italian Renaissance itself, and were absorbed and transformed during the second half of the sixteenth century and most of the seventeenth. Moreover, the artistic logic and basic principles of the architecture of the State of Moscow at this time also display features associated with Mannerism and Baroque. The whole period was one of complex synthesis, in which late medieval elements combined in Moscow architecture with reinterpretation of Classical motifs arriving from the West.

Russian architecture of this period by and large saw an absorption and forging of the most diverse components into a unified, essentially ornamental and decorative style. Among these components were the following: traditional elements of early Moscow architecture having their origins in the Byzantine heritage and the medieval schools of Rus'; the innovations of Italian Renaissance masters working in Moscow in the late fifteenth and early sixteenth centuries and the forms that emerged as a result of the subsequent interpretation of these innovations by several generations of Russian architects; Northern Mannerist motifs that spread through the influence of German and Dutch engravers and the work of Scottish masters active in Russia; and finally, compositions and detail executed by Belorussian and Ukrainian masters interpreting the Polish manner. It is also possible that during the period of the Muscovite State, Moscow architecture was influenced by the decorative arts of the East; concrete evidence of this, however, has not so far come to light. At any rate, motifs in Moscow architecture of the period clearly draw on a combination of late medieval, Renaissance, Mannerist and Baroque elements.

The architectural programme for such a combination was often rich in content, and certainly in the case of the most important buildings, such as the cathedral of St Vasily the Blessed (St Basil's) or the Terem (or Belvedere) Palace in the Kremlin. Indeed, the "literary" content of major buildings had already become extremely complex by the time of Ivan the Terrible, with an accumulation of themes, allegories and whole narratives such as will be examined in the particular case of St Basil's Cathedral. A spiritual depth is clearly felt in the buildings of the reign of Boris Godunov and in those raised by the first three Romanovs and the Patriarch Nikon, different though the political and religious ideas here expressed by architectural means may be.

A characteristic shared by most buildings of the Muscovite State is an emphasis on sheer artistry, producing extreme complexity of form, seen at its unbelievable height in St Basil's. In the seventeenth century this tendency becomes dominant. At that time the concept of *uzoroch'ye* began to be applied to architecture. The term denotes decorative and ornamental abundance, with a separate overtone suggesting exquisite artistry expressive of a buoyant outlook on the world.

The role of the individual patron also became more important. In the second half of the sixteenth century and in the course of the next, a number of special architectural "manners", or fashions, emerged, each associated with a particular ideological theme or with the taste of a particular patron and having its own distinctive features. The buildings raised by Ivan the Terrible are very different from each other, as are the churches built by Boris Godunov and members of his family. Among the buildings commissioned by Mikhail Romanov, two distinct "manners" predominated. One was associated with the idea of continuity of power from the previous dynasty and repeated the building styles of the period of Tsar Fyodor Ioannovich and Boris Godunov. The other sought to glorify the new, legitimate ruling line. The buildings raised by Patriarch Nikon formed a group of their own. And in the last quarter of the seventeenth century, numerous such "manners" emerged, associated with aristocratic or especially wealthy families, the Naryshkins, the Golitsyns, the Stroganovs. The best known of these, "Naryshkin Baroque", was named after the family of the mother of Peter the Great.

The emergence of these individual manners was probably the result of the sharp decline of the Byzantine architectural ideal. From the tenth to the fifteenth century, adherence to that ideal lent Russian architecture a high degree of artistic unity. In the post-Byzantine era of Muscovy, this unity disintegrated into a multiplicity of successive or coexistent manners, which in the course of the seventeenth century gradually gave way to Baroque elements. It was not until the end of the reign of Peter the Great, however, that Baroque achieved full dominance in Russian architecture.

At the same time, a persistent search for new architectural forms took place over the second half of the sixteenth century

and the seventeenth. This concerned plans and design, size, and constructional methodology. Buildings became increasingly complex, like the cathedral of the Resurrection in the New Jerusalem monastery outside Moscow or the wooden royal palace of Tsar Alexis in Kolomenskoye. The continuous succession of architectural innovations in the Muscovite State will be traced in this chapter.

Russian architectural evolution at this time was not purposeful, uniform or constant. These characteristics, little evident in typical buildings of any given decade of the period, nevertheless seem to point towards an overall direction taken by Russian architecture in the second half of the sixteenth and the whole of the seventeenth century that is entirely comparable with Mannerism, not so much with the Italian movement as with its northern, German or French, form, in which, as in Russia, Renaissance and medieval elements were combined. Clearly, there is no question here of a coincidence of stylistic forms, only of comparability of general architectural characteristics.

Thus Russian architecture during the period of the Muscovite State may be seen as fitting the description of "post-Byzantine Mannerism". The term would seem apt to its inclination towards ornamental and decorative artistry and elaboration in comparison with the appearance of earlier buildings, to its spiritual vitality that could achieve a narrative expressiveness, and to its innovative urge, both in unusual combinations of familiar forms and in its use of foreign sources. In this Mannerist period, post-Renaissance developments coexisted with late medieval phenomena. This combination assured both the preservation of national tradition and a progressive movement – towards entry into the European architectural world.

2 St Basil's Cathedral and the Architectural Tastes of Ivan the Terrible

Ivan IV, known to history as Ivan the Terrible, succeeding his father Vasily III as a minor, was crowned tsar, on the initiative of Metropolitan Macarius, in 1547, the first Russian ruler to be so designated.[1] It was to be a few more years before he fully mastered the apparatus of autocratic power. In the eyes of his subjects he became an outstanding ruler after the subjugation of the Tatar khanates of Kazan' and Astrakhan in 1552 and 1556 respectively.

Dmitry Likhachev has written that "the significance of the absorption of the khanate of Kazan' into Russia is defined by the previous history of Kazan' [in Russian eyes the khanate was the successor state to the great Mongol empire]".[2] This event

marked what was probably the most important stage of all in the eastward expansion of the Russian state. This was noted by sixteenth-century writers, above all by the author of the monumental triumphal narrative *The History of Kazan'*, chronicling the previous greatness of the Tatar city as well as the course of the siege conducted by Ivan the Terrible. *The History of Kazan'* was itself part of a much wider and most carefully planned project – the ceremony marking Moscow's annexation of the state of Kazan'.[3] This was the project that lay behind the building of a cathedral on Red Square, Moscow, to commemorate the capture of Kazan'. And the cathedral was built, in its turn, to tell, in symbolic form, the story of the tsar's victories.[4] This in itself was a major innovation as a founding purpose for a cathedral, and determined the fantastic and unprecedented architectural forms of the building (pl. 124).

Before detailed consideration of these, some explanation of the name of the building is called for. The complex of shrines which we are today accustomed to calling the cathedral of Vasily the Blessed (sobor Vasiliya Blazhennogo), better known in English as St Basil's Cathedral, was not referred to by this name until much later. In the sixteenth century the complex was referred to variously by one or other of the names of its nine churches; one part of the whole would be singled out at a particular moment to suit the purpose of a particular document, event or occasion. At first the whole complex was called the church of the Trinity (Troitskiy tserkov'), and later the cathedral of the Intercession by the Moat (sobor Pokrova na rvu), which remains its official name today. The name of Vasily (Basil) the Blessed became attached to the cathedral as early as the seventeenth century, and a side-chapel was added in memory of the saint. This dedication of the latest of the constituent elements of the building then came to be used as the everyday name for the whole complex. Following George Hamilton and also for convenience, since it is the one most commonly used today, this is the name that will be used henceforth in the present book. It should be remembered, however, that the variety of names for this building has its significance for any understanding of its history under Ivan the Terrible and subsequently, and of its complex ideas content, rich symbolism and multi-layered historical meaning.

It must be said at the outset that St Basil's Cathedral is wholly extraordinary. It is like no earlier Russian building. Nothing similar is to be found in the entire millennium of Byzantine tradition from the fifth to the fifteenth century. Commentators over the centuries have remarked on its strangeness, a strangeness that astonishes by its unexpectedness, complexity, and dazzling interweaving of the manifold details of its design. It must have astounded contemporaries on first seeing it, but then yielded up its rich narrative content to them

124 (*facing page*) The cathedral of St Basil the Blessed, Moscow (?Barma), 1555–61.

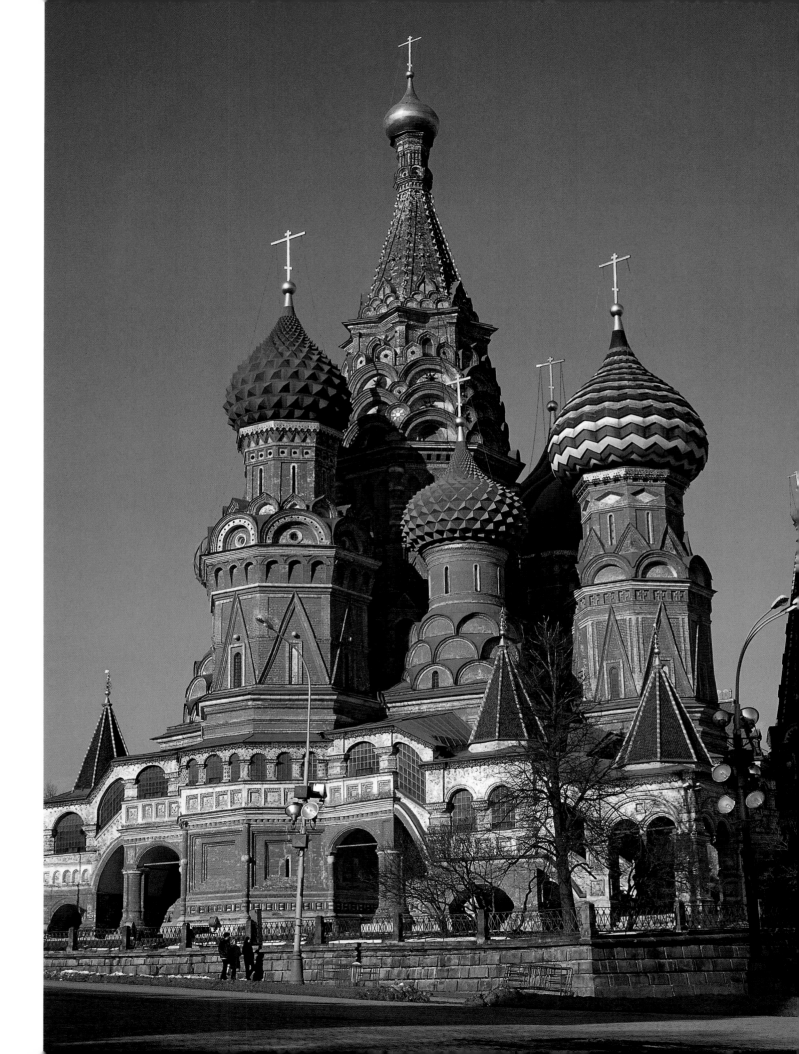

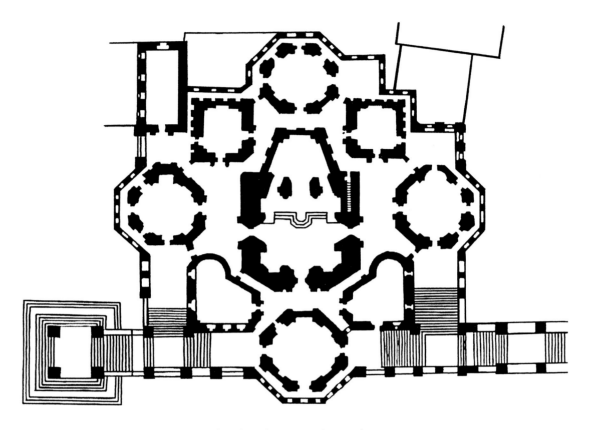

125 Plan of the cathedral of St Basil the Blessed, Moscow (?Barma), 1555–61.

– not to everyone, but in the first instance to those thoroughly familiar not only with recent political events but also with the theological aspects of the ideology of Muscovite rule. To the initiated, the cathedral revealed the tsar's ideas about his state, the meaning of his victories, and the blessing of the heavenly powers on all he did.

There has been much recent study of the ideology of this building.[5] Scholars have addressed either its commemorative meaning, connected with military history and the capture of Kazan',[6] or have considered the cathedral as, in its own way, a theological tract about the Heavenly City of Jerusalem; some have even seen it as a representation of the sacred buildings of the real, earthly Jerusalem.[7] It has been generally emphasized that the cathedral was intended to convey the image of a whole city.[8]

Whilst the importance of the ideology of this outstanding building is not open to doubt, analysis of the subject preceding the creation of its architectural forms means that the latter are considered in a preconceived way. In other words, it hardly seems worthwhile to study the architecture of the cathedral from the vantage point of a previously formulated ideological conception. It might be more profitable to try another approach – to forget, for the moment, about the complex content of St Basil's and to try to read what the architectural forms themselves, as used by the builders of the cathedral, might be saying.

I shall begin with the plan and the overall spatial composition. The plan that had been typical of Russian churches for centuries was here completely abandoned. As first built in the sixteenth century, the structure consisted of nine separate churches. The scheme is extremely precise and regular, not to say rationalist.[9] Around the extensive, high central space, at the cardinal points, four octagonal towers are placed, the straight lines joining them forming a rhombus. Around the centre, four more churches are placed, forming an exact square, the sides of which are centrally intersected by the diagonals of the rhombus (pl. 125).

Similar geometrical schemes are found in Italian Renaissance projects of the mid-fifteenth and early sixteenth centuries, for example, Bramante's and Sangallo the Younger's designs for St Peter's, Rome. The independence of each unit of the complex of St Basil's leaps to the eye; however, the arrangement of the axes of the plan and their subordination to the whole closely resembles the scheme of the above-mentioned Italian Renaissance designs. The plan of St Basil's has often been compared by Russian scholars with Leonardo da Vinci's

126 The ideal city of Sforzinda; from Filarete's *Trattato d'architettura* (1460s).

sketch plans of churches. But the latter can scarcely have been known to the architects who worked in Moscow.

It is highly probable, on the other hand, that the Kremlin library contained a copy of Filarete's *Trattato*. The close personal link between Aristotele Fioravanti, creator of the cathedral of the Dormition in the Kremlin, and Filarete and his treatise was shown in Chapter 2. Moreover, Filarete's plans and sketches of churches for his ideal city of Sforzinda (pl. 126) and those for the church in the Ospedale Maggiore, Milan, bear a striking resemblance to the appearance of St Basil's. In all three cases, faceted towers looking like fortifications form the basis of compex compositions. One of Filarete's designs shows a high, ribbed cupola crowned with a lantern which looks very much like the tent-shaped spire crowned with a small cupola at the centre of the St Basil's complex. In both the latter and in Filarete's design, an arched gallery with an access staircase at both sides provides a link with all parts of the building. The ornate onion domes of St Basil's belong to the rebuilding of the seventeenth century, and so the building's similarity to Filarete's design was greater still in the sixteenth century. Complete certainty as to the direct influence of Filarete's drawing would be possible only on the basis of written contemporary evidence. In its absence, it may at least be said that

both the plan and the main structure of St Basil's have reference to Renaissance ideas of an ideal church, and in particular their expression in Filarete's treatise.

Many parts of the cathedral are without analogue either in Russian or in Western Christian architectural tradition. One special feature is that the churches of medium height are placed at the cardinal points. More than anything, these churches look like sumptuously decorated fortified towers. Their model is the Italian type of fortified tower dating from the turn of the fifteenth/sixteenth centuries, such as those built by Italian masters in the Moscow Kremlin (pls 127, 128).

Besides the Renaissance rationalism of its composition and the tower shape of its vertical structures, a third basic feature of St Basil's Cathedral is a rich ornamental element in *architectural* terms, which is entirely new in Moscow architecture. The Romanesque churches of Vladimir, as shown in Chapter 1, were no less ornamental, but in their case the ornament took the form of figurative motifs. Here, on the other hand, animals and human figures, sacred symbols and allegorical images are lacking. It is possible that decorative plant forms in extant exterior wall paintings were also used on the original walls of St Basil's, but they are more likely to have first appeared in the seventeenth century.

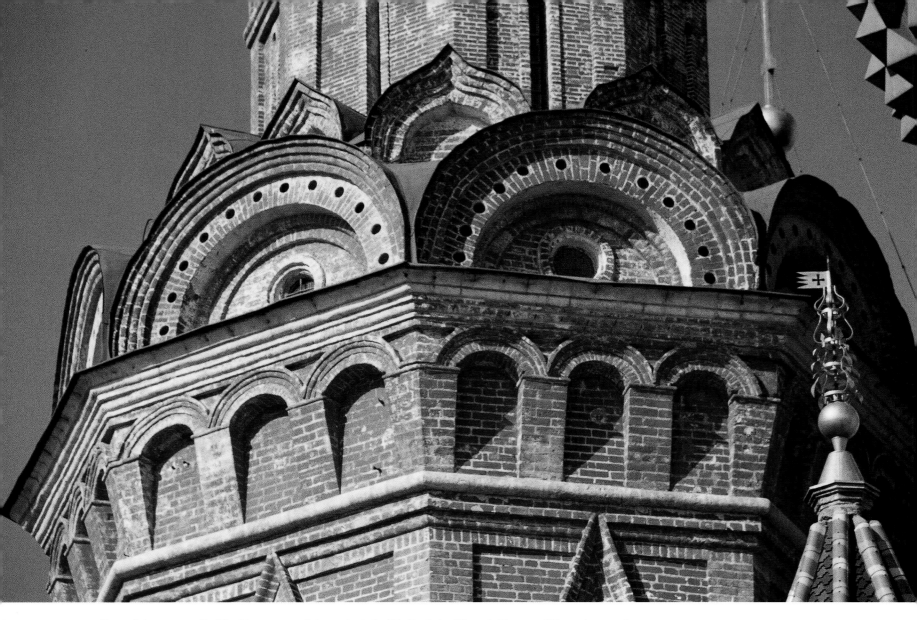

127 Base of the tent roof of flanking tower of the cathedral of St Basil the Blessed, Moscow (?Barma), 1555–61.

The ornamentation of St Basil's takes three different forms. The first of these consists of more or less Classical elements – the customary Renaissance cornices, various types of pilaster without capitals, and engaged columns, also without capitals. It is likely that all the features associated with Classical architecture were taken from the cathedrals and palaces built by Italian masters in the Kremlin, which draw, as already seen, on models of Italian fortification. However, the use of engaged columns, a favourite feature of Italian Mannerism, is surprising, and does not come from the Kremlin; it does not occur in the work of Italian masters in Russia (pls 129, 130).

The second kind of ornamentation seen in St Basil's may be termed "Gothic", and consists of ornamental brick outlines, large superimposed sharp-pointed triangles reminiscent of the Gothic *Wimperge*, canopies, seen on the exterior of the church of the Ascension in Kolomenskoye, and various forms of niches and window-heads with extended triangular apexes. These elements have recently tended to be associated with north German and Baltic brick Gothic (pl. 131).[10] The third kind of ornamentation at St Basil's is typically Muscovite, and modelled on churches built by Russian masters (pls 132, 133); it includes *kokoshniki* placed in triple rows one above the other, and similar large semi-circular structures on the central church and the side towers.

All of these elements, freely drawing, as has been seen, on Renaissance, Gothic and Muscovite tradition, make up a unified architectural scheme, a sumptuous ornamental "carpet" leaving practically no blank surfaces and covering all the exteriors of the structures that form the complex of St Basil's (pl. 134). It is important to note that in this scheme the dominant

128 (*facing page*) Arcade of the lower all-round gallery of the cathedral of St Basil the Blessed, Moscow (?Barma), 1555–61.

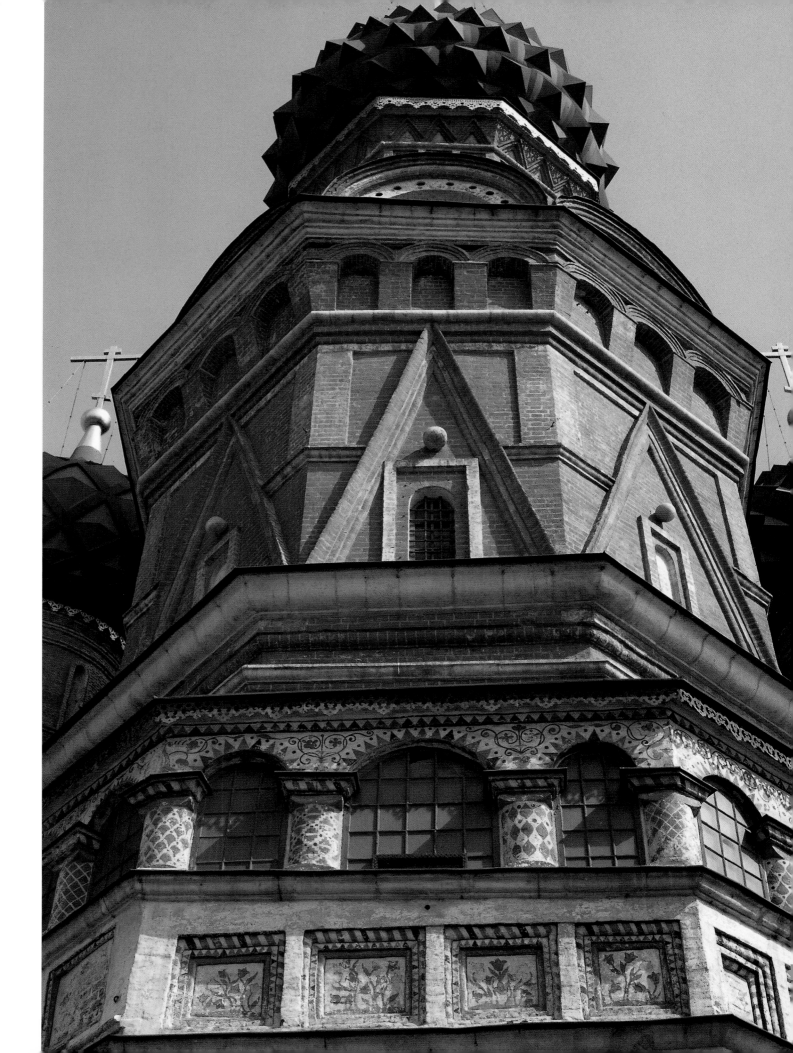

130 Detail of the ornamental frieze above the socle of the cathedral of St Basil the Blessed, Moscow (?Barma), 1555–61.

129 Detail of a column of the lower arcade of the cathedral of St Basil the Blessed, Moscow (?Barma), 1555–61.

motifs are those taken from Kremlin buildings recently raised by the father and grandfather of Ivan the Terrible. This was not the case with the church of the Ascension in Kolomenskoye, although there too, as already seen, Renaissance, Gothic and Muscovite elements were combined. Compared with that church, St Basil's Cathedral is far more complex in both its overall composition and its ornamental scheme. Gothic motifs, too, have an enhanced role, whereas hitherto Gothic has rarely been encountered in Russian architecture (pls 135–37).

The complex of St Basil's undoubtedly continues in the line of evolution of an "ideologized" architectural language which is first seen in the buildings raised by Italian masters in the

Kremlin and attains full expression in the church of the Ascension in Kolomenskoye. The elaboration of architectural forms that took place in the building of St Basil's and that expressed its ideology was certainly a highly conscious process. There are numerous written records of the architects' deliberations and the tsar's interventions. The building looks to the present author very much like the continuation of the development of a post-Byzantine, independent *architecture parlante* of Moscow tsardom, which was begun by Ivan III and Vasily III.

The first part of the reign of Ivan the Terrible proceeded largely after the examples of constructive policy set by his father and grandfather. He carried out progressive reforms with the help of Metropolitan Macarius, his confessor Silvestr, his courtier of humble origins Adashev, and a small inner circle of young courtiers known as the Select Council (*izbrannaya rada*). A new code of laws was produced and a set of rules for household management, the *Domostroy*, a kind of manual of the ideal domestic life as then envisaged in Moscow.[11] This was followed by a monumental series of manuscript collections on the achievements of the church fathers.[12] Among these pioneering intellectual ventures belongs the building of St Basil's Cathedral.

In this building, features comparable with those of northern European Mannerism emerge very clearly. Its architecture displays a Renaissance plan, compositional complexity, and an interweaving of superabundant ornamental elements from widely varying sources. The urge towards novelty, the free adaptation of forms and their appearance in unexpected places – everything about this building looks like Mannerism, hover-

131 (*facing page*) Detail of a flanking tower of the cathedral of St Basil the Blessed, Moscow (?Barma), 1555–61.

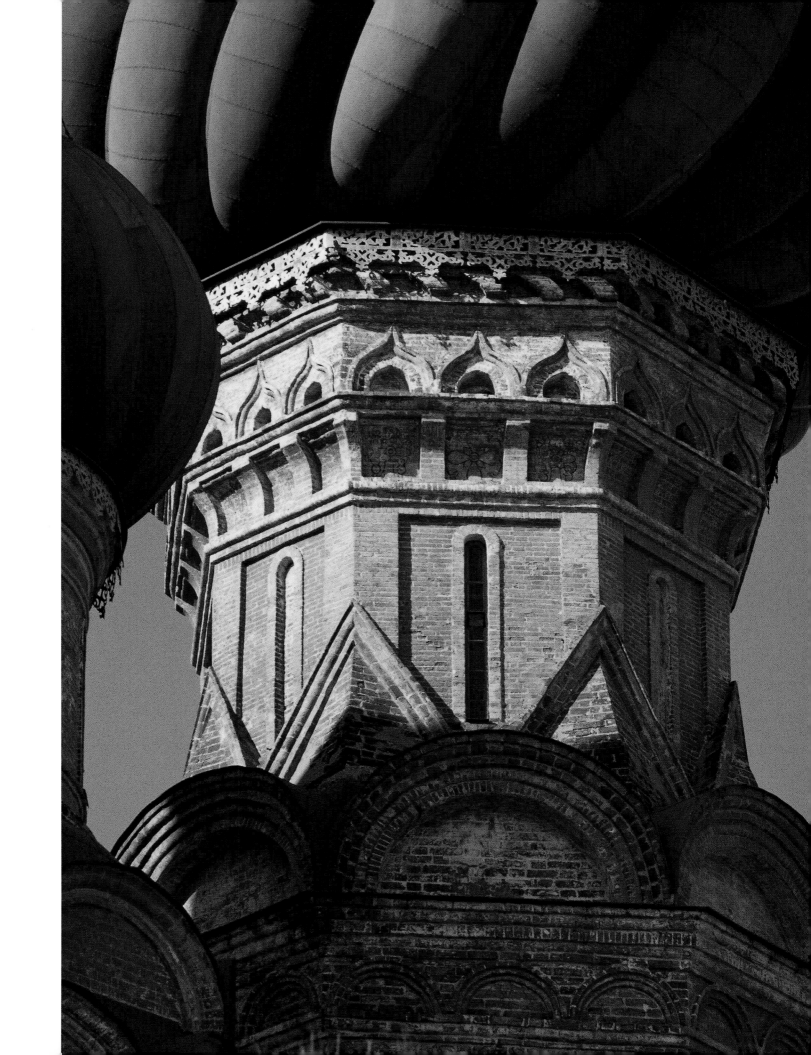

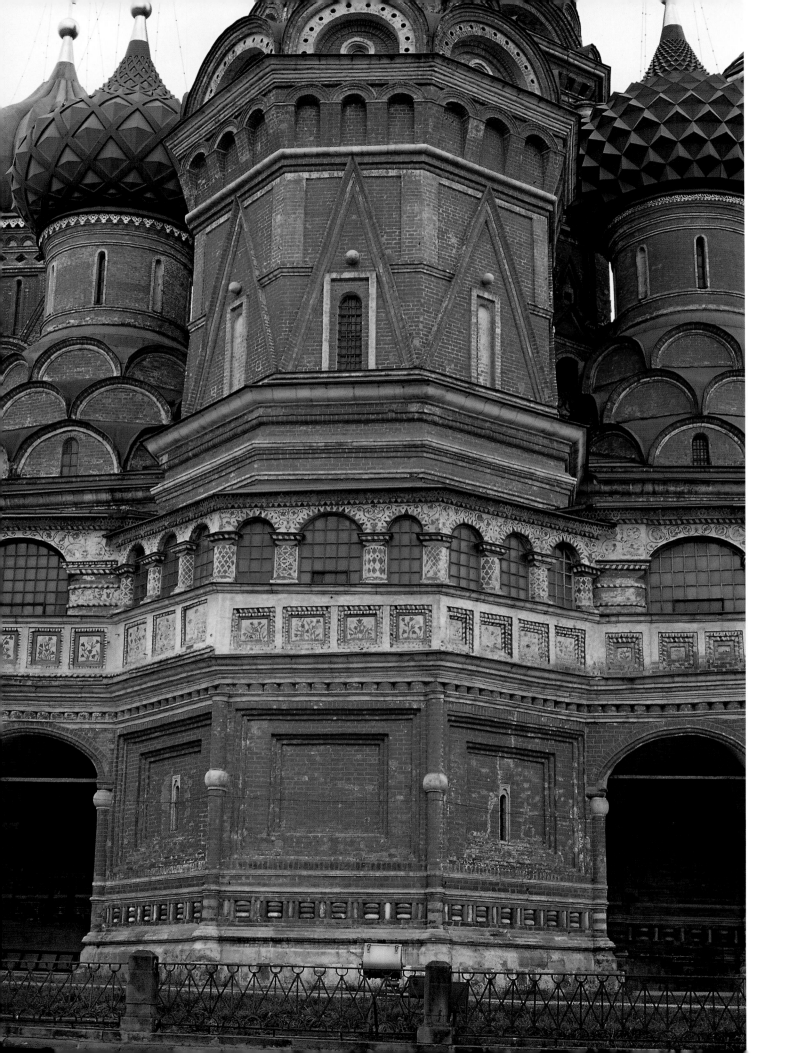

135 Interior of a flanking tower of the cathedral of St Basil the Blessed, Moscow (?Barma), 1555–61.

132 (*page 134*) Detail of the upper part of the central tent roof of the cathedral of St Basil the Blessed, Moscow (?Barma), 1555–61.

133 (*page 135*) Drum of a flanking tent roof of the cathedral of St Basil the Blessed, Moscow (?Barma), 1555–61.

134 (*facing page*) Detail of a flanking tower of the cathedral of St Basil the Blessed, Moscow (?Barma), 1555–61.

136 and 137 (*top and above*) Details of the decoration of the western entrance of the church of the Intercession of the Virgin in the cathedral of St Basil the Blessed, Moscow (?Barma), 1555–61.

ing between the late Middle Ages and the Renaissance. However, even in Italian Mannerism, a complex programme of ideas could play a significant role in a building's reception by contemporaries. St Basil's Cathedral is an especially striking example of rich symbolism and diversity of meaning in architecture. I turn now to its building history and trace the sources of its ideology.

3 The Meaning of St Basil's Cathedral

Kazan' was taken by Russian forces in October 1552. Two days after the final assault, it was formally transformed from a Muslim into a Christian city in a special religious ceremony. As a chronicle records, Kazan' was blessed "in the name of the Holy Trinity, giver of life".[13] In 1553, soon after the tsar's return to Moscow, in accordance with a vow he had made during the war, a small wooden church dedicated to the Holy Trinity was built on the site of the future cathedral of St Basil. The emphasis was at once laid on the conversion of Kazan' to Christianity and veneration of God for the victory over a people of a different faith. This church actually went unnamed for more than two years.

Then in 1555 the concept changed: " [. . .] three years ago the church of the Trinity was built, and our sovereign ordered that the church of the Intercession of the Most Holy [Mother of God] with side-chapels should be added to it."[14] The same chronicle records, in another passage: "the true believer and lover of Christ, Tsar and Grand Prince Ivan Vasilevich of all Russia [. . .] ordered the building of the church of the sacred and glorious *Intercession of the most Holy Mother of God with side-chapels on the occasion of the victory over Kazan'* [emphasis: DS]."[15] The tsar had in mind not only the conversion of the new territories to Christianity but also the special protection of the Mother of God over his whole state, a conception which, as already seen, had also been expressed in the reverence shown by the grand princes of Vadimir, beginning with Andrey Bogolyubsky, for the Miracle of the Intercession of the Mother of God.

The chronicle specifies that in the case of the easternmost of the added side-chapels, or "tower-churches" as they are usually termed, situated behind the altar of the church of the Intercession of the Mother of God, the dedication to the Holy Trinity was kept. No less importantly, the chronicle refers to all the tower-churches in the complex together as "side-chapels on the occasion of the victory over Kazan'". Three lines of thought converge from the testimony of the chronicles. The first of these is that the Intercession, or Protection, of the Mother of God for the Muscovite State, to which the whole

church is dedicated, is placed at the centre of the complex. The second is the glorification of the form of Christian faith that the Orthodox tsar is disseminating over the newly acquired territories; and therefore the tower-chapel of the Holy Trinity is put in the second most important place. Thirdly, actualities play their part in the overall architectural conception, in the shape of gratitude to God and His saints for help in the recent Russian victory over Kazan'.[16]

The northern tower-church was dedicated to Saints Cyprian and Ustin'ya, commemorated by the Orthodox Church on 2 October, the day of the taking of Kazan'. The north-western church was dedicated to St Gregory, founder of the Armenian Church, on whose commemoration day the Russians had blown up the strategically vital Arsk tower of the Kazan' fortress. Two more tower-churches were named in connection with events of the war with Kazan'. Such was the part of the cathedral's programme concerning Kazan'. But there were further levels of meaning.

One of the most important of these was the theme to which the western tower-church was dedicated, which had nothing to do with Kazan': the Festival of Christ's Entry into Jerusalem. The early Byzantine tradition of a special ceremony in commemoration of this event had been preserved in Novgorod and brought to Moscow in the 1550s. The "procession on a donkey" (pl. 138)[17] proceeded from the cathedral of the Dormition to Lobnoye Mesto (a representation of Golgotha) on Red Square and thence to the chapel of the Entry into Jerusalem in St Basil's Cathedral.[18] The tsar led by the bridle a horse ridden by the head of the Orthodox Church, representing Christ. Ears made of cloth were attached to the horse to symbolize those of a donkey, since donkeys did not exist in Russia; and for the procession to accord with the New Testament account, a donkey was absolutely necessary. This detail indicates the festival's emphasis on a literally exact depiction of one of the main events of the Christian story.

Architectural historians have applied the literalness of church ritual to the architecture of St Basil's itself, seeking to prove that the cathedral was intended to symbolize Jersusalem. Sixteenth- and seventeenth-century foreign visitors witnessing the "procession on a donkey" came to the same conclusion. One of them, Jan Streiss, wrote of St Basil's as "the Jerusalem church, which is unquestionably more beautiful than all others in Moscow. Although it is supposed to be built on the model of Solomon's Temple, I haven't seen anything its like or equal."[19] The Jerusalem theme is clearly important in the ideology of the cathedral and its rituals, but at the same time, the introduction of the "procession on a donkey" to Moscow was a further step in the sacralization of the power of the tsar and brought out the inseparability of the latter from the role of the

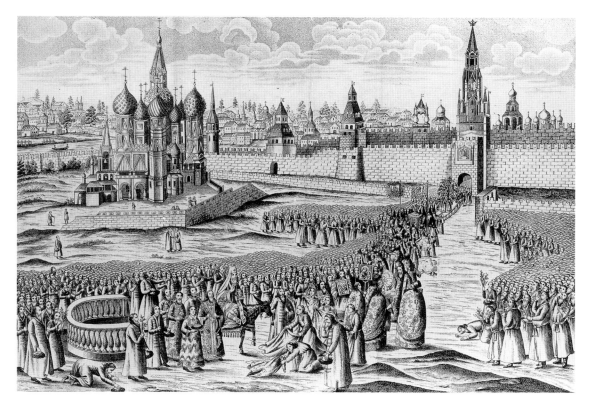

138 Red Square during a seventeenth-century commemoration of Christ's Entry into Jerusalem; engraving, 1867.

church in the state. The tsar himself led the patriarch's horse to the chapel of the Entry of Christ into Jerusalem, which emphasized both his veneration of spiritual power and his own special role in the life of the Church.

The dedications of the three churches on the east-west axis – Christ's Entry into Jerusalem, the Intercession of the Mother of God and the Holy Trinity – conveyed a powerful idea of the theocratic nature of the power of the Moscow tsardom. Christ's Entry into Jerusalem symbolized the founding of a new life for the Sacred City; Moscow was the New Jerusalem. The Intercession of the Mother of God, as already seen, was associated with the idea of the special protection of the Mother of God for the new Orthodox tsardom. And finally, the Trinity carried the meaning of the existence of this tsardom, a confirmation of the righteous Orthodox faith being spread throughout the territories of the new tsardom. The comparison of the cathedral with King Solomon's Temple was demonstrative. The tsar's power, besides, was glorified by the commemorative chapels surrounding the central church, those that had been built in veneration of God for the victory of all Russia over the infidel.

Two more tower-churches were dedicated to the recently canonized Russian saints Varlaam Khutinsky and Nikolay Velikoretsky, which emphasized the central importance of the Russian Church. These dedications may well have been the personal choices of the tsar and Metropolitan Macarius. Ivan's father Vasily III had become a monk before his death, taking the name of Varlaam. And the metropolitan so revered Nikolay Velikoretsky that he was reputed to have worn this miracle-working icon himself after its discovery.

Without doubt, the tsar himself played a leading part in the creation of this outstanding church, as did the metropolitan, whose influence on him was considerable at the time. It is emphasized in the chronicles, however, that the architects who built the cathedral managed to have their own way. Two of them are named: "God sent him [the tsar] two Russian masters by the names of Posnik and Barma."[20] There is also a reference to "Master Barma and a colleague".[21] Their origins have always been the subject of dispute, as also the question of whether the names given by the chronicler might denote one person only, Barma (?Barfolomey), nicknamed Postnik ("strict faster"), or two. No further evidence on this point has come to light.

Testimony exists, however, on the unusually active role played by the architects on this occasion in changing the structure of the building, which even led to alteration of the plan already laid down by the metropolitan. The latter had considered an eight-cell composition necessary. But the chronicler records that the masters changed the structure to nine cells, which "allowed the measurements of the foundations to be

139

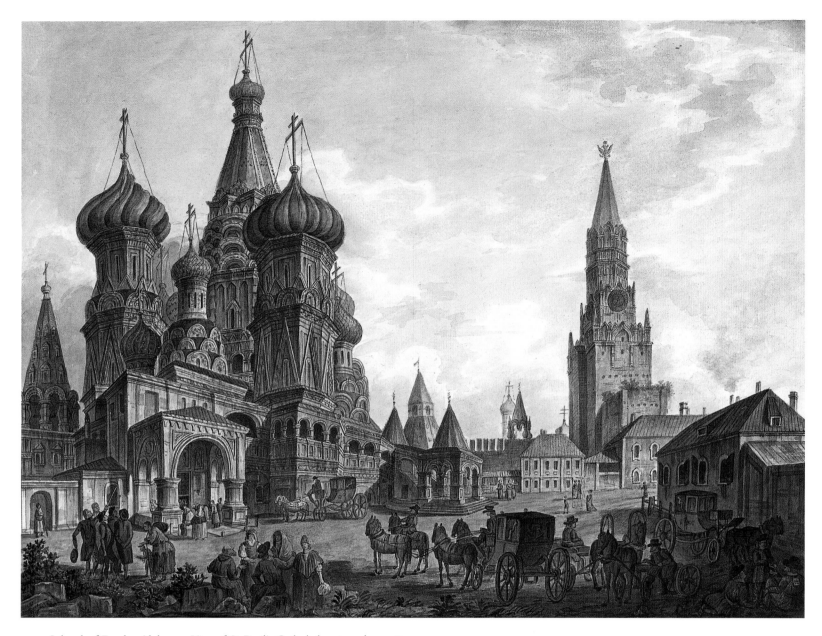

139 School of Fyodor Alekseev, *View of St Basil's Cathedral*; watercolour, 1800–02.

more rational".[22] This is extremely important evidence, show-
ing that architectural characteristics at this time could be
grounded not only in ideas but also in considerations of "mea-
surement". In the present case, what was at stake was doubtless
the harmony of the plan – the most Renaissance of all aspects
of St Basil's.

It would be hard to exaggerate the importance of the style
of this building, so unexpected in the sixteenth century.
Mikhail Ilyin recalls that one of the most talented pioneer
scholars of Early Russian art, Dmitry Aynalov, claimed to "see
in this building [. . .] the prototype of seventeenth-century
architecture".[23] The claim seems to the present writer to be

entirely correct (pl. 139). Without any direct link, the architects
of the St Basil's complex seem to foreshadow many of the fea-
tures of Russian architecture of the following century.

4 New Tower-form and Traditional Churches in the Second Half of the Sixteenth Century

Besides the buildings linked in one way or another with St
Basil's, a whole range of churches was built during the reign of
Ivan the Terrible. They define the innovative character of
Russian architecture of the period, sharing tower form, often

a tent roof, and a virtual absence of any connection with Byzantine tradition. Most of them have a more complex structure than traditional Russian churches.

A paucity of sources makes it difficult to interpret builders' aims and even to establish precise datings. Chronicle records contemporaneous with the construction of these churches, which would reliably yield such information, are lacking. The question of dating, however, is crucial, in order to ascertain whether these churches were built before or after St Basil's. The former case gives a logical progression in increasing complexity of architectural forms, beginning with the church of the Ascension in Kolomenskoye, the first tent-roof church to be built in Rus', and continuing via certain intermediary churches up to St Basil's Cathedral, which is then seen as the culmination of the evolution of this style in the sixteenth century.

If the new churches built under Ivan the Terrible postdate St Basil's, then the case is one of a specific architectural policy being formulated in the first part of the reign of Ivan the Terrible; in other words, the architectural forms of St Basil's influenced those of the new churches, and their style was not the result of an evolutionary process, but was created in Moscow in the middle of the 1550s.

For much of the twentieth century, Russian architectural historians were at pains to find proof or to develop hypotheses establishing the early origins of tent-roof churches, and this reflected a predominance of ideas about the gradual evolution of architectural forms.[24] From the 1980s onwards, however, more and more research has suggested that the new kind of building appeared in response to a call issued by the builders of St Basil's, itself the result of a conscious bid to create a new architectural language. This version of history seems the more convincing to the present writer.

The buildings in question are, first of all, churches that have long been the subject of dispute among architectural historians, those on the tsar's great estates outside Moscow: St John the Baptist (tserkov' Sv. Joanna Predtechi) at Dyakovo, the Transfiguration (tserkov' Preobrazheniya) in Ostrov, and the cathedral of SS Princes Boris and Gleb (sobor svyatykh knyazey Borisa i Gleba) in Staritsa on the Volga. The church of the Crucifixion of Christ (tserkov' Raspyatiya Khrista) in the *sloboda* (suburb) of Aleksandrov may safely be assumed to have been built by Ivan the Terrible and so also belongs in this category, as do churches on the estates of courtiers of Ivan the Terrible in the villages of Yelizarovo, Prusy and Kushalino.

The link between St Basil's Cathedral and the church of St John the Baptist in Dyakovo is visually obvious. Despite the fact that this church stands in eye contact with Kolomenskoye, it bears no resemblance to the church of the Ascension. It may rather be described as a simplified miniature copy of

140 Plan of the church of St John the Baptist, D'yakovo, 1560–70.

St Basil's, and was indeed built later than the latter. Around a central tent-roof church only four additional chapels were built (pl. 140). They too have the look of fortified towers; together they form a square-shaped plan. The ornamentation of this church, more modest than that of St Basil's, repeats some of its elements.

References to St Basil's may be seen in the Dyakovo church in the "fortified" appearance of the central structure and in certain details such as the triangular-topped *nalichniki* (ornamental window-heads) of the side-chapels (pl. 141). The building displays a striking combination of the old and the new in, for example, the juxtaposition of the narrow slit windows, like those of the early churches of north-eastern Rus', and the triangular pediments of the lower part of the façade, which show the influence of German brick Gothic (pls 141–43). Of crucial significance, in the present writer's view, is the Greek cross

141 Lower part of the west front of the church of St John the Baptist, D'yakovo, 1560–70.

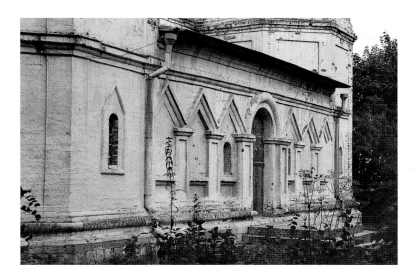

142 and 143 (*following pages*) View from south-east of the church of St John the Baptist, D'yakovo, 1560–70. and drum of the central cupola.

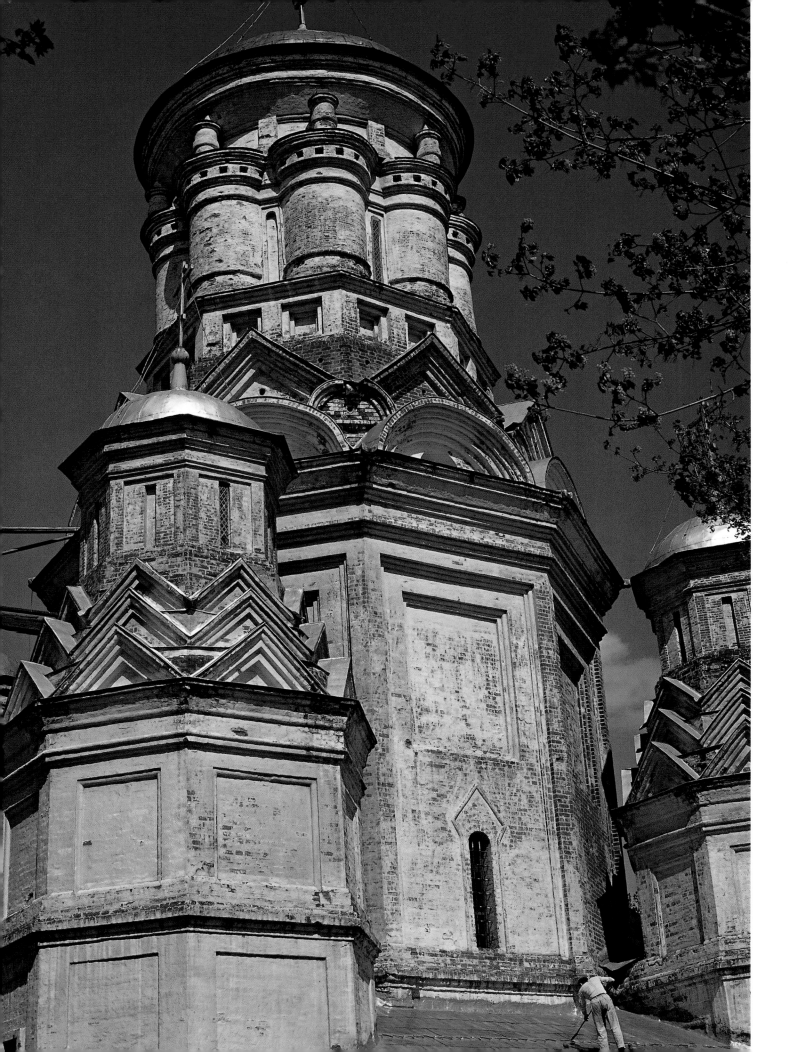

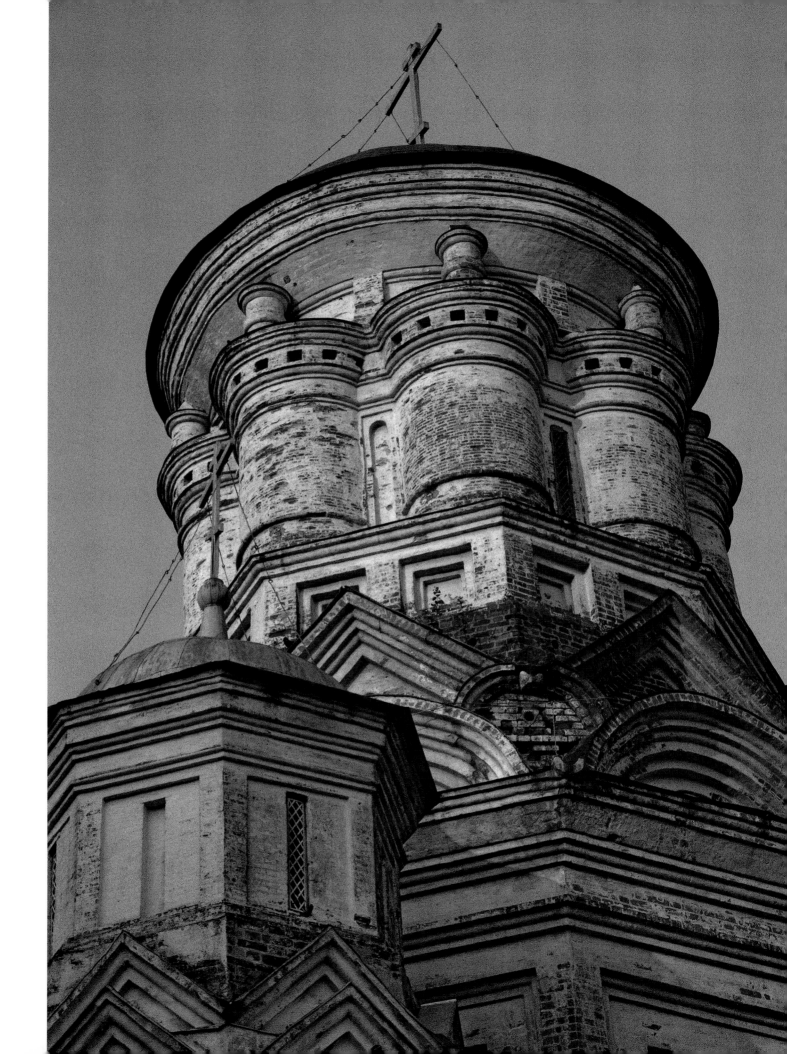

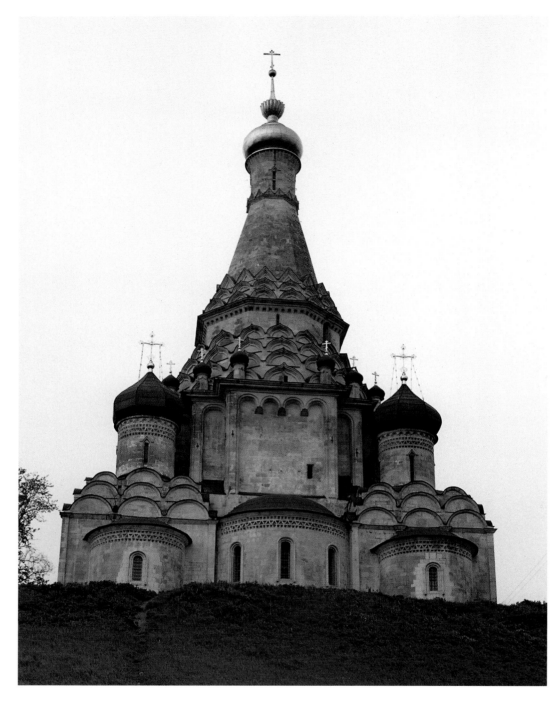

144 Church of the Transfiguration, Ostrov, near Moscow, mid-sixteenth century.

shape that the tall main church forms with the four side-chapels, reminiscent of representations of the Resurrection in the ideal church.

The cathedral of the Saviour of the Transfiguration (sobor Spasa Preobrazheniya) in the Solovetsky monastery is a special case, uniting the early simplicity of the ascetic taste of the far north with up-to-date elements like tent roofs, which take the place of cupolas on the drums.

The dating of the church of the Transfiguration in Ostrov and its placing in Russian architectural history are more difficult matters (pl. 144). The composition of this church displays a striking juxtaposition of an innovatory, fortified-looking main structure surmounted by a tent roof with side-chapels of traditional style crowned with a three-row cluster of typical Moscow *kokoshniki*. Many details in this church, the rose-window for example, suggest the collaboration of foreign crafts-

men whose identity has not come down to us. This window, however, lacks the pronounced Gothic features that might have been expected in such a typically Gothic element, and smacks of reinterpretation by a craftsman familiar with Renaissance architecture. The interior of the main church is reminiscent of that of the church of the Ascension in Kolomenskoye, and here the link with St Basil's Cathedral is less evident. Nevertheless, in this Ostrov church as a whole the interaction, not to say struggle, between the traditional and the new in the artistic languages of Moscow architecture is clearly felt.

Most of the other surviving tent-roof churches of the period are, in the customary term used by Russian architectural historians, of "tower-form" composition, their spires rising from octagonal or square bases. Ornamentation practically always combines elements originating in the Orders, Classical-looking pilasters, cornices and archivolts, with typical Moscow *kokoshniki* and extended triangles reminiscent of the *Wimperge* above the portals of Gothic cathedrals. In Russian tent-roof churches, in contrast to Western European practice, the last element often appears literally anywhere in a composition.

In general, the advent of tower-form churches marks an attempt to change the direction of Russian architecture, to inject new features into it introduced from above. However, like all Ivan the Terrible's reforms, this one was cut short after the death of his much-loved wife Anastasiya Romanova and the onset of his mental illness, when he grew pathologically suspicious, conducted mass executions, and would then be overcome by a spirit of repentance. His changing personal tastes were reflected in architecture.

Throughout this period of fits of suspicion and bloody frenzies, architecture did not cease to interest Ivan. Everything that had been done in the first part of his reign produced a negative reaction in him. In a similar process, periods of blind rage now alternated with times of profound repentance for his sins. He would compile lists of his victims so that he could pray for them; since he was unable to remember all their names, he would break off the list of those tortured and executed with the words "You know their names, O God". At such moments he would make abundant donations to monasteries with requests for prayer for the salvation of his soul. He established monastic regimes in his residences, interspersed with feasts. His generous gifts to churches and monasteries at moments of repentance produced a number of new buildings.

In 1559 work began on the imposing cathedral of the Dormition (pl. 145) in Zagorsk, and at about the same time also on the cathedral of the Smolensk Icon of the Mother of God (sobor Smolenskoy ikony Bogomateri) in the New Convent of the Virgin (Novodevichiy monastyr') in Moscow (pl. 147); both these were built at the tsar's expense, either to his

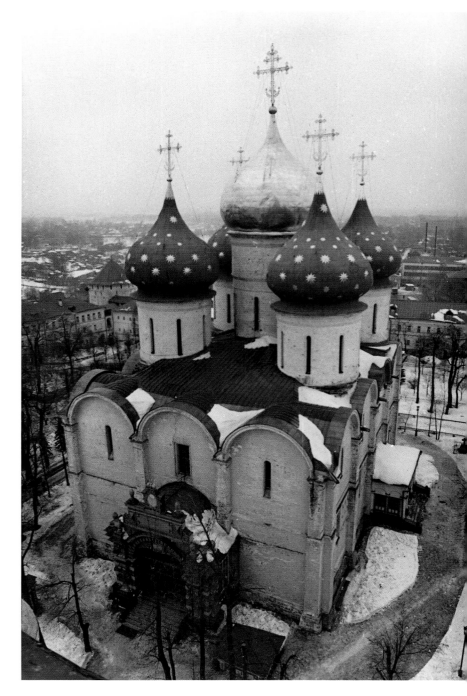

145 The cathedral of the Dormition, 1559, Monastery of the Holy Trinity and St Sergius, Sergiyev Posad.

commission or by his vow. The two cathedrals are notable for their grand scale, simplicity of forms and almost complete absence of ornament. These architectural hallmarks belonging to the second half of Ivan the Terrible's reign are in complete contrast to the abundantly ornamental style of the work of the architects of St Basil's and their circle. It may appear at first sight that this second architectural style under Ivan the Terrible

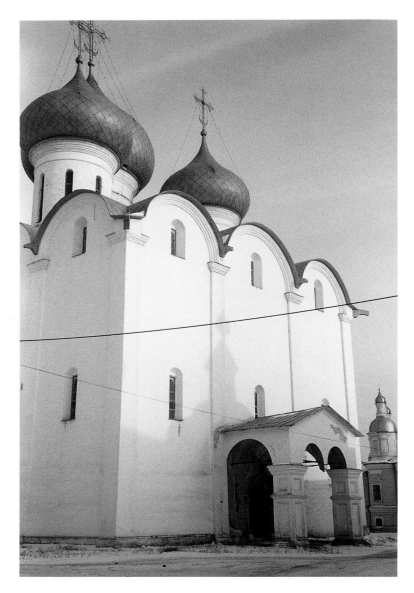

146　The cathedral of St Sophia, Vologda, second half of sixteenth century.

nation cathedral and burial-place for Russian sovereigns, that drew the Russian architects of the mid-sixteenth century to reproduce their scale and forms.

In general, Russian architecture during the reign of Ivan the Terrible was founded on the work of the Italian Renaissance masters as exemplified by the cathedrals, palaces and walls of the Moscow Kremlin built at the turn of the fifteenth and sixteenth centuries, and also by the church of the Ascension in Kolomenskoye. Two distinct "manners", however, may be distinguished in the architecture of this period, based on different branches of the Moscow Paleologue Renaissance heritage. One of these post-Byzantine styles springs from the urge to create a new architectural language based on entirely new forms which emerged in the course of a process of interpretation of Renaissance ornamental elements and a search for new architectural symbols of non-Byzantine origin. The key factor here, in the tent- or canopy-shaped church roofs, is the idea of the ciborium representing God's protection of the Russian Church and Orthodox tsardom. The second style, based on features of the selected Kremlin cathedrals, for all the seemingly traditional appearance of exteriors, is characterized by a new treatment of space and the first steps towards the use of motifs drawn from the Orders in the development of exterior ornamental detail such as cornices, *lopatki* and portals.

This duality is typical of the period, and is to be seen in the contradictory and changeable character of Ivan the Terrible himself, who could perhaps be called a "Mannerist" monarch. Such a stage was probably natural in the post-Byzantine era, with the disappearance of the authority of Constantinople and its attendant ideal. Russia was in search of a sense of identity. In the domains of art and especially architecture, this condition is apparent in the absence of the unity that had reigned in earlier times. The political situation, war with Livonia and bad relations with other Western powers made it impossible to invite foreign masters to Russia who could have introduced Western ideas. For the time being, the urge to create a general Russian style led to the emergence of different post-Byzantine "manners".

is clearly linked to early Muscovite tradition. But it is not; it was modelled on the forms of Kremlin buildings dating from the turn of the fifteenth and sixteenth centuries.

Certain cathedrals in the Kremlin served as models for these new buildings, as also for the cathedral of St Sofia in Vologda (pl. 146). Such a choice of prototypes was entirely natural for building activity by the tsar. It is revealing, however, that it was not the most traditional of the Kremlin's churches – those built by Russian masters (the cathedral of the Annunciation or the church of the Miracle of the Veil) – that were imitated by the creators of the new cathedrals of the middle of the sixteenth-century, but Fioravanti's cathedral of the Dormition and Lamberti da Montagnana's Archangel Michael. It was the primary purpose of these churches, serving respectively as coro-

5　English Architects at the Court of Ivan the Terrible

On 5 December 1564 Ivan the Terrible, taking with him his wife and children, bodyguards, some of his court, the entire state treasury and some holy relics, left Moscow for his estate in the *sloboda* of Aleksandrov, some hundred kilometres north-east of Moscow. From there he sent a document to the head of the Russian Church, Metropolitan Afanasy, accusing his subjects of treason and abdicating from the throne. The country

147 (*facing page*)　The cathedral of the Smolensk Icon of the Mother of God, (?)1524–25, New Convent of the Virgin, Moscow.

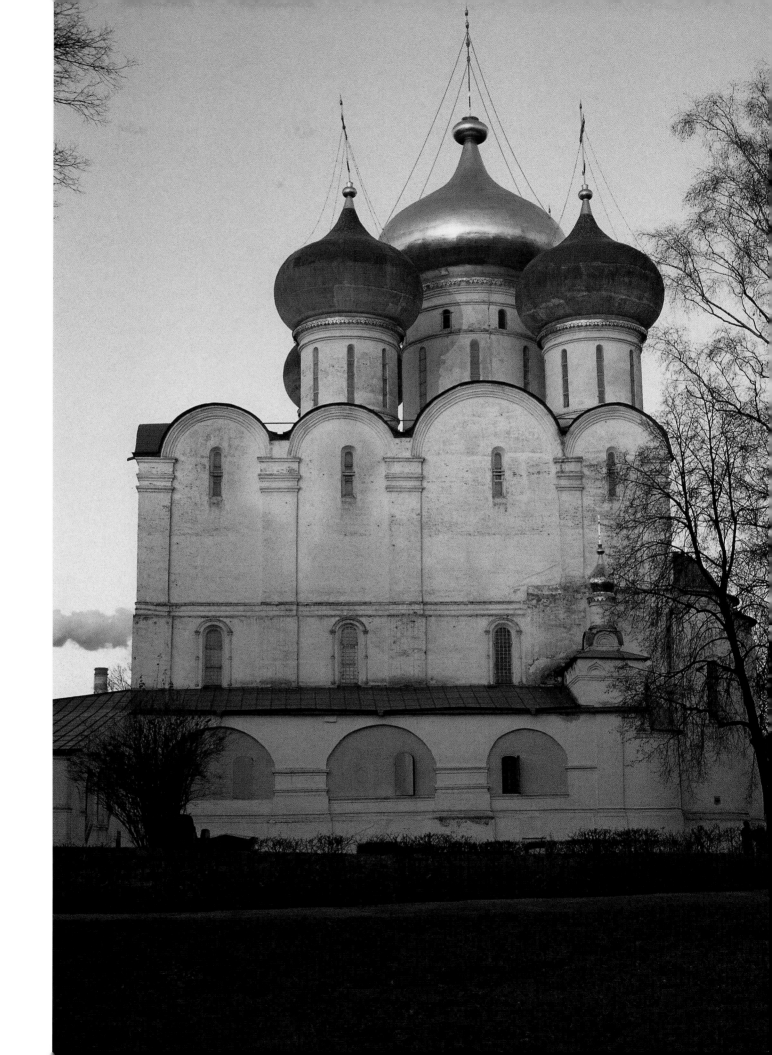

was without a ruler, money or an army. Panic seized Moscow, and Ivan took advantage of this to strengthen his power. He abolished the Church's right to seek mercy for those whom he wished to execute. He divided the country into two halves, the *Zemshchina*, the "normal" part (i.e. in his eyes the suspect and tainted part), which would be ostensibly responsible for carrying on the government and defence of the country, and the *Oprichnina*, the tsar's own part, with his own court and apparatus of government. Russia was on the eve of one of the bloodiest periods of its history.

Little is known of Ivan the Terrible's two chief residences during the Oprichnina period. Sparse written reminiscences are the only surviving record of the Oprichnina palace in Moscow, which stood behind the River Neglinka opposite the Kremlin. More is known of the palace at Aleksandrov, the tsar's main residence outside the capital, even though scarcely any of its buildings survive today. It probably consisted of wooden buildings, with a stone socle floor and cellars. The Trinity cathedral (Troitskiy sobor) most probably originates from the time of Ivan the Terrible. The unusual ornamentation of its portals, unique in Russian architecture, is in striking contrast to its entirely traditional Moscow plan and main structure. Foreign participation in the construction of buildings belonging to the Oprichnina has been considered possible. No special architectural style associated with the Oprichnina emerged, although an interesting but little-studied episode in Russian sixteenth-century architectural history appears to have been connected with an attempt to create one – Ivan's invitation to English master craftsmen to enter his service.

Foreign participation in building activity in sixteenth-century Russia is largely a matter of Italian masters working in the first four decades. As already seen, the last Italian known from documentary evidence to have worked in Moscow is Little Petrok (Pietro Annibale). His flight from Russia in 1539 sets a closing date for the activities of foreign masters in the country for some time to come.[25] A further factor influencing events during Ivan the Terrible's reign was the virtual cessation of diplomatic relations between Italy and Russia.[26] The new chapter in the story of the activities of foreign architects in Russia is usually taken as beginning with the arrival of Scottish masters in the reign of the first Romanov, Mikhail Fyodorovich, in the 1620s. Conclusions that have been drawn about Western European and especially German influence on Oprichnina architecture under Ivan the Terrible can be no more than speculative in the absence of documentary evidence.

There is record, however, of an unsuccessful mission by Hans Schlitte, sent to Lübeck in 1547 by Ivan the Terrible to hire building craftsmen.[27] Those he did find were prevented from entering Russia by the rulers of the Baltic countries, and Schlitte himself was arrested in Reval (now Tallinn). It looked as if this had put a stop to Ivan's attempts to attract craftsmen from any European country to work in Russia.

But there is evidence to the contrary. The will of one Thomas Chaffin, dated 10 November 1567, was discovered in London by John Harvey while he was working on his *Dictionary of English Medieval Architects* (1987). It stated that Chaffin "was appointed by the Power and Authority of our Sovereign, Her Royal Majesty, and by Her Command and in Her Name was sent to serve at the Court of the Emperor of Russia in the art and science of Stone-masonry, in which he had been trained since his childhood".[28] Little is known of Thomas Chaffin. He was born in 1520, and is mentioned as a Freemason in documents dating from November 1557. It is likely that he belonged to the family of the mason Robert Chaffin. Like his father, he was apprenticed with a mason named Stephan between, as Harvey estimates, 1535 and 1550. By his will of 1557 Stephan bequeathed Thomas Chaffin land and a stone quarry.[29]

While this book was being written, the name of another master craftsman who left London to serve Ivan the Terrible in the reign of Elizabeth I came to light. This was Humfry (or Humphrey) Lock, previously known as a traveller and merchant. In a letter to Lord Cecil he writes that he "doesn't expect to return to his home country [. . .] if the Emperor continues his building programme".[30] Lock was probably a fortifications specialist; in 1559 he was appointed surveyor and chief carpenter for the construction of the fortress at Sheerness.[31] He arrived in Moscow no later than 1567; it is not known how long he was in Russia, but surviving letters testify that he was in the service of Ivan the Terrible until 1571–72 or even later,[32] when at least 25 Englishmen perished in a fire in the course of a raid on Moscow by the Crimean khan. It is now certain that the appearance of Thomas Chaffin in Moscow was not fortuitous, but part of a building programme involving a whole group of English master craftsmen.

A period of close commercial and diplomatic relations between Muscovite Russia and England began in 1553 after Richard Chancellor's ship *Edward Bonaventure*, taking part in Sir Hugh Willoughby's ill-fated expedition in search of a new northern trade route by sea to China, reached the mouth of the Dvina, from where he went on to Moscow.[33] In February 1554 Ivan the Terrible wrote his first message to King Edward VI; the following year Chancellor brought the tsar a reply message from Philip of Spain (the future Philip II) and Queen Mary, and the Muscovy Company began its activities in Russia.[34] In July 1556 Ivan's first envoy to England, Osip Nepeya, set sail with Chancellor in the *Edward Bonaventure*. There is no record

of the contents of the message he bore, but it evidently contained the tsar's first request for craftsmen to be sent to his court from England. King Edward's reply to the tsar read:

We have received the letter [. . .] delivered to us by Osip Nepeya [. . .] and we have readily met all your expectations and requests [. . .]. It is our gracious pleasure to permit merchants and craftsmen from our realm to go to cities and settlements in your country, should any desire to do so.[35]

A new path was thus opened up to Russia by which foreign craftsmen could enter the service of the tsar. It is not known whether these first masters who went to work in Russia included any architects. At any rate, nearly ten years later Ivan the Terrible wrote to Elizabeth I to ask her to grant permission for English architects to come to Russia to work for him.

The text of this important document is only partially preserved, but from the surviving part it emerges that the tsar asks Queen Elizabeth to send him a specialist "in the construction of fortresses, fortified towers and palaces [. . .] and also other masters [. . .]". He goes on to say:

We have sent you letters patent for the use of any who may wish to come to our country and to work in our service for a fixed term of years, like those who came last year, and also any who may wish to join our permanent service [. . .] we invite any of your men with skills, *architects* [emphasis: DS], doctors, apothecaries and others, as set out in the letters patent, to enter our service [. . .] and we shall maintain at our cost those who wish to remain in our service permanently and we shall remunerate them in whatsoever way they wish, but those who wish to leave our service we shall remunerate according to their needs [. . .] and we shall send them back to their country with such remuneration, without any hindrance.[36]

The Freemason Thomas Chaffin's will of 10 November 1567 was made in connection with his departure for Russia. His appointment there, "by the power and authority" of Queen Elizabeth I, may be directly linked to Ivan the Terrible's above-quoted letter and Elizabeth's positive reply of 18 May 1567, six months before his will was made, and it may be supposed that he went to Russia in response to the tsar's appeal.

One of the earliest scholars of Anglo-Russian relations in the sixteenth century, Iosif Gamel', established that the Englishmen invited to Russia by Ivan the Terrible arrived at the end of 1567. He does not give or does not know their names and professions,[37] but it is possible that Chaffin was amongst them. Some indication of the conclusion of his time in Russia emerges more clearly: his will was proved on 14 April 1572.[38]

In 1571 the English ambassador Anthony Jenkinson arrived in Russia. He delivered a message to the tsar from Queen Elizabeth, in which the fourteenth point read: "There are in Your Majesty's service certain master craftsmen and artists, who complain that they have not been granted permission to return home [. . .]."[39] This must refer to those who had agreed to work in Russia "for a fixed term of years" rather than permanently; again, Thomas Chaffin may have been one of them.[40] Jenkinson did not return to England until July 1572, but he might have managed to send home information about Chaffin earlier,[41] since the latter's executors were able to prove his will on 14 April.[42]

The request put to the tsar in 1571 for permission for English craftsmen to return home (which would seem to have gone unheeded) confirms the presence in Russia at that time of a number of master craftsmen who were bringing English elements into Russian architectural culture. Another English ambassador, Jerome Horsey, records a conversation with Ivan the Terrible that took place in 1576. The tsar asked Horsey if he had seen the ships and barges in Vologda. The latter replied that he had been there to "admire their extraordinary ornamentation and its unusual detail". The tsar asked him what he meant. "I mean," said Horsey, "those beautiful sculptures of lions, dragons, eagles, elephants and unicorns decorated in gold, silver and all kinds of exotic colours [. . .]." The tsar then said to one of his courtiers standing beside him: "The cunning fellow is praising the art of his fellow countrymen."[43]

It has not been established what kind of work Chaffin, Lock and the other English craftsmen of unknown identities were engaged on in Muscovy at this time. But Ivan's above-cited appeal to Elizabeth clearly indicates the kind of buildings most in demand, "fortresses, fortified towers and palaces". Gamel' was probably right in seeing the call for a specialized architect in direct connection with building plans for the Oprichnina in Moscow, Vologda and Aleksandrov.[44] It is scarcely to be doubted that the masters commissioned from England worked for the tsar himself. It is significant that the activities of all Englishmen in Russia during this period were exclusively with the "privatized" half of the country, Ivan's personal domain, the Oprichnina, and that the revenue from trade with them went into the exchequer of the Oprichnina.

The ambassador Jerome Horsey writes:

The Tsar himself spent most of his time in Vologda [. . .] and Aleksandrov [. . .] and he sent to England for experienced builders, architects, carpenters, joiners and stonemasons, jewellers, doctors, apothecaries and other specialists, to build a treasury vault in stone, and also large barges and vessels [. . .].[45]

It is not known what kind of "treasury vault" the tsar had in view, and whether it was for Aleksandrov or the Oprichnina palace in Moscow.

The presence of English master craftsmen in Moscow in the mid-sixteenth century has not occasioned particular attention on the part of architectural historians and indeed has generally gone unremarked. Jumping ahead a little, it should be pointed out that contemporaries were of another mind. It was not by chance that when the Time of Troubles was over, the first of the Romanovs invited Englishmen to enter his service. Details of the English architects who worked for Ivan the Terrible fill a gap in the story of Russia's international architectural links at that time. Russian architecture can no longer be seen as "isolated" from the rest of Europe during the second half of the sixteenth century. On the contrary, despite the unfavourable diplomatic situation, dominated by war with Livonia over access to the Baltic, the search for new craftsmen and new sources for the development of Russian architecture actively continued.

6 The Reign of Boris Godunov:
Tradition and a New Wave of Italianisms

Having killed his eldest son, the Tsarevich Ivan, in a fit of suspicion, Ivan the Terrible was succeeded by his second son, the feeble-minded Fyodor Ioannovich, who was married to the sister of one of Ivan's closest advisers, Boris Godunov, of Tatar extraction. During Fyodor's reign, Godunov was the country's effective ruler. After the death of Ivan's youngest son, Dmitry, in obscure circumstances, and then of Tsar Fyodor, the ruling Ryurik dynasty came to an end. Following some cunning political manoeuvring, Boris Godunov was elected to the throne in 1598 and attempted to found a new dynasty.

At the end of the sixteenth century, two architectural "manners" coexisted in Russia, as described above. During the brief rule of Boris Godunov (1598–1605) attempts were made to unite traditional Muscovite forms with ornamental motifs associated with the idea of Moscow as the capital of a new empire, the Third Rome. In this process the architectural face of the European Renaissance on display in Russia in the work of Italian masters was not lost. As Andrey Batalov shows, a new "wave of Italianisms" appeared in Russian architecture in the reign of Boris Godunov,[46] seen in the use of elements from the Classical Orders within traditionally Muscovite church forms.

The idea of the Moscow tsardom as "the Third Rome" and of the Russian Church as the true Othodox Church remained alive in the ideology of Boris Godunov's reign. Alongside the use of architectural symbols expressing the power of the state, endeavours continued to be made at this time to convey the role of Moscow as the centre of the Eastern Christian world. Following the proclamation of the Russian Church as a patriarchate in 1589, and its acceptance by the heads of the ancient Eastern Orthodox churches, this had special importance. It was at this time too that the first imitations of the Holy Places appeared in Russian church architecture. A plan was even made to build a symbolic replica of the Tomb of the Lord, the "Holy of Holies", in the Kremlin.[47]

At the same time, Boris Godunov carried on with Ivan the Terrible's efforts to re-equip the Russian army and make use of other countries' technical and scientific achievements where European contacts afforded opportunities to do so. England continued to have an important place in his policies, and to England he dispatched the first Russian students to be sent to study abroad. Although most of them did not return home, the mere fact that young people were sent to a European country is an index of the seriousness of Boris Godunov's desire that Russia should be joined to European culture.[48]

In respect of style, the union of traditional Muscovite with Renaissance motifs adapted by Russian craftsmen continued. Boris Godunov's desire to emphasize by all possible means the legitimacy of the dynasty he had founded had a significant part to play here. Detail borrowed from the major Kremlin buildings served to symbolize the continuity of power. In consequence, Classical motifs that had been used by the Italian masters who had worked for Ivan III and Vasily III in Moscow at the turn of the sixteenth and seventeenth centuries became "sacralized" symbols of legitimacy.

At the end of the 1580s, when Boris Godunov was still an uncrowned adviser to Fyodor at the helm of state, a cathedral (which no longer survives) was built in the Ascension convent (Voznesenskiy monastyr') in the Kremlin as a burial-place for grand princes and their spouses; the latter, in the event of a grand prince's death, traditionally took the veil in this court convent. The cathedral's function decided its model, another cathedral in the Moscow Kremlin, the Archangel Michael, where the rulers of Moscow were buried. In order to make the building's purpose recognizable, certain basic features of the façades of its model were reproduced, such as cornice profiles and circular windows with *nalichniki*.

In its turn the Ascension cathedral, as a model built by the highest authority, was imitated in places remote from Moscow. Similar features may be seen in Boldino cathedral in Dorogobuzh, a town 400 kilometres south-west of Moscow, which at the end of the sixteenth century was near the western frontier of Muscovy. In the 1590s motifs from the Archangel cathedral, in particular the first-tier niched arcades, were used in the

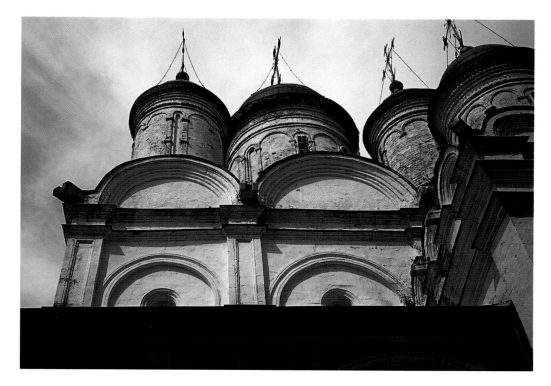

148 Detail of the upper part of the church of the Transfiguration (originally church of the Holy Trinity), Bol'shiye Vyazyomy, after 1595.

church of the Trinity (tserkov' Troitsy) in Khoroshovo, Boris Godunov's own village. The influence of the ornamentation of the Archangel cathedral is also reflected in distinct "Italianisms" that appeared in tent-roof churches, such as that of the Smolensk icon of the Mother of God (tserkov' Smolenskoy ikony Bogomateri) in the village of Kushalin, built in 1592. Imitation of motifs drawn from the Orders, introduced to Russia by Alevisio Lamberti da Montagnana in the Venetian manner at the turn of the fifteenth and sixteenth centuries, continued to change the ornamentation of churches throughout the country for a hundred years.

Features of the architectural style of the Godunov period are especially clearly to be seen in a church built at the tsar's residence in the village of Vyazyomy, 40 kilometres west of Moscow (pls 148, 149),[49] the church of the Transfiguration (tserkov' Preobrazheniya), originally known as the church of the Holy Trinity (tserkov' Sv. Troitsy). Here a complex spatial composition is achieved with entirely traditional elements. The basic structure is a comparatively small church with four pillars, a wide central and two narrow side apses. But unusually, monumental side-chapels are built onto the presbytery on two sides, from which a two-tiered open arcade extends round the entire exterior, ending in a staircase on the west front. The whole building is raised on a high socle. The main church is crowned with five cupolas, placed close together because of its

small scale, and a further cupola crowns each of the side-chapels, making seven in all. All the cupolas rest on *kokoshniki* in pyramid formation one behind the other.

In its ornamentation, the main church clearly imitates the Order-based motifs of the cathedral of the Archangel in the Kremlin. As models for the side-chapels, those of another court shrine in the Kremlin were chosen, the cathedral of the Annunciation. While the Archangel cathedral, the burial place of the rulers of Russia, symbolized the continuity of power, the cathedral of the Annunciation, the private court church of former monarchs, conveyed the dynastic idea and the title of tsar in a more intimate, family setting. One of the main supporting factors for Boris Godunov in his accession to the throne was his sister Irina's status as Tsar Fyodor's wife. The church at Vyazyomy conveyed a clear assertion of "tsardom", of the royal status of the Godunov family.

From a stylistic point of view it is important that the ornamentation of this Vyazyomy church incorporates the most pronounced Classical features in all Russian sixteenth-century architecture, after the Archangel cathedral in the Kremlin had been built by Italian masters. However, in this church dating from the end of the sixteenth century, Renaissance motifs appear not as naturally belonging to a European style that had reached Russia, but rather as a consciously chosen style summoned in the service of a particular idea, that of royal power,

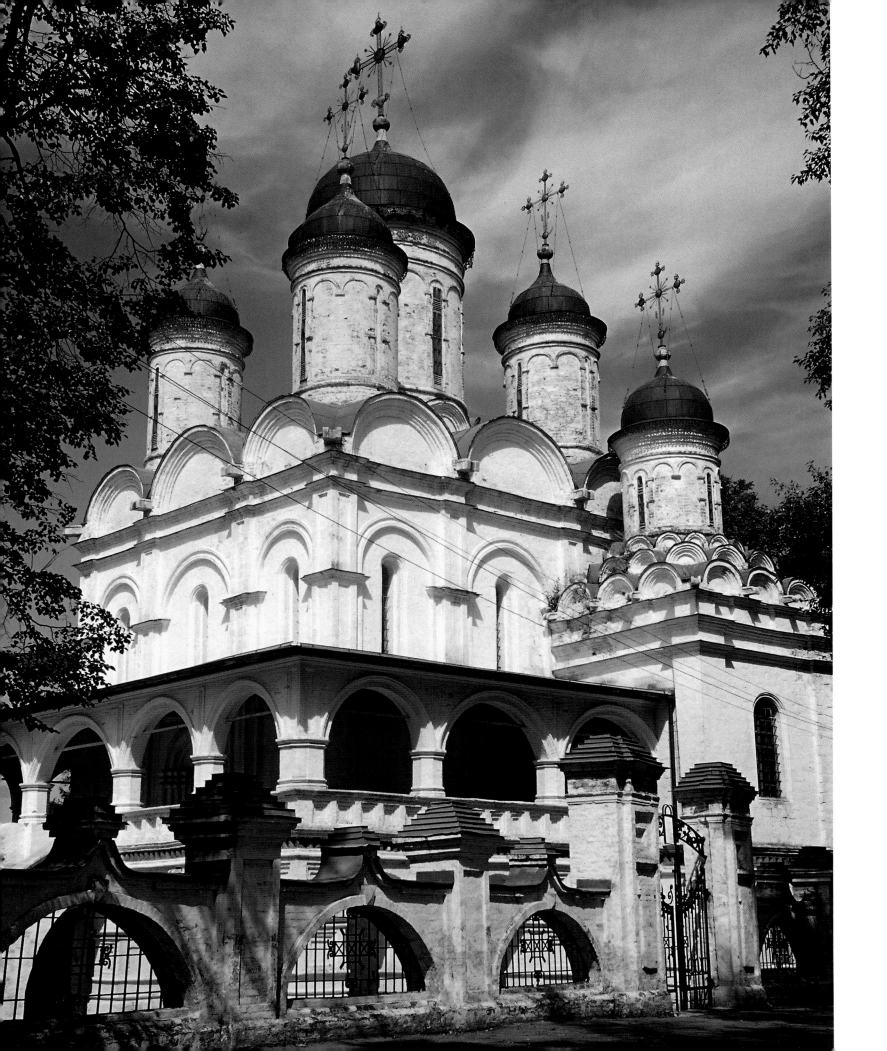

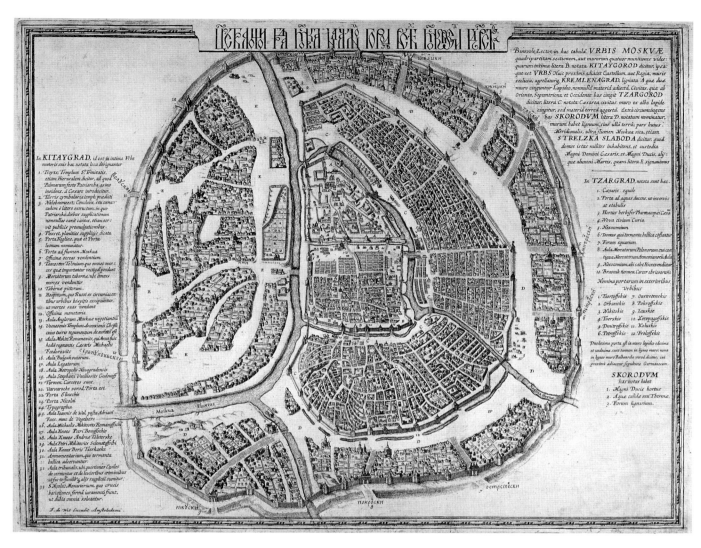

150 Luke Kilian's plan of Moscow, 1610; engraving, after 1632.

and expressed through architectural symbols based on the imitation of sacralized forms.

After the death of Boris Godunov in 1605, building activity in Russia was interrupted by political events in the interregnum known as the Time of Troubles (1605–13). The first years of the reign of Tsar Mikhail Fyodorovich, founder of the new Romanov dynasty, were devoted to repairing the damage done during this period. He was to reign until 1645.

7 The Architecture of the First of the Romanovs and Christopher Galloway

Who does not lament and weep bitter tears from the bottom of his heart [. . .] for the sovereign city which used to be great and exalted, and beautiful without equal [. . .] and still strikes the hearts of many, in cities near and far, with astonishment and wonder [. . .] All the more is this sovereign city of Moscow now known as the Third Rome . . .

So wrote the treasurer of the monastery of the Trinity and St Sergius, Avramy Palitsyn, on the destruction of the capital of the Russian tsars during the Time of Troubles.[50] What is especially surprising in these words of one of the leading figures of the Russian Church in the first quarter of the seventeenth century is the memory of the significance of Moscow as the New or Third Rome, which Vasily III and his court had hoped the city, as capital of a truly Orthodox tsar, would remain until the end of time, until the Last Judgement. And now it had been taken by foreigners and destroyed. All the same, Avramy Palitsyn's words make clear that the idea of Moscow as the Third Rome remained very much alive (pl. 150).

For the rest of the seventeenth century, a continuous process of development and transformation took place in Moscow up

149 (facing page) Church of the Transfiguration (originally church of the Holy Trinity), Bol'shiye Vyazyomy, after 1595.

to the emergence of the Russian Empire under Peter the Great. For all the novelty of his reforms, personal example and artistic choices, the radical changes of the Petrine period would not have been possible had the ground not been prepared for them by the development of the country following the Time of Troubles. Invitations to foreigners, moves to found a regular army, the first steps towards the creation of a fleet (despite the disastrous termination of the enterprise when the first ship *Oryol* was destroyed in the Stenka Razin rebellion) – all this was achieved by Peter the Great's predecessors, by his grandfather Mikhail Fyodorovich and his father Alexis Mikhaylovich. In other words, for much of the seventeenth century changes were taking place in the Russian state to which Peter gave final form. These processes also affected architecture.

For the first decade of the reign of Mikhail Romanov, architects in Russia, intent on renewing interrupted tradition, mainly imitated buildings raised under Boris Godunov. Once again, the idea of continuity of power was fundamental. This is particularly clearly seen in the imitation of building types dating from the turn of the sixteenth and seventeenth centuries and their ornamentation, as for example in the church of the Intercession of the Mother of God (tserkov' Pokrova Bogoroditsy) in Rubtsovo, now in Moscow (pl. 151) or the church of

151 Church of the Intercession of the Mother of God, Rubtsovo, 1619–27; lithograph, 1850s.

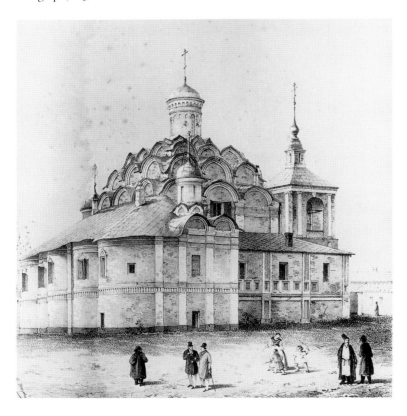

St Nikolay Nadein in Yaroslavl'. However, if architects in the reign of Tsar Mikhail successfully imitated the general composition and detail of buildings of the Godunov period, the refinement of their forms was lost. "Italianisms" either disappeared from the regular repertoire of motifs or appeared in considerably cruder forms. Court architecture required new forms befitting royal status.

The return of political stability to Russia in the mid-1620s brought a new architectural atmosphere. In 1624–25 the main entrance to the Moscow Kremlin, the Saviour's Tower (Spasskaya bashnya), was rebuilt. Tsar Mikhail's architects turned Pietro Antonio Solari's Lombard-style fortified structure dating from the end of the fifteenth century into a tower which has a markedly Gothic look (pl. 152),[51] with an imposing upper structure ornamented with pointed pinnacles and arches. This is the first substantial use of Gothic motifs in Russia; the rare Gothic detail seen in St Basil's Cathedral is combined, as already described, with stylistically different elements.

Closer inspection of the ornamental elements of the new Saviour's Tower, however, reveals that despite the general Gothic style, the finer ornamental detail, for example the cornices and the miniature columns of the pinnacles, is Classical in style (pl. 153). Furthermore, the ornamentation originally included a sculptural scheme of nude figures probably belonging to Classical mythology, now lost. Muscovites were so indignant at these naked figures round the exterior that the tsar was obliged to have them clothed in cloth.

The style of the rebuilt Saviour's Tower becomes evident from the name of its architect, Christopher Galloway from Edinburgh,[52] who collaborated with the Russian Bazhen Ogurtsov and the German Wilhelm Graf. As Jeremy Howard has established, this Scot arrived in Moscow in 1621 and stayed there for 25 years.[53] He not only worked in the Kremlin, but also built the complex of the Printing House (Pechatnyy Dom) in Kitay-Gorod. Although this building was almost entirely rebuilt at the beginning of the nineteenth century, the architects of that time made an attempt to reproduce Galloway's ornamental detail. And the figures of the lion and the unicorn, which have become emblematic of the Moscow Printing House, can still be seen today on the exterior of the building, despite its restoration during the Romantic period.

It is likely that Galloway was an architect of the kind that Sir John Summerson has described as "artisan mannerists",[54] for he concerned himself with both engineering and building matters. With him worked another British architect, John Taller, who began the reconstruction of the tsar's palace in the Kremlin; little is known of him. Christopher Galloway's appearance in Moscow is easily explained. In the early seventeenth century an increasing number of Scottish émigrés

152 *(facing page)* Saviour's Tower, Kremlin, Moscow (Christopher Galloway and Bazhen Ogurtsov), 1624–25.

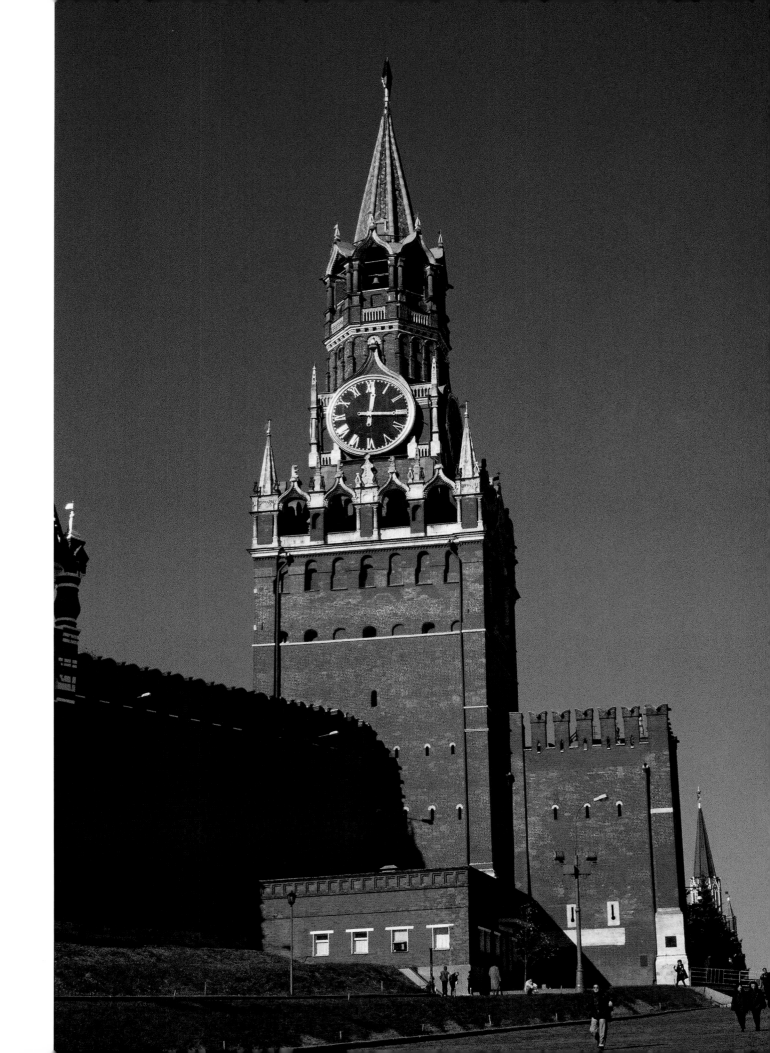

settled in continental countries, and some reached Moscow.[55] Boris Godunov's army included Scottish officers, and they played an important role in the guards units of the first Romanovs. The invitation from Moscow to masters from Edinburgh, despite deteriorating relations with London, sprang from continuing memories of the work of builders and masons from the British Isles for Ivan the Terrible. It is also highly probable that not the least consideration was Mikhail Romanov's general emulation of the last representatives of the defunct dynasty, including their predilection for masters from abroad.

The upper part of the Saviour's Tower as rebuilt by Galloway is important in showing features of a new court style which were to be influential in Russian architectural evolution. The ornamental richness and complexity of composition made for a triumphant and uplifting model. The stylistic freedom displayed in the knitting of forms of diverse stylistic origins into a fine and original composition pointed the way to a new architectural language, and this was achieved without the hindrance of the traditional motifs of Moscow architecture or the laws of Classical ornament, here mingling at will with Gothic elements.

Galloway's work appears all the more "Gothic" today after many rounds of restoration resulting in the disappearance of all traces of the original sculpture. It is hard to imagine how an architect from Scotland in the 1620s could have adopted a purely Gothic style; even in Scotland itself, this never occurred at the beginning of the seventeenth century. Galloway was most likely making a conscious attempt to develop a style that he thought suitable for Russia. He could hardly have avoided looking at St Basil's, standing next to the Saviour's Tower. The latter represents the concern of an architect familiar with Classical architectural forms to accommodate to a local style of the past as he understands it.

Be that as it may, however, Galloway began a new architectural "manner" in Moscow, which made its impact on Russian architecture as a whole during the reign of the first of the Romanovs. It is characterized by an abundance of ornament, a rich variety of forms, and a unity made up of the most diverse elements. The restraint of the Godunov period is overcome. Galloway opened up the path to a reinterpretation of the Muscovite heritage of the fifteenth and sixteenth centuries and a new attitude to it. Combining the familiar and the new in a striking composition of his own, he showed how it was possible to make a brilliant ornamental impact which chimed in with the artistic appetite of a Russia once again picking itself up from the ruins. The upper parts of other Kremlin towers were rebuilt in the course of the seventeenth century in the style of the Saviour's Tower (pl. 154).

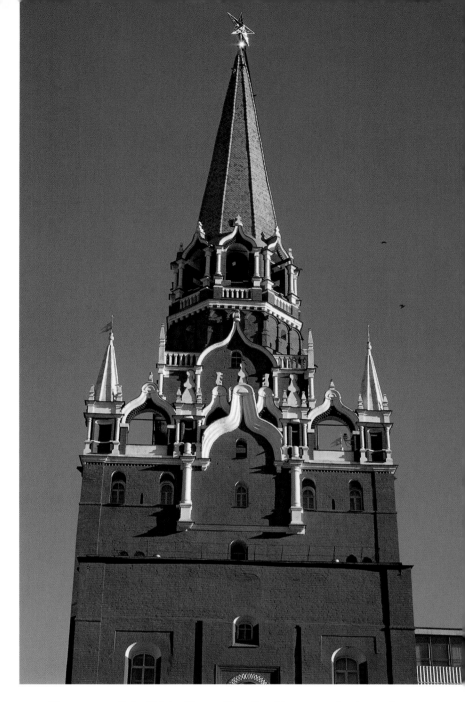

154 Upper part of the Trinity Tower, Kremlin, Moscow, early sixteenth century; rebuilt in the seventeenth and eighteenth centuries.

The first half of the reign of Mikhail Romanov, the 1620s–30s, was devoted to the restoration of the buildings inside the Kremlin that had been damaged when Russian forces had retaken it in the course of wresting back the capital from Polish occupation during the interregnum. The rebuilding of the principal royal palace, the Terem or Belvedere Palace, began with the court chapels, known as the Terem churches.[56] In 1624 John Taller built St Catherine's church (tserkov' Sv. Yekateriny). The full history of the building of the Terem Palace is not entirely clear. The Russian architects Bazhen

153 (facing page) Detail of the upper part of the Saviour's Tower, Kremlin, Moscow (Christopher Galloway and Bazhen Ogurtsov), 1624–25.

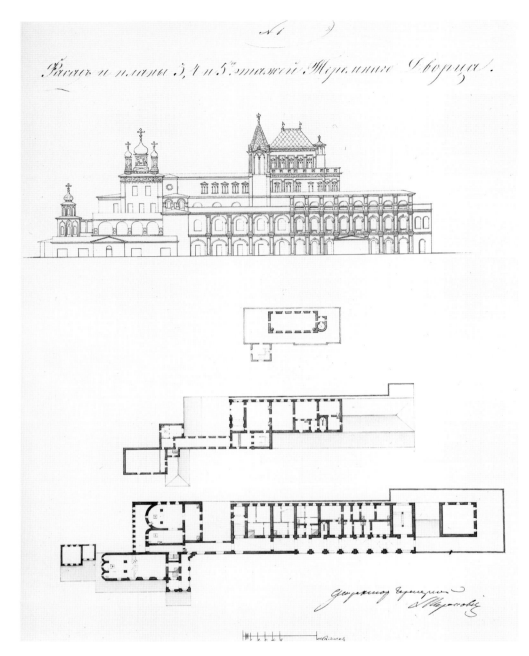

155 Elevation and plans of the Terem Palace, Kremlin, Moscow (Bazhen Ogurtsov, Antip Konstantinov, Trefil Sharutin, Larion Ushakov), 1635–37, drawn in 1830s.

Ogurtsov, Trefil Sharutin and Larion Ushakov, under the direction of "the tsar's master" Antip Konstantinov, are known to have worked on it in 1635–36.[57] It is not known, however, what work was done in the interval between 1624 and 1635, to what extent the Russian architects collaborated in John Taller's work of the 1620s, or whether he was involved in their activities in the 1630s.

The new Moscow architectural language was begun with the building of the Terem Palace, the central part of the tsar's residence in the Kremlin, a historically developed complex of state rooms, living and service quarters. Its upper storeys were built in the seventeenth century to a very simple plan. The principal rooms open one into the other to the full width of the building on each floor. At the rear, the rooms become narrower where space is occupied by private and service quarters. The simplicity of the architectural design (pl. 155) concentrates all attention on the elaborate decoration of the interiors, though what is seen today is nineteenth-century restoration work rather than the sumptuous original decoration (pl. 156).

156 (*facing page*) Room in the Terem Palace, Kremlin, Moscow, 1635–37, restoration of the nineteenth and twentieth centuries.

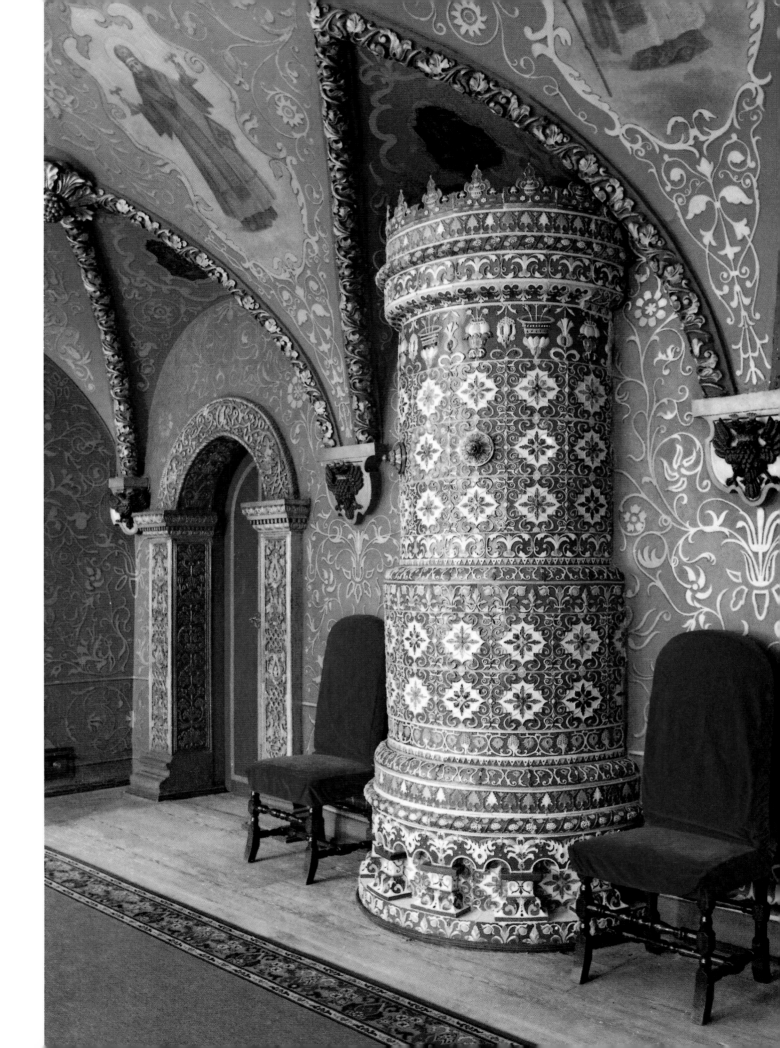

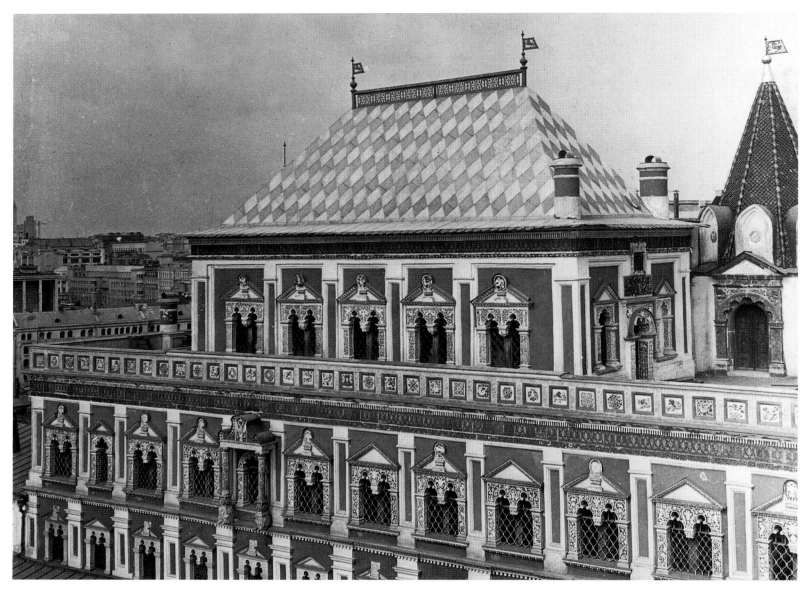

157 Detail of the south front of the Terem Palace, Kremlin, Moscow, 1635–37, restoration of the nineteenth and twentieth centuries.

It is significant that many of the Russian craftsmen who worked on the Terem Palace had worked earlier with Galloway and Taller; and also that the new complex was based, as it were, on a platform on the roof of a two-storey palace raised by Renaissance Italian masters and surrounded by cathedrals they had built. Imitation of the detail of these buildings, which had become the sacred places of tsardom, was the chief means by which the ideological symbolism of the palace was conveyed.

The role played by these details and motifs was now quite different from the use to which they had been put in the reigns of Ivan the Terrible and Boris Godunov. The architects of the Terem Palace removed the Renaissance elements of the Kremlin buildings of the fifteenth and sixteenth centuries from their original context, strongly enhancing their ornamental

aspects (pl. 157). Tuscan pilasters, for example, are turned into extended frames for tall niches. The short columns of the Venetian-style windows are covered in designs that almost transform the grotesques of the Italian stone-carvers into eastern carpet designs. Windows are surmounted with broken pediments. The cornice above the piano nobile is enlarged to Renaissance proportions, with ornamental mouldings over its entire surface. All these Classical elements, transformed, are placed next to each other to form a rich ornamental carpet round the entire exterior. This tendency to massive, dense ornamentation becomes a fundamental feature of Russian seventeenth-century architectural style. The creation of sumptuous abundance in a composition full of the unexpected and at the same time made out of familiar elements, such as is seen

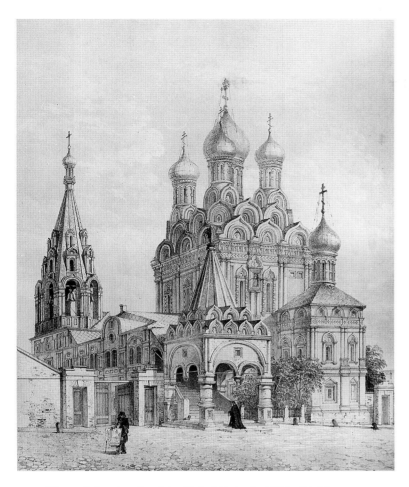

158 View of the church of the Holy Trinity in Nikitniki, Moscow, 1631–50s; lithograph, 1850s.

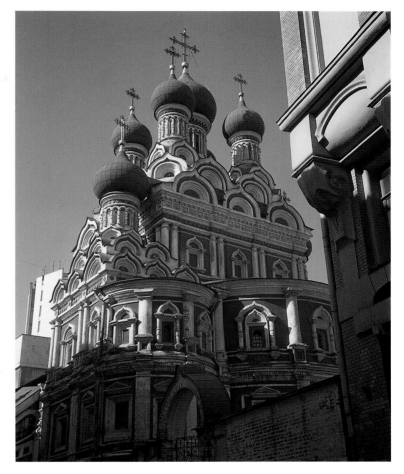

159 Church of the Holy Trinity in Nikitniki, Moscow, 1631–50s.

here in the Terem Palace, has much in common with the work of the Northern European Mannerists.

The fondness for the rare, the astonishing and the exquisite during this period was evident in the fashion for hanging gardens on the roofs and terraces of the Kremlin palaces. The nineteenth-century historian Ivan Zabelin comments on their exquisite appearance:

> [. . .] all were beautiful, both as regards the species of flowers and plants grown in them and as regards their layout, which usually featured a display of variegated colours [. . .]. The tsar, the princes and the princesses had their own personal gardens on stone vaults above their chambers [. . .] which is why they are to be called "hanging".[58]

Usually these gardens were surrounded with painted wooden balustrades, and featured a gilded carved throne or armchair, pavilions with twisted columns, often bird-cages with nightingales, canaries and parrots, and sometimes even small ponds, with lead borders and mechanically piped water. Around these

ponds, flowers and fruit-trees of exotic kinds to Muscovites were planted – "walnuts and hazel-nuts, and also the usual apples and pears. In the flowerbeds grew luxuriant cabbage-roses, pungent-smelling cloves, violets, tulips and lilies of many colours."[59] The palace's stepped structure and the hanging gardens were reminiscent of the palaces of Babylon and the hanging gardens of Semiramis; descriptions of the Seven Wonders of the World had reached Moscow at this time.

The splendour and scale of the Moscow Kremlin entirely suited the way in which Russian architecture evolved in the second quarter of the seventeenth century. Further ornamental features continued to be invented, and motifs were taken from the architecture of Classical Antiquity and transformed. The church of the Holy Trinity (tserkov' Troitsy) in Nikitniki is one of the most striking examples of this (pl. 158, 159). It was built over a comparatively long period, between 1625 and 1653, but its design and ornamental scheme are contemporaneous with those of the Terem Palace, and the same architectural forms are used. In this church the basic features of the Russian seven-

160 Plan of the church of the Holy Trinity in Nikitniki, Moscow, 1631–50s.

tal band consisting of several superimposed elements (pl. 161), above which rise the *kokoshniki* and five onion domes. This version of an Order-based composition (see frontispiece) has an important place in Russian architectural history. Previously, elements of the Orders had been seen in Russia only in buildings designed by Italian masters and in St Basil's Cathedral. In Nikitniki, a "Russian" Order appears for the first time, and will become the basis for schemes of exterior ornamentation setting out both to imitate Classical ornamental design and to unite it with Muscovite tradition. The architect of the Trinity church makes entirely conscious use of an Order, in a two-tiered composition, perhaps doing so in connection with a new edition of either Hans Blum's or Jacopo Barozzi da Vignola's treatise of the previous century on the Five Orders. The Order

161 Detail of the entablature and corner column cluster of the church of the Holy Trinity in Nikitniki, Moscow, 1631–50s.

teenth-century church are established. Furthermore, since religious architecture was considerably more developed than secular at this time, the unity of the old and the new seen in this building had a significant influence on Russian architectural evolution for the rest of the century.

The history of the commissioning of this church is not entirely clear. There is documentary evidence that it was built on the initiative and by the means of one of the wealthiest Moscow merchants of the day, Georgy Leont'yevich Nikitnikov, on land next to his house, and its architecture would seem to suggest a private commission. At the same time, its features and dedication have overtones of a state commission. It is possible that the dedication of the main altar and the side-chapels commemorated events of the Time of Troubles, in particular the successful defence of the Trinity-St Sergius Monastery against Polish and Lithuanian forces.

In comparison with buildings of the Godunov period, the plan of this parish church is more subdivided and the main composition more picturesque (pl. 160). Traditional Muscovite *kokoshniki* in three tiers become a prominent feature, rising above the vaults of the interior. At the same time there are references to Kremlin buildings, from the cathedral of the Archangel Michael to the newly rebuilt upper part of the Saviour's Tower. Elements of traditional architectural language and symbolic forms associated with the idea of the power of Russian sovereigns are enhanced here by a more radical transformation of Classical ornament than is seen in the Terem Palace. Around the main exterior, double columns on pedestals support a cornice that takes the form of a complex ornamen-

162 (*facing page*) Window on the south front of the church of the Holy Trinity in Nikitniki, Moscow, 1631–50s.

163 Upper part of window surround on the south front of the church of the Holy Trinity in Nikitniki, Moscow, 1631–50s.

used here is markedly Roman, with prominent pedestals and capitals which are Tuscan in character.

Such unifying of Classical elements with traditional Muscovite motifs has been taken to mark the appearance of Baroque features in Russian architecture (pls 162–64).[60] And this increased ornamental emphasis might indeed appear to belong to the Baroque. But it is also the case that when the Trinity church was built, Russian architecture was not yet Classical enough to proceed to Baroque; the Muscovite ornamental tradition was too strong, handling of the Orders was too free, and architectural ensembles were too often made up of elements of completely different origins. Russian architecture at this time was closer to Mannerism, with its mingling of late medieval, Renaissance and Baroque ideas. To the present writer, the Trinity church in Nikitniki is the most "Mannerist" of all Russian seventeenth-century buildings. It had a huge influence on Russian architecture for the rest of the century, its motifs being reproduced in the most remote parts of the country.

The urge towards architectural innovation through increased compositional complexity and ornamental enhancement is especially evident in tent-roof churches from the 1620s onwards. The roof of the church of the Dormition (Uspenskaya tserkov') in the Alekseyev monastery in the city of Uglich on the Volga, for example, known to contemporaries as "the Miraculous", looks similar to that of the church of the Ascension in Kolomenskoye (pl. 165); its structure is more complex, but it maintains monumentality. Like the Kolomenskoye church, it has a tall central tent roof surrounded by a row

of keel-shaped arches below. On either side of the central spire two lower tent roofs rise from side-chapels. Still more complex in structure than this building is the church of the Intercession of the Mother of God (tserkov' Pokrova Bogoroditsy) in the village of Medvedkovo, now in Moscow, with a central tent roof soaring above the seven cupolas of side-chapels. The rich complexity of the exterior is matched by that of the graduated space of the interior. A dramatic effect of opulence and variety in both is created by the juxtaposition of the upward thrust of the huge central structure with the small, narrow side-chapels.

At the end of the fourth decade of the seventeenth century, the two basic "manners" considered in this section, the one originating in sixteenth-century tent-roofed churches and the other incorporating ornamentation in the manner of the church of the Holy Trinity in Nikitniki, coalesced. This is seen

164 Interior portal of the church of the Holy Trinity in Nikitniki, Moscow, 1631–50s.

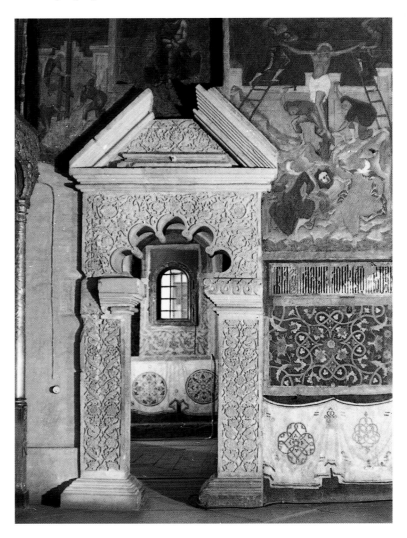

165 Church of the Dormition, Alekseyev Monastery, Uglich, 1620s.

166 View of the church of the Nativity of the Mother of God, Putinki, Moscow, 1644–52; lithograph, 1860s.

in the church of the Mother of God (tserkov' Bogoroditsa) of Odigitriya in Vyaz'ma (1637), where a single tent roof or a trio of densely ornamented ones, having the appearance of inverted giant vases, is placed above the traditional central square of the plan. This manner reaches its apogee in the middle of the century, in the church of the Nativity of the Mother of God (tserkov' Rozhdestva Bogoroditsy) in Putinki, Moscow (pl. 166). Here, a side-chapel and a bell-tower beside it with its own tent roof supported on a fascicle of columns, reminiscent of the church of the Trinity in Nikitniki, are built onto the central square of the main structure, which is roofed by three tent-spires whose ornamentation bears undoubted reference to St Basil's Cathedral (pl. 167). Indeed, the use of ornamental elements modelled on those of St Basil's continues to be noticeable in churches built throughout the first half of the seventeenth century. The ornamental manner based on these models was popular in Russia towards the end of the reign of Mikhail Fyodorovich and the early years of the reign of his son Alexis Mikhaylovich, father of Peter the Great.

167 Church of the Nativity of the Mother of God, Putinki, Moscow.

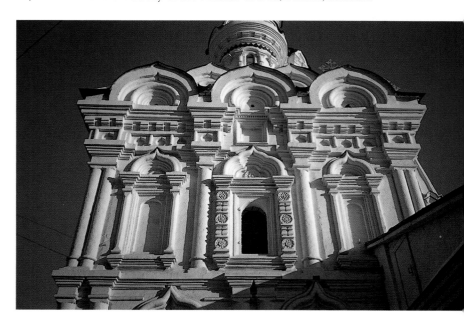

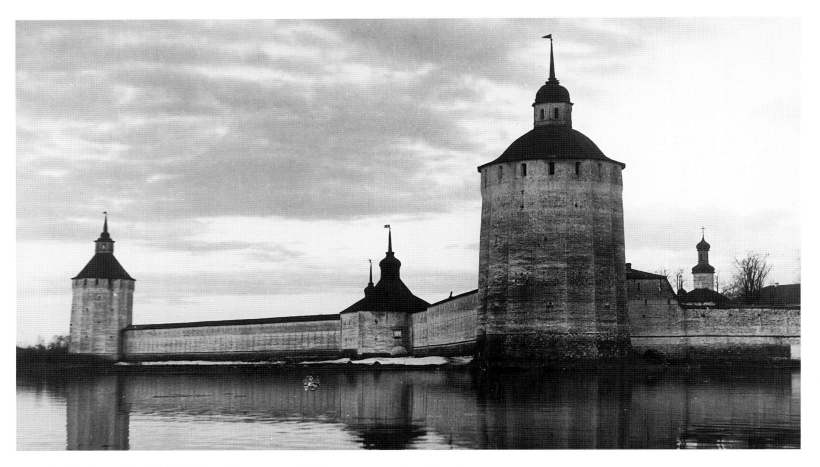

168 Fortifications of the Kirillo–Belozersky monastery, Kirillov; reconstruction after 1653.

8 The Architecture of Alexis Mikhaylovich

Peter the Great's father safely assumed the throne after the death of his father Mikhail Fyodorovich in 1645. His over-30-year reign to a significant degree prepared the way for Peter the Great's reforms. His own plans could not be carried out, however, in the absence of even a preliminary programme for their practical accomplishment. In the State of Muscovy, programmes on such a scale, each replacing the last, took the form of ideas based on an ideal image of the country. The external, visible features of this image, moreover, were especially important to Russian rulers. It seemed to them that the creation of new external forms for the organization of life would be sufficient for life itself to fill these with new content, which would guarantee the country's prosperity. Alexis's programme for the reconstruction of Russia took on a theocratic character in the sacralization of the tsar's power and the personality of the monarch.

This explains the huge amount of religious building that took place in the second half of the seventeenth century. New churches were raised all over the country, keeping to forms modelled on those of royal churches. Celebrated ancient monasteries were extended on a large scale, acquiring monumental walls and towers, previously attributes of the private residences of the rich and powerful. Historic monasteries like the Trinity-Sergius, the Kirillo-Belozersky (pl. 168), the St Savva-Storozhevsky, Zvenigorod (pl. 170) and the Saviour-St Euphymios, Suzdal' and numerous others were virtually turned into sacred towns. In many of them monumental new cathedrals modelled on those in the Moscow Kremlin were built, with bell-towers and stone cells. The new buildings of the St Savva-Storozhevsky Monastery, Alexis's favourite among the monasteries outside Moscow, are especially interesting. The tsar frequently stayed here for long periods. Thanks to his endowments, this monastery became a magnificent architectural ensemble; his commissions resulted in buildings that rival those created by Patriarch Nikon. The picturesque composition of the whole St Savva-Storozhevsky complex is in perfect harmony with the consistency of the plans of individual buildings and the lively overall ornamental detail (pls 169, 171).

Ideas of the New Jerusalem, of the New Constantinople as a Second Rome, and themes connected with local Russian

saints predominated in the ideology of tsardom as a new Orthodox empire. This contributed to the preservation of long-standing features of Russian architecture, going back to Byzantine times and medieval Moscow, and rooted in two prominent strands of Russian culture. One of these was an innate conservatism, taking many different forms and manifested in a variety of social groupings. For example, those reformers who desired a strengthening of Russian Orthodoxy and the enhancement of Russian tsardom readily became upholders of tradition, and for their liking change was going too far. Conversely, those inclined to seek out forms of the past, to authentic use of the Byzantine experience, were seen as transmitters of dangerous novelty. Eventually, these two strands developed into a schism both in society, to be overcome only

169 Ornamental urn, main entrance, St Savva-Storozhevsky Monastery, Zvenigorod.

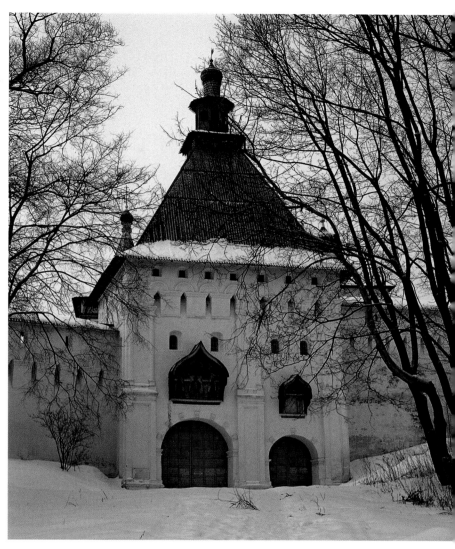

170 Entrance gate of the St Savva-Storozhevsky Monastery, Zvenigorod; 1650–56 (Ivan Sharutin).

by the iron hand of Peter the Great, and in the Russian Orthodox Church. The latter continues to the present day; in its first stages in the second half of the seventeenth century, it took particularly savage and dramatic form.

Tsar Alexis Mikhaylovich interpreted reform of tsardom and the church – to him the two were indistinguishable – as contributing to the restoration of the greatness and the culture of Eastern Orthodoxy. His reign saw increasing links with the ancient patriarchates of Jerusalem, Antioch and even Constantinople, and also with the monasteries of Mount Athos, although these were under Turkish rule. For Muscovites of the time of Alexis Mikhaylovich, "the Third Rome" was still, and first and foremost, thought of as the New Rome, the Second Constantinople, as it had been in the sixteenth century. The difference, however, was that now these ideas were nourished

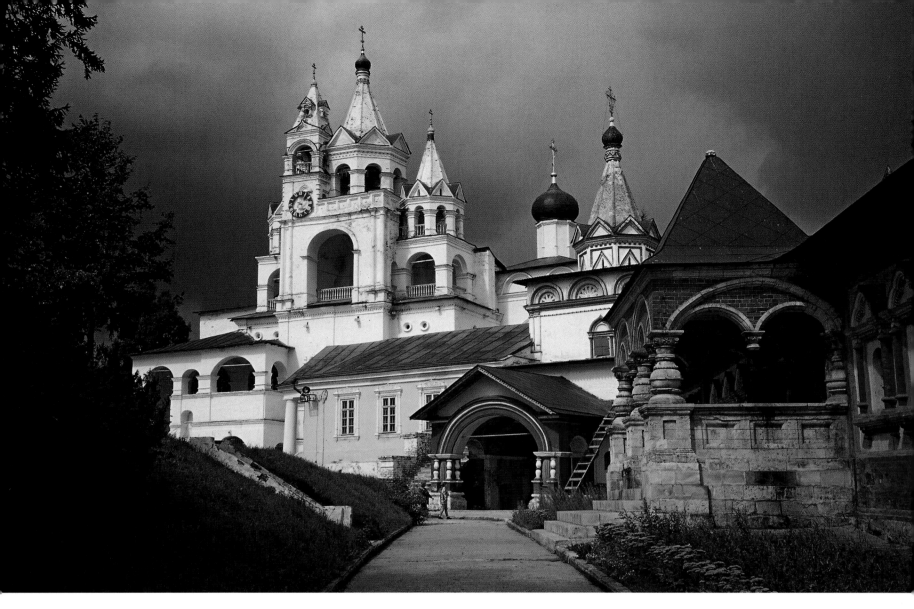

171 Bell-tower (1650; nineteenth century) and Tsarina's Palace (1650–52), St Savva-Storozhevsky Monastery, Zvenigorod.

not only by Russian debate but also, to a large extent, by the situations in which the leaders of Eastern Othodoxy found themselves. In 1649 the patriarch of Jerusalem appealed to Tsar Alexis: "May the most Holy Trinity support you and grant you many years of ripe old age, and reward you with the most exalted throne of the great Emperor Constantine."[61] Removed from his post under pressure from the Turkish government, the patriarch of Constantinople, Afanasius Patelar, wrote to Tsar Alexis in 1653 to call on him to drive the Turks out of Constantinople and restore the holy places of Byzantium: " [. . .] my brother, Your Majesty [. . .] and the Most Holy Nikon, Patriarch of Moscow and all Russia, bring light to the Apostolic Cathedral Church of Sophia, the cathedral of Holy Wisdom."[62] The Turks had turned the principal cathedral of the Byzantine capital into a mosque. Nikon himself, on his appointment as patriarch in 1652, addressed his sovereign as fol-

lows: "[. . .] may you be a universal sovereign and Christian autocrat and shine like the sun among the stars."[63]

Such sentiments, having no place in ordinary life in a political or a military sense, were felt most of all in the changes that took place in the life of the church. The modelling of the church rite more closely on the practice of the early Eastern Orthodox Church and new and revised translations from the Greek of both the New Testament and the liturgical texts lay at the heart of Nikon's reforms, which were prompted by a sense of Muscovite Orthodoxy as a universal force and of the necessity of going back to Byzantine practice in hopes of a future imperial rebirth, a Byzantine *reconquista* propelled from Moscow. This ideology, however, was held by only a limited section of the population in the higher echelons of state, and was incomprehensible to many believers, especially those on the outskirts of the expanded territories of Russia and in the

new settlements around Moscow. This incomprehension, compounded by natural Russian conservatism, caused a schism in the Russian Church and a hostility to "Greek" innovations that reached a fanatical level, with self-immolations and armed conflict with the authorities.

From an architectural point of view, the impact of the Schism was limited in view of the necessity for concealment on the part of those who observed the old rite. The Schism apart, Nikon's reforms had a profound influence on architecture. While he was head of the Russian Church, licences to build new churches issued by the patriarchate began to include a description of the prescribed building style. All religious building was to be "as laid down by Church rule and statute [. . .] with one, three or five cupolas, but tent roofs are on no account to be built".[64] In various documents the patriarch stressed that cupolas were to be "spherical, not pointed". In these simple words, material changes were contained which had the force of law and influenced building practice for the rest of the century.

The prohibition of tent roofs was essentially an outlawing of the new architectural language whose formation had begun with the building of the church of the Ascension in Kolomenskoye in 1530–32, continued through the first half of the reign of Ivan the Terrible, and re-emerged in the building programmes of Tsar Mikhail Romanov. As already seen, this new architectural language, although used primarily in church architecture, expressed ideas connected with the state. Among these was the conception of Moscow as the Third Rome and various commemorative themes such as the capture of Kazan' (St Basil's Cathedral) or links with the previous dynasty (widespread in the buildings of Boris Godunov and Mikhail Romanov).

Patriarch Nikon's formula of "one, three or five cupolas" indicates his architectural orientation. Fundamentally, he had in mind the early Russian cross-domed tradition and the architectural idea associated with it, enshrined in Metropolitan Iona's mid-fifteenth-century ideal of "early Greek piety laid down by God". In the course of his Byzantine-oriented reforms, Patriarch Nikon aimed at exact reproduction of his models, and this lay at the heart of his whole programme and approach to church architecture. No less important to him in the latter was the rejection of any motifs conveying ideas relating to tsardom and the state. And here he met his greatest problem, how the power of the church was to be reconciled with the power of the state, which eventually led him into bitter conflict with Tsar Alexis and loss of the patriarchate.

In the first half of the seventeenth century an unusual system of rule had arisen in Russia. During the Time of Troubles Fyodor Romanov, the closest surviving relative of Tsar Fyodor,

son of Ivan the Terrible, had been removed from the political scene and compelled to become a monk under the name of Filaret, eventually being taken into captivity in Poland. As a monk he was ineligible for the throne, and so his son Mikhail had been proclaimed tsar. On his return from captivity in 1619, Filaret had been consecrated patriarch. As not only a churchman but father of the tsar, he received special rights. His official status was on a level with the tsar's: he was addressed as "Your Great Majesty" (*Velikiy gosudar'*). During the first years of his young son's reign he played a decisive role at the helm of state. In Tsar Alexis's reign, memories of this diarchy of tsar and head of the church were still very much alive, and now Patriarch Nikon aspired to the same position. He was strengthened in this by his close friendship with the tsar, and by the fact that they shared the dream of Russia as the centre of universal Othodoxy and were both adherents of the Byzantine tradition. Alexis gave his firm support to the church reforms that brought the Russian rite into line with that of the ancient Eastern churches. Patriarch Nikon possessed a passionate nature, and would get carried away to the point of forgetting political realities. He came to hold that "the sanctity of tsardom is supreme". His independent policies ultimately brought him exile in monasteries in the far north, where he died.

His ideas and views are revealed not only in his writings and administrative records but also in a number of outstanding buildings, various in their architectural style but unified in their ideological programme. For Nikon, content and meaning of architectural form were paramount. All buildings in remote monasteries destined for those withdrawing from the world had to be of ascetic appeararace. A typical building in this restrained style is the cathedral of the Dormition (Uspenskiy sobor) in the monastery of the Miraculous Icon of the Iberian Virgin (commonly called "Iversky monastyr'" in Russian) on Valdaysky Island, one of the patriarch's favourite residences, built by Averky Mokeyev in 1655–58.[65] More severe still in style is the cathedral of the Monastery of the Cross (Krestnyy monastyr') on the Island of Kiy in the White Sea, commissioned by Nikon at the beginning of the 1660s.[66] Nikon is reputed to have vowed to build a church here after his life was miraculously saved in a storm. The plan of this church reverts to Early Russian models, a typical structure with four pillars, three cupolas, three apses and a façade divided into three bays by broad *lopatki*. When he built his New Jerusalem monastery near Moscow, however, the capital of his ecclesiastical "state", Patriarch Nikon resorted to different methods and a different style.

In building the monastery of the Resurrection (Voskresenskiy monastyr'), known as New Jerusalem, the patriarch entered into architectural competition with the tsar. The

monastery was intended to become the centre of universal Orthodoxy. Before the altar of its cathedral, thrones were placed for all five Orthodox patriarchs, those of Constantinople, Antioch, Alexandria, Jerusalem and Moscow. The model for the cathedral, which was intended to have just as great an importance as the monastery itself, was the church of the Holy Sepulchre in Jerusalem. It must be said that there were many imitations of this church in medieval Western Europe,[67] and it is possible that some were known to Russians, in particular the celebrated example in Bologna.[68] The first attempt to build such a church in Moscow, as seen above, was made at the beginning of the seventeenth century in the reign of Boris Godunov.[69] Nikon's realized project appears to have been the largest-scale and most exact imitation of its Jerusalem model in all European architectural history (pl. 172). The patriarch's desire to create narrative architecture that could tell the Christian story thoroughly, as well as his idea of the place of the Russian Church in it, was entirely fulfilled here in the cathedral of Christ's Resurrection (sobor Voskreseniya Khristova).

In 1649, before attaining high office, when he was archimandrite of the New Monastery of the Saviour (Novospasskiy monastyr') in Moscow, Nikon was given a model of the church of the Holy Sepulchre by the visiting patriarch Paisius from Jerusalem.[70] The plan of the Jerusalem church as it was in the seventeenth century was very faithfully reproduced in the cathedral of the Resurrection. It is possible that Russian pilgrims visiting Jerusalem, in particular Arseny Sukhanov, obtained more precise details of the church of the Holy Sepulchre. It is also likely that Nikon stipulated the use of drawings of the latter from Bernardino Amico's *Trattato delle piante ed imagini de sacri edificii di Terra santa* published in Rome in 1609 and in a new edition in Florence in 1620.[71] Comparison with these images shows the Russian church to lack a number of service buildings that were present in the Jerusalem model building. A major change was an increase in the number of side-chapels from fourteen in the latter to twenty-nine in Nikon's church, most of them dedicated to events in the life of Christ and the Stations of the Cross. Architectural narrative was more detailed in the Russian complex, the theme of the New Testament being even stronger than in the Jerusalem model. For Patriarch Nikon, founding a new universal centre for the Orthodox world, this took on eschatological significance, not belittling but enhancing the transferred shrine. The train of thought is reminiscent of the conception of the Third Rome, which unlike its two predecessors, Ancient Rome and Constantinople, was supposed to last "for all time".

The extraordinary compositional complexity of the cathedral of the Resurrection is largely due to the fact that some three-tenths of the sacred space of the interior is occupied by junctions with the surrounding churches and side-chapels at very different heights from cellar to cupola. The latter was replaced by a tent roof during the building's construction, Nikon's dislike of this roof form notwithstanding. The impact made by this complex structure, both exterior and interior, is one of monumental grandeur (pls 173, 174). The effect is enhanced still further by extensive use, on interior and exterior surfaces throughout the complex, of brilliant, multicoloured ceramic tiles, executed by craftsmen brought from the recently annexed territory of eastern Belorussia (pls 175, 176). It has been conjectured that these craftsmen (Pyotr Zaborsky, Stepan Polubes and others) made use of illustrated books from the West;[72] it is more likely, however, that the use of such glazed ornamental tiles had Eastern origins, for they appeared in the time of Nikon on exteriors in Volga towns that traded with Central Asia.

Patriarch Nikon's New Jerusalem, although Italian drawings of the church of the Holy Sepulchre were probably used as models, was the apogee of the Byzantine movement in seventeenth-century Russian culture, or more precisely, the high-water mark of Russia's community with the older Eastern Orthodoxy. Here the idea of the Third Rome absorbed features of the New Jerusalem, and this, perhaps, is the chief meaning of Muscovite architectural ideology during the reign of Alexis Mikhaylovich, despite the fall and exile of Patriarch Nikon.

By the middle of the seventeeth century, Russia had recovered from the ruin of the Time of Troubles. Trade had revived and the advantages of a huge and unified state, with its own natural resources and vast internal market, had begun to take effect. The role of towns was increasingly important. Merchants became a powerful social force and developed into patrons, with means comparable to those of the tsar. Numerous parish churches were built on their initiative, not only in Moscow but also, and especially, in the wealthy market towns of the Volga. In the second half of the reign of Alexis Mikhaylovich local architectural schools, above all in Yaroslavl', flowered to such an extent that they left Moscow architecture behind and exercised their own influence on it, especially in the use of decorative tiles. Complex and multi-layered compositions were seen, church plans grew more varied, decorative schemes combined brick with coloured tiles. At the same time, the provinces remained attentive to those motifs of Moscow architecture that were perceived as indications of the tsar's power.[73] In Yaroslavl' churches such as that of St John the Baptist (Sv. Ioanna Predtechi), Tolchkovo [74] and St John Krysostom (Sv. Ioanna Zlatousta), Korovniki (pl. 177), and in numerous other churches dating from the second half of the seventeenth century, from the celebrated monastery church of the Holy

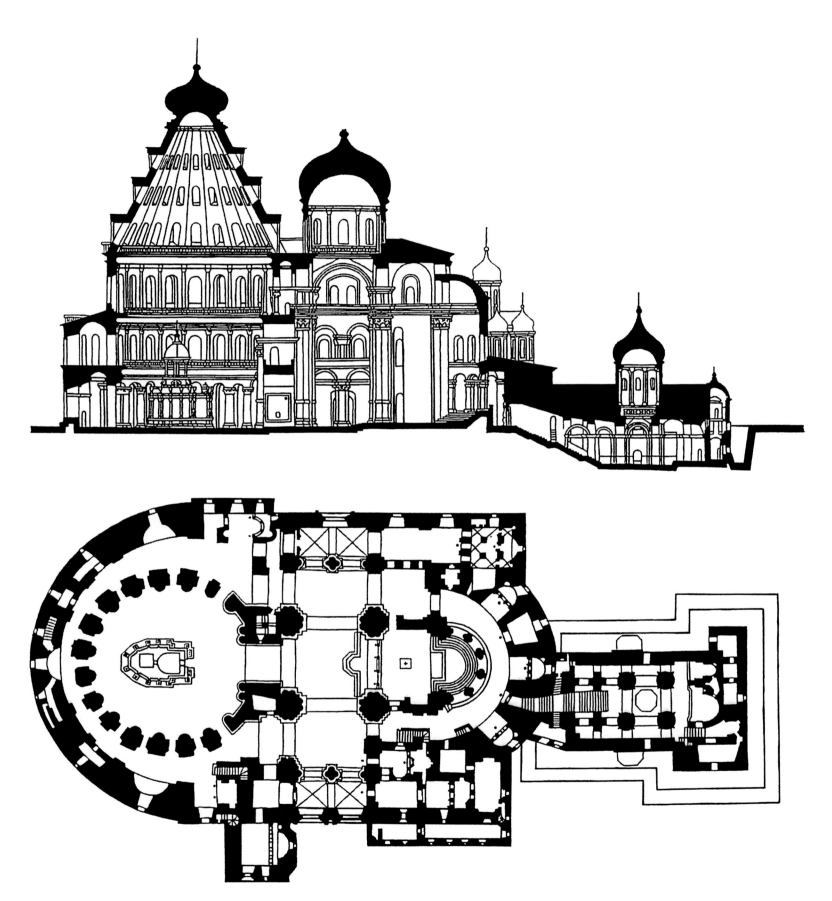

172 Plan and elevation of the cathedral of the Resurrection, New Jerusalem Monastery, Istra, 1658–85.

173 and 174 (*following pages*) View from the east and the interior of the cathedral of the Resurrection, New Jerusalem Monastery, Istra, 1658–85.

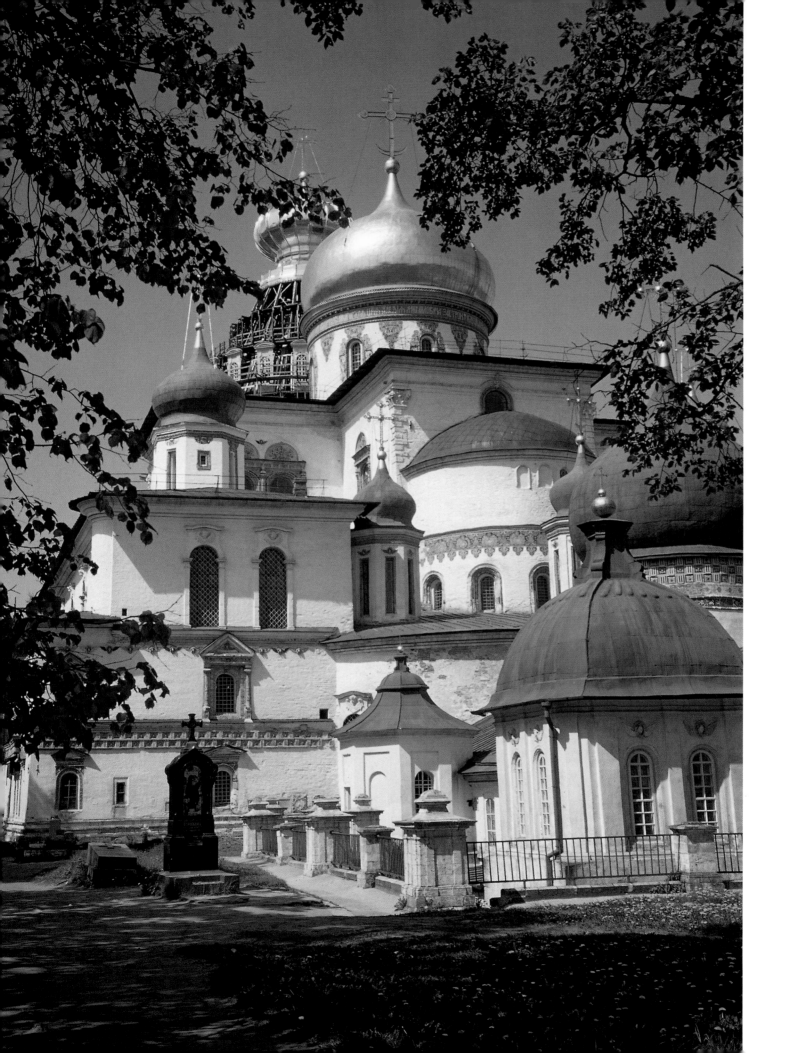

175 Iconostasis in a side-chapel of the cathedral of the Resurrection, New Jerusalem Monastery, Istra, 1658–85.

176 Decorative tiling, cathedral of the Resurrection, New Jerusalem Monastery, Istra, 1658–85.

Spirit (Sv. Dukha) in Solotcha near Ryazan' (pl. 179) to almost entirely forgotten village churches like that of Khrapovo in the province of Ryazan' (pl. 180), rich ornament became almost the main architectural feature. In this, perhaps, Russian architecture to some extent displayed its Eastern aspect.

Meanwhile, as many parish churches were being built, the church type of the Holy Trinity in Nikitniki was evolving in Moscow. This type is especially clearly seen in the church of St Nikolay, Bersenevka (1656), standing on the embankment of the Moskva on the diagonal from the Kremlin to the Kamenny Bridge, one of the main crossing-points from the south to the city centre; or the church of St Grigory of Neocaesarea (tserkov' Sv. Grigoriya Neokessariyskogo) on Bol'shaya Poly-

anka Street, crossing the district of Zamoskvorech'ye (pl. 178).[75] These churches share an organized composition with an upward thrust and emphasis on the crowning five domes. The ornamentation of the *chetverika* (central square of the interior) of the church of St Nikolay is modelled on the composition of the façades of the Holy Trinity in Nikitniki, with their great cornice and column-clusters. But dominant here are not the Orders, but the central division of each façade, with three large windows set close together with imposing *nalichniki*, and surmounted not, like the windows of the flanking divisions, with a single *kokoshnik* but with three. Above the cornice are two platforms set one above the other: a rectangular one with false *zakomary*, and above it an octagonal one pierced throughout

174

with ornamental arches. Above these, the drums of the cupolas are still more richly ornamented. The church of St Grigory has a similar ornamental scheme, and additionally, some breathtaking highly coloured tiled friezes by Stepan Polubes. The tall tent-roof belltower above the main entrance is also decorated with brilliant-coloured tiles. The patron made the following demands in regard to the decoration of this church: "paint [. . .] different decorations, and where there is bare wall, paint on [stuccoed] brick [. . .], and line the spire with *strelki* [pinnacles on the ribs] and whitewash between them, and [. . .] paint the *zakomary* and *nalichniki* in different colours; and paint the carved stonework of the belltower."[76] The tendency to extreme decorativeness was not only the choice of craftsmen but also a desire of patrons.

Domestic buildings of the time of Alexis Mikhaylovich could not compete with those of the church, at any rate those built of brick, although their number steadily increased. Most of them were of rectangular plan, with simple, often symmetrical room layout and two or at most three main storeys. Ornament was usually limited to *nalichniki* over the windows (pl. 181). In rare cases, as for example the palaces of the Princes Golitsyn or the government official Averky Kirillov in

Moscow, ornamentation was more developed, taking forms borrowed from or strongly influenced by religious architecture, and in alterations around the turn of the seventeenth and eighteenth centuries acquiring an increasingly Baroque character (pl. 183).

It must be remembered, however, that today we are mainly judging by brick buildings surviving from a time when urban estates included large numbers of wooden buildings, often multi-storeyed and taking strongly individual forms, with miniature towers and elaborate, often painted wooden fretwork. Although no example of such urban architecture has survived from the seventeenth century, some idea of its splendours and complexity may be gained from depictions and descriptions of Tsar Alexis's out-of-town palace in Kolomenskoye, which was demolished in the eighteenth century.

The Kolomenskoye palace was built mainly in 1667–68 by Semyon Petrovich and Ivan Mikhaylov, and completed in the early 1680s by Savva Dement'yev. From a distance this gigantic building must have looked like a whole town of wooden buildings, with numerous pointed towers, exotic-looking cupolas and church roofs (pl. 182). To Western visitors it seemed a fantastic and precious marvel. Jakob Reitenfels wrote in 1680

177 View of the churches of St John Krysostom (Zlatoust) and of the Vladimir Icon of the Mother of God in Korovniki, Yaroslavl', second half of the seventeenth century.

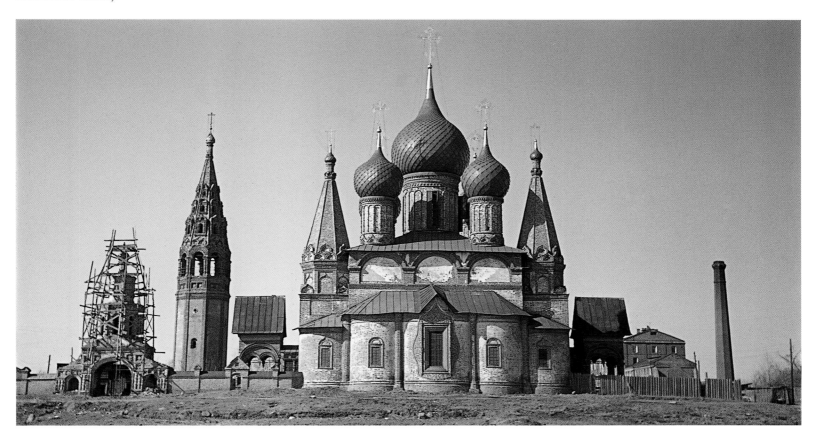

178 (following page) Church of St Grigory of Neocaesarea, 1667–69, Moscow.

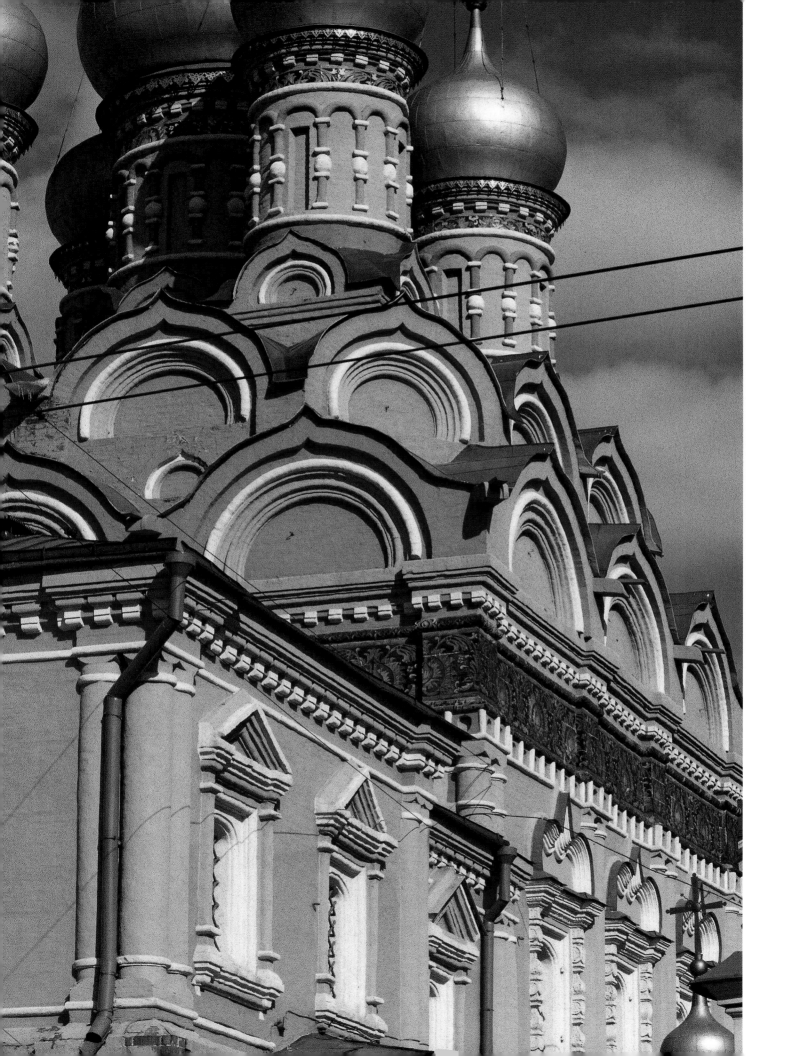

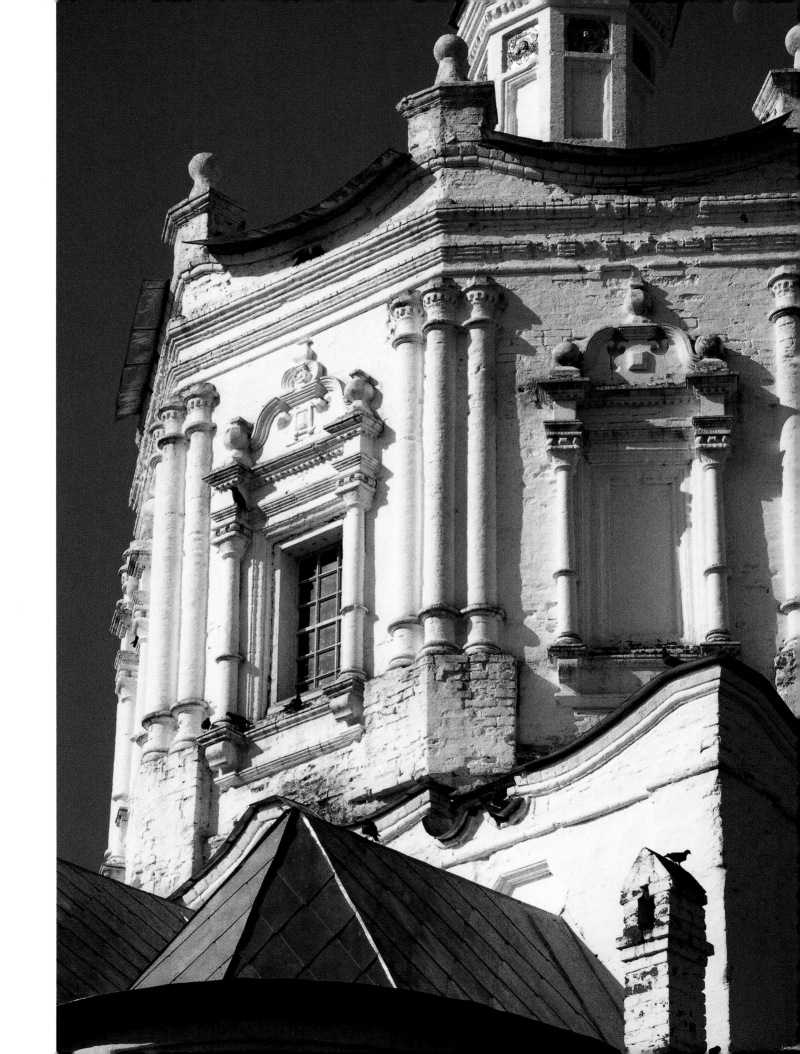

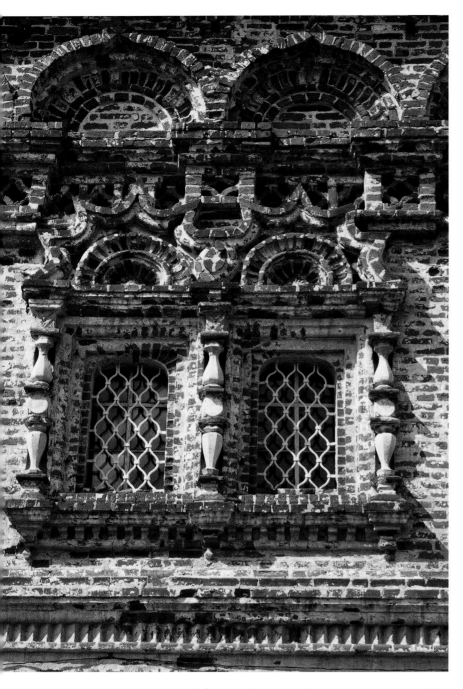

allotted individually to the tsar, the tsaritsa, the tsarevich and the four princesses. The tsar's rooms, of course, were larger than the others, and the reception rooms included a sumptuous dining hall. The masonry church of the Icon of the Mother of God of Kazan' (tserkov' Ikony Kazanskoy Bogomateri) was joined to the palace, and there were a number of service rooms and outbuildings.

The whole wooden complex was divided vertically into a high ground floor with a lower service floor, several storeys of main rooms, each clearly distinguished by elaborate window ornamentation, and an attic storey. Roof forms and the treatment of exterior wall surfaces were in strict accordance with palace hierarchy. The walls of the tsar's rooms were shingle-covered over the timber framework, with cornices between storeys and ornate carved *nalichniki* over the windows. The roofs of this part of the palace were especially striking and varied, with "barrel", "cowl" and cube forms alongside tent roofs; all roof surfaces were covered with *lemekh*, a kind of wooden tiling. The exteriors of the quarters of the tsaritsa and the tsarevich were ornamented in a similar manner to those of the tsar, but with simpler fretwork and more standard roof forms. The plain roofs of the princesses' quarters were four-sided, and walls were plain timber uncovered with shingles; the windows had almost no ornament and were smaller than those elsewhere, so that the princesses could not be seen from outside. A tall tower belonging to the tsar's part of the building dominated the whole complex.

It has been remarked that the individual units of the palace in Kolomenskoye are not very different from the houses of typical well-to-do citizens of the time, in which there was also usually a ground floor, reception rooms, and private quarters on an attic floor,[78] and that such houses, with their service buildings, would have formed complexes no less picturesque. Nevertheless, the Kolomenskoye palace, both in its scale and in the flavour it contained of the palace hierarchy and way of life, undoubtedly stood out among other houses to the extent that Muscovites considered it "the eighth wonder of the world". And even by modern architectural historians it, or the enduring image of it, is seen as a shining symbol of Russia during the era of Tsar Alexis Mikhaylovich, of a country on the eve of the reforms carried out by his son Peter the Great, who would replace this rich, organic picturesqueness with a strict new regime of ordered regularity.

German, Dutch and Italian architectural publications reached Russia more and more frequently during the reign of Alexis Mikhaylovich.[79] Books of this kind were held in the library of the Gunnery Department, responsible for artillery and fortifications, and also in the Embassies Department where, in the time when it was headed by Artamon Matveyev,

180 Window surrounds (*nalichniki*) on the façade of the church of the Intercession, Khrapovo, 1686

that "thanks to its astonishing form and expertly fashioned shining gilded ornament, the whole looks as if it had just been taken out of a treasure chest".[77]

Measuring more than 200 metres by approximately 150 metres, consisting of some 70 wooden units on three to six levels, this palace was a thoroughly picturesque composition. It lacked any hint of a regular plan, its main and private rooms being divided into seven "mansions", each with many rooms,

179 (*previous page*) Upper part of the church of the Holy Spirit, monastery of the Intercession, Solotcha, 1688–89.

181 Seventeenth-century house, Kaluga.

182 The tsar's wooden palace, Kolomenskoye (Semen Petrov, Ivan Mikhaylov and Savva Dement'yev), 1667–68, 1681; engraving, 1790.

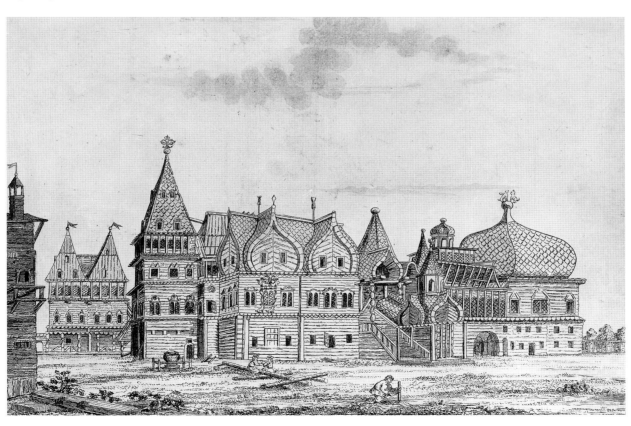

who was close to Alexis and known for his interest in foreign innovations, a library of some dozens of architectural books was built up. Patriarch Nikon was another collector of foreign architectural books, especially in connection with the building of New Jerusalem; after his fall, much of his collection was taken over by the tsar. Later, one of the favourites of Princess Sofya, elder sister of Peter the Great, made use of both this collection and the volumes remaining in the Embassies Department library after the death of Matveyev.[80] Attempts by numerous Russian and foreign architectural historians to identify Western architectural books and treatises mentioned in the inventories of Russian libraries of the period have hitherto met with no success; and similar research using later sources, for example inventories of the archives of pre-Petrine institutions made during the reign of Catherine the Great, has been almost equally unsuccessful. It is therefore possible to speak of book knowledge of architecture in Russia at the time of Alexis Mikhaylovich only in the most general sense. And indeed, no influence of classic architectural treatises on building practice of the time has yet been traced.

Western sources connected with other art forms, on the other hand, such as book illustrations and jewellery, made a more pronounced impact on Russian architecture in the second half of the seventeenth century, and often bring out the meaning of Russian decorative motifs of the time. The illustrations in the Latin Piscator's Bible,[81] published in the Netherlands, for example, provided motifs that influenced not only Russian icon-painting but even architectural ornamentation and decoration after the edition reached Moscow. Both Mannerist and Baroque works were influential in this way, but gradually Baroque began to play the major role. The popularity of Baroque models increased after Russia's annexation of eastern Ukraine, Kiev and eastern Belorussia. In the last quarter of the seventeenth century, Ukrainian and Belorussian craftsmen, mostly stone-carvers, sometimes also performing the work of architects, began to enter the tsar's service and also to undertake commissions for the families of courtiers.[82]

Their work resulted in the carpeting of new buildings with ornamental designs of diverse origins. This *mélange* was in a constant state of development, which was not simply the next evolutionary stage. On the contrary, throughout the seventeenth century Mannerist features of one type or another, late medieval, post-Renaissance, and in the case of Moscow post-Byzantine, combined with traditional Russian forms and Baroque elements, the latter, again, of diverse origins and traceable to numerous European architectural schools. The process is significant in that it helps towards an understanding of non-Classical and non-Baroque characteristics of many buildings of the period. It is to be stressed once more that the case is never

one of a specific form of European Mannerism becoming established in Russia, but rather the manifestation of Mannerist elements in the heightened ornamentation and stylistic indeterminacy seen in the post-Byzantine architecture of the Muscovite State. In the course of the seventeenth century Mannerist elements associated with the sixteenth century were displaced by Baroque; the swelling population of the Foreigners' Suburb of Moscow, the Nemetskaya *sloboda* contributed to this,[83] and the resulting buildings had their influence on the formation of the tastes of Muscovites with an interest in the Westernization of Russian life. This process took place during the years of Peter the Great's full reign as tsar, up to the moment of the official proclamation of the Empire in 1721. Alongside Baroque ornament, the role of motifs drawn from the Orders steadily gained in importance. In essence, though, free interpretation of the Classical Orders had already emerged in Russian architecture in the seventeenth century. It was to be only a moment of time before Russian architecture entered the European context.

A just appreciation of the relative stages of development of West European and Russian architecture in the seventeenth century is not easy to achieve. Architectural historians have traditionally seen this period as a belated last stage of the Middle Ages, and the Western European idea of a late medieval flowering is commonly applied to the Russian architecture of this period. A disparity of one and a half or two centuries thus arises as between what happened in Russia and in the West. This, surely, is highly contradictory.

To be consistent, the Late Middle Ages should be followed by the Renaissance. If the seventeenth century were to be the Late Middle Ages, Russian architecture in the eighteenth century should be the Renaissance, beginning in the reign of Peter the Great. But this would be to destroy the logic of cultural history. Seventeenth-century Russian architectural forms suggest not only the features of a "late medieval" flowering, but also those of the beginning of a new one, of an emerging style which sought to make use of European attainments, even if their impact on Russian architecture took a random and mediated course rather than a direct one. The Terem Palace and the church of the Holy Trinity in Nikitniki, the most important achievements of Muscovite architects of the period, paved the way for the "architectural revolution" of the early eighteenth century. The post-Byzantine "Mannerism" of the Muscovite State, the typical style of Russian architecture for at least one and a half centuries, from Ivan the Terrible to Alexis Mikhaylovich, and finally Baroque influences from the Ukraine and Poland, prepared Russian architecture for the reforms of Peter the Great.

183 (*facing page*) The house of Averky Kirillov, Moscow, c. 1657, rebuilt early in the eighteenth century.

IV

Russian Imperial Baroque

1 Peter the Great's Architectural Reforms

Peter the Great was the first Russian monarch to travel abroad. He gained his own first-hand impressions of foreign architecture, and his extensive library contained a large number of books and treatises on architecture and fortifications published in the Netherlands, France, Germany, England and Italy. New architecture played an important part in his programme of reforms and Russian architecture underwent radical change during his reign. This was largely because, unlike his predecessors on the throne, the first Russian emperor had a very precise idea of what he wanted the towns and buildings in his new state to look like.

Russian architectural reforms were carried out in accordance with his own ideas and personal tastes by a multitude of foreign masters whom he invited first to Moscow and then to St Petersburg. Their number was greater than that of the architects and craftsmen brought to Russia by Ivan III and his son Vasily III in the late fifteenth and early sixteenth centuries. The latter had come from Italy only, but Peter the Great engaged masters from a number of different European countries. It would be wrong, however, to imagine the changes that took place in living conditions in Russia during the first quarter of the eighteenth century as being due to their activities alone. Architectural development at this time was determined in the first place by the needs created by state reforms. A major role in this process was played by the new ideology created by Peter and bearing the stamp of his personality. Important too was the emperor's organization of the training of Russian architects and craftsmen abroad or by the foreign masters invited to Russia. By the end of the 1720s this programme had produced a new generation of European-educated Russian architects.

It all began in the early 1680s, in the most apparently innocent way, with the boyhood games of the young tsar blocked from power by his elder half-sister Sofya Alekseyevna when she became regent. Peter lived at this time in an old palace of his father's in the village of Preobrazhenskoye on the north-eastern outskirts of Moscow (pl. 185). His mother, Natalya Kirillovna, née Naryshkina, second wife of Tsar Alexis, endeavoured to give him the best possible education. The young Peter was fascinated by the illustrations of foreign life used by his teachers. He would play dressing-up games in foreign styles, and then he formed units of young people and played war games with mock regiments, building a miniature fortress in Western style. The "mock" regiments played a serious role in Peter's struggle with Sofya and his seizure of power in 1689. The young tsar's passion for change was soon evident, resulting in a grand tour abroad in 1697–98. He travelled incognito as a member of the Great Embassy of 250 persons, visiting a number of German principalities, the Netherlands and England. On his return to Moscow in 1698, reform of all departments of state became not merely his personal desire but his official policy.

He aimed to transform the appearance of his subjects, their homes, towns and cities, simultaneously and as rapidly as possible. He ordered everyone to dress in Western style and men, excluding clergy, to shave their beards, an unimaginable step to take in seventeenth-century Moscow. The use of coffee and tobacco was encouraged. An enormous quantity of decrees was issued, devoted to the reorganization of every conceivable detail of everyday urban life, from the positions of houses on a street to the required form of fences and gates, from measures for the prevention of fires to the stipulation that butchers should cover their counters with white linen. All this seemed like a continuation of childhood dressing-up games expanded into a huge mascarade. But it had the most profound consequences for the country, including its architecture.

The first half of the eighteenth century is a key period in Russian architectural history, beginning with Peter the Great's assumption of full power and ending in the mid-1760s when

184 *(facing page)* Detail of the west front of the cathedral of the Smol'nyy convent, St Petersburg (Francesco Bartolomeo Rastrelli), 1748–64.

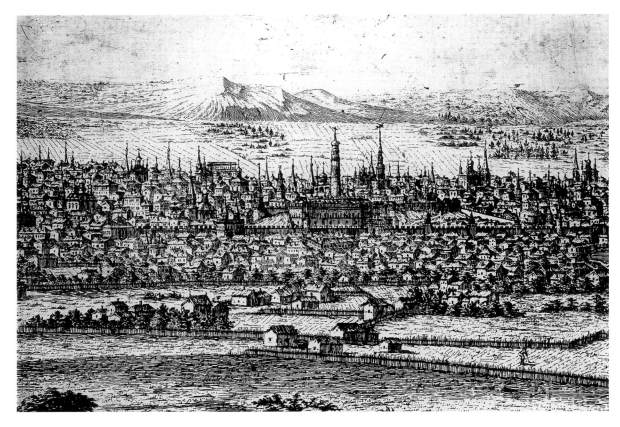

185 Johannes van Blicklant, panorama of Moscow (detail), 1708.

Catherine the Great's reforms began to take effect, and when a decisive change in national taste finally took Russia into the mainstream of European architectural evolution.

During this period the consistency and rate of architectural development in St Petersburg, Moscow and the provinces varied. Before the foundation of St Petersburg, and when building came to a halt there on Peter's death, Moscow took the lead. The new capital on the Neva naturally experienced the full force of political and architectural events of the Petrine period. Here the most important foreign masters worked, and the sovereign's new projects succeeded each other more rapidly than anywhere else. It was in St Petersburg that elements of the Baroque style converged from the most diverse points of origin – Italy, Prussia, Saxony, France, Sweden, the Netherlands and a number of other countries. In St Petersburg in the late 1730s and early 1740s, under the great architects Pyotr Yeropkin and Francesco Bartolomeo Rastrelli, Russian Imperial Baroque achieved its consummate form as the state style, spreading through the whole country, ousting local traditions or sweeping through them in a mighty new tide. In Kazan', Yaroslavl', Tot'ma and numerous other cultural centres remote from the imperial capital, lively stylistic variations emerged in which traditional local features assumed an overall Baroque character.

In Moscow the new architecture of the first half of the eighteenth century took hold in a different way, in several stages, which architectural historians have often characterized as successive varieties of Baroque. The present writer prefers to think of these as a mingling of a Russian kind of "Mannerism" and Baroque, with gradually increasing features of the latter. One of these stylistic stages was "Naryshkin Baroque" which emerged at the turn of the seventeenth and eighteenth centuries, the style of buildings raised by the family of the mother of Peter the Great, Tsar Alexis's second wife, Natalya Naryshkina, who played a leading role in the first years after his assumption of power. This was followed by the "Petrine Baroque" of the first quarter of the eighteenth century, seen mostly in the buildings commissioned by Peter himself and his courtiers, especially his leading favourite, Prince Aleksandr Danilovich Menshikov. Finally, lasting through the second quarter and middle years of the eighteenth century, came "Imperial Baroque".

The achievement of a unified, Europeanized architectural style in Russia was a complex and gradual process. It took Peter the Great his entire reign simply to find the basis for such a style. He left the transformation of Russian architecture uncompleted at his death in 1725. The final form of Russian Imperial Baroque was attained only during the reigns of his

niece Anne, Empress for ten years after seizing the throne in 1730, and his daughter Elizabeth (1741–61). The present chapter is devoted to the role of foreign sources and masters in the development of this style.

2 Architectural "Manners" in Moscow in the Early Petrine Era

It is important to understand the links between the new architecture of the Petrine era and earlier Russian architectural history. This is particularly the case with Moscow (pl. 185). The dominating personality of Peter the Great and the emphatic Europeanism of his tastes often obscure the fact that changes brought about in Russian architecture at this time were the result of a prolonged process in which Russian architecture was gradually led towards the West. Indeed, Russia almost acquired a "European" capital in Moscow at the end of the fifteenth century, 200 years before the founding of St Petersburg. In both political and ecclesiastical history, new elements from the West always, and particularly in the twelfth and fifteenth centuries, found their way into the ideology of the state, through architects and craftsmen invited to Russia by its rulers, and the work of these foreign masters expressed the mentality of their employers' courts first and foremost.

Another important aspect of Petrine architecture was that it expressed new concepts of the tsar's power and the structure of the Russian state, creating a tangible, future-oriented image of the new empire and itself embodying the utopia towards which it pointed. Such an image, however, had existed in Russian art and culture for a long time. It had been connected with the idea of Russia as the heir of Byzantium, of Moscow as the Second Constantinople, the Third Rome and the New Jerusalem. In the sixteenth and seventeenth centuries this ideal had been mainly a theocratic one. Peter the Great built up a secular and pragmatic side to it. But his ideal of the Russian state preserved a utopian character.

During his reign radical changes took place in architectural language which enabled it to express this ideal, a language that Russia's ruler wished to make understood throughout Europe. Peter's new conception of his authority was expressed not only in his political ambitions and the imperial terminology and system of titles he adopted from Ancient Rome,[1] but also in the first buildings he raised in Moscow before founding St Petersburg. After his victory over Turkey in 1696 (seven years before the founding of St Petersburg) he ordered, on his return to Moscow, the organization of a "triumph" in the ancient Roman manner.[2] Wooden arches were subsequently built which were modelled on the triumphal gateways of Ancient Rome (pl. 186). This was the first direct appeal to Antiquity in

Russian architectural history. In inscriptions and depictions on these arches, Peter compared himself with the Emperor Constantine after his victory over Maxentius, and especially with Julius Caesar.[3] His library contained a manuscript translation of a work by Giovanni Giacomo de Rubeis on Roman triumphal arches[4] published in 1690,[5] which probably served as a source for triumphal building projects in Moscow.

For the previous three centuries churches had always been built to mark triumphs of Russian arms. Under Peter the Great, secular structures in the Classical tradition were built for this purpose; they were unconnected with any current European architectural style, Baroque or Classical for example, and this is typical of buildings of the early Petrine period. A programme of buildings modelled on Classical Antiquity in type and spirit emerged before imitation of any particular variety of Classical architecture existing in Europe at the time. At the beginning of Peter's reign, various motifs thought of as "Roman" continued to combine with "mannerist" freedom in Russian architecture, and triumphal structures were built in which inscriptions and allegorical depictions played the main role. These displayed an intense complexity and compositional richness using fully Classical elements in unusual and whimsical combinations. The "mannerist" character of the wooden triumphal arches that appeared in Moscow at the turn of the seventeenth and eighteenth centuries sets them off markedly from those built in the mid-eighteenth century when Russian Imperial Baroque was fully formed, such as the numerous arches that sprang up in celebration of the coronation of Elizabeth Petrovna in 1741.

The years of Peter's minority brought the re-emergence of a process first seen a hundred years previously in the buildings raised by Boris Godunov and his relatives and inner circle. Each of the leading aristocratic families of Moscow began to build in its own special "manner". This trend was based not only on individual family tastes but also on preferences for a particular architect or builder. It should be noted that the features of a new architecture were common to all these varying manners. The buildings of this period, of great ornamental and decorative sophistication, perhaps make an even stronger impression today than the severe architectural forms of early St Petersburg. Had the Petrine reforms never occurred, these buildings suggest that Russian architecture would still have undergone significant change. It would have evolved at a more sedate pace and with greater use of the pre-Petrine heritage, but change there would surely have been, with absorption of European experience and a movement towards Baroque.

The Golitsyn family was responsible for some highly distinctive buildings, despite the dramatic reversals in the fortunes

ВРАТА ПРИ ДВОРѢ ЕГО СВѢТЛОСТИ КНЗА МЕНШИКОВА

186 Triumphal gateway in the grounds of Prince Menshikov's mansion, Moscow; engraving, 1710.

of some of its leading members. Prince Vasily Golitsyn, favourite of the regent Sofya, was famous for his Westernizing tastes, and his palace was designed "in the Polish manner".[6] After his fall from favour and exile, his first cousin Prince Boris Golitsyn became one of Peter the Great's closest advisers. He commissioned the church of the Sign of the Mother of God (tserkov' Znameniya Bogomateri) in Dubrovitsy outside Moscow (1690–1704), in the building of which Italian masons

most probably collaborated (pl. 187).[7] Of centralized plan, with a single cupola crowned by an ornate cross, a heavy rusticated socle and much sculptural ornamentation, some of it heraldic, this is one of the most Mannerist buildings of the Petrine era (pls 188–90).

The buildings of the Naryshkin family[8] included a number of tall central-plan churches whose exteriors were composed of geometrically clear-cut masses raised on a socle and with an

187 (*facing page*) Church of the Sign of the Mother of God, Dubrovnitsy, 1690–1704.

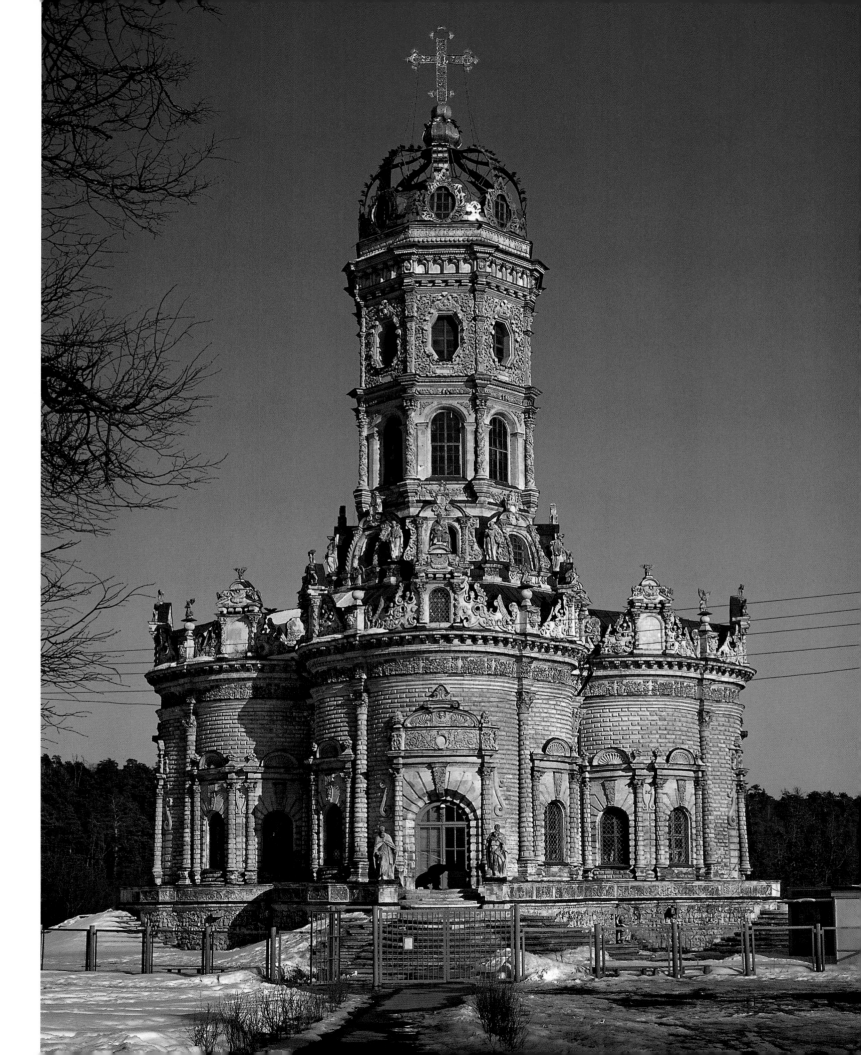

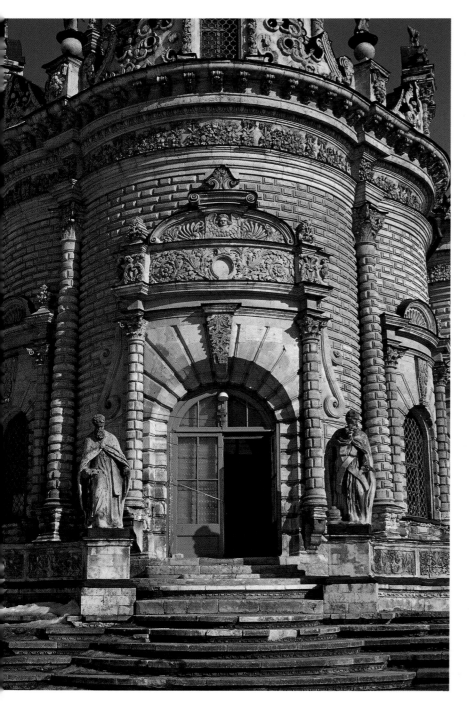

189 Plan of the church of the Sign of the Mother of God, Dubrovnitsy, 1690–1704.

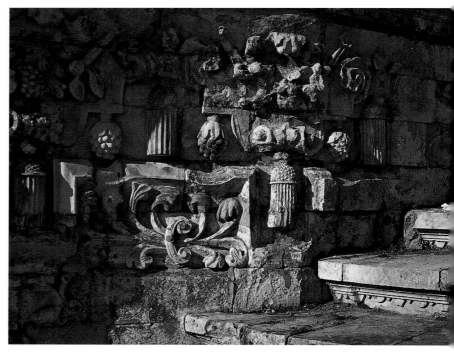

188 Portal of the main entrance of the church of the Sign of the Mother of God, Dubrovnitsy, 1690–1704.

190 Socle with sculptural ornament, church of the Sign of the Mother of God, Dubrovnitsy, 1690–1704.

open all-round gallery. The ornamentation of this sort of church used versions of Baroque motifs from the Ukraine, and its style was still known as "Naryshkin Baroque" at the beginning of the twentieth century, even where the builders were not always Naryshkins. Churches built outside Moscow in the 1690s such as the Intercession of the Mother of God (Pokrova Bogoroditsy) in Fili (pls 191–93), the Saviour (Spasa) in Ubory,

the Holy Trinity (Sv. Troitsy) in Troitsko-Lykovo and many others represented the taste of this court clan whose status rested on its legitimate right to the throne but whose members did not fully share Peter the Great's desire for reform or his taste for the new.

The use here of the term "Baroque" is very approximate. The overall design of "Naryshkin Baroque" churches indicates,

191 (*facing page*) Church of the Intercession of the Mother of God, Fili, Moscow, 1693–94.188

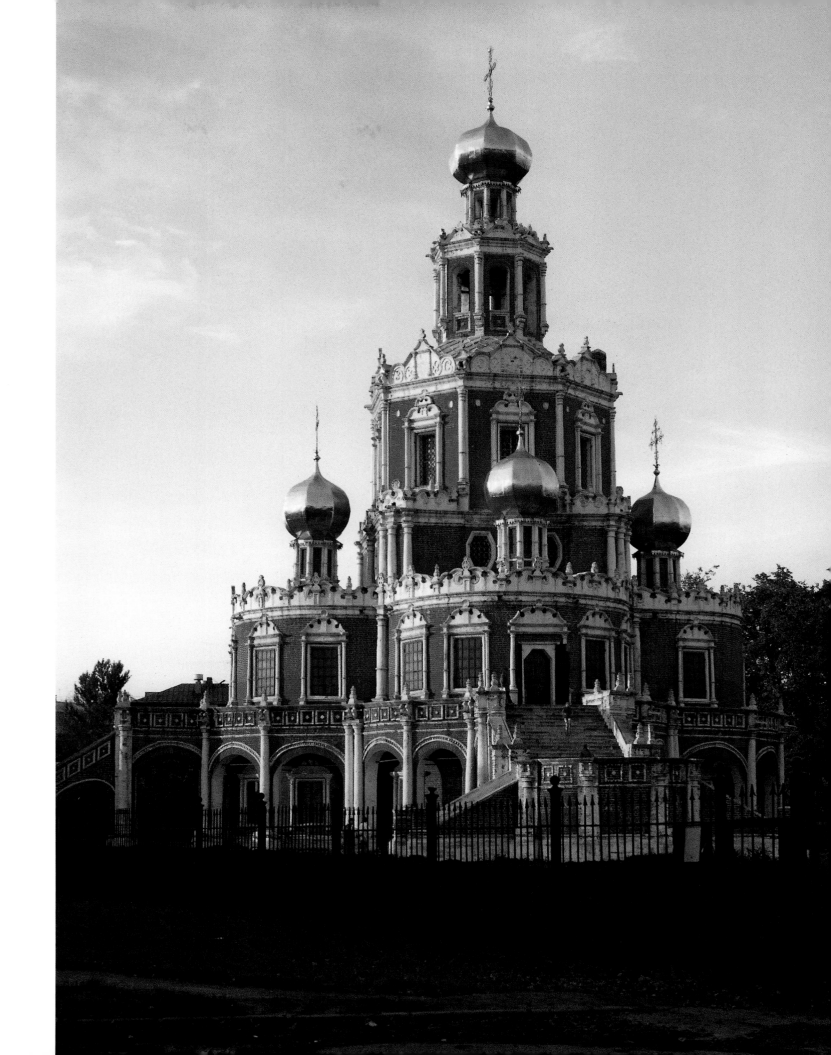

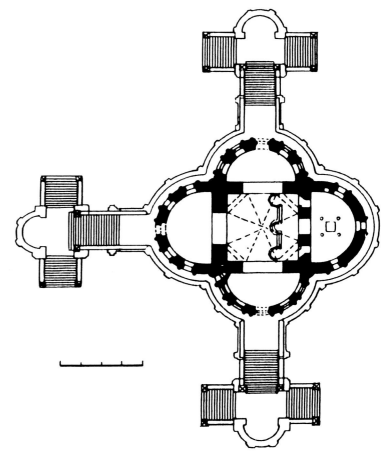

193 Plan of the church of the Intercession of the Mother of God, Fili, Moscow, 1693–94.

192 (*left*) Detail of the exterior gallery of the church of the Intercession of the Mother of God, Fili, Moscow, 1693–94.

rather, their connection with centralized Renaissance buildings illustrated in architectural treatises that reached Eastern Europe before practical use was made of them by architects in the Ukraine and Belorussia. These territories were then part of Poland, but a fair proportion of their population maintained their Orthodox faith and links with Russia. The centralized designs of many "Naryshkin" buildings most probably reached Moscow, after a long delay, from Italian sources via Poland and the Ukraine. At any rate, Ukrainian architects and stone-carvers certainly worked in Moscow.

However, although their work displays affinities with the Baroque in ornamental motifs, it is more correct to speak of

194 (*right*) View of the church of St Nicholas on Il'yinka, Moscow, 1690s; lithograph, 1840s.

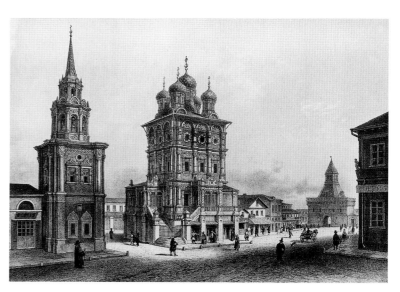

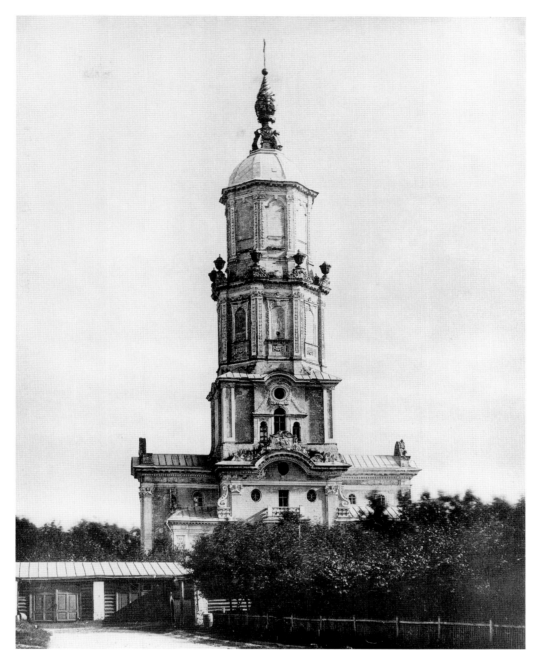

195 Church of the Archangel Gabriel (Menshikov Tower), Moscow (?Ivan Zarudny), 1701–07; phototype, 1881.

experiments with a particular architectural manner, and of entry of Baroque elements into Moscow post-Byzantine mannerist architecture, than of the emergence of the Baroque style in its European form (pl. 194). In Russian buildings of the Petrine era much detail may be found that is reminiscent of Baroque elements in the buildings of other countries. But only in very rare cases is it possible to observe in the work of foreign architects any consistent use of the principles and characteristic forms of Baroque.

The Moscow buildings of Peter the Great's chief favourite, Prince Aleksandr Menshikov, possess their own distinct manner. The story of the building of his residences is extremely confused. The church of the Archangel Gabriel, known in Moscow as the Menshikov Tower, built on his land in 1701–07, undoubtedly contains elements of full European Baroque in its northern variety (pl. 195).[9] However, these are not integrated into a stylistic system; on the contrary, they are torn out of it. To take just one example: in this church volutes, usually serv-

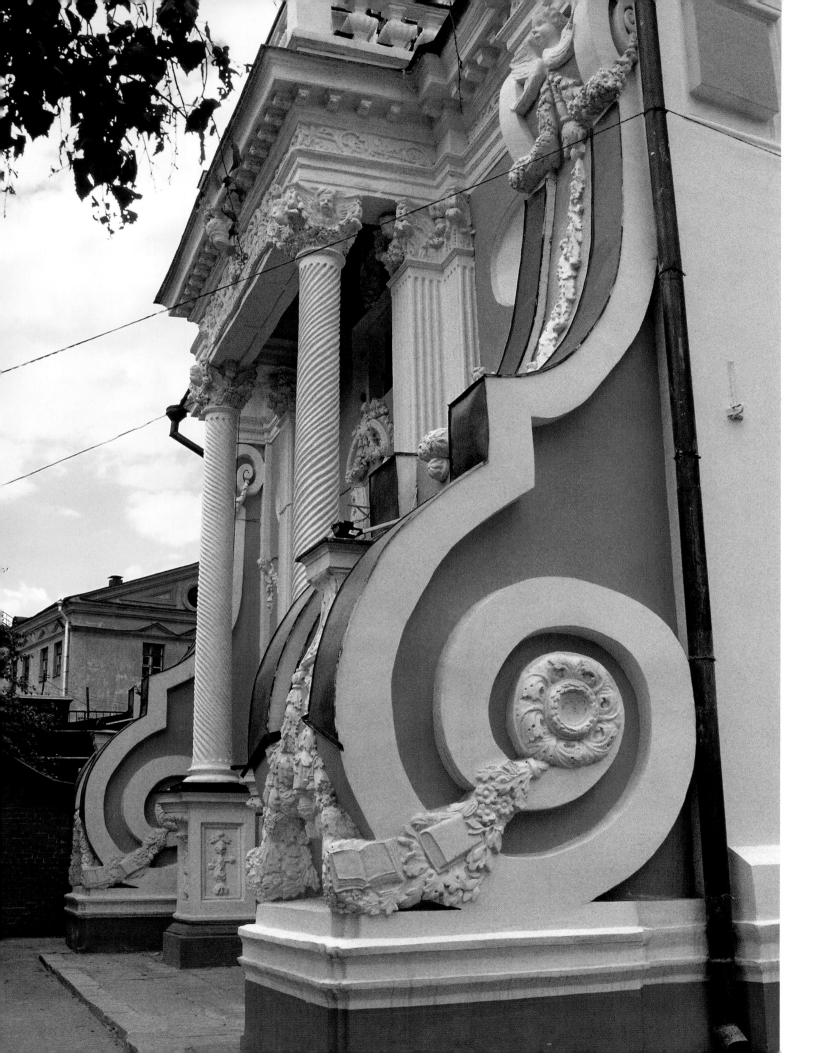

ing as ornamentation of portals, windows or roofs, are lowered to the ground and converted into huge buttresses (pl. 196), while retaining their Baroque scroll-shape outlines. Here the characteristic details of Baroque separate out and are used individually in true Mannerist style. A similar architectural process is discernible in the church of St Ivan the Warrior (Sv. Ivana Voina), built in Moscow in 1709–17.

More of these architectural manners of the Petrine era could be listed. All of them, it is to be noted, have Western connections of one kind or another. The German Gottfried Schädel[10] and the Italian Domenico Fontana[11] worked for Menshikov, and the Swiss-born Nicolas Tessin[12] for Boris Golitsyn. The Ukrainian architect Ivan Zarudny[13] worked for a number of leading figures, including Menshikov and the Naryshkins.

Moscow architecture at the turn of the seventeenth and eighteenth centuries has an eloquence and brilliance that seem to hint at the birth of a new style, displaying new ways of organizing space, especially centralized space, and ornamental elements – columns, portals, sculpture, various forms of *nalichniki* – connected to a greater degree than before with motifs from Polish, Dutch and even Italian Baroque. This architecture not only gives promise of change, but also indicates possible directions for change. The churches in Fili and Dubrovitsy have the impact of freshness and the young strength of a new-born style, and may be interpreted as manifestos suggesting a new direction in architectural evolution. In historical context, however, they were only steps on the way to European Baroque. They show possible versions of a Russian architectural style during a period of active experiment with innovation, versions of a kind of interrupted development that might have followed the path laid down by one of the individual manners of this period had the course of history been otherwise.

At the same time, these churches retain close links with seventeenth-century traditions in Moscow architecture. The marked inclination towards tall vertical compositions goes back to the tower-form churches of the previous two centuries, beginning with the Ascension in Kolomenskoye and its derivatives. The abundance of complex and picturesque detail in Golitsyn and Naryshkin Baroque buildings fully reflects prevailing architectural tastes in Moscow under the first three Romanovs.

In conclusion, it is impossible to speak of a single "Moscow" architectural style in the Petrine period. For the creation of such a style, an overall state initiative was required to regulate the various private attempts to emulate European architecture. Peter the Great transformed the polyphony of individual manners into a unified national style. In St Petersburg the tsar's power alone provided such an initiative, untrammelled by the need to consider the customs and tastes of the inhabitants of an old-established capital and free to concentrate entirely on the creation of a new city, with the new ideology demanding visible artistic and architectural expression. It was essential for Peter the Great and his court to choose which architectural forms best suited a state undergoing root and branch reform.

3 The Founding of St Petersburg and the Transformation of Moscow: The Image of a New Empire

The legend of Peter the Great clearly imagining the new city he was founding as it would be a century later is one of the enduring myths about the first emperor of Russia. The inner city as known today emerged in the 1740s, at the beginning of the reign of his daughter Elizabeth I. It was important for her to underline the significance of her father and of his dynasty as distinct from the other branch of the Romanovs descending from Peter's elder half-brother and, for a few years, co-ruler of Russia, Ivan V. Her predecessors, Empress Anne and the young Ivan VI, dethroned by Elizabeth, belonged to this branch. It was during Elizabeth's reign that the court mythology about the first emperor began to take shape, and it found many forms in the course of the next two centuries in the life of the Russian Empire. The founding of the new capital city of St Petersburg was its cornerstone, symbol of a new and flourishing state; on this ministers of the realm, leaders of the church, historians and poets were all agreed. In the Age of Enlightenment, Catherine the Great based the legitimacy of her tenure of the throne specifically on her own continuation of the first emperor's policies. Her inscription for Etienne Falconet's famous equestrian statue of Peter, which has become the emblem of St Petersburg, was carefully worded: "To Peter I from Catherine II". For Alexander Pushkin, Petersburg was "a window cut through to Europe", "a new empress", in other words, a symbol and paradigm of a new, Europeanized Russian tsardom. Under Peter the Great Moscow, on the other hand, became, in another of Pushkin's memorable phrases, "a purple-clad widow".

Pushkin's contemporary Prince Vladimir Odoyevsky also conveyed the achievement of the building of St Petersburg particularly vividly in one of his Romantic tales. "Meanwhile the tsar [. . .] began to raise wall after wall and hammer them into shape in the air. He continued to build in this way for a whole year, and then lowered [his city] to the ground."[14] The state-created myth that a final image of St Petersburg existed in the mind of Peter the Great eventually found a lasting place in the Russian national consciousness. Even today, Peter's role in the creation and realization of the image of the city remains undiminished in the popular mind. It is indeed the case that the

197 Sketch-plan for "a capital city on the Island of Kotlin", possibly in the hand of Peter the Great.

originality of Peter's thinking and his extraordinary energy not only played a defining role in the construction of Russia's new capital but also had a decisive impact on Russian architectural evolution in general.

The reality of the creation of St Petersburg, however, differs greatly from the myth. In the chorus of voices from the eighteenth to the twentieth centuries, it is necessary to listen to the most important one, that of Peter the Great himself, in order to begin to appreciate this. His endless ukases, letters and autograph sketches indicate that the building of the city was the result of an entirely different course of events from that of the imperial myth, namely, a complex, fevered, at times insane process of creation.

The founding date of St Petersburg, 27 May 1703, unquestionably marked a watershed in Russian architectural history and urban planning. Much has been written on the subject by Russian and non-Russian authors, from Igor Grabar', whose *History of Russian Architecture* (1912)[15] summarizing all known facts to date remains, in the present writer's view, unsurpassed, to James Cracraft's seminal *Petrine Revolution in Russian Architecture* (1988).[16] All scholars are in agreement that after the foundation of St Petersburg, Peter the Great's building activities took on entirely new aspects. It was at this moment that the emperor set about the realization of his utopian dream, the concrete construction of a new kind of state hitherto unknown in Russia. It is important to note that he created not only new laws and institutions but also a new living environment.

In previous times, ideology had been conveyed in architectural terms through symbolic forms and ornamental motifs.

Now ideology began to be expressed in architecture primarily through urban planning. To Peter the Great, a city and the character of life led in it were inseparable. In the new capital, the monarch offered an ideal model of the new state, believing that the innovatory character of the new forms he had invented could in itself substantially change real life.

Striking testimony of this is a rough sketch-plan dating from around 1709, which may have been drawn by Peter himself, for a new capital city on the Baltic (pl. 197).[17] He proposed a site 30 kilometres from present-day St Petersburg, on the open sea, on the long, narrow Island of Kotlin in the Gulf of Finland. He issued a whole series of ukases relating to the foundation of a "capital city" on Kotlin even after he had begun construction of the Peter and Paul Fortress (Petropavlovskaya krepost') and the Admiralty in future St Petersburg. The planned fortress of European type, with the usual residential quarter for service personnel, similar to Peter and Paul, and the fortified dockyard, also with its residential quarter, along the lines of the Admiralty complex, were by no means unusual projects for the emperor, who had already founded more than twenty similar settlements in the South in 1695–96, in the course of war with Turkey, on the Russian estuaries to the Black Sea. The latter had all been military settlements; the conception of a civilian settlement, in accordance with the emperor's imagined pattern for ordinary civilian life, was entirely new. The sketch-plan for a "capital city" on Kotlin provides a picture of the kind of "ordinary life" envisaged, and it is a chilling one.

In Peter's plan the whole island is turned into a city, threaded as on a sword-edge along a central canal with streets on either side. This main thoroughfare is intersected at regular intervals by smaller canals and streets. The scheme's impression of mechanical regulation is heightened by the identical dimensions of the plots of land that were intended for individual house-owners, all of equal size despite Peter's stipulations that the settlement on Kotlin would be composed of different social classes – courtiers, merchants and craftsmen – with three thousand persons in each. This plan, regulated to an extreme with absolute precision, conveys its author's conception of his relationship with his subjects, all equal in their lack of rights before their autocratic ruler.

Peter the Great was unable to realize this particular plan, for no one was willing to live in the middle of the sea. However, he stuck to his idea of a regular city plan, having the architect Domenico Trezzini base his plan of St Petersburg of 1714 on his first conception (pl. 198).[18] He again decided to site his "capital city" on an island, this time Vasil'yevsky Island on the estuary of the Neva.[19] A plan with the same kind of spatial organization as for Kotlin was at last executed, expressive of the regulated nature of life in the empire, with a uniform grid of

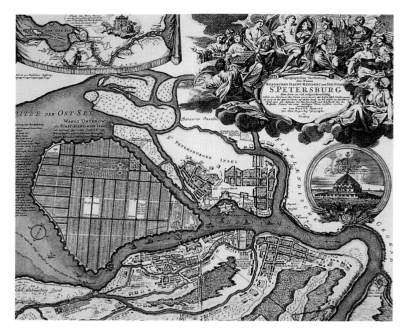

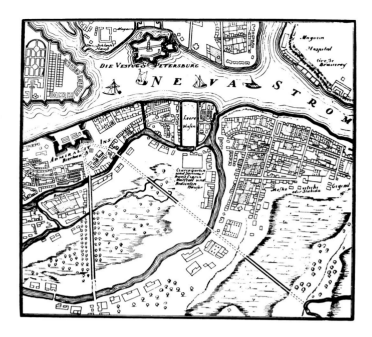

198 Plan of St Petersburg, 1720s; engraving showing Domenico Trezzini's city plan on Vasil'yevsky Island.

199 Plan of St Petersburg, 1720s.

streets and canals perpendicular to the main axis stretching from bank to bank. The layout of Vasil'yevsky Island still follows this plan today, with streets, called "lines" (*linii*), added to the early eighteenth-century canal system.

The social structure of the population living in the "city on Vasil'yevsky Island" was conveyed in spatial terms by a complex system. It was at this time that Peter classified all his subjects on the Prussian model. Those serving in the army, the navy, civilian departments of state, the imperial court and the church were ranked in fourteen classes according to a "table of ranks". In the new capital city on Vasil'yevsky Island each rank was allotted a residential "cell" of a defined size, in ascending order of place in the imperial hierarchy. Merchants were classified by the amount of tax they paid.[20] A typology of houses was devised by Trezzini; dwellings were built to a uniform design with specified dimensions for each rank of citizen,[21] and were also distinguished in surface ornamentation and decoration that bore features of restrained Northern Baroque. On Vasil'yevsky Island, which was designated "the city", these regulations were very strictly adhered to. In the more outlying parts of St Petersburg, on the Admiralty side, for example, control was less tight; there too, however, streets were laid out in a regular grid and imperial ukases on the placing of houses on their plots and the use of building materials were precisely carried out.

Nevertheless, despite all such efforts towards the creation of a strictly laid out city, plans dating from the end of Peter's reign

and the first years after his death show quite another, at first sight even chaotic picture (pl. 199). The city has broken up into disparate parts: the Peter and Paul Fortress and Gorodskoy (City) Island (now called the Petrograd Side) lying behind it, the Admiralty and nearby streets, the imperial residence in the suburb surrounding the Summer Palace (Letniy dvoretz) and its Gardens (Letniy sad), various *slobody*, and the heart of the capital on Vasil'yevsky Island. The *slobody* were settlements of craftsmen of one skill or another, and might belong to the Alexander Nevsky Monastery or to separate state institutions. The Admiralty, for example, put up buildings in a number of locations where tar was produced or worked with, such as Peter's Tar Yard (Smolyanoy dvor).

None of this appears to have had much to do with the ideal of a European city as it was understood at the beginning of the eighteenth century. In this connection, the fate of the well-known plan for St Petersburg by Jean-Baptiste-Alexandre Le Blond prepared in 1716 (pl. 200) is typical.[22] This was a classic example of the European city ideal of the time in all respects: the compactness, surrounding ring of fortifications in Vauban style, the complex, precisely regulated structure. The character of the planned city is marked by the prominence given to public spaces, prospects and squares instead of residential "cells", as in the plans of Peter the Great and Trezzini. Le Blond also gives consideration to the supremacy of the monarch in his central siting of the imperial palace. However, the new state structure, the strict control exercised by the sovereign over each of his

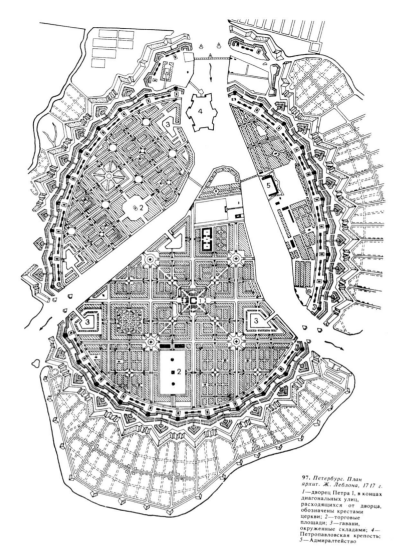

97. Петербург. План
архит. Ж. Леблона, 1717 г.
1—дворец Петра I, в концах
диагональных улиц,
расходящихся от дворца,
обозначены крестами
церкви; 2—торговые
площади; 3—гавани,
окруженные складами; 4—
Петропавловская крепость;
5—Адмиралтейство

200 Jean-Baptiste-Alexandre Le Blond's plan of St Petersburg, 1716

because he hated Moscow, or that he gave no thought to the old capital while creating the new one, is mistaken. Peter the Great wrote much about Moscow, and an enormous quantity of his ukases devoted to the replanning of the old city has been preserved. The essentials of his replanning, down to the level of detail, are contained in the *Instruction to the Moscow Chief of Police's Office* (1722),[24] which lays down the image of Moscow that Peter wanted to see.

The purpose of the replanning was to "correct" the characteristics that had become typical of the face of the city, with its intricate network of winding streets and alleys, some wide, some narrow, passing through each district, and with yards, barns, fences and houses giving directly onto the public thoroughfare. In the Foreigners' Quarter (Nemetskaya sloboda) in Moscow, and in the foreign countries he visited, Peter was struck by the fact that the disposition of component buildings within a mansion was such that main façades looked onto the street. Peter much preferred straight new streets of uniform width. He was attracted, overall, by the consistent appearance of European cities achieved by means of building regulations, and was particularly impressed by the Admiralty Arsenal (Zeemagazijn) district of Amsterdam, newly developed Friedrichstadt in Berlin, and the City in London, restored after the Great Fire of 1666 with a more regular street layout than before.

It should be noted that the *Instruction* covered residential and commercial buildings only, and not the siting or style of churches. The transformation of Moscow was to be achieved at residents' expense. The residential side of Peter the Great's ideal Moscow was to be governed by the planning principles set out in the first four points of the *Instruction*, particularly the first two.

The first point concerned "linear" building: "all residential building, whether new building or rebuilding is involved, shall be executed in linear fashion, in accordance with the ukase on streets, and no building shall be built out of line".[25] Streets were to be made of uniform width throughout their extent, "so that in time, streets and alleys shall be equal".[26] The second point of the *Instruction* prescribed "the construction of stone buildings along streets and alleys, and not inside courtyards, as in olden times".[27] This was a radically new principle concerning the siting of houses, which were to be "joined to neighbouring houses by one shared wall".[28] It meant that streets would be of unified and uninterrupted architectural design, giving rise to the concept of "continuous façade building" which became widespread in the eighteenth century. These prescriptions, taking the street as the central planning model rather than an image of the whole city, sought to resettle the Moscow population in model streets consisting of regularly planned plots.[29]

citizens, whose place is hierarchically defined, is not reflected in the plan, and this is probably why it was rejected.

The shape of St Petersburg as it had developed when Peter died in 1725 was not that of a new Amsterdam or Berlin, although it possessed features of both. The city's lack of cohesiveness, its subdivision into separate quarters on a professional or social basis, and at the same time the urge of central power to intervene in people's lives and to regulate every detail as precisely as possible – all this throws up what at first sight might seem an unlikely parallel.

First and foremost, St Petersburg was a New Moscow. Not the Moscow of earlier times, the sixteenth or seventeenth centuries, and not the Moscow of later, as replanned by the architects of Classicism. The new capital would seem to have been an imagined ideal Moscow, as sketched by the first emperor in his utopian plans.[23] The notion that he founded St Petersburg

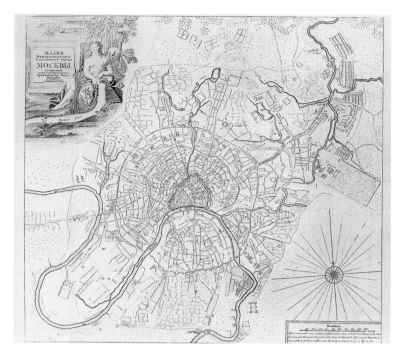

201 Ivan Michurin's plan of Moscow, 1739; engraving.

The *Instruction* of 1722 was followed by a vast quantity of further decrees concerned not with architecture but with everyday life. Sellers of bread, for example, were required to wear "white linen caftans with white fastenings", and this decree continued: "shelves and benches on which loaves are placed for sale should be covered with clean sackcloth, and anyone who fails to abide by this shall be beaten with cudgels."[30] From this and hundreds of other decrees and documents that could be cited, it is clear that Peter the Great expected the transformation of the face of Moscow, its architecture and its customs to lead to a new way of life, and he gave the visible embodiment of change special attention.

It might appear to be the case that all this was simply a matter of detail, and that the Petrine era did not produce radical innovations in the layout of Moscow (pl. 201). However, the development of the old capital of Russia did proceed apace, and furthermore, closely followed the pattern of new state-imposed regulation of urban space that was transforming everyday life in St Petersburg. The difference was that in Moscow this process took place in a huge built environment that had evolved over a long period of time and where large-scale change could be harmful, whereas in St Petersburg Peter the Great and his architects had a free and extensive arena for the execution of their plans, and were untrammelled by the burden of centuries-old tradition.

★ ★ ★

4 Peter the Great's Foreign Architects

DOMENICO TREZZINI

Peter the Great's rationalistic approach to urban planning had its impact on stylistic features of the buildings of the period. Architects invited from all over Europe – Switzerland, Italy, France and a number of German states including Saxony and Prussia – were obliged to follow not only the emperor's general building prescriptions regarding area schemes and building methods, but also his personal tastes and individual instructions. Professional questions of architectural style and the use of experience gained in Russia were relegated to a level of secondary importance, especially since in St Petersburg architects of different nationalities often succeeded one another in work on the same buildings. Each of them contributed his own interpretation of turn-of-the-century European architecture.

A consistent pattern of preference for particular nationalities of foreign architects during Peter the Great's reign cannot be discerned. However, architects were chosen systematically from the highest professional ranks of their countries, their appointment being dependent, of course, on their willingness to go to Russia. They were also selected according to their suitability, as it seemed in St Petersburg, for a specific task of the moment. Peter the Great's tastes were constantly changing, according to his reading and his visits abroad. After his first foreign tour of 1697–98 to the Netherlands, some German states and England, he made two more journeys abroad: to Pomerania in 1712 and to Denmark, the North German region, the Netherlands and France in 1716–17. From his new impressions, new architectural passions and dreams resulted. Sometimes he was seized with a desire to surpass other European monarchs. In 1720 he attempted to obtain the services of a Chinese architect to build pavilions in his gardens,[31] but his embassy failed to secure the appointment. During the first quarter of the eighteenth century the architecture of Russia's new capital absorbed a stylistic mix in the work of masters invited from a number of European countries, successively northern Italy and the Netherlands, Prussia, France and Italy once again.

First, the leading role was played by Domenico Trezzini (c. 1670–1734), of Swiss extraction, and his assistants. Trezzini was born in Astano near Lugano, studied, it would seem, in northern Italy,[32] and went to Copenhagen in 1699. He was the first foreign architect to appear in St Petersburg, soon after the founding of the city.[33] His stylistic links were with northern Italy, especially late seventeenth-century Lombard Baroque.[34] His austerity and graphic treatment of exterior ornamentation (seen, for example, in his general preference for pilasters and restriction of columns to key parts of a composition) were presumably acquired during his four years in Denmark.

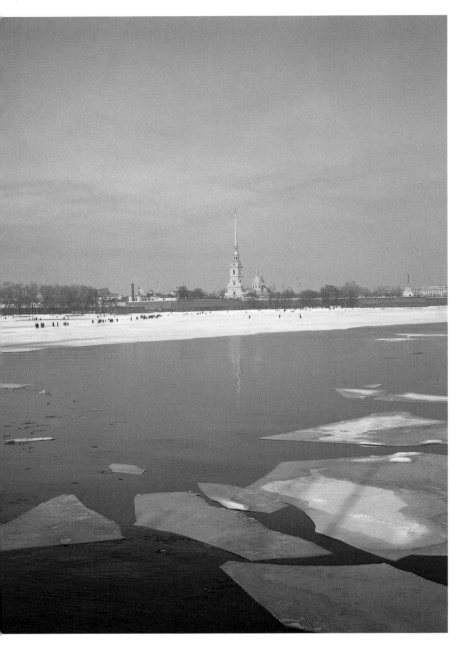

202 View of the fortress and cathedral of SS Peter and Paul, St Petersburg across the Neva.

Dutch ships, port installations, locks and gardens is well known,[39] but whether he considered seventeenth- and eighteenth-century Dutch architectural styles the most suitable for his new capital has not, in the present writer's view, been established. England also had an appeal for the emperor as a great maritime, though not a great architectural, nation. The work of Christopher Wren certainly made a strong impression on him, and he sketched the west front of St Paul's Cathedral.[40]

Be all this as it may, it is generally agreed that the principal shrine of St Petersburg, the cathedral of SS Peter and Paul (Petropavlovskiy sobor; pls 202, 203), built to Trezzini's design over a period of more than twenty years (1712–33), is stylistically quite unlike Wren's church. St Paul's and SS Peter and Paul, the former with two towers and the latter with one, cannot be compared in overall structure or in the composition of their west front. The essential difference between the two buildings lies in the spatial nature of Wren's thinking, characteristic of the great geometer that he was. The façade of Trezzini's cathedral of SS Peter and Paul, on the other hand, is conceived purely as a flat surface, a kind of screen. The two architects, nevertheless, have sources in common – certain seventeenth-century Dutch Protestant chapels and treatises on the Orders published in Amsterdam. Wren's attachment to the work of Lorenzo Bernini, however, points up the difference in their tastes; it would be difficult to think of anyone who could have been less of a model for Trezzini, despite his origins in the Italian part of Switzerland.

Comparison is often made between the Twelve Collegia building (Dvenadtsat' Kollegiy) on Vasil'yevsky Island (pl. 204), begun by Trezzini in 1722, and the Exchange in Copenhagen (1619–25).[41] Construction of the chief government building in the new Russian capital, housing the twelve "ministries", was begun in 1722 and completed in 1742 with a number of architects collaborating. It seems surprising to the present writer that comparison between the two buildings is ever made at all,[42] and that this can only be because of their very considerable length, and the fact that the roof of each building has a series of ornamental gables, albeit taking very different forms. The buildings have quite distinct functions, which has produced a distinct difference in their designs.

The Copenhagen Exchange, designed as a meeting-place for merchants, has a marked structural unity. The division of the Twelve Collegia building into twelve constituent parts is given visible exterior form by the forward breaks in its façades. The distinction between the two buildings arises essentially from their architects' contrasting handling of the Orders. The Order used in the Copenhagen Exchange is turned into Mannerist ornamental sculpture, columns becoming caryatids; in Trezzini's building it takes the form of sumptuous but strict

Trezzini's style has been the subject of conflicting opinions among architectural historians: his work has been classified as belonging to the Dutch-Danish strand of St Petersburg architecture;[35] some have stressed his Dutch affinities,[36] others his Danish.[37] More recently, the influence of Christopher Wren has been seen in his style.[38] Trezzini was clearly familiar with the principal buildings of Copenhagen. Convincing proof of his knowledge of Dutch or English architecture, however, is lacking; the influence of these traditions is possible, most likely as mediated by Peter the Great. The emperor's partiality for

203 (facing page) Cathedral of SS Peter and Paul, St Petersburg (Domenico Trezzini), 1712–33.

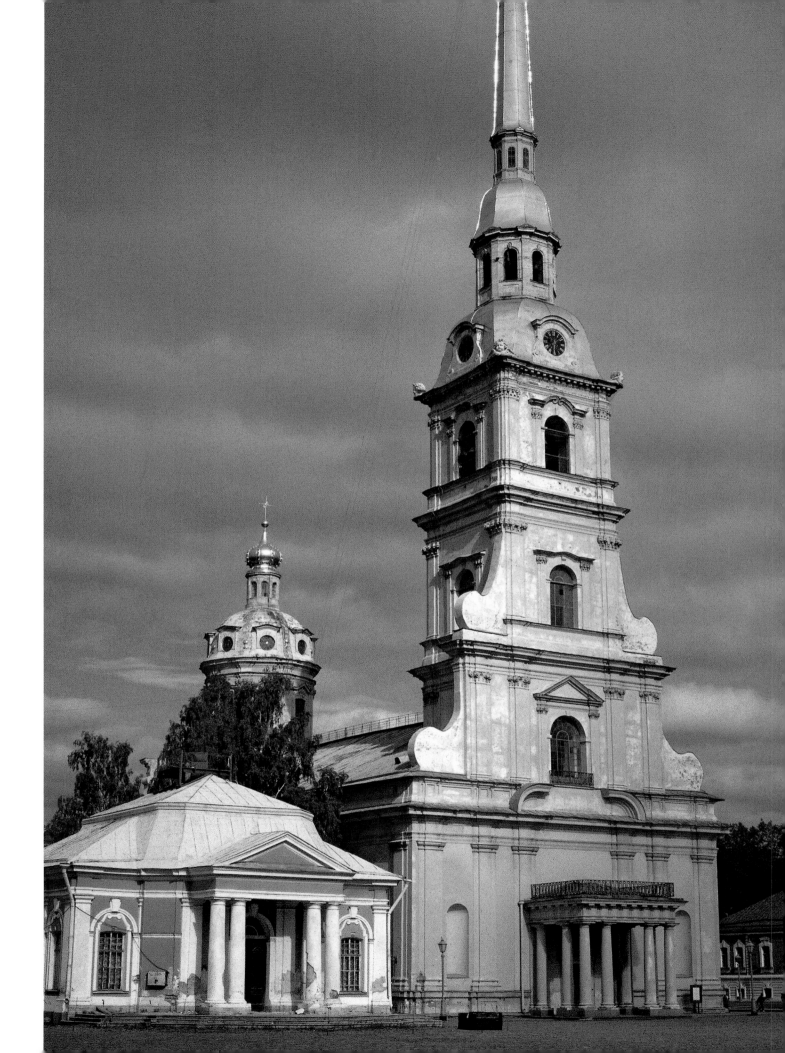

204 Façade of the Twelve Collegia building, St Petersburg (Domenico Trezzini), 1722, as seen from the Neva.

tomary Russian construction a more regular plan than his Russian colleagues and clothes its exterior with Order-based elements.

A recent summation of Trezzini's work by a Russian architectural historian is as follows: "Throughout his career [he] was true to his Dutch-Danish-Russian-Italian style."[44] Leaving aside his city-planning work, the present writer would single out the Italian element from this fourfold blend. Trezzini was clearly not a free agent in St Petersburg. The changing tastes of the emperor, his successive periods of enthusiasm for Dutch, Prussian and French architecture, exercised a strong influence on him. He had spent his formative years and early career, up to the age of twenty-nine, in an Italian environment, in Ticino and Lombardy. The contract with the Danish court undoubtedly came in recognition of his achievements during these years.

Russia no doubt attracted Trezzini because it offered the prospects of a secure position and self-fulfilment in large-scale projects. It is equally evident that he was stretched to the full in an unfamiliar environment. However, his buildings show a "personal" style of his own which, while absorbing Russian architectural characteristics of the Petrine era, still displays features seen in Milanese *palazzi* of the time, in which ornamentation of plane surfaces was predominant. Despite the presence of architects of other nationalities in St Petersburg, Domenico Trezzini continued to play a leading role throughout Peter the Great's reign, and founded a building dynasty in the capital. Carlo Giuseppe[45] and Pietro Antonio Trezzini[46] collaborated on many of his buildings and worked on their completion after his death; they were both active in St Petersburg until the late 1760s,[47] their work spanning the entire period of Russian Baroque, an important point for a true appraisal of the achievement of the whole Trezzini dynasty as well as its founder. The Baroque period in St Petersburg saw the constant input of architects trained in the late seventeenth-century northern Italian, especially Lombard tradition.

ANDREAS SCHLÜTER AND GERMAN ARCHITECTS IN EARLY ST PETERSBURG

The official designation of St Petersburg as the Russian capital in 1712 brought a change in its architectural situation. In 1713 Andreas Schlüter was invited to the new capital. He had been director of building works to the king of Prussia until the death of Frederick I, and had built the Royal Palace and Zeughaus (Arsenal) in Berlin.[48]

Frederick I was Peter the Great's staunchest ally, and in the course of his reforms the latter borrowed much from the Prussian legislature, notably the strict ranking of state employ-

Corinthian pilasters. The first building is an example of early seventeenth-century Danish Mannerism, the second of the early stages of the St Petersburg style as it seeks to overcome Mannerism to become Baroque.

The appearance of the Twelve Collegia, an elongated block divided into equal-sized parts, makes obvious reference to the building housing the pre-Petrine departments of state, the *prikazy*, in the Moscow Kremlin.[43] Here a general phenomenon is encountered which is typical of the work of foreign architects in Russia. A foreign architect gives a building of cus-

205 Peter the Great's Summer Palace, St Petersburg (Domenico Trezzini, Andreas Schlüter, Niccolo Michetti, Mikhail Zemtsov), 1710–14.

206 Ornamental detail on the exterior of Peter the Great's Summer Palace, St Petersburg, 1710–14.

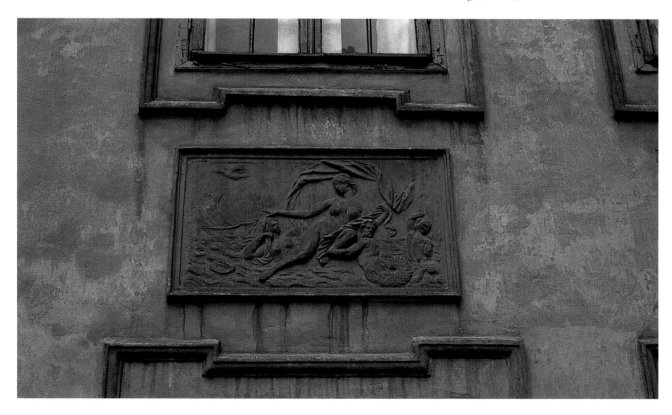

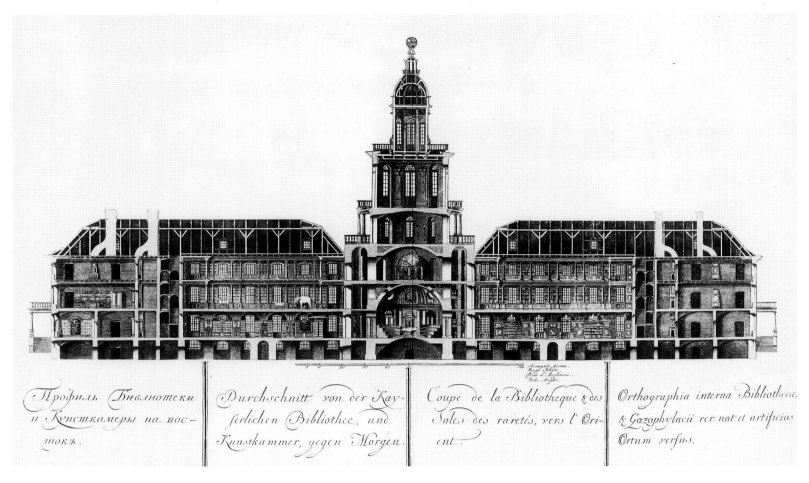

Профиль Библиотеки и Кунсткамеры на постиок. *Durchschnitt von der Kayserlichen Bibliothec, und Kunstkammer, gegen Morgen.* *Coupe de la Bibliotheque & des Sales des raretés, vers l'Orient.* *Orthographia interna Bibliothecæ, & Gazophylacii rer. nat. et artificios. Ortum versus.*

207 Section of Peter the Great's Kunstkammer, St Petersburg (Georg Mattarnovi, Nicolas Herbel, Gaetano Chiaveri, Mikhail Zemtsov), 1718–34; engraving, 1740s.

ees and the system of privileges which particularly concerned urban planning. The role played by Prussian models in the planning and building of St Petersburg has not been adequately appreciated. Comparison of the celebrated Trident of great roads converging at the Admiralty with the replanned suburb, the Friedrichsvorstadt in Berlin dating from the first years of the eighteenth century begins to demonstrate the point.[49]

With the arrival of Andreas Schlüter in St Petersburg, its architecture becomes more sumptuous and more Baroque, both in sculptural ornament and in growing complexity of building forms. Schlüter died little more than a year after he came to the city, and it is difficult to discern his particular contribution to a "St Petersburg style". It was undoubtedly on his initiative, however, that Peter the Great's previously austere Summer Palace was decorated with bas-reliefs (pl. 205), though these are more restrained than, for example, his decorative work at the Berlin Zeughaus and have a marked allegorical character (pl. 206). It has been asserted that in St Petersburg

Schlüter narrowed his range to Dutch tradition,[50] but too little of his work has survived to support this. After his death his assistant Johann Braunstein, who spent all his working life in Russia, continued to develop his manner.[51] Gottfried Schädel from Hamburg accompanied Schlüter to Russia, where he worked up to his death in 1752, but it is hard to distinguish what part he might have played in the formation of a Petersburg style. It is clear from numerous documents in his own hand that he was a master-mason, not an architect, mainly working on and completing the projects of others.[52]

The German line of contribution to the architecture of St Petersburg did not cease with Schlüter's death. On the latter's previous recommendation, Georg Johann Mattarnovi from Dresden, a colleague of Schlüter in the service of Augustus II (the Strong), elector of Saxony and king of Poland, and another ally of Peter the Great, was invited to Russia. Mattarnovi built the church of St Isaac the Dalmatian (on the site of the later St Isaac's Cathedral) and the second Winter

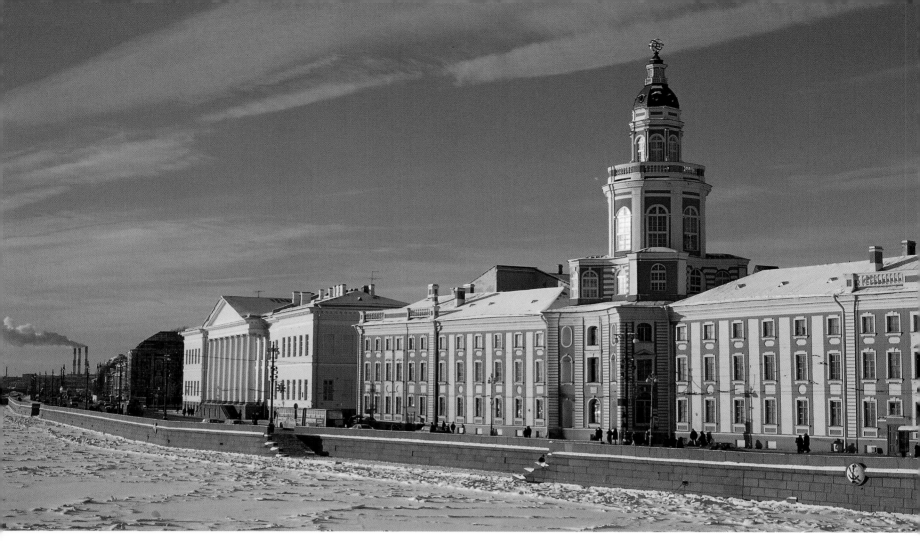

208 Façade of Peter the Great's Kunstkammer, St Petersburg (Georg Mattarnovi, Nicolas Herbel, Gaetano Chiaveri, Mikhail Zemtsov), 1718–34, seen from the Neva.

Palace. The best-known building on which he worked was "the first Russian museum", Peter the Great's Kunstkammer on Vasil'yevsky Island, the design of which he completed in 1718 (pls 207, 208).[53] When he died a few months later, work on the building went on continuously until 1734 under another German master, Nicolas Herbel, an Italian, Gaetano Chiaveri, and a Russian, Mikhail Zemtsov; Chiaveri's contribution was probably limited to giving more expressive form to the tower. After a fire that occurred in the middle of the eighteenth century, the Kunstkammer was rebuilt by the celebrated Russian architect Savva Chevakinsky. Two equal-sized blocks are linked by a five-storey tower standing between them. Its relatively complex structure and decorative richness make the Kunstkammer the "most Baroque" of surviving buildings of the Petrine period. It has been thought to correspond closest of all to the "style" of Schlüter, whose plans and sketches Mattarnovi seems to have followed, and also to show a clear Baroque input from Chiaveri. It may be said with cer-

tainty only that the building is an excellent example of the growing formal complexity and increasingly Baroque features that characterize this period.

At almost the same time as Schlüter and Mattarnovi, in 1714, another important Prussian architect arrived in St Petersburg, Theodor Schwertfeger, to remain in Russian service until 1738, when he left the country. He worked for Peter the Great's chief favourite, Prince Menshikov, until 1720, when he was appointed architect to the Alexander Nevsky Monastery, the principal religious centre of the new capital. An original model survives of the cathedral built there by Schwertfeger,[54] which was entirely reconstructed by Ivan Yegorovich Starov under Catherine the Great. Schwertfeger's cathedral displayed numerous reflections of various Roman Renaissance and Baroque churches, among them Il Gesù (in the form of the main portal) and St Peter's Cathedral (the cupola). The building's general character, however, was closer to South German and Austrian Baroque.

Schwertfeger's cathedral in the Alexander Nevsky Monastery is unique in St Petersburg and in all Russia.[55] This building would not be out of place in the environs of Vienna or Würzburg. Some have seen in it affinities with Russian tradition, but such a view could only have been held in the competitive atmosphere of the Soviet era. In the present writer's view, it would be hard to find a more European building in St Petersburg in the whole of the Baroque period. Thirty years later Francesco Bartolomeo Rastrelli made an attempt at such a style in his unfinished Smol'ny Convent,[56] but Empress Elizabeth Petrovna put a stop to it, demanding a more traditional Orthodox approach, only executed some eighty years later. In St Petersburg during its earliest period, when its individual style was in the process of formation, such direct importation from Western Europe to Russia was possible. The cathedral was completed, after Schwertfeger's departure from St Petersburg in 1719, under the direction of Domenico Trezzini, with little variation from Schwertfeger's model.

JEAN-BAPTISTE-ALEXANDRE LE BLOND

After Peter the Great's visit to France in 1716, he invited Jean-Baptiste-Alexandre le Blond to take up the post of "General Architect" of St Petersburg.[57] Le Blond's *La Théorie et le Pratique du Jardinage* (1709) may have caught his attention;[58] he wrote of the French architect: "This master is one of the best, a real marvel."[59] Le Blond developed the Summer Gardens in St Petersburg and designed the emperor's seaside palace, Peterhof (Petrodvorets). He is also famous for his new utopian-style general plan of St Petersburg, surrounded with fortifications in the manner of Vauban. As already noted, despite the beauty of Le Blond's drawings (pl. 200), the plan did not please Peter the Great, since it did not correspond to his ideas of the connection between his city-planning and his imperial designs. The uncompromisingly Western European style of this plan suited the emperor's taste even less than Schwertfeger's Alexander Nevsky cathedral was to suit his daughter's, and it played no part in the development of St Petersburg. The majority of Le Blond's plans for imperial palaces outside the city were unexecuted, although they made a strong impression on Peter and his courtiers.

Many of Le Blond's unrealized ideas, preserved in his drawings in Peter the Great's archive, influenced the design of the great imperial seaside residences, at Strel'na and at Peterhof. In France at the beginning of the Rococo era, Le Blond's projects must have appeared excessively austere, but in Peter's Russia, with its passion for system and order, their solemn grandeur and brilliant geometry were entirely appropriate. At Peterhof the intersection of two radial systems is the basis of the origi-

nality of the whole layout of the park. One axis of the composition extends from the Great Cascade (Bol'shoy kaskad) to the foot of the Great Palace (Bol'shoy dvorets); the other runs from the Marly Palace on the west side to the Monplaisir Palace on the east side. In the Summer Gardens in St Petersburg, Le Blond was obliged to adopt a more traditional approach; Peter the Great wanted a formal "kitchen garden" like the one at Versailles, and here Le Blond imitated André Le Nôtre.[60]

In 1718 Le Blond died of smallpox. Despite the brevity of his time in Russia, his work there is of cardinal importance. He introduced French Classicism to Russian architecture. He brought a grandeur of scale and a new refinement to the planning of parks, which changed the face of Russian Baroque in many ways. Particularly important was his attempt to create an integrated architectural complex in which planning, building design and ornamental detail could accommodate the emperor's architectural needs both in and outside the city. He sought to transform building practice with a comprehensive system that would include all aspects of the building process, from the making of a general city plan to the organization of nineteen specialized workshops,[61] which would execute all building tasks including interior decoration and furniture-making. Le Blond brought with him to Russia a large number of leading craftsmen, among them Nicolas Pineau, the celebrated creator of Rococo interiors.[62]

NICCOLÒ MICHETTI

French influence on the building of early St Petersburg, however, was very limited. Even while Le Blond was still living, the Russian ambassador in Rome was charged with the task of finding an architect for the new capital.[63] An architect of high standing was offered the post, Niccolò Michetti, then in papal service, and completing the San Michele orphanage as a colleague of the aged Carlo Fontana. His work in St Petersburg, especially in the decoration of interiors, has features reminiscent of Fontana's work.[64] His façades show a northern restraint, with Baroque handling of detail. Only occasionally does he allow himself dramatic flourishes such as a canal passing through the grotto in the middle of the palace at Strel'na. He is best known in Russian architectural history as a hydrodynamic engineer and the designer of the cascades and fountains of Peterhof for Peter the Great.[65] Another Roman architect, Gaetano Chiaveri (see page 203), came to St Petersburg at the same time as Michetti; he achieved later fame for his buildings in Warsaw and Dresden.[66] Neither of these architects settled in Russia: Michetti was in St Petersburg for four years, some of this period being spent in Italy buying sculpture for the

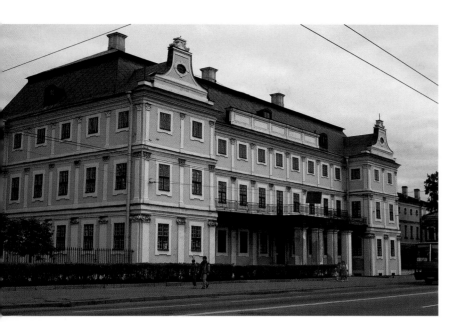

209 The Menshikov Palace, St Petersburg (Giovanni Mario Fontana and Gottfried Schädel), 1710–22.

Summer Gardens; Chiavieri stayed rather longer, up to 1727, but with no large-scale projects coming his way.[67]

The work of these architects, however, strengthened the Italian line in the Petrine period, which all in all is substantial, other Italians active in St Petersburg at the same time including the Trezzinis, Giovanni Mario Fontana, one of the builders of the Menshikov Palace (pls 209, 210),[68] and (from 1716) the internationally renowned sculptor Carlo Bartolomeo Rastrelli, father of the great Francesco Bartolomeo Rastrelli, creator of Russian Imperial Baroque in the 1730s–50s.[69]

Elements of this style had been laid down by the Italian architects of Peter the Great's reign. Among its characteristic features are "moulding that protrudes as if about to tear itself off a wall".[70] Michetti was the first to use this style in St Petersburg, but it is seen at its best in the interiors he designed in the Summer Palace at Katherinental near Tallinn, Estonia.[71] It is possible that he designed similar interiors for other buildings for which he was responsible, in particular the palace at Strel'na.[72]

In the present writer's view, this high-relief ornamentation, architectural as well as sculptural, with full use of the Orders and round columns, is one of the main indications of the arrival of the fully fledged Baroque style in Russian architecture. In both planned and executed designs of the Petrine era, the way was prepared for a new direction in Russian architecture, which half a century later would decisively converge with the European mainstream.

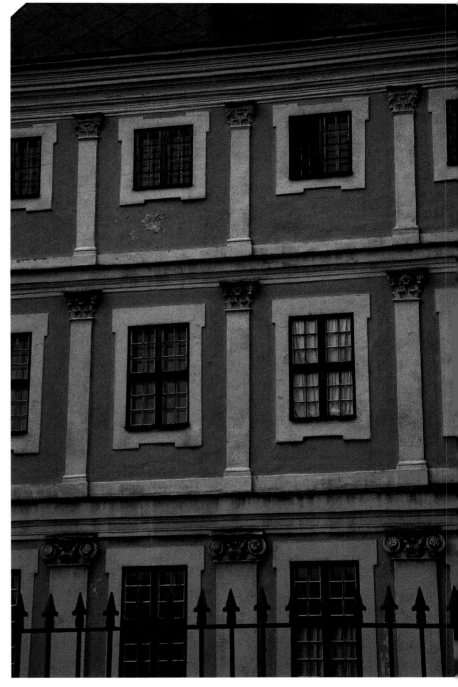

210 Orders of the Menshikov Palace, St Petersburg (Giovanni Mario Fontana and Gottfried Schädel), 1710–22.

5 Baroque St Petersburg

Meanwhile, stylistic polyphony remained a leading characteristic of Russian architecture during the reign of Peter the Great. The activity of foreign architects and craftsmen in St Petersburg produced unexpected transformations. The Italians became more restrained. The work of the Germans became

somewhat italianized. The Swiss inclined towards northern varieties of Baroque. And they all had to come to terms with the emperor's fondness for Dutch interiors and gardens. The French, on the other hand, especially Le Blond, remained intractable, but as already noted, they did not settle in Russia permanently at this time.

Overall, the work of these architects of diverse nationalities acquired typical St Petersburg features, first and foremost among which was regularity, visible everywhere – in the rationality of general city-planning, the urge towards simple contours and interior layout of buildings, an even rhythm of decorative elements. Façades took on a predominantly linear character. The extremely rapid rate of building did not allow for much decorative subtlety. This was an entirely new kind of architecture for Russia. The "post-Byzantine Mannerism" of the sixteenth and seventeenth centuries entirely disappeared, to be replaced by a single Russian "imperial" style based on Baroque ideas.

Thus might Peter the Great have imagined the nature of the architecture of Ancient Rome to have been. He still entertained the time-honoured Russian idea of Russia, the Russian Empire, as a Third Rome. There is a similarity between images of St Petersburg during his reign and depicted reconstructions of buildings of Ancient Rome in seventeenth-century German and Dutch engravings in the library of the first emperor of Russia.[73] Here indeed was the Third Rome, resurrecting the heritage of Antiquity as architects of the northern Baroque tradition imagined it.

The architectural style of St Petersburg during its founder's reign is difficult to define. It might be called restrained Baroque, in the process of overcoming mannerist freedom through insistent regulation raised to ideological status. Peter the Great himself did not succeed in giving his city or the new architectural style definitive form. The stylistic architectural characteristics brought to the new capital from various countries by foreign architects and craftsmen became their individual manners, with the taste and mentality of Peter the Great presiding over the sum total of diverse architectural phenomena. In Moscow he accommodated to a mannerist extravaganza; in St Petersburg he attempted to control such a free-for-all by strict regulation of the new state and its architecture.

It was to be a quarter of a century before the safety of the city Peter had founded was assured and before a unified style, Russian Imperial Baroque, emerged. Only during the reigns of the Empresses Anne and Elizabeth, under the direction of Francesco Bartolomeo Rastrelli, was Mannerism, with its interpretative variety and strange mixture of diverse forms, finally ended. The grand new Baroque style, reflecting the regulated life of the court, was now established in Russia.

After the death of Peter the Great in 1725 and that of his widow Catherine I in 1727, his grandson Peter II, aged twelve, succeeded to the throne. In February 1728 the court and institutions of government left St Petersburg for Moscow to attend Peter II's coronation. The new capital on the Neva was still scarcely half-built, and exposed to mortal danger. Peter II, unlike his distinguished grandfather, was surrounded not by new men raised by reforms to wealth and high positions, like Menshikov, but by members of the old aristocracy who wished to break free of Menshikov's influence; this faction was led by the Princes Dolgoruky, who had close links with Moscow. Having made the journey to the old capital for the coronation of the new emperor, the court preferred not to return to St Petersburg, and turned to the favourite Moscow pastimes of tsars, which also attracted the young monarch – wolf- and bear-hunting and falconry. In the course of one of these expeditions two years after his coronation the tsar fell ill, and died on his return to Moscow, still several years from his majority. Once more the question of succession arose; it was closely connected with the fate of the new capital.

Peter II left no direct heir, and the Supreme Secret Council, largely composed of members of the old Moscow aristocracy, took power into its own hands. Its members were not in favour of continuing Peter the Great's radical reforms and wished to keep his descendants, above all his daughter Elizabeth Petrovna, from the throne. It was Anne, Duchess of Courland, daughter of Ivan V (the feeble-minded half-brother of Peter the Great), who was now chosen to succeed. Married to the duke of Courland by Peter the Great, she was now a widow and ruled this small Baltic state by herself. She was obliged to sign a document in the nature of a constitution, granting significant rights to the old aristocracy. Moscow seemed to have defeated St Petersburg. However, the Supreme Secret Council had failed to read the mood of the new employees of the state and the army officers, who were filled with the "Petersburg spirit". With their support, Anne I managed to crush those seeking to limit her power. These events, as well as the whole system of government and way of life created by Peter the Great, necessitated an entirely new court and a distancing from the old Moscow sources of power. The Empire needed to present a new face to the world. Having decided to take this path, Empress Anne chose St Petersburg as a symbol of reform and Western orientation, and moved her court back to the new capital.

The position of the empress, of her government and of Russia as a whole during the years of her reign – from 1730 to 1740 – was difficult in the extreme. The economy had been ruined by the headlong rate of Peter the Great's innovations and the huge expenditure on reform of the army, the founding

of the fleet, and the building of St Petersburg. The people were in a state of unrest, and hostile to innovation that they found hard to comprehend. Empress Anne surrounded herself with foreigners in order to make best use of Western technology and administrative method. From Courland, whose population was largely German, she brought numerous courtiers with her to Russia, including her favourite, Ernst Biron.

Under Empress Anne, Russia was culturally orientated towards Germany. Of 245 cadets attending the country's only military school, 51 studied French and 237 studied German. Advancement was difficult without a knowledge of the German language. However, foreigners did not show a corresponding interest in Russians, so that a degree of "Europeanism" was expected from them. At the same time, the ratio of Russian to foreign architects, compared with the situation in the Petrine era, changed in favour of Russian nationals.

The course of reform begun by Peter the Great was not interrupted during the reign of Empress Anne. At the highest administrative level, numerous initiatives left unfinished by Peter were ruthlessly but consistently carried out to the full, and a rationalist approach and the pursuit of unified systems, both as regards city-planning and the built face of St Petersburg, were the hallmarks of 1730s–40s Russia.

RUSSIAN ARCHITECTS RETURNED FROM ABROAD

In 1716 Peter the Great had sent some young men abroad to learn "various arts", among them eight architectural trainees. Four were sent to Italy and four to the Netherlands. They returned to Russia shortly before Peter's death, but did not begin active work until the reign of Empress Anne.[74]

Three of these students, Pyotr Yeropkin, Timofey Usov and Fyodor Isakov, went to Rome to study with the architect Cipriani.[75] The last-named did not show any special aptitude and was sent back to Russia in 1718 as an interpreter to Niccolò Michetti. Little is known of how and what Cipriani, not among the best-known architects of his country, taught those sent to him by the Russian emperor, except that they copied his drawings and the graphic work of famous Italian masters.

When the students who completed their time in Rome returned home, all three showed their drawings of the church of San Carlo alle Quattro Fontane by way of certification of their studies. The choice of Francesco Borromini's church reveals their teacher's architectural orientation towards the most dramatic and extravagant Baroque movement in Rome,[76] though no doubt part of the intention was simply to astonish those who looked at the drawings in Russia with Borromini's brilliance and originality. None of these three young architects, however, set out to imitate Borromini on return to Russia.

One of them, Pyotr Yeropkin, seems to have stood out from his companions even at this stage.[77]

Ivan Korobov, Ivan Mordvinov and Ivan Ustinov, sent to the Netherlands in 1718, were envious of the students who had been sent to Italy. Korobov even petitioned the emperor to be given the chance to study French and Italian architecture, but his request was refused.[78] Peter personally insisted that his future architects should make a thorough study of the technical side of the building crafts as practised in the Netherlands, including the most low-lying areas of the country near the sea.[79] In 1723 Mikhail Bashmakov was sent to the Netherlands to learn "how to build palaces", and Ivan Michurin followed him in 1724. The latter so enjoyed his time in the Netherlands that he asked to be allowed to prolong his stay.[80] The Russians had different teachers. The first three to arrive were entrusted to the architect Jan Pieter van Baurscheit in Antwerp,[81] and then, moving to Amsterdam, to Simon Schignfoet; Bashmakov studied with Klass Klinkeibel[82] in Amsterdam and Michurin with Baurscheit.[83] They were all taught similar things: "how to construct sluices, how to lay out gardens, how to insert piles and their foundations as it is done here."[84] Korobov and Mordvinov were the first to return home in 1727, and the last was Michurin in 1729.

Ivan Korobov was the leading student from Antwerp.[85] On his return to St Petersburg he was immediately appointed architect to the Admiralty in place of Chiaveri who had moved to Dresden. This was a responsible post in a city full of maritime buildings. His principal achievement was the Admiralty building itself, with the tower and spire which became the city's outstanding reference point. This magnificent building, with other examples of his work in St Petersburg such as the church of St Panteleymon, is typical of Korobov's approach. He is inclined to austerity, the most striking thing about his buildings being the combination and intersection of large, simple masses. His ornamentation is restrained; he has a fondness for serene Tuscan pilasters.

Another Russian architect who achieved fame in the 1730s was Mikhail Zemtsov, who studied with Domenico Trezzini; he also worked with Michetti.[86] Even more intimately linked to the Italian architectural tradition was Pyotr Yeropkin, who had been in the first group of students sent to Rome,[87] where he undoubtedly received a thorough grounding in architecture and engineering. His translation of Palladio's *Quattro libri dell'architettura* is the first in Russian.[88] Having completed his studies he advanced rapidly, and in 1737 was heading a newly founded commission on the future development of St Petersburg.[89] Plans for each area of the city were prepared in his studio and discussed with Zemtsov, Korobov and Trezzini *fils* before submission to the empress.

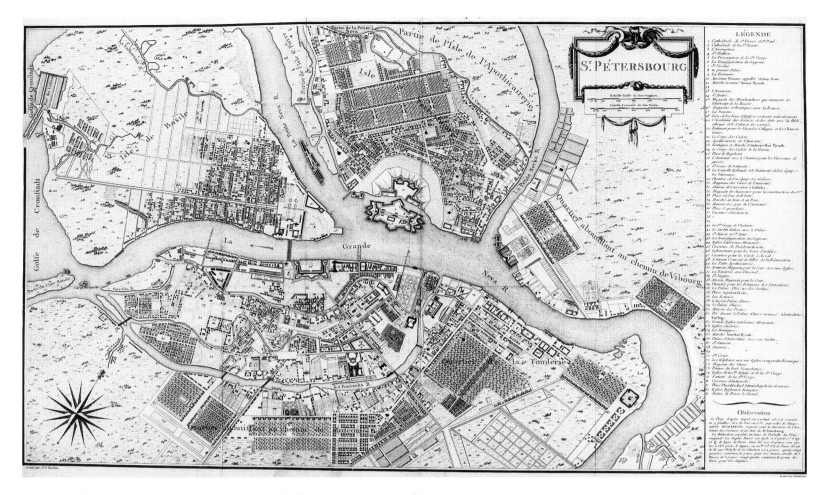

211 Plan of St Petersburg, 1750s, in accordance with the ideas of Pyotr Yeropkin.

More than half the population had left St Petersburg, major government buildings were uncompleted, and fires had caused much destruction, wiping out the timber-frame buildings that had lent its face some similarity with that of other Northern European cities.[90] The commission was to report on the condition of the city, prepare detailed plans for the development of all its districts, fix locations of "public squares" and courses of streets, site residential areas and divide them into quarters with "large, medium-size and small houses" for different ranks of citizens, and much else. In other words, St Petersburg was to be entirely replanned, not in empty space as in the first years of its existence, but starting from the often pitiful urban reality that now existed. All this opened up wider possibilities for Yeropkin, who approached the replanning of the Russian capital on quite a different footing from that on which the architects of Peter the Great's time had proceeded (pl. 211).

His plans proved remarkably successful. The entire subsequent development of St Petersburg has been based on his conception of the city. First of all, it was definitively decided that its centre should be not on Vasil'yevsky Island but on the Admiralty side. The famous Trident was made the city's structural centre, formed by three great thoroughfares, the Nevsky Prospekt, Gorokhovaya Street and the Voznesensky Prospekt, each running from the outskirts to the Admiralty, and oriented to its spire. The commission emphasized that "no obstacle to the view of the Admiralty spire shall be permitted".[91] The primacy of all the embankments was declared, and there, especially along the Neva and on the Moyka and Fontanka rivers, the houses of the wealthiest citizens continued to be built and their gardens laid out. A system of semi-circular streets was constructed, linking the diverging prospects, the prongs of the Trident on the Admiralty side. Beyond this, Yeropkin created the extensive residential suburb of Kolomna. Vasil'yevsky Island was left just as it had been laid out by Domenico Trezzini executing Peter the Great's conception. All other parts of the city were replanned.

These plans succeeded brilliantly in displaying the essential structure of the city, lending it a harmonious lucidity and fine

proportions and at the same time maintaining its logic. With astonishing art, Yeropkin managed to include existing buildings and streets in his new plans, and to make enchanting use of the courses of rivers and canals. To this day, if plans are compared, the continuing influence of this outstanding urban planner is strikingly apparent throughout the historic city.

It was at this time that St Petersburg was truly founded, to become one of the masterpieces of Baroque city-planning, with this style's typical fondness for distant perspectives, geometrically defined spaces, and the ordering of complex, beautiful and regular structures, like constituent ornamental parts, into a harmonious whole. In the reign of Empress Anne the city was born a second time, and thanks to Yeropkin's achievements was destined to display the splendours of its ordered architectural compositions for centuries to come.

The style that emerged in Yeropkin's replanning of St Petersburg, thrillingly communicated in his drawings, may aptly, in the present writer's view, be called "Russian Imperial Baroque". Yeropkin used a number of typical Baroque city-planning ideas, including that of the "trident", familiar to him from his time in Rome. His attention to skyline silhouetting, the dramatic effects of juxtaposition of flat-fronted blocks of buildings forming a "continuous horizon"[92] with the tall tower forms of the principal state institutions and churches, testifies to the consummately Baroque character of this architect's thinking, formed as it was in Rome during the 1720s.

At the same time, the Russian, or more specifically St Petersburgian, character of this style should not be overlooked. Yeropkin's planning activities were subject to strict regulation from the social, landowning and bureaucratic points of view. In his planning of residential areas he thought in terms of "cells" sized according to the property-owner's position in the imperial hierarchy, and this determined the finer detail of his plans, which remained in touch with the ukases of Peter the Great, confirmed by Empress Anne. In other words, his planning work was in full accordance with the empire-building ideas of Russian sovereigns. It also answered the need for a built environment that would display the grandeur befitting a great state and also demonstrate the principle of regulation, visibly symbolizing the new order established by the supreme power.

6 The Birth of Russian Imperial Baroque

Comparatively few architectural monuments remain from the ten-year reign of Empress Anne. During this period the building priority was to complete many buildings begun under Peter the Great. Most surviving buildings are churches that are the work of Russian architects who studied abroad. Because of

scarcity of materials and the need for rapid completion, the largest buildings of Anne's reign were constructed of impermanent materials and have not survived. One example is the most ambitious Moscow palace of the period, the empress's summer palace in Lefortovo. It was built of wood, stuccoed and painted to look like stone. Standing on the high bank of the Yauza, the building must have been an imposing sight with its long gilded façade richly ornamented with sculpture.[93] It was one of the earliest works of the young Francesco Bartolomeo Rastrelli,[94] and marked the beginning of the formation of the style of the great architect who is no less important for his part in the creation of Russian Baroque in the middle of the eighteenth century than Pyotr Yeropkin for his definitive planning of St Petersburg.

Before tracing the sources of Rastrelli's style, it will be instructive to consider a building that particularly clearly conveys the flavour of Anne's reign, at once brutal and startlingly theatrical. One of the most remarkable buildings raised in St Petersburg during the Baroque period, it stood for just three months, while the frost lasted. When the thaw came, it disappeared. This was the Ice Palace, made in the winter of 1740. Empress Anne loved entertainments on the grand scale, while not neglecting the responsibilities of state. Everyday life reduced her to such a nervous and unpleasant state of mind that she was in constant need of distraction. She always had jesters at her court. One of these, the elderly Prince Golitsyn, was ordered, as an amusement for the empress, to marry "an exotic lady", a Kalmuck, belonging to a people that had just been brought within the frontiers of Russia. A house was built for the couple between the imperial palace and the Admiralty, and fully furnished. Everything was made of ice. That winter was a severe one in St Petersburg.

A member of the St Petersburg Academy of Sciences, Georg Kraft, witnessed the building of the Ice Palace: "Pieces of pure ice were cut [. . .] carved into ornamental architectural shapes, measured with compass and rule, and one slab placed upon another by means of levers, water being poured over each and, freezing immediately, serving as strong cement [. . .]."[95] The Ice Palace was more than sixty metres in length of façade, some six metres from front to rear, and six and a half metres in height. A balustrade ran round it at ground floor level, a gallery with statues was placed on columns on top of the roof, the windows were ornamented with *nalichniki*, and on the exterior walls were pilasters of mock marble. Inside the house, the visitor could see a bedroom made of ice, with a bed, a dressing-table, and a hearth with logs of ice lying in it, and a dining-room in which stood a clock complete with its mechanism of ice, and beside it a dresser containing ware of various kinds all made of ice. At night the house was lit up inside with candles. In the

street in front of the palace stood cannon made of ice, which were fired from time to time for popular entertainment. Near the cannon some dolphins and an elephant were placed, which spewed running water during the day and burning oil at night. The elephant, Kraft recalled, "uttered a sound just like a real elephant, made on a trumpet by a man hidden inside it."[96] The most astonishing thing of all was the jester's wedding. A number of men and women had been brought from St Petersburg to represent each of the numerous peoples belonging to the Russian Empire, dressed in national costume. They took part in the wedding feast and the procession leading the bride and bridegroom into the Ice Palace, where the couple were left for their first night.

The occasion was organized by Ober-Jägermeister Artemy Volynsky and Pyotr Yeropkin, and greatly pleased Empress Anna. It would seem to have advanced the careers of both organizers, and perhaps edged aside certain close favourites of the empress. Indeed, such widespread hatred, indeed, did the success of the Ice Palace arouse at court that Volynsky was slandered as a plotter against the throne, tried and tortured to death. His colleague Yeropkin was put to death with him. Thus fate removed the most dangerous of Francesco Bartolomeo Rastrelli's rivals.

Empress Anne died without issue on 17 October 1740, having nominated as her successor the newly born son of her niece the Princess of Braunschweig-Bevern-Lüneburg, known in Russia as Anna Leopoldovna. She had appointed her aged lover and favourite Ernst Biron as regent. He was soon overthrown, however, by Anna Leopoldovna, who proclaimed herself regent and her husband, the duke of Braunschweig-Bevern-Lüneburg, commander-in-chief of the army. But their rule did not last long either. On the night of 24 November 1741, a tall woman in a cuirass, accompanied by a posse of guardsmen, burst into the regent's bedroom with the words: "Up you get, little sister!" and ordered her arrest. This was Peter the Great's daughter Elizabeth. She was crowned Empress Elizabeth I and reigned for twenty years, until 1761.

Elizabeth Petrovna's reign was beneficial to Russia. The effects of Peter the Great's reforms began to be felt. There were military successes, and Russia played a more active political part in European affairs. An alliance was concluded with Austria and France against the king of Prussia, Frederick the Great. Change continued in Russia, taking milder forms than before. The moral temper of the country changed too; the harshness of the reigns of Peter the Great and Anne gradually disappeared. This had partly to do with the character of the monarch herself. Elizabeth Petrovna adored festivals and masquerades, but also had real religious feeling; she loved choral church music. She was content with one favourite all her life,

Aleksey Razumovsky whom she made a count, who had a voice of remarkable timbre. Execution was rare in her reign, during which life in St Petersburg became more peaceful and affluent. In the history of St Petersburg art and architecture her reign coincides with the flowering of Russian Imperial Baroque.

Igor Grabar', whose unsurpassable history of Russian art and architecture has already been mentioned, wrote of this period:

[. . .] Under Peter the Great, St Petersburg was first and foremost a theatre of architectural experiment. All kinds of visiting performers passed through the city, great, middle-ranking, and many small fry. Each invariably recast what had been done before [. . .] and either soon died or left St Petersburg for ever. How could any definite [. . .] style emerge in these circumstances? Italian Baroque reached St Petersburg in fragmentary form, and German in significantly stronger forms, but a guiding hand was still lacking [. . .] there was no towering artistic figure to take the whole task on his shoulders and leave his personal stamp on the Petersburg of his time. But such a figure appeared at last [. . .] and only then did St Petersburg take on its own definitive Baroque appearance. This figure was Rastrelli.[97]

7 The Style of Francesco Bartolomeo Rastrelli

Francesco Bartolomeo Rastrelli came to St Petersburg at the age of sixteen when his father, the sculptor Carlo Bartolomeo, was invited there in 1716. Carlo Bartolomeo had been living in Paris with his family for some time, making gravestones and altars for French churches. Through the Paris nuncio he had bought the title of count from the Pope. His son received his schooling in Paris;[98] at his own cost Peter the Great sent him from St Petersburg to study abroad.[99]

Francesco Bartolomeo returned to St Petersburg for a short time in 1724, and when Peter the Great died the following year, his widow, briefly empress of Russia as Catherine I, allowed him to continue his studies abroad for at least two years.[100] The locations of both his spells of studies abroad are unknown. It has been surmised that he was in Italy for most of the time, and the Florentine origins of his family have been taken to support this,[101] as has his daughter's subsequent marriage to the Piedmontese architect Francesco Bertugliatti, although the latter was from Lugano.[102]

The early development of a master such as Rastrelli is not simply a matter of an individual life. His name is synonymous with the Russian architectural style of the reign of Elizabeth Petrovna, and it would be extremely useful in architectural historical terms to establish its sources. At these, however, we can

only guess. His first teacher was undoubtedly his sculptor father, a Florentine with close links to the Vatican, who had experienced the impact of Roman Baroque. The Paris years during the second decade of the eighteenth century will also unquestionably have been an important influence. Apart from that, there are arguably five or eight years of further education to be accounted for, in locations and countries unknown; Italy, France and Germany are all equally possible. Rastrelli in his late twenties, however, carried with him no blueprint instilled into him by any teacher; he returned to Russia, after his second period abroad, already a master in possession of an individual style. A number of aspects of his work seem specifically Russian. He is rooted in the "European" aspiration of Russian architecture of the time of Peter the Great, and his style seems to have developed from that particular point in architectural history.

So great was Rastrelli's reputation by the late 1730s that Empress Anne gave him the title of Chief Architect of St Petersburg, which had previously been held only by Schlüter and Le Blond.[103] His position was somewhat shaken by the palace revolution of 1741, but within a few years he became Empress Elizabeth Petrovna's favourite architect and executed all major building projects in the capital and its environs up to her death.[104]

Rastrelli's buildings reflect the buoyant mood dominant in Russian culture around the middle of the eighteenth century, the colour and magnificence, the optimism, the love of ceremony and monumentality. Imperial Baroque in Russia was far from mystical emotionalism and exquisite refinement. Rastrelli's work is characterized by its grand sweep and lucidity, rational regularity, and luxurious abundance of form, colour and ornament. Boris Vipper thus describes his interiors:

> His sumptuous salons are full of *joie de vivre* and movement, a-glimmer and a-tremble. The reflections of many mirrors, the lively carved and gilded ornament, the splendour of the ceilings and the patterns on parquet floors, the cartouches and scallops, the lush roses and fluttering cupids – everything sparkles and flows in breathtaking splendour for a dazzlingly dressed court.[105]

Rastrelli had another astonishing capability, that of expressing the essence of any aesthetic surroundings in which he found himself. An Italian who spent his youth in Paris, he was sensitive to distinctive characteristics of national taste. Working in Moscow and Kiev, he acquainted himself with their monuments of early Russian architecture. Without copying from such monuments, he was able to grasp their qualities and to make use of them while employing typical Russian compositional approaches. This is seen especially in his churches.

His style is quite distinct from other varieties of European Baroque: in, first of all, what might appear an unlikely combination – decorative splendour and a principle of regularity which he raised to monumental dimensions. It was in Rastrelli's work that a new Russian architecture found its own form within the wider European context in the age of Baroque.

Rastrelli's success would scarcely have been possible had it not been for the general raising of Russia's cultural level that took place in Empress Elizabeth's reign. The engravings of St Petersburg by Mikhail Makhayev, dating from 1753, show an unusually beautiful city, of fresh and lively hues, abounding in watery expanses, distant vistas, rows of trees, and majestic buildings sumptuously decorated and gilded and ornamented with sculpture. Yachts and rowing and sailing barges pass along the rivers and canals past the splendid façades and open galleries where moorings are provided. In the distance cupolas and spires of churches can be seen, the golden spire of the Admiralty, the silver-coloured roofs of palaces and park pavilions picked out with gilded detail, but few private houses of any size. Makhayev's plan of St Petersburg, too, showing an accumulation of wealthy urban estates with drawings of their gardens forming broad strips extending along river-banks, juxtaposed with the straight streets and spacious squares of mid-eighteenth-century St Petersburg, shows an attractive graphic combination of a rich variety of elements within a single style.

St Petersburg's overall unity and the dominance of its own Baroque style distinguished it from other cities during this period. As depicted in engravings and plans, Russia's northern capital may well have appeared more burgeoning, ordered and European than it really was. The small dwellings of artisans and lingering vacant patches of bog were not attractive to artists. Nor did they pay much attention to the military quarters of St Petersburg, the austere rows of barracks on the south side of the Fontanka, though in actuality even these buildings often displayed decorative elements in the prevailing style. Contemporary artists succeeded, however, in conveying the main aspects of the city, its spaciousness, its grandeur, its coming into flower after half a century of extraordinarily rapid development, the sumptuous fabric into which it was woven in the Baroque era. Like huge blooms or jewels, Rastrelli's celebrated buildings sprang up to enrich this fabric: the Winter and the new Summer Palaces, the palaces of the aristocracy such as the Vorontsovs, Shuvalovs, Bestuzhev-Ryumins and Stroganovs, the Smol'ny convent, as well as the buildings of his only rival, the no less talented Russian architect Savva Chevakinsky, above all the St Nicholas Cathedral or "Sailors' Church" (Sobor Nikoly Morskogo).

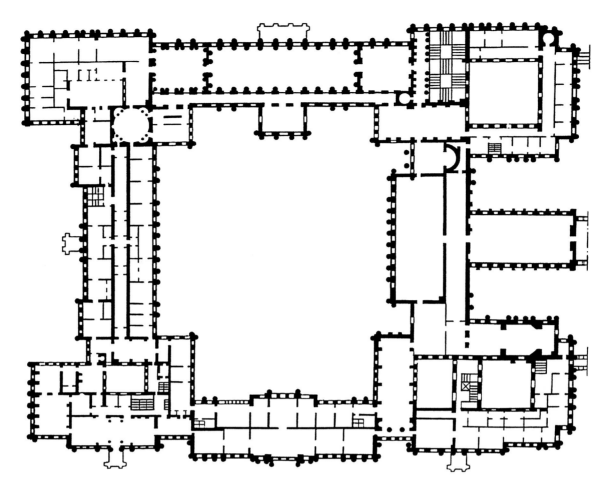

212 Plan of the Winter Palace, St Petersburg (Francesco Bartolomeo Rastrelli), 1754–62.

In the reign of Empress Anne, Rastrelli began to build a huge new summer palace to the south of the Summer Gardens, on the site of the present-day Engineers' Castle (Inzhenernyy zamok). He based its design on that of the Palace of Versailles, with blocks surrounding an entrance courtyard, to a lesser height than their models, but with façades equally rich with Baroque sculpture. In the 1740s Mikhail Zemtsov began to build the Anichkov Palace on the corner of the Nevsky Prospekt and the Moyka, and Rastrelli took over this project. Both these palaces, though neither was to preserve its original Baroque form, fixed the locations of two of the most important imperial residences. In city-planning terms, the very fact that they were designed in Baroque style placed them in this part of St Petersburg.

In 1746–57 Rastrelli built a palace for Count Mikhail Vorontsov, Chancellor of the Russian Empire, on the Fontanka Embankment. This marked a further step towards the final formation of the Russian Imperial Baroque style. Rastrelli replaces the concept of the flat, single-dimensional façade typical of early St Petersburg architecture with that of a moulded façade, brought out in the Vorontsov Palace by the contrast between austere smooth walls and an ornate central forward break. His experiment with round columns and pilasters, which have the effect of filling façades with light and shade, also greatly enhances the palace's appearance. Here, in the link between the Orders and sculptural ornament, Rastrelli has found his rhythm.

In his palace of 1752–54 for Baron Sergey Stroganov, a scion of one of the country's wealthiest families, which from the reign of Ivan the Terrible had owned most of the salt-mines in Russia, Rastrelli developed the ceremonial, sculptural element of his style. With the increasing scarcity of building space in the capital, there was increasing need for palaces built on the line of the street rather than surrounded by a garden. Rastrelli now designed a type of palace building enclosing a square courtyard.[106] The inner space is surrounded by façades with exquisite mouldings, shallow ground-floor rustication, prominent first-floor windows, alternating square and round windows on the second floor, and massively grouped columns at the edge of the central portico.

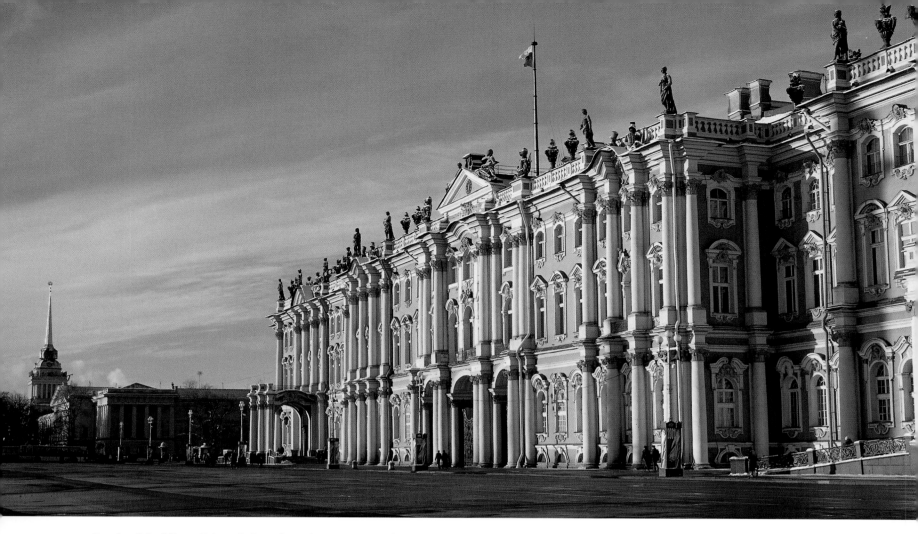

213 Façade of the Winter Palace, St Petersburg (Francesco Bartolomeo Rastrelli), 1754–62, overlooking Palace Square.

The most architecturally important palace of this period was the main imperial residence in St Petersburg, the Winter Palace (Zimniy dvorets). Two palaces had been raised on the same site during the reign of Peter the Great. In 1732–35 Rastrelli had built a third palace on the Palace Embankment for Empress Anne, which he almost entirely rebuilt in 1754–62 on the instructions of Empress Elizabeth, and it is this fourth Winter Palace on the site that stands today.[107] The building was completed just after the death of Elizabeth, in the reign of her nephew Peter III in 1762.

Once more Rastrelli's concept was a single palace complex. This rather unexpected design for such an important building arose from the plan for a ceremonial square in front of it. Rastrelli at first most likely thought of a round square entirely surrounded by a colonnade, with an equestrian statue of Peter the Great cast by his father at the centre of it.[108] In the middle of this gigantic building Rastrelli placed a courtyard enclosed by four blocks linked by passages (pl. 212). The ground storey of each block served as a socle for the two upper storeys, with linking Corinthian columns. The rhythm of the columns,

which gradually diminish in size, is striking, as is the alternating pattern of sculpted figures and urns on the roof (pl. 213). The *nalichniki* to the windows take diverse forms, with masked angels' heads and intricate triangular and segmental pediments (*sandriki*) above the windows. The palace has more than two thousand windows, a quantity which gives some idea of the almost infinite wealth of detail contained in the building, constituting an aesthetic quality in itself (pl. 214). This decorative abundance, together with the white columns, gilding and turquoise colour of the walls, creates an effect of extraordinary, even somewhat barabaric splendour (pl. 215).

The Winter Palace was built with three of its façades facing the Neva, Palace Square (Dvortsovaya ploshchad') and the Admiralty, with other buildings joining it on the fourth side which later became the Hermitage. It dominates the surrounding space. It is so large that its shape can distinctly be seen from the other side of the Neva, from the Peter and Paul Fortress and the Spit (Strelka) of Vasil'yevsky Island. No less an impact is made by its exterior when seen close to, when the ornament on the façades seems to be in motion, the columns,

214 Capitals on the façade of the Winter Palace, St Petersburg (Francesco Bartolomeo Rastrelli), 1754–62, overlooking Palace Square.

215 Window surrounds (*nalichniki*) of windows on the façade of the Winter Palace, St Petersburg (Francesco Bartolomeo Rastrelli), 1754–62, overlooking Palace Square.

216 The Great Cascade, Peterhof (Niccolò Michetti, Georg Fel'ten, Andrey Voronikhin).

cornices and sculptured figures appear foreshortened, and the contours of the forward breaks and the stepped corners stand out. The unity of Rastrelli's city-planning and architectural conceptions, one of the leading characteristics of Russian Imperial Baroque, is vividly apparent here.

Rastrelli was not the only architect to design palaces in St Petersburg in the mid-eighteenth century. The huge Sheremetev residence on the Fontanka Embankment, preserved to this day after several rebuildings, was designed by Savva Chevakinsky, with some participation by the Sheremetevs' serf-architect Fyodor Argunov, who became famous as a designer of fortresses. In 1753–55 Chevakinsky, in collaboration with Aleksandr Kokorinov, built a palace on Malaya Sadovaya Street for Empress Elizabeth's favourite Count Ivan Shuvalov. In this restrained exterior a transition from Baroque to Classicism can be felt; although the palace was rebuilt in 1816–19 and 1846–52, the features of the previous century are still predominant. It was not only aristocrats who built themselves palaces. Rastrelli designed the residence of the wealthy merchant Stegel'man on the Moyka Embankment (1750–53) which still stands. An example of an average-sized

dwelling of the mid-eighteenth century is the Grabbe House on Gorokhovaya Street. All surviving Baroque buildings in St Petersburg have a pronounced stylistic unity. Their monumental solidity, imposing elegance and wealth of picturesque detail fix a firm image of the ceremonial and festive Russia of Empress Elizabeth Petrovna's reign.

The magnificence and sheer scale of Russian Imperial Baroque is seen at its most impressive in the imperial residences of Peterhof and Tsarskoye Selo outside St Petersburg, rebuilt by Rastrelli. Both were begun by Peter the Great, and by the mid-eighteenth century the palaces and surrounding parks had already been repeatedly rebuilt and replanned with ever-increasing size and splendour. The concept of Peterhof is based on the meeting of two aquatic elements, the sea and a cascade of fresh water from the high bank on which the palace stands. A canal oriented to the centre of the palace ensemble runs from the shore of the Gulf of Finland straight to the Great Cascade (Bol'shoy kaskad) with its numerous gilded statues and fountains, directly above which the Great Palace (Bol'shoy dvorets) stands (pls 216, 217). Rastrelli drew together all the elements that Niccolò Michetti had created before him.

217 (following page) View from the top of the Great Cascade, Peterhof (Niccolò Michetti, Georg Fel'ten, Andrey Voronikhin).

219 The Catherine Palace, Tsarskoye Selo (Francesco Bartolomeo Rastrelli), 1752–56.

Architecture and sculpture join inseparably in one majestic ensemble flashing with the spray and gilded sculptures of the cascade and the ornamental detail of the palace façades. On the landward side of the palace a central axis runs for a number of kilometres through the symmetrically planted trees and shrubs of formal gardens and ponds along a canal which carries water from some distance away to the top of the Great Cascade, from there to descend to the sea. The Peterhof ensemble is a superbly organized mechanism for moving vast quantities of water within Rastrelli's sumptuous architectural framework.

The village of Tsarskoye Selo (now the town called Pushkin) is situated in a flat and rather boring region. Here Rastrelli cre-

220 Plan of the Catherine Palace, Tsarskoye Selo (Francesco Bartolomeo Rastrelli), 1752–56.

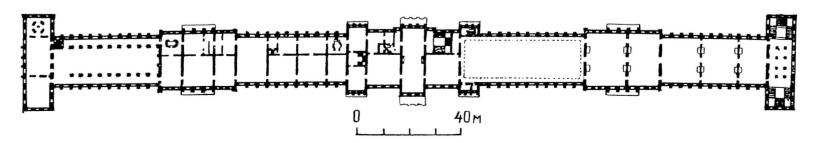

218 (*previous page*) Principal staircase of the Great Palace, Peterhof, 1750, restored 1970s.

ated a palace with surrounding landscape which is perhaps an even more thrilling composition than Peterhof (pls 219, 220). He again threaded the plan through a central axis many kilometres long. He radically rebuilt the existing palace as a summer residence for Elizabeth I, completing it in 1724. The delighted empress named the palace after her mother, Catherine I, and it became known as the Catherine Palace. It has a 300-metre façade and an enfiladed interior of the same length (pl. 221) which survives in restored form after its destruction in the Second World War. The enfiladed rooms, each in the same decorative style with abundant carved gilded ornament, make an astonishing impact. In the Dance Hall (Tantseval'naya zala), containing thousands of gilt ornamental pieces, the combined mass of candlesticks, sculptures and architectural detail in no way diminishes the perfection of individual objects. Nor is the effect of this extraordinary sumptuousness at all heavy; on the contrary, the surface of the walls gives the impression of an appealing airiness; as conveyed in Vipper's above-quoted general description of the effect of Rastrelli's interiors, they seem almost mobile, as if alive. The same could be said of the exterior of the Catherine Palace. Despite the enormous length and single continuous rhythm of the building, the façades never cease to fascinate. The same theme, expressed at window embrasures and in relationships between columns and sculptures, is repeated with endless variations and nuances, as in Baroque music (pl. 222). Rastrelli's original park at Tsarskoye Selo, with its strict but at the same time varied layout – it has undergone much change since its creation – must have had the impact of musical rhythm, harmony and form to an even greater extent. His design was both ordered and elegant, like the proof of some complex geometrical theorem.

It would not be possible to discuss Rastrelli's work or the history of Baroque architecture in imperial Russia without reference to the Smol'ny Convent (Smol'nyy monastyr'), perhaps the most strikingly impressive of all surviving Baroque buildings in St Petersburg. Empress Elizabeth was very fond of church services. She never failed to attend church festivals and often stood in church with the choir and sang hymns and chanted prayers with the singers. She kept fast-days and -weeks with the utmost rigour. The imperial chancellor Count Bestuzhev-Ryumin was obliged to write to the patriarch in Constantinople to be asked for special permission to be excused fasting and not eat mushrooms, which were the empress's staple during weeks of strict fasting. Whilst she did not parade her religious feelings, she treated the customs and views of the church with deep respect, and often thought of abdicating in her old age to enter a convent and become an abbess. It was for this purpose that Rastrelli built a convent on the site of the extensive Peter's Tar Yard, where tar (*smola*) had

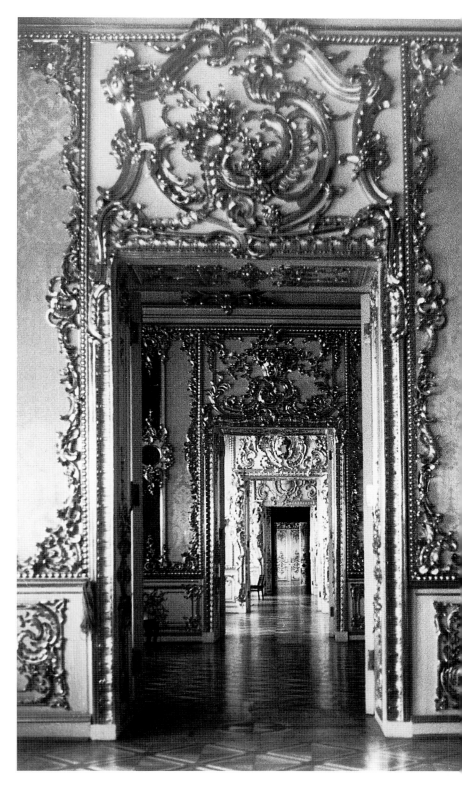

221 Enfilade of the Catherine Palace, Tsarskoye Selo (Francesco Bartolomeo Rastrelli), 1752–56.

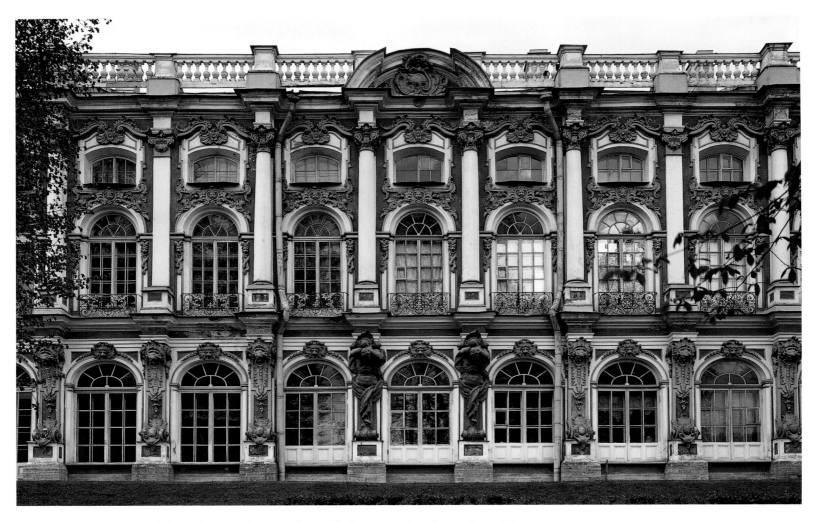

222 Detail of the façade of the Catherine Palace, Tsarskoye Selo (Francesco Bartolomeo Rastrelli), 1752–56.

once been stored for use on ships. The building became popularly known as the Smol'ny Convent, and the name stuck. Its official name was the New Resurrection Convent of the Virgin (Voskresenskiy Novodevichiy monastyr'). In this dedication two famous old Russian religious premises that the empress loved to visit were remembered: the Monastery of the Resurrection or New Jerusalem (Novyy Ierusalim) outside Moscow and the New Convent of the Virgin (Novodevichiy) in Moscow itself. These names were not invoked at random; behind them lay the St Petersburg mythology that arose particularly strongly in the Baroque era. The theme of the New Jerusalem was connected with the idea of the resurrection of Orthodoxy, of its unique truth among the systems of Christian teaching. The New Convent of the Virgin was intimately linked with Moscow tradition: it had been a ritual from early times for women of noble families to enter a convent at the end of their lives. These associations are reflected in the architecture of the Smol'ny Convent.

The building is sited in a remote quarter of the city, not far from the bank of the Neva at a sharp turn of the river. To those approaching by water its splendour offers an immediate "image of the capital". Rastrelli completed his first design in 1744, but building did not begin until 1748. The essential structure of the cathedral and other buildings of the convent was finished in 1764, but work on the interiors dragged on until completion by the architect Vasily Stasov in 1832.[109]

Rastrelli's ideas changed[110] at least three times in the design stage, as preserved plans indicate.[111] While the overall character of the composition did not change, its grandeur, still considerable in the final building, underwent a process of some diminishment. Rastrelli's first concept was a major monastic cathedral in Roman Baroque style, reminiscent of Borromini's churches.[112] Empress Elizabeth herself was responsible for this clear Italian intervention into Russian Baroque. She directed the architect to follow Byzantine traditions and even the examples of specific Orthodox churches in Moscow, thus

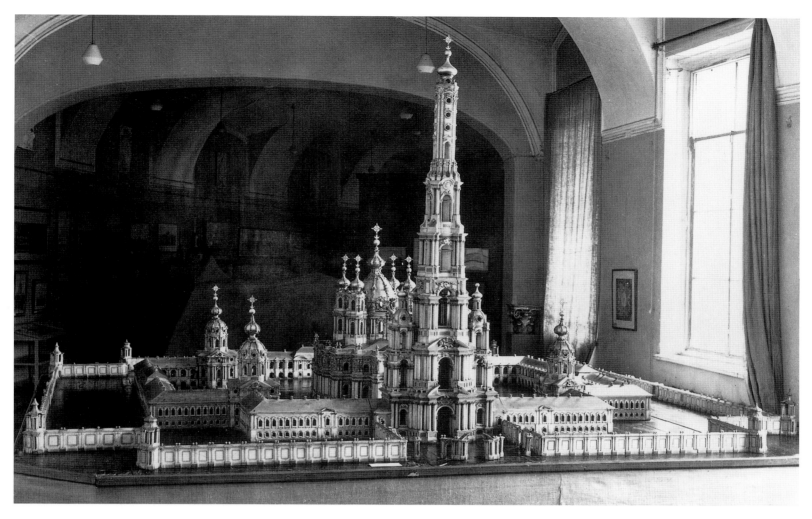

223 Model of the Smol'ny Convent made in 1750–56.

revealing the desire of the supreme power that the Russian Imperial Baroque style should take account of the national heritage. It was natural that the primary arena for this should have been church-building, and it was this genre that would henceforth see an ongoing interaction between Moscow architectural tradition and Western ideas. For the rest, the Smol'ny Convent bears Rastrelli's hallmarks in full measure (pl. 223).

Its general composition is strictly centralized. Around the five-cupola, nearly square-plan cathedral centred on the shape of a Greek cross stretches a great courtyard, also Greek-cross-shaped. Around the perimeter of the courtyard run monastic cells; at the corner of each of the four blocks is a small church crowned with a cupola. The whole is surrounded by a wall with turrets. Before the west front of the cathedral, facing the city, is an elongated public square, its central axis brought out by the symmetric placing of the service blocks that dominate the entrance to the square. Such a strictly ordered composition is highly typical of St Petersburg Baroque architecture.

Especially effective is the relationship of the accumulated mass of cell blocks with the monolithic cathedral and of the cupolas of the small churches standing on the diagonals of the ensemble with the five cupolas of the cathedral overlooking them. The whole makes an impact of majesty and monumentality and a powerful dynamism, arising not so much from its unruffled façades as from the mutual proximity of all the blocks in the composition (pls 224, 225).

The hidden references to early Russian tradition in the Smol'ny cathedral are of great interest to the architectural historian. Directing Rastrelli to use not Catholic but Russian Orthodox churches as models, Empress Elizabeth specifically mentioned the cathedral of the Dormition in the Moscow Kremlin and the Ivan the Great bell-tower which stands next to it. Rastrelli obediently changed his original design for the cathedral, making a new, broadly rectangular plan. As in the case of the Moscow cathedral, he kept to the time-honoured scheme, with six mighty pylons supporting the roofs and five

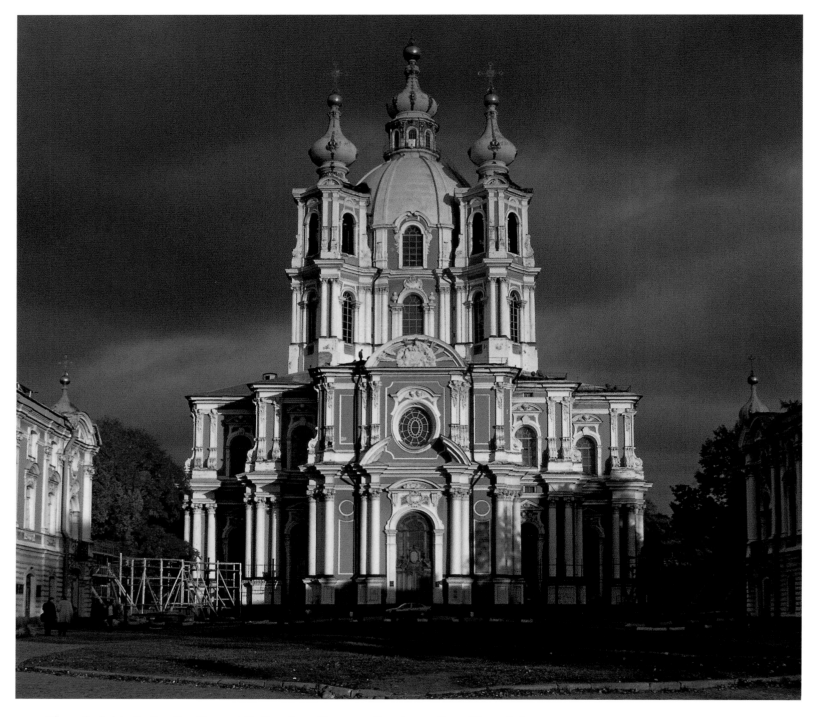

224 The cathedral in the Smol'ny Convent, St Petersburg (Francesco Bartolomeo Rastrelli), 1748–64.

cupolas. Architectural forms and detail, however, were entirely his own. He used some traditional features in the bell-tower, which was not built but is known from a model.

The Smol'ny Convent has always been considered Rastrelli's most inspired masterpiece. Giacomo Quarenghi, exponent of Classicism and one of Catherine the Great's finest architects, would take off his hat when passing its cathedral and exclaim:

"What a church!" Its and its architect's only rival in St Petersburg was Savva Chevakinsky's cathedral of St Nicholas (pl. 226).

This church, founded in 1753 at the zenith of Imperial Baroque, was completed in 1762, just at the moment when the style went out of fashion in St Petersburg. Savva Chevakinsky, one of the most gifted Russian architects of the middle of the

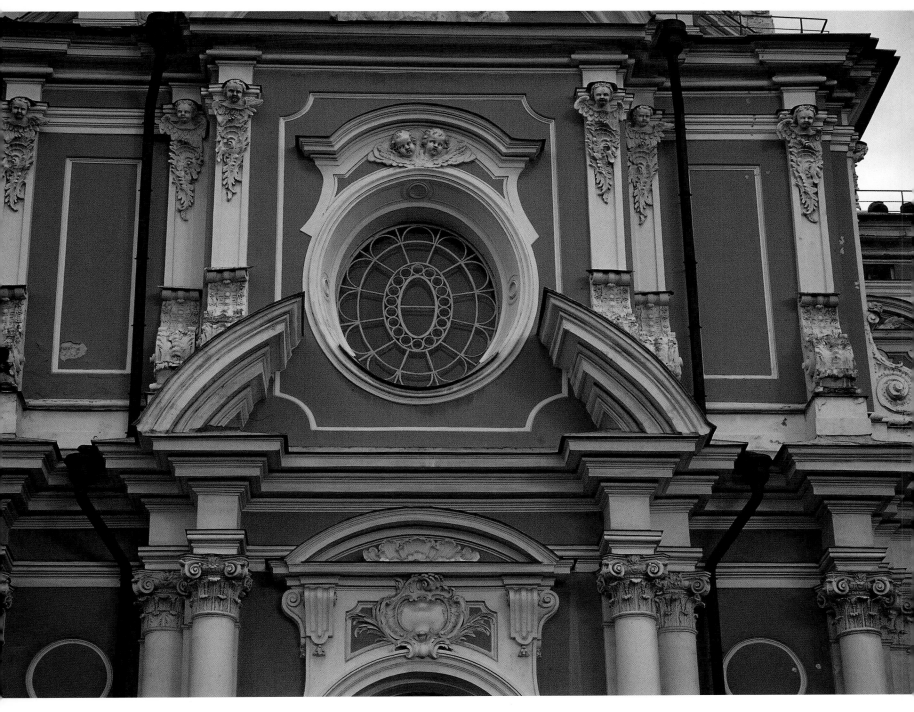

225 Detail of the west front of the cathedral in the Smol'ny Convent, St Petersburg (Francesco Bartolomeo Rastrelli), 1748–64.

eighteenth century, studied at the Naval Academy in St Petersburg.[113] He entered the architectural workshop of the Navy Department where he worked with Ivan Korobov, the famous creator of the Admiralty building, succeeding the latter on his death as architect of the Admiralty, a key post in St Petersburg. The commission for the building of St Nicholas's Cathedral as the principal church of the Russian fleet naturally went to

him. It became known popularly as the Maritime Cathedral of St Nicholas (sobor Nikoly Morskogo).[114]

This cathedral has much in common with the Smol'ny – the same monumentality, compositional complexity, and richness of brightly coloured decorative detail; and it too has echoes of early Russian churches in the centralized plan in the shape of a Greek cross and the five cupolas. But its greater serenity,

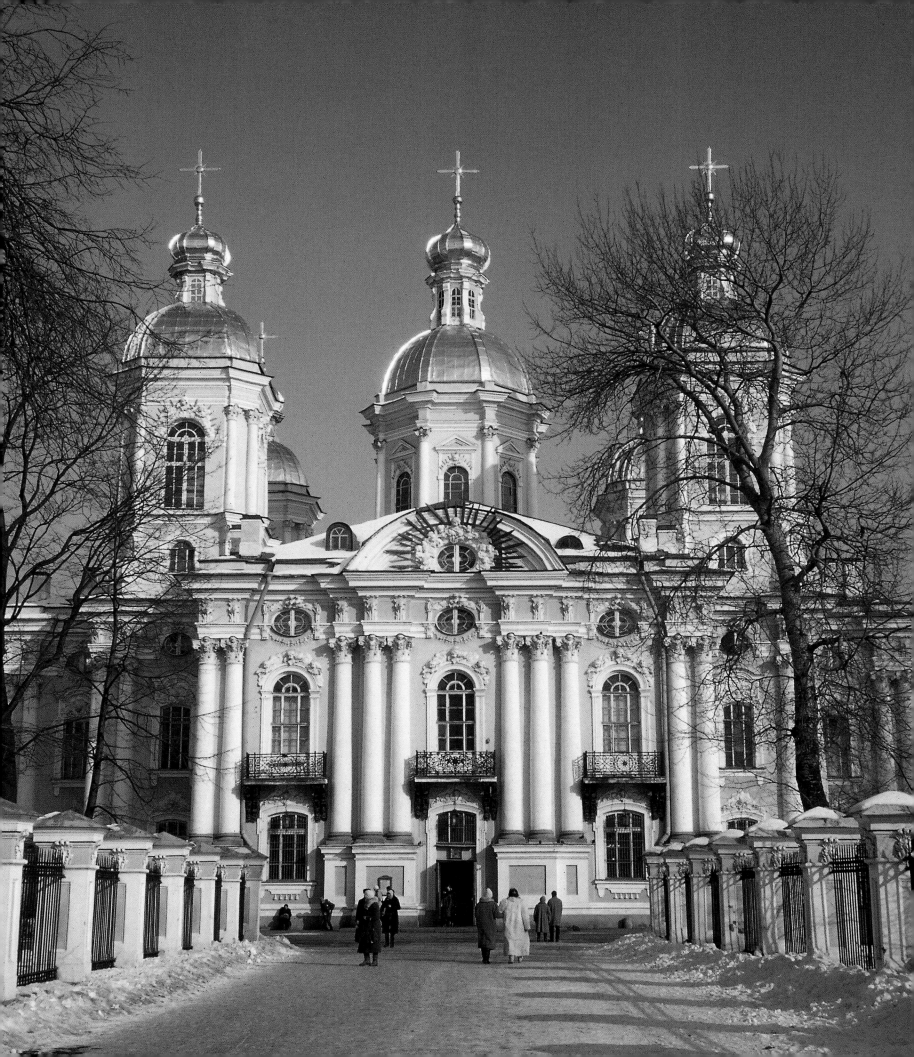

majestic solidity and less dynamic quality in no way lessen its appeal. It has the effect of two churches, upper and lower. When one enters the cathedral, it feels dark and squat in shape. Ascending, however, to the upper storey by the long side stairway, one is struck by the height attained, the spaciousness of the interior illuminated by daylight entering under the cupolas, and the rich gleam of the gilt ornamentation. The iconostasis, designed by Chevakinsky himself, has a pre-echo of Neoclassicism in the precise proportions of its gilded Corinthian colonnade, but the effect of the luxuriant wreaths of flowers and foliage entwining the columns keeps it Baroque. Before the west front stands a three-storey bell-tower crowned with a tall guilded spire, which combines the traditional features of the complex structure of Moscow bell-towers with the typically St Petersburg love of spires.

In Moscow in the second quarter and middle years of the eighteenth century the Baroque style evolved very much as it did in St Petersburg. It is true to say that from the 1730s to the 1750s, following the direction taken by architecture commissioned by the court, a single Russian architectural style emerged in both capitals. This convergence was cemented by the fact that the leading architects of the capital – Rastrelli, Yeropkin, Zemtsov, Korobov – were also associated with architectural developments in Moscow, especially where the building of palaces was concerned. Although these St Petersburg architects did not spend very much time in Moscow, Rastrelli and Zemtsov paid a number of later visits. Ivan Mordvinov[115] and Ivan Michurin,[116] who studied in the Netherlands, settled in Moscow. A new generation of Moscow architects was trained in the studios of these masters, gaining experience not only in imitation of the work of Western European architects, known only from books, but also from everyday familiarity with the historic Russian architectural monuments the care and restoration of which was one of their main duties.

Of the architects of the mid-eighteenth century – Prince Dmitry Ukhtomsky,[117] Andrey Yevlashev, Karl Blank[118] – whose work formed the face of Moscow during this period, none trained abroad or even in St Petersburg. Nevertheless, their careers depended on the sovereign, and in view of this it was essential to follow the unified St Petersburg style, at least in its main features. The most important state commissions had to be executed in Imperial Baroque style, and architectural forms had to be similar to those that emerged in St Petersburg in the decade 1740–50.

At this time an ambitious project arose in Moscow that was not to be realized until a later period. Ukhtomsky planned a complex of hospital buildings for the old and disabled[119] "of military status [. . .] and similar civilian status [. . .] in extreme need [. . .] and orphans", on the models of the Hôtel des

227 The Apraksin house, Moscow, 1760s.

Invalides in Paris and Chelsea Hospital in London.[120] The project consisted of a huge ensemble of buildings and a park, to be sited on a bank of the Moskva. Identical rectangular blocks would surround all sides of a central square, each with a passage through the middle leading into the square, which would contain a cathedral. The park would surround the complex on three sides, divided into quarters by two diagonal alleys intersecting in the middle. Had Ukhtomsky's project been realized, Moscow would have acquired a major Baroque ensemble to surpass even the Smol'ny Convent in St Petersburg. The Red Gate of the 1740s gave a good idea of typical Muscovite Baroque triumphal ensemble style.

Few mid-eighteenth-century architectural monuments remain in Moscow today, and especially few private houses. Almost the only surviving palace from this period is one that used to belong to the eminent Apraksin family (pl. 227). It was built in 1766, but its style goes back to an earlier time. Its composition is elegant and complex, with the curved line of its

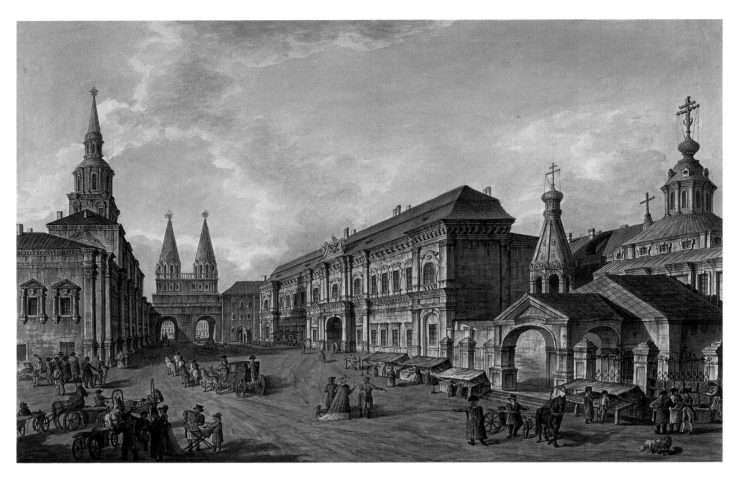

228 View of the Mint and Iversky Gate, Kitay-Gorod, Moscow (workshop of Fyodor Alekseyev), late eighteenth century.

façade, rounded corners, and an oval forward break dominating the centre. At the centre and at the ends of each façade, monumental columns rise to the extent of the upper two floors; at ground-floor level, pilasters take their place. Windows of various shapes – rectangular, arched, square and round – take up all available wall space, their sumptuous *nalichniki* abutting each other and making the whole building look like a carpet woven with a decorative pattern. All this, contrasting with the bright turquoise walls and white-painted detail, invokes a mood of élan typical of mid-century Russian Baroque.

The same features are seen in the churches built in Moscow during this period, such as that of the Saviour of the Transfiguration (tserkov' Spasa Preobrazheniya) on Novaya Bolvanovka Street (1749–55), Nikita the Martyr (Nikity-Muchenika, 1751) and Nikola the Bell-ringer (Nikoly v Zvonaryakh, 1760). The Russian Imperial Baroque style is especially clearly displayed in the massive, monumental forms of the church of the Roman Pope Clement (tserkov' Klimenta Papy Rimskogo), built in 1762 by Andrey Yevlashev, which is divided into two levels, a lower (winter) and an upper (summer) church. Above the main

structure of this church, which makes light ornamental use of the Orders and is punctuated by narrow windows with slender *nalichniki*, rise five great cupolas, which can be seen from a distance. In general, Imperial Baroque held full sway over Moscow's rapid architectural development of the mid-eighteenth century (pl. 228).

The style also reached the provinces, though in more outlying regions local architectural traditions lived on. Old structures were often preserved with new Baroque exteriors built on, and sometimes new Baroque interiors, as in the case of the celebrated New Jerusalem Cathedral of the Resurrection. Octagonal upper structures, cupolas with richly decorated ribs and ornate portals became widespread. New secular buildings raised on the country estates of courtiers and magnates would be in the latest style of St Petersburg and Moscow, and this would be passed on to local builders. Baroque decoration of interiors spread particularly rapidly because of the abundance of experienced wood-carvers even in remote parts of north-eastern Russia and Siberia. Such craftsmen made many fine iconostases, which would be displayed in the most strikingly

229 (*above left*) Church of the Resurrection, Voskresenskoye, province of Vladimir, 1743.

231 (*above right*) Detail of the decorative scheme of the church of the Resurrection, Voskresenskoye, province of Vladimir, 1743.

230 (*left*) Iconostasis in the cathedral of the Gledinsky Monastery, Veliky Ustyug, first half of the eighteenth century.

Baroque parts of new church buildings. The Baroque style lingered longer in Russian provincial architecture than in St Petersburg and Moscow; it survived official stylistic change and was to influence local builders throughout the second half of the eighteenth century (pls 229–30).

No new buildings of the last years of the reign of Empress Elizabeth, in Moscow, St Petersburg or especially the provinces, showed any signs of stylistic staleness. There was no warning of the change that was coming. But the reign of Catherine the Great was about to begin, and would bring about a radical change in the faces of both the new and the old capitals. Russian architectural development in a Western direction was once more to be firmly accelerated by the supreme authority.

V

The Russian Enlightenment

1 "Legislomania" and the Architectural Utopia of Catherine the Great

Russian Imperial Baroque attained its high point in the 1760s. Its sudden disappearance and the emergence of Neoclassicism in its place had entirely political causes. On 24 December 1761 Empress Elizabeth Petrovna, daughter of Peter the Great, died after a twenty-year reign. She did not live to see the completion of the masterpiece of her chief architect, Francesco Bartolomeo Rastrelli – the Winter Palace in St Petersburg. In fact, very little work remained to be done on it, and Elizabeth's nephew Peter III moved into it on his accession to the throne.

Peter III was more attached to the playful fancies of Rococo than to the solemn uniformities of Russian Baroque. His modest-sized palace at Oranienbaum had been built for him in Rococo style by Antonio Rinaldi in the 1750s when he was heir to the throne. It contained a miniature (though in fact quite large) fortress to full military specifications, where the grand prince played with live soldiers.[1] He was by no means displeased with Rastrelli's style, however, and contemporaries record that he was content with the Winter Palace and happily celebrated moving into his new residence.[2] Had he lived longer, Russian architectural evolution might have taken a rather different course, with Baroque continuing for a longer period and Neoclassicism beginning later. But history turned out otherwise.

Peter III was a complete failure as a ruler; his court found his behaviour provocative and abnormal. His wife, Sophie-Augusta-Frederica, daughter of a German princeling, the future Catherine the Great, thus described the situation: "[. . .] it was a matter of either perishing with a lunatic or of escaping with the people, who heartily wished to be rid of him."[3] On 28 June 1762, after only five months as tsar, Peter III was assassinated, bringing his wife to power. In architecture as in much else, the new empress knew exactly what she wanted.

She aimed immediately to take Russian architecture into the cultural mainstream of the great European powers. By means of her unlimited power she led the Neoclassical movement in Russia, but her aspirations went wider: she put into practice many and diverse European architectural concepts of the Age of Enlightenment.

When Princess Sophie-Augusta-Frederica von Anhalt-Zerbst was crowned Empress Catherine II in the cathedral of the Dormition in the Moscow Kremlin, an event took place in the ancient capital that initiated the programme of her entire reign. It took allegorical form, as described in an eyewitness account of what happened in the first days of 1763:

> I found all the people in Moscow [. . .] at this time talking about [. . .] a street masquerade [. . .]. Our new Empress had decided to divert herself [. . .] with an ingenious spectacle. This masquerade [. . .] mocked [. . .] the vices, exemplified especially by bribe-taking judges, gamblers, wastrels and drunkards [. . .] over which the sciences and virtues were shown to triumph; which was why it was called "The Triumph of Minerva".[4]

The masquerade's title, proclaiming the triumph of Enlightenment, became the slogan of Catherine the Great, who assumed the role of the Roman goddess of wisdom for the whole of her thirty-three-year reign. In this she succeeded to perfection. In sculpture, painting and poetry, Catherine was depicted in the guise of Minerva or Pallas Athene not only thoughout her reign but even after her death (pl. 233).[5]

The reign of Catherine the Great was perhaps the best time for Russia in its entire history. It brought continually increased political and economic power, an unbroken series of military victories, and annexations of extensive territories to the south and west. The empress was a consummate politician and a sound economist. Above all, she possessed vision, a lively imagination, and a fondness for large-scale projects. Once, in the

232 (*facing page*) Semi-rotunda of the church of the Vladimir Icon of the Mother of God, 1780–99, Muromtsev estate, Balovnevo, Lipetsk province.

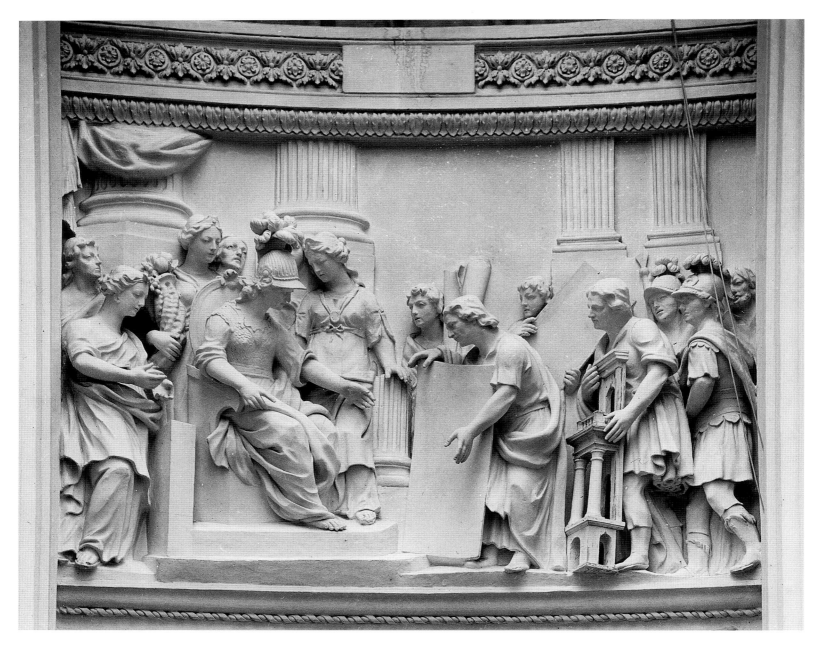

233 Catherine Hall, Senate building, Kremlin, Moscow (Matvey Kazakov), 1776–87; bas-reliefs by Gavriil Zamarayev.

course of a literary game, she had to finish a sentence begun by one of her courtiers. "My castles in the air . . .", he wrote: ". . . are not in the air, and I add something to them every day," concluded the empress.[6]

Catherine had a remarkable capacity for conceiving plans of huge scale and audacity, which could be only partly realized at any given moment. This, in fact, brought great political benefits. Her antagonists, deafened by the thunder of her propagandizing teams, were glad to agree to the comparatively modest parts of the empress's plans that could be realized. Thus, her famous "Instruction" (*Nakaz*) to the Legislative Commission

for the creation of a new legal code was so radical, not to say revolutionary, that those charged with its execution would not promulgate it in its original draft. Going to war with Turkey, Catherine announced her "Greek Project", the re-establishment of a Christian state centred on Istamboul, a new Byzantium. Her second grandson, whom she named Constantine, after the founder of the city,[7] was to be its sovereign; he was entrusted to a Greek nurse and Greek children were found for him to play with.[8] The Greek Project was widely proclaimed abroad through all possible channels. I shall now suggest how it was made to inform the architecture of Catherine's resi-

dences so that it should be driven home to ambassadors and important visitors. Overawed by her far-reaching plans, European monarchs more readily agreed to Russian annexation of the Crimea and eastern Poland. Catherine's plans, however, were more than mere diplomatic ruses.

She believed what she said and wrote. Her political and even family thinking may have in large part consisted of utopias, in which she saw Russia's future – but utopias that were no mere abstract content of conversations with her courtiers. Catherine really did "add something every day" to her "castles in the air", and in the architectural field in particular. Here her activities were decidedly utopian, invariably based on an ideal that could never be fully realized.

To her regular correspondent in Paris, the envoy of the tiny German duchy of Saxe-Coburg-Gotha, Baron Melchior Grimm, Catherine thus described the country she ruled:

> There is not a single goat or a single cabbage left here, there is only the King of Epirus, whom every sculptor must carve, every painter depict, and all poets sing. This is a country of exquisite art [. . .] Raphaels, Titians [. . .] the gardens at Tsarskoye Selo and Prince Potemkin's wonderful palaces [. . .] all this has its place alongside legislomania [. . .].[9]

On another occasion she wrote to Grimm: "There is a disease here – legislomania, the Empress of Russia has contracted it too: the first time she laid down only principles, this time she is concerned with everything that leads to good."[10] The image of a "country of exquisite art" where the passion for lawmaking is ingrained is a key one for the understanding of Catherine's utopian vision, in which the process of civilizing the state, seen in her development of the country by legislative means, was combined with a new, aesthetic approach to the environment of everyday life. In this process the legislator's reforms were aesthetically clothed, and artistic policy took on the features of regulations that it was obligatory to obey.

The scale on which Catherine's ideals of Russian national life were embodied in architecture, parks and landscape design surpassed all that was being done at this time in the rest of Europe. In her reign the utopia of the new Russia, some features of which had already emerged, as has already been observed, in the Petrine era, took on a systematic form, which the empress described as "most profound, most thoroughly grounded in researches". This rich and imaginative model for the improvement of the country incorporated the entire environment of citizens' lives. "A building frenzy rages in our country now more strongly than ever before," wrote Catherine.[11] A general land survey was carried out, which changed the system of land use throughout European Russia. The Commission for Masonry Building in St Petersburg and Moscow not only replanned the capitals but throughout Catherine the Great's reign produced regulated plans to be implemented by all administrative centres in Russia. A commission for roads improved the network of imperial communications. Catherine's reign saw a transformation of the countryside.[12] The freeing of the gentry from compulsory state service gave rural life an altogether different character. For centuries the owners of landed estates had not enjoyed the right to live on them uninterruptedly, but were obliged to make themselves available for military or civilian service in return for the land and peasants granted them by the sovereign. Under Peter III this system was abolished, and during the reign of Catherine the Great the countryside burst into life. In the last third of the eighteenth century, tens of thousands of new houses with surrounding gardens were built in Russia by the gentry. These developments led to one of the most profound changes in the overall face of any country in recorded history.

The most up-to-date means of bringing about each aspect of this transformation of the environment of everyday life were sought, and the experience of many European countries was drawn upon, the chief criterion lying in the degree of innovation. It didn't matter which country an idea came from. A store of appropriate measures for the reform of Russian architecture and urban planning was built up, originating in a variety of countries – France, England, Italy, Germany, both directly and in combination. All these influences and models were moulded into a well-defined system in accordance with the tastes of leaders of the Russian Enlightenment during the second half of the eighteenth century.

Here was no simple mosaic of other countries' architectural achievements composed on Russian soil. Extraordinarily persistently and systematically, Catherine informed herself about the artistic and technical discoveries of European architects; their books and accounts of their work were found, bought and purloined for her by an army of agents in all the main capitals of Europe. Each new foreign architectural development thus brought to Catherine's notice, the construction of boulevards on the site of ancient fortifications or a new type of pavilion in a park, became a letter in the architectural language that formed her ideal image of the enlightened state.

The reduction of links with Germany and the Netherlands accompanied by the strengthening of French and the emergence of English influence that had begun under Elizabeth Petrovna came to affect architecture at the beginning of Catherine's reign, and these were major factors giving check to Russian Baroque when it was in full swing. How Catherine the Great launched a new period in Russian architectural history by exploiting the full gamut of the latest Western European ideas will now be considered.

2 Jean-Baptiste-Michel Vallin de la Mothe and the Emergence of Russian Neoclassicism

The last years of the reign of Elizabeth Petrovna saw the birth of a new architectural style, not on her initiative but on that of her favourite Count Ivan Shuvalov, one of the earliest leaders of the Enlightenment in Russia. The founding of Russia's first university, in Moscow, was due to his efforts, and in 1757 he persuaded Empress Elizabeth to found the Academy of Arts. It was first proposed that the latter should be built in Moscow, and Shuvalov commissioned Jacques-François Blondel to plan a design (pl. 234).[13] Elizabeth then decided that the Academy should be built in St Petersburg. Aleksandr Kokorinov, a pupil of the Moscow Baroque architect Prince Dmitry Ukhtomsky, was commissioned to adapt Blondel's plans to the new site.

Kokorinov obtained the commission because he knew Shuvalov, for whom he had built a house in St Petersburg,[14] an ornate Baroque building in the manner of Rastrelli. The unfamilar style of French Classicism was something of an obstacle for him in working on his new project. He was not averse to new ideas, but Shuvalov considered it necessary to bring in a further architect from France, and he succeeded in persuading Blondel's cousin, the thirty-year-old Jean-Baptiste-Michel Vallin de la Mothe, to come to Russia. The latter had concluded his studies at the French Academy in Rome with distinction,[15] and his abilities had been confirmed by his election to the Academies of Arts in Florence and Bologna. He was recommended to the Russian court not only by Blondel but also by the eminent Neoclassical architect Jacques-Germain Soufflot, which indicates the young de la Mothe's high reputation in Parisian professional circles. He was not only to collaborate in the building of the St Petersburg Academy of Arts but

also to become its first professor of architecture. Shuvalov perceived the importance of adequate preparation for those who were to execute innovative architectural projects. "We have scarcely any arts here," he wrote, "because there is not a single [. . .] skilled artist; young [. . .] people approach their studies without any grounding in foreign languages or any of the basic disciplines essential to the arts [. . .]."[16] With the arrival of de la Mothe in Russia the situation began to change, though slowly, until Catherine intervened.

When Shuvalov was sent into virtual exile abroad, he was succeeded as president of the Academy of Arts by another person close to the empress, Ivan Betsky. On 28 June 1765 the foundation-stone was ceremonially laid for the new Academy building designed by Kokorinov and de la Mothe, with the main façade adapted by de la Mothe from Blondel's plan. It was Catherine's intention that this monumental building should set the tone for Russia's new architectural style (pls 235–37).

The Academy, situated on Vasil'yevsky Island, a huge rectangular complex measuring 140 by 125 metres, consists of a main block overlooking the Neva, with three subsidiary blocks designed as teaching areas. At its centre, a round block surrounds a circular courtyard. The composition of the façade giving onto the Neva Embankment is typical of Blondel's school, with its prominent rustication at ground floor level, two Order-linked upper storeys and three forward breaks, one at each corner and a more prominent one at the centre surmounted with a cupola. However, the building shows marked differences from Blondel's plans. De la Mothe and Kokorinov's version of Classicism is more "up to date", with its more strongly geometrical conception and interaction of the main masses, especially noticeable in plan. It is striking that where Blondel specified a Corinthian Order, the stricter Roman

234 Jacques-François Blondel, design for an academy of arts building, Moscow, c.1758.

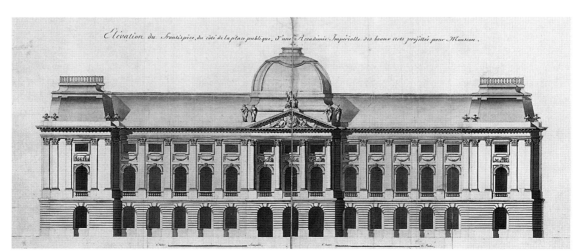

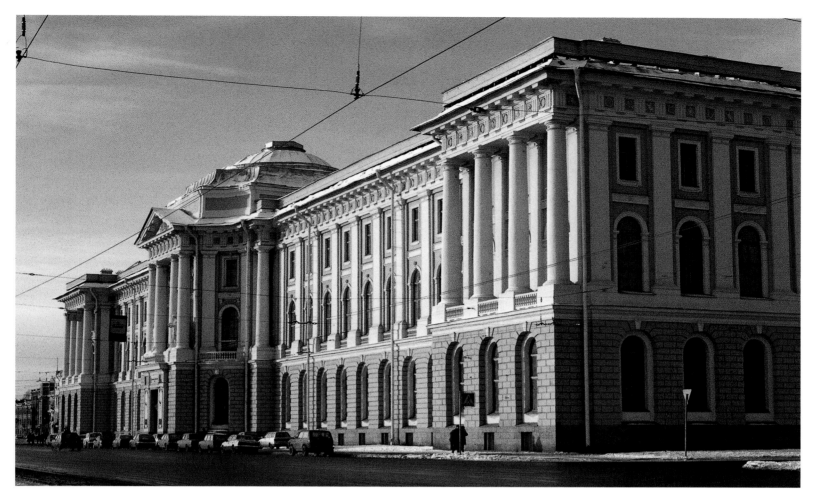

235 The Imperial Academy of Arts building, St Petersburg (Jean-Baptiste-Michel Vallin de la Mothe and Aleksandr Kokorinov), 1765–88.

Doric was actually used. The cupola too is more laconic than as designed by Blondel. The completed building turned out even more austere than it appears in de la Mothe's drawings. Round columns were used at forward breaks and pilasters in the intervals between them.

No less important in establishing Russian Neoclassicism was another of de la Mothe's buildings, New Holland (Novaya Gollandiya), a huge depot for ship building timber (pl. 238). The original structure was built with the collaboration of Dutch engineers in the 1730s. In 1763–65 Savva Chevakinsky produced new plans for the whole complex, which were executed. His Baroque façades, however, were rejected, and de la Mothe was commissioned to design new ones. He left the whole enormous complex virtually unornamented, but emphasized its rounded corners with mighty paired columns and placed a triumphal arch above the canal where it enters the depot. The stark grandeur of his design and his bold use of Classical principles give the structure an affecting, even Romantic character.

Nevsky Prospekt, the main thoroughfare of St Petersburg, contains further major buildings designed by de la Mothe. The Merchants' Yard (Gostinyy dvor), designed by him in 1759 but not completed for many years, and St Catherine's Roman Catholic Church, begun in 1763 and completed in 1788, gave a new aspect to these types of buildings within the canons of Classicism. The Small Hermitage (Malyy Ermitazh) was built in 1764–75 alongside the Winter Palace (pl. 239): the façade overlooking the Neva, with a high Ionic colonnade and socle storey, is preserved intact today; the façade giving onto Palace Square was built by another architect who played a leading role in the emergence of Russian Neoclassicism, Georg Fel'ten,[17] who took over from de la Mothe when the latter returned home to Angoulême. De la Mothe also designed some outstanding interiors, among them two in the Great Palace at Peterhof, the East and West Chinese Studies.

Georg Fel'ten, born in St Petersburg, the son of Peter the Great's chief cook, was educated in Stuttgart and Berlin, and on his return to Russia worked with Francesco Bartolomeo

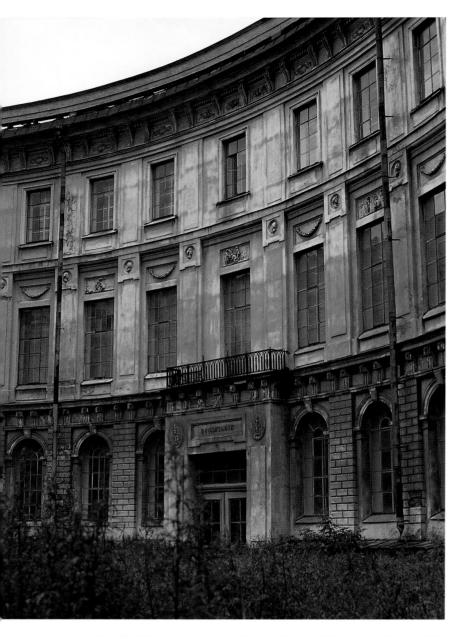

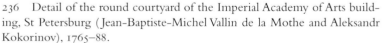

236 Detail of the round courtyard of the Imperial Academy of Arts building, St Petersburg (Jean-Baptiste-Michel Vallin de la Mothe and Aleksandr Kokorinov), 1765–88.

237 Detail of the façade of the Imperial Academy of Arts building, St Petersburg (Jean-Baptiste-Michel Vallin de la Mothe and Aleksandr Kokorinov), 1765–88.

Rastrelli. Grabar' describes his work as "pellucid, without shade [. . .] light-hearted and elegant, but not profound – it is the art of the early morning hour, the first light of the working day" of Neoclassical St Petersburg.[18] His work belongs mostly to the 1770s, and includes the Throne Room of the Great Palace of Peterhof, the famous wrought-iron gate and railings of the Summer Gardens (Letniy sad), the churches of St Catherine on Vasil'yevsky Island and St Anna on Saltykov-Shchedrin Street, and the Armenian church on Nevsky Prospekt (pl. 240). His most famous achievement is the northern wing of the

Catherine Palace at Tsarskoye Selo (Pushkin), built at the end of the 1770s; this later became known as the "Zubovsky wing" after the name of the empress's last favourite, Platon Zubov, who lived there. The summation of Early Neoclassicism in Russia, the architectural style of the first fifteen years of Catherine the Great's reign, the Zubovsky wing exhibits the mastering of a compositional system whose features the sovereign's approval made canonical. The next architectural period of the Russian Enlightenment had a looser and more lively relationship with Antiquity.

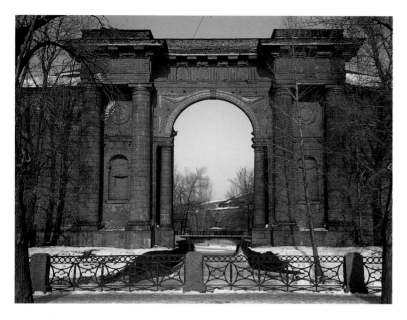

238 The New Holland timber depot, St Petersburg (Jean-Baptiste-Michel-Vallin de la Mothe), 1764–68.

239 The Small Hermitage, St Petersburg (Jean-Baptiste-Michel Vallin de la Mothe and Georg Fel'ten), 1764–75.

240 The Armenian church, St Petersburg (Georg Fel'ten), 1771–80.

Antonio Rinaldi was the principal architect of Catherine the Great's new palaces outside St Petersburg during the first half of her reign.[19] He was apprenticed with Luigi Vanvitelli in Naples. In 1752 Kirill Razumovsky, brother of Empress Elizabeth's morganatic husband, commissioned him to undertake work on his Ukrainian estates, after which he went to St Petersburg, where he became architect to Catherine's husband and heir to the throne, Grand Duke Peter, and eventually to Catherine.

Before Catherine assumed the throne, she conceived a desire to build a palace where she could be completely independent, free from her husband and from his aunt, Empress Elizabeth. This plan was realized at the turn of the 1750s and 1760s when she bought some land for herself at Oranienbaum, where Rinaldi designed a palace and a park, built in 1762–74, the most important Rococo ensemble in Russia.[20]

Rinaldi's park combines the ornamentality of German Rococo gardens with the picturesque artifice of the Anglo-Chinois garden, which was fashionable in France at this time. The two styles are not mingled, but used separately in the west and the east of the park ensemble, between which a huge early form of rollercoaster (Katal'naya gorka) 532 metres in length is placed. The palace that Rinaldi built in the east park later came to be known as the Chinese Palace (Kitayskiy dvorets). Its exterior is reminiscent of Frederick the Great's Sans-Souci. The role of the exotic is to the fore in the Chinese-style interiors, the Large Chinese Cabinet (Bol'shoy Kitayskiy kabinet; pl. 241) and the Glass Bead Cabinet (Steklyarusnyy kabinet), which contemporaries found the most memorable rooms in the palace. Here Rinaldi attained a greater freedom and integration than other architects working in this mode in the palaces of Russia, Germany and France. The Large Chinese Cabinet is divided by a white arcaded cornice into two parts decorated in different colours, a cooler-hued, azure and gold upper part with painted ceiling and a warmer lower part, the walls being covered with a mosaic combining ivory and wood of twenty different kinds and styled after Chinese landscape paintings, the whole creating the illusory space of a fantasy Chinese garden of delights. The allegorical ceiling painting by the Barozzi brothers depicts the Union of Europe and Asia, which was the overall theme that Catherine worked into the interiors of the palace.

Antonio Rinaldi's work at Oranienbaum fills in a whole stage of Russian architectural evolution between Elizabethan Baroque and Catherinian Neoclassicism, covering almost the whole of the brief life of Rococo in Russia. A significant historical phenomenon was the simultaneous existence of early Neoclassicism and Rococo. Although it was Neoclassicism that soon became the prevailing style, the playful spirit of Rococo did not disappear. In many of Catherine the Great's later buildings, in Ancient Classical, Gothic and Chinoiserie styles, Rococo, as it were, had the rest of its say. Rinaldi gave Oranienbaum an atmosphere of freshness and divertissement which caught the tone of the early part of Catherine's reign, when she allowed herself the freedom to create an extraordinary artistic world. The Eastern dream was the first aesthetic lodestone that drew her imagination. At the same time, Neoclassicism was becoming established as the official style of urban architecture. In the greater freedom of her country palaces, Catherine could pursue more adventurous ideas and tastes.

"In the next world, when I see Caesar and Alexander and other old friends," wrote Catherine to Grimm,[21] "I shall be sure to find Confucius [. . .]. I want to have a discussion with him." She often asked her friend what was the latest book about China. "Tell me, have you read the description of China in the three volumes published in Paris last year? Do you know that great little ruler Huan-Huan [. . .] whom Confucius served?"[22] Her revealing preference for Confucius before Caesar and Alexander is wholly in the spirit of Voltaire's *Princess of Babylon* and Montesquieu's *Persian Letters*.

At Tsarskoye Selo at the turn of the 1760s and '70s, construction work began on the largest ensemble of buildings in Chinoiserie style in Europe;[23] a number of foreign architects collaborated in this project, including Antonio Rinaldi, Georg Fel'ten and Charles Cameron. At first, Dutch and Prussian models of Chinoiserie were imitated, and then the work of William Chambers, the only European architect of the time to have visited China, and his British popularizers.

The visitor to Tsarskoye Selo from St Petersburg passed the arch of the Great Chinese Caprice (Bol'shoy kitayskiy kapriz; pl. 242) and came to a "rock face" through which a gateway was cut, surmounted by a pavilion in the form of a Chinese temple. To the left of this spread Cameron's Chinese Village (Kitayskaya derevnya), its structures brightly decorated and bristling with dragons. Ahead was the arch of the Small Chinese Caprice (Malyy kitayskiy kapriz), and on the right Fel'ten's Chinese Pavilion (Kitayskaya besedka). If the visitor did not now turn towards the Catherine Palace but continued round the park, he saw Rinaldi's miniature Chinese town. The idea was that the visitor should pass through a fantasy world of foreign structures before finally approaching the palace.[24] The Enlightenment entered Russian architectural history in play, in an environment of entertainment and stimulation. Catherine wanted her visitor to experience the manifold possibilities offered by art before turning to reason.

241 (*facing page*) The Large Chinese Cabinet in the Chinese Palace, Oranienbaum (Antonio Rinaldi), 1762–68.

242 The Great Chinese Caprice, Tsarskoye Selo, 1770s.

243 Gatchina Palace (Antonio Rinaldi, Vincenzo Brenna), 1770s, 1780s.

It was in this context too that the Gothic Revival style emerged in Russia at the beginning of the 1770s, as a result of Catherine the Great's determined bid to imitate English garden pavilions. The earliest of these medieval-style buildings were the pavilions in the gardens of the Admiralty and the Hermitage kitchen (Ermitazhnaya kukhnya) at Tsarskoye Selo, both built by Vasily Neelov who had visited England, and Chesme Palace (Chesmenskiy dvorets) on the road to Tsarskoye Selo from St Petersburg,[25] designed by Fel'ten and built in the mid-1770s; next to the last Fel'ten also designed a church, which was completed in 1780.[26] Chesme Palace was built to resemble a castle, with Inveraray Castle as its model. The triangular-plan building itself, which had a low tower and lancet windows, was not particularly Gothic. Its interest lay rather in the legends that Catherine invented about it. She would tell the tale of a frog-queen who had once lived there. She ordered a dinner service from Josiah Wedgwood with 1149 views of British castles, parks and old ruined buildings, each piece bearing the coat of arms of Chesme Palace in the form of a green frog. She claimed that the portraits of European sovereigns displayed in the rooms of the palace periodically came to life. "An old sentry," she wrote,

> walking round Chesme Palace, suddenly heard sounds within [. . .] the portraits and medallions were talking to each other [. . .]. Louis XVI: "I desire good." Queen Marie-Antoinette: "I embrace you, sire, for those excellent words, and in consequence I shall give a ball [. . .]." Her mother, Empress Maria Theresa: "Antoinette is so fond of appearing in society that I fear for the salvation of her soul." Joseph II: "But she is so beautiful, so adorable, so young [. . .]."[27]

These imaginary conversations show that literary sport played a greater part in the birth of Gothic Revival in Russia than architectural ideas. However, the situation would soon change, and an attempt, based on English Gothic Revival ideals, would be made to find an architectural language for the Enlightenment in Russia.

The English theme took quite a different course at Gatchina – in the first place, because it was built by an Italian. In 1765 Catherine gave the estate to her favourite Grigory Grigorevich Orlov,[28] and during the period of their liaison she personally supervised the design and creation of the park.[29] At the centre of the ensemble was to be the palace (pl. 243), designed by Rinaldi in 1766. This building is in the mid-eighteenth-century Neapolitan Classical mould, the dramatic handling of space being decidedly Baroque. Overall, it is more reserved than the work of Rinaldi's teacher Luigi Vanvitelli and his Neapolitan school, having the air of a remote castle, aloof from the bustle of the capital.[30] It has been suggested that this is due

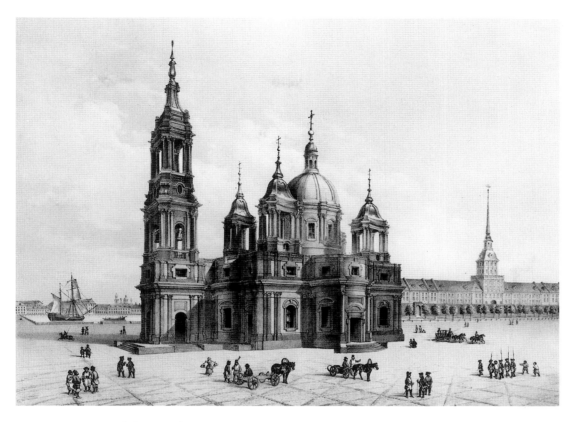

244 Auguste-Ricard de Montferrand, view of St Isaac's Cathedral, St Petersburg, at the beginning of the
nineteenth century, built to Antonio Rinaldi's design; drawing, 1820s.

to English influence.[31] The palace at Gatchina certainly resembles English Baroque country houses – Blenheim Palace (Vanbrugh) and Castle Howard (Hawksmoor), prompting assertions that Rinaldi visited England, of which, however, proof is lacking.[32] To absorb English Baroque to the degree to which it was taken at Gatchina, it was not actually necessary to leave Russia. Colen Campbell's *Vitruvius Britannicus*, in the opening chapter of which plans of English country houses were reproduced, was well known to Catherine and her court.[33] The plan of Rinaldi's palace is proof of his familiarity with the houses of Vanbrugh and Hawksmoor.

Gatchina Palace, drawing on a combination of Italian and English sources, represents an attempt to move away from French influence. This building, like Blenheim, consists of a main block extending round a courtyard and semi-circular galleries of short frontage leading to two huge square blocks accommodating the service quarters. It is built on a rise, with the north façade looking down on a lake, on the shore of which is a jetty-terrace in line with the central axis of the building. On the other side of the palace, a stone wall was built round the courtyard and service blocks, with a forward projection also in line with the main axis of the complex. The palatial façades are neither English nor Baroque. On an English-style plan rise façades resembling those of Italian palazzi. The contours of each individual block are delineated with extraordinary ingenuity. Wall surfaces, finished by Rinaldi, are flat and unornamented at the edges, the whole giving the appearance of being cut out of a huge stone mass.

In 1767–68 Catherine conceived the idea of creating a landscape garden at Gatchina;[34] the Irishman John Sparrow and his brother Charles were invited from England to lay it out,[35] and the empress made use of the English landscape garden design books in her possession.[36] Russian gardeners who had worked at Peterhof were selected to work under Sparrow.[37] Two further landscape architects were commissioned from Britain, James Meader and James Hackett.[38] The design of this first park at Gatchina was based on the juxtaposition of a central area surrounding a picturesque lake with shaped banks, in the style of an English landscape garden, and a planned area of hunting woodland.

In his buildings in St Petersburg as well as his palaces outside the capital, Rinaldi hovered on the borders of Baroque, Rococo and Neoclassicism, eventually settling for the last, as seen in St Isaac's Cathedral (pl. 244),[39] built on the site of its huge successor raised in the nineteenth century (1768–1802), and his cathedral in the small town of Yamburg (1762–82).[40]

245 Detail of the façade of the Marble Palace, St Petersburg (Antonio Rinaldi), 1768–85.

Rinaldi modelled his churches on Rastrelli's cathedral in the Smol'ny Convent, in which the new architectural forms were adapted to traditional Orthodox canons. He combined typical Russian features – five cupolas, the placing of apses in the east part of the church, multi-storeyed bell-towers – with sumptuous Baroque interiors and light-handed exterior use of the Orders. This double aspect is also seen in the Marble Palace (Mramornyy dvorets) which he built for the owner of Gatchina, Count Orlov, in St Petersburg (pl. 245); its façades have a reserve bordering on Classical austerity, while the interiors display striking, variegated compositions with detail in Rococo spirit (pl. 246). Rinaldi remained in Russia until 1784, when after sustaining an injury at work he returned to his homeland, spending his last ten years in Rome.[41]

246 Main hall of the Marble Palace, St Petersburg (Antonio Rinaldi), 1768–85.

4 Russian Pupils of Charles de Wailly:
The Return of Vasily Bazhenov and Ivan Starov

Despite the innovations of Rinaldi, French Classicism exercised an increasing influence on Russian architecture. This was connected not only with the work of de la Mothe, but also the return to Russia of the first graduates of the Academy of Arts after finishing their studies abroad. In 1765, Vasily Ivanovich Bazhenov arrived in St Petersburg after a period with Charles de Wailly in Paris.[42] Following the triumphant conclusion of his studies and the success of his designs in competitions held by the French Academy of Architecture he visited Italy, where

he was made a professor at the Roman Academy of St Luke and the Academy of Florence and a Member of the Academy of Bologna. He was not, however, received with enthusiasm in his homeland, and it was only after he had completed a number of projects that he managed to secure the favours of Grigory Orlov and a commission to build an arsenal in St Petersburg.[43] This project was successfully executed, introducing his countrymen to the Parisian architectural style of the early 1760s, Classicism based on a sound grasp of the rules for

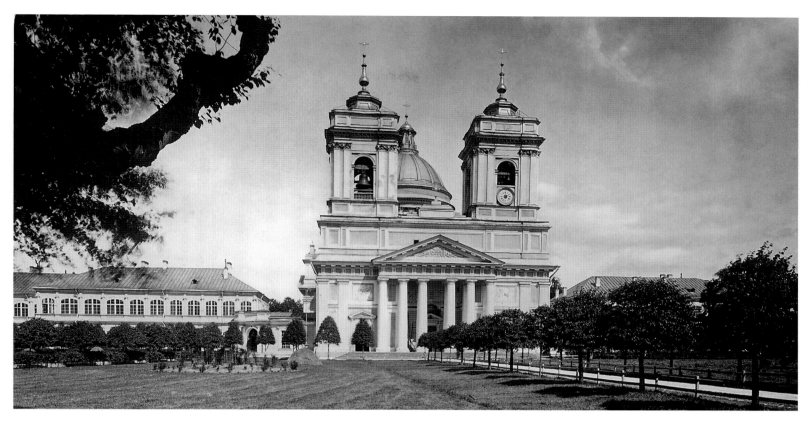

247 The cathedral of the Trinity, Alexander Nevsky Monastery, St Petersburg (Ivan Starov), 1778–90.

the use of the Orders with symmetrical overall composition and Classical ornamental sculpture – without recourse, however, to archaeologically exact reproduction of buildings from Antiquity.

In 1767 the architects of St Petersburg breathed sighs of relief when Bazhenov was sent to Moscow to redesign the Kremlin, a project which will be considered later.[44] But this brief respite came to an end in the following year, with the return of the other Russian architect who had been studying with de Wailly in Paris, Ivan Yegorovich Starov.[45] The direct link with French Classicism continued unbroken. At first this young architect did not receive prestigious commissions either, and he was appointed to the planning body for provincial towns.[46] Only after he became personally known to Catherine at the beginning of the 1770s, when he built palaces for the illegitimate son of the empress and Grigory Orlov at Bogoroditsk and Bobriki near Tula,[47] did he obtain a crucial commission in St Petersburg.

This came in 1775; it was for the building of a new cathedral in the Alexander Nevsky Monastery, which at that time was the residence of the head of the Russian Church, Gavriil, metropolitan of Petersburg and Novgorod. Starov's building, the cathedral of the Trinity (Troitskiy sobor), intended to serve

as an example of the new church architecture (pls 247, 248),[48] had little to do with Orthodox tradition, but entirely followed the contemporaneous image of the ideal church established in the 1760s by French Classical architectural theory as laid down by the abbés Jean-Louis de Cordemoy and Marc-Antoine Laugier.[49] It had three aisles, a Latin-cross-shaped plan, two towers, bell towers on the west façade, a broad transept, a single cupola and a semi-circular choir. A fully rounded Order played a central role. The west front featured a monumental Tuscan portico. The colonnaded cupola was reminiscent of Jacques-Germain Soufflot's church of St Geneviève in Paris. In the interior, Starov reached a compromise in the matter of columns and pylons, being familiar, from his period of study with de Wailly, with the dispute among French theorists as to which should be preferred. He set pairs of round columns into massive piers and placed a semi-circular colonnade at the altar.

This was an extraordinarily bold building for Russian architecture, a real Western Neoclassical manifesto, and executed in the sensitive field of church architecture. Neither Rastrelli nor Rinaldi would have conceived of such a design. Although Starov's model was by no means universally accepted, it was imitated, and more importantly, it marked the moment when active creative attempts began to be made within the Russian

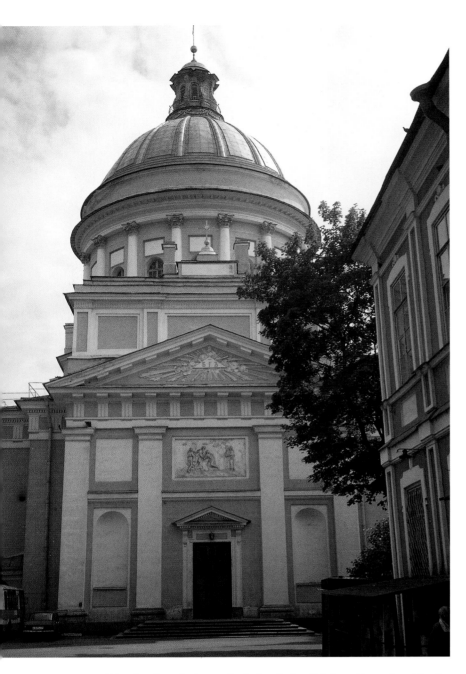

248 Side façade of the cathedral of the Trinity, Alexander Nevsky Monastery, St Petersburg (Ivan Starov), 1778–90.

Neoclassical movement, exemplified in many hundreds of churches, to combine the Classical approach with Orthodox tradition in various ways. Ivan Starov's further work, first for the most famous of Catherine the Great's favourites, Grigory Potemkin,[50] and then for Catherine herself in her last years, will be considered later. Throughout his life he was to belong consistently to the French Classical school, the evolution of which he followed attentively through the latest publications and engravings.

5 Catherine the Great's Architectural Programme for Moscow: Vasily Bazhenov, Matvey Kazakov and Nicolas Legrand

The new appearance of Moscow played a special part in Catherine the Great's reforms. It was here, in this huge city, with its many surviving medieval features, that age-old traditions of Russian life collided most starkly with the utopia being created by the empress. Forming her image of what she wished Russia to be with the help of European Enlightenment thinkers, Catherine could not have put Moscow to one side even if she had wanted to. The French *philosophes* with whom she corresponded would have reminded her of the importance of the old capital. The location of a capital city and its links with national history were cardinal points of Enlightenment theory of the state. On his visit to Russia in 1774, Denis Diderot declared to Catherine: "Your Majesty, I have been told that Peter the Great gave his preference to St Petersburg before Moscow because [. . .] he thought that he was not loved there. This idea is not held by Catherine II: she loves all her children, and they all love her."[51] Diderot insisted that a capital city should be located in the middle of its country: "It is obvious that to and from this centre many routes will lead, which may be compared with veins and arteries; the veins will bring it blood or nutritional substance, and the arteries will circulate the blood, or gold, by which it lives."[52] He did not at all like the location of St Petersburg: "A state with its capital situated at the edge of the country is like an animal with its heart positioned at the tip of its paw or its stomach on its big toe."[53]

Catherine had already understood this before her conversation with Diderot and acted accordingly, although she preferred living in St Petersburg. There was to be no radical replanning of the city, only certain changes in specific locations. Fundamental change to St Petersburg was in fact unnecessary; its existing plan accorded with European ideas concerning the regulated distribution of populations. It was Russia's elder capital that was to undergo radical change – in its centre, its general plan and its overall appearance. Diderot advised: "It would be appropriate for Your Majesty to have a large palace in Moscow."[54] With this Catherine agreed, but her ideas went further. She wished the palace to provide an architectural image of Russia as "enlightened" by her.

The manner in which the project was begun was indicative. In 1767, when Vasily Bazhenov was commissioned to build the new palace,[55] a commission assembled in Moscow to frame a new code of laws, its members representing the most important imperial institutions and all its estates, an elective body reminiscent of the French Estates-General.[56] Catherine planned that this event would launch the triumph of the Enlightenment movement in Russia. The new palace was to

accommodate the administrative centre of a reformed Russia, and the empress insisted that those parts of the complex that were to house the administration should be completed before the reception rooms of the palace and her personal apartments.

The whole enormous ensemble, which would have been the largest Neoclassical complex in Europe had it been completed, was to replace the existing Kremlin itself (pl. 249), with only the great cathedrals, symbols of Russian history and Orthodoxy, being preserved. A mighty framework of new buildings in the most "modern" style of their time would take the place of the old walls. The language spoken by this architecture was the collaboration of past and present – wholly in the spirit of French Classical theory from Roland Fréart de Chambray (*Parallèle de l'Architecure Antique et de la Moderne*, 1650) to Jean-Nicolas-Louis Durand one and a half centuries later (*Receuil et parallèle des édifices de tout genre*, 1800).[57] Architectural monuments were to serve a new purpose, the glorification of the Enlightener of Russia.

> And the Kremlin adorns itself in its new destiny.
> Pallas Athene comes to inhabit this place in glory
> To the glory of the Russians [. . .]

These words of the poet Aleksey Sumarokov were inscribed on a column when the foundation-stone of the Great Kremlin Palace was laid.[58]

Another motive lay behind this project. Catherine wished to make a major demonstration of Russian wealth and power in the circumstances of war with Turkey. No better way of doing this could have been imagined than the construction of this immense ensemble in the old capital. Visitors and envoys were shown Bazhenov's model of the palace, the façades of which were to be 1200 metres in length and 30 to 40 metres in height.

Bazhenov's conception was a monumental centre for Moscow using Classical forms. One of the obelisks raised to mark the laying of the foundation-stone bore the inscription:

> What Greece and Rome gave birth to in Antiquity
> The Kremlin in its greatness will give a lasting place.[59]

Bazhenov conceived of the Kremlin area as one huge triangular structure, each side of which was built with careful consideration for what lay immediately beyond. The Kremlin hill was to be topped with the high walls of the new Neoclassical buildings, while the vantage-point of Red Square offered the "historic" prospect of the preserved parts of the earlier walls and the old cathedrals. A contrast was designed between the new architecture (pl. 250) and the older buildings standing picturesquely in the background. The palace, of four high storeys on a vast socle (pl. 251), was to face the River Moskva. The two lower storeys, heavily rusticated, would serve, in their turn, as a

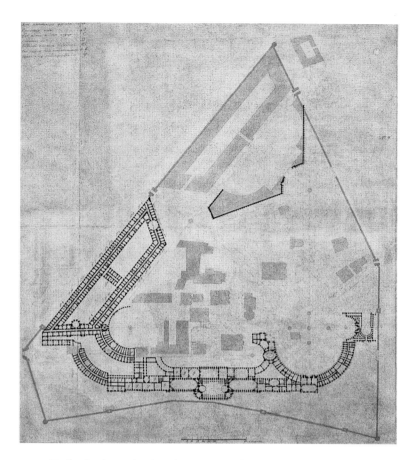

249 Vasily Bazhenov's plan for a new palace in the Kremlin, Moscow, 1767–75.

socle for the two principal storeys with a grand overall Ionic Order, a prominent cornice and an attic storey. For 630 metres this façade, with its rich rhythm of forward breaks and porticos, was to run along the bank of the Moskva. Each end of it was curved, leading the eye to other parts of the ensemble. A magnificent central stairway was to descend to the river below.

The composition in the other, inward direction was quite different, being based on a combination of three open oval courtyards containing the inner space of the Kremlin and its cathedrals.[60] Bazhenov's designs for the new Kremlin developed de Wailly's Neoclassical ideas in the direction they were taking in Paris. His designs for the new complex seem to herald the giganticism that runs through the designs submitted through the 1770s for the Rome Prize awarded by the French Academy of Architecture. Bazhenov's designs, however, contain stronger reminiscences of Baroque; he works in curved, dynamically powerful forms and gives theatrical perspective to his panoramas.

Catherine fairly soon lost her enthusiasm for the idea of an elective body for the formulation of new laws. In her estimation the commission assembled for this task worked too

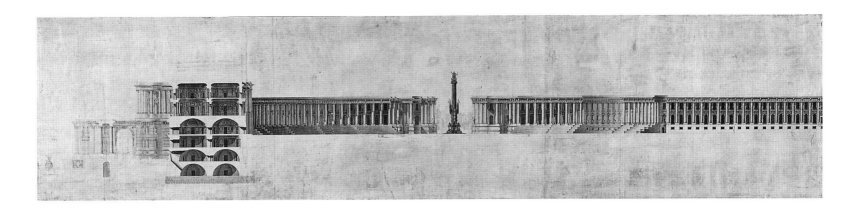

250 (*above*) Section of Vasily Bazhenov's design for a new palace in the Kremlin, Moscow, 1767–75.

251 (*left*) Fragment of the model of Vasily Bazhenov's design for a new Kremlin Palace.

252 (*below*) Outline of Nicolas Legrand's new city plan for Moscow, 1775.

slowly and was at times excessively cautious for a monarch in a hurry to "introduce" the Enlightenment to her country. In 1771 its inefficiency led to its demise. The architectural image of the new order, however, lasted rather longer. The ceremonial laying of the foundation-stone of the new palace in the Kremlin took place on 1 July 1771, unattended, however, by Catherine; a bad omen. Construction work proceeded at an excruciatingly slow pace, and ceased altogether when only the foundations had been laid. The order was given to restore the parts of the Kremlin walls that had been demolished.

The idea of recasting the face of Moscow in Neoclassical style was not, however, entirely rejected. In 1775 Catherine approved a new plan for the old capital (pl. 252). This was the first real project for the replanning of Moscow. Efforts in this direction had been made over a number of decades, beginning with the coming to power of Peter the Great, but without success. The plan submitted by Ivan Mordvinov and Ivan Michurin in the 1730s was a survey only, and proposed no radical changes to the city. The 1775 plan, prepared under the direction of the French architect Nicolas Legrand,[61] was the

first to introduce changes to the layout of the city. Around its centre, the Kremlin and Kitay-Gorod (originally the city's trading district), a semicircle of squares was planned, and a semicircle of boulevards and squares in place of the medieval walls of the White Stone City. Great attention was paid to the strengthening of the embankments along the Moskva. The plan was intended to bring about the same process that was taking place in most European cities during a period of transition from medieval city structures to the Neoclassical planned approach.

Taken together, Bazhenov's designs for the restructuring of the Kremlin and Legrand's city plan indicate Catherine the Great's ideas of how Moscow should develop. Above the centre of the city the immense palace replacing the historic Kremlin was to rise, looking down on a chain of new squares designed for the conduct of trade. From this area the old radial streets would lead to a semicircle of boulevards broken up into separate districts by ten further squares. Catherine decreed that the inner ring of boulevards should constitute the boundary of the city itself, which would therefore consist solely of the Kremlin, Kitay-Gorod and Bely Gorod (the White Stone City). Outside this central area would be the suburbs, Zemlyanoy Gorod. Consistent planning principles and a Neoclassical architectural style were to prevail in all these districts. Unlike the Kremlin project, and despite huge difficulties, the 1775 plan was ultimately realized in its essentials. The creation of Neoclassical Moscow was due in large part to the untiring efforts of Legrand, who worked in Russia up to his death in 1799. Despite the fact that Russia's urban administrative system changed three times during this period, he retained control of the execution of his plan, making every effort to ensure consistency of composition in all corners of the city and personally preparing plans of individual districts and properties. His achievement in this first replanning of Moscow is still undervalued in Russian architectural historiography. His couple of famous Moscow buildings, the Krigskomissariat (Army Supply Centre) on what is now called the Maxim Gorky Embankment and the church of the Dormition on Mogil'tsy (tserkov' Uspeniya na Mogil'tsakh; pl. 253), have obscured his crucial role in the evolution of Russian Neoclassicism. It is not known exactly how, after his studies in Paris, Legrand came to Russia, where he remained throughout his life, familiarizing architectural students not only in his own studio but also at Moscow University with French buildings as models.

Moscow underwent rapid change, although Catherine the Great's aspiration to establish the "Triumph of Minerva" in the visible face of the huge city was essentially unrealistic. She had two main problems in this initiative, the state budget and the people of Moscow. The attitude of Muscovites to the rebuild-

253 Church of the Dormition on Mogil'tsy (Nicolas Legrand), 1799–1806.

ing of their city was decidedly unhelpful. They were strongly against giving up without compensation even small portions of land they owned for the building of squares or the widening of streets. The administration of regulated city planning required enormous sums, which the empress simply did not command. Furthermore, even when the inhabitants of the old city followed the new fashions in dress and gastronomy and in the rebuilding of their houses and façades, it remained impossible to induce them to discard habits that the empress and her friends the *philosophes* found uncongenial.[62]

In Moscow the gentry, merchants, and countless less substantial citizens continued to live not next to their neighbours in terraces lining the streets but in spacious individual grounds. Even the smallest and most insignificant houses were sur-

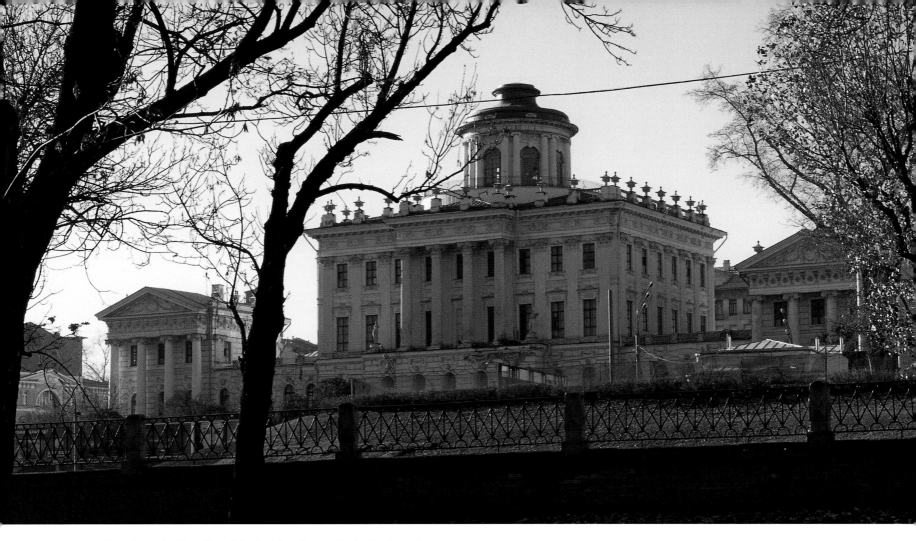

254　View from the Kremlin of the Pashkov house (Vasily Bazhenov), 1784–88.

rounded by outbuildings and had ornamental and kitchen gardens, often with ponds where fish were kept. All this gave Moscow a very special flavour, far removed from the ideal city of the Enlightenment era, when residential areas were supposed to be compact and regulated. The empress was exasperated:

> Moscow is a city of idleness, and its enormous size will always be a reason for this [. . .] a single visit means a whole day spent in a carriage, and that is a whole day lost. The nobility [gentry] who have settled in Moscow enjoy life there; that is not surprising; from the earliest age [. . .] they have grown soft, always driving about six-in-hand [. . .] every noble has not a city house, but a small estate. And what an ill-assorted crowd [. . .].[63]

Only gradually, house by house, district by district, was a "Classical" appearance achieved that satisfied the empress.

Residential, state and church building in Moscow during the reign of Catherine the Great and up to the Napoleonic Wars took parallel courses within a single architectural style.

The direction in which Moscow Neoclassicism developed was laid down by Vasily Bazhenov, while the building that took place in the city was mainly executed under the leadership of Matvey Kazakov and his numerous pupils. The Pashkov house stands as the architectural manifesto of Moscow Neoclassicism of the last quarter of the eighteenth century.[64] Centrally sited on a rise opposite the Kremlin, it is thought to have been built in 1784–86 to Bazhenov's design. Its main façade, formed by a central block flanked by symmetrical wings, faces the Kremlin (pl. 254). Its principal courtyard, enclosed by low blocks and a wall, gives onto a narrow street. The complex but balanced spatial organization of this house, its mature, Order-based ornamental scheme with finely drawn detail, display the direction that Moscow residential architecture took under the influence of de Wailly and his circle and the ideas of the French Classical architects of the 1760s (pl. 255). Bazhenov enhanced the impact and picturesqueness of the Pashkov house with prominent use of relief sculpture, complexity of design and silhouette, and the inclusion of garden architectural elements in his overall composition. A conspicuous part is played by statues: in the origi-

255 (facing page)　Detail of the main façade of the Pashkov house (Vasily Bazhenov), 1784–88.

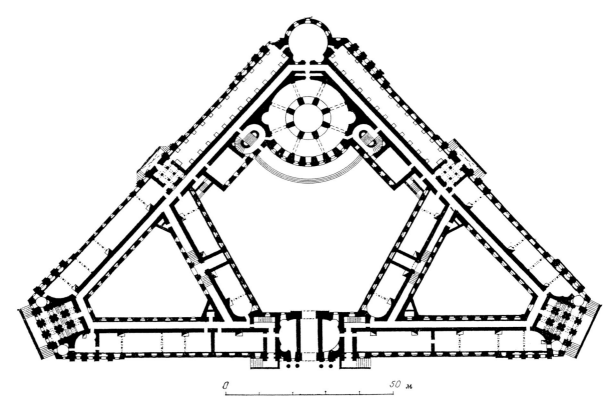

256 Plan of the Senate building, Kremlin, Moscow (Matvey Kazakov), 1776–87.

nal plan not only on either side of the central colonnade of the main façade but also on the roof. Bazhenov's belvedere (later replaced) took the form of an Ionic rotunda crowned with a representation of Minerva in glorification of Catherine the Great. In the late 1780s and early 1790s Bazhenov built the Yushkov house on Myasnitskaya Street, the Dolgov house on Meshchanskaya Street (now prospekt Mira – Peace Prospect) and the Prozorovsky house on the Polyanka. The last-named of these is not preserved; the first two were later rebuilt.[65] Bazhenov actually built comparatively little, although numerous buildings in Moscow, and throughout Russia, have been and still are attributed to him, especially examples considered to be successful or striking.

Kazakov was the architect who shaped the character of building in Moscow in the Neoclassical era as decisively as Legrand gave his stamp to its planning.[66] An idea of many of the city estates he designed that have not survived can be gained from drawings in the famous "Kazakov albums", compiled for the preparation of a "façade plan" of Moscow which resembled Turgot's plan of Paris and was designed to show all principal buildings with their façades. This plan was not executed, but the albums convey an image of the whole city as Kazakov conceived of it, and they show most of this architect's buildings no longer extant.

Among those that have survived are the Senate in the Kremlin (1776–89; pls 256, 257), the Golitsyn Hospital (Golitsynskaya bol'nitsa, 1796–1801), and his best known building of the 1780s, housing the Assembly of Gentry (Dvoryanskoye sobraniye).[67] By the end of the eighteenth cen-

257 Workshop of Fyodor Alekseev, view of the Senate Building, Kremlin, Moscow (Matvey Kazakov), 1776–87; watercolour, late eighteenth century.

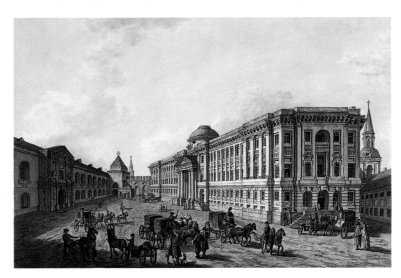

258 The Gubin house, Moscow (Matvey Kazakov), 1790s.

tury the last-named had become one of the most popular symbols of Catherinian Moscow. The building's austere façade concealed a magnificent interior, the Hall of Mirrors, the subject of ecstatic descriptions by scores of memoirists. Its rows of majestic white Corinthian columns, illuminated by crystal chandeliers and reflected in great wall mirrors, produced an overwhelming effect on contemporaries. Typical of Kazakov's residential buildings is the Gubin house on Petrovka Street (pl. 258), with its Corinthian colonnade in a shallow but wide niche ornamenting the main façade to a height of three storeys and two-storey wings ornamented with a slender Ionic Order and sculptural compositions. This type of house, with main block and wings aligning on the street, was popular in Moscow at the turn of the eighteenth and nineteenth centuries. The Baryshnikov mansion on Myasnitskaya Street (1797–1802) represents another of Kazakov's favourite types of affluent urban house, built on three sides of a courtyard and open to the street on the fourth.

Kazakov built the most interesting of Moscow's churches of the second half of the eighteenth century, those dedicated to Metropolitan Filipp and to SS Cosma and Damian.[68] The first introduces the type of the rotunda church in Russia (pl. 259). The monumental cylinder of the main structure is juxtaposed with slender colonnades at north and south points. A round

belvedere crowned with a semi-opaque cupola, gazebo-style, contrasts with the heavy cornice. The church of SS Cosma and Damian (1791–1803) is more complex in composition, the smaller cylinder shapes of the chancel and side-chapels being added to the main cylindrical mass, the gradually sloping cupolas bringing out the gentle fluidity of its overall outlines. Typically late-eighteenth century in style is the church of Martin the Confessor (tserkov' Martina Ispovednika) built by Matvey Kazakov's relative and pupil Rodion Kazakov (1782–92), a traditional five-cupola Russian church type clothed in the forms of Classicism.

Kazakov and his pupils were trained neither abroad nor in St Petersburg. They learned much from the ideas of Bazhenov and Legrand, and even more from printed books that appeared in France from the late seventeenth century up to the 1780s, not so much theoretical treatises as books with engraved illustrations of buildings that could be used for training purposes as models to be copied. Kazakov's "Classicism" was essentially a bookish style. This explains both the French orientation of Kazakov's architectural circle and the fact that his buildings so often seemed to be composed of fragments taken from a variety of earlier models. At the same time, his buildings were considerably more practical than Bazhenov's, more adapted to Moscow life.

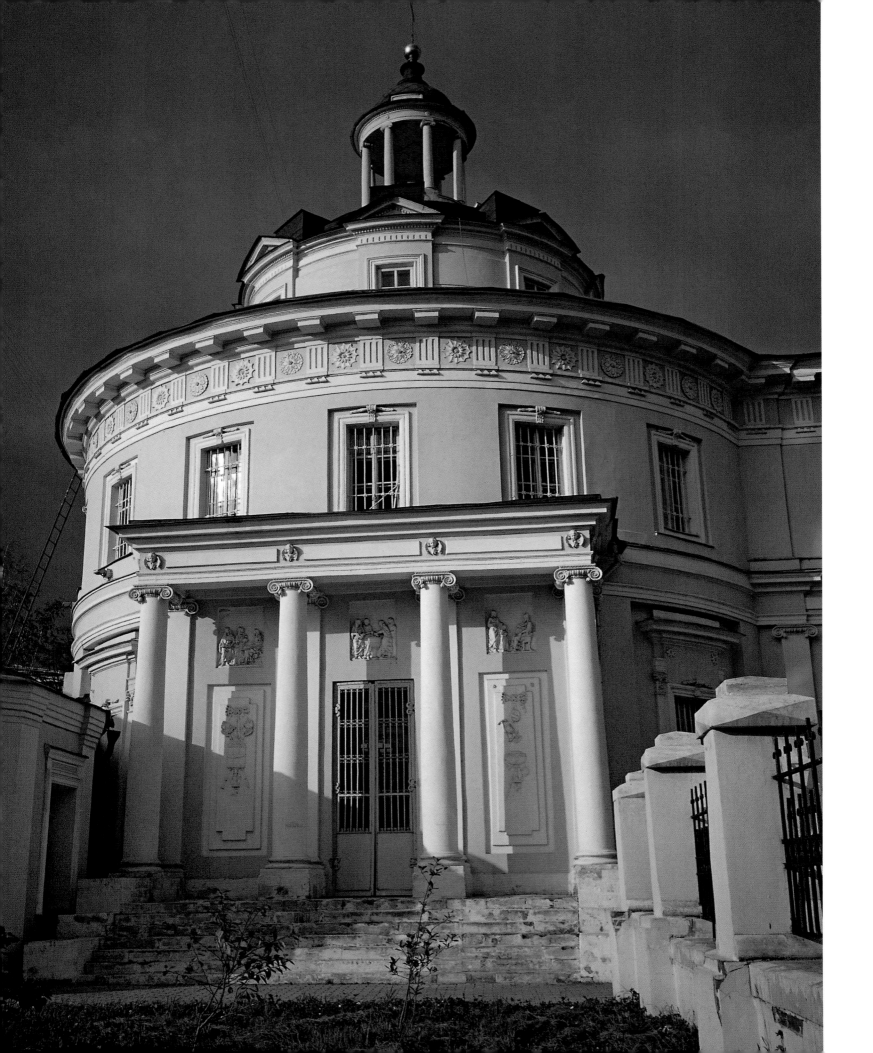

Both Bazhenov and Kazakov are more accurately described as architects of the Enlightenment than as masters of Neoclassicism, which was not their natural style. The continued evolution of Russian Gothic Revival, which had been born in St Petersburg, sprang from a celebrated conversation between Catherine the Great and Bazhenov which took place in Moscow in 1775 during preparations for the celebration of peace with Turkey on the Khodynka Field. Catherine sharply condemned the use of allegories in the manner of Antiquity, and rejected the building of "temples of Janus and Bacchus" and "God knows what other devils and hags".[69] She wished allegories to be concrete: the Khodynka Field was to be the Black Sea, the roads around it the rivers Don and Dnieper, the triumphal temporary buildings specific fortresses. Bazhenov

understood perfectly what the empress wanted. The buildings raised for the celebrations on the Khodynka Field were not remotely Classical or Neoclassical; they owed their success to the recognizability of their basically Gothic Revival forms (pl. 260). More generally, Bazhenov made frequent *architecture parlante* use of detail taken from a variety of sources. Merlons such as those on the Kremlin walls stood for Russian fortresses, while fantastic Oriental elements denoted Turkish cities.

Bazhenov turned imitation of the English Gothic Revival movement into an attempt to create a universal stylistic language for Russian architecture combining typical elements of medieval buildings of both East and West, motifs from Antiquity, and pure fantasy. Apart from this, he did succeed, for the first time since the Petrine period, in giving a markedly

260 Matvey Kazakov, *Triumphal Ensemble on the Khodynka Field* (Vasily Bazhenov), 1774; engraving, 1775.

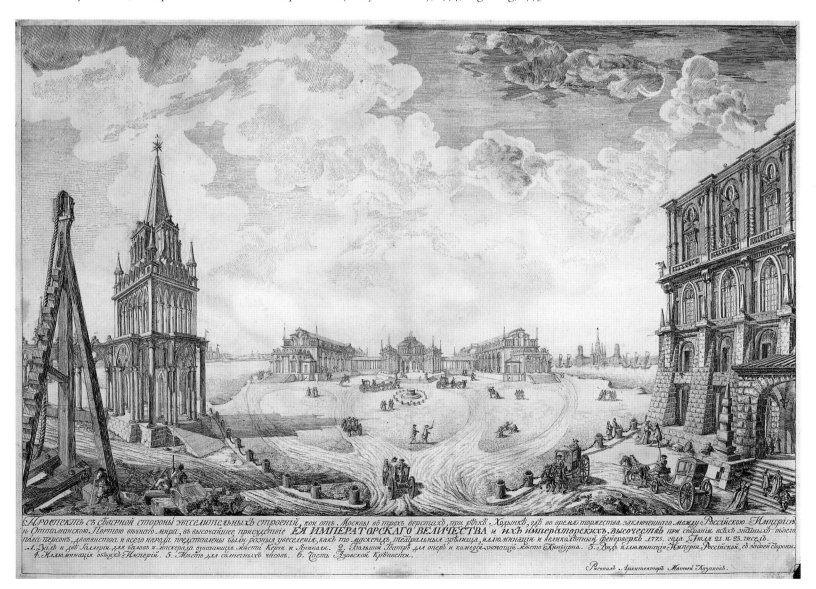

259 *(facing page)* Church of Metropolitan Filipp, Moscow (Matvey Kazakov), 1777–88.

261 Vasily Bazhenov, *Design for an Imperial Palace Complex*, Tsaritsyno, 1775–76.

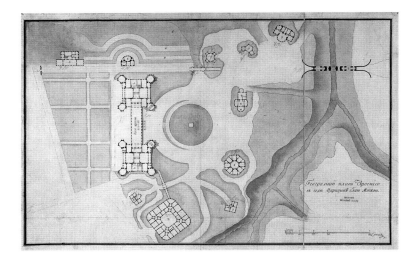

262 Matvey Kazakov, plan of Tsaritsino, 1786.

national character to architectural language used in Russia. His system of citations from early Russian buildings, particularly those of Moscow, lent his style an explicitly Muscovite flavour. These characteristics were indicative of the new direction opened up by Catherine's "Moscow utopia". Her aspirations went beyond the mere fact of establishing "the triumph of Minerva" in Moscow, the victory of the new Enlightenment ideal of life; she considered it important to ground this in ancient traditions and to bring out the national character of the new architecture.

Catherine was so pleased with the triumphal buildings on the Khodynka Field that immediately after the ceremonies she commissioned several palaces in similar style, the one on the greatest scale, at Tsaritsyno, then on the outskirts of Moscow, being intended as an imperial residence (pl. 261). Bazhenov worked on the planning and building of this project for ten years, from 1775 to 1785.[70] His vast palace complex, full of Gothic Revival ideas, sited on high ground overlooking ponds, was the largest of its time in Europe. Two palaces, for the

empress and Grand Duke Paul, heir to the throne, a huge kitchen and storage block (Khlebnyy dom), a residential building for imperial courtiers, an opera house, and numerous pavilions, bridges and gates were contained in a picturesque, completely non-Classical ensemble, its *architecture parlante* combining Gothic Revival, Early Russian and symbolic forms borrowed from Masonic allegories. The ornamental scheme, in contrast to that of the buildings on the Khodynka Field, was permanent. Although the project was rebuilt by Kazakov in 1786–96, the general character of Bazhenov's work was retained (pl. 262).

Another palace of similar architectural forms was built by Kazakov, the Peter Palace (Petrovskiy dvorets) on the St Petersburg road (pl. 263 and p. viii), where the empress could rest before ceremonial visits to Moscow. This building has a decidedly more Muscovite flavour than the Great Palace at Tsaritsyno. Along with the Classical balance of its plan, its

263 Matvey Kazakov, *Design for Peter Palace*, Moscow, 1775–82.

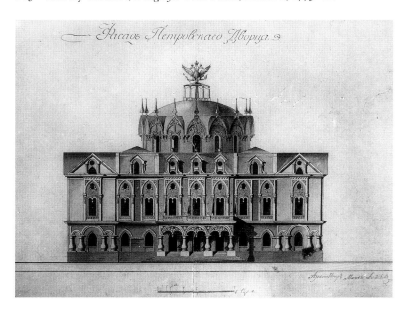

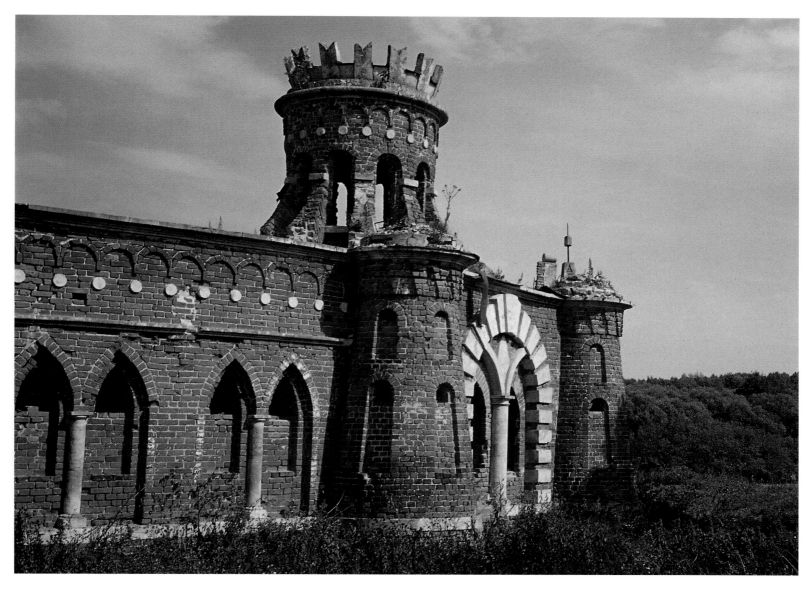

264 Stables, Krasnoye, Ryazan' province (?Vasily Bazhenov), late eighteenth century.

ornamental scheme contains elements borrowed from seventeenth-century Moscow buildings, those with the most sharply defined features of the city's architectural monuments.[71] Catherine commissioned a whole chain of further imperial palaces and mansions in the environs of Moscow – at Kon'kovo, Bulatnikovo, Troitsky-Kaynardzhi and other locations, the last-mentioned being the only one to be completed.[72] A ring of imperial residences and important officials' mansions was built by the empress as a "picture-frame" round the old capital. Each of these had its grounds and gardens, which Catherine wished to be in the English landscaped form, inviting Francis Reid and John Munro from Britain to plan them.[73] The architectural aim of most of these country palaces and mansions was to produce a picturesque impact in the half-

Gothic, half-Oriental, half-Classical language invented by Bazhenov. And indeed, the "Russian Gothic" of Bazhenov and Kazakov made an indelible impression on contemporaries, the wealthiest landowners in particular. Within a short time, similar-looking buildings began to appear on many country estates – churches and mansion-houses, stables and park pavilions. Without consideration of such buildings as well as those in Neoclassical style, it is impossible to gain a true picture of the architecture of the country seats of the Russian gentry in the late eighteenth and early nineteenth centuries.

The stables at Kraskoye near Ryazan', the Yermolov estate, probably designed by Bazhenov, make a striking impression strongly reminiscent of Tsaritsyno (pls 264, 265). More striking still are the churches on the Dashkov estate of Bykovo (pl. 266)

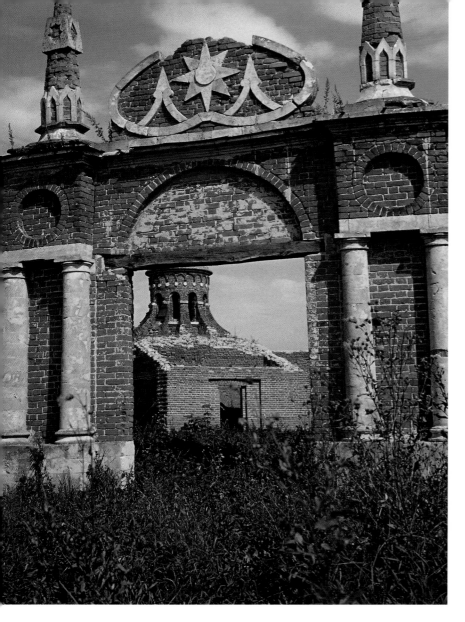

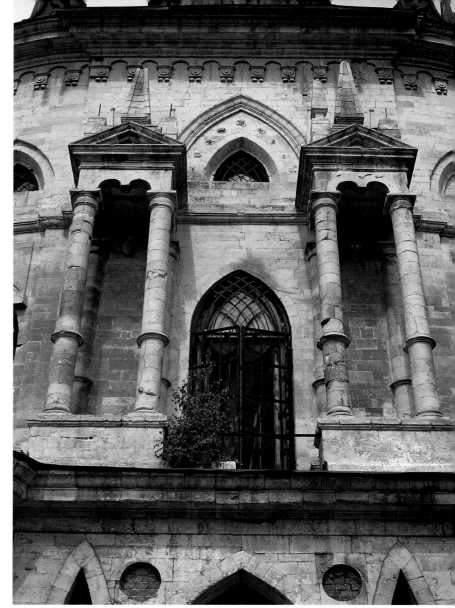

265 Stables, Krasnoye, Ryazan' province (?Vasily Bazhenov), late eighteenth century.

266 Detail of the façade of the church of the Vladimir Icon of the Mother of God, Bykovo (?Vasily Bazhenov), 1789.

and in the village of Gus' Zheleznyy, an estate and manufacturing centre belonging to the Batashov family (pls 267, 268). Here, at the turn of the eighteenth and nineteenth centuries, Russian Gothic Revival attained its fullest development, resembling no other European Gothic style, in which adherence to Russian national heritage was combined with the urge to classicize unusual new forms, with sometimes extraordinary results.

Around 1785 Catherine the Great tired of her current architectural projects. The political reasons for this will be considered in the last section of the present chapter. No less important a factor was that once again foreign architects showed Catherine that her ideas could be successfully expressed in Neoclassical forms – by a combination of the Palladian style and an archaeologically accurate "revival" of Antiquity.

6 The Revival of Antiquity and Palladianism: Charles-Louis Clérisseau, Charles Cameron, Giacomo Quarenghi and Nikolay L'vov

In 1773 Catherine the Great sent a letter to the French Academy announcing a competition in which "one architect or a group of architects shall seek out [details of] a house [. . .] from Greek or Roman Antiquity, with all its furnishings [. . .]. The object is to recreate the age of the Emperors, Augustus, the Ciceros and the Maecenases [. . .] and build a house in which all these might have been present together [. . .]".[74] These words express both a tendency to generalization – "all [. . .] together" – and an interest in concrete reality to the point of imitation of the physical detail of a way of life – "a house [. . .] with all its furnishings". Catherine's tastes were turning from

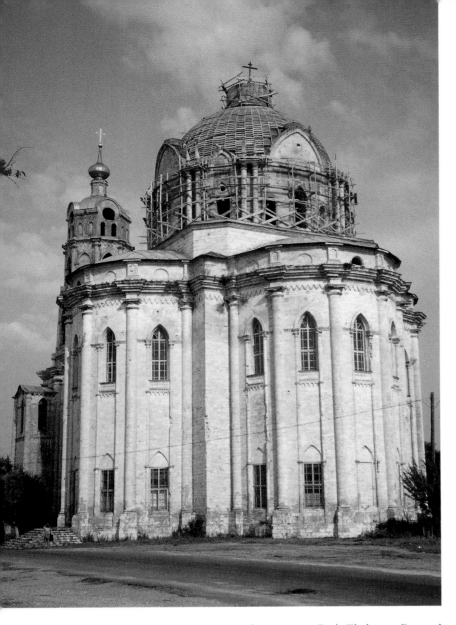

267 Church of the Trinity, Batashov estate, Gus' Zhelezny, Ryazan' province, late eighteenth century.

268 Detail of the apse of the church of the Trinity, Batashov estate, Gus' Zhelezny, Ryazan' province, late eighteenth century.

Neoclassicism as a current artistic and architectural style towards a revival of Antiquity in its felt actuality.[75] Two well-known French architects sent designs in response to the empress's invitation, Charles de Wailly, already with Russian connections through his pupils, and Charles-Louis Clérisseau, who was looking for work at this time.

De Wailly's design for a "Pavilion of Minerva" created a "norm" for idealized Antique architecture, with the precisely calculated dimensions of its Order (unconnected with any particular building from Roman or Greek Antiquity), its symmetrically balanced composition, and its aim of combining intimacy with monumentality (pl. 269).[76] Clérisseau submitted his design for a "Roman palace".[77] It was this architect, one of the founders of the European Neoclassical movement, who knew Winckelmann, Piranesi and the Adam brothers, author of pub-

lications on the architecture of Antiquity including many of his own drawings, who caught the attention of Catherine the Great. "I pulled out one of Clérisseau's sheets, showing a square house in Nîmes, and had a sudden appetite for Clérisseau."[78] This architect's design struck a new note, a concern with precise recreation of an Antique building. Clérisseau quite reasonably suggested that "Caesar, Cicero and Maecenas", required to be brought together by the terms of the competition, "might have been present together" in the Roman baths. With consideration for the empress's title as an Augustan patroness, Clérisseau chose Diocletian's Baths as his model (pl. 270). Unfortunately, Catherine wanted her "Roman house" to be in the form of a garden pavilion, and the imperial baths were on too grand a scale even for her. The idea of imitating Diocletian's Baths attracted her nevertheless, as did the attempt

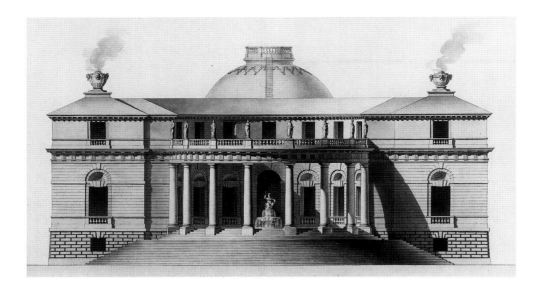

269 Charles de
Wailly, *Design for a
"Pavilion of Minerva"*,
1772–73.

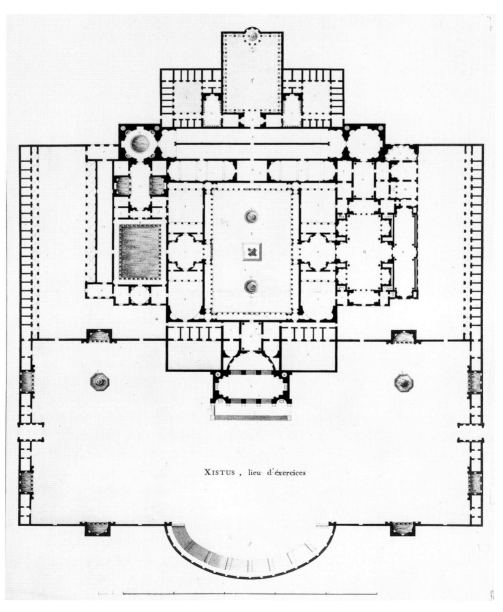

XISTUS , lieu d'éxercices

270 Charles-Louis
Clérisseau. *Plan for a
Palace in Ancient Roman
Style*, 1773.

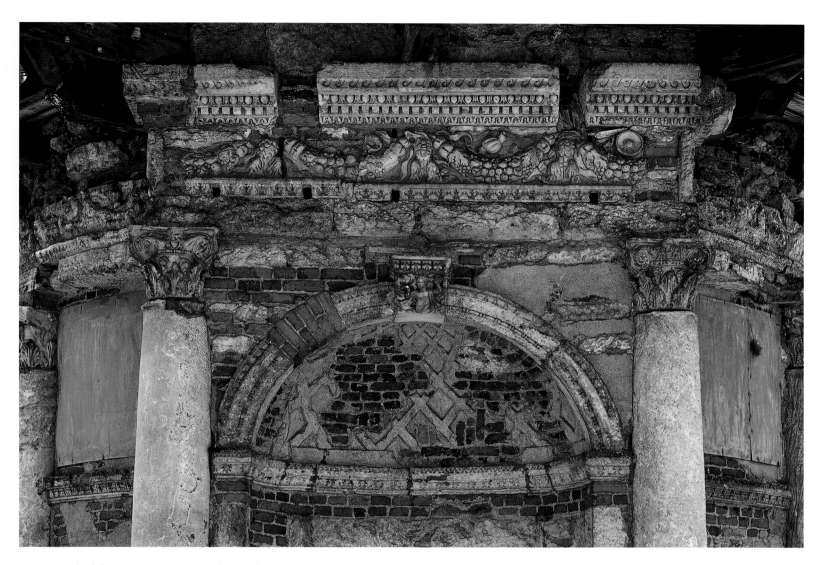

271 Detail of the Kitchen-Ruin, Tsarskoye Selo (Giacomo Quarenghi), 1785–86, showing Antique fragments incorporated into the façade.

at precise reproduction of an Antique monument. Lack of success with Clérisseau and de Wailly caused Catherine to look for architects from other countries.

In 1778 Catherine announced that she "would like two Italians, because the Frenchmen we have here know too much and build dreadful houses – all because they know too much".[79] The demand for "two Italians" signified a change in architectural policy at the Russian court. In the first place, there was a new desire for greater authenticity in Antique models used, and where possible for the use of actual archaeological fragments in new buildings. On 5 June 1779 Catherine wrote to Baron Grimm about "a recent discovery of two mosaic fragments from floors of Ancient Roman rooms, which once decorated the boudoir of the Empress Claudia [. . .]. See to it that you obtain them [. . .] they might go in the apartment that [. . .] in two thousand years' time they might be taken

from here by an emperor of China or some other idiotic tyrant ruling most of the world."[80] These mosaic fragments were bought in Rome and included in the decoration of the "Evening Hall" concert pavilion at Tsarskoye Selo. This is the earliest example of Antique fragments being used in a Neoclassical building in Russia; some are also incorporated in the façades of the Kitchen-Ruin (Kukhnya-ruina) at Tsarskoye Selo (pl. 271).

Concern for authenticity and concrete Antique detail led to Catherine's desire to find architects with the most knowledge of Ancient Roman buildings, who had either been born in Rome or had spent a considerable time there. Her agents quickly began a search for the specialists needed, in which such leading figures of the Roman art world as Reiffenstein, Tischbein and Mengs took part. On 6 June 1779 Grimm wrote to Catherine from Paris:

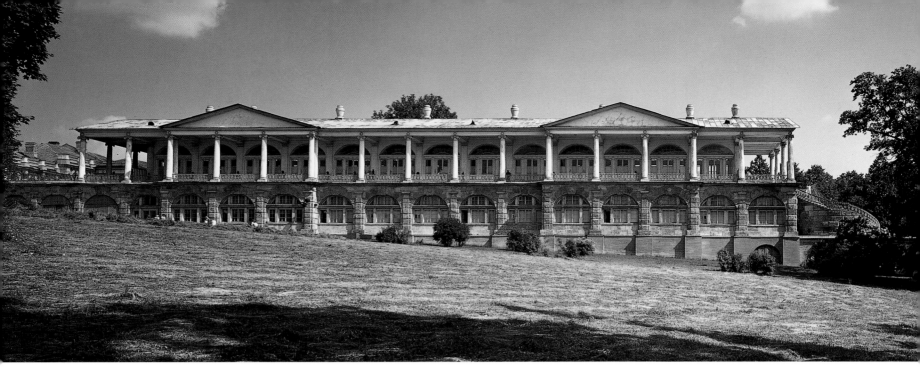

272 The Cameron Gallery, Tsarskoye Selo (Charles Cameron), 1783–86.

In conclusion, Madam [. . .] I have told Your Majesty about two Italian architects whom we shall see at our empress's feet before the year is out [. . .]. I have given much consideration to these two architects. It does seem to me that it would be far better if Your Majesty had an Italian and a Frenchman, the first for stylistic purity, the second for good sense and sound planning. But lastly I will say that the decision is Your Majesty's, not mine.[81]

Catherine replied on 23 August:

I find that dear Mengs [. . .] has held discussions on the matter of the two architects and has treated it as thoroughly as negotiations at a peace conference [. . .]. At present I am very taken with Mr Cameron, a Scot by nationality and a Jacobite, a great draughtsman, well versed in Antique monuments and well known for his book on the baths of Ancient Rome: at the moment we are making a garden with him on the terrace, with baths below and a gallery above [. . .].[82]

From this correspondence it is clear that Charles Cameron was the key foreign architect of the new generation who entered Russian architectural history at the turn of the 1770s and 1780s. After him came Giacomo Quarenghi and Giacomo Trombara. Characteristically, Catherine would always emphasize Cameron's knowledge not only of British but also of Italian architecture, and especially his contacts with the international Roman circle of architects, artists and specialists in monuments of Classical Antiquity. "I have someone else besides

Quarenghi and Trombara, his name is Cameron – he has spent many years in Rome studying architecture," we find her insisting.[83] Catherine was not, however, eager to break off all contact with French tradition. The architect "who is working at Tsarskoye Selo," she wrote of Cameron, "esteems Clérisseau most highly."[84]

Catherine turned simultaneously to what seemed to her to be three reliable sources of interpretation of the architectural heritage of Antiquity. All three had a Roman background. Quarenghi represented Italian tradition, Clérisseau the French school in Rome, and Cameron, the "Roman Scot" who belonged to the circle of followers of Bonnie Prince Charlie living in Rome, the British. If to this are added the close ties that existed between these three and other international figures like the antiquarians Tischbein and Reiffenstein, successors of the recently deceased Johann Joachim Winckelmann, a picture builds up of a unique crossroads of sources crucial to the formation of Russian Neoclassicism of the 1780s.

At this time Cameron worked on his contributions to the ensemble at Tsarskoye Selo, the cold baths on two levels, the Agate Rooms, the Gallery (pl. 272) which bears his name, and the ramp to which the triumphal alley leads across the park (pl. 273).[85] Cameron was the first to reconstruct Ancient Roman architecture in Russia. Scholar and archaeologist, he would often capture authentic detail; in the Agate Rooms he reproduced the interior decoration of Titus's baths, and in the apartments of the empress and the heir to the throne in the Catherine Palace he brought the wall-paintings of Pompeii to life.[86] The "archaeologizing" trend in Russian Neoclassical

273　　The ramp of the Cameron Gallery, Tsarskoye Selo (Charles Cameron), 1792.

architecture begins with his Roman baths at Tsarskoye Selo. It is curious, however, that his "game" with Ancient Roman ablutions remained simply a game. Catherine complained to her secretary, Aleksandr Vasil'yevich Khrapovitsky: "[. . .] the whole structure of the baths is built, but the baths haven't come out well, it is impossible to bathe in them."[87]

The exterior of the lower storey of the baths has the appearance of being worn away by time, but the upper storey is resplendent and in perfect condition, symbolic, as it were, of the Classical ideal, invulnerable to the passage of centuries. This contrast is also typical of English handling of Antiquity during the Enlightenment, of which Cameron was an exponent, along with contemporaneous architects of pavilions in English landscape gardens with allegorical programmes such as at Stowe.

At Tsarskoye Selo the theme of Antiquity, carrying notions of the ideal, harmonious life of the Ancient Greeks and Romans, merged with glorification of the national achievements of the reign of Catherine the Great. A series of images was created that was vitally connected with the contemporary world of political memories and aspirations. "When this war is over," wrote Catherine in one of her letters,

> my gardens at Tsarskoye Selo will look like a children's playground, after each successful military action we put up a fitting monument there. The battle on the Kagul – an obelisk with an inscription was raised . . . Victory in the Bay of Chesme – a rostral column was put up in the middle of the Great Pond. The taking of the Crimea [. . .] is commemorated in different ways in different places [. . .].[88]

One of these monuments, a tower-ruin built by Fel'ten, is particularly interesting. The slumbering power of Antiquity is symbolized by a huge column dug into the ground, and joined to it is a piece of a wall from the Moscow Kremlin, symbolizing the history of Russia, while the Turkish side is represented by a tiny pavilion.

These monuments to Russian victories were all carefully placed. The general idea was as follows. From the triumphal Orlov Gate, which had been built in the 1770s, the route of a victory procession was followed along the broad central alley to finish at the baths, symbol of the Ancient Classical ideal. A banner explaining the allegory was originally fixed to the gate, reading: "Through the waves you will enter the shrine of Sophia";[89] in other words, "You will reach Constantinople by sea." The phrase was enacted architecturally. On the far side of the lake in which the rostral column symbolic of maritime victories was set, Cameron built a cathedral dedicated to St Sophia (1780–87); in the eighteenth century it was thought to be a copy of Hagia Sophia in Constantinople.[90] The exterior bore no resemblance to that of the latter, but inside, the dome actually was reminiscent of the cathedral in Constantinople. The allegories of the whole scheme were linked not only with the themes of war and victory but also with domestic achievements, above all the creation of the "peace of enlightened wellbeing". South of the gardens at Tsarskoye Selo, around the cathedral, Cameron built a miniature ideal city, called Sophia, after Catherine's German name but also maintaining the Constantinian allusion to Divine Wisdom. Visitors, notably the Prince de Lignes, found the view of the miniature city from

274 Pavlovsk Palace (Charles Cameron), 1782–87.

the gallery above the baths one of the principal sights of the whole ensemble.[91] Catherine decreed that its streets should be laid out "to resemble alleys through the park."[92] The houses were designed after some of Cameron's models, and the streets were illuminated, almost uniquely in Russia at the time, and greatly astonishing foreign visitors to Tsarskoye Selo.[93] The illumination, however, was lit only when the empress was at the palace. The city also contained educational manufactories. As in the case of the reconstructions of Roman baths, this ideal city, as conceived in Russia during the Enlightenment era, was made a working model as far as possible.

A replanning programme was begun for the villages nearest to Tsarskoye Selo, and improved new settlements were laid out.[94] Quarenghi designed model schools and churches for these projects, among them an agricultural school directed by the tutor of Grand Princes Alexander and Constantine, the priest Andrey Samborsky, at which the latest agronomic methods of the time were tried out. Samborsky's school played a central role in the new movement of land management throughout the surrounding area, serving as a kind of *ferme ornée* – an essential element of the eighteenth-century English landscape garden.[95]

The estate belonging to the heir to the throne, Grand Duke Paul, was also situated in the area and belonged to the same architectural nexus as Tsarskoye Selo.[96] In 1779–86, when Cameron worked here, the layout of Pavlovsk (pl. 274) had a greater landscape element than as redesigned by Vincenzo Brenna, and the park had not yet acquired the theatricality that Pietro Gonzaga gave it at the beginning of the nineteenth century. In this early form, the estate was the ideal residence of an enlightened gentleman. It also heralded the future, albeit in idyllic form. Its landscape park had an aura of poetry quite removed from the political associations of Tsarskoye Selo. "The god of poetry holds sway in the park," one early visitor commented.[97] The theme of family memories, so important in the life of a country estate, was also prominent here.

The original palace at Pavlovsk was one of the earliest examples of a Palladian mansion in Russia. Cameron contrasted a grand central block, crowned with a cupola above a round hall as at Palladio's Villa Capra (*La Rotonda*), with modest wings and narrow covered colonnades leading to them. This model of a residential palace in the middle of a landscape park quickly spread throughout Russia. Alas, Pavlovsk was rebuilt when its owner succeeded to the throne.

At Pavlovsk no less than at Tsarskoye selo, Cameron aimed to bring Antiquity to life just as he had done with the Roman baths. This is clear from his original designs for the palace interior. Cameron's idea was that the visitor should find himself in an austere entrance-hall stylistically reminiscent of the exterior of the palace,[98] with rusticated walls and a cornice with triglyphs. Through the arch opposite the entrance a grand, well-lit staircase with tall white marble columns was to be visible, leading to an upper vestibule whose doorway would open into the round central hall, Italian-style, where eight columns would lead the eye upwards to the cupola. Between the columns four semicircular niches displaying Graeco-Roman statues were to alternate with four broad open passageways. A corridor ran round the perimeter of the hall, thought-provoking as to its purpose. It was plunged in darkness, but in its walls numerous niches were set, preserved to this day, in which Cameron planned to place relics of Antiquity such as pitchers, busts and fragments of capitals, objects of the kind he had copied in his youth from engravings in Italy. Here these pieces were to break free from museum rooms and the pages of drawings to become real, lamp-lit objects in a country house. The visitor would have the experience of being in a freshly dug underground passage where the architect himself had been during excavation of the baths in Rome. At Pavlovsk, as at Tsarskoye Selo, Cameron aspired to give Antiquity flesh and blood, a tangible presence; his purpose was to fill this Palladian country house with "the life of Ancient Rome".

Most who have written on Cameron's work in Russia have focused largely on comparison of his buildings with those of his English contemporaries, above all the Adam brothers and William Chambers.[99] And indeed, many coincidences and similarities between decorative motifs at Pavlovsk and Tsarskoye Selo and at Kedleston and Syon House may be found. But these similarities are no more than external; Cameron belonged to a different branch of English Neoclassicism from the Adam brothers. It is true that he often took up the Adams' ideas, especially unusual ones like the mirror decoration of the London house of the dukes of Northumberland (pl. 275). However, a number of documents in Cameron's hand testify to direct links between himself, Isaac Ware whose pupil he was, and Lord Burlington, whose influence on the latter was considerable. This background is important for a full appreciation of Cameron's role in eighteenth-century Russian architectural history.

Besides Cameron's direct personal contribution, his foundation of a "British architectural colony" at Tsarskoye Selo also played an important part in the history of Anglo-Russian architectural relations. That a number of architects went on from this centre to disseminate the features of "the English

275 Bedroom of Catherine the Great, Catherine Palace, Tsarskoye Selo (Charles Cameron), early 1780s.

manner" in Russia was largely due to the efforts of two of Cameron's appointees, William Hastie and Adam Menelaws.[100]

Cameron worked entirely outside the capital. Of his contemporaries, Giacomo Quarenghi played the leading part in the creation of Neoclassical St Petersburg. Responsible for a large number of state-commissioned and private buildings, he was one of the most colourful St Petersburg characters. He is remembered by a contemporary going about the streets visiting his numerous building projects: "Everyone recognized him by the enormous blue-coloured onion dome that Nature had placed on his face instead of a nose."[101] Born in Bergamo in northern Italy,[102] Quarenghi studied in Rome with the

German-born painter Anton Raffael Mengs, after which he embarked on extensive travels, going in 1780 to Russia, where three years later he won the special favour of Catherine the Great, who commissioned him to build the Hermitage Theatre, enlarging the imperial residence on the Palace Embankment still further. This theatre's interior was built in the style of Palladio's Teatro Olimpico in Vicenza and its façade too abounds in Palladian motifs. Grabar' comments that in this building Quarenghi "created architecture in a style of impeccable strictness that was at the same time no less picturesque than Rastrelli's".[103]

At the same time, on the opposite bank of the Neva, on the embankment of Vasil'yevsky Island, Quarenghi put up the

276 Façade of the State Bank overlooking the Catherine Canal (Giacomo Quarenghi), 1783–1790.

Academy of Sciences building, which is even more formally laconic than the Hermitage Theatre. It is a long and rectangular block without ornament but with a heavy Ionic portico under a high plain pediment. The features of this building – a marked reserve, fine proportions and solemn interiors in the Ancient Roman manner – are the hallmarks of Quarenghi's style.

Another of Quarenghi's celebrated ensembles, the State Bank (Assignatsionnyy bank) was built in 1783–88 (pls 276, 277).[104] Its central component, of the comparatively modest proportions of an average mansion, takes the form of a standard three-storey Palladian villa, with a Corinthian portico and statues at the angles of the pediment. The main two-storey building, surrounding this in a gigantic horseshoe, is threaded along a long curving corridor with equal-sized pilasters to right and left. An all-round colonnade links the central block with the horseshoe, seeming to draw it towards the centre of the complex. Quarenghi's remaining outstanding building, not preserved, was the English-Palladian-style palace in the English Park at Peterhof (pl. 278), probably modelled on Catherine's anglophile cousin Prince Leopold von Anhalt-Dessau's palace in Wörlitz.

Quarenghi worked in Russia for many years. In 1784 he began work on the Stock Exchange (Birzha) on the Spit (Strelka) of Vasil'yevsky Island, but this project was not completed and became a ruin. He continued to be active in Russia after the death of Catherine the Great in 1796. In 1798 he built the church of the Maltese Order to Paul I's commission, in 1800–04 the Horse-Guards' Riding-School (Konnogvardeyskiy manezh), in 1803–05 the Imperial Chancery (Kabinet) and the colonnade of the Anichkov Palace (Anichkovskiy dvorets), and in 1806–08 a new building for the school for daughters of impoverished gentry founded by Catherine and which she had named the Smol'ny Institute (it acquired different associations in 1917 when the Bolsheviks made it their headquarters). Quarenghi's most important building in Moscow is the Shopping Arcade (Gostinyy dvor) in Kitay-Gorod, with its gigantic Corinthian Order (pl. 279). Quarenghi also worked in the provinces, building Palladian mansions for Catherine's courtiers.

Another Russian exponent of the Palladian style active at the end of the eighteenth century was the nobleman Nikolay L'vov, possessor of an extraordinarily versatile talent: he was a musician, engineer, poet, translator, and as an architect he had a more varied stylistic mastery than Quarenghi.[105] His first building in St Petersburg, the Main Post Office, dating from the 1780s, was Palladian, while his churches built at this time on the estates of magnates outside the city, now within St Petersburg itself, had a tendency to pure geometric forms, as

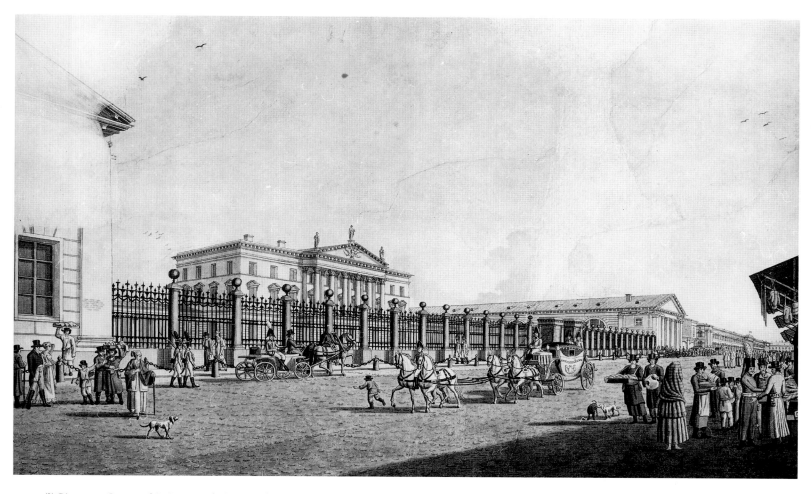

277 (?)Giacomo Quarenghi, *State Bank*, St Petersburg (Giacomo Quarenghi), 1783–90; drawing, late eighteenth century

278 The Palace in the English Park, Peterhof (Giacomo Quarenghi), 1781–94.

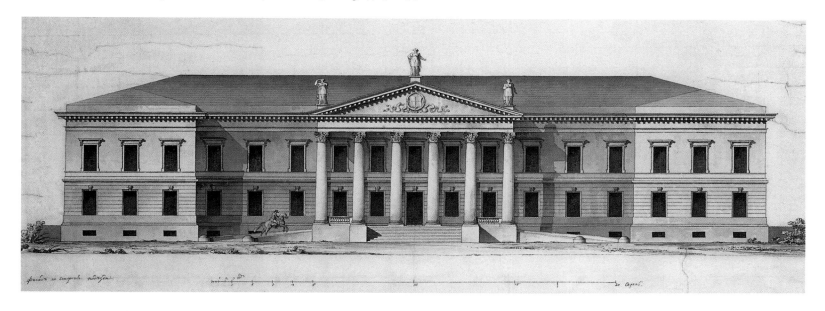

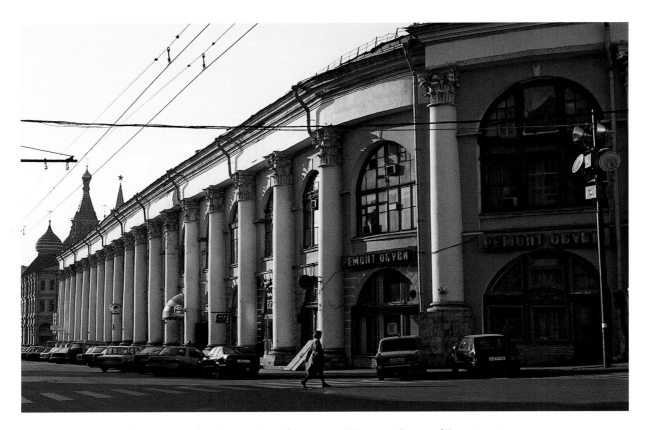

279 Shopping Arcade (Gostinyy dvor), Kitay-Gorod, Moscow (Giacomo Quarenghi), 1789–96.

280 Church of the Blessed Mother of God's Entry into the Shrine, Vvedenskoye (Nikolay L'vov), late eighteenth century.

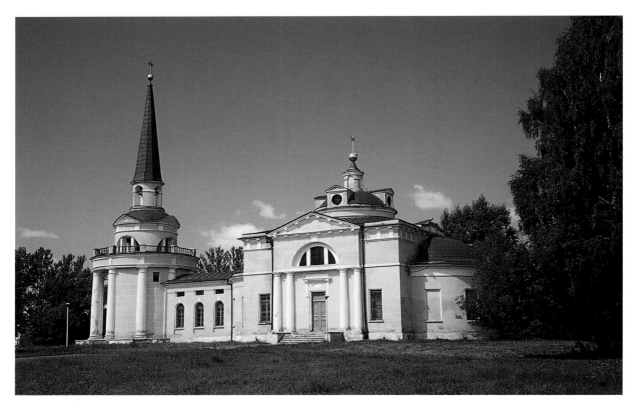

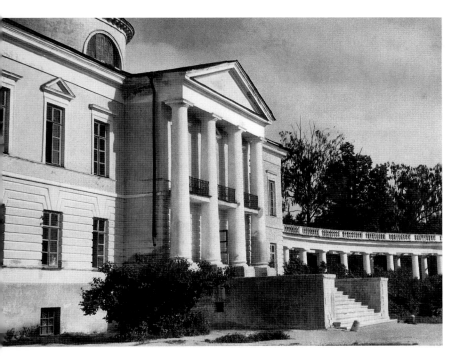

281 Mansion of the Glebov estate, Znamenskoye-Rayok (Nikolay L'vov), late 1780s/early 1790s.

283 Gateway on the Glebov estate, Znamenskoye-Rayok (Nikolay L'vov), late 1780s/early 1790s.

282 Nikolay L'vov's design for his own house at Nikol'skoye, late 1770s/early 1780s.

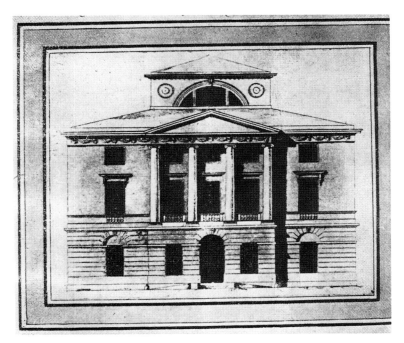

demonstrated by St Catherine's on the Vorontsovs' estate of Murino. L'vov also built a rotunda-church surrounded by an Ionic colonnade and a tall pointed pyramidal bell-spire. With these buildings he was conducting experiments with architec-

tural form in similar ways to those of pre-revolutionary French Classicism, and he continued them into a later period, an example being his church at Vvedenskoye outside Moscow (pl. 280). This combination of Palladian features with geometricized monumentality, emerging at the end of the Enlightenment era, seems to the present writer typical of late eighteenth-century Russian architecture.

L'vov was extremely active in the provinces, especially in his native Tver' region, where, with varying degrees of certainty, some forty country houses and churches are attributed to him. On the Glebov estate of Znamenskoye-Rayok (pls 281, 283) and his own Nikol'skoye (pl. 282) L'vov adapted Palladio to Russian needs. He translated *I quattro libri dell'architettura* into Russian, and printed the first book with his commentaries.[106] With all his reverence for Palladio, in the interiors of his buildings he always had regard for the Russian climate. "In Italy," he wrote, "of course houses can be built to a chessboard plan [. . .]. Italians have no concept of a biting wind [. . .]. So how can the principle of equilibrium [symmetry of apertures on one side of a house against those of another] suit our climate, and what equilibrium of 28 degrees [Celcius] of frost will not be excessive?"[107]

Starov also continued to be active at the same time as Cameron, Quarenghi and L'vov, retaining his taste for French Classicism. His taste was eventually for restrained façades and sumptuous, multi-columned interiors. His aim was to recreate

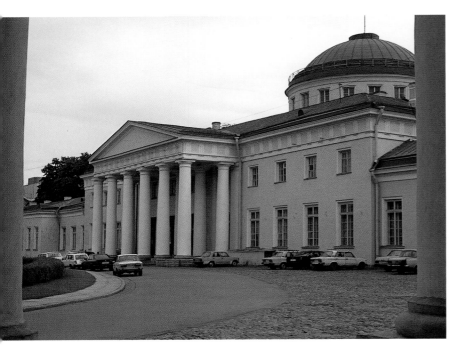

the greatness of Imperial Roman architecture with as much historical accuracy as possible, and this is particularly evident in the Tauride Palace (Tavricheskiy dvorets), which he built in 1783–89 for Prince Potemkin (pl. 284),[108] who after Russia's annexation of the Crimea (known to the Ancient Romans as Chersonesus Taurica) was given the title of Prince of Tauride. Of his new palace the poet Derzhavin wrote: "Its exterior is resplendent with neither carved nor guilded nor any other kind of rich ornament. Its quality is the fine taste of Antiquity! It is simple, it is sublime."[109] When it was built, the palace overlooked the Neva from its raised position not far from the bank, from which a canal led to it. A later building now unfortunately obscures the view of it from the river, and the visitor's first sight of it is of the simple, ascetic-looking façades on entering the main courtyard. The main building lies deep in the centre of the ensemble, and square wing-blocks are linked to it on either side by galleries (pl. 285). At the centre of the main façade is an austere Doric portico.

284 The Tauride Palace, St Petersburg (Ivan Starov), 1783–89.

285 Plan of the Tauride Palace, St Petersburg (Ivan Starov), 1783–89.

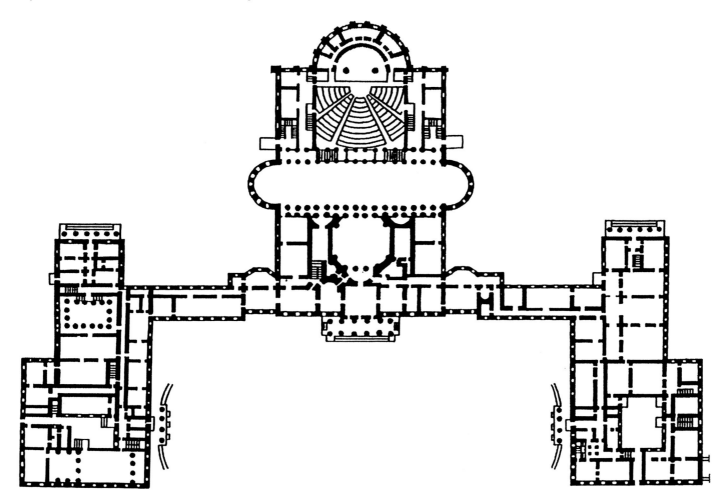

On 28 April 1791, a few months before his death, Potemkin gave a masquerade ball at the Tauride Palace in honour of Catherine the Great, the grandest of all St Petersburg celebrations of the era. The palace's interiors at this time are thus described by a contemporary:

> Inside the main entrance was a narrow vestibule, from which doors gave onto an octagonal hall, with a choir and a cupola above it [. . .] the effect was of some kind of sacred building [. . .]. On the cornice, a legend in gold letters read: TO CATHERINE THE GREAT. This hall was called "The Pantheon". Beyond it was the magnificent Great Gallery [Bol'shaya galereya]. On entering this, you were aware of the long oval shape of the room, or it would be better to call it a "square", which could take five thousand people comfortably. All the gigantic forces of Nature seemed to be contained in it.[110]

Thirty-six white columns with capitals modelled on those in the Erechtheum Temple in Athens separated this gallery from a no less magnificent conservatory (Zimniy sad, "winter garden"): here "everywhere it is Spring, Art competes with the delights of Nature. The spirit is bathed in bliss."[111] Around the palace a landscape garden had been laid out by William Gould, a pupil of Capability Brown.[112] The sheer splendour of Potemkin's masquerade ball is indicated by his own dress. He wore a scarlet caftan and a cloak of black lace; his hat bore such a weight of diamonds that he couldn't wear it on his head, and it had to be carried behind him by an aide. The occasion was a great success, but Potemkin did not win back his former closeness to the empress.[113] It is possible that the ageing Catherine did not wish to return to the days of the beginning of her reign, when its success was far from certain. In her last years, surrounded by adulation and legends of her extraordinary wisdom, she thought increasingly of the future and conceived ever more ambitious plans combining architecture with politics.

7 Town and Country in the Age of Enlightenment

During the thirty-year reign of Catherine the Great the appearance of almost the whole of central Russia – towns, villages, country estates – was transformed. This was perhaps the most fundamental change in the environment of everyday life in the country's history. Urban planning measures were punctiliously carried out by the state authorities, and all urban building had to be officially approved. Country estates and peasant settlements were free from building restrictions. However, the tastes of the imperial court and newly constructed imperial country residences and magnates' country houses served as models for the rest of the country; changes that took place in rural building were generally in a direction that met with the empress's approval and accorded with her architectural tastes.

Most urban building under Catherine the Great took place in a framework of urban planning. Both state administrative officials and architects thought first and foremost in terms of rational planning, not the creation of individual buildings. The latter would be raised in areas that had already been duly planned, after the elapse of time and in accordance with individual means. This was why it was always practicable to draw up new plans for imperial settlements but impossible, for economic reasons, to change existing ones. Catherine's urban planners followed the advice Diderot gave her: "If, Your Majesty, you could wave your magic wand and build as many houses as you liked instead of palaces, I should still repeat my appeal to you: 'Build streets'."[114] And this indeed was done, in all provincial and district towns in Russia, with great energy and determination.

At the end of 1762, shortly after Catherine's accession to the throne, a "Commission for Masonry Building in St Petersburg and Moscow" was founded by the Imperial Senate.[115] In the middle of the following year, however, a catastrophic fire destroyed much of Tver', and the Commission was charged with the restoration of that city, which was situated halfway between the old and the new capital. In the same year Catherine issued a decree to the Commission "On the preparation of special plans for all towns, for building works and [the construction of] streets in them, by individual provinces". The remit of the Commission was now extended to the whole country. A further imperial decree was issued which was to influence building activity in the main centres of population, "On the construction of public buildings in stone in all towns". This covered lawcourts, residences of provincial governors and other administrative centres.

Between 1762 and 1796 more than 350 urban replanning projects were passed by the Committee. Its key officials were the president of the Academy of Arts, Ivan Ivanovich Betsky, the chief architect and a number of architectural assistants, and a group of land-surveyors who were given general area plans and prepared detailed plans on site. The crucial role was that of the chief architect, who was responsible for planning decisions. From 1762 to 1772 the post was held by Aleksey Kvasov, after his death until 1774 by Ivan Starov, and for the remaining 22 years by Iogann Leym, an architect of German extraction (pl. 286). Under Kvasov new plans were passed for eleven towns and cities, and work proceeded for four more; under Starov perhaps ten urban plans were passed, the exact number being disputed. What is certain is that there was no compari-

286 Plan for the town of Kashin (Ivan Leym), end of eighteenth century.

287 Plan for the city of Kaluga (Pyotr Nikitin), end of eighteenth century.

son between the number of plans executed in the time of Kvasov and Starov and the 300 or more dating from Leym's period in office.

The year of imperial approval of a plan could, of course, be very different from the date of its execution. Work often went on for decades, especially in the cases of cities with a complex history, such as Moscow or Arkhangel'sk. Some projects, when executed in simultaneous groups within the same province, proceeded with great rapidity, and here the initiatives of decision-making provincial governors could influence the tempo.

The organization of the planning work carried out by the Commission is of interest. A new urban plan customarily went through several stages. The first was a survey carried out by local land-surveyors or the Commission's topographers. The second would be the preparation of the planning project. In most cases this was done in St Petersburg, but sometimes by an architect working in the provinces, such as Pyotr Nikitin in Kaluga (pl. 287) and Aleksey Dokudnikov in Kargopol'. In exceptional cases special groups were formed to work on the reconstruction of a particular city or town, as for Tver', where Nikitin and Kazakov collaborated. In the south of Russia, urban plans tended to be drawn up by architects who worked for Prince Potemkin; among these Starov was especially active, and later William Hastie. All draft plans, whoever the local architect involved, were reviewed by the Commission, which might make amendments. The third and final stage before the passing of a plan was the dispatch of the draft to the relevant city or town and the making of any necessary amendments on the spot. Where a plan was "impracticable", the Commission could decide "to amend it [. . .] not departing from the plan itself [i.e. maintaining its basic features]".[116]

The urban ideal that the Commission had in mind was defined by Betsky in "Notes on the Restoration of Tver'" (1763).[117] The plan for the reconstruction of Tver' was prepared in such a way that it "could serve as a model for the reconstruction of other towns in the future".[118] Betsky regarded a town as a single architectural organism, with the same laws applying to it as to any given architectural task: "Three criteria should be observed in the building of houses – solidity, suitability and beauty [cf. Vitruvius: "permanence, utility and beauty"]; a town is the same as a house, on a larger scale."[119] In the planning of new settlements he held "regulation" to be essential.[120] His Commission laid down numerous requirements: "streets should be wide and straight, squares large, public buildings suitably sited [. . .] all houses in a street should be built on both sides of it, up to the crossing with the next street, to form one unbroken façade . . ." (pl. 288).[121]

It was also considered desirable that a population centre should have compactness. Betsky maintained that "society will

288 Regulated development at the turn of the eighteenth/nineteenth centuries, Tver'.

have greater capacities when a town is less spread-out and its inhabitants live in closer proximity to each other."[122] Much attention was devoted to the town centre. Betsky laid emphasis on the building priority of main streets, and extended to all towns the requirement of brick building in central urban areas, which attempts had been made to introduce in the two capitals for the previous half-century. The Commission considered that buildings relating to administration and trade should be sited in the centre of a town. To ensure this in conditions of private land ownership, however, was difficult, and so Nikitin declared it essential in his plan for Kaluga that the central area of the town "should contain public land".[123] Betsky also aimed to develop new house designs with model "plans, façades and silhouettes", which in fact had already been introduced in Catherine's reign.[124]

Many "explanations" in town plans that serve as sources of our knowledge of urban planning theory in the second half of the eighteenth century stipulate the separation of the popula-

tion into residential areas according to the different estates – streets for the gentry (*dvoryanstvo*) and districts for the merchant class (*kupechestvo*), petty bourgeoisie (*meshchanstvo*) and the educated class not belonging to the gentry (*raznochintsy*). Those who had previously lived in the centre of a town but lacked the means to build a new house in brick were given a vacant suburban plot.[125]

In reviewing new urban plans, the Commission proceeded in the belief that completeness and finality were both possible. Its decisions were made in accordance with a "regulatory" ideal by which "a permanently valid general plan could be set up for any given town".[126] In central Russia town boundaries were precisely defined, often by low earthen walls. Future development was expected to take place within the framework of a scheme that had been laid down once and for all. Betsky took account of possibilities of a future rise in population in the following way: "The foundations of all houses should be of such proportions as to allow, if the need arose, the creation of one or

269

half an extra living unit" – in other words, by adding a storey, or part of one, to a house while not enlarging its ground-plan.[127]

In its working methods the Commission exhibited Classical characteristics: the aim of completeness in a planned design, the idea that it would last "for ever", precise territorial structuring of a population, the establishment of a social hierarchy of private space. The system of putting these principles into practice was codified in regulated planning practice. The Commission laid down the boundaries of each town, and architects made every effort to execute these with geometrical exactitude. Populations had to accommodate themselves to straight boundary lines. The accepted overall shape of a town or city with a complex history, such as Vladimir, Tula or Vyshnyy Volochok, was usually polyhedronic, though a simple geometrical figure was the norm, most often a rectangle or a square, as with, for example, Kashin, Borovsk, Vytegra and Yukhnov. Rarer are examples of the shape of a town being governed by natural features, for reasons either of history (a town having grown up along a river, like Kalyazin) or of topography (as with Ostashkov, which stands on an isthmus between two lakes).

The problem of continuity with the past was resolved in favour of the new. The Commission almost always decided on radical replanning of towns and cities. Long-standing inhabited locations, with their major topographical features, were maintained. All masonry buildings were preserved, but wooden buildings were left entirely out of account. The most important point regarding continuity was the use of past landmarks – kremlins, fortifications, monasteries, cathedrals and bell-towers. A new town plan would be oriented round the historical centre where such buildings were located, as in the cases of Kazan', Tver', Yaroslavl' and Kostroma. However, the contours of historical cities and towns were usually altered, only the course of main streets generally being preserved, not always completely. Picturesque street networks of ancient Russian towns had no claims for those who carried out the new progamme of regulated planning.

In the new plans all streets were straightened and many shifted to new routes, and the proportions of whole districts would be changed when areas were cleared for the construction of squares. The radical nature of the new plans threw up many obstacles in the way of their realization. What was feasible in a new town was problematic in one of historical complexity, and the larger the town, the greater the problems. Starov, Kvasov and Leym were all highly sensitive to varying local situations and were able to reach satisfactory solutions. Small principal towns of districts presented few replanning problems compared to ancient cities like Pskov and Yaroslavl', where historic quarters were preserved unaltered under Starov. The layout of central Moscow, the largest historical city in the country, was left substantially unaltered by the Commission, Legrand gradually and only where feasible replacing some ancient fortifications with new boulevards and squares and bringing individual districts and estates into line with new planning regulations. His work in Moscow was continued by Kazakov, who replanned the trading rows on Red Square with a rectangular arcade surrounding the square (pl. 290).

Besides urban plans, the Commission prepared designs for façades on streets and squares and models of private houses and public buildings.[128] These would be sent to individual towns along with the town plan. Eight private house types were developed:

Masonry in a terrace.
Free-standing masonry.
Single-storeyed masonry with cellar and attic.
Single-storeyed masonry with cellar.
Single-storeyed wooden with cellar.
Wooden on masonry foundations.
Wooden throughout.
Wooden with shop premises on ground floor and living rooms on a first floor, or with separate shop premises on one or two storeys.

All urban residential areas were to consist of these components. Public buildings at the end of the eighteenth century, such as lawcourts, gaols, offices and work-places, were usually designed by provincial architects in uniform style for all towns within the same province.

By the end of Catherine the Great's reign the Commission for Masonry Building had completed its planning programme throughout European Russia, and her son and successor Paul I dissolved it. Special institutions for the regulation of urban building in the Empire were restored under Alexander I, and

289 Reconstruction of a regulated development of the turn of the eighteenth/nineteenth centuries.

290 *View of Red Square*, Moscow, engraving after the drawing by Alexandre de la Barthe, 1797.

then building controls and the organization of urban populations went considerably further than before, covering all building activity public and private. This process, however, will be described in the next chapter. Our present subject relates to the no less profound changes that were brought about in rural Russia during the reign of Catherine the Great.

The life of the Russian country estate in its classic form was all too brief. It began in 1762 with Peter III's decree freeing the gentry from compulsory state service, and experienced a rapid revival with Alexander II's Emancipation of the Serfs in 1861. The culture of the country estate underwent its formative period in Catherine the Great's reign, an extraordinarily short time for the evolution of a whole way of life, with its everyday routines and customs, psychology, and tastes in architecture and landscape design.[129] Of course, the Catherinian country estate had a lengthy prehistory, extending from the *votchiny*, inherited estates, of the boyars in medieval Russia to the *pomest'ye* system, land held under service tenure, of the gentry which lasted from the sixteenth to the mid-eighteenth century. Under the latter system owners of country estates were not allowed to live permanently on them; they received the land, and the peasants on it, only after fulfilling their obligations of military ser-

vice, or their ancestors had already received the land in return for such service.

The agronomist, horticulturalist and scholar Andrey Timofeyevich Bolotov writes of those times in his famous memoirs:

[. . .] to tell the truth, at that time our neighbourhood was deserted, we had no good, wealthy neighbours anywhere near us. Those times were not like now [1789]; the countryside wasn't full of gentry living on their estates as it is now: all the gentry were away on military service then, and only the very elderly lived in the villages [. . .].[130]

The lifestyle on a country estate was extremely modest at that time, and varied little throughout Russia.

Our house was small [. . .] as was usual at the time, it consisted of empty and uninhabited rooms. For example, there were two very large outer lobbies [. . .] the front one was completely empty, and from the one at the back there was only a passage-stairway leading up to the first floor [. . .].[131]

[. . .] The outer lobby [. . .] led to a vestibule, or as we would say today, an entrance-hall [. . .] the icons were its

291 Andrey Bolotov, *View of the Park at Bogoroditsk*, 1780s.

only decoration [. . .]. As the windows were tiny [. . .] this room was almost completely dark. The next room [. . .] was my mother's sitting-room, dining-room, bedroom and living-room [. . .]. As for furniture, all those sofas, settees, armchairs we have nowadays [. . .] card-tables and all sorts of other little tables [. . .] those smooth, clean bench-seats round the walls and dozens and dozens of chairs [. . .] they weren't yet the custom [. . .].[132]

Even more striking is this glimpse of the considerations that governed the siting of houses on country estates in those times:

A house would be as good as the ground it stood on. I don't know which ancestor of mine chose the site of our house, but I do know that it was the worst possible spot in the whole of the estate; the best places were chosen for kitchen-gardens and cattle-yards [. . .] it was the custom in former times to hide a house by siting it so that it could never be seen from a distance [. . .].[133]

The medieval tradition of siting houses of country estates so that they could not be seen from a distance, a tradition that lingered on in later times, originally arose, of course, because of the danger of sudden attacks. Russian towns, unlike country estates, were traditionally sited in prominent spots. All this changed in Catherine the Great's reign, when country houses began to be sited at the most advantageous points in a landscape (pl. 291).

Thousands of the gentry, back on their estates after Peter III's decree freeing them from compulsory service, could have said with Bolotov: "After I left the service, I settled down in my small house [. . .] carried out repairs and got my household in order [. . .] then I married, raised a family, built a new house, made gardens [. . .] I had a happy life [. . .]."[134] This was the pattern in the 1770s throughout the central provinces of Russia, which had a long tradition of country estates. The era of the deserted countryside was over, and the gentry population swelled. Life was full of festive occasions, name-days, birth celebrations, weddings, besides hunting and fishing expeditions after which everyone would repair to the nearest neighbour's house for fish soup. Not everyone, however, had such a free-and-easy life in the new conditions. "My grandfather felt cramped, living in the province of Simbirsk on a hereditary estate granted to his forebears by the tsars of Muscovy," Sergey Aksakov begins his *Family Chronicles* (1856).[135]

Towards the end of the eighteenth century, country estates began to spread rapidly to the east of European Russia and even beyond the Urals, and to the vicinity of prosperous lands in the Ukraine and Belorussia, where Catherine the Great

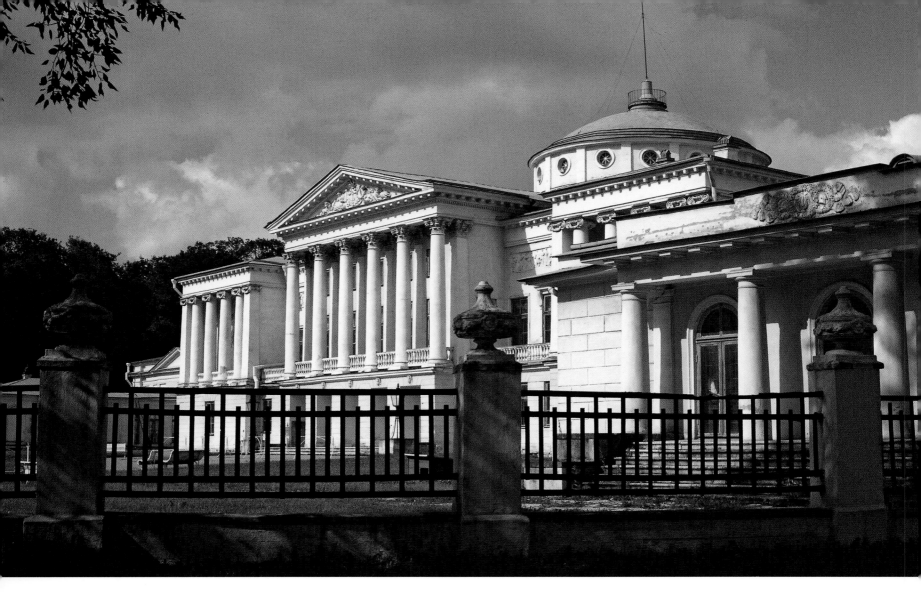

292 The palace at Ostankino, Moscow (Giacomo Quarenghi, François Kasie, Pavel Argunov et al.), 1791–98.

granted substantial lands to her courtiers and to generals and officers of the victorious Russian armies of the day. Over the whole of this huge area a homogeneous culture sprang up in which, despite the diversity of personalities and localities, a unified architectural and landscape style evolved. Life on the Russian country estate in the 1780s combined the splendour of the capitals with rural freedom. The estates situated near Moscow formed a special type, in which the social life of the capital continued in the lap of nature. Some most unusual buildings appeared, such as the palace of Count Nikolay Sheremetev at Ostankino, its central component a magnificent theatre where serf actors played; the entire house was designed round the auditorium, which was surrounded by drawing-room suites and galleries (pls 292–94).

One of the best descriptions of a country estate at the end of the eighteenth century is given by Aksakov in his account of a summer visit with his parents to his father's aunt, from whom they were waiting to inherit. On the way they stopped at the village of Nikol'skoye in the province of Kazan', and were invited by the owner of the estate to (midday) dinner.

In the middle of a large square, on two sides of which were rows of *izby* (one-storey peasant houses), stood a stone church in the latest architectural style. A two-storey stone house linked by colonnades to side-wings occupied one side of a rectangular courtyard, which had round towers at its corners. All the outbuildings in the courtyard seemed to serve as walls for this house; an endlessly long garden, with ponds and a stream, came up to the rear of the house [. . .]. I had never seen the like before in my life and was astounded, and the images of great country houses belonging to English lords that I had read about in books, so vivid in my memory, joined the real world at last [pls 295, 296].[136]

No detail of this estate escaped Aksakov's notice.

293 The theatre of the palace at Ostankino, Moscow, 1791–98.

In the middle of the courtyard was a marble fountain and a sundial; these were surrounded by beautiful, broad flowerbeds with sanded paths running through them. A magnificent porch with lanterns, urns and statues and a still more magnificent stairway, with a carpet running up it in the middle and orange-trees and flowering plants, surpassed the wildest reaches of my expectations, and from the palace of an English lord I floated on to the enchanted castle of Scheherazade.[137]

There to marvel at "mahogany furniture upholstered in velvet or damask and with bronze mounts, various kinds of decorative clocks, some with lions' paunches and some with human heads [. . .] such richness and luxury everywhere [. . .]" – and all this at the back of beyond in the province of Kazan', a thousand miles from St Petersburg or Moscow.[138] "Then Durasov [the owner of the house] offered to show us his garden,

orange-trees and hothouses." The park was laid out in English Picturesque style, with "follies". " 'And I've got pigs', Durasov told us, 'of a species you won't find in Russia. I had them brought over from England in a special cart.' "[139] In an out-of-the-way part of the garden he had "a beautiful little house. The swineherd and his wife lived in the front room, and in the two other large rooms lived two gigantic pigs, each the size of a small cow."[140] On many country estates belonging to the gentry factories were built as a means of increasing income; they often displayed the formal Neoclassical features of the main houses (pl. 297).

Novelties and surprises of various kinds were provided in the house described by Aksakov to stimulate the imagination of visitors: "The back wall of the room began to move, and rose up in the air, and loud music sounded in my ears. Girls in beautiful white dresses began to sing."[141] Horn music was played at

294 (facing page) Enfilade on the first floor of the palace at Ostankino, Moscow, 1791–98.

295 Mansion, Nechayev-Mal'tsev estate, Polibino, Lipetsk province, turn of the eighteenth/nineteenth centuries.

festive meals, but the sound of a horn ensemble was especially exhilarating as an accompaniment to boating on a river or pond. None of these entertainments, however, could wholly satisfy the sophisticated. Not even the serf theatres, or the theatres with amateur actors from the gentry that became fashionable later, could compete with the theatricalization of reality that was perfected on the Russian country estate.

The word "theatricalization" is not entirely apt here. Theatre presupposes an audience, but the owner of a country estate structured his world around himself. Almost every head of an estate aspired to make it something like a "working model" of an ideal world, whether patriarchal or progressive. The basis of this model was always a conception of personal happiness, to be realized either by an improvement of living conditions or by the creation of an ideal image of such an improvement of life, contained in architecture or park or landscape design. This is

perhaps the most important feature of the Russian country estate, less strongly present in its French, English or American counterparts. In all countries the estate was a closed entity, created in accordance with pragmatic traditions and needs and its owner's desires. It would seem, however, that in no other country was the world of the country estate so little connected with older traditions of rural life, were economic and agronomic considerations so often sacrificed to an ideal, as in Russia, where, throughout the reigns of Catherine the Great and Alexander I, one great carefree provincial pastoral was played out.

An estate-owner aspired to create a picture of improvement and prosperity, as far as he understood these concepts – for his family, his house-servants and serfs. There were of course monsters and scoundrels among landowners, and they left a tangible image of their particular way of organizing life, of their per-

296 Mansion, Vvedenskoye, late eighteenth century (?Nikolay Lvov), restored 1912.

sonalities and views of the world. But more common were decent folk who aimed at general happiness, and they conducted their lives in their own particular way – from the eminent Russian mason and Rosicrucian Nikolay Novikov, with his "communal" family houses for serfs, to Count Andrey Aleksandrovich Arakhcheyev, who turned his estate of Gruzino into a model "military settlement".

Realization of the ideal of perfect rural life meant that landowners had to address a number of tasks, the most important of which were shared with them by the state. The general land survey led to a gradual change in land structure. Agronomical developments produced new methods of working the fields and garden management, which were promoted by the Free Economic Society (Vol'noye ekonomicheskoye obshchestvo) and the Practical School of Agriculture (Prakticheskaya shkola zemledeleniya) established near

Tsarstvoye Selo under the patronage of the imperial court. In both the eighteenth and nineteenth centuries various agronomic innovations *à l'anglaise* became especially fashionable.

The country homes of the gentry exemplified the new culture, breaking away from centuries of tradition. The impact of medical advances and new agricultural methods improved the lives of serfs. Neoclassicism, the dominant style of country houses, expressed the idea of orderliness and concentration of the life of an estate in the hands of its owner. This style, as it were, represented the capital in the country, and its evolution was ruled by the norms of St Petersburg and Moscow. There was no recognizable stylistic difference between the houses of wealthy country estates and new houses of the same period built in the principal cities.

In parks freedom reigned. The concept of a "garden" was understood in Russia in widely varying ways in the second half

297　Needle factory, Khlebnikov estate, Kolentsy, 1790s.

298　Pavilion in the park, Dashkov estate, Bykovo.

of the eighteenth century. On nearly all estates English Picturesque composition admitted some strict formal features borrowed from parks designed in the French or Dutch style. Multi-tier terraces, their sources in Baroque Italian garden design, became popular. Some features were preserved from the great late medieval estates, such as miniature flower- and vegetable-gardens and various kinds of fishpond, many of which can be seen to this day, often in the most attractive corner of a park.

Russian garden follies would express their owners' leitmotifs. Garden pavilions would usually take forms taken from books on landscape gardens. Although this type of garden was called "English" in Russia, pavilion styles often came not directly from British sources but from German and French publications and engravings showing gardens in the English style.[142] In Catherine the Great's reign estates often glorified their owners' military gallantry and displayed triumphal features, as at Troitskoye-Kaynardzhi or Vishenki belonging to Field Marshal Count Pyotr Rumyantsev or Saburovo belonging to Field Marshal Mikhail Kamensky; the latter was designed entirely as a fortress.[143] Monuments in honour of tsars would also frequently be found – and sometimes quite the reverse: the estate-owner would feel like a monarch himself, and imitations and parodies of court life would result. The Dmitriyev-Momonov family, for example, gave its domestic serfs court titles and functions on social occasions such as dinners and promenades. Park buildings and features in this spirit, redolent of Pavlovsk or Tsarskoye Selo, are frequently to be found, as at the Kurakin estate of Nadezdino, at Sukhanovo (Volkonskys), Yaropolets (Chernyshevs) and Bykovo (Dashkovs; pl. 298).

The stylistic evolution of country houses in Russia was similar to that of town houses. A leading early influence was Starov, who built houses, as already mentioned, at Bobriki and Bogoroditsk for Count Bobrinsky and then at Ostrovky and Ozerki for Prince Potemkin. The first two were in the Classical style of French town houses of the 1760s, and the last two, at Potemkin's express wish, in the Gothic Revival style of Horace Walpole's Strawberry Hill. After Cameron's creation of Pavlovsk, Quarenghi's house at Lyalichi for Count Zavadovsky, a favourite of Catherine, and L'vov's numerous houses in Tver' Province (1780s–90s), the Palladian style became popular, in English or Italian interpretations according to whether Cameron or Quarenghi was the model. The country houses of L'vov, Starov and Kazakov represent attempts to adapt the precepts of Palladio's *I quattro libri dell'architettura* to Russian conditions, with an admixture of motifs borrowed from French illustrated books, above all from Jacques-François Blondel and Jean-François de Neufforge.[144]

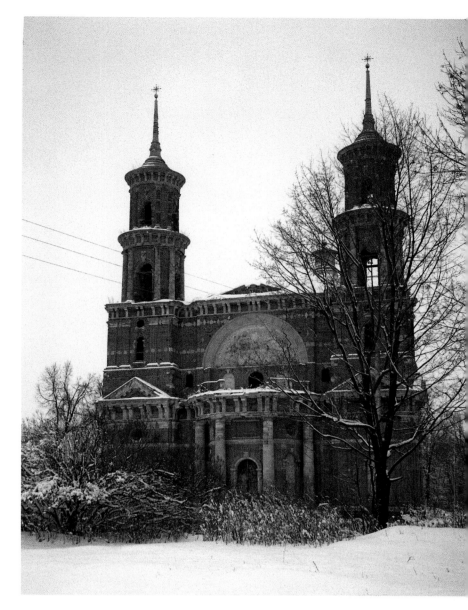

299 West front of the church of the Vladimir Icon of the Mother of God, Muromtsev estate, Balovnevo, Lipetsk province, 1780–99.

One last important aspect of the life and architecture of Russian country estates of this period was church building. Churches were a leading component of the built ensemble of country estates.[145] In designing a church in the country, an architect would feel far less inhibited than in a town or city, where state and ecclesiastical authorities exercised far greater control. Because of this, and also as a result of the input of the individual estate-owner and rivalry between neighbours, some very unusual churches were built, often as large as any major church in Moscow or St Petersburg, for example at Balovnevo near Lipetsk (pl. 299), Gusevskiy pogost or Voyeykovo in Ryazan' province (pl. 300), or Shkin' near Kolomna. The pre-

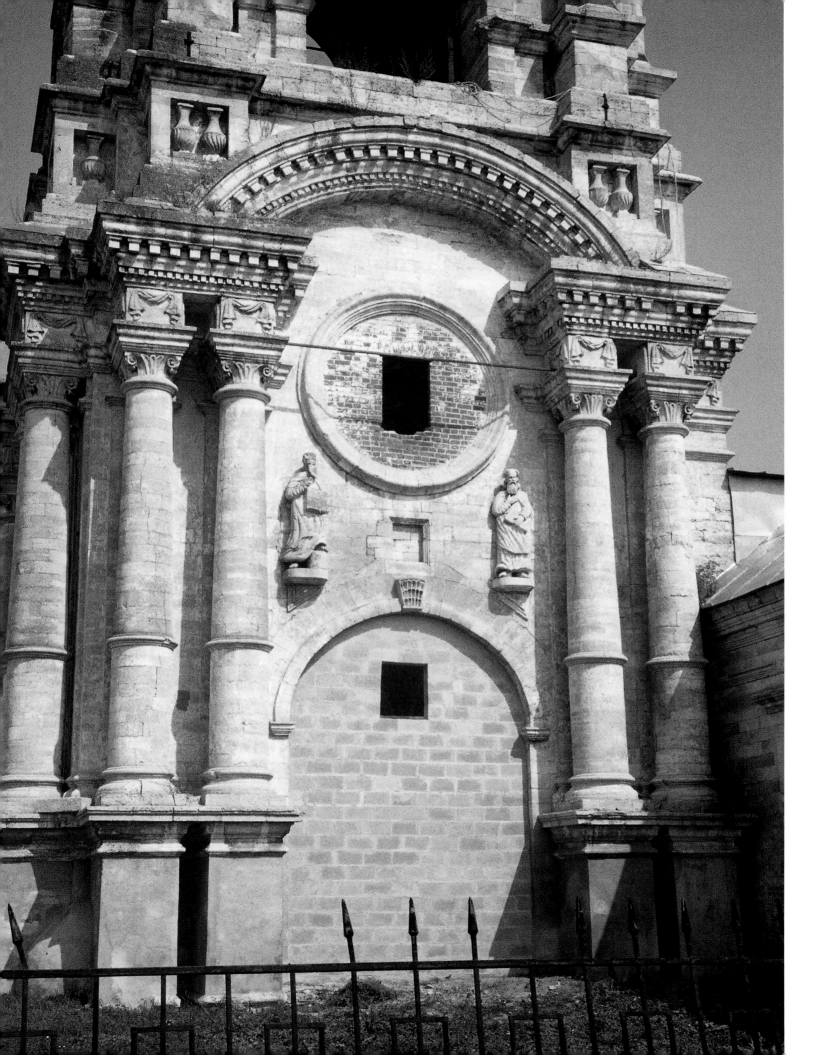

dominantly Neoclassical style of churches on country estates such as these often underwent extreme degrees of refinement. Churches were imitated from illustrations in foreign publications, especially French. Not infrequently, Classical forms were used in experimental ways, and sometimes a reverse process took place, in which the provinces saw the continuation of Baroque and even earlier traditions; the time-lag with the rest of the country could be several decades. As already seen, especially following the work of Bazhenov and Kazakov at Tsaritsyno and Peter Palace (Petrovskiy zamok) in the latter half of the reign of Catherine the Great, churches appeared on country estates that contemporaries called "Gothic". Alongside Gothic and Classical elements, the architects of these churches would also employ Early Russian motifs (pl. 301).

A major problem in the building of new churches, the relationship of the traditional spatial setting for Orthodox worship with the new Classical forms, found various solutions in the conditions of architectural diversity found on Russian country estates during the reign of Catherine the Great, just as Palladian ideas were adapted to suit a very different climate and way of life in the design of houses. Overall, the typical features of the Russian Enlightenment were particularly clearly reflected in the country estate.

301 The church on the Muromtsev estate, Voyeykovo, Ryazan' province, 1781–early 1800s.

8 Architecture and Politics in the Last Years of the Reign of Catherine the Great

Towards the end of the eighteenth century two imperial palaces were demolished just after they had been built. Each had been commissioned by Catherine the Great and taken ten years to complete. Had they survived, the two enormous buildings would undoubtedly have been the most magnificent of monuments to the reign of this empress. The two palaces were Tsaritsyno near Moscow and Pella on the bank of the Neva, the largest of the imperial residences situated near St Petersburg.

As has already been described, Catherine approved Bazhenov's designs for the palace ensemble at Tsaritsyno in 1775. Ten years later the ensemble was completed, and the famous episode of the empress's inspection visit took place. She found Bazhenov's palace highly displeasing, "returned to her carriages in a rage, and commanded [. . .] that [the new complex] should be razed to the ground."[146] The causes of Catherine's unexpected displeasure have been the subject of much scholarly debate, and the demolition has been linked to persecutions of masons that were going on in Moscow at the time.[147] It has been suggested that the empress discovered some evidence of a freemasons' plot against her at Tsaritsyno.

Bazhenov was dismissed from all imperial projects on which he was working and then forced into retirement. Every indication is that he had aroused the empress's suspicions. This alone, however, is unlikely to have caused Catherine's dislike of the ensemble at Tsaritsyno. In any event, her visit there took place before the consequences of Bazhenov's links with the masons were revealed.

Catherine may have understood the meaning of the masonic symbols incorporated by Bazhenov in some of his ornamentation at Tsaritsyno as insulting or even of potentially hostile magical effect. Masonic symbolism certainly influenced this ornamental work. The symbolic motif of interwoven compasses and vine in the arch of the Vine Gate (Vinogradnyye voroty; pl. 302) is typically masonic and may be interpreted as uniting the symbols of "the measurement of virtue" (the compasses being one of the principal masonic symbols) and "the source and symbol of true life" (going back in masonic ideology to Christ's words (St John 15:1): "I am the true vine, and my Father is the husbandman"). This union might then be taken to denote that for the attainment of perfection it is necessary to "measure the virtue" in oneself.

The present writer is not inclined to accept such precise interpretation of Bazhenov's ornamentation, which is preserved to this day at Tsaritsyno. It was evidently not received as reprehensible, or it would have been destroyed. Symbolism

302 The Vine Gate, Tsaritsyno, 1775–85 (Vasily Bazhenov).

one significant difference between the work of the two archi-
tects at Tsaritsyno. Bazhenov built two separate palaces, identi-
cal in form and importance – one for the empress and the
other for the heir to the throne. Kazakov built a single imper-
ial palace, with no doubt as to its owner (pl. 303). Bazhenov's
design, approved by Catherine ten years earlier, emphasized the
equal importance of the monarch and the heir to the throne.
In that ten-year period, however, Catherine's relations with her
son changed profoundly. After reaching his majority and mar-
rying, Grand Duke Paul began to present a danger to his moth-
er's security on the throne. Entering into direct relations with
him was cause both for the charges against the Moscow masons
and for the fall of Bazhenov, who had been an intermediary
between them and the heir to the throne. Catherine wished to
have only one imposing and magnificent palace at Tsaritsyno,
her own. Hence Kazakov's commission to build a new palace,
which was completed but abandoned after Catherine's death,
falling into the ruined state in which it may be seen today.
Outlying built features of the original estate, with their suspi-
cious esoteric symbols, have been preserved just as Bazhenov
built them.

The state that relations between Catherine the Great and
Grand Duke Paul reached was revealed at Tsaritsyno, and at
other imperial residences, in the 1780s. The question of succes-
sion was one of the major problems facing both the empress
and Russia as a whole. The political struggle between mother
and son did not take place, however, in the open; it was not in
the interests of either of them to reveal their plans. But the ten-
sion between them was inevitably to influence the ideology of
power. Avoiding direct conflict, Catherine the Great and the
heir to the throne performed a series of actions that had secret
significance hidden from the uninitiated but known to the
court.

The ideology of their residences was involved. In the "battle
of the palaces" each formulated and put into practice a pro-
gramme expressing ideas of sovereign power. The first move in
this battle was made by Catherine when she destroyed
Bazhenov's twin palaces at Tsaritsyno. The struggle continued
on the outskirts of St Petersburg.

There was a further casualty at Pavlovsk (pl. 304). The grand
duke dismissed Cameron, the architect appointed by his moth-
er to build a palace and park on the tract of land on the River
Slavyanka she had presented to him in 1777 after his twenty-
second birthday, in a flush of positive feeling towards him when
his wife Mariya Fyodorovna had given birth to a son (the
future Alexander I). Not only did Paul heartily dislike
Cameron because he was his mother's favourite architect, but
he might also have suspected that in his work at Pavlovsk
Cameron was carrying out orders given him by the empress.

scarcely comes into consideration in the ensemble's general
architectural forms. It might have been thought most likely to
be contentious in the garden pavilions which, however, have
survived unscathed. There seems no doubt that the empress's
anger was aroused by the central part of the complex, which
was "razed to the ground". Why?

It might be imagined that the Gothicism displayed by
Bazhenov at Tsaritsyno was at the bottom of it. But this could
not have been so, for Catherine approved the Gothic designs
of her next architect on the site, Matvey Kazakov. There is only

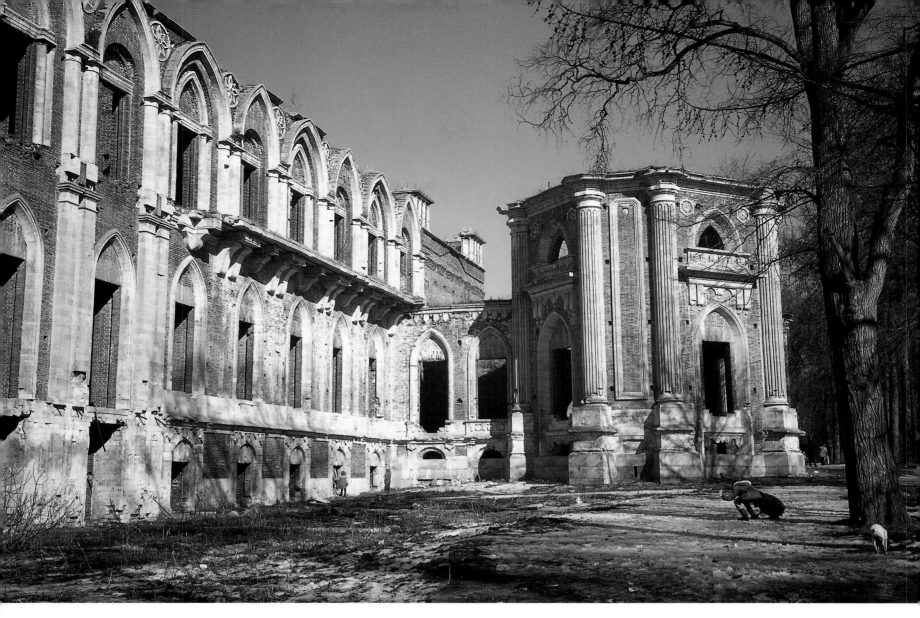

303 The Great Palace, Tsaritsyno (Matvey Kazakov), late eighteenth century.

Many essential aspects of an imperial residence were indeed totally absent from Cameron's design of Pavlovsk; there were no motifs of war or military victories, reminders of sovereign power, or glorification of the virtues of the owner of the palace as an Augustan personage. Cameron created a markedly private world for the grand duke. The palace could have belonged to anyone, to the most refined and demanding connoisseur of the arts, but not to the tsar of Russia in waiting. To the grand duke, totally excluded by his mother from affairs of state since the 1780s, all this could not appear as anything but a humiliating diminishment of his importance. He took no action, however, before his mother's destruction of the twin palaces at Tsaritsyno, which transcended the limits of his patience.

He decided to give another meaning to Pavlovsk. Having rid himself of his mother's chosen architect, he invited Vincenzo Brenna to take his place. Brenna promptly proceeded to over-turn his predecessor's efforts.[148] He had arrived in Russia early in 1784, but began his work at Pavlovsk only in 1786, shortly after the demolition of Bazhenov's palaces at Tsaritsyno. In the course of two periods of activity, he completely transformed the character of Pavlovsk Palace. The first of these periods, from 1786 to the early 1790s, is of interest for present purposes; during the second, Pavlovsk's owner was on the throne and had other concerns.

Brenna's first changes at Pavlovsk embraced not only the style but also the content of the palace's decorative schemes. He kept the central part of Cameron's composition, the round hall with columns around the perimeter and niches in the walls containing Ancient Roman sculpture, so maintaining the palace's aura of the Antique ideal, albeit a changed one. But the

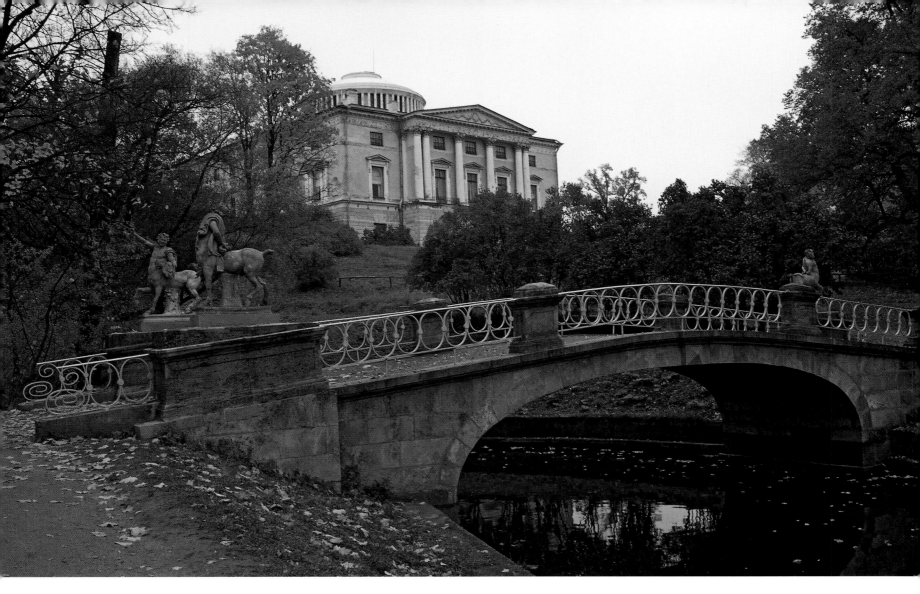

304 The palace, Pavlovsk (Charles Cameron), 1782–87.

sumptuous scale of his decorative schemes took on palpable overtones of an imperial palace.

Furthermore, motifs now appeared that had previously been missing at Pavlovsk. The first-floor vestibule commemorated Russian victories over the Turks,[149] and many rooms were ornamented with arms and armour. Of especial significance was a suite of front rooms overlooking the Slavyanka: in the middle was the Grecian Room (Grecheskiy zal), with the War and Peace Rooms (zal Voyny and zal Mira) on either side. These had been designed by Cameron as a suite of drawing rooms; their redesignation by Brenna speaks for itself. Their new themes lent them imperial significance. In the ceremonial of Ancient Rome, such rooms were used on special occasions of state, for appearances of the emperor when the fate of the nation was at stake. The new scheme, symbolic of the heir to the throne's impatience to succeed, could not have been further from Catherine's ideas. Brenna thus described the War

Room: "At eight corners are eight large depictions of military trophies and figures of slaves [. . .] represented sitting on cannon [. . .]. The lunettes are decorated with figures in national dress from all parts of the globe."[150]

This description indicates the *architecture parlante* of the ornamental scheme executed by Brenna at Pavlovsk to its owner's commission. Allegorical figures representing the countries of the world, trophies, captives and slaves are all features found in interiors made for a ruling monarch, and at Pavlovsk this iconography was the stronger because the grand duke did not participate in military action himself and so his personal virtues could not be commemorated.

The Grecian Room (pl. 305), one of Brenna's finest creations, affords further evidence of how Cameron's conception of Pavlovsk as a cultured gentleman's residence in the Age of Enlightenment was changed to focus on the theme of imperial power. Cameron's conception had been a simply decorated

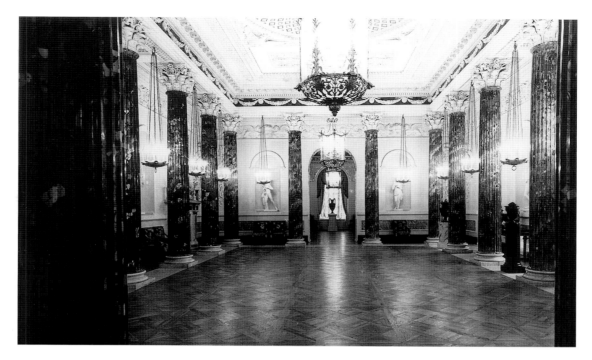

305 The Grecian Room, Pavlovsk (Vincenzo Brenna), 1786–97.

room concentrated around two large fireplaces. Brenna put in an all-round marble Corinthian colonnade with niches containing statues of Heracles, Hermes and other deities and heroes of Antiquity.

Brenna's early drawings executed in Italy include a reconstruction of the Aula Regia, a kind of throne room in the palace built by the Emperor Domitian on the Palatine Hill,[151] in which the style of the colonnade, the niches and even the choice of subjects of the statues closely resemble what is seen in the Grecian Room at Pavlovsk. The choice of this source for the ceremonial centre of the heir to the throne's palace reveals the latter's imperial self-image.

These allegories and symbols did not, of course, escape the notice of Catherine the Great, who was at this time preparing to give the coup de grâce to her son's hopes. Her eldest grandson, Grand Duke Alexander, was increasingly occupying her thoughts. She was considering how best to transfer the succession to him, bypassing his father, Grand Duke Paul.[152] The architecture of the palaces she built from the mid-1780s onwards clearly sounded the Alexander theme.

The symbolic significance of the name of the grandson to whom Catherine planned to pass the succession was well known at the time even abroad. It was not by chance that in the dedication of his celebrated work *L'Architecture considérée sous le rapport de l'art, des moeurs et de la législation* (written before the Revolution but published only in 1804) the great French Neoclassical architect Claude-Nicolas Ledoux, who had

gained much experience in such matters while working for Madame du Barry, called the grand duke "the new Alexander" and "Alexander of the North", identifying him with Alexander the Great.[153] It was just such greatness that the ageing grandmother desired for her favourite grandson, imagining his future as ruler of an empire similar in scale to that of Alexander the Great, linking the East with the West. She ordered pictures of scenes from the latter's life to be hung in his rooms in all the imperial palaces,[154] and gave him a sabre with a handle bearing a cameo of the Greek hero.[155]

The empress was well aware that to assure her grandson of such a brilliant future it was necessary that he should receive an appropriate education, a matter that she took out of his parents' hands and into her own. A result of this was one of the most astonishing ensembles created during her reign, the gardens and buildings known as the Alexander Dacha (Aleksandrova dacha), situated between Tsarskoye Selo and Pavlovsk, with adjoining lands also intended for the boy's education.[156] (In the eighteenth century the word *dacha* meant a gift of land, often extensive in area.)

Catherine wanted her grandson to become "a perfect man", above all in the moral sphere, and that he should practise virtue based on the dictates of reason. The Alexander Dacha had a literary source, a tale entitled "Tsarevich Chlor", written by the empress and published in St Petersburg in 1782, which may have been influenced by René-Louis de Girardin's attempt to create, in his estate at Ermenonville, a landscape that

could serve as an illustration for his friend Jean-Jacques Rousseau's novel *La nouvelle Héloïse*. In both cases the literary content of a landscape garden was intended to exercise a moral influence.

In the empress's tale, Tsarevich Chlor and his servant Reason meet a youth who replies to their remark: "We are looking for a rose with no thorns which does not prick" as follows: "I have heard tell of a rose with no thorns which does not prick from our teacher; the meaning of that rose is virtue [. . .]. You see that hill in front of you – that is where the rose with no thorns grows [. . .]."[157] Such a view was created in the grounds around the new palace. On a high, cone-shaped hill, visible amongst trees, stood a pavilion, in the middle of which, on a pedestal, was a pot in which grew a flowering rosebush.

> Chlor with his companion went at once towards the hill and found a narrow, stony path, along which they walked with difficulty. All at once they saw an old man and an old woman coming towards them [. . .]. They held out their crooks towards them, saying: "Rest on these [. . .]." People hereabouts said that the first was named Honesty, and the second Truth.[158]

At the top of the hill Chlor and Reason find the rose they have been seeking.

> As soon as they had plucked it from the bush, trumpets and kettledrums sounded from the church there, and word spread everywhere that at such a young age the Tsarevich had found the rose with no thorns which does not prick [. . .].[159]

The Alexander Dacha, which has not survived, was completed in 1789. It was possibly the work of Cameron or L'vov, although definite evidence of the participation of either is lacking. The account of the ensemble in a long descriptive poem devoted to it by Stepan Djunkovsky, published with accompanying engravings in Harcov in 1810,[160] closely resembles the descriptions of landscape and architecture in Catherine's tale. All the main features are there: the palace standing on a hill; the round Antique temple – the pavilion containing the "rosebush with no thorns" – on a cone-shaped hillock in perfect view from the palace; the straight and curved roads; the lakes and fruit-garden; the buildings and pavilions in various national styles, Western and Oriental; and the ideal peasant's farm with fields of rye and barley. Overall, and on a relatively modest scale, the composition corresponded closely to the type of landscape garden developed in Russia on the English model in the 1770s. The palace was of an unusual type, consisting of a Classical ground floor and a belvedere above it in the form of an Oriental tent with a gilded cupola.

In the general scheme of the ensemble, the "temple of the rosebush with no thorns" opened the way into an ideal world, represented by picturesque groves and pavilions in Antique style, a ten-columned rotunda on an island in the main lake providing a counterpart to the first temple. Between the Alexander Dacha and Tsarskoye Selo stretched the fields of a model school of agriculture, which could be seen from the upper floor of Cameron's Gallery two miles away. Nowhere else in Russia was the ideology of the Age of Reason more clearly expressed.

In 1784 Catherine decided to build her grandson's new palace outside St Petersburg, on the Neva some thirty kilometres upriver from the city. Its name had a very clear symbolic link with the Alexander theme: Pella, the name of the ancient Macedonian capital. It was to be the palace from which the new Alexander would rule. Its rationalist grandeur and emphatically Neoclassical style embodied Catherine's image of the future Alexandrine empire (pl. 306).

The structure of the palace complex, designed by Starov, was completed by 1789, but the decoration of its interiors dragged on up to Catherine's death in 1796.[161] Unfortunately, not only has Pella disappeared, but virtually all depictions of it have also vanished. Its general appearance may be judged from a drawing on a fan that is thought to have belonged to Catherine the Great.[162] However, this ensemble was undoubtedly one of the most important achievements of Russian Neoclassical architecture of the second half of the eighteenth century, comparable with Bazhenov's Kremlin Palace project, even surpassing the scale of Boullée's celebrated design for the rebuilding of Versailles palace.[163] It is undeservedly forgotten in the architectural historiography of European Neoclassicism, although Boullée's Versailles design is an accepted event in architectural history without having ever been built.

The composition of Pella was more complex than that of any other Russian palace ensemble of the second half of the eighteenth century known to us. One façade of the main building, which was constructed round a vast central hall, faced the Neva. Two identical square blocks, each with a circular hall at its centre, were connected to the main building by straight colonnaded galleries, which began at two small pavilions joining the corners of the main building. The whole complex consisted of the main block and twenty-four smaller blocks of varying dimensions. No less a role than the buildings in the whole composition was played by the endless-seeming double-colonnaded galleries and their central passageways. "[. . .] all my country palaces are hovels compared with Pella," wrote Catherine, "which rises like a phoenix."[164] This comment reveals the empress's secret intent. The palace built for the new Alexander is imaged as the mythical bird which dies

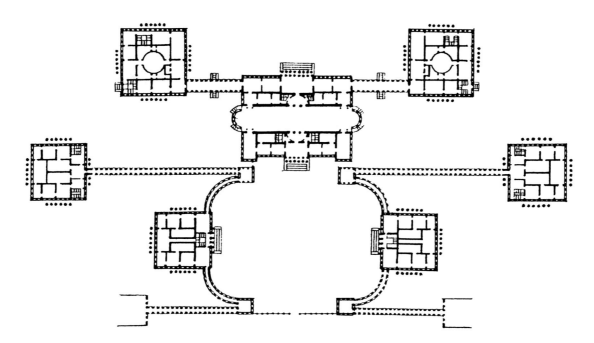

306 Plan of the imperial residence Pella, outside St Petersburg (Ivan Starov), 1786–96.

and comes to life again. Catherine the Great hoped that her appropriately educated grandson would continue to realize her plans, that her own spirit would be resurrected in Alexander's reign.

At about the same time, the empress made another striking observation: "Sitting in the gallery, I see Pella before me."[165]

Catherine would often sit with courtiers in the Cameron Gallery at Tsarskoye Selo looking at the park. Pella was actually too far away to be seen even through a telescope. The view was in the empress's mind, and the new palace was not what she meant. To "see Pella before me" was to think of Alexander's reign, which was what Pella meant for her. Among the build-

307 Alexander Palace, Tsarskoye Selo (Giacomo Quarenghi), 1792–96.

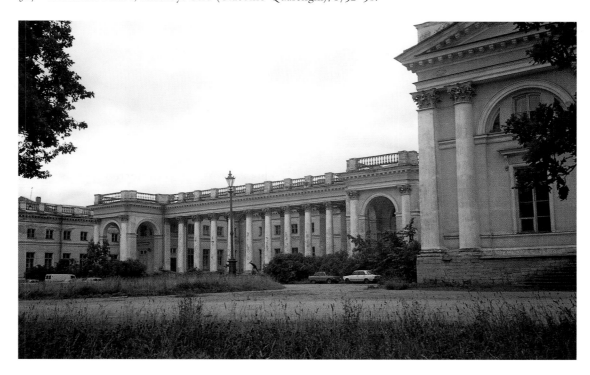

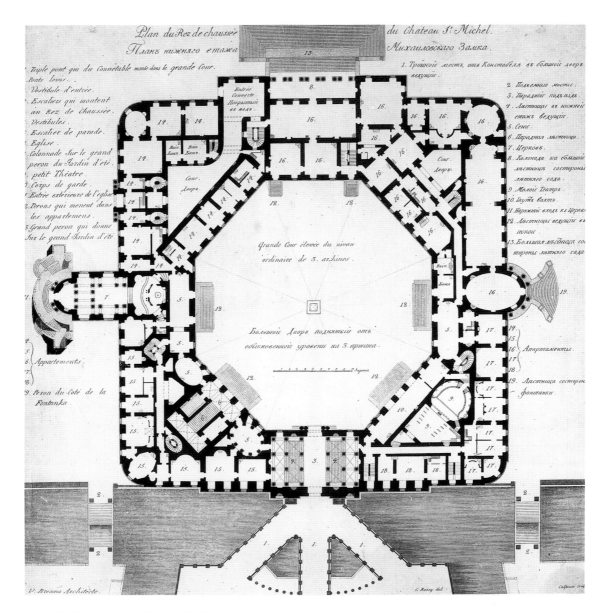

308 Karl Rossi, plan of St Michael's Castle, St Petersburg (Vincenzo Brenna), 1797–1800.

ings she raised in the 1790s for her eldest grandson was Quarenghi's Alexander Palace, sited next to the imperial residence at Tsarskoye Selo (pl. 307).

Grand Duke Paul, too, seems to have appreciated the significance of all these buildings only too well. As soon as his mother died and her grandson decided not to carry out his mother's will and keep his father from the throne, Emperor Paul I ordered Pella to be razed. This was done with the utmost thoroughness, leaving practically no traces of the palace's existence. The new emperor wanted to expunge all Catherine's projects from the national memory. While he was destroying the monument to his dead mother's dreams at Pella, he commissioned a fortified residence for himself in St Petersburg, St Michael's

Castle (Mikhaylovskiy zamok), designed by his favourite architect, Vincenzo Brenna (pl. 308), after Bazhenov's original design was discarded. The site was highly significant. The Archangel Michael was said to have appeared to Paul in a dream and told him to build a church on the site of his birthplace, the summer palace built by Rastrelli for Empress Elizabeth in 1741–45. This charming building, surrounded by gardens bordered by the Moyka and Fontanka rivers, was where his mother had been proclaimed empress, and Paul now demolished it to build not only a church but also his new castle. So ended the "battle of the palaces", and with it the architectural expression of the Enlightenment in Russia. St Michael's Castle as realized by Brenna has a strong Baroque flavour, most strikingly in its

richly ornamental main entrance, which is in pointed opposition to Catherinian Neoclassicism.

It was Neoclassicism, nevertheless, that continued its triumphant architectural progress in Russia. In the reign of Catherine the Great it was established as the national style throughout the vast territories of the Russian Empire. "Snow-white columns" became one of the symbols of imperial Russia – in architecture, poetry, painting and stage scenery. The present chapter has traced how in its formative years Russian Neoclassicism first drew on French mid-eighteenth-century ideas, then absorbed various interpretations of Palladianism, especially from England and Italy, and the ideas of an international circle of architects of the 1770s–80s trained in Rome and pursuing an archaeologically faithful recreation of Antiquity. The last decade of Catherine's reign saw a turning towards French models once again, this time the most recent examples of giganticism. The features of all these different European schools coalesced in Russian architecture. For all its grand sweep, however, Russian Neoclassicism was not an embodiment of "correct" architecture as measured in terms of closeness to Antiquity so much as a belief in the beneficial new life which Russian buildings of the Catherinian era demonstrated. It was this that gave Russian architecture of the period its special flavour – animated, sensitive and, while by and large stylistically more fluid than the architecture of much of Western Europe, still unquestionably European.

VI

The European Century

1 Neoclassicism, the Russian Style and Eclecticism

Of all periods of Russian architectural history, the nineteenth century may perhaps most appropriately be termed "the European century". The acceleration of the westernizing reforms that shaped Russia in the first hundred years of the new Empire related above all to the appearance of towns and country estates. In the Enlightenment period architecture in the widest sense, including town and garden planning, gave visible expression to the changes that took place. The author of the first account of the Russian garden, John Loudon, who visited Russia in 1812, wrote that, whereas a century earlier gardens had not existed there at all, more pineapples grew in hothouses around St Petersburg now than in the whole of Europe.[1]

The rapid succession of architectural styles in the course of the eighteenth century, the huge number of foreign architects, engineers and skilled craftsmen, the training of Russian architects abroad, the tastes of the imperial court and, following in its wake, the predominant demand among magnates and gentry for the latest Western European styles – all this led to a convergence of the architectural processes that were taking place in Russia and the West. As seen above, Russian architecture of the Enlightenment period was based on the norms of French mid-eighteenth-century Classicism, transformed in Russia under the influence of the Italian Palladianism of Giacomo Quarenghi as it was developed in the 1770s, and of the English Palladianism of Charles Cameron as it evolved into Neoclassicism in the manner of the Adam brothers. At the end of the reign of Catherine the Great, as was shown in the last chapter, the renewed interest of St Petersburg architects in French ideas led to attempts to realize the monumentality and magnitude of Etienne-Louis Boullée.

After the death of Catherine the Great in 1796, her son Paul I broke with half a century of architectural evolution.

His reign constitutes a special period in Russian art history, dominated by his repudiation of Catherine's artistic tastes and architectural initiatives. After his assassination in 1801, however, his son Alexander I's words spoken to the Guards – "In my reign everything will continue as it was in my grandmother's" – were to prove true in the architectural domain at least.

Nineteenth-century Russian Neoclassicism was grounded in French ideas, especially those entered for the Rome prizes of the Paris Academy of Architecture, informed with Neo-Palladian principles. During the first half of the nineteenth century, Western models continued to be adapted to Russian building and urban planning practice as under Catherine the Great. So great, in fact, was the stylistic momentum from Catherine's reign that Enlightenment ideas continued to evolve in St Petersburg architecture throughout the first third of the nineteenth century. And furthermore, what had been presented as utopian in French architects' plans of the 1780s was realized in Russia. Catherine the Great's dreams of a utopia in Neoclassical garb containing the entire living environment of European Russia became actuality, as a result of strict legislative control of architecture and urban planning, in the reigns of her grandsons Alexander I and Nicholas I. At the same time Russian architects sensitively followed the nuances of changing fashion in Paris, London, Edinburgh, Berlin and Munich.

Through the first half of the nineteenth century it was Neoclassicism that gave buildings and urban plans forms expressive of state power in the imperial Russia of Alexander I and Nicholas I. Never since the days of Ancient Rome had a single architectural style been so systematically used to express the idea of an established imperial order. It is natural, therefore, that Neoclassicism became an important part of the popular image of the Russian Empire, and is associated closely with it, in Russian eyes, even today. Social factors in this use of Neoclassicism explain its national distinctiveness in Russia and its

309 (*facing page*) Detail of the central tower of the Admiralty, St Petersburg (Andreyan Zakharov), 1806–23.

relationship with similar architectural developments in other European countries.

The official status of Neoclassicism had long life and special importance in nineteenth-century Russian architecture. As a result, no doubt, styles associated with the Renaissance, the Middle Ages and the Far East had less currency in St Petersburg and Moscow than in many other European capitals. In park architecture of the Romantic period, however, as in most Western countries, a variety of styles may be seen in Russia, where Picturesque parks and their pavilions became widespread after the conclusion of the Napoleonic Wars, sowing the seeds of Gothic Revival in the English style and nineteenth-century Orientalism. Here too the first attempts were made to imitate Russian wooden architecture, and Gothic Revival experiments adopted motifs from Early Russian architecture. Architects of the first half of the nineteenth century proceeded from Romantic restoration – not so much restoration of what had been lost as stylistic imitation – to a search for national originality in architecture, and in this there was a historic logic similar to developments in English and French architecture of the time.

However, whereas in these countries, at the beginning of the nineteenth century, the increasingly strong attraction to medieval architecture was felt as the basis for a new style which could replace the Classical ideal, in Russia the borrowing from architecture of an earlier period had a different significance. In the West, Gothic was admired for its universality, its organic character, its naturalness, qualities felt to be lacking in contemporary art. In Russia the use of the medieval heritage was in the first place a means of expressing the political and religious originality of the Russian state. Revival of local traditions was typical of Medieval Revival architectural styles everywhere in Europe in the nineteenth century, but in Russia it took on a markedly ideological colouring. Count Uvarov's formula of the era of Nicholas I, "autocracy, Orthodoxy, nationality", describing the basis of the Russian polity, was apt to its architecture too, in which the conception of imperial Neoclassicism as a "civilizing" style controlled by the sovereign was combined with the rediscovery of national roots and continuity in the life of the Russian tsardom.

Numerous stylistic movements closely linked with various Western trends coexisted with Neoclassicism and the "Russian style" throughout the nineteenth century. It would be hard to find any variety of any of the main historic styles in any European country that was not taken up in Russia, from English Picturesque cottages to Loire châteaux, from German Renaissance Revival impulses to Manueline decorative motifs picked up at the end of the nineteenth century by a wealthy Russian traveller in Portugal for his house in Moscow.

The nineteenth century stands out from all previous periods of Russian architectural history by virtue of the enormous quantity and variety of contacts between Russian architects and the West. The amount of information about foreign technology and architectural detail possessed by the Russian building industry grew steadily throughout the century. The virtually complete availability to architects working in Russia of the entire international corpus of professional information that existed at the time is clear from surviving records of the libraries of the Spanish engineer Augustin de Béthencourt who worked in St Petersburg and Moscow, the French architect Auguste Ricard de Montferrand, builder of St Isaac's Cathedral in St Petersburg, and the famous Russian architect Vasily Stasov, or from the holdings of nineteenth-century books and periodicals, still extant, of the former Puteysky Institute or the Imperial Academy of Arts in St Petersburg. The comprehensive scope of these sources of information through the second half of the nineteenth century and first years of the twentieth was unprecedented in Russia. Complicated summaries of architectural developments in other European countries were no longer necessary; gone were the days when news of innovations in the West would reach Russian architects by roundabout routes, often in very imprecise or even imaginary form.

An important contributing factor in this situation was a system of professional education focused on the world architectural heritage and also the latest European achievements. The best graduates received state funding to complete their studies abroad. What was required was a broad familiarization with the architectural culture of several countries rather than mastery of a single national tradition. At the same time, far-reaching changes took place in the period in the tastes and knowledge of architectural clients. The nineteenth was the first and so far only century that saw Russian citizens travelling abroad in large numbers, and its end ushered in the beginning of an era of regular foreign trips for the prosperous sector of the population, that is, those who could afford to commission buildings for their own use.

The emergence of these new clients was possibly the most significant development of the nineteenth century in Russian architecture. By 1900, the role of the private client was as important as that of the tsar, and during the period up to the outbreak of the First World War even surpassed it, with private clients playing a leading part in the creation of links between Russian architects and the rest of the world. These links, direct, personal and all-embracing, seemed to indicate that "the European Century" had arrived in Russia for ever – until the October Revolution cut the country off from the rest of the world as comprehensively as the Mongol invasion had seven centuries earlier.

It will not be worth rehearsing the general developments that characterized the nineteenth century in all countries – the growth of cities, the spread of rail, technological improvement, the emergence of new building materials, rising standards of living. A different task lies ahead: establishment of the definitive features of Russian architecture of the nineteenth century and comparison with contemporary architecture in Western countries.

2 Vincenzo Brenna and the Architectural Fate of Paul I

Despite the brevity of his reign (1796–1801), Paul I played an important part in Russian architectural history. His reign saw in the new century. With his eccentric character, strange and dramatic behaviour and inclination to flights of fancy, he was one of the most striking figures of the Russian Romantic era. He was shaped by his unhappy life – the assassination of his father, his mother's hatred of him, long years of enforced idleness impatiently awaiting his accession to the throne. His changing architectural tastes were in full accord with the transition from the Enlightenment to Romanticism. For him, the Romantic period began twenty years before the beginning of the nineteenth century.

In May 1782 Grand Duke Paul and his wife, Maria Fodonovna travelled to Europe under the names of the Comte and Comtesse du Nord. They attended a royal ball at Versailles, and were invited to Chantilly by Louis Joseph de Bourbon, 8th Prince de Condé and to the residence of the tax farmer Lorraine Grimaud de la Renière. Their host assembled a number of artists and decorative craftsmen at a reception and introduced them to the Russian heir to the throne.[2] The famous architectural draughtsman Charles-Louis Clérisseau, whose work was greatly admired by Catherine the Great, was among those invited to this gathering where he was introduced to the grand duke. "I'm well known in your country," said Clérisseau suddenly to the grand duke, "but you've never paid any attention to me here in Paris." "I very much regret that," replied Paul. "You did not receive me because you had no desire to do so," the Frenchman continued, "which was very wrong of you. I shall write [. . .] to Her Imperial Majesty, your Mother." "Please forgive me," said the grand duke calmly; "yes, do write to Her Imperial Majesty, my Mother, and tell her how you delayed me before dinner."[3] This conversation was to have its effect on Russian architectural history.

It testified not only to Paul's determination to have nothing to do with any of his mother's favourite architects, but also to his repudiation of Enlightenment Classicism, among the principal representatives of which was Clérisseau. Both as grand duke and emperor he disliked exact reproduction of models from Antiquity and what he saw as the inadequate emotional content of architecture expressive of edifying Enlightenment ideas. Living under the constant and aggressive surveillance of his mother's courtiers, the grand duke longed for freedom, including the freedom to build as he pleased. As tsar he made even greater efforts to ensure that his buildings spoke in a different language from that of Catherine's architects.

After the death of her first favourite, Count Grigory Orlov, Catherine the Great bought the estate of Gatchina from his heirs and gave it to her twenty-nine-year-old son, who adopted Rinaldi's palace with a fierce passion. The image of a fortress brooding amongst earthworks and picturesque gardens became his dominant architectural idea. It was not fortuitous that of all the impressions from his European travels, in Austria, Italy, France and Germany, it was Chantilly that made the strongest impact on him; the picturesque palace and surrounding park stuck in his mind, replacing the strict formality of André Le Nôtre's approach to garden design with the English concept of imitation of natural landscape.

While still heir to the throne, Paul conceived the idea that the Empire should be fundamentally restructured on much stricter lines than the Catherinian. It was at Gatchina that he set about this.[4] "The Grand Duke", a German traveller noted,

> who is very clever and can be charming [. . .] has some unaccountable oddities, including the absurd habit of having everything around him in the Prussian style. On his estates he has barriers painted red, black and white after the Prussian manner, with sentries on guard [. . .]. Worst of all is that he has Russian soldiers disfigured in the antediluvian uniforms of the time of Frederick-William I [. . .].[5]

Count Fyodor Rostopchin, famous for his part in the burning of Moscow in 1812, wrote: "It is impossible to see anything the Grand Duke does without a shudder of regret [. . .]. During the Wednesday military manoeuvres at Gatchina [. . .] the slightest inconsistencies drive him mad [. . .]."[6] After the death of Catherine the Great, this frenetic atmosphere was transferred to St Petersburg, and the customs of Gatchina spread throughout Russia. Enlightenment naturalness and freedom were supplanted by a mechanistic rationalism allied with the most obsessive Romantic emotionalism.

The relationship of Paul I's favourite architect, Vincenzo Brenna,[7] with Neoclassicism has been insufficiently examined. Born in 1747, he arrived in Rome somewhat earlier than his contemporaries Cameron and Quarenghi, and there, studying with Stefano Pozzi, a master of perspective drawing, came upon the last remnants of Baroque influence, which were soon stamped out by the international circle of European Neo-

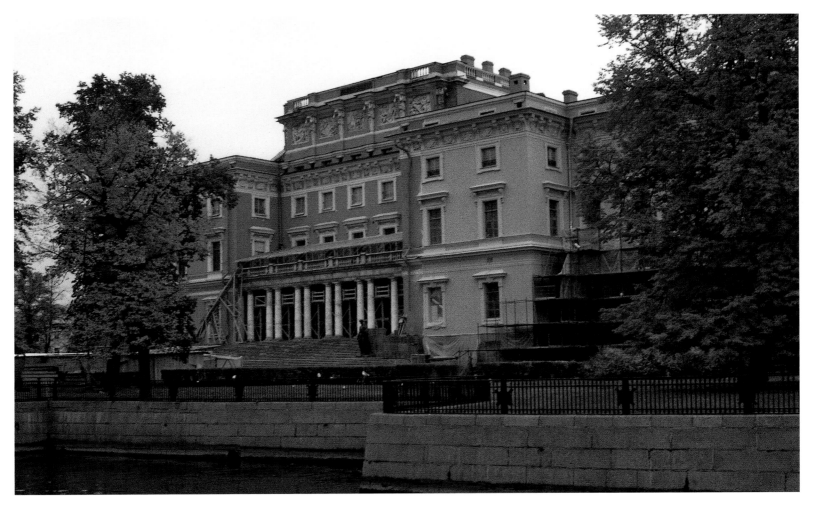

310 North façade of St Michael's Castle, St Petersburg (Vincenzo Brenna), 1797–1800.

classical architects. He continued Cameron's studies of ancient Roman baths, arriving at a more theatricalized conception of Antiquity than the Scot. No partisan of the strict Antique ideal like Cameron, he was able to combine the solemn image of imperial Rome with heightened pre-Romantic emotionalism. He is hardly to be called an Enlightenment architect. Time almost seems sublimated in his work in Russia because of the impact of an imperial patron who wanted a complete break with the Catherinian period. Brenna made the shift from early Baroque-clothed Enlightenment Neoclassicism to another form of the style containing early Romantic impulses. If Paul was the first emperor of the Romantic era, Brenna was the precursor of Romantic Neoclassicism; this explains the long-standing closeness between them, unusual for the irascible monarch.

The architectural tastes of each are clearly revealed in the building of St Michael's Castle (Mikhaylovskiy zamok) in St Petersburg (pls 310, 311), the first plans for which go back to 1784.[8] Building began no less than thirteen times; the interior designer Henri-François-Gabrièle Viollet, invited by the grand duke from France, and Vasily Bazhenov worked on the earlier projects, and Brenna and Carlo Rossi on the one that was completed. The earliest structures were reminiscent of the château at Chantilly, already discussed. A series of projects was the work of a single architect of unknown identity, probably an Italian; all these were pentagonal in plan and closely imitative of Cardinal Alessandro Farnese's fortified villa built by Vignola in Caprarola. These close imitations led by degrees to a structure stylistically similar to Bazhenov's Kremlin Palace, and on Paul's accession to the throne this architect, as a figure who had suffered the disfavour of Catherine the Great, was summoned to the capital and made vice-president of the Academy of Arts. Brenna, however, was given the task of adapting his plans for the castle. On 26 February 1797 Emperor Paul, with a silver spade, laid the foundation stones of jasper brick. The building was substantially completed in 1800 on the feast day of the

311 Detail of the attic storey of the north façade of St Michael's Castle, St Petersburg (Vincenzo Brenna), 1797–1800.

Archangel Michael. Its owner had fourteen months and three days left of his reign to run.

From a distance the exterior of Saint Michael's Castle makes the impression of a dark, monolithic mass. Its approach is by a straight avenue flanked by long, low stable buildings and two large octagonal pavilions giving onto a square containing an equestrian statue of Peter the Great modelled on that by Fracesco Bartolomeo Rastrelli, with the inscription: "To Great Grand-father – from his Great Grandson", in marked and equally symbolic contrast with that on Falconet's statue: "To Peter the First from Catherine the Second". Paul's emphasis, unlike his mother's, is on his blood tie with the founder of the Empire.

The composition of the castle's main façade is oriented towards the centre, where between majestic obelisks, beneath a heavy pediment set into a stepped attic storey, is the single entrance to the octagonal courtyard. The ground floor is a monumental socle storey, with the arch above the entrance covered with brilliantly carved rustication. The upper two storeys are linked by an Ionic porphyry colonnade. The corners of the main façade are deeply recessed and curved, leading the eye on to the central towers of the flanking façades. St Michael's Castle is in no sense a Neoclassical building, but a rare example of an imperial palace genuinely redolent of the Romantic era.

Emperor Paul was assassinated in St Michael's Castle on 1 March 1801 just when he had begun to change the face of St Petersburg. In 1800 a competition was announced for the design of the largest church in the capital – the cathedral of Our Lady of Kazan', or Kazan' cathedral (Kazanskiy sobor) on Nevsky Prospekt. The emperor wished it to include features of St Peter's in Rome, especially the colonnades which had made such an impression on him. He rejected a Palladian design for the Stock Exchange Building (Birzha) on the best-known spot in St Petersburg, the Strelka (Spit) on Vasil'yevsky Island where the Neva divides; it was redesigned by Quarenghi, who was in

turn replaced by Jean-François Thomas de Thomon. The completion of these projects, however, belongs to the next reign, that of Paul I's son Alexander I.

3 The "Rome Prize" Style in St Petersburg in the Reign of Alexander I

The reigns of Catherine the Great's grandsons Alexander I and his seven-year-younger brother Nicholas I occupied the entire first half of the nineteenth century, five of the nine decades in which Neoclassicism was predominant. The first third of the century saw a continuation of the flowering of the style originated by Catherine and the international circle of court architects she created around 1780. A witness from the early Alexandrine period, Filipp Vigel', writes:

> In this beautiful young man Catherine has risen from the grave. The child of her heart, her favourite grandson, has issued a manifesto which brings her days back to us. But no, even in her reign we did not experience that feeling of well-being in which the whole of Russia was enveloped in the first six months of Alexander's reign. The country was ruled by love, and freedom and order were reborn [. . .]. Everyone became more gracious, walked with a bolder step, breathed more freely.[9]

The beginning of the reign of Alexander I was indeed an unprecedentedly liberal moment in the nation's history. The young emperor set out to continue the reforms of Catherine the Great. Under Secretary of State Mikhail Speransky a historic codification of law was being prepared. State finances improved, trade and contact with Western Europe increased.

Russia became actively involved in Europe, joining most of the coalitions against revolutionary France. After Napoleon's crushing defeat of the Russian and Austrian armies at Austerlitz and then of Prussian forces at Jena and Auerstädt, peace was concluded between Russia and France at the small town of Tilsit on the Russian border. From a cultural point of view, war or peace with France made little difference. In the first years of the new century French Neoclassicism dominated architecture in St Petersburg and Moscow.

Soon after his accession to the throne, Alexander recalled Charles Cameron, dismissed by Paul I, making him chief architect of the Admiralty.[10] At a time when the entire enormous complex of naval installations in St Petersburg was in need of rebuilding, this was the most important architectural post in the country. However, Catherine the Great's favourite architect was unable to adapt to either the administrative or the artistic priorities of the new era. His failure may have been connected with the unpopularity of French influence in the 1800s. He

was replaced by a pupil of Jean-François-Thérèse Chalgrin, Andreyan Zakharov, who was well acquainted with the style of entries for the Rome prizes of the Paris Academy of Architecture.

When many of these designs were published at the beginning of the nineteenth century,[11] their influence became more marked. The style of the Rome Prize entries of the last quarter of the eighteenth century may be called the first of the Neoclassical trends prevalent in St Petersburg during the reign of Alexander I: the grandeur which seemed to look towards the future, the clear geometrical lines, the abundance of colonnades fitted the architectural scale of Russia's capital. The architectural evolution of the Enlightenment era, interrupted by the French Revolution, continued in Alexandrine St Petersburg, and French architects' ideas that under the ancien régime had existed only on paper found realization at last.

In the words of Vigel':

> When the Persian ambassador [. . .] was asked whether he liked St Petersburg, he said, once built, this city would be especially miraculous [. . .] at the beginning of Emperor Alexander I's reign [. . .] with the construction at one and the same time of the Horse Guards' Riding School, magnificent guards barracks all over the city, the huge column-clad Exchange with its quay and embankments around it, the rapidly rising Kazan' cathedral with its grove of colonnades, already clearly imitating St Peter's in Rome, and three- and four-storey dwelling-houses springing up on every street not merely by the day but by the hour [. . .]. The four most famous architects of the time were Zakharov, Voronikhin, the Italian Quarenghi and the Frenchman Thomon.[12]

When Jean-François Thomas de Thomon went to Russia in 1799, he was already a mature master in his forties.[13] He had been a pupil of Julien-David Le Roy, famous for his knowledge of ancient Greek architecture,[14] and was primarily a draughtsman, executing a magnificent series of views of ancient Roman architectural monuments and landscapes in the course of his long stay in Rome. His tastes were formed by his numerous entries in Paris architectural competitions during the 1780s. He was well known as an "ardent royalist and fervent Catholic", and for his connection with the Comte d'Artois, the future King Charles X.[15] His political sympathies may well have been the cause of his leaving his homeland and his motivation for seeking to realize the architectural dreams of the last years of the ancien régime.

His Exchange (Birzha; now the Naval Museum – Voenno-Morskoy muzey) on the Spit (Strelka) on Vasil'yevsky Island, a straight imitation of a winning entry in one of the Paris competitions,[16] has come to be celebrated as a leading architect-

312 View of the Exchange and the base of a rostral column, St Petersburg (Jean-François Thomas de Thomon), 1804–10.

ural example of Neoclassical St Petersburg (pl. 312). Thomon mounted an elaborate display to mark the commencement of building, constructing an amphitheatre where invitees gathered to view a theatrical representation of the completed Exchange building, with an eagle soaring above it holding in its talons a cornucopia and the flag of the Russian merchant marine. Building began promptly and was completed in 1810, though the ceremonial opening did not take place until after the defeat of Napoleon.

The Exchange is a massive temple-like building rising above the Neva on a granite socle; it is surrounded by a Doric colonnade, with fourteen columns on each of the longer sides and ten on the shorter – the columns of Paestum. Thomon was following his teacher Le Roy in imitating ancient Greek temples. The colonnades are crowned with a restrained Doric frieze. At a moment in Russian cultural history that was poised between the cult of the ideal Graeco-Roman world and concrete archaeological studies, Thomon found in Ancient Greece the primary sources of beauty, the defining features of Classical architecture at their point of historical origin. Behind the "Greek" colonnading of the Exchange there is an ancient Roman presence: ornamental arches on the façades, doorways of distinctly Roman style. The huge hall of the Exchange has a vaulted ceiling similar to those of Roman baths. In front of the Exchange a semi-circular granite terrace juts out into the Neva, with two gigantic rostral columns flanking the Exchange building, each ornamented with protruding cast-iron triangular bowls ("rostral" means literally "decorated with beaks") and with a statue at its granite pedestal. On ceremonial occasions a dramatic effect was created when hemp oil was lit in the bowls; this is graphically shown in Thomon's drawings.[17] These rostral columns recall the Roman columns of the third century BC ornamented with prows of captured ships.

In the first years of the nineteenth century Giacomo Quarenghi did not abandon his Palladianism. In his most important St Petersburg building of the period, however, the Horse

Guards' Riding School (Konnogvardeyskiy manezh) on Senate Square, he was scrupulous in taking account of changed tastes (pl. 313). Here the interrelationship between an all-round monumental order and prominent Classical sculpture is as active as in Thomon's work, although Quarenghi does not share the latter's predilection for the architecture of ancient Greece.[18]

Andrey Voronikhin, most outstanding of the generation of Russian architects of the beginning of the reign of Alexander I, was acquainted with French architecture at first hand.[19] It is probable that he was a natural son of one of the wealthiest of Russian aristocrats, Count Stroganov. He was educated together with the latter's legal heir and spent a lengthy period with him in Paris. The two were brought back to Russia in 1790 in order to protect them from Revolutionary ideas. Like de Thomon, Voronikhin was stylistically formed in the tradition of late eighteenth-century Rome Prize designs. In any case, this was the spirit in which he began to design Kazan' cathedral, combining imitation of the colonnades of St Peter's in Rome with the application of French Neoclassical ideals of church-building in their various manifestations from Laugier to Soufflot (such as the Panthéon). Thereafter his style changed and like de Thomon he sought out models from Ancient Greece. This can be seen in the heavy Doric portico of the Alpine Institute of Mining [Gornyy Institut] building (pl. 314) and in the caryatids in the "Lantern" Study (Kabinet "Fonarik") at Pavlovsk (pl. 315).

Graduating from the St Petersburg Academy of Arts with a gold medal, Andreyan Zakharov completed his studies in Paris under Chalgrin.[20] He did not, however, follow his teacher's style at all closely, his most famous building, the Admiralty, being closer to the work of Boullée, though his use of the Orders is more traditional and his sculpture more decorative than that architect's (pl. 316).

The poet Osip Mandel'shtam has the Admiralty building "shining from the distance like a frigate or an acropolis, brother to water and sky".[21] The brilliant image captures the essence of this gigantic building, the central naval structure of St Petersburg, commanding the estuary of the Neva and representing the heart of the whole city. It is indeed like an acropolis, hovering over the city and spreading the mantle of Classicism over it. Such associations would seem to have come naturally to Andreyan Zakharov. In 1806 he was appointed chief architect for all naval building in St Petersburg, and the

313 (*top*) The Horse Guards' Riding School, St Petersburg (Giacomo Quarenghi), 1804–07.

314 (*left*) The main colonnade, Alpine Institute, St Petersburg (Andrey Voronikhin), 1806–08.

315 The "Lantern" Study, Pavlovsk Palace (Andrey Voronikhin), 1803–07.

romantic image of the naval capital has grown from the numerous structures belonging to the Admiralty that he raised all over the city. That from both a stylistic and a planning point of view its creator indeed thought of the Admiralty as St Petersburg's "naval acropolis" is attested by the composition of the building and by the themes of its sculptural ornamentation (pl. 309).

The Admiralty, first established by Peter the Great as a fortified shipyard, had by the Baroque era become the focal point of the main part of the city, situated on the left bank of the Neva. The famous trident of the city layout was oriented on the Admiralty tower and gilded spire, which of course Zakharov could not move. He had to preserve the general shape of the building, which had to contain, on the three landward sides, the huge dock and shipbuilding area which was then open to the Neva. Unlike Quarenghi and Cameron before him, Zakharov refused to contemplate half-measures. He managed to persuade Alexander I to allot funds to a wholesale reconstruction of the Admiralty building. On 23 May 1806

his plans were approved, and he proceeded with the construction of a new building whose main façade was 407 metres in length, majestically extending nearly 200 metres on each side of the central tower and spire. At each end of the façade is a gigantic forward break, reminiscent in scale and form of the large city houses of the eighteenth-century Neoclassical period. Completed in 1823 after Zakharov's death, this building is perhaps the largest realized project in Russia that reflects the influence of the "megalomania" of Ledoux and Boullée.

The central tower and spire belong to St Petersburg tradition, though its lower part is reminiscent of Chalgrin's Arc de Triomphe (pl. 317). This structure contains the main entrance to the Admiralty building, with the mass of the square-plan triumphal arch typically being above the doorway. Zakharov enhances the effect of his architectural forms with allegorical sculpture. Above the arch are soaring winged genii of glory, and on either side, on granite pedestals, nymphs bearing heavenly and earthly globes, all the work of Fyodor Shchedrin. Running the entire length of the attic storey is a bas-relief by Ivan

317 Upper colonnade of the central tower of the Admiralty, St Petersburg (Andreyan Zakharov), 1806–23.

Terebenev depicting "the creation of the Russian fleet", with Neptune giving his trident to Peter the Great amid tritons and nymphs building ships for the emperor. At the corners of the attic storey are the sitting figures of Achilles, Ajax, Alexander the Great and King Pirus. Petrine mythology is combined here with the glorification of heroes of Antiquity, who pointedly include Catherine the Great's intended role model for her eldest grandson.

Above the triumphal arch Zakharov places an Ionic temple with eight columns on each side and twenty-two statues round its roof representing the seasons and the elements, which include Isis, ancient Egyptian goddess of water and wind, and Urania, muse of astronomy and guide to helmsmen. The appearance of Isis in this scheme is unsurprising. When the subject-matter of the sculpture was planned, the cultural results of Napoleon's Egyptian expedition had reached Russia and Egyptian motifs were beginning to enter Russian art and architecture.

Up to his death in 1811, Zakharov continued to realize ideas that were typical of entries for the Rome Prize during the last quarter of the eighteenth century. After the peace of Tilsit in 1807, however, as a result of the reopening of communications and the appearance of new publications, a new architectural fashion took firm hold in St Petersburg and Moscow after long-drawn-out beginnings, having originated in Paris at the time of Napoleon I's coronation in 1804 – the Empire style, seen primarily in decoration and interior design. With a keen eye, Vigel' noted its advent in St Petersburg:

> Somehow or other, a style of dress commemorated only in sculpture from the shores of the Aegean Sea or the banks of the Tiber was revived on the Seine and brought to the Neva. At balls, if it weren't for the uniforms and tail-coats, one might imagine one was looking at Antique bas-reliefs [. . .]. And indeed, it wasn't bad to look at: young women and girls looked so pure, simple and fresh [. . .]. Everywhere one saw alabaster urns carved with mythological figures, incense-burners and little three-legged tables [. . .] long divans where the hand leant on a carved eagle, griffon or sphinx. Gilded, painted or lacquered wood [. . .] was forgotten [. . .]. Mahogany came into general use, adorned with gilt-bronze mounts [. . .] Medusa heads, lions' heads, even rams' heads [. . .][22]

The Empire style long outlived Napoleon I's reign, continuing in Russia up to the 1840s. In the course of time it assumed a grander scale in St Petersburg, while keeping to a domestic decorative level in Moscow and taking on a comfortable and sometimes even light-hearted note in the provinces. From the point of view of international contacts, the evolution of the Empire style in Russia was paradoxical. French architects had

316 *(facing page)* The Admiralty, St Petersburg (Andreyan Zakharov), 1806–23.

practically no role in introducing it. In St Petersburg the leading part was played by Karl Ivanovich Rossi, of Italian extraction but born in Russia, the Russian Vasily Stasov, the Scotsmen William Hastie[23] and Adam Menelaws,[24] and the Swiss Luigi Rusca from Ticino.[25] In Moscow, émigrés from the same Swiss canton, the numerous members of the Gilardi and Adamini families, and Iosif Bove, son of a Neapolitan artist, laid down the architectural style of the reign of Alexander I.

During this period an important role was played not only by architects connected with different European countries but also by Russians who had studied at the St Petersburg Academy of Arts or the Kremlin Architectural School in Moscow.[26] Russian publications on architecture were rare, and teaching at both these schools was done from French-language books. Obligatory French at most educational institutions directed the attention of the young to books in that language. The language of the practitioners of French Neoclassicism in the late eighteenth and early nineteenth centuries was thus the language of architectural education in Russia,[27] and this had a crucial influence on Petersburg-trained architects such as Ivan Ivanov,[28] Andrey Mikhaylov[29] and Avraam Mel'nikov,[30] Moscow architects such as Rodion Kazakov[31] and Ivan Yegotov,[32] and many others who spread the style throughout the country.

4 Moscow after the Fire of 1812:
Iosif Bove and Domenico Gilardi

The chief role in the formation of the Empire style in Russia was played by Moscow, arising from the necessity of a total reconstruction of the city after the fire of 1812. Out of 9,000 buildings standing in Moscow on the eve of Napoleon's invasion, 6,500 were destroyed during the occupation. Over a period of five years from spring 1813, more than 6,000 new buildings were constructed. A further 2,500 houses were repaired with new exteriors. In the course of the rebuilding of Moscow the Empire style underwent substantial change, diverging both from its original French models and from the forms it had taken in St Petersburg. The main reason for this was that much of Moscow's rebuilding used the plans and often the actual foundations and walls of previous buildings. Moscow Empire was closely bound up with the city's architectural evolution through the second half of the eighteenth century. Another factor was that most buildings in Moscow were private houses. There were far fewer state buildings in Moscow than in St Petersburg, the administrative centre of the empire. Consequently, Moscow Empire focused on decorative interiors of often intimate scale. Not the least part in the formation of Moscow Empire was played by the traditional Muscovite love

of abundant decoration. Interior decoration was carried out by specialist firms which catered for all tastes.

Small private houses in the new style were built in quantity, mostly single-storey with an attic floor or two-storey, some in brick, but most of wood and plaster. Almost all of them had porticos, Order-based ornamentation, ground-floor rustication and arched niches. Antique-style reliefs were common; they featured military armature, griffons, wreaths and the like, which gave these modest-scale houses a triumphal aura in the aftermath of the Napoleonic Wars.[33] Few of them have survived; some wooden houses on Taneyev and Burdenko Streets are among those that have (pl. 318). The large number of new and restored houses in Moscow in Empire decorative style ensured the aesthetic consistency of the city's image, and overall stylistic unity was also the aim of architects of major state and public buildings, the houses of the wealthy and churches raised between 1813 and 1830, masters like Iosif Bove,[34] Domenico Gilardi[35] and Afanasy Grigor'yev.[36]

In 1814 Bove received an official appointment that enabled him to exercise a defining influence on the architecture of Moscow; director of façades for the Moscow Commission for Buildings, with responsibility for ensuring that the façades of all new structures were built in uniform style. His method was most strikingly demonstrated in the rebuilding of Red Square (Krasnaya ploshchad') and the creation of Theatre Square (Teatral'naya ploshchad'). At the end of the eighteenth century Red Square was strictly rectangular in plan in the style of the royal squares of French cities. On all four sides trading rows with open arcades cut off the area from the architectural monuments of the city centre. Bove restored Red Square to its own history by resiting the trading rows opposite the Kremlin walls. The Red Square area thus came to include some of the symbolic monuments of national history – St Basil's Cathedral, the walls and towers of the Kremlin. Bove's noble Neoclassical forms served as a triumphal framework for a panorama of the age-old glory of Russia.

Bove employed the same principle with no less striking effect in creating Theatre Square. The monumental Bol'shoy Theatre, with its majestic portico, took up one side of the square, the uniform façades of new buildings ran along two more sides, while the fourth side was left open to another historical panorama, the churches and fortifications of Kitay-Gorod (pl. 319). Bove achieved a continuity of the old and the new Russia by combining the emotional power of ancient monuments with Classical order and uniformity.

The distinctive features of the Moscow Empire style are seen in the Bolshoy Theatre as rebuilt by Iosif Bove in 1821–24 (pl. 320) and other buildings of his such as the second City Hospital (Gradskaya bol'nitsa), the round church of the Mother

318 The Polibin house, Moscow, 1818.

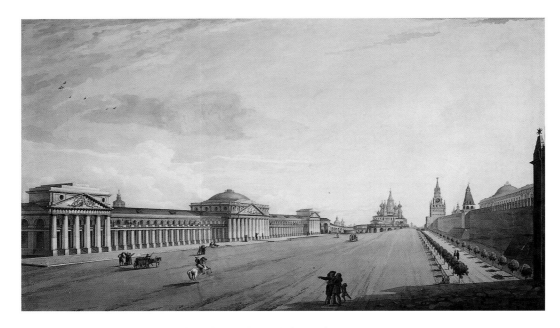

319 *Red Square, Moscow: View from the North-west*; lithograph, 1840s.

of God, Joy of all the Grieving (tserkov' Bogoroditsy Vsekh Skorbyashchikh Radosti; pl. 321) and the Triumphal Arch in commemoration of victory over Napoleon. Other architects who contributed to the overall Empire image of the city were Domenico Gilardi (Moscow University; pls 322, 323) and Augustin Béthencourt, joint architect, with Auguste-Ricard de Montferrand, of the Riding School that stood next to the University, with its mighty Doric colonnade and unadorned pediment.

321 (*right*) Rotunda of the church of the Mother of God, Joy of all the Grieving, Moscow (Vasily Bazhenov and Iosif Bove), 1783–90, 1828–32.

320 The Bol'shoy Theatre, Moscow (Iosif Bove and Andrey Mikhaylov), 1821–24.

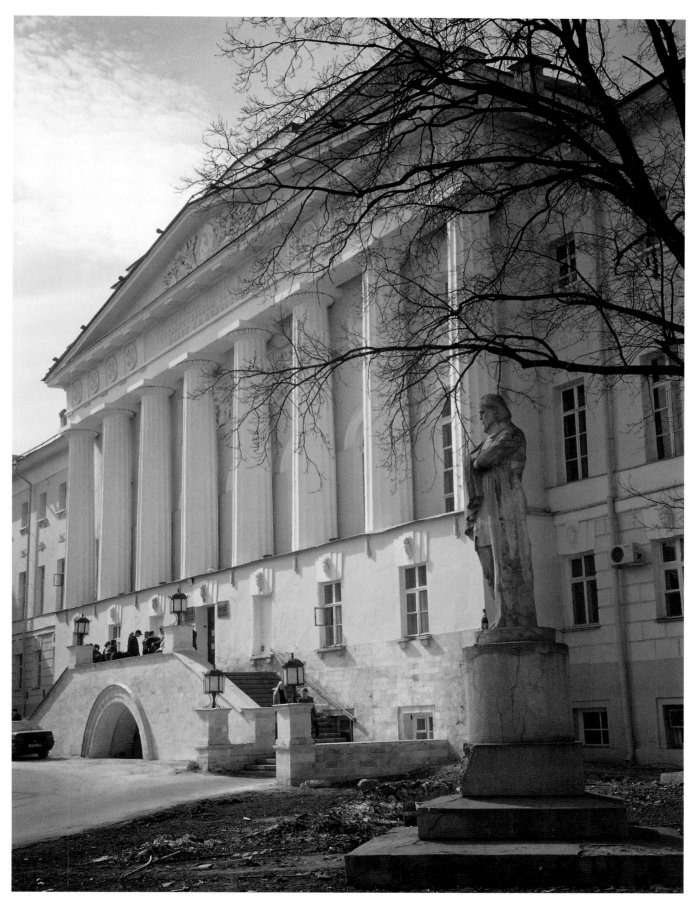

322 Central portico of Moscow University (Domenico Gilardi), 1817–19.

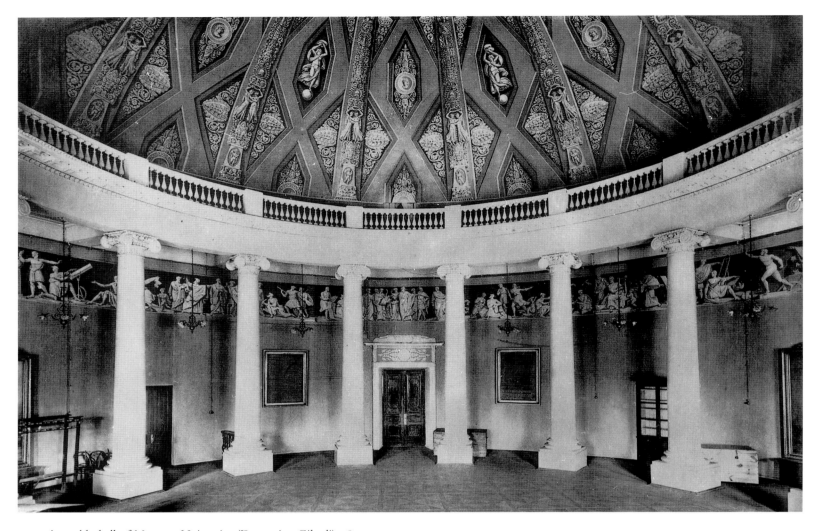

323 Assembly hall of Moscow University (Domenico Gilardi), 1817–19.

In even greater demand than Bove with the Moscow aristocracy were Domenico Gilardi and Afanasy Grigor'yev, often working in collaboration. Gilardi was a member of an architectural dynasty that had settled in Moscow at the end of the eighteenth century. His father Giovanni, an architect, had him educated together with a serf boy, Grigor'yev.[37] The latter is famous for building two houses in Prechistenka, for the Lopukhin-Stanitskaya (pl. 325) and Khrushchev-Seleznev families (pl. 324), which are among the outstanding surviving examples of Moscow Empire houses. Among the other fine Empire houses that have survived are Domenico Gilardi's Lunin house on Nikitsky Boulevard, Opekun Council (Opekunsky sovyet) building on Solyankaya Street, and mansion for the Usachev-Naydyonov family on which he collaborated with Grigor'yev.

Gilardi's style was demonstrated at its most impressive in the Opecunsky Council (Opekunsky sovyet) building, which has not survived. It consisted of three main blocks of typical

Empire cube shape. The central block had an Ionic portico, a favourite feature used by Gilardi. The ground-floor arcading served as a pedestal, another central element in this architect's work, and it is again typical that the most striking feature of this part of the building, containing the main entrance, was its blank wall surface, which dominated the arch embrasures. The precisely proportioned shapes of the central cube and the cylindrical drum beneath the cupola were key aspects of the Empire style. Gilardi's Romanticism is especially evident in the mausoleum of the church on the estate of the Volkonsky family at Sukhanovo (pl. 326), its rotunda behind the neo-Greek portico bearing a prominent white stone corona, probably symbolizing the princely status of the ancient Volkonsky family.

In Moscow the Empire style also found expression in gardens and park pavilions. Bove created the Alexander Gardens adjoining the west wall of the Kremlin, Menelaws the gardens at Peter Palace, and Gilardi completed the park at Kuz'minki, seat of the Princes Golitsyn, now within the city. The park in

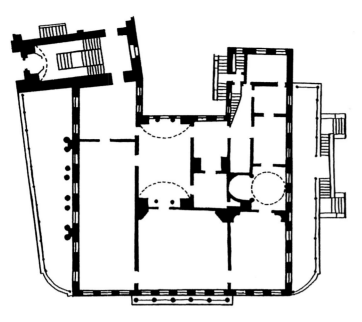

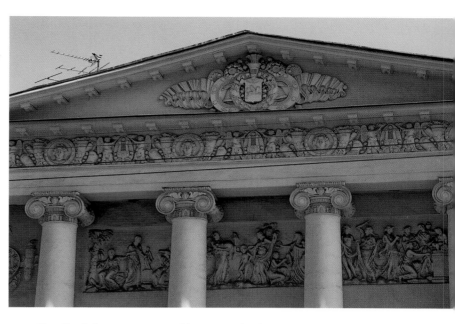

324 Plan of the Khrushchev-Seleznev house, Moscow (Afanasy Grigor'yev), 1814.

325 Detail of the portico, Lopukhin-Stanitsky house, Moscow (Afanasy Grigor'yev), 1817–22.

326 Portico and wing of the mausoleum of the church of St Dimitry, Volkonsky estate, Sukhanovo (Domenico Gilardi), 1813–17, rebuilt 1934.

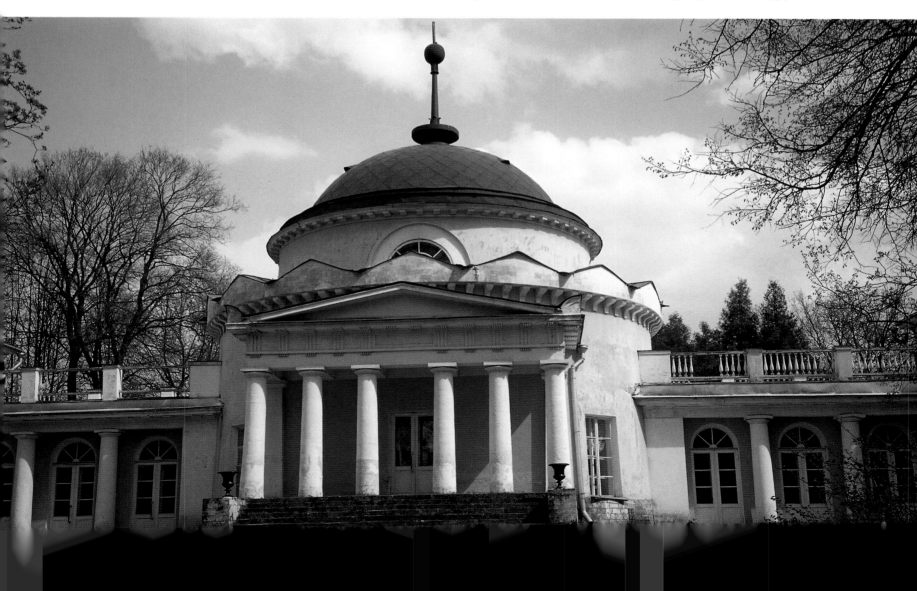

Moscow Empire style combined early nineteenth-century English ideas of the Picturesque garden, elements of the regulated compositions of the central parts of French gardens of the Napoleonic era, as on the Clisson estate near Nantes, and the strong Russian landscape garden traditions of the second half of the eighteenth century. Its compositional core usually consisted of garden buildings positioned along calculated geometrical axes through winding paths and lakes in a designed landscape. Among the few original structures of this period that have survived, Bove's grotto in the Alexander Gardens is of special interest. The walls of the Kremlin are turned into a Romantic backdrop against which the Ancient Greek-style columns of the grotto stand out dramatically. Here Moscow Empire renders its due to the Antique ideal in combination with the national past.

5 Vying with Ancient Rome: The St Petersburg of Karl Rossi, Vasily Stasov and Auguste-Ricard de Montferrand

Zakharov died in 1811, Voronikhin in 1814, Quarenghi in 1817, de Thomon in 1819. After the Napoleonic wars other architects began to shape the face of St Petersburg. In the first decade of the nineteenth century the city's architectural course was charted by major individual, often very large-scale buildings, such as St Michael's Castle, the Exchange, Kazan' cathedral and the Admiralty. After 1812 the whole city began to be considered as a unified ceremonial ensemble, and until well into the 1830s architects saw a new building in relation to all the other buildings in the city. It was officially decreed that architects must "consider the correctness, beauty and propriety of each new building according to its contribution to the city as a whole".[38]

In 1816 Emperor Alexander I, spurred by his decisive role at the Congress of Vienna in determining the future of Europe, decreed that "in its architectural aspect, this capital shall be raised to a level of beauty and perfection which shall be commensurate with its worth in all respects".[39] To this end, a new department for urban planning and public services was created, the Committee for Building and Hydraulic Works. It was charged with the replanning of the old squares of St Petersburg and the building of a number of new ones. A fundamental principle had changed – the conception of city space. Now the city's impact was to be achieved not only through the creation of large-scale buildings, but also by clearly defined transitions and harmonious forms. The architects who led the development of St Petersburg in this direction between 1815 and the 1840s were Vasily Stasov,[40] Aleksandr Bryullov,[41] Auguste-Ricard de Montferrand[42] and, above all, Karl Rossi.[43]

Discussing a building on which he was working, Rossi perfectly expressed the urban-planning-oriented architectural ethos of St Petersburg of this era:

My project surpasses the buildings of the ancient Romans in scale. Surely we should not be afraid to compare ourselves with them in splendour? By this word we should understand not decorative abundance but greatness of form, nobility of proportions and solidity of materials.[44]

The thinking of the urban planner was uppermost in Rossi. Although he was a brilliant master of composition and detail, he was attracted most of all by tasks demanding grand-scale solutions. He once wrote that he would like to "surpass everything that the Europeans of our time have done [. . .]".[45] Rossi's genius was many-sided. He could design a wonderfully poetic private house such as he created for Alexander I on Yelagin Island, and he could also set himself the aim of remodelling the entire centre of the city. He built St Michael's Palace (Mikhaylovskiy dvorets; now the Russian Museum), placing a square in front of it, rebuilt Palace and Senate Squares (pls 327, 328), and created Theatre Square (Teatral'naya ploshchad') with the Aleksandrinsky Theatre and the street that leads to it (pl. 329), now named Rossi Street (ulitsa zodchego Rossi). In all, he collaborated in the replanning of twelve squares and thirteen streets in St Petersburg. Stylistically, he continued in the direction laid down by Zakharov and de Thomon – his Classicism is monumental, ceremonial, grand-scale, rich in sculptural ornament. His ensembles secured the permanent supremacy of Neoclassicism in St Petersburg, not only in the architecture of individual buildings but also in key elements of the city.

The Admiralty building designed by Zakharov was still uncompleted when in 1819 Rossi began to remodel Palace Square. His solution to this task is a striking demonstration of his gifts (pl. 330). Through the first half of the eighteenth century this area, situated in the very centre of St Petersburg, adjoining the imperial winter residence, remained architecturally undefined. When Francesco Bartolomeo Rastrelli completed his sumptuous Baroque Winter Palace in 1762, only one side of the future square was formed, though the most significant in terms of the life of the capital. In front of the new palace Rastrelli wanted to construct a gigantic round courtyard surrounded by a colonnade, and at the centre of it proposed to place an equestrian statue of Peter the Great which his father, a sculptor, had cast long previously, and which would be the symbolic centre of the city. With the death of Empress Elizabeth I, Rastrelli's projects were abandoned, but the idea of a round square in front of the Winter Palace was not forgotten. In 1819 the radical decision was taken to build a square in front

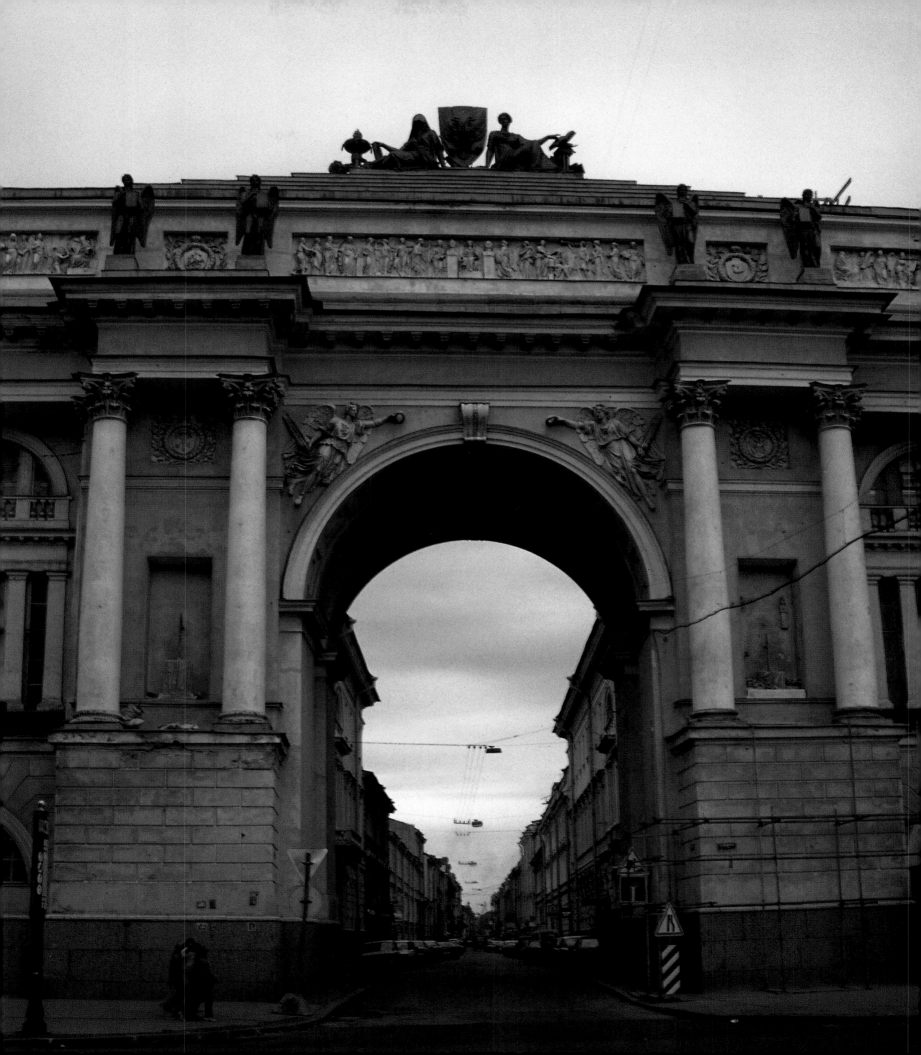

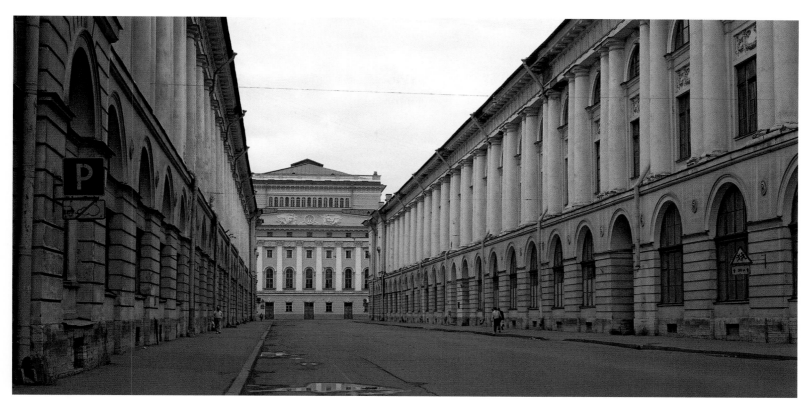

329 Theatre Street, St Petersburg (Karl Rossi), 1828.

of the Winter Palace which would be the administrative centre of Russia, the site of not only the General Staff of the Army but also the Ministries of Finance and Foreign Affairs. A "Commission for the Building of a Proper Square facing the Winter Palace" was set up. To Russian architects of the time the term "proper square" meant a square of exact geometrical dimensions and with the façades of the buildings round it in uniform Neoclassical style, and Rossi proceeded on this basis. He also took up Starov's idea of placing a slanting line of buildings opposite the Winter Palace and Fel'ten's plan of forty years earlier for a uniform sweeping curve of façades to face the Winter Palace.

Rossi knitted all the buildings facing the Winter Palace into a unified whole to a complex internal plan, with blocks in tens and numerous rear courtyards of the most varied shapes, from round to rectangular, giving anyone in them the feeling of being inside a fantastical, mystifying labyrinth. From an exterior viewpoint all this is hidden behind the impression of a massive, inscrutable monolith. Sections of façades look onto the Admiralty Meadow, Nevsky Prospekt and Moyka River. Facing the Winter Palace is the 500-metre curve of a façade rising to a height of four tall storeys (pl. 330).

Such crescents are familiar in other famous Neoclassical cities. The semi-elliptical Royal Crescent, Bath, open to the

countryside and organically linked with it by virtue of its gentle but firm forms, is of no smaller proportions. The difference is that Rossi's crescent takes the form not of a section of an ellipse but of a parabola, with the geometrical property of carrying movement forward. And it is not the hilly landscape of western England, with its country houses and estates, but the supersaturated mass of the Russian imperial palace towards which movement is directed. It is not a question of opening city space into the countryside, as in Bath, but of the creation by architectural means of perpetual triumphal ornament. This allies Rossi's work with the theatre décor of a remarkable Italian artist working in St Petersburg during the reign of Alexander I – Pietro di Gottardo Gonzaga. With Rossi, sometimes, it is as if some English or Scottish Neoclassical city has been conjured by the hand of an Italian master of dramatic and monumental perspectives.

Rossi began the formal approach to the Winter Palace on St Petersburg's main thoroughfare, Nevsky Prospekt. A turn to the right and a short side street lead to a triumphal arch with the depth of a short tunnel. The interior of the arch is turned so that the last bay is exactly oriented towards the centre of the palace on the opposite side of the square. Ornamental sculpture on either side of the arch includes giant warriors of cast-iron, symbolic arms and armour between Corinthian columns,

328 (*facing page*) Detail of the colonnade of the Senate and Synod building, St Petersburg (Karl Rossi), 1829–34.

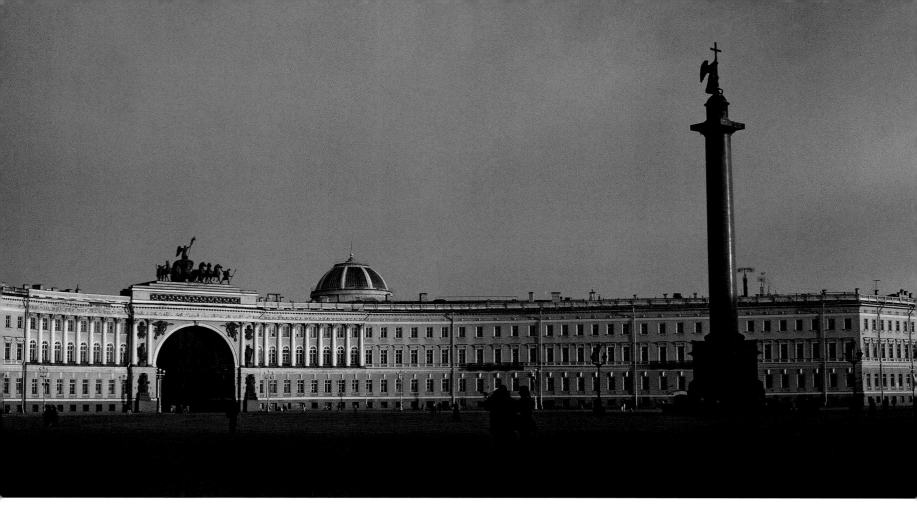

330 Palace Square, St Petersburg, with the General Staff building (Karl Rossi), 1819–29, and the Alexander Column (Auguste-Ricard de Montferrand), 1829–34.

flying genii bearing garlands; and crowning the arch is a team of six horses drawing the chariot of the goddess of Victory towards the palace. The arch bisects a colonnade. At the centre of the square Rossi planned to place a gigantic column resembling Trajan's Column in Rome. It was Montferrand who eventually raised it in 1830–34, to the memory of Alexander I and his defeat of Napoleon.

Of Rossi's contemporaries, who vied with him in the scale of their projects, the best architect was Vasily Stasov. He spent his early working life in Moscow, and after distinguishing himself in the staging of the coronation of Alexander I he was rewarded by being sent abroad to complete his architectural studies, spending six years (1802–07) in France, England and Italy. In Rome he became a member of the Accademia di S. Luca. On his return to Russia he was appointed the emperor's private architect. In character, a contemporary describes him as being "the complete opposite of Rossi [. . .]. He wasn't an unpleasant person, but he was always shrouded in gloom."[46] It is all the more surprising that Stasov's work, even such major official buildings as the Imperial Stables (Pridvornyye konyushni) on the Moyka with their church (pls 331, 332) or

the barracks of the Pavlovsk Regiment on the Field of Mars (Marsovo pole), makes a less solemn, cold impression than Rossi's. His Neoclassicism has a greater gentleness and freedom; he introduced the "comfortable" vein of Russian Empire, especially in its Moscow variety, to St Petersburg, at the same

331 Façade of the church of the Imperial Stables, St Petersburg (Vasily Stasov), 1817–23.

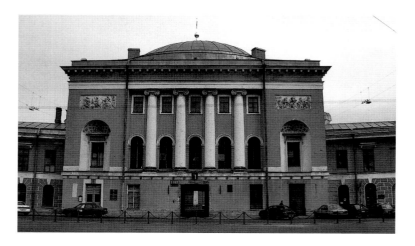

332 (facing page) Under the cupola of the church of the Imperial Stables, St Petersburg (Vasily Stasov), 1817–23.

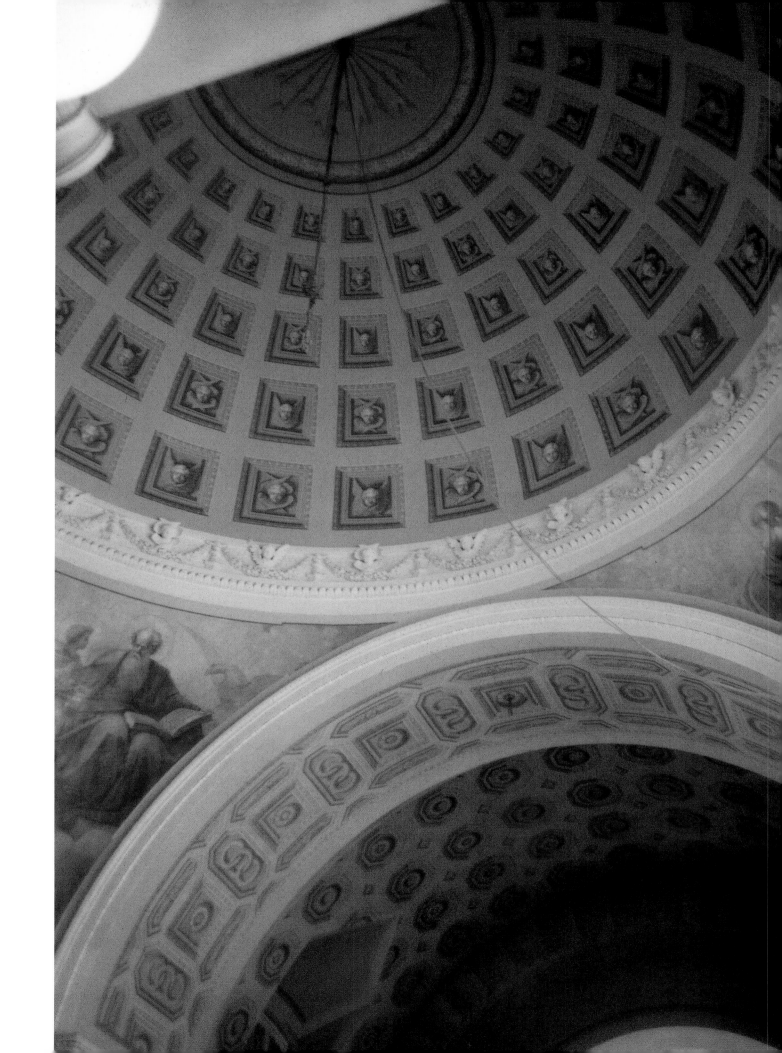

time giving Petersburgian features to military supply depots in Moscow.

Stasov did most of his work for the Army Department. He remodelled the city's main open space, the Field of Mars, on which parades of the guards regiments took place. Parades were a leading element of life in the capital, a most important state ceremonial, even a sacred ritual, in which the emperor himself took part. Paul I held parades every day, and Alexander I and Nicholas I very frequently. It was on parades, surrounded by smoothly moving guardsmen in full dress, that the emperor appeared before his subjects more frequently than on all other occasions. Alexander I considered it essential that the place where these appearances occurred should have a fitting aspect. Stasov took over a sizeable portion of the Field to raise a huge barracks for the Pavlovsky Guards Regiment – which had distinguished itself in 1812 – on its long western side, with a trapezium-shape plan and three spacious inner courtyards. He adopted the same approach to the creation of this extensive façade as Zakharov had done ten years before with the Admiralty, dividing it with a mighty Doric colonnade surmounted by a monumental attic storey with many sculptural panels depicting arms and armour.

Besides the barracks on the Field of Mars, Stasov built a range of further barracks, depots, churches and triumphal structures. Guards regiments had their own churches in the capital. Stasov built very large cathedrals for two of the most celebrated regiments, the Preobrazhensky and the Izmaylovsky. These outstanding Neoclassical buildings, with their monumental scale and five cupolas, as was traditional in Orthodox cathedrals, had a great influence on the evolution of church architecture in Russia (pl. 333).

The Empire style continued its evolution in St Petersburg long after it had lost its popularity in France. The empire of Alexander I and Nicholas I was the stylistic heir of the empire of Napoleon I. St Petersburg saw the realization of many Empire style features which were known only in plan in Paris. Many of these belonged to city-planning projects on a major scale, huge ensembles of solemn grandeur continuing the spirit of triumph and victory that had sprung up in the campaigns of 1812–14. In the years following the end of the Napoleonic Wars, which saw the full flowering of the Empire style in Russia, Neoclassicism burst into a variety of forms in St Petersburg to reach its final stage. This stylistic period is usually termed "late Neoclassicism" and dated to the reign of Nicholas I. However, the architects of the principal late Neoclassical buildings began their work in the second half of the reign of Alexander I.

"I don't remember whether it was in June or July of this year [1816]," Filipp Vigel' recalls,

when someone arrived from Paris who went completely unnoticed by our leading architects but whose success was to make him a constant object of their envy and vexation. One morning I went to see [Augustin] Béthencourt [at that time in charge of all building activity in St Petersburg as chairman of the Committee for Building and Hydraulic Works], and found with him a tow-haired Frenchman of about thirty who had brought a letter of recommendation from a friend of his, the watch-maker Breguet. When he had gone I asked who he was – it was Montferrand.[47]

Working for the architect Jean Molinois in Paris, Auguste-Ricard de Montferrand was not very successful, but soon after his arrival in St Petersburg he proved himself: "[. . .] he designed twenty-four buildings [. . .] amongst which all styles could be found – Chinese, Indian, Gothic, Byzantine, Renaissance, and of course ancient Greek."[48] All these were really one and the same building in different forms, the great city cathedral. Alexander I liked his design album, and Montferrand was commissioned to build a new St Isaac's Cathedral to replace Rinaldi's unsatisfactory building (1768–1802), which he did not complete until 1857, not only the largest cathedral in St Petersburg but also the major monument of late Russian Neoclassicism (Isaakiyevskiy sobor; pl. 334).

Visiting St Petersburg in 1859, Théophile Gautier describes St Isaac's in these enthusiastic terms:

As the traveller approaches St Petersburg by steamer via the Gulf of Finland, the cupola of St Isaac's Cathedral catches the eye, rising above the silhouette of the city like a golden mitre [. . .]. Its aspect [. . .] is like a harmonious synthesis of the Basilica of St Peter and the Pantheon in Rome, St Paul's Cathedral in London, and the Panthéon and the dome of the Chapel of the Invalides in Paris.[49]

This grandest of all St Petersburg churches is not to be linked with the architectural fashion that flourished in the capital when it was being built, exemplified in Zakharov's and Rossi's buildings standing next to it. Its tectonic style and proportions are different, and it employs a different approach to architectural ornament and a different way of citing historical precedents. It would seem more logical to see this building in connection with contemporary architectural developments in Montferrand's home city, but it is hard to think of any comparable building raised in Paris during the Restauration. It is possible, on the other hand, to link some general features of St Isaac's Cathedral, as Gautier does, with those of a number of the great shrines of Europe dating from different times from Ancient Rome to eighteenth-century Paris. In the construction of the cupola of St Isaac's there is indeed an echo of the

333 (facing page) The cathedral of the Trinity, Izmaylov Regiment, St Petersburg (Vasily Stasov), 1827–35.

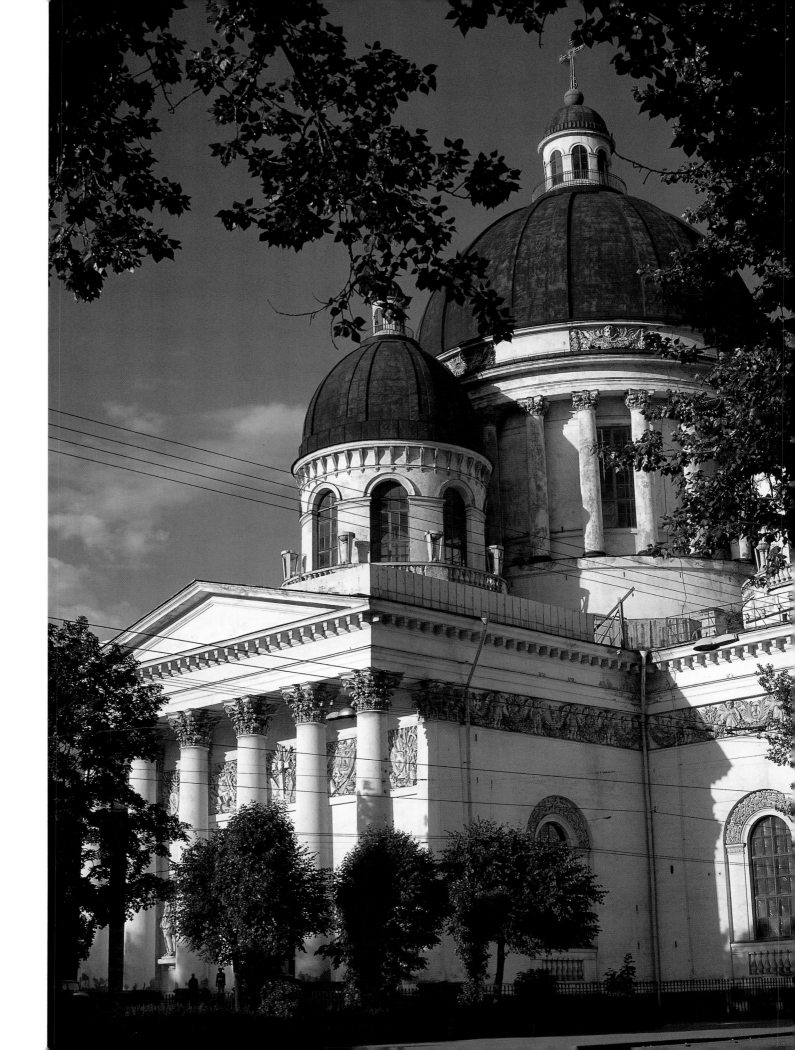

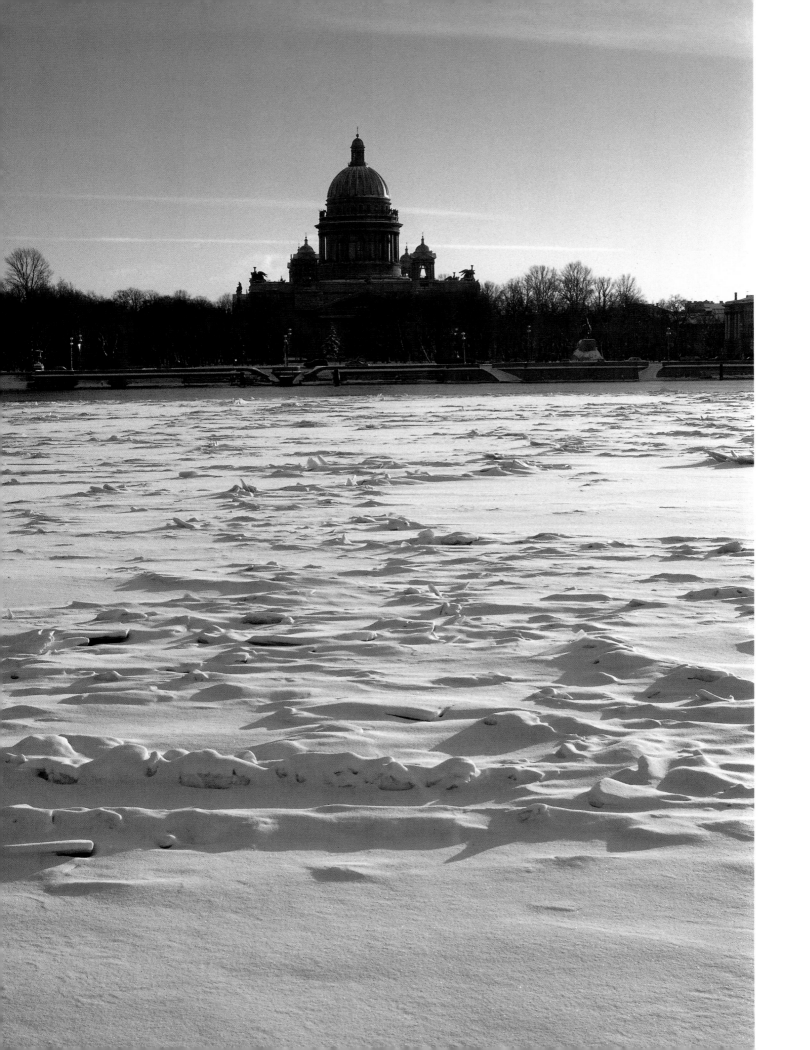

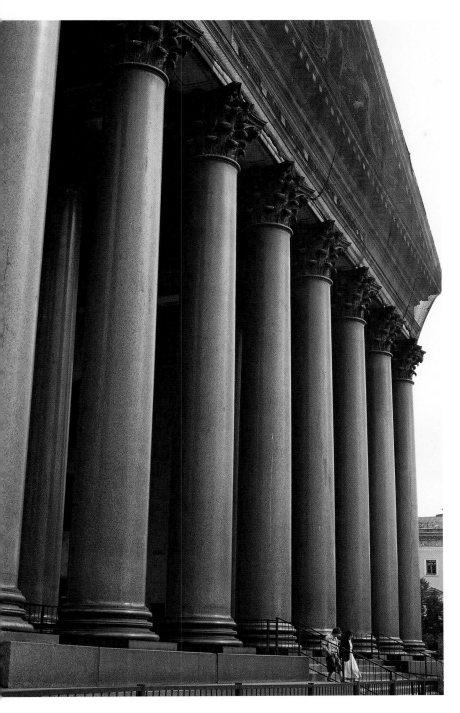

The dark grey marble mass of St Isaac's Cathedral makes a powerful impression, giving a marked austerity to its grand Classical forms. Forty-eight granite columns, each weighing 110 tons, form four gigantic porticos facing the cardinal points. The heavy pediments are densely covered with ornamental sculpture on biblical themes. There is a minimum of architectural ornament. The eight windows of the cathedral, although huge, still do not admit sufficient light. The four bell-towers are each crowned with a Classical pavilion with a small gilded cupola. Above the sharply defined, serene crowning horizontal of the body of the cathedral, dominating the city, rises a majestic drum, surrounded by twenty-four granite columns. The latter, although not so massive as the columns of the porticos at 64 tons each, had to be raised to a height of 48 metres, just below a balustrade and a graceful gilded cupola.

In the decoration of the interior marble, porphyry, lapis lazuli and malachite with much gilded bronze have been used, and there are exquisite mosaics and sculpture, besides some two hundred individual paintings by Academicians. Such a collection of official art in the chief shrine of the Empire creates an atmosphere strongly redolent of the era of Nicholas I.[51]

Montferrand did not shun commissions for work in a number of different styles. He would play with exotic settings within a generally Classical composition. Especially successful is a whole street "in Chinese style" – the tea-traders' rows in the largest market in Russia, in Nizhny Novgorod, for which he prepared a number of designs.[52]

Neoclassicism remained the official style of urban architecture through the second quarter of the nineteenth century, the reign of Nicholas I. It continued to be used for the major new ensembles of the northern capital, while in Moscow attempts were made to develop a style in keeping with the older city's ancient traditions. One of the last major Neoclassical architects active in St Petersburg during this period was Aleksandr Bryullov who, after graduating from the Academy of Arts, St Petersburg, continued his studies together with his brother Karl, the well-known painter, in Munich, Rome, Naples, Paris, and finally London. This comprehensive educational grand tour was neither exceptional nor incidental; it shows the scale of Russian artists' interests during this period, their strong links with Germany, the obligatory study of Antiquity, beginning with Rome and devoting special attention to Pompeii, and finishing off by sampling the latest architectural ideas in Paris and London. Better than any other Russian architect, Aleksandr Bryullov knew how to draw upon the widest European experience in his work while at the same time preserving the imperial spirit of St Petersburg. Rational composition in both individual buildings and in the planning of façades was typical of his approach, as well as the strictly graphic nature of his

335 Portico of St Isaac's Cathedral, St Petersburg (Auguste-Ricard de Montferrand), 1818–53.

dome of St Paul's, and in the relationship of the St Petersburg cathedral's Corinthian portico, with its extensive unadorned wall surfaces, it is possible to see an analogue with the Panthéon. The closest parallel of all, however, is surely with the Nikolaikirche in Potsdam, built at about the same time by Karl Friedrich Schinkel, with its massive geometrical forms, monumentality and minimum of ornament (pls 335, 336).[50]

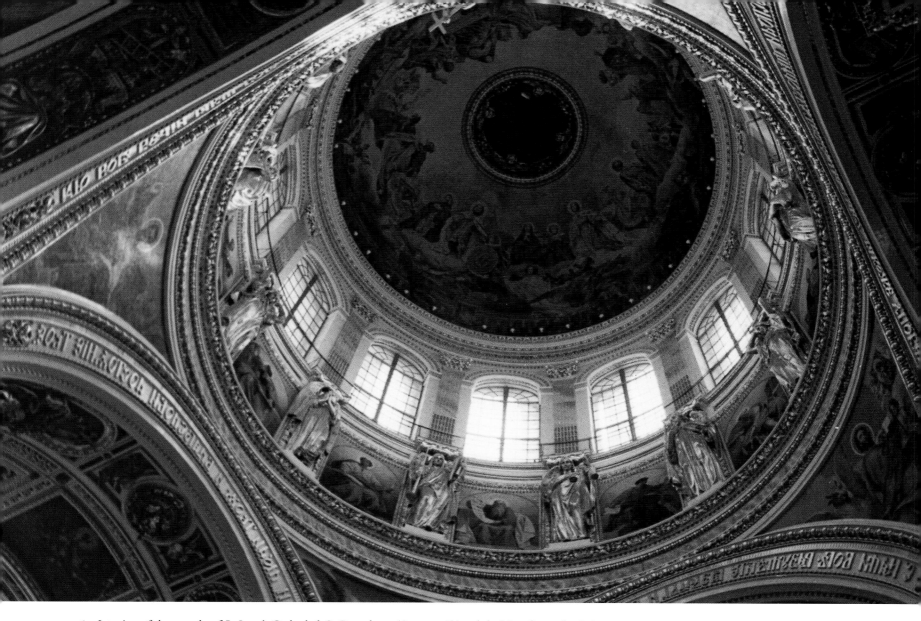

336 Interior of the cupola of St Isaac's Cathedral, St Petersburg (Auguste-Ricard de Montferrand), 1818–53.

emphatically precise, rather detached Classical forms. These qualities are especially clearly exemplified by his Guards Headquarters building (Shtab gvardeyskikh voysk) on Palace Square and the Lutheran church of St Peter and St Paul on Nevsky Prospekt. In the former, Bryullov pointedly moved away from both Rossi and Rastrelli, although Baroque Revival ideas had already begun to find their way to Russia. He adopted a Greek Revival manner, with an archaeologically authentic Ionic colonnade above a socle containing a main doorway with ornamental mouldings in Ancient Greek style, evidently guided by German publications on early Greek monuments.

As already noted, Montferrand, despite his Parisian background, was obliged to design St Isaac's Cathedral in a similar style to that of Schinkel. Bryullov too, in many of his buildings, and especially his Lutheran churches, frequented by St Peters-

burg's sizeable German community, used a style reminiscent of Schinkel and Klenze, both of whom were at this time executing commissions for the Russian imperial court. Schinkel built a chapel in Alexandria Park, Peterhof, and designed a palace in Livadia in the Crimea.[53] Leo von Klenze was commissioned to design a new building to house the imperial collection of works of art – the New Hermitage, Russia's first purpose-built art gallery (pl. 337).[54] The majestic atlantes of the main entrance strike the last grand note of Petersburg Neoclassicism of the first half of the nineteenth century, supplanting the movement's attachment to the French "Rome Prize" tradition and the decorative style of the Napoleonic empire with an orientation towards German architecture, especially that of Prussia and Bavaria, kingdoms well disposed towards Russia. Nicholas I's marriage to a Prussian princess and

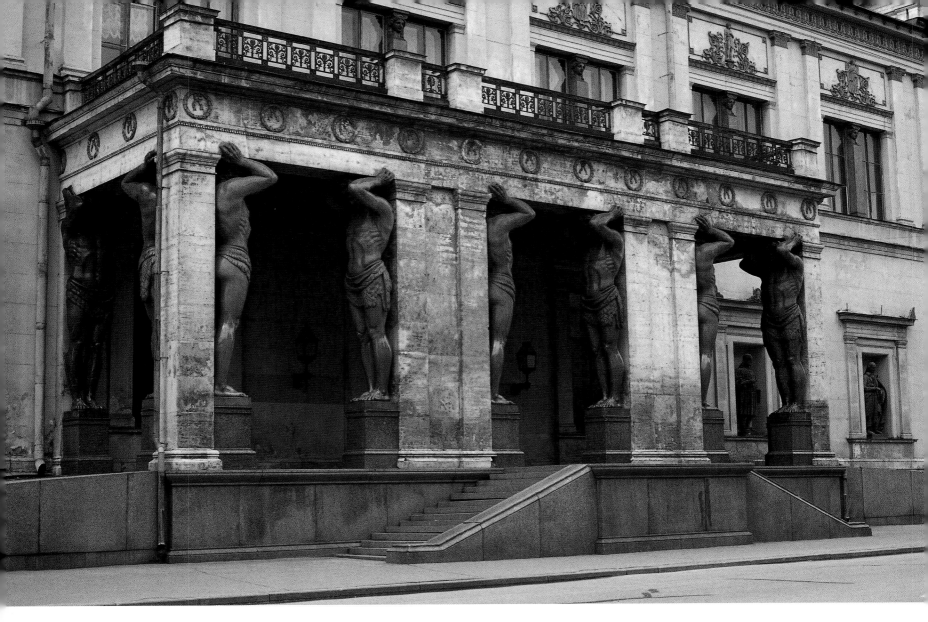

337 The portico of the New Hermitage, St Petersburg (Leo von Klenze), 1839–52.

numerous further ties of blood and friendship between the St Petersburg court and Berlin, Munich, Weimar and Dresden formed a political foundation for an intensification of Russian and German architectural links during this late stage of Russian Neoclassicism. That process, however, took place predominantly in the northern capital; in hundreds of provincial towns, Russian architectural evolution took a different course.

★　★　★

6 Utopia in Neoclassical Garb: William Hastie's Model Planning System

In the course of the first half of the nineteenth century the model planning system became more widespread in the Russian Empire than at any other time in world architectural history.[55] It originated, as seen above, in Peter the Great's policy of having the inhabitants of his new city build their houses to a typology of designs. At that time the design of a house depended on its owner's social position and rank in the imperial hierarchy. Throughout the eighteenth century, the building of new and the rebuilding of established cities and towns proceeded on the same criteria.[56] The situation changed radically in the reign of Alexander I as a result of the urban planning work undertaken by the Ministry of Internal Affairs. In the first

three decades of the nineteenth century, every single aspect of building was regulated for all kinds of built structures, squares, street frontages, housing estates, bridges, post-station buildings and their yards, even garden fences. No more graphic example of Alexander I's conception of the utopia of the Russian state could be offered than this totally regulated planning system in a uniform style.

Buildings to model designs were put up in huge number in the first half of the nineteenth century, beginning soon after the accession of Alexander I to the throne in 1801. An imperial decree was issued at the beginning of 1803 confirming that designs were prepared for all main administrative buildings in provincial capital cities:[57] houses of governors and vice-governors, state institutional and other office buildings, law-courts and gaols, wholesale shops for wine and spirits and salted provisions. Trade in vodka and salted goods was then a state monopoly, and premises for their sale belonged to the state. Designs for all these building types were produced by Zakharov in late eighteenth-century Catherinian Neoclassical style. Gaols were an exception to this pattern, taking the form of castles with towers. Boullée's influence was seen in the frequent contrast between monumental, bare walls and elaborate central ornamental detail.

In 1808 work began on the preparation of a "Collection of Façades approved by His Imperial Majesty for Private Houses in Cities and Towns in the Russian Empire".[58] This was contained in five albums illustrated with engravings, which were distributed all over the country. The imperial approval gave these designs a compulsory character.[59] Local authorities were ordered to grant building permission for new private houses only if façades were in accordance with those prescribed. The first two albums, with a hundred new house designs, were issued in 1809 (pls 338, 339).[60] Two years later, further albums appeared containing model plans for residential squares and housing estates as well as literally every element of the built urban environment – gateways, fences, perimeter walls and so on.[61] Before the invasion of 1812, 124 more designs for houses, shops, barns and other domestic buildings were published.[62] There were even model designs for churches, approved by the Synod in 1810.

At the same time, work was proceeding on urban plans that had remained uncompleted during the reign of Catherine the Great. Late eighteenth-century plans that turned out not to be in accordance with prescription, or were inadequate to the scale of increased populations, were revised. In all, over the first thirty years of the nineteenth century, more than a hundred general urban plans were approved.

The processing of urban plans and the preparation of model designs were the work of a special commission set up by the Ministry of Internal Affairs. It was headed for a quarter of a century, from 1808 to 1833, by the Scottish architect William Hastie, invited to Russia by Charles Cameron.[63] He arrived at an early age and studied with Catherine the Great's favourite architect. At first his work bore unmistakable traces of Cameron's influence, but in time, in his urban planning capacity, he moved more and more decisively away from the gentle Palladianism of his teacher and his fondness for the Picturesque landscape garden. By the 1810s he had become an advocate of strict regulation of every aspect of urban architecture. This was a result of the leading ideas about the conduct of public life in the Empire under Alexander I. It was no coincidence that Vasily Stasov and the Swiss Luigi Rusca, collaborating in the preparation of model designs, produced façades virtually indistinguishable from Hastie's. Stylistic unity in all new buildings in the country was one of the principles of Alexander's reforms. Neither was it by chance that the introduction of model designs occurred at the same moment as the reform of the imperial administrative organs and the beginning of a process of standardization of the legislature that was to result in the promulgation of the Full Legislative Code of the Russian Empire (1830–43). This codification included both an administrative and a civic codex. The model planning system similarly embraced state and private building. The new legislative code answering the needs of the time and the architectural formation of a "civilized" living environment were both intended to serve as bases for the flourishing of empire. In essence, both these developments brought the systematic fulfilment of Enlightenment ideas of the state that had emerged piecemeal in Catherine the Great's reign.

As a result of the model planning system, Neoclassical architecture in Russia during this period had a markedly state-imposed character, with no possibility of private initiative in new urban building. Only the owners of country estates had the freedom to build as they liked. Urban building plots were allotted in strict geometrical shapes. Apart from the dictates of housing estates and squares, plots for new houses could be triangular, rectangular, round, pentagonal or hexagonal. The vagaries of local topography or previous architectural use of sites would be met by geometrically precise elements put together like cubes in a child's puzzle. The process of new building took precise account of the boundaries between plots, gardens being placed in the middle of housing estates.

The planning ideal of the period was to place the population around a town perimeter, with uniform distribution of similar-sized plots giving a smooth, regular rhythm of similar-sized houses and large squares of varying geometrical proportions. All fortuitous elements were excluded from plans; nature was the architect's subordinate. Although model designs offered

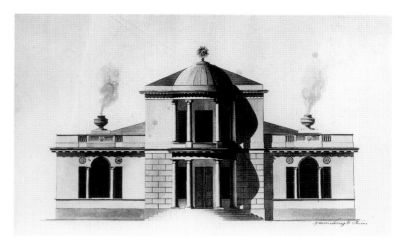

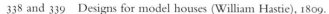
338 and 339 Designs for model houses (William Hastie), 1809.

a number of options for the ornamentation of façades of private houses, both the simplest single-storey, three-window houses and huge three-storey urban mansions with wings on their own estates had to keep within the prescribed limits of Neoclassical ornament. Great inventiveness was called for in order to achieve both overall stylistic unity and distinguishing features between houses. All this made up the typical Neo-classical urban model.[64]

In the standard designs for housing estates the input of British ideas may be seen. The squares and terraces of Bath and especially of Edinburgh's New Town are perhaps the nearest analogue to what Hastie brought about in Russia,[65] and it is highly probable that he saw plans for some of these before leaving Scotland. It may be said that Hastie's planning approach was developed largely in parallel with the work of his contemporaries in Scotland. His designs for urban housing estates are reminiscent of William Playfair's for Edinburgh.

At the moment when Hastie began his work for the urban planning commission (1808), the idea of the establishment of "military settlements" arose in Russia,[66] inspired by French plans for the creation of a territorial army. It grew from a desire to radically reduce the costs of a standing army by settling most of it in the countryside and obliging the soldiers to devote themselves to agriculture "in their spare time from war". It was considered necessary, however, for the entire life of these settlements to be organized on a military basis. The project was realized on a huge scale and took decidedly ugly forms. Andrey Aleksandrovich Arakhcheyev, minister of war from 1808 to 1810 and eventually Alexander I's chief minister, who was in charge of the scheme, introduced total regulation of all departments of life in the settlements, from hair-style, seasonal dress, daily routine and the time to be spent on different tasks, to road-construction and the distances to be set between houses.

Vasily Stasov was responsible for the architectural side of the scheme. Arakhcheyev established the settlements with the utmost cruelty. After three decades of existence and a number of uprisings, they were eventually terminated. The very term "military settlements" came to be synonymous with the idea of the regulation of everyday life by external means *ad absurdum*.

The model planning system overall, however, was far from absurd. It proved to be a highly effective mechanism for the inculcation of the Neoclassical style as a basis for the transformation of the appearance of Russian cities and towns. To trace concrete instances of the use of the new town plans would amount to naming all the provincial and district centres in Russia, particularly since in 1828–29 Aleksandr Shtaubert prepared additional plans for administrative buildings,[67] and in the decade 1830–40 many popular manuals using the prescribed designs were published, as for example a "Guide to Building Wooden Houses" by Vasily Fedoseyev (1831).[68] When Neoclassicism ceased to be the current style, the output of model designs still continued. In the 1850s Russian-Byzantine and Renaissance Revival versions appeared;[69] by this time, however, their use was no longer obligatory.

Monotonous Neoclassical uniformity was avoided by the continuation of many wooden buildings, old or lowly traditional dwellings in use, as well as the almost ubiquitous presence of medieval and Baroque churches. Low building density was also of very great significance, an abundance of gardens and orchards giving provincial and district capitals a picturesque aspect. A further factor was the emergence, from the beginning of the nineteenth century, of local architects. Although in principle they were obliged to follow the model designs, in practice they were often allowed to alter the scale of a building in order to adapt the design to local topography; and they were

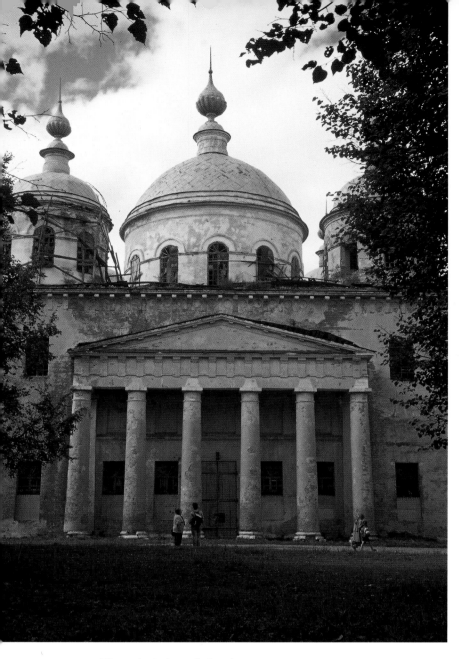

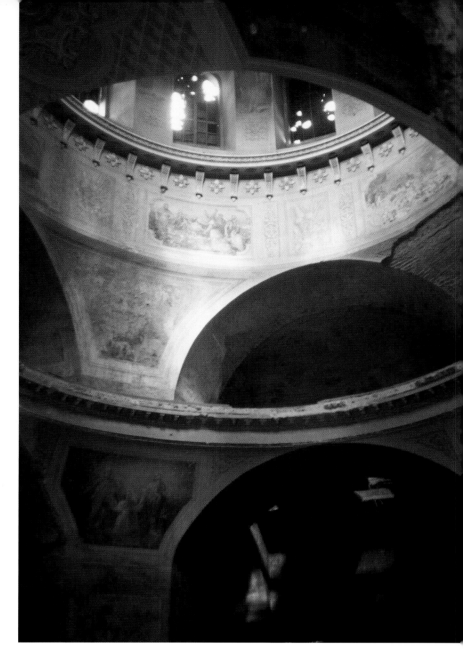

340 The cathedral, Meshchovsk, 1829.

341 Interior of the cathedral, Meshchovsk, 1829.

allowed greater freedom than architects in St Petersburg and Moscow in handling Neoclassical ornament.

Local architects, especially in provincial capitals, often used the whole available palette of model designs in a complex of ensembles incorporating, for example, the needs of the various state institutions with their obligatory grand porticos, arcaded traders' rows, and high fire-watching towers. It was thanks to these architects that in the first half of the nineteenth century Neoclassicism became the flesh and blood of the urban environment in Russia.[70]

The Russian Empire style also held church architecture in its sway, cathedrals and parish churches being built to model designs, very grand buildings not infrequently appearing in small towns, such as the cathedral in Meshchovsk in the province of Kaluga (pls 340, 341). Architects trained at the St Petersburg Academy of Arts were capable of impressively consistent compositions in unusual topographical conditions. One magnificent example of this is the monastery of St Nicholas (Nikol'sko-Chernoostrovskiy monastyr') in Maloyaroslavets, built on a steep hillside, a complex of churches on different levels. By the middle of the nineteenth century Empire churches had become a prominent part of the landscape of Central Russia (pls 342–44), and Neoclassicism had found a firm place, in both town and country, in Russian architectural culture as a whole.

★ ★ ★

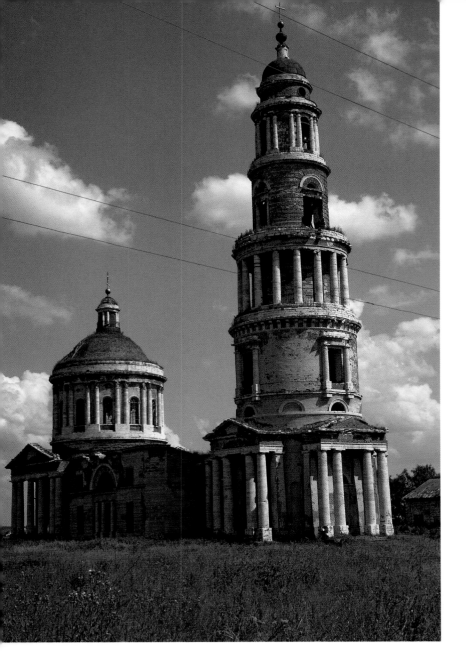

342 (*above left*) Church of the Nativity of the Mother of God, Perevles, Ryazan' province, 1824–32.

343 (*above right*) The bell-tower of the church of the Nativity of the Mother of God, Perevles, Ryazan' province, 1824–32.

344 (*right*) Church of the Intercession, Cherepovo, Smolensk province, 1824.

Chronologically, the search for the national character of Russian architecture virtually coincides with the history of the Gothic Revival in Western Europe. In its beginnings the "Russian style" of the nineteenth century went through the same evolutionary stages as the cult of the Middle Ages in other European countries. Russian-British architectural links, stimulating enthusiasm for the national heritage, played an

345 The Chapel, Alexandria Park, Peterhof (Karl Schinkel), 1831.

important part in the process. Aspects of eighteenth-century architectural history are relevant to the formation of the Russian style in the following century. The first of these worth examining is the survival, as in Britain, of architectural styles of earlier periods in the provinces; styles predating the Petrine reforms lived on in Russia.[71] Older traditions continued in the building of wooden houses and in church architecture, especially in the countryside, uninfluenced by developments in the capitals, until the mid-nineteenth century. Furthermore, interest in Early Russian architecture was fostered by the continuing obligation to maintain old buildings "in their original form", as noted in surviving documents from the reigns of Empresses Elizabeth and Catherine the Great. Ancient buildings that were symbols of the power of the Russian tsars, especially those of central Moscow, were conserved untouched long after the advent of the technology of scientific restoration.[72] To the architects of the Baroque and Neoclassical movements it was essential that the typical features of the cultural monuments of the past should be left unaltered. Their professional practice included the recording of earlier architectural forms as a symbolic language carrying the memory of the nation's history. The church authorities, too, insisted on the strict conservation of traditional Orthodox structures.

The first deliberate citation of specific historic monuments in a new building is found in Rastrelli's use of the upper structure of the Ivan the Great Bell-tower in the Moscow Kremlin in the bell-tower belonging to his model for the Smol'ny Convent (Smol'nyy monastyr'). Mention was made in Chapter 5 of the widespread use of motifs from Early Russian architectural forms in the Gothic Revival work of Bazhenov and Kazakov at a time when triumphal constructions and imperial palaces were being built outside Moscow. Under Catherine the Great decorative motifs had been borrowed from Kremlin buildings to serve as architectural allegories expressing the idea of continuity of power from early Russian rulers. The next generation of architects decided at the turn of the century that the impact of the past should continue to be maintained, and accordingly imitated the style of earlier buildings (see, for example, the designs of Ivan Yegotov and Andrey Bakarev for the Kremlin and Kitay-Gorod).[73]

In St Petersburg Gothic Revival continued, following British models, during the reign of Alexander I. Menelaws filled Alexander Park at Tsarskoye Selo with Gothic pavilions,[74] and in Alexandria Park at Peterhof, Nicholas I's favourite seashore residence, he built a Picturesque cottage orné (pl. 346), its exterior ornamented with lancet arches and interiors decorated in the manner of Horace Walpole's villa at Strawberry Hill.[75] Near the latter Schinkel built a Gothic chapel (pl. 345). A contemporary wrote in 1829:

346 (*facing page*) Drawing room in the palace cottage, Peterhof (Adam Menelaws and Andrey Shtakenshneyder), 1826–41.

In St Petersburg, Gothic is all the rage. A cottage-palace has been built at Peterhof [. . .] in Gothic style, and a farm at Tsarskoye Selo [. . .] everyone is mad about Gothic [. . .]. Montferrand does nothing but produce Gothic designs.[76]

At the same time, in the imperial parks outside St Petersburg, Rossi and then Montferrand began to put up pavilions with

347 The Nikol'sky Tower, Kremlin, Moscow; restored after 1812 by Iosif Bove.

richly carved decoration reminiscent of peasant houses in Russian villages.

Meanwhile, an opposite process was taking place in Moscow, where Gothic Revival in the European style was a rarity compared with the frequent imitation of Early Russian architecture. Wealthy gentry with estates in central Russia, following the fashion of the imperial court, built pavilions and even entire houses in Gothic style, like the mansion at Marfino by Mikhail Bykovsky. In the historical centre of Moscow, however, a special style evolved, combining Gothic Revival with Early Russian forms. The restoration of Moscow's historic monuments that followed the fire of 1812 produced an efflorescence of Romantic features. Soon after the emergence of the "Russian style" in the 1830s the impact of Slavophilism, concentrated in Moscow, also became apparent. In direct contrast to European St Petersburg, Moscow had become the centre of the national movement, and it was the home of the leading figures seeking to restore national traditions in all departments of life. The architecture of early Moscow was the starting-point for the development of the Russian style, in which various strands coexisted and rapidly succeeded each other.

The policy of restoration of the medieval face of the Kremlin and Kitay-Gorod inspired attempts to imitate Early Russian architectural forms in many new buildings and a large number of designs dating from the first third of the nineteenth century. The best surviving examples of this trend are the building for the Synodal Press (Sinodal'naya tipografiya) on Nikol'skaya Street (pl. 348) built by Ivan Mironovsky in 1811 (and restored in 1814 after the Fire of Moscow) and the Nikol'sky Tower (Nikol'skaya bashnya) of the Kremlin, rebuilt by Iosif Bove after being badly damaged during the French retreat from Moscow in 1812 (pl. 347).[77] The Russian style continued to seem desirable to Russian architects in the 1830s. In 1834 the most original of them, Mikhail Dorimedontovich Bykovsky gave a lecture "On the Unfoundedness of the View that [Ancient] Greek or Graeco-Roman Architecture can be Universal and that Beauty in Architecture is based on the Five Orders".[78] The kernel of his argument was that Russians "should imitate not ancient forms, but ancient example: we should have our own, national architecture, and the true spirit of our country should be displayed in works of architecture which will teach the newest generations about the solidity and moral strength of Russia".[79] Despite such convictions, Bykovsky built in various styles – Late Neoclassical, Renaissance Revival, or styles mixing Roman and Byzantine forms or Early Russian ornamentation and Renaissance Revival motifs, as for example in the Ivanovsky Convent complex in Moscow (pl. 349).[80]

The evolution of the Russian style in Moscow architecture is closely connected with the work of the leading Russian architect of the middle of the century, Konstantin Andreyevich Ton (1794–1881).[81] Born and educated in St Petersburg, he studied abroad for ten years, mostly in Italy. On his return to St Petersburg in 1828, he took part in a competition for the building of the church of Christ the Redeemer (sobor Khrista Spasitelya), which was to be on no lesser scale than St Peter's Basilica in Rome. The building was conceived as a memorial to the end of the Napoleonic Wars,[82] the idea of its being located in Moscow arising in 1813. Alexander I commissioned Aleksandr Vitberg as the architect, and he made designs for a Neoclassical building steeped in mystical symbolism associated with masonic ideas. Work on the project ceased, however, as a result of Vitberg's lack of building experience and his client's change of ideology. Nicholas I decided he wanted the church to be in Russian tradition. This was a defining moment for the establishment of the Russian style in the nineteenth century. Vitberg's accepted design of 1828 was for a gigantic building 103 metres in height, with a floor area of 6,800 square metres and the diameter of the main cupola 25.5 metres. It was eventually completed in 1883. Standing on the bank of the Moskva not far from the Kremlin, it dominated the Moscow skyline

348 (*above*) Detail of the façade of the Synodal Press building, Moscow (Ivan Mironovsky), 1811.

349 The Ivanovsky Convent, Moscow (Mikhail Bykovsky), 1861–79; photo, 1882.

350 The cathedral of Christ the Redeemer, Moscow (Konstantin Ton), 1830–83; photo, 1886.

351 The eastern apse of the cathedral of Christ the Redeemer, Moscow (Konstantin Ton), 1830–83; photo, 1886.

until 1934, when it was demolished in a plan to replace it with an even more colossal building, a Palace of Soviets. War, however, prevented its construction, and in any case it was found that the water level on the site precluded the raising of such a large structure. The church has now been rebuilt in its original form (pl. 350).

The style in which the cathedral of Christ the Redeemer achieved completion in 1883 is customarily called "Russian-Byzantine". This term is based on statements by Ton, who considered that "the Byzantine style, with its kinship to elements of our national character, shaped our church architecture".[83] This does not, however, explain all the features of the style, in which the spirit and traditions of Neoclassicism are strongly felt. What was new was the use of an expressive language that could refer to Early Russian and Byzantine architecture. All architectural embellishment, however, was stiffly correct and impassive in comparison with the early models for the style (pl. 351).

Ton made considerable changes to the face of the Kremlin. He rebuilt the Great Kremlin Palace and the Armoury Palace (1839–49). On the exterior of the new Kremlin Palace he used

traditional ornamental Russian motifs, again with the effect of arid grandeur (pl. 352); the interiors were eclectic, with the emphasis on Renaissance Revival. The Romantic restoration of all the main Kremlin buildings carried out at this time also had great significance in its historical symbolism. The residences of the tsars from the fifteenth to the seventeenth centuries, the interiors of the Terem and the Faceted Palaces, were extensively rebuilt. The Russian-Byzantine style, the

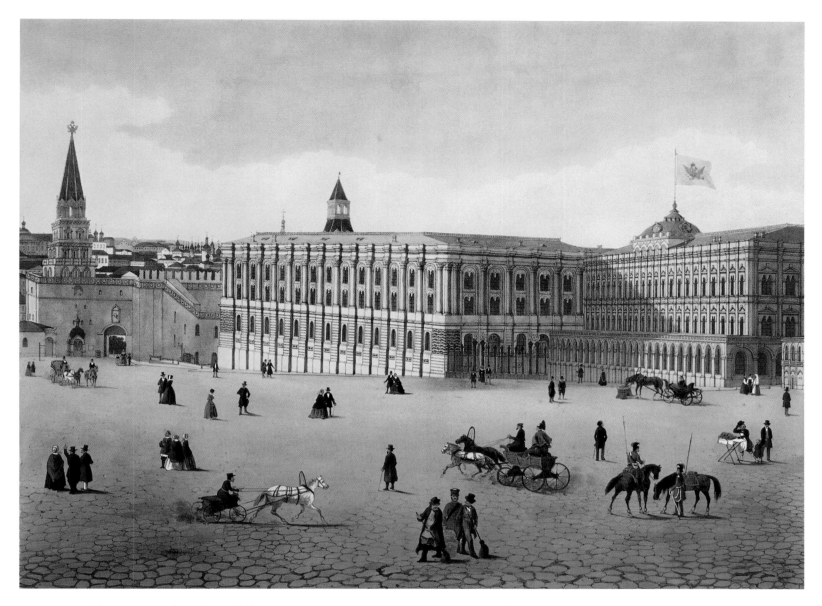

352 View of the Great Kremlin Palace and the Armoury, Moscow (Konstantin Ton), 1838–49; coloured lithograph, 1852.

leading representative of which was Ton, had become the offi-
cial national style, approved by the imperial court and the
higher dignitaries of the church. It embodied a conception of
art and architecture as adjuncts of the state, in keeping with the
ideology of the era of Nicholas I and the well-known watch-
word of the time, that the prosperity of the Empire rested on
"autocracy, Orthodoxy and the national character". The style
developed by Ton in accordance with these ideas spread over
the whole country; typical of new buildings of the time is the
church of the Transfiguration (tserkov' Preobrazheniya) in the
village of Preobrazhenskoye in Ryazan' province (pl. 353).

New trends emerged in Moscow architecture after Alex-
ander II's accession to the throne and the launching of his

reforms in 1861. The Emancipation of the Serfs, reform of the
state financial system and the introduction of trial by jury
changed the everyday life of the country. With the increased
importance of merchants and industrialists, economic develop-
ment gathered momentum. This had a direct impact on archi-
tecture. The nature of the client changed, the role of the state
decreased, central control over the appearance of buildings was
relaxed; the tastes of private clients and public opinion played
an increased part in planning decisions. In this context, from
1870 to the 1890s, yet another variety of the Russian style
evolved, embracing the forms of the Russian past but aban-
doning the Byzantine elements that had been adopted by
Ton.[84]

353 Church of the Transfiguration, Preobrazhenskoye (Konstantin Ton), 1850s.

The models for this style were sixteenth- and seventeenth-century monuments and buildings in the vernacular tradition. In the words of a celebrated art historian of the time, Ivan Zabelin: "the old Russian country house, evolved organically from the peasant shed, preserved the beauty of natural disorder [. . .]. According to our early forebears' way of thinking, the beauty of a building consisted not in the conformity of its parts to a pattern but on the contrary, in its individuality [. . .]."[85] This amounted to a campaign against Neoclassicism on behalf of the national heritage.

The first structures to realize the ideals of Russian popular architecture were small wooden buildings. In the 1850s Nikolay Nikitin constructed for the historian Mikhail Pogodin, next to his house, a depository for his manuscript archive, known as "the Pogodin Hut". This was in the style of a prosperous peas-

ant's dwelling, with traditional carved decoration.[86] In 1872 the architect Viktor Hartman put up some wooden pavilions in peasant style at a polytechnic exhibition in Moscow. These had great success, and after the appearance of his book *Models of Russian Ornament* in the same year his version of traditional ornamentation quickly became widespread,[87] being taken up by Ivan Petrov, who used the pseudonym Ropet (pl. 355),[88] and other Moscow architects.[89]

Soon the Russian style dominated private architecture in Moscow, and its forms found their way into stone and brick. The appeal of the style lay largely in the romanticized image it gave of seventeenth-century Russian architecture. Moscow architects were attracted by its richness, picturesqueness and compositional complexity, ornamental abundance and diversity, its use of multi-coloured ceramics and hammered metal

ornament. All this perfectly met the tastes of the last quarter of the nineteenth century, with its love of intricate decoration and fondness for large-scale buildings in which the very latest constructional methods were used and the highest degree of comfort was provided.

The Russian style attained its zenith in the Historical Museum (1875–83) by Vladimir Sherwood, of an English family who settled in Russia (pl. 356).[90] This building was intended to serve as a symbol of Early Russian history. Its architects aimed not only to give it typical Russian architectural form, but also not to destroy the integrity of the ensemble of buildings surrounding it. The museum presents an image of some fantastical medieval town with pointed towers abounding in motifs taken from specific early buildings in Moscow. In 1890–93, along the entire east side of Red Square, the Upper Trading Arcade (Verkhniye torgovyye ryady), which became known in Soviet times as the State Department Store or GUM, was built by Aleksandr Pomerantsev (pl. 357).[91] Its decoration has something of the atmosphere of Russian seventeenth-century architecture, although the overall decorative composition is rather "academic" in feel. The roof of this building, with its bold metal constructions, aroused the excitement of contemporaries (pl. 358). The City Duma of Moscow (Gorodskaya duma Moskvy), in the Soviet era the Lenin Museum, was built next to the Historical Museum by Dmitry Chichagov in 1890–92, continuing the development of the Russian theme in the city centre. The intricately decorative façade of the colossal Polytechnical Museum designed by Ippolit Monighetti on Lyubyanka Square (1875–1907) is a further outstanding example of the Russian style.[92] This whole area, from the Kremlin walls to the Historical Museum and the Duma and further as far as the fortifications of Kitay-Gorod,

354 The Igumnov mansion, Moscow (Nikolay Pozdeyev), 1889–93.

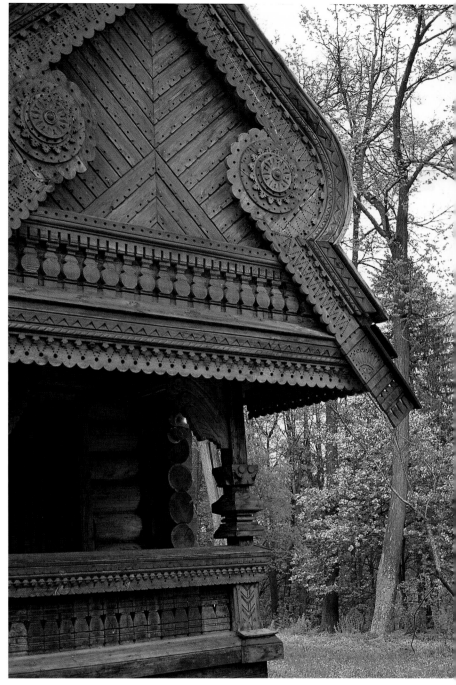

355 The Little Tower (Teremok), Abramtsevo (Ivan Ropet), last third of the nineteenth century.

forms an extended composition containing a combination of actual medieval buildings and later stylizations in their manner.

One of the most interesting houses in Moscow in the Russian style is the Igumnov mansion on Bol'shaya Yakimanka Street (1889–93), Nikolay Pozdeyev's only Moscow building in which he made use of motifs from the medieval buildings in his home city of Yaroslavl' on the Volga (pl. 354).[93] Its exterior

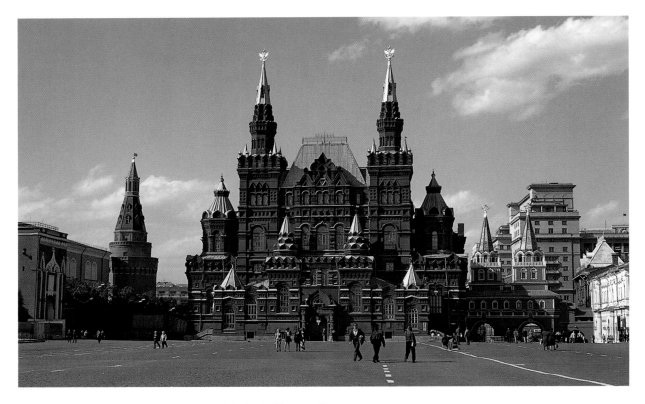

356 The Historical Museum, Moscow (Vladimir Sherwood), 1890–92.

358 (*facing page*) Interior of the Upper Trading Arcade, Moscow (Aleksandr Pomerantsev), 1890–93; photograph, 1890s.

357 The Upper Trading Arcade, Moscow (Aleksandr Pomerantsev), 1890–93.

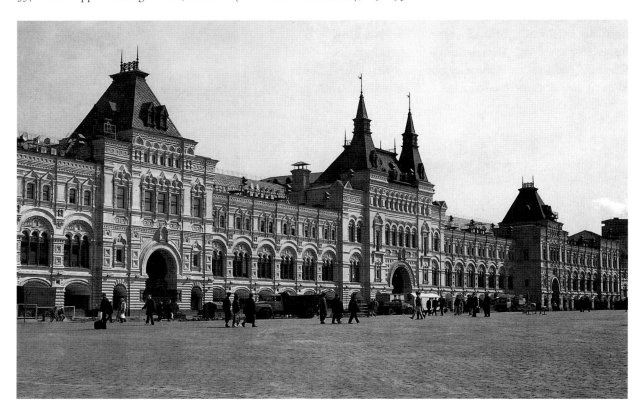

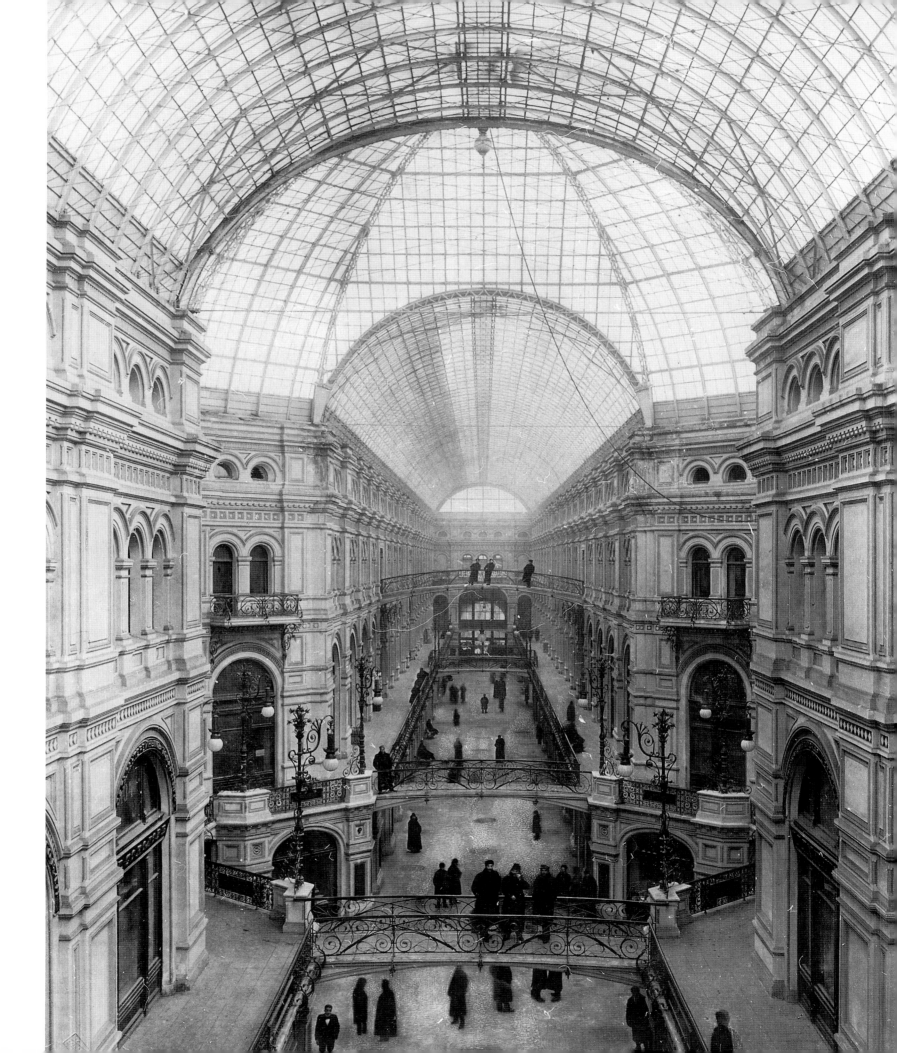

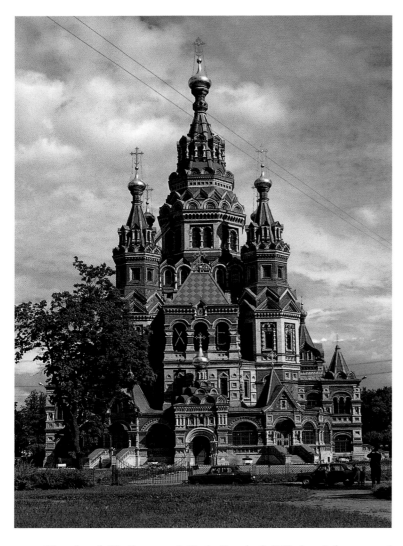

359 Church of SS Peter and Paul, Peterhof (Nikolay Sultanov and Aleksandr Kosyakov), 1894–1905.

360 Interior of the church of SS Peter and Paul, Peterhof (Nikolay Sultanov and Aleksandr Kosyakov), 1894–1905.

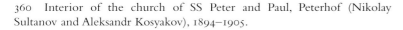

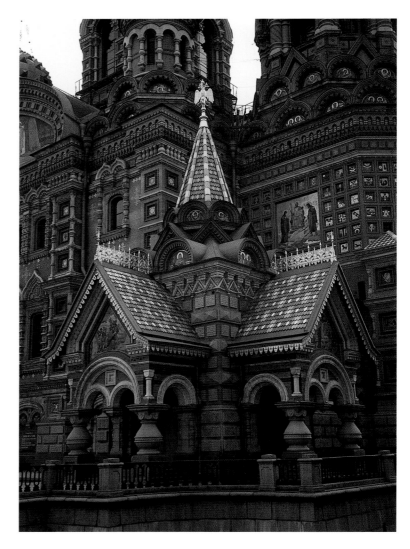

361 Church of the Resurrection on the Blood, St Petersburg (Alfred Parland), 1883–1907.

shows this architect's uncertainty with non-Classical forms. Features he considered "Russian" were compositional complexity, the combination of a number of differently shaped blocks, and decorative detail that included the use of variegated tiles common in seventeenth-century Yaroslavl' architecture. The interiors of this house, however, are highly successful, making a remarkably unified impact, especially the entrance hall and the main stairway, where space is theatricalized by an intense decorative element. Wall paintings incorporate motifs from popular art, complementing ceramic citations from the decorative schemes of well-known seventeenth-century buildings. Perfection of decorative detail throughout makes a major contribution to the overall fairy-tale effect.

In 1882 a pioneering specialist in Early Russian architecture, Nikolay Sultanov, gave a speech to an audience of engineers and architects in St Petersburg in which he said the following:

The use of the Russian Style began with small objects – portrait-frames, caskets, albums [. . .] iconostases, and then whole rooms and façades. And today, every well-appointed apartment inevitably has a room in the Russian Style: most of our dachas are built in this style [. . .] what exactly is its character, whether we have a pure version of it – we don't concern ourselves with that, what's important is not the style itself, but the fact that we have it.[94]

It is hard not to agree with these thoughts, especially in relation to the architecture of St Petersburg. In the 1890s Sultanov himself built a church in the Russian style at Peterhof (pls 359, 360). He drew on this experience in creating perhaps the most fascinating Russian style building in St Petersburg, the church of the Resurrection on the Blood (tserkov' Voskreseniya na krovi), also known as the church of the Saviour on the Blood (tserkov' Spasa na krovi).[95] It was built on the Catherine Canal not far from St Michael's Palace, on the spot where Alexander II had been mortally wounded in 1881 by a member of the revolutionary People's Will party. His son Alexander III wished the church to be built in the "pure Russian style of the seventeenth century". The chosen design for the church was the work of an architect of German origins born in Russia who became close to the court, Alfred Parland, in collaboration with a remarkable figure, the archimandrite Ignaty, superior of a suburban monastery who before becoming a monk had studied architecture at the St Petersburg Academy of Arts. Work on the project began in 1883, but it was not completed until 1907, some years after the death of Alexander III.

The church of the Resurrection on the Blood is remarkable above all for its extraordinarily rich decorative exterior detail, including an abundance of mosaics. It displays a combination of features taken from a number of famous Early Russian buildings, especially the seventeenth-century churches of the Volga towns, Yaroslavl' above all, palaces of the higher nobility of that period, celebrated monuments of the Moscow Kremlin such as the Ivan the Great Bell-tower, and St Basil's Cathedral on Red Square. Despite the diverse sources of its composition, this church makes a vivid and picturesque impression all its own (pl. 361).

On a national level, alongside the Russian style the inspiration of medieval European architecture continued. Nikolay Benois built the station and court stables at Peterhof in the Gothic Revival style, which flourished through the whole of the last third of the nineteenth century on the country estates of the St Petersburg aristocracy all over Russia. This style was adopted especially often for stable and stud-farm buildings, such as those on the von der Launits estate of Kargashino (pls 363, 364) or the von Derviz estate of Starozhilovo, both in

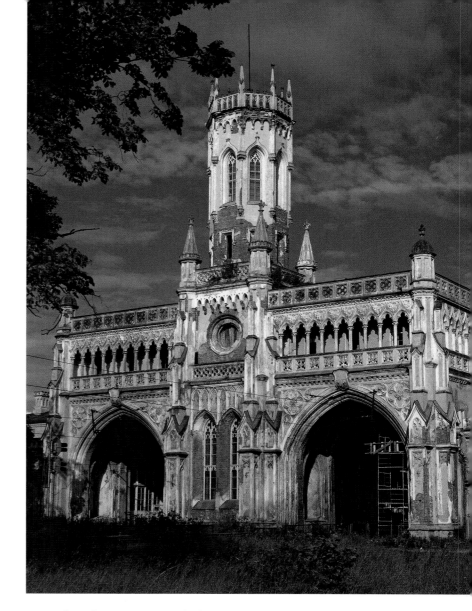

362 The railway station, Peterhof (Nikolay Benois), 1854–57.

Ryazan' province. A system of stylistic levels became general in the latter half of the nineteenth century: country houses would most often be in one of the variant Neoclassical styles, churches in Russian style, and outbuildings, especially stables, in Gothic Revival (pl. 362).

8 Alexander II and Alexander III: An Era of Retrospection

Russian architectural evolution in the middle and latter half of the nineteenth century followed the same course as in Western European countries. The close of the century saw the conclusion of the long process of convergence between Russian architectural forms and those of the rest of Europe that had begun with the reforms of Peter the Great at the turn of the seventeenth and eighteenth centuries. The technical aspects of

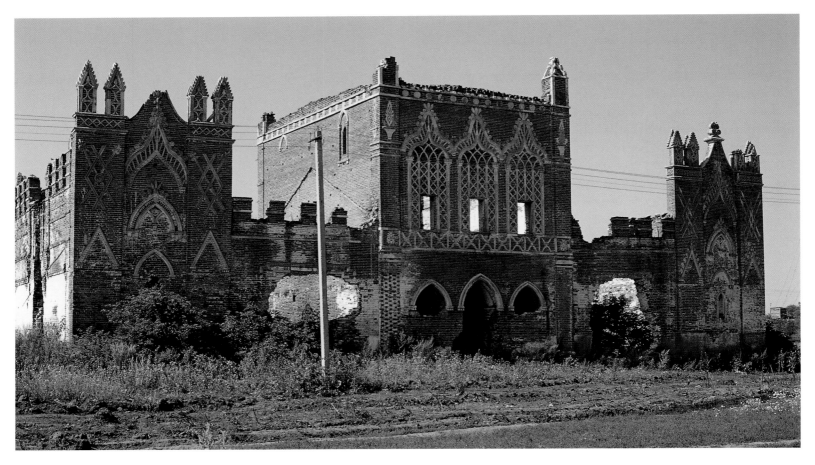

363 The stables, von der Launitz estate, Kargashino, mid-nineteenth century.

architecture, the typology of buildings, their functional structure and standards of comfort were now the same in St Petersburg and Moscow as in other European capitals. From a stylistic point of view there was also much common ground: the same interest in reproducing different historical styles, the popularity of Renaissance and Baroque Revivals, the emergence of Gothic Revival and imitation of the East, and finally, stylistic eclecticism. All this proceeded in the majority of cities and towns throughout the vast expanses of Russia contemporaneously with similar movements in other European countries during the second half of the nineteenth century.

As elsewhere as nineteenth-century civilization unfolded, new types of building emerged: rail stations, trading arcades and department stores, large-scale industrial installations. In St Petersburg, Moscow and provincial cities multi-storey tenement buildings appeared, and their number constantly increased. New political and social functions demanded their own buildings – local government offices, premises for scientific institutions, universities and museums. All this, in both functional and technological aspects, resembled developments in Western Europe.

In spite of these convergences, Russia in the second half of the nineteenth century, taken up largely by the reigns of Alexander II and Alexander III, son and grandson of Nicholas I, today remains something of a mystery to historians. In the Soviet era, this half-century was perceived in a clear-cut way, as a period that saw the rapid development of Russian capitalism and a change of economic system while tsarist autocracy lingered on. With the abolition of serfdom in 1861, the foundations of modern industry were created and the Russian bourgeoisie moved into the forefront of history. It seemed that the country advanced extraordinarily fast and without problems, the best proof of which was the intensive growth of St Petersburg and the establishment of scores of industrial settlements with huge factories and purpose-built workers' housing.

Russian and especially Soviet historians have made detailed study of the emergence and activities of the various anti-tsarist groups, from the liberal opposition to the numerous revolutionary organizations. The riddle lies in why, at a time of accelerating economic growth, the revolutionaries were successful in overturning the tsarist regime. Many answers have been given to this question, both in the West and in Russia. How-

365 Vestibule, Nicholas Palace, St Petersburg (Andrey Shtakenshneyder), 1853–61.

ever, a wholly satisfactory explanation of the historical events of the period is still lacking. Nor do the cultural phenomena considered in this book throw up any real leads towards a solution to what is today the main problem facing historians of the country – the emergence of revolution out of Russia's economic success in the latter half of the nineteenth century and the early years of the twentieth. The architectural history of the period can only show the grand decorative backdrop against which events unfolded that were to turn the world upside down.

One will scarcely get the true feel of the architecture of this period if one neglects its "heroes", the characters who appear on its streets in the great Russian novels written at the time. St Petersburg is the city of Dostoyevsky's *Crime and Punishment* and Tolstoy's *Resurrection*. Its broad prospects and the grubby corners of its back-streets conceal the sweep and swirl of its passions. In *The Diary of a Writer*, Dostoyevsky notes features he sees in common between the life around him, described in his novels, and the architecture of St Petersburg.

In general the architecture [. . .] of St Petersburg [. . .] particularly struck me because it expresses all its characterlessness and impersonality. The most typical thing about it, in a positive sense, is perhaps those rotting little wooden houses that still stand even on the grandest streets alongside the most immense buildings and that suddenly catch your eye like a pile of firewood in front of a marble palazzo [. . .] really, it's hard to sum up the architecture of our day.

Somehow it's all a complete muddle, just like the muddle of the passing moment. It's – a lot of extraordinarily tall tenement buildings – their tallness is the main thing about them – with extraordinarily thin walls, which form monotonous rows of astonishing façades – Rastrelli, the latest form of Rococo, arcades like the ones on the doges' palace [. . .] all this in the same façade.[96]

Dostoyevsky has a vividly imagined and wholly convincing conversation between the owner of a plot who wants to build a tenement block and his architect. He demands a window in doges' palace style:

You must build me a window like that, my good fellow, because I am in no way inferior to any of your doges. And do me five storeys, so that I can have tenants. A real proper window, and a proper set of storeys – I can't spend my capital on playthings.[97]

Five storeys seemed to mark the upper limit of the possible height of a building in St Petersburg in the last quarter of the nineteenth century, while individual features like Venetian windows or rocaille medallions would be chosen personally by the client. In this passage Dostoyevsky exactly conveys the dynamic of architectural evolution in St Petersburg in the second half of the nineteenth century. A vast amount of new building took place, tenement houses above all, assuming forms from the past borrowed from almost every country in Europe. In this mélange the individual and consistent character of St Petersburg's architectural style, so sharply defined in the Neoclassical era, was lost.

In the first Russian architectural journal, *Zodchiy* ("The Architect"), it was stated in 1882 that "St Petersburg is taking on a more and more European aspect".[98] The palette of historical styles used in Russia's capital in the middle and second half of the nineteenth century indeed very much resembled the stylistic mix found in architecture throughout Europe at this time: Baroque and Renaissance Revivals, Louis Quinze and Second Empire, Gothic and Greek Revivals, eclectic and Oriental. Architectural evolution in St Petersburg throughout the period, however, had its own special character. It showed the strong influence of Neoclassicism, and among the historical styles adopted in the city, the ones that prevailed were unquestionably those that were compatible with Neoclassicism, not the medieval styles: Gothic and Romanesque Revivals are found comparatively rarely in St Petersburg, where purity of Neoclassical composition is combined with contemporary rationalism during this period.

The first main exemplar of this combination is Andrey Shtakenshneyder,[99] who was appointed architect to the imper-

ial court in 1848 and for the next two decades built new palaces and altered old ones n St Petersburg. He is often seen as aiming to combine Renaissance with Baroque architectural principles. His style developed rapidly, although his starting-point was late Neoclassical. This has significance as some indication of the general character of the changes that Petersburg architecture was to undergo (pl. 365).

Renaissance Revival continued to evolve in St Petersburg throughout the second half of the nineteenth century. Among the earliest monuments in this style, the Shuvalov Palace on the Fontanka Embankment stands out for the graphic lightness of its façade, designed in 1846 by Nikolay Yefimov, one of the most refined practitioners of the style in St Petersburg. Another gifted early St Petersburg exemplar of Renaissance Revival was the German-born Harold Bosse,[100] who built the Department of Crown Domains building (Dom departamenta udelov) on Liteyny Prospekt in the 1840s. A combination of Renaissance Revival and the fashionable German Rundbogenstil (round-arched style) is displayed in another of Bosse's buildings, the Nechayev-Mal'tsev house.

The influence of Florentine palazzi is evident in Alexander Rezanov's palace built for Grand Duke Vladimir Aleksandrovich at the end of the 1860s on Palace Embankment (pl. 366),[101] which has bold, complex, deeply incised rustication covering the whole of the façade, a magnificent staircase with stucco grotesques, and carved wooden ceilings. As in most St Petersburg palaces of this time, its interiors are decorated in all imaginable styles, with a Russian-style banqueting hall, a Rococo-style dance hall and a Louis Seize salon.

The 1880s were the heyday of Petersburg Renaissance Revival, seen in the work of such architects as Maximillian Messmacher,[102] Viktor Schröter,[103] Vladimir Schreiber and many others. The most successful work of these architects includes Messmacher's palace for Grand Duke Mikhail Mikhaylovich on the Admiralty Embankment, with its complex, prolix but harmonious façades, and the same architect's State Council Archive (arkhiv Gosudarstvennogo sovyeta) building, which faces the New Hermitage. The latter is quite unlike Messmacher's usual work in its decorative strictness and restraint and rationalistic construction and plan.

St Petersburg Baroque Revival was based in the first place upon local tradition, with the buildings of Francesco Bartolomeo Rastrelli as its prototypes. Shtakenshneyder, as already seen, turned to the example of this architect in the 1840s, and Bosse and Schröter did the same in the 1850s and 1860s respectively. By the next decade, however, fashion had moved on from imitation of Petersburg Baroque; preference for European Baroque forms had strengthened. Purity was hardly the concern of these imitations; in the 1860s Bosse and

366 Detail of the façade of the palace of Grand Duke Vladimir Aleksandrovich, St Petersburg (Aleksandr Rezanov), 1864–72.

Ludwig Bonstedt[104] had already thrown all kinds of varieties of Baroque into their work.

Eighteenth-century Neoclassicism continued to exercise a hold on St Petersburg architects throughout the second half of the nineteenth century; together with Italian and French Renaissance and Russian and Western European Baroque architecture, it provided them with their most important source of stylistic models. It is typical that the Neoclassical

work of Quarenghi, Zakharov and Rossi was not imitated during this period, possibly because its monumental grandeur was associated too closely with the official, state-imposed tastes of the preceding era. The architecture of the early Catherinian era, with its even-surfaced façades, decorative inclinations and Rococo features, was influential, which in its turn stimulated a marked interest in Louis Quinze and Louis Seize styles. Generally speaking, if Renaissance Revival in St Petersburg in the second half of the nineteenth century sprang primarily from German and partly from Italian influence, the city's Neoclassicism undoubtedly had a French flavour.[105]

By the end of the nineteenth century, the purity of historical styles in St Petersburg, the preference for any single one of them, had begun to disappear. The sizes of buildings were increasing, tenement blocks growing taller, new forms demanding departure from stylistic canons. An even more important factor was that the very idea of an architectural ideal was being questioned. The poet Aleksandr Blok's thought: "[. . .] we can distinguish everything: the bedlam of Paris streets and the coolness of Venice, the far-off aroma of lemongroves and the smoky vastness of Cologne" was in all minds. It seemed that the modern age united all periods of history to create a complete civilization in itself, and that it was necessary only to choose specific elements from the past and combine them in a way that the present day found beautiful. The theory of "judicious choice" of historical forms, historicism, became the basis of architects' thinking. The more rapidly and successfully the building industry developed in St Petersburg, however, the clearer it became that using architectural forms of the past in different combinations could not continue ad infinitum and that at last it had become necessary to find a new architectural style. At the turn of the century, Russia's capital was ready to receive Art Nouveau.

In Moscow throughout the second half of the nineteenth century, new buildings belonging to the Neoclassical tradition appeared alongside others in Russian and Russian-Byzantine styles; Neoclassicism itself continued uninterrupted in Moscow for the whole of the nineteenth century. Renaissance Revival, which began in Moscow in the 1840s, remained popular for the rest of the century, as evidenced by the Stock Exchange (Birzha) on Il'yinka Street, first built in 1830 and redecorated in the mid-1870s, and the State Bank (Gosudarstvennyy bank; 1893–95). The numerous apartment buildings put up in Moscow at this time took on a new aspect. Tenement buildings of five storeys and more did not begin to appear until the close of the century, but the façades of most of the comparatively small, two-to-four-storey ones were rebuilt through the second half of the century with Baroque, Rococo or eclectic decorative elements. Large and prominent buildings in Russian style stood

out in contrast to the mass of these smaller buildings. In the mid-1890s exotic styles emerged: the Perlov teashop on Myasnitskaya Street was sumptuously decorated in Chinese taste, and the house of the merchant-industrialist Morozov on Vozdvizhenka Street took the form of a Portuguese castle with interiors in Ancient Roman, Ancient Greek and Renaissance styles. Gothic Revival also became increasingly popular in Moscow, being used especially for industrial buildings. Such was the architectural situation in Moscow when Art Nouveau first made its appearance.

In the second half of the nineteenth century a building surge took place in provincial Russia. In most towns, it is true, especially district (uyezdnyye) capitals, the majority of new houses were of wood in traditional style, put up beside brick and stucco houses built to standard designs. However, all buildings connected with the new economic trends – factories, commercial offices, industrialists' homes – would correspond to the latest St Petersburg fashion. The section of the gentry most highly placed in the imperial hierarchy was still dominant and affluent, its representatives customarily owning both a town house for the winter and a country house for the summer. As a result, country houses remained close in style to houses being built in Moscow and St Petersburg and to the dwellings of the wealthiest industrialists. Historicism, in its various manifestations, spread all over the country in the tranquillity of rural estates rather than in large towns and cities. In a pattern similar to that already seen in the Neoclassical era under Catherine the Great, on estates that had survived the shock of Emancipation, new buildings were put up in styles that were familiar in the national capitals.

9 Russian Art Nouveau and Neoclassical Nostalgia on the Eve of Revolution

Never before had Russia known such supercharged intellectual and artistic life as in the early years of the twentieth century. The brilliant symbolism of Alekandr Blok, the piercing lucidity of Ivan Bunin, the lyric strength of Anna Akhmatova, the Romantic exoticism of Nikolay Gumilyov – Russian poetry was filled with new rhythms and new images. Painters gave their representations of the new century, the exquisite stylization of the World of Art (Mir iskusstva) illustrators alongside uncompromising avant-garde groups – "The Knave of Diamonds" (Bubnoy valet), "The Donkey's Tail" (Oslinoy khvost) – and the epic-philosophical canvases of Nikolay Roerich. It was only another step to abstract art, Futurism and Constructivism. In music, Sergey Rakhmaninov and Aleksandr Skryabin reflected their time in fascinatingly different yet

equally original ways. Philosophy wasn't only suffering from a radical interpretation of Marxism; in these years it went through an apogee of idealism. The meetings of the Religious-Philosophical Society founded on the initiative of the novelist, poet and critic Dmitry Merezhkovsky caused furore among the intelligentsia of St Petersburg.

Meanwhile, in Russian public life the spirit of the nineteenth century still reigned. The imperial court and the grand dukes continued to play their accustomed roles, and parades and ceremonial occasions remained the centre of the life of the capital as they had done for the last two centuries. In architecture, innumerable varieties of historical styles appeared more often than ever on the streets of provincial towns. Behind this diversity, however, there was a clash between two fundamental styles – Art Nouveau, known in Russia (and in France too as an alternative term) as *stil' modern*, and Neoclassicism. Neither of these was seen in Russia in pure form, but with an admixture of myriad nuances following the personal tastes of architects and their clients, which often reflected their particular interpretations of new Western European ideas.

Moscow's first Art Nouveau buildings appeared in the mid-1890s, the style attaining its efflorescence in the first years of the new century. By 1910 its popularity was giving way to a Neoclassical revival. Despite its short period of ascendancy, Art Nouveau left its mark on Moscow and a number of Russian industrial cities. In the 1890s some Russian architects began to express their increasing dissatisfaction with historicism and eclecticism. These architects held a congress in 1892 and a second in 1895 which emphasized the urgency of finding a new architectural style that would answer the needs created by recent changes in the functions of buildings and methods of construction. Mikhail Konstantinovich Bykovsky, representing the third generation of an architectural dynasty, emphasized in his keynote speech at the second congress that "beauty of form that is unconnected with the circumstances of the origins of that form amounts to nothing more than decoration of façades". He called for "freshness, simplicity [. . .] a complete departure from old forms and from the fundamentals of the past and the establishment of architecture on the path of rationality".[106] Rationalism was one of the watchwords of the era both in Russia and in Western Europe, and was well attuned to the rapid development of Russian constructional engineering and the incoming use of new building materials, especially ferroconcrete, which was promoted at the 1895 architects' congress. In 1902 Pyotr Maksimov made the following comment on the new architecture in the journal *Zodchiy*:

The significance of the new style, of course, lies not in new decorative forms (which are trivialities), but is to be found at a much deeper level. Only an architect who can create something new in the general form of a building, in the disposition of its mass and the planning of its rooms, may be called original [. . .].[107]

It would be wrong to see this statement merely in terms of developments connected with Art Nouveau. This kind of thinking, coming from Russian architects, had a wider perspective. It looked forward, in fact, to the avant-garde of the 1920s. It was recognized at the very beginning of the twentieth century, when Art Nouveau was beginning to flourish, that the realization of the conception of a new living environment would require major social changes in Russia. "As in human society," wrote the architect Igor' Volnukhin in 1902, "in architecture there is a struggle going on between the old and the new, and in architecture too a revolution is urgently needed as a business plan."[108] Such ideas may well have sprung up in Russia as a result of reports of the activities of the Deutscher Werkbund. An architectural revolution, like revolution in any form, could not be brought about without thorough preparation, without the continuous development of twentieth-century architectural methodology in several stages. In this respect Moscow Art Nouveau played a key role.[109]

The style had contradictory features. On the one hand, Art Nouveau practitioners working in the ancient capital of Russia attempted to work out a new system of architectural form based on the interior organization of a building. In other words, they pursued rationalistic ideas and seized upon new constructional methods and building materials. On the other hand, their work showed Moscow Art Nouveau architects to be decidedly romantic and unrationalistic, concerned with the creation of new myths in symbolic graphic form. Many developed their own architectural mythology in decorative schemes featuring strange figures, wondrous foliage forms, fabulous beings and sea beasts. Neo-Romantic feeling played an important part in Moscow Art Nouveau.

The new movement was preceded by the achievements of an artistic coterie founded by the merchant Savva Mamontov, whose family used most of its wealth to foster the development of new art. This became known as the Abramtsevo Circle, much of the work of its artists – who included leading painters such as Viktor Vasnetsov, Vasily Polenov and Mikhail Vrubel' – being executed on the Mamontovs' estate of Abramtsevo outside Moscow (pl. 367).[110] The artists, architects and craftsmen of this circle based their work on a Romantic perception of folk art and Early Russian architecture and aimed at a new approach to the decorative arts (pl. 368). The work of the Abramtsevo Circle during the 1870s and early 1880s, and of the workshops of Princess Tenisheva on her estate of Talashkino

367 The Church on the Mamontov estate, Abramtsevo (Viktor Vasnetsov), 1881–82.

near Smolensk in the 1890s,[111] were a Russian equivalent of the Arts-and-Crafts movement in England. Former members of the Abramtsevo Circle played their part in the design or commissioning of many of the most important Art Nouveau buildings in Moscow, including the Yaroslavl' Station and the Metropole Hotel.

Moscow Art Nouveau was also influenced by the evolution of Gothic Revival, especially in its English version, in the last quarter of the nineteenth century. Romantic images of medieval architecture were among the sources of this

Moscow style. Its range of models, however, was extremely wide, from the Gothic Revival of Eugène-Emmanuel Viollet-le-Duc to William Morris's medievalism "by the people for the people", from the Hispano-Moresque Revival to the recent Romanesque Revival work of Henry Richardson in America, which was well known in Russia. It is important to note that Art Nouveau came to Russia in the first place via the influence of the Arts-and-Crafts movement and the Gothic Revival, and only after that took up the new architectural ideas of the Vienna Secession.

At the end of the 1890s, Russian architects' contacts with the West were especially intensive. The favourite decorative motifs of the architects of the Vienna Secession quickly reached Moscow, where the ideas of the artists' colony in Darmstadt were also well known. Paris was still a Mecca for Russian artists, though more for painters than architects, and the same could be said of Italy. The sombre Scandinavian forms of Art Nouveau, with their predilection for unadorned stone, reached Moscow via St Petersburg. At the 1901 International Exhibition held in Glasgow, Russian visitors to the city, in particular the architect Fyodor Shekhtel', who built the Russian pavilions for the occasion, discovered the work of Charles Rennie Mackintosh.[112] The Art Nouveau architectural movement in Moscow sprang from a number of different centres of new aesthetic ideas all over Europe in a rich synthesis of influences, a synthesis of a kind new for Russia, involving not merely the reception of accessible Western artistic ideas but active participation in the creation of a new European style on a basis of equality with other nations.

In the mid-1890s Moscow architecture was poised between Gothic Revival and the new style. In 1893 the leading Moscow Art Nouveau architect, Fyodor Osipovich Shekhtel',[113] built a sumptuous house for Zinaida Morozova, wife of Savva Morozov, on Spiridonovka Street. While its exterior style was strictly Gothic Revival in the English manner, in its interiors the dynamic, sinuous lines of Art Nouveau made their appearance along with Neo-Romantic sculpture. In the house Shekhtel' built for himself on Yermolayevsvsky *pereulok* in 1891, he took these features further in a generalized Romantic medieval recreation decorated in English Perpendicular style. His breakthrough to Art Nouveau came with the turn of the century.

368 Detail of a majolica bench, Abramtsevo (Mikhail Vrubel').

370). The exterior consists of contrasting geometrically well-defined blocks, with extended, organic decorative forms displaying the architect's familiarity with the work of the Vienna Secession (pl. 371). A broad, brightly coloured mosaic frieze depicts fantastic flowers rising above water. The wave-shaped

5 m

369 The Derozhinskaya's house, Moscow (Fyodor Shekhtel'), 1901.

370 Plan of the house of Sergey Ryabushinsky, Moscow (Fyodor Shekhtel'), 1900–02.

In 1900–02 Shekhtel' built two Art Nouveau masterpieces, a mansion for the art-collector and publisher Sergey Ryabushinsky on Malaya Nikitskaya Street and at more or less the same time another for A. I. Derozhinskaya, the daughter of a wealthy merchant, on Kropotkin *pereulok* (pl. 369). In Ryabushinsky's house (now the Gorky Museum) the principle of building from the inside outwards, from the central point to each of the linked blocks, is logically carried through. All the rooms of the house are grouped around the main staircase, which falls freely and smoothly like a wave, to strike the ground floor and break in the circles of its parquet pattern (pl.

stone external staircase, capitals of columns and lamps in the form of sea creatures and, in one room, swaying reeds painted on the ceiling, all plunge the house into the fairytale world of an underwater kingdom or paradise garden, interior and exterior decorative motifs combining to create a total mythology (pl. 372). It is perhaps this saturated, poetic architectural content, leading away from the everyday world, that is the definitive characteristic of Moscow Art Nouveau (pl. 373).

Two more important examples of Shekhtel's work in Moscow are his new Art Theatre (Khudozhestvennyy teatr) for Konstantin Stanislavsky and Vladimir Nemirovich-Danchenko,

371 *(facing page)* Garden façade of the house of Sergey Ryabushinsky, Moscow (Fyodor Shekhtel'), 1900–02.

372 Staircase in the central hall of the house of Sergey Ryabushinsky, Moscow (Fyodor Shekhtel'), 1900–02.

373 Detail of the façade of the house of Sergey Ryabushinsky, Moscow (Fyodor Shekhtel'), 1900–02.

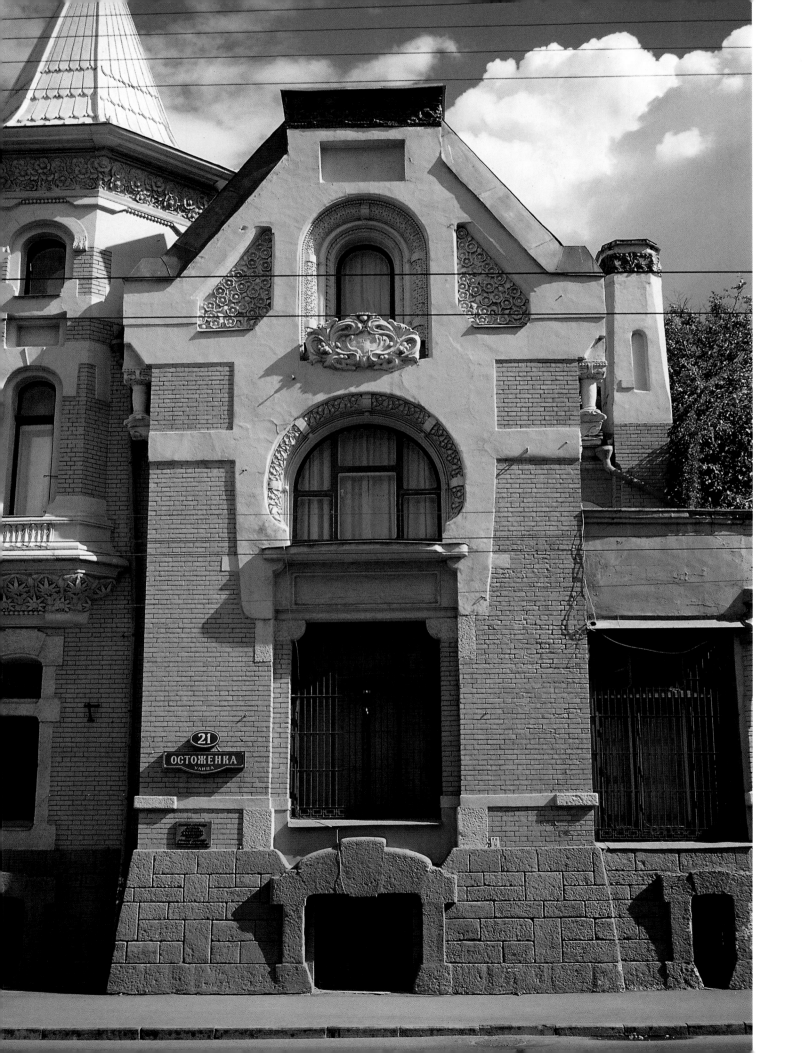

375 Portico of a mansion, Nikitin estate, Kostino, Ryazan' province (Fyodor Shekhtel'), 1910s.

1902 and the Yaroslavl' Station commissioned by Savva Mamontov. In the architectural forms of the latter he sought to recreate some of the legends and tales of northern Russia.

A major Moscow architect active at the same time as Shekhtel', Lev Kekushev, pursued a similar path.[114] The mansion he built for the industrialist Fyodor List on Glazovsky *pereulok* in 1899 displays much of the decorative panoply of Moscow Art Nouveau – mosaics, sculptured bas-reliefs, the curving metallic forms of handles and railings replace the traditional elements of historic styles, as in his own house on Ostozhenka Street (pl. 374). William Walcott,[115] of British extraction but born in Russia, was another architect working in Moscow at this time. His houses, and above all the Metropole Hotel on Theatre Square (1899–1903), are among the finest examples of Art Nouveau architecture in Moscow. His work is typified by flat façades and monumental embellishment of exteriors with the work of leading artists. The façades of the

376 The Moscow Merchants' Building (Fyodor Shekhtel'), 1909.

374 (*facing page*) The Kekushev house, Moscow (Lev Kekushev), 1898–99.

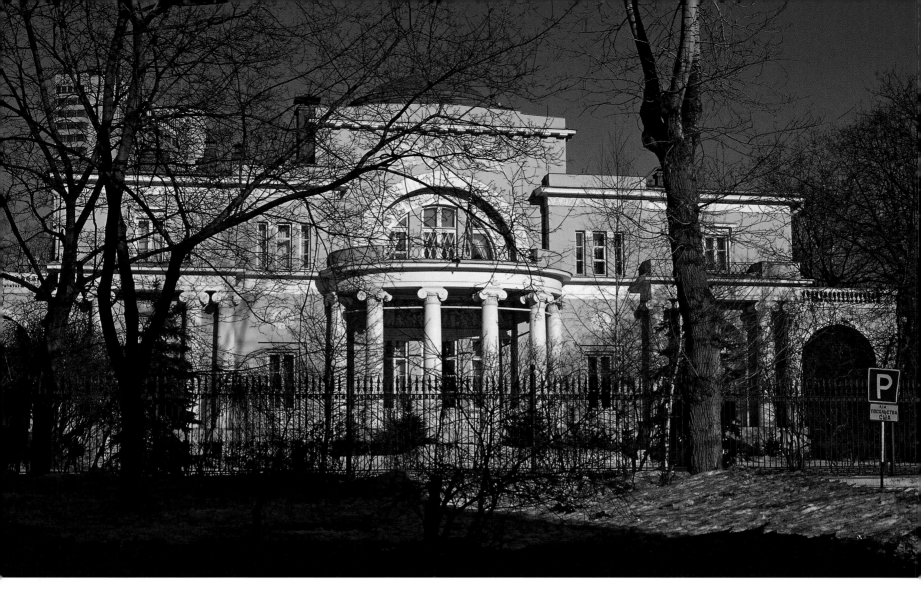

377 The Vtorov house, Moscow (Vladimir Adamovich and Vladimir Mayat), 1913.

Metropole Hotel have ceramic panels by Mikhail Vrubel' and Aleksandr Golovin and bas-reliefs by the foremost sculptor of the time, Nikolay Andreyev. A ceramic frieze above the second floor displays a quotation from Nietzsche above the city centre: "When you build a house, you see that you've learned something."

It is undoubtedly Shekhtel', however, who played the leading role in Russian architectural evolution in the first years of the twentieth century, defining the main lines along which Art Nouveau developed in Moscow. A new strain of the style emerged in his commercial and office buildings which is customarily termed "rationalist-modern", its hallmark being a rigorously rationalistic approach subordinating all questions of interior design to function. The construction of the carcases of Shekhtel's buildings of this time is clearly revealed in their façades. Between simple pylons extending to the full height of a building, large windows take up most of the wall surfaces. As

Shekhtel's style developed, decoration became more and more laconic. If eclectic decorative detail lingered on in the Kuznetsov office building on Myasnitskaya Street (1899–1901), in the Boyar's Hall (Boyarsky Dvor) Hotel on Old Square (Staraya ploshchad'; 1901–03) he dispensed with it altogether. In 1904–05 he built the Ryabushinsky office building on Il'yinka Street, the most laconic of all his buildings, almost in the spirit of Adolf Loos. Later still, he composed the façade of the Moscow Merchants' building (Torgovyy dom Moskovskogo kupechestva) on Maly Cherkassky *pereulok* (1909–11) with great plain piers and plate-glass windows (pl. 376), looking forward to 1920s Avant-Garde architecture. In 1909–10 he turned to Neoclassicism, building himself a house in this style on Bol'shaya Sadovoya Street, followed by a Greek Revival palace, uncompleted, on the Kostino estate in Ryazan' Province (pl. 375) – indicating that Neoclassicism was winning out in the struggle with Art Nouveau in Moscow.

The Neoclassical tradition continued uninterrupted in Moscow and the provinces for the whole of the nineteenth century and the first years of the twentieth, but in the mid-1900s burst into new efflorescence[116] in mansions for the wealthiest industrialists.[117] Outstanding among these were the houses for Vtorov on Spasopeskovsky Square designed by Vladimir Mayat and Vladimir Adamovich (1906; pls 377, 378), for Mindovsky on Myortvy *pereulok* built by Nikita Lazarev (1906; pls 379, 380), and for Gribov on Khlebnyy *pereulok* designed by Boris Velikovsky). Tenement houses were also put up in this Neoclassical Revival, the most interesting example being built by Aleksandr Tamanyan on Novinsky Boulevard for Prince Shcherbatov (1912–13),[118] combining a tenement block and the typical Moscow city mansion layout of the Neoclassical era, with its central corpus and wings. The owner's living quarters, as spacious as the Moscow mansions of the Empire period, were placed above all the other apartments as the principal upper floor. At this time too Ivan Zholtovsky, who was to be the leading practitioner of Stalinist Neoclassicism, built the Tarasov house on Spiridon'yevsky Street in Renaissance Revival style, in imitation of Palladio's Palazzo Thiene, and also the Racing Society house for which he used Russian eighteenth-century Palladian models.[119]

At the beginning of the twentieth century, provincial architects followed the example of Moscow rather than St Petersburg. Towns grew up especially rapidly in areas where the textile industry was concentrated, with Vladimir Semyonov leading the garden city movement in Russia and the example of American "company towns", like Pullman near Chicago, no less influential. Russian architects, however, gave aesthetic features to these factory settlements, each of which belonged, as it were, to an industrialist's extended family. The "Paris" workers' block sited beside the art-collecting Morozov family's textile factory in Tver' combines Art Nouveau fantasy with typical features of English brick factories (pls 381, 382). In the Konovalov textile settlement of Bonyachki in Ivanov province, wooden peasant-style workers' houses were put up next to elegant Neoclassical public buildings.[120]

Art Nouveau buildings in St Petersburg are markedly restrained by comparison with those in Moscow, their façades usually covered with low-relief and graphic ornament in natural stone of subdued colouring, frequently in dark Finnish granite, and contrasting bright mosaic tiles. The planning of interiors of tenement houses, mansions and public buildings was thoroughly rationalist, with geometrically well-defined blocks, though occasionally smooth-flowing forms would be found. Furthermore, if on the arrival of Art Nouveau in St Petersburg the city's architects seized on the stylized figures and plant motifs, majolica panels and stained-glass windows of

378 Columned hall of the Vtorov house, Moscow (Vladimir Adamovich and Vladimir Mayat), 1913.

the new fashion, by the beginning of the second decade of the century, before the beginning of the First World War, its favourite modes and motifs began to mingle more and more frequently with the familiar elements of historicism, Classical and Rococo Revival wreaths and garlands appearing alongside blossoming flower and vine forms and spiderweb balcony railings.

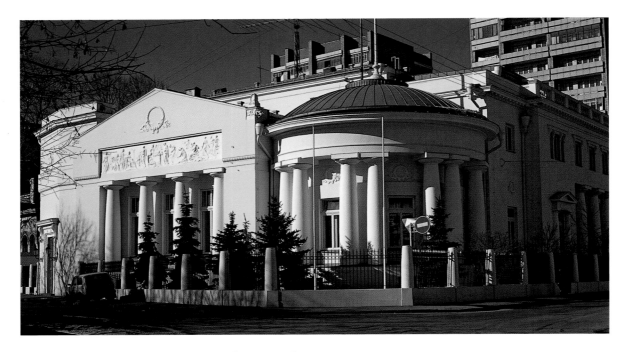

379 The Mindovsky house, Moscow (Nikita Lazarev), 1905–06.

380 Sculptured frieze on the façade of the Mindovsky house, Moscow (Nikita Lazarev), 1905–06.

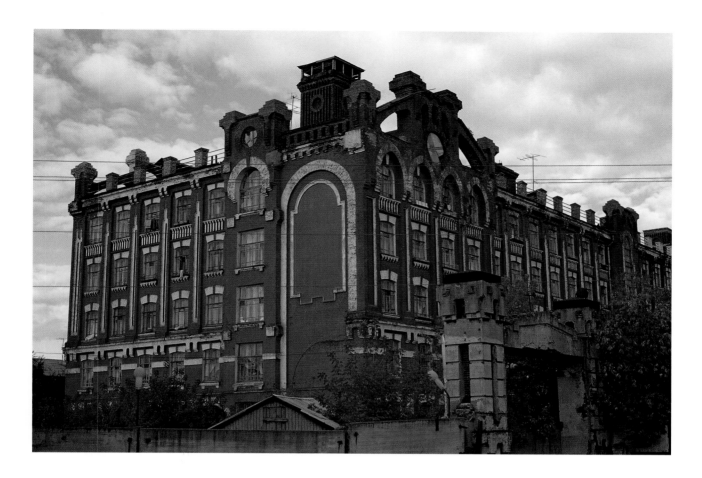

381 (*above*) The "Paris" housing block for workers at Ivan Morozov's textile factory, Tver' (Vladimir Tersky), 1910s.

382 Detail of a façade of the "Paris" housing block for workers at Ivan Morozov's textile factory, Tver' (Vladimir Tersky), 1910s.

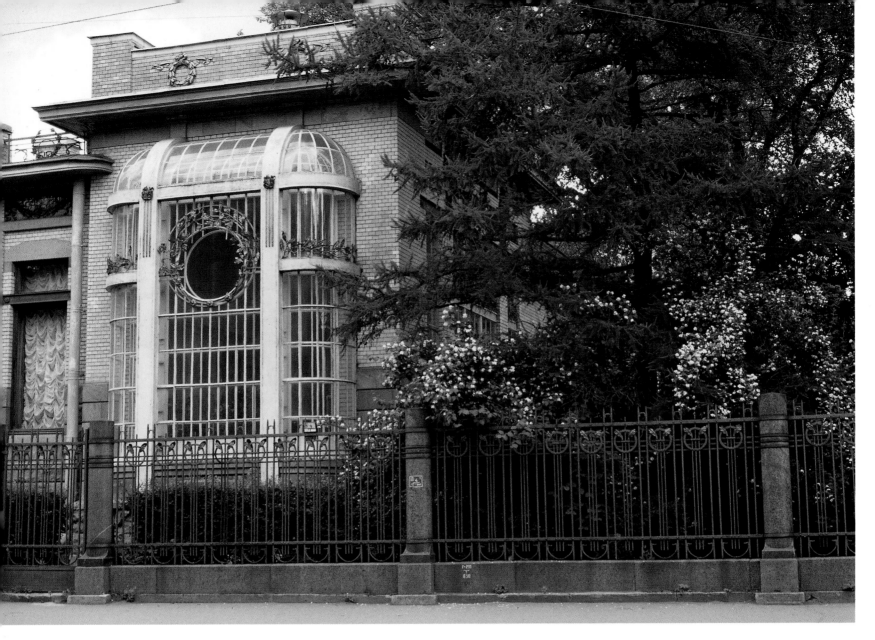

383 Kshesinskaya's house, St Petersburg (Alexandr Gogen), 1904–06.

Art Nouveau retained, nevertheless, an essentially romantic style in St Petersburg. This can be felt in its aestheticism, its combination of cultivated refinement and deliberate simplicity, and its abundance of decorative symbols, in the dream of a future never to come that infuses the confident modernity of its forms and constructions. It derives a high degree of elegance from the splendours of early twentieth-century building technology and materials, which give polished perfection to details of a practical nature such as door-handles, window fastenings, ventilation openings, and even locks and hinges.

St Petersburg architects of this period were indeed masters of building methods. The leading practitioners of Art Nouveau in the northern capital were Aleksandr Gogen, Pavel Syuzor, Ernest Wirrikh, Nikolay Vasil'yev, Gavriil Baranovsky[121] and,

above all, Fyodor Lidval'.[122] The latter could combine the latest architectural forms with practicality and comfort on an intimate scale. These qualities are most strikingly exhibited, however, by Gogen in a mansion built in 1904–06 for the celebrated ballerina Mathilda Kshesinskaya on Kronverksky Prospekt, the quintessence of Art Nouveau in St Petersburg (pl. 383).

Neither the failed first Russian Revolution of 1905 nor unexpected defeat in the war with Japan could check the rapid growth of St Petersburg. In the first seventeen years of the twentieth century its population increased by a million, and its area expanded accordingly. The development of Stone Island Prospect (Kamennoostroskiy prospekt), extending from the Peter and Paul Fortress (Petropavlovskaya krepost') across the

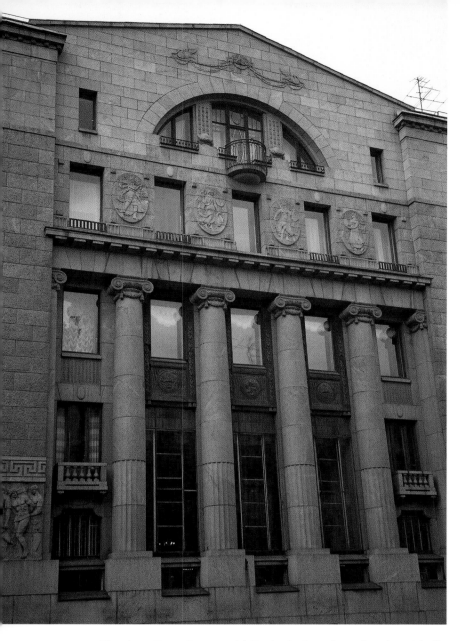

384 The Azov-Don Commercial Bank, St Petersburg (Fyodor Lidval'), 1907–09, 1912–13.

385 Detail of the main façade of the Junkers' Bank, St Petersburg (Viktor van der Guht), 1910–12.

whole of Petrograd Side as far as Stone Island, was especially typical. In the course of the first two decades of the twentieth century, it was entirely built up with multi-storey housing blocks, Neoclassical style replacing Art Nouveau around 1910.

The pre-revolutionary decade in St Petersburg brought the rapid transformation of Art Nouveau, a return of historicism and a strengthening of the position of Neoclassicism. In the Azov-Don Commercial Bank built by Lidval' in 1912–13, Neoclassicism wholly replaces Art Nouveau (pl. 384), although the strict, plane-surface composition of the façades is in opposition to the traditional plastic monumentality of St Petersburg Neoclassicism. The "new rationalism", making its own use of

Neoclassical forms, is strongly present in the Junkers' Bank, built by the St Petersburg architect V. I. van der Guht shortly before the First World War; the building strikes a contradictory note, simultaneously retrospective and contemporary, rationalistic and romantic (pl. 385). This and the Mertens building on Nevsky Prospekt demonstrate the new contemporary "imperial" style of the Russian capital, succeeding Art Nouveau. Traditions of imperial Neoclassicism were destined to be reborn. After the Russian Avant-Garde had enjoyed twenty years of riot, the Stalinist era saw a return to a very similar architectural style in St Petersburg, now Leningrad, and to an even greater extent in Moscow.

VII

The Soviet and Post-Soviet Eras

1 The Architecture of Soviet Russia and the West

For the best part of nine centuries Russian architecture had gradually drawn closer to that of the West. The Revolution of 1917 broke with that tradition. The situation was not simply the result, in obvious ways, of political confrontation between the Soviet system and the surrounding world, and the changing degrees of penetrability of the Iron Curtain during different periods of the Soviet era. Architectural links between Russia and the West continued through the entire Communist period, but they took on a new meaning. When developments originating in the so-called capitalist world reached Russia, they were perceived in a different social, cultural and psychological context from that of circumstances prevailing in Europe or America, and directed towards different goals.

In order to understand the changes that took place in Russian architectural thinking after 1917, it is necessary first of all to appreciate the scale of the complexities and contradictions in Soviet attitudes to the West, continually shifting in response to the internal and external political situation. Furthermore, in contrast to previous periods in Russian history, the goals of architects and of the guardians of state ideology were often strikingly opposed. Soviet architects, without taking undue risks, frequently found diplomatic ways of resisting the dictates of the Party, which were so often patently unreasonable, and being in touch, as far as lay within their capacities, with leading architectural developments in the rest of the world.

Soviet attitudes to the West were manifested on various levels. According to Communist theory, it was other countries that were supposed to be the first to change, not Soviet Russia, which had chosen the "most advanced" path of development. The espousal of Western ideas or the adoption of a "capitalist" way of life were considered crimes, punishable with differing degrees of severity from Stalin to Brezhnev. Nevertheless, the Soviet system, including architecture and the building industry, could not make progress without Western technology, and this, in turn, brought with it external features influencing the appearance of buildings and the design of many elements of daily life. The authorities did their best, of course, to conceal the use of foreign models. Numerous books and periodicals on architecture and the building industry were stocked in libraries with the rubric "for official use only". This meant that for access to these publications a special permit was required, and it was forbidden to refer to them in print. Relations with the West in the architectural domain were therefore conducted under the mantle of secrecy, except in the years immediately following the Revolution or during the so-called "Thaw" under Khrushchev. In the post-Revolutionary Avant-Garde period international contacts were no less, if no more, intensive than at the turn of the nineteenth and twentieth centuries. In the 1960s information about architectural developments in foreign countries was relatively widely available in the Soviet Union. Throughout most of the Soviet era, however, any stylistic similarity to this or that aspect of Western architecture went without public comment. It was not always possible to maintain this reserve, although under Stalin new buildings very successfully adopted Neoclassical dress. Such use of architectural forms of the past was sharply contradictory.

According to the Communist utopian ideal, the environment of everyday life had to be radically changed even at the socialist stage; a complete break with the past was held to be imperative. Architectural development in the Soviet era took place against a background of general destruction of historical monuments and the traditional environment of life on a scale hitherto unseen in Russian history. This was brought about by the war waged by the new rulers of the country against the culture of the church and the gentry and the resulting fundamental changes in the life-style and property relations of the population. Some two-thirds of all churches and more than

ninety per cent of country houses of the gentry were destroyed. Most houses of merchants and petty bourgeoisie in historic towns were turned into multi-family apartment blocks. Despite the prodigious restoration of the most famous architectural ensembles that took place after the Second World War, such as Pavlovsk and Peterhof and the historic centres of cities like Novgorod and Smolensk, Russia's architectural monuments suffered irrecoverable losses during the Soviet period, and this included the built heritage of the minority peoples of the Soviet Union.

It is impossible within the compass of the present book to give an account of all the national architectural traditions that existed on the territories of the Soviet Union up to and including the twentieth century. The architectural traditions of each of the peoples of the former Soviet republics demand individual research into both their previous history and their survival under Soviet rule. The final part of this book will concentrate on those elements of Soviet architecture that have provided the starting-point, at the beginning of the twenty-first century, for a new Russian architectural school. The first subject to be considered will be the forms taken by architectural links with the West during the Soviet period and the impact of these on the present situation.

Russian architectural history from the early 1920s after the conclusion of the Civil War to the collapse of the Soviet Union in 1991 was determined by the development of the Soviet system, the milestones in which laid down the complete course of Soviet architecture, which was characterized by a rapid succession of largely heterogeneous aesthetic and technological conceptions enforced by central authority. This was not entirely new; a succession of architectural styles had been similarly laid down in the imperial era and earlier. In those times, however, stylistic changes had most often had some closeness to Western European architectural developments. In the Soviet period the course of architectural history swung repeatedly in different directions, at times "forward" towards new technologies of scale, at times "backward" to styles of the past, at times in accordance with, at other times counter to general international trends. In earlier times, furthermore, stylistic changes had not been so extreme or so frequent, and had affected the environment of everyday life to a far lesser extent. The thoroughness, rapidity and brutality with which political decisions were carried out were far greater in the Soviet era even than in the reigns of Ivan the Terrible and Peter the Great, when it had been physically impossible to put major new measures into force on a national scale with such speed. The Soviet system was extremely effective in bringing about the already-mentioned change in the appearance of towns and villages, and its "transformation of nature" and

"building of a new world" were calculated to shape the landscape and built environment of Russia long after its own demise. The new order was not established, however, all at once. In the first years after the Revolution, for example, it seemed that architects themselves were to be able to choose the new forms and images of a reorganized lifestyle in the creation of a new world.

The one and a half decades of the Avant-Garde, from the Revolution to the beginning of the 1930s, was the only time in the thousand-year history of Russian architecture when it not only freely absorbed different influences from abroad but also itself influenced the pace-setters of world architecture. The Russian Avant-Garde exercised a significant influence on the thinking of foreign architects throughout the twentieth century. It stamped Soviet architecture with an extreme radicalism which set it off sharply from the left-wing architectural movements of Western Europe. However, at that time the technological means for widespread expression of original artistic ideas was lacking in Russia; the creative aspirations of architects outstripped practical building possibilities. The impact of the Russian Avant-Garde on world architecture continued, nevertheless, even after its development was cut short at the beginning of the 1930s under Stalin, when it was banned in the Soviet Union even in reminiscence.

If the value of any given period in architectural history may be reckoned in units of new and persuasive forms and bold projects which maintain their impact for decades after their creation, the latter yardstick in particular will determine the place of the Russian Avant-Garde in twentieth-century world architectural history. The urban plans of Nikolay Ladovsky and Nikolay Milyutin, the new types of communal housing blocks designed by Moisey Ginzburg and Ivan Nikolayev, the monument to the Third International by Vladimir Tatlin, the Workers' Factory Club buildings of Konstantin Mel'nikov, the dynamic compositions of Kazimir Malevich and Lazar' ("El") Lissitzky, the Futurist architectural fantasies of Yakov Chernikhov, the free-standing constructions of Ivan Leonidov – these alone are sufficient to earn the period a place in world architectural history.

Russian Avant-Garde architecture stands out among other twentieth-century architectural schools for its clearly expressed concern with the environment of living. For the architects of the exhilarating first years of the Revolution, breathing a daily atmosphere of change, expectations of the "radiant future" were no less a reality than the grim present. Their passionate espousal of the new contained a creative power which led to the rapid supremacy of functionalism and rationalism. These movements gained currency in the West much more gradually than in Russia in the late 1920s.

By its very nature, architecture was amenable to the spirit of Revolutionary Russia,[1] and it was at the heart of the Revolution from the beginning. Architects planned for a new way of life, which they attempted to predict. In the well-known concept of the collaboration of the arts they saw ways of creating a new image of the everyday world. Artists vied with architects in addressing themselves to the transformation of urban space and laid down the stylistics of new forms in many areas.[2] In the 1920s architects and planners in a number of countries sought to transform the environment of everyday life by creating new forms of mass collective housing. This kind of building was much more typical of Russia and Germany than of Great Britain, the United States and even France. Le Corbusier, considering a house to be "a machine for living in", won a greater degree of individualism for the living cell than it was accorded by Soviet architects, whose attention was focused on a type of dwelling with minimal individual living space and greater common utility areas, the "communal block" (*dom-kommuna*), designed with collective social development in mind. Surviving examples of the latter type of building dating from the 1920s are Ivan Nikolayev's communal block for students of the Textile Institute and Moisey Ginzburg's house for employees of the People's Commissariat for Finance (Narkomfin; pl. 387) in Moscow and Il'ya Golosov's collective block in Ivanovo-Voznesensk.[3] From the 1930s onwards, high-ranking Party officials made use of these designs in the construction of recognizably modern but more luxurious housing blocks for themselves. The so-called "Government House" ("Dom Pravitel'stva") in Moscow, built by Boris Iofan, came to be seen as a kind of citadel of the new way of life for the new power elite (pl. 388).

The 1920s was a time of intense discussion of the theoretical bases of contemporary architecture, with differing viewpoints on building tasks, building methods and means of realizing creative ideas dividing architects into a variety of professional groups and associations. This period saw opposing trends in urban theory, disputes between the proponents of urbanization and de-urbanization, changes in the principles of architectural training, and finally, innovatory conceptions of architectural composition and experiments in the analysis of architectural form. The attempt to find solutions in all these areas produced constant public debates and competitions throughout the 1920s.

Soviet architecture, despite the control exercised over it by central authority, was never homogeneous. In the early post-revolutionary years professionally grouped architects in Moscow and St Petersburg continued to work in pre-revolutionary styles.[4] At the same time other leading figures such as Peter Behrens and Ivan Fomin attempted a reconstruction of

387 Communal residential block, People's Commissariat for Finance (Narkomfin), Moscow (Moisey Ginzburg and al), 1928–30.

Classical architecture based on generalized Order-based forms, creating the so-called "Red Doric".[5] El Lissitzky, Il'ya Golosov and Konstantin Mel'nikov conceived of architectural expressiveness in Symbolic-Romantic forms.[6] Ginzburg's manifesto *Style and Epoch* (1924) espoused mechanical forms.[7] By the mid-1920s the credos of the first Soviet architectural groups,

388 Cinema in the residential block for high-ranking Party officials ("Government House"), Moscow (Boris Iofan), 1928–31.

Asnova (Association of New Architects) and OSA (Association of Contemporary Architects), had been formed, both declaring a close affinity with science and technology. Each classified building methods and the handling of aesthetic questions as separate specialities. Asnova, its leading figures Nikolay Ladovsky, Vladimir Krinsky, Mikhail Turkus and others, propagated Rationalism.[8] Its members focused their attention on artistic tasks, seeking to establish objective, psychophysiologically based laws of form and the possibilities of objective perception of architecture (pl. 389). The OSA (Aleksandr Vesnin, Moisey Ginzburg, Yakov Kornfel'd, Andrey Bukov and others) had as its aim the complete transformation, by architectural means, of the environment of everyday life in accordance with

the new principles of social reconstruction.[9] It did not deny the significance of aesthetic architectural questions, but saw them as directly dependent on industrial and social processes and new technology; it contributed the functionalist planning method to contemporary architectural thought. In addition to these two leading associations, a number of other architectural groups sprang up and dissolved in Russia during the 1920s.[10]

The Constructivist movement in Soviet architecture was founded chiefly by architects of the OSA.[11] One of its principal aims was the exposure of internal spatial structure in laconic façades shorn of traditional ornamental detail. Plain wall surfaces, plate-glass windows and clearly articulated rhythms of horizontal series of window apertures, geometric, flat-roofed

391 *(facing page bottom)* The Zuyev Club, Moscow (Ilya Golosov), 1927–29.

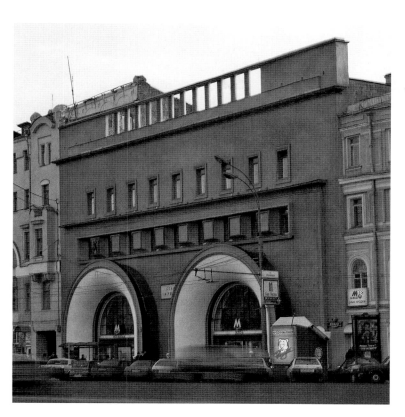

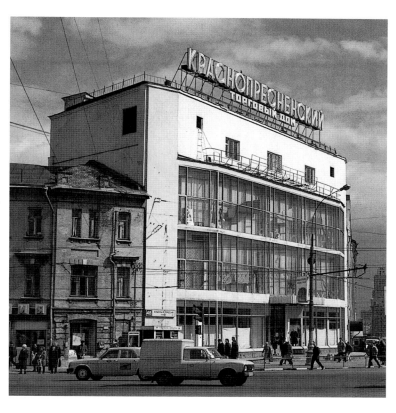

389 Lubyanka Metro station, Moscow (Nikolay Ladovsky), 1937–38.

390 Mostorg department store, Moscow (Vesnin brothers), 1927.

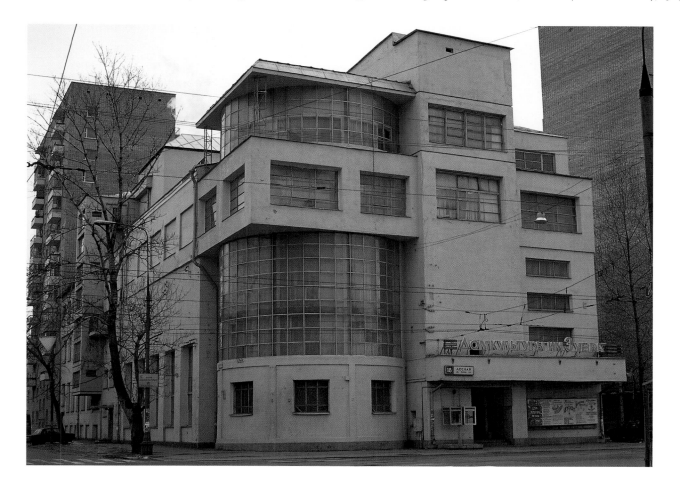

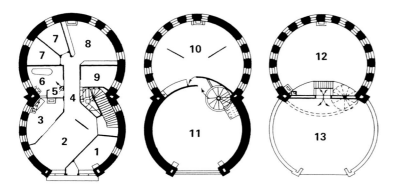

392 Plan of the house of the architect Konstantin Mel'nikov, Moscow (Konstantin Melnikov), 1927–29.

1 entrance-hall
2 dining-room
3 kitchen
4 corridor
5 lavatory
6 bathroom
7 children's study rooms
8 dressing-room
9 wife's workroom
10 bedrooms
11 living-room
12 studio/workshop
13 terrace

393 The house of Konstantin Mel'nikov, Moscow (Konstantin Mel'nikov), 1927–29.

building blocks, contrasts between bare walls and exterior and interior spiral-staircases designed to accommodate large numbers of users – such were the hallmarks of Constructivist architecture (pls 390, 391). The overriding aspiration was the creation of an aesthetic in keeping with the general orientation of international "modern architecture". I shall demonstrate later how Russian Constructivist architects readily scrapped their own plans in favour of those of celebrated foreign ideologues of the Modern Movement, so eager were they for Soviet architecture to become more "international".

A different direction was taken by Konstantin Mel'nikov, architect of the Makhorka pavilion at the All-Russian Agricultural Exhibition of 1923, the Soviet pavilion at the Paris Exposition of 1925, the series of Factory Workers' Clubs of 1927–28 (pl. 394), and his own house in Moscow (pls 392, 393).[12] Typical of his work was a new treatment of space that gave artistic meaning to functionalist solutions. His idiom would not seem to have been directly connected with the ideas of the Modern Movement, but he certainly belonged to the Avant-Garde in the fullest sense of the term, although he had no wish for his work to be associated with any particular trend or movement, however important.

It would be wrong to portray the 1920s as a period of the Avant-Garde's unrivalled supremacy. Architects who had made their reputations before the Revolution continued to be active and were hard to dissuade from their established ideas. Architectural students by no means always wanted to study with the Avant-Garde. On the contrary, even at the leading schools most preferred to enrol with older teachers with substantial professional experience rather than with Avant-Garde figures who had not yet proved themselves in professional practice. There was, however, no overt clash between the old and the new at this time. For the first fifteen years after the Revolution the authorities were on the side of the innovators. As always, an important role was played by mid-way figures such as Aleksey Shchusev, who was capable of building in both Russian Style and in the manner of le Corbusier (pl. 395).[13] Despite the fact that he had built a number of churches before the Revolution, it was no surprise when in 1924 it was he, and not one of the Avant-Garde, who was commissioned to build the Lenin Mausoleum.[14] After designing some preliminary versions he built, in 1929–30, a mausoleum in marble and granite uniting Classical monumentality with Cubist forms (pl. 396).

The 1920s and beginning of the 1930s was the only time in the Soviet era that saw the establishment of links with leftist movements in world architecture. Furthermore, by the end of the 1920s Moscow had become one of the world's leading centres of modern architecture, visited by architects from many different countries, among them Le Corbusier, Erich

394 (*facing page*) Detail of the main façade of the Rusakov Factory Club, Moscow (Konstantin Mel'nikov), 1927–28.

395 The People's Commissariat for Agriculture building, Moscow (Aleksey Shchusev), 1928–33.

Mendelsohn, Ernst May and Hannes Meyer.[15] The work of Soviet architects was in turn published in leading international journals, and appraisals of their achievements appeared in monographs on modern architecture by Taut and Mendelsohn.[16] As Irina Kokkinaki has shown, Le Corbusier began to show an interest in what was happening in Russia at almost the moment that new building recommenced after the conclusion of the Civil War. He first tried to establish contacts with Moscow in 1922, sending some issues of his journal *L'Esprit Nouveau* to the People's Commissar for Education, Anatoly Lunacharsky,[17] who found time in his busy life to arrange publication of a translation of Le Corbusier's article "Unseeing Eyes", with his own highly complimentary preface.[18] It is interesting that the architect's first Russian contact was not with an architect or an artist but with the Soviet government. He may have expected to be able to realize his ideas sooner in a country of such rapid reorganization than in other countries, and in this he was right. At about the same time further articles of his appeared in the journal *Veshch'* ("Thing") published in Russian in Berlin, for which El Lissitzky worked.[19] Discussing the architectural stands at the Paris Exposition with the writer Ilya Ehrenburg in 1925, he called the Soviet pavilion built by Mel'nikov "the only one [...] worth looking at".[20] Although there was an element of politeness in this, Mel'nikov's construction was undoubtedly more radically innovatory than even Le Corbusier's own pavilion *L'Esprit Nouveau*.

In 1927 Le Corbusier's competition design for a League of Nations palace in Geneva failed to win. It is possible that it was the situation of being "misunderstood in the West" that led to his being invited to enter for a competition to design the Moscow headquarters of the Tsentrosoyuz, the central Union of Cooperative Societies, one of the most important Soviet institutions of the time. The building was to be multifunctional, accommodating an extensive club besides administrative staff. Designs by more than forty Soviet architects, in a wide stylistic range from the Neoclassical Ivan Zholtovsky to the Avant-Gardist Ivan Leonidov, were represented in the three stages of the competition. Besides Le Corbusier, the Scottish architects John Burnet and Thomas Tait and the Germans Max Taut (brother of Bruno) and Peter Behrens were also invited to enter the competition at different stages.[21] The collective opinion of the Russian entrants, representatives of the Avant-Garde, weighed with the jury, to whom they wrote a joint letter expressing their support for Le Corbusier as the international leader of modern architecture:

> We are totally agreed in our opinion of such a figure as Le Corbusier, and we [...] consider it desirable, from the point of view of the dissemination of the basic ideas by which we are guided in our work, that Le Corbusier should be chosen for the Tsentrosoyuz building [...]. It would be important and valuable to us if such a great Moscow building were to be created by Le Corbusier.[22]

The Tsentrosoyuz building was completed in 1935 (pls 397, 398). Le Corbusier's most important pre-Second World War building, it wasn't entirely what his Russian admirers, familiar with the features of his fully formed pre-war style, were expecting – a building raised from the ground on pilotis, a free-form plan, strip-windows and a roof-terrace. The last-mentioned was clearly impractical in the Moscow climate. The plan of the administrative parts of the building could not be free-form for functional considerations. And on main and side façades Le Corbusier chose plate-glass rather than strip-windows. The most interesting thing about this building, perhaps, is the wholehearted way in which its architect has responded to the fascination of the new Russian aesthetic, in particular the plastic compositions of Tatlin and Lissitzky. The Tsentrosoyuz building is remarkable for its complex plastic composition and the dynamic contrast between its rectangular blocks and the curved forms of the club hall and stair-towers. On the one hand, it is a volumetric composition wholly in the spirit of the experiments of the Russian Avant-Garde, and on the other, it displays its architect's typical elegance in the handling of pure geometric form.

During the seven years of planning and construction of the Tsentrosoyuz building, Le Corbusier made constant visits to Moscow and thoroughly acquainted himself with all the architectural groups and movements in the city. He himself became part of the cultural life of the Soviet capital, meeting Meyer-

396 (facing page) The Lenin Mausoleum, Moscow (Aleksey Shchusev), 1924–30.

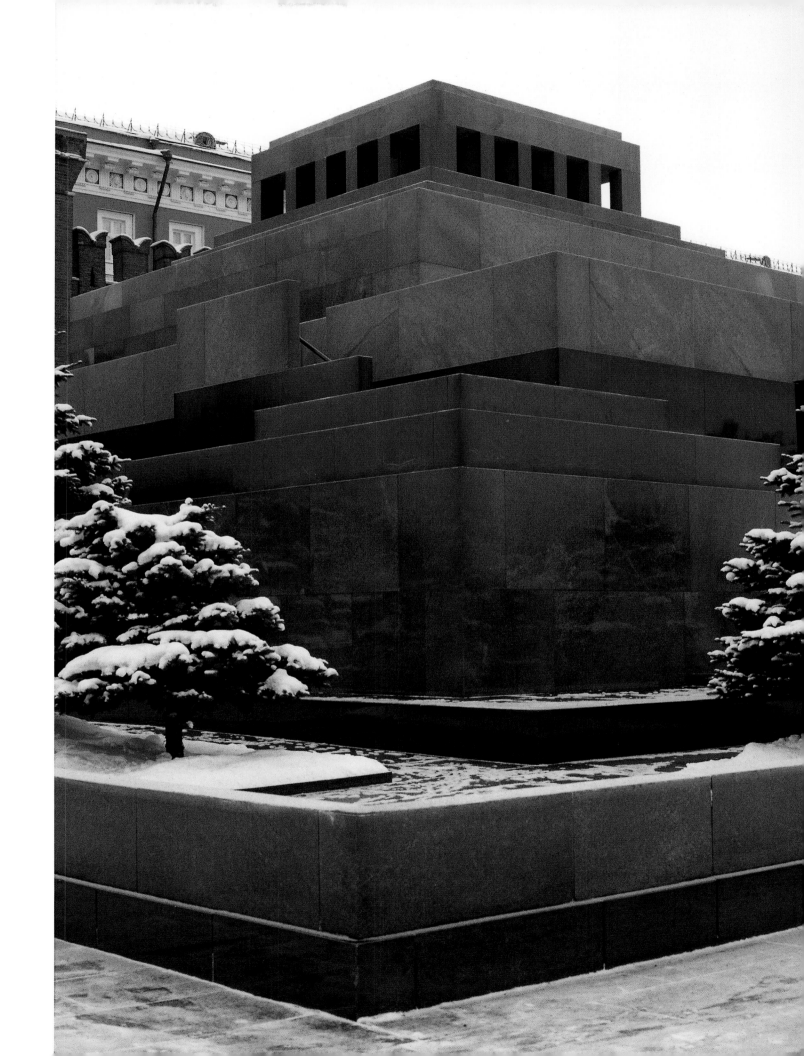

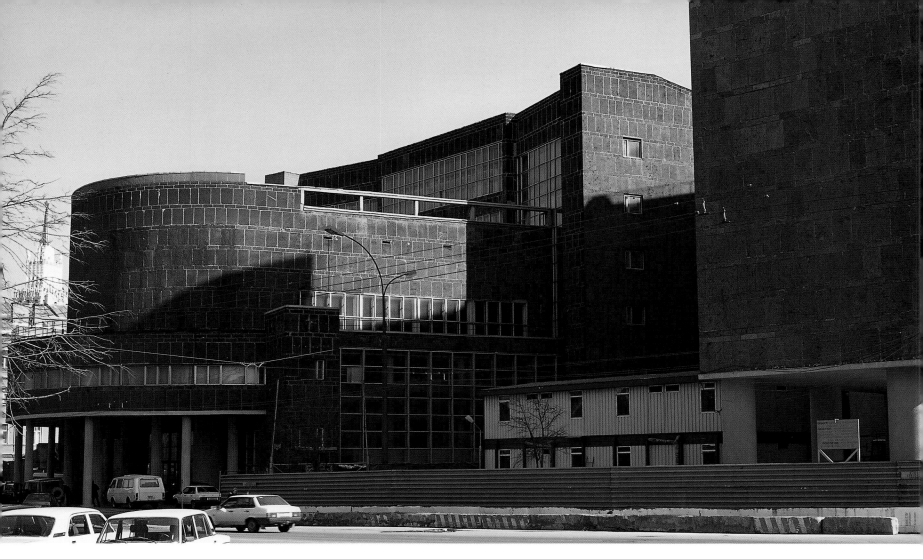

397　The Tsentrosoyuz building, Moscow (Le Corbusier, Nikolay Kolli et al.), 1928–35.

khol'd, Eisenstein, Aleksandsr Vesnin and Ivan Leonidov.[23] In 1931 he was invited to enter the latest competition to design the Palace of Soviets (Dvorets Sovetov), which was conceived as the most important architectural monument of the new era. The decision to build it had been taken in 1922, and several competitions had already been organized, in which some two hundred designs in all had been submitted, including many from other countries. Taking a radically Avant-Garde stance, Le Corbusier submitted designs for a gigantic Constructivist structure from which different halls and other constituent parts of the building would "hang". At the same time he joined the debate on the replanning of Moscow with equally radical ideas,[24] which included the demolition of a large part of the historical city centre except for the most important architectural monuments and the construction of an extensive system of residential and administrative skyscrapers. These plans were rejected, most of all because of a change in the overall direction of architectural policy in the Soviet Union at the moment when the matter of the Palace of Soviets was being decided.

Besides le Corbusier and the Soviet architects, a number of German architects entered for the competitions for the design of the Palace of Soviets.[25] This is clear demonstration of the underlying character of Soviet architectural relations with the rest of the world in the Avant-Garde period, and of German-Soviet relations in particular. The First World War, the success of the Russian Revolution and the failure of the German architects generally precluded meaningful cultural relations during the interwar decades. However, in the field of architecture and the building industry at least, there were intensive contacts between Germany and the Soviet Union throughout this period, and not only contacts but also parallels are to be seen in the architectural evolution of the two countries at this time. In large part, this was due to a restoration of the situation in the last years before the First World War.

The first contacts with Germany after 1914–18 were made in St Petersburg, where links between Germany and Tsarist Russia had been strongest. The first German-designed building in the new Russia was the textile-dyeing factory Red Banner

398 The main façade of the Tsentrosoyuz building, Moscow (Le Corbusier, Nikolay Kolli et al.), 1928–35.

(Krasnaya Znamya), work on which began in 1926 to Erich Mendelsohn's design.[26] Soviet interest in German architecture was fully declared in 1927 at the Moscow exhibition marking the tenth anniversary of the Russian Revolution[27] in which a dozen German-speaking architects participated, including Walter Gropius, Josef Hoffmann, Max Taut and Hannes Meyer.[28] In 1928 Peter Behrens, as has been seen, was among the foreign architects specially invited to enter for the concluding stage of the competition for the design of the Tsentrosoyuz building.[29] Behrens was well known in Russia as the architect of the German embassy building that stood on St Isaac's Square. His competition entry, a laconic Neoclassical design which was based on a highly simplified Order, may have been one of the chief sources of the so-called "Red Doric" movement of the 1920s which combined Avant-Garde features with forms based on a generalized Order. Behrens's Tsentrosoyuz design, although passed over by the jury in favour of Le Corbusier's, aroused the keen interest of Russian architects.

Modern architectural evolution in both Germany and Russia owes much to contacts between the two leading design schools Vkhutemas (Vysshiye khudozhestvenno-tekhnicheskiye masterskiye – Higher Artistic and Technical Workshops) and the Bauhaus.[30] The ideas produced by each of these two great schools have much in common. The Bauhaus was founded at the beginning of 1919, Vkhutemas at the end of 1920. Their educational programmes were similar, designed to produce a new type of technologically oriented architect and artist working in industry, concerned with the rational organization of everyday life and seeking artistic forms which would meet practical requirements. In both Germany and Russia these aims were largely inspired by the ideas of the English Arts-and-Crafts Movement, which had been tried out in industry and large-scale building projects before the First World War by members of the Deutscher Werkbund. The new ideas in Russian art and architecture were of interest to the Bauhaus primarily from an artistic point of view. A leading role in these links with the Bauhaus was played by Kandinsky and Lissitzky,

who both taught there, and by the impact of Malevich's work in Moscow. Members of Vkhutemas and Russian architects of the 1920s in general were interested in the ideas linking modern building technology with industrial production that had been developed at the Bauhaus.

The Bauhaus and Vkhutemas/Vkhutein continued to be similar in their later history. In 1928 Gropius was replaced as director of the Bauhaus by the Swiss Hannes Meyer, a much more leftist figure, under whom contact with the Russian school became especially close. Meyer remained in the post, however, only until 1930, when owing to conflict with the municipality of Dessau he was in turn replaced by Ludwig Mies van der Rohe. The Bauhaus was closed by the Nazis in 1933; Vkhutein was dissolved in 1930. In the latter case, however, conflict with the authorities did not surface, change taking place within the framework of general reform of Soviet higher education. The method taught by Vkhutemas/Vkhutein and its members' artistic ideas survived the Stalinist era and has been preserved in Moscow's educational institutions.

At the time of the dissolution of Vkhutemas, Meyer was working in the Soviet Union, having come to Russia soon after he had left the Bauhaus in 1930.[31] He arranged for a number of his former students to be invited to Moscow – René Mensch, Klaus Neumann, Konrad Püschel, Bella Schäfler, Philipp Tolzinger, Anton Urban and Tibor Weiner.[32] All of these joined another group of German architects led by Hans Schmidt, who had been working since 1929 in the State Architectural Planning Institute, concerned with the planning, and later the building, of new industrial towns. Schmidt and the Bauhaus graduates played a leading part in the planning of Orsk in the southern Urals, designed as a model Socialist city. Their plans remained only partially realized, however, although work on them was continued up to the mid-1950s, by which time most foreign architects had long since left the Soviet Union. Meyer returned to Switzerland in the summer of 1937, a wise decision at the height of Stalin's Great Purge. The other Bauhaus-educated architects who remained in the country and survived first the Stalinist Terror of the 1930s and then war made no significant impact on the further course of Soviet architecture, their former involvement with the Modern Movement long since forgotten.[33]

The most tragic aspect of the course of Soviet architecture after the 1920s was its abandonment, forced on it by Stalin's growing dictatorial tendencies, of the social direction it had taken at that time. Today we know the price of the industrialization of the country, the impoverishment of a whole people deprived of the necessities of food and clothing. In these circumstances Stalin and his lieutenants knew how important it was to maintain the illusion of prosperity. They perceived the vital contribution that could be made by architecture, which could provide not only the tangible aspects of social life but also its adornments. In this process, discussions of social equality or a new way of life were totally unnecessary and even dangerous to the emerging ruling class. The asceticism of Avant-Garde architecture did not serve the purpose of central authority; its language was incapable of expressing prosperity or triumphant ceremonial, or of representing what purported to be the life of the Soviet citizen. In consequence, in 1932 all Avant-Garde groups in architecture and other forms of artistic activity were dissolved, and Soviet architecture, plucked from the mainstream of the international Modern Movement, turned backward to styles of the past that had only recently been rejected.

2 The Soviet Neoclassical Revival and its Displacement by Industrialized Architecture

The period from the 1930s to the 1950s was a complete antithesis of the Avant-Garde one. The Soviet Neoclassical Revival was ushered in by the Stalinist regime as the obligatory state architectural style in 1932, and it proved by far the most powerful movement among the twentieth-century varieties of Neoclassical Revival – as much owing to the "life-building" direction taken by architecture in the new Russia during the Avant-Garde period as to the totalitarianization of Soviet society. It was found necessary to clothe the Communist utopia in the forms of the "assimilated Classical heritage". The architecture of the period between 1932 and 1954 produced an especially clear-cut type of Neoclassicism, maturing with its own individual character and embracing every scale, from decorative detail to wholesale urban planning. The use of the "age-old" forms of Classicism served the Soviet authorities well for the representation not only of the immutability of the established regime but also the idea that Communism would exist forever.

Depressing as the enforced universal use of the style was for many architects, it did bring them a nostalgic return to the pre-1914 Neoclassical Revival.[34] Major traditionalist architects of the tsarist era, surely with a certain Schadenfreude, returned to their former style. In 1934 Zholtovsky built an apartment house on Mokhovaya Street in Moscow in Palladian style, using a six-storey Giant Order in imitation of the Loggia del Capitaniato in Vicenza. Like the clubs of the Avant-Garde period, this building was a manifesto declaring that historical architectural forms were needed for the Socialist present.

Return to older architectural traditions was generally taken as mandatory even by Modernist architects, with the excep-

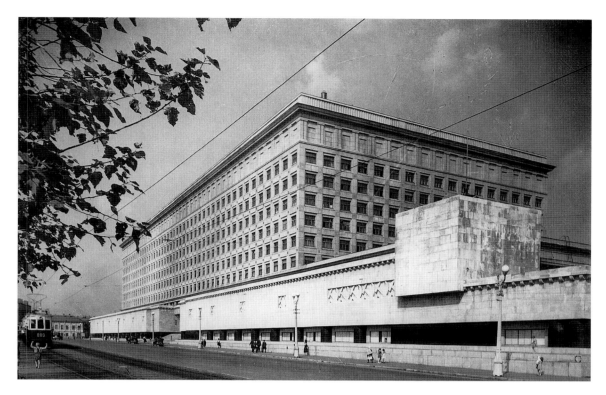

399 The Frunze Military Academy building, Moscow (Lev Rudnev), 1937.

tions of Mel'nikov and Leonidov, acknowledged Avant-Garde masters, who remained outsiders for the rest of their lives, among the tragic figures of twentieth-century Russian cultural history. The return to Neoclassical forms was neither a smooth nor a uniform process. Some architects sought to preserve what they could of the achievements of the 1920s, others made changes only to exteriors in completing projects begun earlier (pl. 399). But it was not they who set the tone for the architecture of the 1930s. They were secondary figures beside the pleiad of architects who represented Socialist Realism and played a leading role in the transformation of the urban environment that got under way in 1935 with the general plan for the reconstruction of Moscow.[35] This involved the demolition of hundreds of historic buildings, including many churches, their destruction belonging to Stalin's bid to rewrite history at this time. It would seem probable that even the plan's preservation of Moscow's ring-system was dictated not by respect for history but by its significance in emphasizing the dominance of the Kremlin under the absolutism that was once more emerging in Russia.

The Soviet Neoclassical Revival was primarily a propagandist style. The central authorities focused their attention at this time on major public buildings and complexes, which undeniably achieved powerful architectural expressiveness, albeit in the service of totalitarian ideology.[36] Huge significance was attached to the construction of the Moscow metro system, the planning of which began in the early 1930s. In contrast to the practice of other nations, whereby underground railway stations in most cases had a utilitarian character, the Moscow metro was conceived as an aesthetically imposing and ambitious architectural ensemble. Stations built by such leading architects as Aleksey Dushkin, Ivan Fomin and Leonid Polyakov are to be counted among the most important achievements of Soviet Neoclassicism and Art Deco.[37] For it was here that the latter made its greatest contribution to Soviet architecture. This was possible because in underground conditions in which architecture had to satisfy highly specialist technological requirements, even the most dedicated Neoclassical Revivalists understood that departures from traditional canons were inevitable (pls 400, 401).

The definitive example of the pre-war Soviet Neoclassical Revival style is the Palace of Soviets (Dvorets Sovetov) in Moscow.[38] After several rounds of international competition, as already mentioned, the plan submitted by Boris Iofan, Vladimir Gel'freykh and Vladimir Shchuko was accepted. It was decided to crown the palace with a huge statue of Lenin, 75 metres in height, and to treat the whole building as a monumental pedestal for this. The turning of a public building into a pedestal for a statue was a clear contradiction of democratic ideals, a statement of political totalitarianism. Architects and

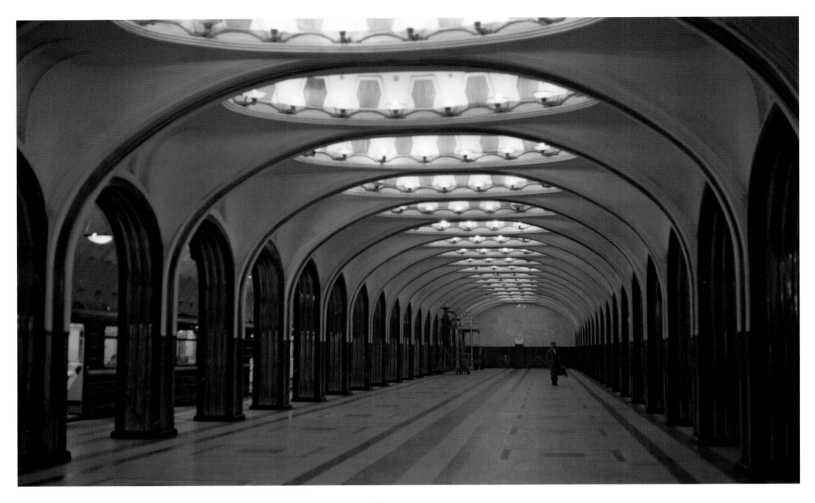

400 Interior of the Mayakovsky Metro station, Moscow (Aleksey Dushkin), 1937–38.

artists, however, were well able to carry out the task they were set. As more and more work was done on the project, the Palace of Soviets became more and more monumental. Its stylized forms, severe, massive, crude and arid, strove upwards in gigantic tiers like some kind of Tower of Babel.

The stylistics of the Palace of Soviets, a subject of wide-ranging debate to which numerous editions of alternative plans contributed, became canonical for other public buildings. Symbolic monumentality, inflexible optimism and the adaptation of Classical forms in the service of the new ideology became the hallmarks of Soviet Neoclassicism, to be seen in the Central Red Army Theatre (Tsentral'nyy teatr Krasnoy armii), for example, built in 1939–40 by Karo Alabyan and Vasily Simbirtsev (pls 402, 403). The auditorium and all other parts of the building were ingeniously squeezed into the shape of a five-pointed star. The stage could be extended to accommodate mass spectacles with cavalry and tanks.

Soviet architecture of the 1930s, however, was not simply a matter of forms foisted on it by the central authorities; it included genuine achievements in graphic expression and solutions to artistic tasks and in collaboration between architecture and other arts. The Soviet Neoclassical Revival soon attained maturity in high degree and a capacity for exerting psychological influence. The Soviet Pavilion at the Paris Exposition of 1937, designed by the architect Boris Iofan and the sculptor Vera Mukhina, vied with Nazi Germany's pavilion, the work of Albert Speer – an artistic parallel to the struggle for supremacy between two totalitarian regimes. The German pavilion was more Classical and "architectural". The Soviet one applied features of 1920s "expressive" architecture – which still lingered on in Russia – to new tasks. A key role was played by the sculpture crowning each pavilion. Mukhina's "Worker and Kolkhoz Girl" in sheet stainless steel, with its vast dimensions and majestic symbolism, put the bronze German eagle in the shade.

Soviet Neoclassicism cannot be fully understood without reference to the All-Union Agricultural Exhibition, covering the late 1930s to the 1950s, which was held in Moscow in 1954

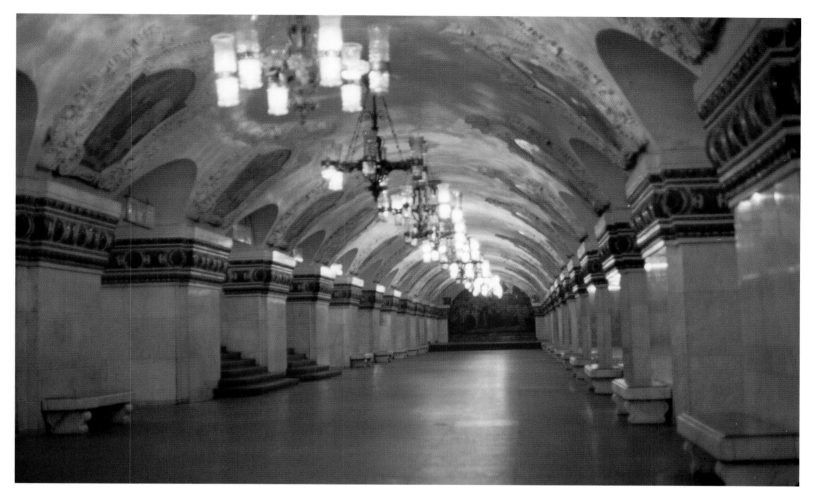

401 Interior of the Kievsky Metro station, Moscow (Vladimir Litvinov et al.), 1953.

following the Exhibition of People's Economic Achievements. In 220 pavilions on 136 hectares, graphic architectural language attained a peak of expressive power comparable only to that of the triumphal monuments built in France in the Revolutionary era.[39] *Architecture parlante*, to use Ledoux's term, was especially eloquent and uplifting in Russia during the Stalinist period. The pavilions at the 1954 exhibition displayed a wealth of sculptural and stucco ornamentation and painted and mosaic decoration, all with a narrative depicting the efflorescence of the Soviet state and the happy life led by the Soviet people. The aim of this symbolic architectural decoration, of course, was to conceal the true state of things. Never before had Neoclassicism been so inventive while serving such mendacious rhetoric on the part of the ruling authorities (pls 405, 406).

The Soviet Union's entry into the Second World War and the first tragic years of conflict halted Soviet architectural evolution without causing a stylistic change of course. Many famous ancient Russian, Ukrainian and Belorussian cities lay in ruins. Major architects led urban replanning projects, among

them Aleksey Shchusev (Istra and Novgorod), Nikolay Kolli (Kalinin, now Tver'), Moisey Ginzburg (Sevastopol'), Georgy Gol'ts (Smolensk), Vladimir Semyonov (Rostov-on-Don), and Karo Alabyan and colleagues (Stalingrad, now Volgograd).[40] Grand triumphal compositions formed the basis of each of these projects, varying only in detail and in the historical prototypes followed. The forms that proved suitable as models for the triumphal mood now officially desired were taken from the Russian seventeenth and nineteenth centuries and adapted from specific compositions and detail from Antiquity and the Italian Renaissance. Stalinist architecture reached its culmination with the high-rise buildings that began to appear in Moscow in the late 1940s.[41] Like many key architectural decisions made by the central authorities, the emergence of high-rise buildings in the Soviet Union was quite unexpected. It was associated with the 800-year anniversary of the founding of Moscow, celebrated throughout Russia in 1947. For many years previously, the building of skyscrapers in capitalist countries had been criticized in the press and dismissed as unsuitable for

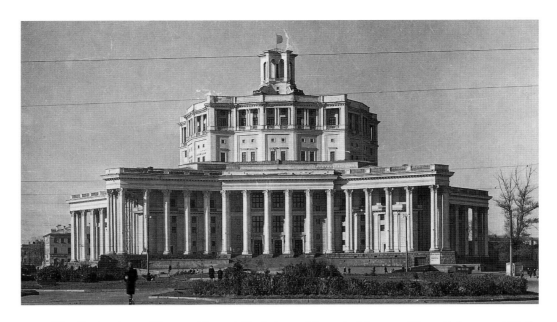

402 The Soviet Army Theatre (Central Red Army Theatre), Moscow (Karo Alabyan and Vasily Simbirtsev), 1939–40.

403 Plan of the Soviet Army Theatre (Central Red Army Theatre), Moscow (Karo Alabyan and Vasily Simbirtsev), 1939–40.

the Soviet Union. By the end of the 1940s the rapid growth of Moscow had lost the city its architectural unity, picturesque skyline and prominent landmarks. High-rise buildings had the potential to correct this situation to some degree, and in practice actually did so. Despite their variety of purpose (a university, administrative and residential blocks, hotels) and the aspirations of their architects towards individuality, they all had the same dynamic, triumphal character. The spire-topped, multi-tiered, pinnacled blocks of the Stalinist skyscrapers turned out to be not only architectural constructions but also consciously created monuments to an era (pl. 404).

It is hard to find any close analogue with the Soviet Classical Revival style in any other national architecture of the period. The buildings and plans of Albert Speer and his team in Nazi Germany were more rigorous and rationalistic, more hyperbolic and less connected with the nineteenth-century heritage. The Italian Neoclassical movement of the same time reflected contemporary architectural developments to a larger extent. Its laconic, generalized forms issued from a markedly new interpretation of the Antique ideal. The Federal style in America, for all its monumentality, was not comparable with Soviet Neoclassicism since it did not use Classical architectural forms as elements of a propagandist language to express the ideas of a totalitarian regime.

Strangely, the intensity of the experiments of the Russian Avant-Garde performed a useful service to the Soviet Neoclassical Revival. Architects working with historical forms had to take account of the existence of a radically new and brilliantly effective approach to architecture and to make their own work as expressive as possible alongside it. In the Neoclassical style of this period there was, furthermore, an important underlying feature. This was nostalgia for pre-revolutionary times, for the colonnaded mansions of the country gentry and the urban bourgeoisie. Typically, almost all the architects of the Stalinist period sought to recreate the atmosphere of the nineteenth-century Russian estate in their own personal living environment. This is especially evident in the rebuilding of the mansion of the Princes Volkonsky at Sukhanovo outside Moscow as an architects' club. In winter the leading architects of the Stalinist era would be met at the railway station by sledges furnished with bearskin rugs and taken along snowed-up avenues to the former mausoleum of the Volkonsky family, now a formal dining hall where traditional Russian country dishes were served. Alas, one of the most gruesome of Stalin's prisons was situated next to Sukhanovo, although famous architects rarely saw the inside of it. The homes of architects of the Stalinist era, filled with mahogany furniture and Piranesi prints, also evinced the general nostalgia for the nineteenth century.

404 High-rise building on Rebellion Square, Moscow (Mikhail Posokhinin et al.), 1950–54.

The relative democratization of Soviet society that occurred during Khrushchev's "Thaw" of the early 1960s arose from a modification of the conception of the Communist utopia which took place under the influence of the industrial civilization of the West. The new form of the Communist utopia was based on the idea that if the mass-produced and cheap forms of subsistence of Western industrial society were intro-

405　The "Friendship of Nations" fountain (Konstantin Tapuridze) at the Exhibition of People's Economic Achievements, Moscow, 1954.

duced into Soviet social conditions, prosperity would result, which in turn would guarantee the advent of true Communism This idea was carried into building technology. Once more, as in tsarist Russia, external forms had great significance in the attempts to bring about a utopian state, as did the prevalent design of buildings, which was now largely determined by industrial technology. In the middle and second half of the twentieth century, few new architectural ideas found their way into the Soviet Union from foreign sources. Those that did, however, acquired a holistic character by virtue of the totalitarianism of the Soviet state and society. Industrialized house-building with prefabicated ferroconcrete slabs was introduced to the Soviet Union in the late 1950s, taking on a massive scale and degree of uniformity comparable only with the Chinese housing programmes of the 1970s.

In the 1960s architects had one primary concern – a solution, once and for all, to the housing problem.[42] Attempts had been made to achieve this in the 1920s, 1930s and 1950s, but the damage done to the infrastructure of the country by war and over-ambitious political schemes slowed up or deprioritized housing construction. The housing shortage was made more and more acute by the migration of millions of people from the countryside to the towns, starving in the aftermath of the tragic destruction of the country's traditional agricultural system. It became common for several families to share not only one apartment but even just a single room. The urgent need to solve the housing problem dictated radical changes in architecture and building technology. This process took place from the mid-1950s to the early 1960s, with mass-scale new housing programmes and the industrial specialization of entire regions;

406 (*facing page*)　Glavmyaso (meat production) pavilion (Victor Lisitsyn et al.) at the Exhibition of People's Economic Achievments, Moscow, 1954.

by the turn of the 1960s/70s it had all but eliminated the artistic element in architecture in the Soviet Union, resulting in utilitarian buildings with almost no aesthetic features.

This was the third and most thoroughgoing architectural "revolution" of the Soviet era, in all respects of far greater significance than the rejection of the Avant-Garde and the return to the Neoclassical heritage in the 1930s. At those previous turning-points, building technology had remained practically unchanged and the scale of buildings had increased only gradually. Now it was the latter that determined the nature of architecture. For Neoclassically educated architects, who had spent years endlessly sketching and erasing Order-based compositions in Indian ink, the shock of this new development was unimaginable. The architect's very role had changed. Everything an architect had learned was declared false "adornment", almost tantamount to criminal activity.

The radical changes that began in the mid-1950s could not proceed very far immediately. Almost all Soviet architects of the time were drawn into a debate about the definition of architecture. One side, attempting to maintain architecture's fast disappearing status as a fine art, was led by the art and architectural historian Ivan Matsa, who insisted on the special artistic significance of architecture. Against this, Konstantin Ivanov and his school argued that architecture was simply the result of any given building task, that it was purely utilitarian and without any claim to aesthetic content. This position subordinated architectural creativity to building technology. For young architects trained by the tenets of Stalinist Neoclassicism, the sudden new architectural trend was full of contradictions. They had long felt the need for architectural change in accordance with twentieth-century rationalism. But their tentative attempts to freshen up their creative palettes stumbled against the insurmountable obstacle of not being understood, not only by their own professional circle but also by the wider public; having lived through the postwar building boom, they had lost their desire to see triumphal ensembles and complex urban architectural compositions. The emphasis on mass-scale building schemes and industrialized and typologized building rapidly achieved quantifiable results, but soon showed a disadvantageous side. Within a very short time, over 400 constructional factories were built which produced houses made of large ferroconcrete panels. The size of individual living units was minimized. In the second half of the 1950s the dimensions of individual apartment rooms were sharply reduced in the interests of economy; kitchens were made smaller and ceiling heights were lowered to 2.5 metres.

The dire effects of this measure on the urban environment were very soon seen. From the early 1960s voices had been raised in the architectural press criticizing the monotony of newly developed residential areas. The manufacturers of new housing blocks, fulfilling their role in increasing output, usually produced only one or two types of building which supplied the housing needs of entire new towns. The idea advanced in the early 1960s that in the mass-scale building schemes of the mid-twentieth century the key unit was not the individual building but a combination of buildings in an overall urban planning perspective, was not only no solution to the problem but made it worse. It was not individual housing block designs that were identically repeated, but entire groups of buildings, producing still greater monotony. "Free" planning of housing complexes came close to causing the loss of such fundamental elements of the traditional urban environment as streets, squares and courtyards, leaving vast empty spaces interspersed with randomly placed housing complexes (pls 407, 408).

The cultivation of the Soviet domestic interior began in the 1960s as a counter-movement to this monotony. People who had long not possessed an apartment of their own set about decorating their homes with passionate enthusiasm to suit their personal tastes and possibilities. This process coincided with a general awakening of interest in the past. Objects and furniture recovered from barns and lumber-rooms began to appear in newly built apartments – antique armchairs, cupboards dating two or more generations back, kerosene lamps adapted with electrical fittings by craftsmen. On summer holidays in the far north young people collected old icons and other artefacts and brought them back to equip and decorate their standard new Soviet homes with objects of nineteenth-century everyday culture. All this was clearly part of people's quest for an individual, private environment in reaction against the generalized, faceless uniformity of the exteriors of the buildings in which they lived. The phenomenon would seem to have played an important political role, opening up the opportunity for people to turn their backs on Communist slogans and the collectivized world for the privacy of family life, and contributing in no small part to the eventual unexpectedly straightforward fall of the Communist regime.

However much it was officially insisted on during this period that any new direction in architectural thinking should focus on mass types of building, things turned out otherwise, architectural creativity, as in previous times, proving most active with projects for individual buildings of social purpose. At the same time the relatively liberal atmosphere of the "Thaw" stimulated the emergence of a new, more democratic architecture. Work began on the Palace of Pioneers (Dvorets pionerov) in the Lenin Hills, Moscow, designed by a group of young architects (Viktor Yegerev, Vladimir Kubasov, Feliks Novikov, Boris Paluy, Igor' Pokrovsky et al.) at the end of the 1950s, and

407 Housing complex, Togliatti (Boris Rubanyenko et al.), 1967–80.

408 Housing complex at Volodarsky Bridge, Leningrad (Sergey Speransky), 1970s.

the building was completed in 1962.[43] These architects played a central role in the architectural evolution of the last decades of the Soviet era. The Palace of Pioneers, a complex ensemble, was conceived as an antithesis to the social buildings of previous decades. Its architects did not group all rooms together in strict multi-storey symmetry as had been done in all the social buildings raised from the late 1930s to the early 1950s which fronted the arterial roads and squares of cities like architectural leitmotivs. Instead, the low-rise blocks of the Palace of Pioneers were sited in a park and orientated, unusually, towards their interiors rather than their exteriors. In this way the complex could command an environment of its own, freely organized and picturesque, quite different from the geometrical aridity of Neoclassical Revival blocks. Like the Workers' Club buildings of the 1920s and quite unlike the practice of the following years, the palace was designed with functional flexibility, while not repeating the functionalist principles of the Avant-Garde. No close contemporary analogues to this building are to be found even in the West. The relative liberalization of Soviet life during this brief, optimistic period gave architects the chance to organize built space more freely and to create simple, human architectural forms.

Such concepts, however, were short-lived. In 1961 a group of architects led by Mikhail Posokhin completed the Palace of Congresses (Dvorets S'yeszdov) in the Moscow Kremlin. With its severe monumentality, cold inhumanity and calculatedly inflated scale, this building no less than the skyscrapers of the Soviet Neoclassical Revival displayed an apt image of the Soviet regime. The construction of Kalinin Prospekt in the historic centre of Moscow, also by the Posokhin team, revealed the determination of the central authorities to continue large-scale urban planning projects using industrially produced architectural forms without consideration for historical traditions (pl. 409). Posokhin and his colleagues were essentially reproducing the type of arterial road typical of other industrial countries. Kalinin Prospekt cut across historic parts of Moscow and destroyed its convenient, age-old system of alleyways. Its indented, geometrically precise silhouette brought a stark change from the panoramas of the old districts of Moscow – the least successful alternative it was possible to imagine to the city's architectural traditions. The project, however, fully corresponded to the aggressive, anti-Rationalist Soviet ideology of the time.

In the last decades of the Soviet era the architectural situation saw no radical change. Rapid technological change for mass-scale separate housing projects was impossible, and it became obvious that architectural possibilities with large-panel prefabricated buildings were very limited. Despite these material difficulties, however, which were typical of the 1970s and intermittent in the 1980s, architects in Moscow, Leningrad and the republican capitals were determined to continue to pursue new architectural approaches, essential if new mass-scale housing projects of any successful degree of novelty were to be built. Architects' attempts to vary the approach to large-scale schemes usually stumbled on the incomprehension of the authorities at various levels. Many imaginative and original plans were rejected by clients incapable of looking beyond the technology of past years and by apparatchiks fearful of any novelty. Members of the Party hierarchy themselves preferred not to live in prefabricated housing but rather in spacious apartments in specially built brick blocks or in discreetly located out-of-town dachas. All these kinds of housing, however, unvaryingly true to type, belong to social rather than architectural history.

One of the solutions to the problem of monotony was found in the use of works of monumental art and large-scale sculptural ensembles, introducing ideological motifs and an aesthetic dimension into otherwise uniform urban architecture.[44] The development of new architectural forms and the creation of recognizable ornamental shapes during the last part of the Soviet era were concentrated predominantly in planned housing schemes and major public buildings.[45]

The era of Leonid Brezhnev and his geriatric successors was a period of germination of architectural aspirations cruelly stifled in the inescapable monotony of standard model building. Only occasionally, among public buildings of the late 1970s and 1980s, were tentative attempts made to follow one Western trend or another, out of context and after its time. The quest for new plastic architectural forms, for example, characterizes the Theatre on the Taganka, Moscow, an unusually complex building for its time, designed by Aleksandr Anisimov, Yury Gnedovsky and Boris Tarantsev, or the Museum of Palaeontology in Moscow. In the latter, built by a group of architects under the direction of Yury Platonov, the bare and austere red-brick walls of the exterior contrast with the exquisite works of monumental art that ornament the interior: images from the earliest periods of the earth's history in various ceramic forms, carvings and, most imposing of all, bas-reliefs of prehistoric animals on the walls of a shaft which by the effect of mirrors appears to vanish into the infinite depths of time. These are rare examples of "living" architecture amongst the mass of official buildings of the Brezhnev era.

Perhaps the most important development in Soviet architecture during the 1980s was the growth of individual regional and national schools which combined many of the general processes of late Soviet architectural practice but in which, at the same time, specific attitudes to tradition, the context of everyday life and the natural environment, history and traditional materials were increasingly clearly crystallized. This period, which saw the most rapid emergence of regional architectural schools in the entire Soviet era, seemed to bear witness to the appearance of the centrifugal forces which led to the collapse of the Soviet Union.

3 Architecture of the Post-Soviet Era

During the last decade of the twentieth century, Russian architecture emerged from a truly Orwellian world of hopeless, inexorable uniformity. The standard buildings that were ubiquitous in Russian cities and towns and surrounding countryside in the post-Stalinist era exhibited the worst visible features of this world, from which there was no escape. Awareness of

the grim architectural desert was especially acute because the architectural profession included many talented individuals who had not had the life crushed out of them by the regime. Furthermore, a number of architects were still alive who had belonged to the Avant-Garde in the 1920s or been taught by masters of the movement. The fully developed Stalinist Empire style, officially "abolished" during the struggle with the "decorative" Neoclassical Revival of the late 1950s–early 1960s, still lingered in the national architectural consciousness. All this in combination brought about a central and striking contradiction in the architecture of the last years of the Soviet period – the gap between the deadening reality of the building industry and the creative aspirations of architects. Architects of the older generation attempted to overcome this by departing from established norms in housing for the Party elite, collaborating with monumental artists or introducing unobtrusive post-Modernist elements into the decorative and ornamental schemes of the kind of public buildings over which Party control had weakened, such as academic institutes or the buildings of prosperous kolkhozy.

The only opportunities for a way forward available to young architects were to be found in "paper architecture", which became the end-of-century means of expression for a special culture of architectural utopianism, comparable to, and perhaps no less intriguing than, the fantasies of the Avant-Garde of the 1920s.[46] The great "paper architects" like Aleksandr Brodsky, Iosif Utkin and Yury Avvakumov created architectural utopias unique in history. Previous architectural utopianism had always been on the widest public scale, and concerned with the organization of mass populations through the construction of a new world. The work of young Russian architects during perestroika displayed a markedly new orientation towards the world of the private individual; thinking in "mass" terms was replaced by the creation of personal worlds. In a historical sense, the "paper architects" were the forerunners of a new "private" architectural trend at the turn of the millennium; they were not, however, prophets of such a trend, for architectural evolution was to take another, less romantic course in Russia, in which architects' dreams were turned into graphic manifestations or installations designed for museums. Such was the situation on the eve of the disintegration of the Soviet Union. The last decade of the twentieth century was a time of concentrated, confused and dangerous change. Architecture, as the precise expression of the mood of history, needed to change in Russia with unusual rapidity.

And everything changed at once. Urban planning, as a branch of architectural planning overall, involving the creation of new towns or the development of established ones, in which the Soviet regime had once taken such pride, practically disap-

peared. A town began to be seen not as a planning project but as a purely economic unit, functioning by the laws of the market, however little these might be connected with civilized life. By sheer inertia, prefabricated housing blocks and entire urban districts continued to be built, but the rationale was quite other than in Soviet times, namely, to make use of and at the same time seek to avoid the overpopulation of large towns. This post-Soviet mass-scale building, however, soon became purely routine, of no architectural significance and falling outside the sphere of key professional interests. In the Soviet period the new world had been constructed by urban planners; now each individual had to construct his own new world.

With the coming of *perestroika*, the urban face of Russia, and of Moscow in the first instance, underwent radical change. Hordes of salespeople and shoppers appeared in the streets. Almost instantaneously, the urban environment became more human. The spread of shops, stalls and cafés restored trade to a leading function in architectural terms. A Western-style tendency towards commercial attractiveness and self-promotion suddenly emerged as dazzling windows; chrome steel and fresh paint became the obligatory signs of flourishing business. It was not retail establishments, however, that led the new architecture; these soon ceded primacy to other types of building.

The mid-1990s brought a wave of new banks, office buildings and houses commissioned by large corporations. Significantly, it was those most closely connected with the state, like Gazprom and Sberbank, that were most willing to commit themselves to major expenditure on architecture. In building for such clients, architects boldly followed American prototypes: tall skyscrapers, vast entrance-lobbies or atria rising to maximum storey height, the use of tinted glass, metal and natural stone in combination. The style was restrained High-Tech and Post-Modernism to a degree hitherto unseen with such conservative clients.

Little building was done by Federal government in the first years following the collapse of the Soviet Union, and architectural ideological expression fell into municipal hands, at least those able to command sufficient funding. The ideology of the Yeltsin period was expressed in the "architecture of mayors and governors", for it was especially the leaders of the most powerful local authorities who were most successful in breaking away from Soviet architectural tradition. In this they were helped by official historicism, from its most radical manifestations such as the restoration of sacred places destroyed in the Soviet period to attempts on a more modest scale to find features of an architectural language which could express local originality. Thus it was that various distinct styles emerged during the closing years of the twentieth century in Moscow, Nizhny Novgorod, Kazan' and other cities and areas, and these

proved to be among the most decisive attempts to break with the Soviet past. It is interesting to note that, irrespective of whether a new building was a cathedral or a new trading centre, re-creations and citations of historical models invariably employed technological innovation, and that the authorities always aimed to demonstrate that, while resurrecting Russia's glorious past, they were looking towards a Western-style market future. In the post-Soviet era, in a society grown accustomed for more than seventy years to general ideology-formation, it is inevitable that a new set of watchwords should have emerged to replace the old. This is especially evident in the extent to which the appearance of Moscow changed in the first years of the new millennium. And most significantly of all, it would seem that the ideology of the new Russia, hitherto incompletely articulated by politicians, was most openly declared in the old capital.

The most ideologically sensitive area of Moscow is the semicircle of squares containing the Kremlin, Red Square and Kitay-Gorod, the oldest part of the city. The cathedrals, walls and towers of the Kremlin and the buildings on Red Square have long served as symbols of the Russian state. Ever since the Middle Ages, these have been not simply architectural monuments but holy places for Russians, expressive both of history and of the national soul. For centuries there has been a continuous process of *architecture parlante* around the Moscow Kremlin in a dialogue between new architecture and old Kremlin buildings symbolizing the national past. A sixteenth-century example of this was the building of St Basil's Cathedral under Ivan the Terrible on Red Square in commemoration of his military victories, and another, after the Napoleonic Wars, the creation of a triumphal framework of Neoclassical buildings in the restored centre of Moscow around the Kremlin to symbolize Russia's age-old existence. Following the collapse of the Soviet empire, the continuity of Russian history once more became a leading theme in the ideological conception of Moscow's centre, and this was immediately evident in architectural terms.[47] The whole central area of the city began to be rebuilt with incredible speed. A huge reconstruction programme was completed by 1997 for the 850th anniversary of the founding of Moscow. This comprised not new buildings in modern style, but the rebuilding of a large number of historic monuments demolished in Soviet times, selected not for their aesthetic worth but for their symbolic value in the nation's or the city's history.

The first of these, raised on a completely empty spot in Red Square without even any ruins, was the seventeenth-century church of the Miraculous Icon of the Mother of God of Kazan' (tserkov' vo imya Chudotvornoy Kazanskoy ikony Bozhiyey materi, pl. 410), demolished in the 1930s. The Iversky

410 Church of the Miraculous Icon of the Mother of God of Kazan' on Red Square, Moscow; reconstruction, 1997.

411 Iversky Gate, Kitay-Gorod, Moscow; reconstruction, 1998.

Gate (Iverskiye vorota), forming the north-east entrance to Red Square, followed, with its celebrated chapel which once housed the Miraculous Icon of the Mother of God of Iver (pl. 411). These two buildings played an important role in the seventeenth- and eighteenth-century history of Moscow as holy places revered by the people. On completion of the Iversky Chapel in 1995, an equestrian statue of Marshal Georgy Zhukov was placed in front of it, the great Second World War commander and proponent of the mass use of tanks. Despite the latter association, he was here depicted seated on horseback during the victory parade of 1945, obvious testimony of the conservatism of the statue. It was a long time since a horse had been sculpted in Russia, and the marshal's mount was distinctive, the tail in particular, which was raised in such a way as to leave old cavalrymen in no doubt as to the animal's intentions.

In 1999, on the bank of the Moskva upriver from the Kremlin, another building was put up on the site of a historic building demolished in the 1930s, the church of Christ the Redeemer (khram Khrista Spasitelya; pl. 412). The original church, as already seen, of similar proportions to the Paris Panthéon, had been Moscow's most important architectural achievement of the nineteenth century, the most clearly defined architectural expression of Russian imperial ideology at its high point. It had articulated the central tenet of that ideology, namely that the prosperity of the Empire was based on the union of "Autocracy, Orthodoxy and Nationality [*Narodnost*]". The decision to build the ideologically key architectural project of post-revolutionary Moscow, the Palace of Soviets, on the site of the church of Christ the Redeemer was not surprising. The symbol of the new Soviet State must

of necessity occupy the very spot from which ideological tradition had previously been consolidated. The Second World War, however, prevented this plan from being realized, and instead a swimming pool replaced the demolished church.

As soon as the complexion of the new Russian polity emerged, a new cathedral was built – an exact reconstruction of the previous building.[48] It would be hard to imagine any bolder political action that could have been taken to emphasize the new regime's disassociation from the Soviet system and announce a return to the cultural values of pre-revolutionary Russia. Both the political authorities and the Russian Orthodox Church insisted on an exact reproduction of the nineteenth-century cathedral. It has been said that the fearfully costly reconstruction of such a large-scale historic building was a form of repentance, expiation for the sins of the Soviet regime, which included the state's persecution of the Orthodox faith and of the Russian national idea. Many architects and artistic figures had previously spoken against the construction of replicas of nineteenth-century buildings. However, when in mid-1996 the cupolas of the still unfinished cathedral appeared above Moscow, the success of the project from an urban planning point of view became obvious. What transpired was totally unexpected: the return of Moscow's principal elevated nineteenth-century landmark had the effect of reactivating the elements of the city's plan relating to that century. Features of the layout of Moscow as it had been in the nineteenth century re-emerged – streets oriented towards the cathedral, squares with a dominant view of the cathedral, the riverside panorama.

Further historic structures destroyed in the Soviet era were recreated inside the Kremlin. A large-scale model of the Red Porch, the formal entrance to the Great Kremlin Palace dating from medieval times, was recreated *in situ*, while the Soviet interiors of the palace were demolished and replaced by exact reconstructions of the ceremonial rooms, which were named after the imperial orders of Saint Alexander Nevsky and Saint Andrew the First-Called (Sv. Andrey Pervozvannyy or, in Byzantine tradition, *Protokletos*). In 1994–95 the Senate building in the Kremlin, one of the finest monuments of Moscow Neoclassicism from the era of Catherine the Great, underwent complete reconstruction in traditional imperial style as the Russian President's palace. In this manner the place of the new supreme authority in Russian history was clearly indicated. In the middle of the River Moskva not far from the church of Christ the Redeemer, a hundred-metre-high statue of the founder of the Russian Empire, Peter the Great – the work of the sculptor Zurab Tsereteli – was erected; it was placed in the water as a monument also to the creator of the Russian fleet.

The architectural initiatives of the new regime began with an attempt to create an area in the centre of Moscow which would be rich with cultural symbols of pre-Soviet, imperial Russia. It does not appear to the present author that this signifies a revival of neo-imperialist ideology, but rather that the new regime's various political gestures symbolized by architecture and sculpture have been made in a spirit of renunciation of the Soviet heritage. The erection of a gigantic statue of the first emperor, the restoration of the ceremonial rooms of the imperial palace, the creation of formal interiors in historical style in the president's palace in the Kremlin, all these would seem rather to indicate the priority being given to the establishment of firm central authority in the Russian state.

At the beginning of the new millennium, Russian architecture faced a choice of either historicism or contemporaneity based on a following of international architectural trends. Western standards have gradually become predominant, with the difference that in Russia the client's role is of even greater importance than in other countries. By the last quarter of the twentieth century a repugnance towards the inescapable monotony of everyday existence had built up in the people of the Soviet Union, eventually producing a spirit of protest against the whole Soviet way of life. Russian architectural evolution over the last few years has been largely characterized by a passion for individuality in every detail of a client's project, by the desire for effect in an environment built according to a client's own will or whim. This process has been led by the building and rebuilding of private houses and apartments, which continues unabatedly, despite the national economic situation, everywhere in Russia, and most of all, inevitably, in and around Moscow.

So many private houses, of all types and sizes, have been built in the countryside around Moscow in the last decade or so that even in this short time the area in question, of rather more than 300 kilometres across, may be said to have undergone one of the most radical landscape changes seen in Russia for many centuries. A similar phenomenon, on a smaller scale, has occurred in the environs of St Petersburg and almost all provincial capitals. In the space of a few years standards of out-of-town houses of the well-to-do have been transformed. In the Gorbachev period, builders of such houses were usually satisfied with dachas with urban-style interiors, built rather more solidly and with more durable materials than in the Soviet period. Under Yeltsin, the increase in scale and in the attention given to the quality of interior decoration of country houses was noticeable from one year to the next. By the beginning of the first decade of the new millennium, new surburban houses far surpassed Soviet dachas and had also passed the stage of being houses pure and simple, taking on the

appearance of manor-houses on estates. Their analogues are to be found more in America than in Europe, not so much the dwellings of the wealthy on the East coast, with its general inclination to modesty and reserve, as the Hollywood-inspired interiors of California.

To New Russians, an indoor swimming pool, a conservatory full of tropical plants, a billiard-room with a dark marble fireplace, a dining room panelled with seasoned oak, are familiar things. Russian manor houses being built today are considerably less sophisticated, however, in their exteriors. Columns conforming to Classical canons may still be met with, but often exhibiting a sad mismatch with the rest of an ensemble of house and garden. The prevalent use of red brick is generally uninspired, shapeless and dominated by constructional pragmatism, and turrets, faceted oriel windows and pointed rooves do not always contribute to aesthetically satisfying exteriors. Markedly Modernist forms, despite their expressive impact, are little used. Landscape architecture is only just beginning to make a reappearance and has yet to amount to a full-scale new genre of the Russian garden. The most interesting architectural developments of the new era, it seems to the present author, are taking place in the creation of domestic interiors, and of apartments rather than entire houses.

The new private architecture has germinated, as it were, from within, inside an outer envelope of earlier conceptions – tenement houses of the beginning of the twentieth century, Stalinist apartment blocks constructed to comparatively higher standards than these, even prefabricated buildings. The progress of interior design in Russia has seen a determined search for new styles, for the most expressive possibilities of materials and unusual properties of built space, attempts to combine and contrast essential features of the old and the new. The rapid development of the domestic interior is one of the surest signs of the discovery of a new way of life, with new tastes, priorities and opportunities.[49] It is above all a social phenomenon, taking place in architectural terms. Over the last few years Russian architects have pursued their own course and learned new skills quite different from those acquired in their training, and they have undergone this process together with their clients, whose professional consciousness has undergone equally precipitous change. Most importantly, they have experienced a new independence from political and social pressures and have been able to build according to their own wishes, and this has proved just as significant for the client as for the architect.

In consequence, no single fashion in domestic interiors can be said to have prevailed or even to be predominant at the present time. On the contrary, almost every architect and designer follows his or her own path, and an individual's style can vary from one commission to the next. The client's wishes, of course, play a part in this, and they are often whimsical. People of means don't usually wish their homes to resemble those of a business partner or fellow employee. More often, they will respond to a neighbour's Neoclassical taste by exhibiting a passion for Baroque or Gothic Revival or abandoning the historicist mode altogether and giving their rooms a contemporary look, either Minimalist or High Tech, as if orientated to the future.

On the threshold of the new millennium, Russian architecture once again stands before a stylistic choice, as it did in the historicist period in the nineteenth century, when the private client had a crucial input on the artistic side of architectural history, in the shaping of architectural characteristics, changes of taste and requirements of comfort. Today, however, after the experiments of the Avant-Garde and the experience of Post-Modernism, the choice is of a different kind, involving the capacity not only for enthusiasm but also for doubt and even self-mockery. Among the leading practitioners of "paper architecture", apocalyptic moods remain popular. At the same time, nostalgia for the harmoniousness of Neoclassicism has become more urgently and deeply felt in recent years. Today Russian architects not only choose ornamental forms reminiscent of Rococo palaces or English medieval gardens, but also decide within which cultural frame to work, and it is the same with their clients' attitudes to interiors. As a result, architects specializing in interiors find themselves with a choice between a new Modernism, a continuation of Post-Modernism, and yet a further variety of Neoclassicism, for it is behind these three leading movements that a whole renaissance of private life has sprung up in Russia after the decades of Soviet collectivization.

An emphatically contemporary world, looking towards the supremacy of the absolutely new, and at the same time an increasing confidence in turning drawn lines, shapes and colours into reality, is emerging in the work of today's architects in Russia, professing a new kind of Modernism and attracted by Minimalism. Not disposed to imitate the Russian Avant-Garde, the Constructivists or the Rationalists, they seek to be in tune with the new life being born. Their work opens up space where people can throw off historical baggage, give free rein to their direct feelings, and live in an environment informed by contemporary ideas of perfect form, of fluid shape and colour. The brutality of the Avant-Garde is alien to this new Modernism which harmonizes opposed forms and colours.

Its free conception of Neoclassicism is characteristic. To today's Russian interior designers, the style is contemporary, not historical. It is a professional tool, and they treat it with respect. Russian architects are familiar with the canons of the Classical Orders from their education; to this day, some

students make a special study of the Classical masters from Antiquity to nineteenth-century Empire and the twentieth century, paying particular attention to English eighteenth-century figures such as the Adam brothers and to Karl Schinkel.

As in other countries, Post-Modernism is not part of the mainstream idiom in Russia today, at least in its unadulterated form as seen in the early work of Robert Venturi or Charles Jencks, with its marked irony, grotesques and symbolism. It is sometimes used, however, in combination, in greater or lesser degree, in composite styles which seek impact with some unusual use of Neoclassical or modernized Neoclassical detail so as to communicate a contemporary attitude to Neoclassicism. This offers opportunities for mixed architectural modes to fit various cultural contexts. Outside Moscow today, for example, one may see dozens of newly built mansions with Neoclassical exteriors and Baroque Revival, Minimalist or Russian peasant-style interiors. It is too early still to speak of any newly established version of the Russian style. Russian architecture is once again searching for its identity, seeking to pursue an evolution of its own alongside that of Western Europe.

It may be said, nevertheless, that in the first years of the new millennium Russian architecture is becoming more international. An intensification of Neo-Modernist tendencies is to be noted, as in the case of most other Western countries. As it has been the concern of this book to demonstrate, the situation is not a new one for Russia. The pattern of history points to continuing architectural dialogue between Russia and the West.

Notes

Abbreviations

BAN	Biblioteka Akademii Nauk
f.	fond
IRI	*Istoriya russkogo iskusstva*, ed. I. E. Grabar', Moscow, 2nd ed., 13 vols, 1953–64
IRIO	*Sbornik Imperatorskogo russkogo istoricheskogo obshchestva*
l.	list
MARKhI	Moskovskiy arkhitekturnyy institut
op.	opis'
PVL	*Povest' vremennykh let*, Moscow and Leningrad, 1950
PSZRI	*Polnoye sobraniye zakonov Russkoy Imperii, sobraniye pervoye*, St Petersburg, 1830
PSRL	*Polnoye sobraniye russkikh letopisey*, Moscow
RANION	Rossiyskaya assotsiatsiya institutov obshchestvennykh nauk
RGADA	Rossiyskiy gosudarstvennyy arkhiv Drevnikh aktov
RGIA	Rossiyskiy gosudarstvennyy istoricheskiy arkhiv
RGVIA	Rossiyskiy gosudarstvennyy voyennyy istoricheskiy arkhiv
RGAVMF	Rossiyskiy gosudarstvennyy arkhiv Voyenno-morskogo flota
stb.	Stolbets
TODRL	Trudy otdela drevnerusskoy literatury
Vkhutein	Vserossiyskiy khudozhestvenno-tekhnicheskiy institut
Vkhutemas	Vserossiyskiye khudozhestvenno-tekhnicheskiye Masterskiye
yed. khr.	yedinitsa khraneniya
ZhMNP	*Zhurnal ministerstva narodnogo prosveshcheniya* (1834–1917)

Names of authors and editors are given variously with one or two initials in accordance with original sources.

INTRODUCTION

1 *Selected Poems* by Aleksandr Blok, translated by Jon Stallworthy and Peter France, Carcanet Press, Manchester, 2000 (quoted by permission of the publishers).

2 H. Laillot, *La Russie blanche*, Paris, 1692.

3 M.V. Krassovsky, *Kurs istorii russkoy arkhitektury*, part 1: *Derevyannoye zodchestvo*, Petrograd, 1916; S. F. Zabello, V. N. Ivanov and P. N. Maksimov, *Russkoye derevyannoye zodchestvo*, Moscow, 1942; Ye. A. Ashchepkov, *Russkoye narodnoye zodchestvo v Zapadnoy Sibiri*, Moscow, 1950; id., *Russkoye narodnoye zodchestvo v Vostochnoy Sibiri*, Moscow, 1953; I. V. Makovetsky, *Arkhitektura narodnogo zhilishcha*, Moscow, 1962; I. E. Grabar' and F. F. Gornostayev, "Derevyannoye zodchestvo russkogo Severa", in I. E. Grabar' (ed.), *O russkoy arkhitekture*, Moscow, 1969; A. K. Chekalov, *Narodnaya derevyannaya skul'ptura russkogo Severa*, Moscow, 1974; S. K. Zhegalova, *Russkaya narodnaya zhivopis'*, Moscow, 1975; A. I. Skvortsov, *Russkaya narodnaya propil'naya rez'ba*, Moscow, 1976; A. V. Opolovnikov, *Russkiy Sever*, Moscow, 1977; V. P. Orfinsky, *Derev-yannoye zodchestvo Karelii*, Leningrad, 1978; id., *Logika krasoty*, Petrozavodsk, 1978; M. I. Mil'chik and Yu. S. Ushakov, *Derevennaya arkhitektura russkogo Severa. Stranitsy istorii*, Leningrad, 1980; Yu. S. Ushakov, *Ansambl' v narodnom zodchestve russkogo Severa*, Leningrad, 1982; A. V. Opolovnikov, *Russkoye derevyannoye zodchestvo*, I: *Grazhdanskoye zodchestvo*, Moscow, 1983; M. A. Nekrasova, *Narodnoye iskusstvo Rossii: narodnoye tvorchestvo kak mir tselostnosti*, Moscow, 1983; A. V. Opolovnikov, *Russkoye derevyannoye zodchestvo*, II: *Kul'tovoye zodchestvo*, Moscow, 1986; Ye. N. Bubnov, *Russkoye derevyannoye zodchestvo Urala*, Moscow, 1988; N. P. Kradin, *Russkoye derevyannoye oboronnoye zodchestvo*, Moscow, 1988; A. V. Opolovnikov, *Sokrovishcha russkogo Severa*, Moscow, 1989; A.V. and Y. A. Opolovnikov, *The Wooden Architecture of Russia: Houses, Fortifications, Churches*, London, 1989.

4 D. Obolensky, "Russia's Byzantine Heritage", in M. Cherniavsky (ed.), *The Structure of Russian History*, New York, 1970, p. 5.

5 J. Simmons, "Russian Printing to 1917: A view from the West; last words" (Sandars Lectures), Cambridge, 1974, typescript, p. 13.

6 E. Panovsky, *Renaissance and renascences in Western art*, London and New York, 1960.

7 J. Billington, *The Icon and the Axe: An Interpretative History of Russian Culture*, London, 1966, p. 88.

1 BETWEEN BYZANTINE AND ROMANESQUE

1 D. Obolensky, "Russia's Byzantine Heritage", in M. Cherniavsky (ed.), *The Structure of Russian History*, New York, 1970, pp. 3, 24–25.

2 D. V. Obolensky, *Vizantiyskoye sodruzhestvo natsiy*, Moscow, 1988, p. 195; Bishop Porfiry (Uspensky), *Chetyre besedy Fotiya, svyatogo arkhiyepiskopa Konstantinopol'skogo i rassuzdeniye o nikh*, St Petersburg, 1864, pp. 18–19.

3 See *Kreshcheniye Rusi v trudakh russkikh i sovet-skikh istorikov*, Moscow, 1988; A. Poppe, "The Political Background to the Baptism of Rus", *Dumbarton Oaks Papers*, V, 30, 1976, pp. 197–244.

4 Metropolitan Makary (Bulgakov), *Istoriya russkoy tserkvi*, I, Moscow, 1994, pp. 227–28.

5 D. Buxton, *Russian Medieval Architecture, with an account of the Transcaucasian styles and their influence in the West*, Cambridge, 1934; R. Krautheimer, *Early Christian and Byzantine Architecture*, Baltimore, MD, 1975, pp. 349–426; C. Mango, *Byzantine Architecture*, New York, 1985, pp. 108–41, 180–84; R. Ousterhaut, *Master Builders of Byzantium*, Princeton, NJ, 1999.

6 Mango, 1985, p. 180.

7 *Povest' vremennykh let* (*PVL* hereafter), Moscow and Leningrad, 1950, p. 83.

8 M. K. Karger, *Arkheologicheskiye issledovaniya Drevnego Kiyeva*, Kiev, 1950, pp. 45–140; N. N. Voronin, "Zodchestvo Kiyevskoy Rusi", in

I. E. Grabar' (ed.), *Istoriya Russkogo iskusstva* (*IRI* hereafter), Moscow, I, 1953, p. 117; V. F. Korzukhina, "K rekonstruktsii Desyatinnoy tserkvi", *Sovetskaya arkheologiya*, 2, 1957, pp. 78–90; M. K. Karger, *Drevniy Kiyev*, Moscow and Leningrad, II, 1961, pp. 36–59; G. Yu. Ivakin and V. G. Putsko, "Impostnaya kapitel' iz kiyevskikh nakhodok", *Sovetskaya arkheologiya*, 1, 1980, pp. 293–99; Yu. S. Aseyev, *Arkhitektura drevnego Kiyeva*, Kiev, 1982, pp. 28–32; A. I. Komech, *Drevnerusskoye zodchestvo kontsa X–nachala XII v.*, Moscow, 1987, pp. 168–76; Mango, 1985.

9 P. P. Tolochko, *Drevniy Kiyev*, Kiev, 1976, pp. 28–31.

10 M. K. Karger, "K voprosu ob ubranstve inter'-yera v Russkom zodchestve", in *Trudy Vserossiyskoy akademii khudozhestv*, Leningrad and Moscow, I, 1947, pp. 15–50.

11 *Polnoye sobraniye Russkikh letopisey*, 41 (Letopis' Pereyaslavlya Suzdal'skogo), Moscow, 1995, p. 41.

12 Ibid.

13 N. I. Brunov, "K voprosu o vostochnykh elementakh vizantiyskogo iskusstva", in *Trudy Sektsii iskusstva RANION*, Moscow, IV, 1930, pp. 21–29; N. N. Voronin, 1953, p. 142; Yu. S. Aseyev, *Spas'kiy sobor u Chernigovy*, Kiev, 1959; A. I. Komech, "Spaso-Preobrazhenskiy sobor v Chernigove", in *Drevnerusskoye iskusstvo. Zarubezhnyye svyazi*, Moscow, 1975, pp. 9–26; id., 1987, pp. 134–60.

14 *PVL*, p. 102.

15 N. I. Brunov, "K voprosu o pervonachal'nom vide Kiyevskoy Sofii", *Izvestiya Gosudarstvennoy Akademii material'noy kul'tury*, 5, Moscow, 1927; N. Brunov, "Zur Frage des Ursprungs der Sophienkathedrale in Kiev", *Byzantinische Zeitschrift*, XXIX, 1929/30, p. 249; V. N. Lazarev, *Mozaiki Sofii Kiyevskoy*, Moscow, 1960; Ch. Delvoye, "L'Architecture byzantine du XIe siècle", *Proceedings of the XIII International Congress of Byzantine Studies*, Oxford, 1967; A. I. Komech, "Postroyeniye vertikal'noy kompozitsii Sofiyskogo sobora v Kiyeve", *Sovetskaya arkheologiya*, 3, 1968, pp. 237–38; A. Poppe, "Kompozycja Sofii Kijowskej. W poszukiwaniu ukladu pierwotnogo", *Bioleten historii sztuki*, 30, 1968, pp. 1–29; G. N. Logvin, *Sofiya Kiyevskaya*, Kiev, 1971; A. I. Komech, "Rol' knyazheskogo zakaza v postroyenii Sofiyskogo sobora v Kiyeve", in V. N. Lazarev (ed.), *Drevnerusskoye iskusstvo. Khudozhestven-naya kul'tura domongol'skoy Rusi*, Moscow, 1971, pp. 50–64; S. A. Vysotsky, *Srednevekovyye nadpisi Sofii Kiyevskoy*, Kiev, 1976; G. M. Shtender, "Issledovaniya galerey Kiyevskogo Sofiyskogo sobora", *Stroitel'stvo i arkhitektura*, 7, 1980, pp. 25–26.

16 Yu. S. Aseyev, "K voprosu o vremeni osnovaniya Sofiyskogo sobora", *Sovetskaya arkheologiya*, 3, 1980; A. Poppe, "The Building of the Church of St. Sofia in Kiev", *Journal of Medieval History*, 7, 1987, pp. 15–16.

17 C. L. Mango, *Byzantine Architecture*, New York, 1976, p. 325.

18 P. A. Rapoport, *Drevnerusskaya arkhitektura*, St Petersburg, 1993, p. 33.

19 Shtender, 1980, pp. 25–26.

20 Komech, 1987, pp. 181, 194–95, 212–13.

21 N. I. Brunov. "Kiyevskaya Sofiya – drevneyshiy pamyatnik Russkoy kamennoy arkhitektury", in *Vizantiyskiy vremennik*, III, Moscow and Leningrad, 1950, pp. 164–65.

22 A. V. Ikonnikov, *Tysyacha let russkoy arkhitektury*, Moscow, 1990, pp. 56–60.

23 Komech, 1987, pp. 212–13.

24 Ikonnikov, 1990, pp. 60–61.

25 N. N. Rozov, *Sinodal'nyy spisok sochineniy Ilariona – russkogo pisatelya XI v.*, Prague, 1963, p. 168; A. M. Moldovan, *Slovo o zakone i blagodati Ilariona*, Kiev, 1984, pp. 88, 92–100.

26 Rozov, 1963, p. 169.

27 Ibid., p. 165.

28 G. M. Shtender, "K voprosu ob arkhitekture malykh form Sofii Novgorodskoy", in V. N. Lazarev (ed.), *Drevnerusskoye iskusstvo. Khudozhestvennaya kul'tura Novgoroda*, Moscow, 1968, pp. 83–107; id., "K voprosu o dekorativnykh osobennostyakh stroitel'noy tekhniki Sofii Novgorodskoy", in A. B. Rybakov (ed.), *Kul'tura Srednevekovoy Rusi*, Leningrad, 1974, pp. 202–12; A. I. Komech, *"Rol' pridelov v formirovanii obshchey kompozitsii Sofiyskogo sobra v Novgorode"*, in G. K. Wagner and D. S. Likhachev (eds) *Srednevekovaya Rus'*, Moscow, 1976, pp. 147–51; G. M. Shtender, "Pervonachal'nyy zamysel i posleduyushcheye izmeneniye galerey i lestnichnoy bashni Novgorodskoy Sofii", in P. A. Rapoport (ed.), *Drevnerusskoye iskusstvo. Problemy i atributsii*, Moscow, 1977, pp. 34–37; id., "K voprosu o galereyakh Sofii Novgorodskoy", in A. L. Batalov, and I. A. Bondarenko (eds), *Restavratsiya i issledovaniye pamytnikov kul'tury*, I, Moscow, 1982, pp. 6–27; Ikonnikov, 1990, p. 61.

29 Rapoport, 1993, p. 38.

30 K. Sherotsky, "Sofiyskiy sobor v Polotske", in *Zapiski otdeleniya Russkoy i slavyanskoy arkheologii Russkogo arkheologicheskogo obshchestva*, X, St Petersburg, 1915, pp. 77–90; V. A. Bulkin, P. A. Rapoport and G. M. Shtender, "Raskopi pamyatnikov arkhitektury v Polotske", in *Arkheologicheskiye otkrytiya v 1976 godu*, Moscow, 1977, pp. 400–11; id., "Raskopi pamyatkikov arkhitektury v Polotske", in *Arkheologicheskiye otkrytiya v 1977 godu*, Moscow, 1978, pp. 410–11; id., "Raskopi pamyatnikov arkhitektury v Polotske", in *Arkheologicheskiye otkrytiya v 1978 godu*, Moscow, 1979, pp. 400–11; V. A. Bulkin, "Raskopi na Verkhnem zamke v Polotske", in *Arkheologicheskiye otkrytiya v 1979 godu*, Moscow, 1980, pp. 358–59.

31 Voronin, 1953, p. 140.

32 Aseyev, 1982, pp. 78–92; M. V. Kholostenko, "Novi doslizheniya Ioanno-Predtechenskoi tserkvi ta rekonstruktsiya Uspenskogo soboru Kievo-Pecherskoi Lavry", in *Arkheologichni doslidzheniya starodavn'ogo Kyivu*, 1976, p. 141; Yu. S. Aseyev and V. A. Kharlamov, "Ob arkhitekture Uspenskogo sobora Pecherskogo monastyrya v Kiyeve", *Arkhitekturnoye nasledstvo*, 34, Moscow, 1986, pp. 208–14.

33 A. V. Kartashov, *Ocherki po istorii russkoy tserkvi*, I, Moscow, 1991, pp. 227–28.

34 Ibid., pp. 228–29.

35 *Paterik Kiyevskogo Pecherskogo monastyrya. Izdaniye Imperatorskoy Arkheologicheskoy komissii*, St Petersburg, 1911, p. 5; Aseyev, 1982, p. 78.

36 Ye. Ye. Golubinsky, *Istoriya russkoy tserkvi*, II, Moscow, 1997, p. 6.

37 Rapoport, 1993, pp. 48–54.

38 D. Aynalov, "Arkhitektura chernigovskikh tserkvey", in *Trudy XIV Arkheologicheskogo s'yezda*, Moscow, 1909, pp. 67–71; B. A. Rybakov, "Drevnosti Chernigova", *Materialy i issledovaniya po arkheologii SSSR*, Moscow and Leningrad, 11, 1949; N. Kholostenko, "Neizvestnyye pamyatniki monumental'noy skul'ptury drevney Rusi (rel'yefy Borisoglebskogo sobora v Chernigove)", *Iskusstvo*, 1951, 3, pp. 84–91.

39 Rapoport, 1993, pp. 52–53.

40 N. N. Voronin and P. A. Rapoport, *Zodchestvo Smolenska XII–XIII vekov*, Leningrad, 1979, pp. 64–91.

41 Komech, 1976, p. 310; id., "Dva napravleniya v novgorodskoy arkhitekture nachala XII veka", in O. A. Podobedova (ed.), *Srednevekovoye iskusstvo. Rus'. Gruziya*, Moscow, 1978, pp. 56–62.

42 P. N. Maksimov, "Obshchenatsional'nyye i lokal'nyye osobennosti russkoy arkhitektury XII–XIV vv.", in B. Rybakov (ed.) *Pol'sha i Rus'*, Moscow, 1974.

43 P. A. Rapoport, "Russkaya arkhitektura na rubezhe XII i XIII vv.", in id. (ed.), *Drevnerusskoye iskusstvo, Problemy i atributsii*, Moscow, 1977, pp. 12–29.

44 Voronin and Rapoport, 1979, pp. 163–96.

45 G. N. Logvin, *Chernigov, Novgorod Severskiy, Glukhov, Putivl'*, Moscow, 1972.

46 D. A. Khvol'son, *Izvestiya o khazarakh, slavyanakh i rusakh Abu Akhmeda ben Omara Ibn-Dasta*, St Petersburg, 1869, pp. 16–18.

47 M. I. Artamonov, *Istoriya khazar*, Leningrad, 1962; M. G. Magomedov, *Obrazovaniye khazarskogo kaganata*, Moscow, 1983.

48 R. G. Fakhrutdinov, *Ocherki po istorii Volzhskoy Bolgarii*, Moscow, 1985; G. A. Fyodorov-Davydov, *Gorod Bulgar. Monumental'noye stroitel'stvo, arkhitektura, blagoustroystvo*, Moscow, 2001.

49 P. S. Savel'yev, *Mukhameddanskaya numizmatika v otnoshenii k russkoy istorii*, St Petersburg, 1847.

50 B. A. Rybakov, "Torgovlya i torgovyye puti", in

id. (ed.), *Istoriya kul'tury Drevney Rusi. Domongol'skiy period*, Moscow and Leningrad, I, 1949, pp. 342–43; Ye. Ch. Skrzhinskaya, *Rus', Italiya i Vizantiya v Srednevekov'ye*, St Petersburg, 2000, pp. 59–60.

51 Obolensky, 1988, pp. 244–45; Skrzhinskaya, "Polovtsy" in id., 2000, pp. 38–69.

52 Pereslavl'-Yuzhnyy, for example, was situated on the left bank of the Dnieper and Pereslavl'-Zalesskiy was founded on the territory of Suzdal'.

53 Yu. A. Limonov, *Vladimiro-Suzdal'skaya Rus'*. Leningrad, 1987, pp. 48–64.

54 N. N. Voronin, *Zodchestvo Vladimiro-Suzdal'skoy Rusi*, IRI, I, Moscow, 1953, p. 341.

55 *PSRL*, I (Lavrent'yevskaya letopis'), 1926, p. 351.

56 *Paterik Kiyevskogo Pecherskogo monastyrya*, p. 9.

57 Ibid., p. 10.

58 Voronin, 1953, p. 353; *PSRL*, I, 348.

59 Golubinsky, 1997, II, p. 6.

60 Metropolitan Makary (Bulgakov), *Istoriya Russkoy tserkvi*, III, St Petersburg, 1868, pp. 105–11; P. Sokolov, *Russkiy arkhiyerey iz Vizantii i pravo yego naznacheniya do nachala XV veka*, Kiev, 1913, pp. 116–17; N. N. Voronin, "Andrey Bogolyubsky i Luka Khrisoverg. (Iz istorii Russkovizantiyskikh otnosheniy XII veka)", *Vizantiyskiy vremyannik*, XXI, Moscow, 1962, pp. 29–50; Golubinsky, 1997, I/i, pp. 320–32, 439–43, 462–68.

61 Ibid., p. 414.

62 Voronin, 1953, p. 349; Golubinsky, 1997, I, p. 403. The latter asserts that the Feast of the Intercession of the Mother of God was established in the city only, and limited to the reign of a specific ruling prince, not referring directly to Andrey Bogolyubsky.

63 Ibid., p. 401.

64 Ibid., p. 400.

65 N. N. Voronin, *Zodchestvo severo-vostochnoy Rusi. XII stoletiye*, I, Moscow, 1961, p. 246.

66 V. N. Lazarev, "Skul'ptura Vladimiro-Suzdal'skoy Rusi", IRI, I, Moscow, 1953, p. 408.

67 Ibid., p. 409.

68 V. N. Tatishchev, *Istoriya Rossiyskaya s drevneyshikh vremyon*, III, Moscow and Leningrad, 1964, p. 246.

69 *PSRL*, I, p. 351.

70 Voronin, 1953, p. 370.

71 N. N. Voronin and V. N. Lazarev, "Iskusstvo zapadno-Russkikh knyazhestv", IRI, I, Moscow, 1953, pp. 309–11.

72 N. L. Nickel, "Berufsmotive der sachsichen romanischen Bauornamentik zu den Schmuckmotiven der Vladimir-Suzdaler Architektur", in E. Smirnova (ed.), *Dmitrovskiy sobor*, Moscow, 1997, pp. 81–92.

73 B. Zagaglia, *Un libro di Pietro. Il duomo di Modena*, Modena, 1988.

74 M. Agili, *San Michele. Splendore e degrado di un*

monumento, Pavia, 1996; S. Chierici, *La Lombardia. (Italia Romanica)*, I, Milan, 1991, pp. 88–114.

75 O. M. Ionisyan, "Romanskaya arkhitektura Lombardii i zodchestvo Vladimiro-Suzdal'skoy Rusi (k voprosu o proizkhozhdenii masterov Andreya Bogolyubskogo)", in *Nauchnaya konferentsiya pamyati M. A. Gukovskogo*, St Petersburg, 1998, pp. 25–29.

76 *PSRL*, I, p. 351.

77 Ibid.

78 G. Millet, "L'Ascension de l'Alexandre", *Syria*, 4, 1923, pp. 85–133; A. Bank, "Molivdovul s izobrazheniyem polyota Aleksandra Makedonskogo na nebo", *Trudy Otdela Vostoka Gosudarstvennogo Ermitazha*, III, Leningrad, 1940, pp. 181–88. Similar ornamentation was recently discovered by V. V. Sedov during excavations of princely tombs in the cathedral of St Sophia, Novgorod.

79 E. S. Smirnova (ed.), *Dmitrovskiy sobor vo Vladimire. K 800-letiyu osnovaniya*, Moscow, 1977; on the dating, see especially T. P. Timofeyeva, "K utochneniyu daty Dmitrovskogo sobora", pp. 38–451; and see G. V. Popov, "Dekoratsiya fasadov Dmitrovskogo sobora i kul'tura Vladimirskogo knyazhstva rubezha XII i XIII vv.", pp. 42–58.

80 Ibid., p. 42; *PSRL*, X, Moscow, 1965, pp. 30, 65.

81 Popov, in Smirnova (ed.), 1977, p. 42.

82 G. V. Popov, "Freski Dmitrovskogo sobora vo Vladimire i vizantiyskaya zhivopis' XII v.", in Smirnova (ed.), 1977, pp. 119–27.

83 Lazarev, 1953, pp. 416–29.

84 G. V. Popov, in Smirnova (ed.), 1977, p. 46.

85 N. N. Voronin, "Skul'pturnyy portret Vsevoloda III", *Kratkiye soobshcheniya Instituta material'noy kul'tury*, XXXIX, Moscow, 1951, pp. 137–39; Timofeyeva, in Smirnova (ed.), 1977, p. 39.

86 K. K. Romanov, "Georgiyevskiy sobor v gorode Yur'yeve-Pol'skom", *Izvestiya Arkheograficheskoy Komissii*, St Petersburg, 36, 1910, pp. 70–96; A. Bobrinsky, *Reznoy kamen' v Rossii*, I: *Sobory Vladimirskoy oblasti XII–XIII stoletiy*, Moscow, 1916; F. Halle, *Die Bauplastik von Wladimir-Suzdal'. Russische Romanik*, Berlin, 1929; K. Romanov, "La Colonnade du pourtour de la cathédrale de Saint Georges de Juriev-Polskij", *Receuil Uspensky*, II, Paris, 1932, pp. 54–67; Lazarev, 1953, pp. 431–41; N. N. Voronin, "Georgiyevskiy sobor v Yur'yeve-Pol'skom", in id., *Zodchestvo severovostochnoy Rusi. XII–XV vekov*, II, Moscow, 1962, pp. 68–126; G. K. Wagner, *Skul'ptura Vladimiro-Suzdal'skoy Rusi. Gorod Yur'yev-Pol'skoy*, Moscow, 1964; G. K. Wagner, *Mastera drevnerusskoy skul'ptury*, Moscow, 1966; N. N. Voronin, *Yur'yev-Pol'skoy*, Moscow, 1985.

87 *PSRL*, I, p. 460.

88 *PSRL*, VII (Letopis' po Voskresenskomu spisku), St Petersburg, 1856, p. 447.

89 Wagner, 1966, p. 9.

90 Ibid.

91 N. N. Voronin, *Zodchestvo severo-vostochnoy Rusi*, II: *XII–XV vekov*, Moscow, 1962, p. 79.

92 Wagner, 1966, p. 10.

93 Ibid, p. 10; Voronin, 1962, p. 86.

94 Lazarev, 1953, p. 434.

95 Wagner, 1964, p. 25.

96 *Fiziolog Aleksandriyskoy redaktsii*, trans. Ya. I. Smirnova, Moscow, 1998.

97 Ibid., p. 50.

98 Ibid., pp. 28–29.

99 K. K. Romanov, "K voprosu o tekhnike ispolneniya rel'yefov sobora Sv. Georgiya v Yur'yev-Pol'skom", *Seminarium Kondakovianum*, II, Prague, 1928.

100 *Fiziolog*, p. 44.

101 Ibid., p. 64; commentary by O. V. Belova.

102 Voronin, 1962, pp. 102–04.

103 Lazarev, 1953, pp. 436–38.

104 Voronin, 1962, p. 99.

105 Wagner, 1966, p. 10.

106 Ibid., p. 11.

107 Ibid., p. 10.

108 Ibid.

109 Ibid.

110 Ibid.

111 Ibid., p. 15.

112 Ibid., p. 17.

113 P. Miquel, *Dictionnaire symbolique des animaux*, Paris, 1992.

114 A. M. Lidov, "Obraz Nebesnogo Iyerusalima v vostochno-khristianskoy ikonografii", in id. (ed.), *Iyerusalim v russkoy kul'ture*, Moscow, 1995, pp. 15–25.

115 Lazarev, 1953, pp. 440–41.

116 Limonov, pp. 189–95.

117 *PSRL*, XV (Tverskaya letopis'), Moscow, 1965, p. 355.

118 Cited from E. F. Gollerbakh, "Iskusstvo Rerikha", in A. M. Prande (ed.), *Rerikh*, Part II, Riga, 1939, p. 78.

119 A. K. Tolstoy, *Sochineniya*, Moscow, 1897, p. 195.

120 L. N. Gumilev, *Ot Rusi k Rossii*, Moscow, 1998.

121 V. V. Sedov, "Tserkov' Nikoly na Lipne i novgorodskaya traditsiya XII veka vo vzaimosvyazi s romano-goticheskoy traditsiyey", in A. Komech (ed.), *Drevnerusskoye iskusstvo. Rus'. Vizantiya. Balkany. XIII vek*, St Petersburg, 1997, pp. 393–412. The author gratefully acknowledges advice given by Professor Sedov on this and other topics.

122 N. V. Sultanov, *Obraztsy drevnerusskogo zodchestva v miniatyurnykh izobrazheniyakh*, St Petersburg, 1891, p. 3.

123 A. I. Nekrasov, *Ocherki po istorii moskovskogo perioda drevnerusskogo zodchestva XI–XVII vv.*, Moscow, 1936, pp. 181–82.

124 M. V. Krassovsky, *Ocherki po istorii moskovskogo perioda drevnerusskogo tserkovnogo zodchestva*, Moscow, 1911, p. 25.

125 Voronin, 1962, pp. 130–33.

126 Ibid., p. 131.

127 Rapoport, 1993, p. 122–23.

128 *PSRL*, XV, 1965, p. 404.

129 Voronin, 1962, pp. 137–43; Rapoport, 1993, p. 122.

130 Voronin, 1962, pp. 399–415.

131 *PSRL*, XVIII (Simeonovskaya letopis'), St Petersburg, 1913, p. 89.

132 Kartashov, 1991, pp. 302–04.

133 V. P. Vygolov, *Arkhitektura Moskovskoy Rusi serediny XV veka*, Moscow, 1988, pp. 178–81.

134 Voronin, 1962, pp. 153–54; N. S. Vladimirskaya, "Arkheologicheskoye izucheniye Sobornoy ploshchadi Moskovskogo Kremlya", in E. Smirnova (ed.), *Uspenskiy sobor Moskovskogo Kremlya, Materialy i issledovaniya*, Moscow, 1985, pp. 7–16.

135 Metropolitan Makary, *Pamyatniki tserkovnykh drevnostey. Nizhegorodskaya guberniya*, St Petersburg, 1857; S. A. Agafonov, *Gor'kiy-Nizhniy Novgorod*, Moscow, 1947; P. N. Maksimov, "K kharakteristike pamyatnikov moskovskogo zodchestva XIV– XV vv.", *Materialy po arkheologii SSSR*, 12, Moscow, 1949, p. 210.

136 Voronin, 1962, pp. 212–16.

137 M. A. Il'yin, *K voprosu o pervonachal'nykh formakh sobora XIV veka v Kolomne*, Moscow, 1961.

138 Voronin, 1962, pp. 201–03.

139 I. Snegirev, "Uspenskiy sobor v Zvenigorode", *Russkaya starina v pamyatnikakh tserkovnogo i grazhdanskogo zodchestva*, III, Moscow, 1847; Archimandrite Leonid, "Zvenigorod i yego sobornyy khram", *in Sbornik Obshchestva lyubiteley drevnerusskogo iskusstva*, Moscow, 1873; Voronin, 1962, pp. 290–98.

140 S. Smirnov, *Istoricheskoye opisaniye Savvino-Storozheskogo monastyrya*, Moscow, 1863; N. I. Brunov, "Sobor Savvino-Storozheskogo monastyrya bliz Zvenigoroda", *Trudy etnografo-arkheologicheskogo muzeya MGU*, Moscow, 1926; G. I. Vzdornov, "K arkhitekturnoy istorii Savvino-Storozheskogo monastyrya", *Pamyatniki kul'tury. Issledovaniye i restovratsiya*, 3, Moscow, 1961.

141 Ye. Ye. Golubinsky, *Prepodobnyy Sergey Radonezhsky: sozdannaya im Troitskaya lavra*, Moscow, 1909, pp. 101–03; N. I. Brunov, "K voprosu o rannemoskovskom zodchestve", *Trudy sektsii arkheologii RANION*, IV, Moscow, 1928, pp. 93–106; V. I. Baldin, *Zagorsk*, Moscow, 1974, pp. 23–67.

142 P. N. Maksimov, "Sobor Spas-Andronikova monastyrya v Moskve", *Arkhitekturnyye pamyatniki Moskvy XV–XVII vv.*, Moscow, 1947; B. A. Ognev, "Variant rekonstruktsii Spasskogo sobora Andronikova monastyrya", *Pamyatniki kul'tury. Issledovaniya i restovratsiya*, 1, Moscow, 1959, pp. 72–82.

143 V. P. Vygolov, *Arkhitektura Moskovskoy Rusi serediny XV veka*, Moscow, 1988.

II THE MOSCOW RENAISSANCE

1 C. Mango, *Byzantine Architecture*, New York, 1985, p. 191.

2 F. Braudel, *Le Modèle italien*, Paris, 1994, p. 24; Ye. K. Skrzinskaya, "Storia della Tana", *Studi veneziani*, X, 1968, offprint, p. 2.

3 Braudel, 1994, p. 26.

4 H. Vast, *Le Cardinal Bessarion (1403–72)*, Paris, 1878; A. Sadov, *Bissarion Nikeysky*, St Petersburg, 1883; R. Nasalli, "Il Cardinale Bessarione legato pontificio in Bologna (1450–1455)", *Atti e memorie della Deputazione di Storia Patria per le provincie di Romania*, IV, xx, fasc. iv–vi, July–December 1930, pp. 17–80; L. Labowsky, "Bessarione", *Dizionàrio biogràfico degli italiani*, IX, Rome, 1967, pp. 686–96.

5 P. Pirling, *Rossiya i papskiy prestol*, part I, Moscow, 1912, pp. 15–16.

6 I. Medvedev, *Vizantiyskiy gumanizm XIV– XV vekov*, St Petersburg, 1977, p. 148.

7 R. Skrynnikov, *Tretiy Rim*, St Petersburg, 1994, p. 40.

8 Ye. K. Skrzhinskaya, *Barbaro i Kontarini o Rossii*, Leningrad, 1971; id., *Inostrantsy o drevney Moskve*, Moscow, 1991, p. 6.

9 Ibid.

10 Ibid., p. 9.

11 Ibid.

12 Ibid.

13 S. Gerbershteyn, *Zapiski o moskovskikh delakh*, St Petersburg, 1908; S. Herberstein, *Notes upon Russia*, New York, 1963; *Sigismund, Baron Gerbershteyn. Sbornik*, published by students of St Petersburg University, I, St Petersburg, 1857.

14 M. Mekhovsky, *Traktat o dvukh Sarmatiyakh*, Moscow and Leningrad, 1936, p. 17; Yu. Limonov, *Kul'turnyye svyazi Rossii s yevropeyskimi stranami v XV–XVII vekakh*, Moscow, 1978, p. 97.

15 P. Iovy, *Kniga o moskovitskom posol'stve*, St Petersburg, 1908, p. 15.

16 Ibid.

17 S. Neygebauer, "Statistiko-geograficheskoye opisaniye Rossiyskogo gosudarstva v nachale XVII stoletiya", *ZhMNP*, 9, 1836, pp. 602–31.

18 V. Semyonov, *Biblioteka inostrannykh pisateley o Rossii*, I, St Petersburg, 1836, p. 47.

19 A. Possevino, *Moskoviya. Istoricheskiye svedeniya o Rossii*, Moscow, 1983, p. 43.

20 Ye. Shmurlo, "Isvestiya Dzhovanni Tedal'di o Rossii vremeni Ivana Groznogo", *ZhMNP*, 5, 1891, p. 132.

21 H.-W. Kruft, *A History of Architectural Theory*, London and New York, 1994, pp. 51–56; P. Tigler, *Die Architekturtheorie des Filarete*, Berlin, 1963.

22 J. Onians, "Filarete and the 'Qualità' architectural and social", *Arte Lombarda*, 18, 1973, pp. 96–114.

23 M. Restle, "Bauplanung unter Mehmet II. Fatih Filarete in Konstantinopel", *Pantheon*, XXXIX, 1981, pp. 361–67.

24 Filarete (Antonio Averlino), *Treatise on Architecture*, trans. J. Spenser, 2 vols, New Haven, CT, and London, 1965, I, p. 216.

25 Ibid., p, 202.

26 Ibid.

27 Ibid., p. 215.

28 Ibid., p. 181.

29 Ibid., ill. p. 102.

30 M. Lazzaroni and A. Munoz, *Filarete, scultore e architetto del secolo XV*, Rome, 1908, pp. 8–9.

31 M. Gualandi, *Aristotele Fioravanti, meccanico ed ingegnere del secolo XV*, Bologna, 1870; L. Beltrami, *Aristotele da Bologna*, Bologna, 1912.

32 V. Snegiryov, *Aristotel' F'yoravanti i perestroyka Moskovskogo Kremlya*, Moscow, 1935; "Aristotele Fioravanti", *Arte Lombarda*, Nuova serie, 44–45, Milan, 1976 (special edition); I. Danilova, "Arkhitektura Uspenskogo sobora Aristotelya F'yoravanti i printsipy postroyeniya kompozitsii v proizvedeniyakh Dionisiya", in id., *Iskusstvo Srednikh vekov i Vozrozhdeniya*, Moscow, 1984; S. Pod"yapol'sky, "F'yoravanti", "Ital'yanskiye stroitel'nyye mastera v Rossii v kontse XV–nachale XVI vekov", in A. Batalov and I. Bondorenko (eds), *Restavratsiya i arkhitekturnaya arkheologiya, Novyye materialy i issledovaniya*, Moscow, 1984, pp. 229–31; S. Zemtsov and V. Glazychev, *Aristotel' F'yoravanti*, Moscow, 1985; S. Pod"yapol'sky, "K voprosu o svoyeobrazii arkhitektury Moskov-skogo Uspenskogo sobora", in E. Smirnova, (ed.), *Uspenskiy sobor Moskovskogo Kremlya. Materialy i issledovaniya*, Moscow, 1985, pp. 24–51.

33 S. Tugnoli-Pattaro, "Le opere bolognesi di A. Fioravanti [. . .]", *Arte Lombarda*, 44–45, 1979, p. 39. Freemasonry originated in everyday medieval guild practice: when a master mason arrived in a strange place in the course of his work, he needed to guard against being taken for an impostor by using signs of recognition.

34 Ibid. ("Anni 1458–1464. Aristotele Fioravanti al servizio di Francesco Sforza a Milano"), pp. 51–53.

35 P. Carpeggiani, "Fioravanti al servizio di Ludovico Gonzaga [. . .]", ibid., pp. 84–85.

36 Ibid., p. 85.

37 J. Balogh, "Aristotele Fioravanti in Ungeria", ibid., p. 225.

38 Fioravanti set out for Buda in January 1467, and by autumn of the same year he was back in Bologna.

39 F. Filippini, "Le opere architettoniche di Aristotele Fioravanti in Bologna e in Russia", *Cronache d'Arte*, Reggio Emilia, 1925, II, fasc. 3, pp. 101–20.

40 Zemtsov and Glazychev, 1985, pp. 58–60.

41 N. Kazakova, *Zapadnaya Yevropa v russkoy pis'mennosti XV–XVI vekov*, Leningrad, 1980, p. 27.

42 Sadov, p. 98.

43 Zemtsov and Glazychev, p. 42.

44 Ibid.

45 *Polnoye sobraniye russkikh letopisey (PSRL)*, XX, part I (L'vovskaya letopis'), St Petersburg, 1910, p. 301.

46 Ibid.

47 Ibid.

48 Ibid.

49 Ibid.

50 Ibid.

51 Ibid.

52 A. Oreshnikov, "Ornistotel', denezhnik Ivana III", *Staraya Moskva*, 2, Moscow, 1914, pp. 50–52.

53 *PSRL*, VIII (Prodolzheniye letopisi po Voskresenskomu spisku), St Petersburg, 1859, p. 192.

54 *PSRL*, VI (Prodolzheniye Sofiyskoy pervvoy letopisi), St Petersburg, 1848, p. 237.

55 A. Pavlinov, *Istoriya russkoy arkhitektury*, Moscow, 1894, pp. 130–31; F. Gornostayev, "Ranneye zodchiye Moskovskoy oblasti", in I. E. Grabar' (ed.), *Istoriya russkogo iskusstva*, II, Moscow, 1903, p. 12; M. Krassovsky, *Ocherk moskovskogo perioda drevnerusskogo zodchestva*, Moscow, 1911, p. 53; K. Khreptovich-Butenev, "Aristotel' F'yorovanti [. . .]", *Staraya Moskva*, 2, Moscow, 1914, p. 35; A. Nekrasov, *Drevnerusskoye zodchestvo*, Moscow, 1935, p. 89; K. K. Romanov, "O formakh Uspenskogo sobora 1326 i 1472", in *Materialy i issledovaniya po arkheologii SSSR*, Moscow, 1955; T. Tolstaya, *Uspenskiy sobor MoskovskogoKremlya*, Moscow, 1979; E. Smirnova (ed.), *Uspenskiy sobor Moskovskogo Kremlya. Materialy*, Moscow, 1985; I. Buseva-Davydova, *Svyatyni i drevnosti Moskovskogo Kremlya*, Moscow, 1997, pp. 13–92; A. Batalov, "Traditsiya stroitel'stva Uspenskikh khramov v XVI veke", in *Materialy konferentsii "Russkoye isskustvo XVI veka"*, Moscow, 2000.

56 A. Kartashov, *Ocherki po istorii russkoy tserkvi*, I, Moscow, 1991 pp. 364 ff.; I. Ostroumov, *Istoriya Florentiyskogo sobora*, Moscow, 1847; A. Shcherbinin, "Literaturnaya istoriya russkikh skazaniy o Florentiyskoy unii", in *Letopis' Istoriko-filologicheskogo obshchestva pri Novorossiyskom universitete*, 10, Odessa, 1902.

57 Kartashov, 1991, p. 356.

58 Ibid.

59 Ibid., p. 377.

60 Ibid., p. 369.

61 *Slovo o sostavlenii [. . .] o'mogo sobora [. . .]*, cited by Kartashov, p. 370.

62 Ibid., p. 377.

63 Ibid.

64 *PSRL*, XXV (Moskovskiy letopisnyy svod kontsa XV veka), Moscow and Leningrad, 1949, p. 293.

65 Ibid.

66 V. Vygolov, *Arkhitektura Moskovskoy Rusi serediny XV veka*, Moscow, 1988, p. 187.

67 *PSRL*, XXV, p. 293.

68 *PSRL*, XX, part I (L'vovskaya letopis'), St Petersburg, 1910, p. 297.

69 Vygolov, 1988, pp. 190–91.

70 *PSRL*, XXIV (Tipografskaya letopis'), Petrograd, 1921, p. 194.

71 *PSRL*, XX, part I, p. 302.

72 *PSRL*, VI (Prodolzheniye Sofiyskoy pervoy letopisi), St Petersburg, 1848, pp. 221; XX, part I, p. 335.

73 See Chapter 1 section 5 on the churches built by Prince Andrey Bogolyubsky in Vladimir and its environs.

74 *PSRL*, XX, part I, p. 302; XII (Letopisnyy sbornik, imenuyemyy Patriarshey ili Nikonovskoy letopis'yu), St Petersburg, 1901, pp. 192–93.

75 *PSRL*, VI, p. 200; XX, part I, p. 302. See also Pod"yapol'sky, 1985, p. 40.

76 *PSRL*, VIII (Prodolzheniye letopisi po Voskresenskomu spisku), St Petersburg, 1859, p. 201.

77 Buseva-Davydova, 1997, pp. 45–46; Tolstaya, 1979.

78 *PSRL*, VI, p. 221.

79 Ibid.

80 Pod"yapol'sky, 1985, p. 37; Buseva-Davydova, 1997, p. 31.

81 *PSRL*, XX, part I, pp. 228–301.

82 Pod"yapol'sky, 1985, p. 40; A. Ikonnikov, *Tysyacha let russkoy arkhitektury*, Moscow, 1990, p. 156.

83 Quoted by Buseva-Davydova, 1997, p. 31.

84 R. P. Dmitriyeva, *Skazaniye o knyaz'yakh vladimirskikh*, Moscow, 1955, pp. 171–213.

85 Kontarini, p. 6.

86 *PSRL*, VI, p. 239.

87 G. Calvi, "Guiniforte Solari", *Notizie sulla vita e sulle opere dei principali architetti, scultori e pittori che fiorirono in Milano [. . .]*, Milan, 1865, pp. 72–85.

88 J. Ackerman, "The Certosa of Pavia and the Renaissance in Milan", in id., *Distant Points: Essays in Theory and Renaissance Art and Architecture*, Cambridge, MA, 1991, pp. 278–87.

89 F. Malaguzzi-Valeri, "Solari, architetti e scultori Lombardi del XV secolo", *Italienische Forschungen*, I, Berlin, 1906, pp. 84 ff.; V. Lazarev, "Le opere di Pietro Antonio Solari in Russia", *Arte e artisti dei Laghi Lombardi*, Como, 1959, pp. 424–41.

90 Ackerman, 1991, p. 285.

91 Malaguzzi-Valeri, 1906, p. 124.

92 B. Florya, "Russkiye posol'stva v Italiyu i nachalo stroitel'stva Moskovskogo Kremlya", in *Gosudarstvennyye musei Moskovskogo Kremlya. Materialy i issledovaniya*, Moscow, 1980, pp. 12–18.

93 *PSRL*, VIII, p. 217.

94 M. Caffi, "Artisti lombardi del secolo XV: i Solari", in *Archivio storico lombardo*, Milan, 1878, pp. 669–93; P. Cazzola, "Mastri Frjazi di origine piemontese al Cremlino di Mosca", *Bolletino della Società piemontese di Belle Arti. Nuova serie. Anno XXX–XXXI*, Turin, 1976–77, pp. 93–101.

95 D. Yakovlev, "Novyye svedeniya o velikoknyazheskom dvortse v Kremle kontsa XV veka", in *Materialy konferentsii "Brunovskiye chteniya"*, Moskovskiy arkhitekturnyy institut (MARKhI), Moscow, 1998.

96 P. Pecchiai, *L'Ospedale Maggiore di Milano*, Milan, 1927, pp. 470–500; L. Grassi, *Lo "Spedale di poveri" del Filarete. Storia e restauro*, Milan, 1972; L. Patetta, *L'architettura del Quattrocento a Milano*, Milan, 1987; L. Giordano, "Milano e l'Italia nord-occidentale", in F. Fiore (ed.), *Storia dell'architettura italiana. Il Quattrocento*, Milan, 1998, pp. 166–75; C. Frommel, "Lombardia", in C. Frommel, L. Giordano and R. Schofield, *Bramante milanese e l'architettura del Rinascimento lombardo*, Venice, 2002, pp. 1–31.

97 G. Lise, *Santa Maria presso San Satiro*, Milan, 1975; A. Buratti Mazzotta et al., *Insula Ansperti. Il complesso monumentale di S. Satiro*, Milan, 1992; R. Schofield and G. Sironi, "Bramante and the Problem of S. Maria presso S. Satiro", *Annali di architettura*, 2000, 12, pp. 17–57.

98 A. Cole, *La Renaissance dans les cours italiennes*, Paris, 1988, pp. 140–41.

99 Construction of the Ca del Duca on the Grand Canal was begun by Bartolomeo Buono at the end of the 1450s, but very little of the project was completed.

100 N. Ernst, "Bakhchisarayskiy khanskiy dvorets i arkhitektor velikogo knyazya Ivana III fryazin Alevin Novyy", *Izvestiya Tavricheskogo obshchestva istorii, arkheologii i etnografii*, II, Simferopol, 1928, pp. 39–54; V. Vygolov, "K voprosu o postroykakh i lichnosti Aleviza Fryazina", in *Drevnerusskoye isskustvo. Issledovaniya i atributsii*, St Petersburg, 1997, pp. 234–45.

101 Pod"yapol'sky, 1984, p. 221.

102 S. Bettini, "Alvise Lamberti da Montagnana. Un grande artisto veneto in Russia", *Le Tre Venezie*, 1944, nn. 7–12, pp. 17–31; G. Fiocco, "Alvise Lamberti da Montagnana", *Bollettino del Museo Civico di Padova*, XLV, Padua, 1956, pp. 83–88; S. Bettini, "L'architetto Alevis Novi in Russia", in A. Pertusi (ed.), *Venezia e l'Oriente fra tardo Medioevo e Rinascimento*, Florence, 1966; G. Mazzi, "Indagini archivistiche per Alvise Lamberti da Montagnana", *Arte Lombarda*, XLIV–V, 1976, pp. 96–101; G. Danieli, "Schede d'archivio per la storia dell'arte a Padova e nel territorio (sec. XV–XVI)", *Bolletino del Museo Civico di Padova*, LXXXII, Padua, 1993, pp. 131–70.

103 P. Paoletti, *L'Architettura e la sculptura del Rinascimento in Venezia*, II, Venice, 1893, p. 180; L. Puppi, *Mauro Cadussi*, Milan, 1977; J. McAndrew, *L'Architettura veneziana del primo Rinascimento*, Venice, 1995.

104 Including, among other work, the presbytery of Montagnana cathedral and the episcopal chapel in Padua cathedral. See G. Lorenzoni,

"Profilo dell'architetto Lorenzo da Bologna", *Palladio*, 1956, VI, pp. 145–57; F. Vignaga, "Montagnana nel Quattrocento", doctoral thesis, Università degli Studi di Padova, 1950–51.

105 Bettini, 1944, pp. 17–31.

106 Paoletti, 1893, p. 176.

107 N. I. Brunov and E. Lo Gatto considered Alevisio a decorative artist (N. Brunoff, "Due Cattedrali del Kremlino construite de italiani", *Architettura e arti decorative*, anno VI, fasc. iii, Milan, 1926; E. Lo Gatto, *Gli artisti italiani in Russia*, I, Milan, 1939), while S. Bettini and then S. Pod"yapol'sky were inclined to think of him as an architect, with building experience from before his arrival in Russia (Bettini, 1944; Pod"yapol'sky, "Venetsianskiye istoki arkhitektury moskovskogo Arkhangel'skogo sobora", *Drevnerusskoye iskusstvo*, 7, Moscow, 1975, pp. 252–79).

108 Buseva-Davydova, 1997, p. 95.

109 R. Skrynnikov, *Tretii Rim*, Moscow, 1994, p. 65.

110 Pod"yapol'sky, 1975, p. 256.

111 A. Vlasyuk, "Novyye issledovaniya arkhitektury Arkhangel'skogo sobora v Moskovskom Kremle", *Arkhitekturnoye nasledstvo*, 2, Moscow, 1952, pp. 105–32; A. Vlasyuk, "O rabote zodchego Aleviza Novogo v Bakhchisaraye i v Moskovskom Kremle", *Arkhitekturnoye nasledstvo*, 10, Moscow, 1958, pp. 101–16.

112 V. Merkelova, "K rekonstruktsii fasadov Arkhangel'skogo sobora", *Gosudarstvennyye muzei Moskovskogo Kremlya. Materialy i issledovaniya*, III, Moscow, 1980, pp. 76–86.

113 Pod"yapol'sky, 1975, p. 261; A. Trucolo, *Santa Maria Formosa*, Venice, 1995, p. 6.

114 S. Shirvinsky, "Venetsianizmy moskovskogo sobora", *Moskovskiy Merkuriy*, I, Moscow, 1917, pp. 191–204.

115 Pod"yapol'sky, 1975, p. 264.

116 Ibid., p. 274.

117 Pod"yapol'sky, 1984, p. 221. The churches mentioned in the chronicles are: (entrance to) the church of the Holy Mother of God on the Great Façade behind the Market (Khram Presvyatoy Bogoroditsy na Bol'shom Fasade za Torgom), St Vladimir in Staryye Sady (Sv. Vladimira v Starykh Sadekh), the Annunciation in Vorontsov (Blagoveshcheniya v Vorontsove), the Nativity of the Mother of God (Rozhdestva Bogoroditsy) in the Kremlin, St Leonty Rostovsky behind Neglinnaya (Sv. Leontiya Rostovskogo za Neglinnoy), the Annunciation on the Vagankov (Blagoveshchen'ya na Vagan'kove), St Aleksey the Man of God in the Devichy Convent (Sv. Alekseya Cheloveka Bozhiya v Devich'em monastyre), The Beheading of St John the Baptist below the Forest in Zamoskvorech'ye (Usekoveniya glavy Sv. Ioanna Predtechi pod Borom v Zamoskvorech'ye), St Peter the Metropolitan in the Upper Monastery of St Peter (Sv. Petra-mitro-

polita v Vysoko-Petrovskim monastyre), (entrance to) the church of the Holy Mother of God on Sretenka (Presvyatoy Bogoroditsy na Sretenke), St Barbara (Sv. Varvary). This information comes from chronicle sources (*PSRL*, VI, p. 254; VIII, pp. 254–55) which give no indication of the style of these churches.

118 V. V. Sedov, "Vysokopetrovskiy monastyr'", in *Guide du Patrimoine de Moscou*, Paris, 1997, p. 446.

119 *Bolletino del Centro internazionale di studi di architettura Andrea Palladio*, VI, part II, Venice, 1964, pp. 73, 74, 80 ff.

120 *Inostrantsy* [. . .], p. 9.

121 *Rossiyskaya istoricheskaya biblioteka*, VI, part I, St Petersburg, 1908, n. 118, cols 795–96. See Zosima, Metropolitan of All Russia, *Slovar' knizhnikov i knizhnosti Drevney Rusi. Vtoraya polovina XIV–XVI veka*, part I, 1988, pp. 305–07.

122 Kartashov, I, 1991, p. 390.

123 Dmitriyeva, 1955, p. 171.

124 D. Miller, "The Lubeckers Bartholomäus Ghotan and Nicolas Bulow in Novgorod and Moscow and the Problem of Early Western Influences on Russian Culture", *Viator*, 1978, 9, pp. 395–412.

125 Bulow himself translated Stoffler's astrological almanac (printed in 1499).

126 N. Gudzy, "Maksim Grek i yego otnosheniye k epokhe italianskogo Vozrozhdeniya", *Universitetskiye izvestiya*, Kiev, 7, 1911, pp. 1–19; B. Dunayev, *Prepodobnyy Maksim Grek i grecheskaya ideya na Rusi v XVI veke*, Moscow, 1916; J. Hanley, *From Italy to Muscovy: The Life and Works of Maxim the Greek*, Munich, 1973; D. Bulanin, "Maksim Grek i vizantiyskaya liternaya traditsiya" [abstract of doctoral dissertation], Leningrad, 1978.

127 V. Malinin, *Starets Yelizarova monastyrya Filofey i yego poslaniya*, Kiev, 1901; A. Gol'dberg, *Ideya "Moskva – Tretiy Rim" v tsikle sochineniy pervoy poloviny XVI veka*, TODRL, XXXVII, Leningrad, 1983, pp. 139–49.

128 Malinin, 1901, appendix, p. 45.

129 Ibid.

130 Ibid.

131 A. V. Ekzemplyarsky, "Glinskiy Mikhail", in *Entsiklopedicheskiy slovar'*, Brockhaus-Efron, XVI, pp. 866–67.

132 V. Bulkin, "O tserkvi Vozneseniya v Kolomenskom", in A. Kirpichnikov (ed.), *Kul'tura Srednevekovoy Rusi*, Moscow, 1976, pp. 113–16; S. Pod"yapol'sky, "Arkhitektor Petrok Malyy", in V. Vygolov, A. Vlasyuk and V. Pluzhnkov (eds), *Pamyatniki russkoy arkhitektury i monumental'nogo iskusstva*, Moscow, 1983, pp. 34–40.

133 Svenska Riksarkivet (SRA), *Livonica*, I/12.

134 J. Kivimae, "Peter Frjazin or Peter Hannibal? An Italian Architect in Late Medieval Russia and Livonia", *Settentrione. Rivista di studi italo-finlandeesi*, V, Turku, 1933, pp. 60–69.

135 N. Sultanov, "Russkiye shatrovyye tserkvi i ikh sootnosheniye k gruzinsko-armyanskim piramidal'nym pokrytiyam", in *Trudy V Arkheologicheskogo s"yezda v Tiflise*, Moscow, 1887; A. Nekrasov, "Problema proiskhozhdeniya drevnerusskikh stolboobraznykh khramov", *Trudy Kabineta istorii material'noy kul'tury*, 5, Moscow, 1930; N. Rogovin, *Tserkov' Vozneseniya v Kolomenskom*, Moscow, 1941; M. Gra and G. Zheromsky, *Kolomenskoye*, Moscow, 1970; V. Bulkin, 1974; M. Il'in, *Russkoye shatrovoye zodchestvo. Pamyatniki serediny XVI veka*, Moscow, 1980.

136 R. Wittkower, *Architectural Principles in the Age of Humanism*, London, 1973, pp. 13–21.

137 A. Uvarov, *Melkiye sochineniya*, I, Moscow, 1910, p. 290; N. Pokrovsky, "Ierusalem ili Sion Sofiyskoy riznitsy v Novgorode", *Vestnik arkheologii i istorii*, XXI, St Petersburg, 1911; G. N. Bocharov, "Tsarskoye mesto Ivana Groznogo v Moskovskom Uspenskom sobore", in A. Sterligov (ed.), *Pamyatniki russkoy arkhitektury i iskusstva*, Moscow, 1985, pp. 39–57.

138 Quoted from P. Lashkaryov, *Kivoriy kak otlichitel'naya prinadlezhnost' altarya v drevney tserkvi*, Kiev, 1883, p. 6.

139 Ibid., p. 8.

III POST-BYZANTINE "MANNERISM"

1 A. V. Kartashov, *Ocherki po istorii russkoy tserkvi*, I, Moscow, 1991, p. 429.

2 D. S. Likhachev, *Velikiy put'*, Moscow, 1987, p. 168.

3 Ibid.

4 Ibid., p. 169.

5 N. I. Brunov, *Khram Vasiliya Blazhennogo v Moskve. Pokrovskiy sobor*, Moscow, 1988.

6 M. A. Il'yin, *Russkoye Shatrovoye zodchestvo*, Moscow, 1980, pp. 56–63.

7 A. L. Batalov and T. N. Vyachanina, "Ob ideynom znachenii i interpretatsii ierusalimskogo obraztsa v russkoy arkhitekture XVI–XVII vekov", *Arkhitekturnoye nasledstvo*, 36, Moscow, 1988, pp. 22–42.

8 I. A. Bondarenko, "Russkoye gradostroitel'stvo XV–XVII vekov", in T. F. Savarenskaya (ed.), *Istoriya gradostroitel'nogo iskusstva*, I, Moscow, 1984, pp. 324–26.

9 Brunov, 1988, p. 60.

10 A. L. Batalov, "K voprosu o prisutstvii zapadnykh masterov v Moskve epokhi Ivana Groznogo", paper read at conference *Lazarevskiye chteniya*, Moscow University, 2001.

11 V. V. Kolesov, "Domostroy kak pamyatnik srednevekovoy kul'tury", in *Domostroy*, Moscow, 1994, pp. 301–57.

12 Likhachev, 1987, pp. 159–74.

13 Cited from Il'yin, p. 69.

14 *PSRL*, XII (*Letopisnyy sbornik, imenuyemyy Patriarshey ili Nikonovskoy letopisæyu*), Moscow, 1965, p. 255.

15 Ibid., p. 251.

16 I. I. Kuznetsov, *Moskovskiy Pokrovskiy i Vasiliya Blazhennogo sobor*, Moscow, 1914; A. L. Batalov, "K interpretatsii sobora Pokrova na Rvu", in A. L. Batalov (ed.), *Ikonografiya arkhitektury*, Moscow, 1990, pp. 15–37.

17 Ibid., p. 16.

18 Ibid., p. 17.

19 V. N. Bochkarev, *Moskovskoye gosudarstvo XV–XVII vekov po skazaniyam sovremennikov-inostrantsev*, St Petersburg, 1914, p. 18.

20 Cited from V. V. Suslov, *Tserkov' Vasiliya Blazhennogo v Moskve*, St Petersburg, 1912, p. 3.

21 *PSRL*, XXXIV, Moscow, 1978, p. 189.

22 Ibid.

23 Il'yin, 1980, p. 74.

24 Ibid., pp. 29–111.

25 S. S. Pod"yapol'sky, "Petrok Malyy", in V. Vygolov, A. Vlasyuk and V. Pluzhnikov (eds), *Pamyatniki russkoy arkhitektury i monumental'nogo iskusstva*, Moscow, 1983, pp. 42–45.

26 Id., "Deyatel'nost' ital'yanskikh masterov na Rusi i v drugikh stranakh Yevropy v kontse XV – nachale XVI vv.", *Sovetskoye iskusstvoznaniye*, 20, Moscow, 1986, p. 84.

27 A. L. Batalov and D. O. Shvidkovsky, "Angliyskiy master pri dvore Ivana Groznogo", *Arkhiv arkhitektury*, 1, Moscow, 1992, p. 108; P. O. Pirling, *Rossiya i papskiy prestol*, I, Moscow, 1912, pp. 344–45; Yu. N. Shcherbachev, "Kopengagenskiye akty, otnosyashchiyesya do russkoy istorii", *Chteniya Obshchestva istorii i drevnostey Rossiyskikh (ChOIDR)*, Book 4, St Petersburg, 1915, p. 307; id., *Datskiy arkhiv. 1326–1690*, Moscow, 1893, p. 290.

28 Public Record Office, London (PRO), Prob. 11/54, f. 78; J. Harvey, *English Medieval Architects*, London, 1987, p. 50.

29 Guildhall Library, London, MS 15211/ff. B9/101; Harvey, 1987, p. 51.

30 Public Record Office. State Papers, Foreign (PROSPF), SP 70/123, v. 123, f. 148; Calendar of State State Papers, Foreign (CSSPF) (1569–72), p. 112 (19 May 1572); PROSPF, SP 70/98, v. 98, f. 62; CSSPF (1566–68), p. 463 (20 May 1568); T. S. Willan, *The Early History of the Muscovy Company*, Manchester, 1956, p. 92.

31 PROSPF, SP 70, v. 100, f. 4; CSSPF (1566–68), pp. 492–93 (1 July 1568); PROSPF, SP 70/147, v. 147, f. 355 (23 June 1569); PROSPF, SP 70/123, v. 123, f. 148; CSSPF (1569–72), p. 112 (19 May 1572); E. D. Morgan and C. H. Coote, *Early Voyages and Travels to Russia and Persia*, I, London, 1886, pp. 261–79; Lansdowne Manuscripts, British Library, V. 10, ff. 89, 93, 130, 134; S. H. Baron, "A Guide to Published and Unpublished Documents on Anglo-Russian Relations in the Sixteenth Century in British Archives", in S. H. Baron, *Muscovite Russia*, London, 1980.

32 Yu. V. Tolstoy, *Pervyye sorok let snosheniy mezhdu Rossiyey i Anglii (1553–1593 gg.)*, St Petersburg, 1875, pp. 6–7.

33 Ibid., pp. 11–12.

34 I. Kh. Gamel', *Anglichane v Rossii v XV–XVI vv.*, St Petersburg, 1869, p. 36; A. A. Sevast'yanova, "Predisloviye", in Dzh. Gorsey, *Zapiski o Rossii XVI – nachala XVII vv.*, Moscow, 1990, pp. 20–30; T. S. Willan, *The Muscovy Company Merchants of 1555*, Manchester, 1953.

35 Gamel', 1869, p. 61; Tolstoy, 1875, p. 15.

36 Ibid., p. 36.

37 Gamel', 1869, p. 77.

38 Harvey, 1987, p. 50.

39 *Inostrantsy o drevney Moskve*, Moscow, 1991, p. 89.

40 Letter from an Englishman of unknown identity describing the burning of Moscow by the Crimean khan Devlet Girey in 1571–72, in *Inostrantsy [. . .]*, pp. 87–79.

41 It must be emphasized that this is only conjecture.

42 Harvey, 1987, p. 51.

43 Gorsey, 1990, p. 72.

44 Gamel', 1869, p. 78.

45 Gorsey, 1990, 78–79.

46 A. L. Batalov, *Russkoye kamennoye zodchestvo epokhi Borisa Godunova*, Moscow, 1998; id., "Osobennosti 'ital'yanizmov' v moskovskom kamennom zodchestve rubezha XVI–XVII vv.", *Arkhitekturnoye nasledstvo*, 34, Moscow, 1986, pp. 238–45; id., "Sobor Voznesenskogo monastyrya v Moskovskom Kremle", in D. Likhachev (ed.), *Pamyatniki kul'tury. Novyye otkrytiya*, Moscow, 1985, pp. 468–82.

47 Id., "Grob Gospoden' v zamysle 'Svyataya Svyatykh' Borisa Godunova", in A. L. Batalov and A. I. Lidov (eds), *Ierusalim v russkoy kul'ture*, Moscow, 1994, pp. 154–74.

48 S. Konovalov, "Anglo-Russian Relations, 1620–24", *Oxford Slavonic Papers* (*OSP*), IV, 1953, pp. 80–89; N. Evans, "Queen Elizabeth and Tsar Boris: Five Letters, 1597–1603", *OSP*, XII, 1965, pp. 49–68.

49 *Pamyatniki arkhitektury Moskovskoy oblasti*, II, Moscow, 1975, pp. 77–80.

50 A. Palitsyn, "Skazaniye vkratse o razorenii tsarstvuyushchego grada Moskvy", *Moskva v istorii i literature*, Moscow, 1903, pp. 65–66.

51 J. Howard, *Christopher Galloway. Clockmaker, Architect and Engineer to Tsar Mikhail, the First Romanov*, Edinburgh, 1997, pp. 65–66.

52 Ibid., p. 11.

53 Ibid., p. 5.

54 J. Summerson, *Architecture in Britain. 1530–1830*, London, 1976, pp. 157–72; H. Lowe, "Anglo-Netherlandish Interchange, c. 1600–1660", *Architectural History*, XXIV, 1981, pp. 1–23; G. Worsley, "Thorpe Hall in Context", *Georgian Group Journal*, 1993, pp. 4–12.

55 I. Anderson, *Scotsmen in the Service of the Czars*, Edinburgh, 1970, pp. 3–36, 53–90.

56 M. Posokhin et al. (eds), *Pamyatniki arkhitektury Moskvy*, I, Moscow, 1979, p. 335.

57 Ibid., pp. 333–34.

58 I. Ye. Zabelin, *Domashniy byt russkikh tsarey v XVI i XVII stoletiyakh*, Book I, Moscow, 1990, p. 141.

59 Ibid., pp. 142–44.

60 S. S. Popaduk, *Teoriya neklassicheskikh arkhitekturnykh form. Russkiy arkhitekturnyy dekor XVII veka*, Moscow, 1998, pp. 21–22; V. V. Zgura, *Problemy i pamyatniki, svyazannyye s V. I. Bazhenovym*, Moscow, 1928, pp. 7–23.

61 Kartashov, 1991, II, p. 122.

62 Ibid., p. 123.

63 Ibid.

64 Cited from S. Zabello, V. Ivanov and P. Maksimov, *Russkoye derevyannoye zodchestvo*, Moscow, 1942, p. 9.

65 Arkhimandrite Leonid, *Russkaya istoricheskaya biblioteka*, V: *Akty Iverskogo Svyatoozyorskogo monastyrya*, St Petersburg, 1878.

66 Arkhimandrite Lavrenty, *Kratkoye izvestiye o Krestnom Onezhskom Arkhangel'skoy eparkhii monastyre*, Moscow, 1805.

67 R. Ousterhaut, "Loca Sancta and the Architectural Response to Pilgrimage", in R. Ousterhaut (ed.), *The Blessings of Pilgrimage*, Urbana, OH, and Chicago, IL, 1989.

68 Id., "The Church of the Holy Sepulchre in Bologna, Italy", *Biblical Archeology Review*, 6, 2000, pp. 21–35.

69 Batalov, 1994, p. 154.

70 N. I. Brunov, "Model' iyerusalimskogo khrama, privezennaya v XVII veke v Rossiyu", *Soobshcheniya Rossiyskogo Palestinskogo obshchestva*, XXIX, Leningrad, 1926; for drawings, see *Pravoslavnyy Palestinskiy sbornik*, 21, St Petersburg, 1889.

71 Bernadino Amico, *Trattato delle piante et imagini de sacri edificii di Terra Sante*, Rome, 1609 (Florence, 1620); English ed.: *Plans of the Sacred Edifices of the Holy Land*, trans. Theofilius Bellorini and Eugene Hoade, with preface by Bellarmino Bagatti, London, 1953.

72 Arkhimandrite Leonid, *Istoricheskoye opisaniye stavropigial'nogo Voskresenskogo, Novyy Ierusalim imenuyemogo monastyrya*, Moscow, 1876, p. 766. For similar material in Russian compilations, see S. Bogoyavlensky, "O pushkarskom prikaze", in *Sbornik statey v chest' M. K. Lyubavskogo*, Petrograd, 1917, pp. 384–85; M. A. Il'yin, "Zodchestvo XVII veka", in *IRI*, IV, Moscow, 1959, p. 60.

73 N. Pervukhin, *Tserkov' Bogoyavleniya v Yaroslavle*, Yaroslavl', 1916; id., *Tserkov' Il'yi Proroka v Yaroslavle*, Yaroslavl', 1915; M. A. Il'yin, "Zodchestvo vtoroy chetverti XVII veka", in *IRI*, IV, Moscow, 1959, pp. 198–215; S. Malenitsyn, *Kostroma*, Leningrad, 1968; Z. Dobrovol'skaya, *Yaroslavl'*, Moscow, 1968.

74 N. Pervukhin, *Tserkov' Ioanna Predtechi v Yaroslavle*, Yaroslavl', 1913.

75 V. V. Sedov, "Eglise Saint-Grégoire de Néo-césarée", *Guide du Patrimoine de Moscou*, Paris, 1997, pp. 148–49.

76 N. N. Voronin, *Drevnerusskiye goroda*, Moscow and Leningrad, 1945, p. 99.

77 Cited from *Moskva v istorii i literature*, Moscow, 1914, p. 101.

78 P. N. Maksimov, "Derevyannaya arkhitektura XVII veka", in *IRI*, IV, Moscow, 1959, p. 96.

79 N. A. Yevsina, "Iz istorii arkhitekturnykh vzglyadov i teorii nachala XVIII veka", in T.V. Alekseyeva (ed.), *Russkoye iskusstvo pervoy chetverti XVIII veka*, Moscow, 1974, pp. 9–26; L. Hughes, "Western European Graphic Material as a Source for Moscow Baroque Architecture", *Slavonic and East European Review*, 55, 1977, 4, pp. 433–43; id., "The Moscow Armory and Innovation in Seventeenth-Century Muscovite Art", *Canadian-American Slavic Studies*, XIII/ 1–2, 1979, pp. 204–23; id., "The 17th century 'renaissance' in Russia: Western influences on art and architecture", *History Today*, February 1980, pp. 41–45; R. Lucas, "Dutch and Polish contributions to Russian architecture", *Newsletter of the Study Group on Eighteenth Century Russia* (Norwich), 8, 1980, pp. 14–22.

80 Hughes, 1977, p. 439.

81 Id., 1979, p. 212; *Teatrum Biblicum hoc est Historiae Sacrae veteris et novi testamenti [. . .] in lucem editum per Nikolaum Iohannis Piscatorem*, Amsterdam, 1650 (posthumously printed by Claus Vissher), and numerous subsequent Dutch editions.

82 M. A. Il'yin, "Svyazi russkogo, ukrainskogo i belorusskogo iskusstva vo vtoroy polovine XVII veka", *Vestnik Moskovskogo gosudarstvennogo universiteta. Seriya obshchestvennykh nauk*, 7, Moscow, 1954, pp. 75–84; L. S. Abesedarsky, *Belorusy v Moskve v XVII veke*, Minsk, 1957; id. (ed.), *Russko-belorusskiye syyazi. Sbornik dokumentov (1570–1667)*, Minsk, 1963; A. P. Ignatenko, *Russko-belorusskiye svyazi vo vtoroy polovine XVII veka*, Minsk, 1972; L. Hughes, "Belorussian craftsmen in late 17th century Russia and their influence over Muscovite architecture", *Journal of Belo-russian Studies* (London), 1976, III/4, pp. 327–41.

83 S. K. Bogoyavlensky, "Moskovskaya Nemetskaya sloboda", *Izvestiya Akademii Nauk SSSR. Seriya "Istoriya i filosofiya"*, 4, Moscow, 1947; L. Hughes, "The Foreigners' colony in 17th and 18th century Moscow", *Newsletter of the Study Group on Eighteenth Century Russia*, 8, 1980.

IV RUSSIAN IMPERIAL BAROQUE

1 I. I. Golikov, *Sravneniye svoystv i del Konstantina Velikogo, pervogo iz rimskikh khristianskikh imperatorov, so svoystvami i delami Petra Velikogo [. . .]*, Moscow, 1810; D. D. Zedov, "Obrashcheniye k naslediyu Drevnego Rima v triumfakh petrovskogo vremeni", *Oranienbaumskiye chteniya*, 1, St Petersburg, 2001.

2 *Pis'ma i bumagi Petra Velikogo*, 1688–1701, I, St Petersburg, 1887, p. 109.

3 I. I. Golikov, *Dopolneniya k Deyaniyam Petra Velikogo*, IV, Moscow, 1790, pp. 192–93.

4 Ye. N. Bodrova, *Biblioteka Petra I. Ukazatel'-Spravochnik*, Leningrad, 1978, p. 41; N. A. Yevsina, *Arkhitekturnaya teoriya v Rossii pervoy poloviny XVIII veka*, Moscow, 1975, p. 59; L. Hughes, "Russia's first architectural books in Peter the Great's cultural revolution", *Architectural Design*, 1983, 53/ 5–6, pp. 4–13; D. D. Zedov, "Zagranichnyye feyerverki kak yavleniye ofitsial'noy prazdnichnoy kul'tury petrovskogo vremeni", *Vestnik MGU. Istoriya*, 2, Moscow, 2001.

5 *Veteres arcus Augustorum triumphis insignes ex Reliquiis, quae Romae adhuc supersunt cum imaginibus triumphalibus restituti antiquis nummis notisquae Jov. Petri Bellori illustrati. Nunc primum per Jov.-Jacobom de Rubeis aeneis typis vulgati*, Rome, 1690.

6 P. P. Golitsyn, *Rod knyazey Golitsynykh*, I, St Petersburg, 1892, p. 283; A. I. Nekrasov, *Ocherki po istorii drevnerusskogo zodchestva XI–XVII vekov*, Moscow, 1936, p. 384; L. Hughes, *Russia and the West: The Life of a Seventeenth-century Westernizer, Prince Vasily Vasilevich Golitsyn*, Newtonville, MA, 1984.

7 A. M. Tarunov, *Dubrovitsy*, Moscow, 1991, pp. 7–22; I. Grech, "Dubrovitsy", *Podmoskovnyye muzei*, 4, Moscow and Leningrad, 1925, pp. 70–87; M. V. Krassovsky, "Tserkov' sela Dubrovitsy", *Izvestiya Imperatorskoy arkheologicheskoy komissii*, 34, St Petersburg, 1910, pp. 55–71.

8 F. F. Gornostayev, "Barokko Moskvy", in I. E. Grabar' (ed.), *IRI*, ist ed., II, Moscow, 1911, pp. 417–68; V. V. Zgura, "Problema vozniknoveniya barokko v Rossii", in A. I. Nekrasov (ed.), *Barokko v Rossii*, Moscow, 1926, pp. 13–42; N. I. Burnov, "K voprosu o tak nazyvayemom 'russkom barokko'", in ibid., pp. 43–55; A. I. Nekrasov, "O proiskhozhdenii tsentricheskikh kompozitsiy v russkom zodchestve kontsa XVII veka", *Pamyatniki kul'tury*, 3, Moscow, 1961, pp. 123–33; I. L. Buseva-Davydova, "Kategoriya prostranstva v russkom iskusstve XVII veka", in N. A. Vevsina (ed.), *Barokko v Rossii*, Moscow, new ed., 1994, pp. 16–26.

9 Ye. Kunitskaya, "Menshikova bashnya", *Arkhitekturnoye nasledstvo*, 9, Leningrad and Moscow, 1959, pp. 157–68.

10 V. G. Vlasov, *Arkhitektura petrovskogo barokko*, St Petersburg, 1996, pp. 70–71.

11 A. A. Kiparisova, "Lefortovskiy dvorets v Moskve", *Soobshcheniya instituta istorii i teorii arkhitektury Akademii arkhitektury SSSR*, 9,

Moscow, 1948, pp. 45–54; R. Podol'sky, "Petrovskiy dvorets na Yauze", *Arkhitekturnoye nasledstvo*, 1, Moscow, 1951, pp. 14–55; T. A. Gatova, "Dzhovanni Mario Fontana", in Yu. S. Yaralov (ed.), *Zodchiye Moskvy*, Moscow, 1981, pp. 106–13.

12 G. I. Vzdornov, "Zametki o pamyatnikakh russkoy arkhitektury kontsa XVII–nachala XVIII v.", in T. V. Alekseyeva (ed.), *Russkoye iskusstvo XVIII veka. Materialy i issledovaniya*, Moscow, 1973, pp. 21–25. The name by which this architect was known in Russia indicated his origins in the Swiss canton of Tessin or Ticino.

13 V. P. Vygolov, "Novoye o tvorchestve I. P. Zarudnogo", *Arkhitekturnoye nasledstvo*, 9, Moscow and Leningrad, pp. 157–68; I. E. Grabar', "Moskovskaya arkhitektura nachala XVIII veka", in *IRI*, V, Moscow, 1960, pp. 40–62.

14 V. F. Odoyevsky, *Sochineniya*, II, Moscow, 1912, p. 146.

15 *IRI*, III, Moscow, 1912, pp. 8–155.

16 J. Cracraft, *The Petrine Revolution in Russian Architecture*, Chicago, IL, 1988.

17 Now in the Library of the Academy of Sciences (Biblioteka Akademii Nauk), St Petersburg (Otdel rukopisey and Otdel redkoy knigi – Departments of manuscripts and of Rare Books). See S. P. Luppov, "Neosushchestvlyonnyy proyekt petrovskogo vremeni stroitel'stva novoy stolitsy Rossii", *Trudy Biblioteki AN SSSR*, III, Moscow and Leningrad, 1957; id., *Istoriya stroitel'stva Peterburga v pervoy chetverti XVIII veka*, Leningrad, 1957, pp. 54–55.

18 D. Trezzini's planning proposals for St Petersburg, primarily for Vasil'yevsky Island, appear on an engraved plan of the city published in Amsterdam in 1715.

19 M. V. Iogansen, "Raboty Domenico Trezini po planirovke i zastroyke Strelki Vasil'yevskogo ostrova v Peterburge", in T.V. Alekseyeva (ed.), 1973, pp. 45–56; *Polnoye sobraniye zakonov Rossiskoy imperii* (henceforth *PSZRI*): *Sobraniye pervoye*, V, St Petersburg, 1830, nos 3016, 3399; Luppov, *Istoriya*, 1957, pp. 35–45.

20 *PSZRI: Sobraniye pervoye*, V, no. 3305.

21 Luppov, 1957, p. 10; S. S. Ozhegov, *Tipovoye i povtornoye stroitel'stvo v Rossii XVIII– nachala XIX vekov*, Moscow, 1984, pp. 16–26.

22 N. Kalyazina, "Arkhitektor Leblon v Rossii", in T. V. Alekseyeva (ed.), *Ot Srednevekov'ya k Novomu vremeni*, Moscow, 1984, pp. 94–124; T. F. Savarenskaya, F. A. Petrov and D. O. Shvidkovsky, *Istoriya gradostroitel'nogo iskusstva*, II, Moscow, 1989, pp. 107–09.

23 A. A. Musatov and D. O. Shvidkovsky, "Predstavleniye o regulyarnosti v arkhitekture i zhizni russkogo goroda v pervoy chetverti XVIII veka", *Gorodskoye upravleniye*, 1999, 7, pp. 21–25; T. F. Savarenskaya, A. A. Musatov,

D. O. Shvidkovsky et al., "Moskva pervoy poloviny XVIII veka", in *Arkhitekturnyye ansambli Moskvy XII–XIX vekov*, Moscow, 1997, pp. 176–201.

24 P. V. Sytin, *Istoriya planirovki i zastroyki Moskvy*, I, Moscow, 1950, p. 240.

25 Ibid.

26 Ibid.

27 *Instruktsiya ober-politsmeysterskoy kantseylarii*, Moscow, 1722. Quoted from T. F. Savarenskaya (ed.), *Arkhitekturnyye ansambli Moskvy*, Moscow, 1997, p. 399.

28 Ibid., p. 400.

29 Savarenskaya, Petrov and Shvidkovsky, 1989, pp. 125–26.

30 Quoted from Savarenskaya (ed.), 1997, p. 402.

31 Rossiyskiy gosudarstvennyy arkhiv Drevnikh aktov (RGADA), f. 9, op. 2, yed. khr. 45, l. 200. See also D. Shvidkovsky, *The Empress and the Architect: British Architecture and Gardens at the Court of Catherine the Great*, New Haven, CT, and London, 1996, pp. 167–69, etc.

32 M. Korol'kov, "Arkhitektory Treziny", *Staryye gody*, April 1911, pp. 17–36; V. F. Shilkov, "Arkhitektory-inostrantsy pri Petre I", in *IRI*, V, Moscow, 1960, pp. 85–87; B. R. Vipper, *Arkhitektura russkogo barokko*, Moscow, 1978, pp. 43–46; I. Lisayevich, *Pervyy arkhitektor Peterburga*, Leningrad, 1971; V. G. Vlasov, *Arkhitektura "Petrovskogo barokko"*, St Petersburg, 1996, pp. 35–61; Yu. M. Ovsyannikov, *Domenico Trezini*, Leningrad, 1987; B. M. Kirikov, "Proobrazy kompozitsii Petropavlovskogo sobora", *Krayevedcheskiye zametki*, 2, St Petersburg, 1994, pp. 13–17.

33 RGADA (Dela o vyyezdakh), f. 150, op. 1, yed. khr. 12, l. 1–8.

34 G. Ricci (ed.), *Milano*, Turin, 1999, pp. 71–80 (especially the chapter by L. Roncai, "The Construction of Great Building Complexes and Private Palaces in Milan during the 17th and Early 18th Centuries").

35 Vipper, 1978, p. 46.

36 Ibid.

37 Vlasov, 1996, p. 56.

38 Kirikov, 1994, pp. 15–16.

39 See a letter from Peter the Great to Ivan Korobov, who was sent to study in the Netherlands, quoted in V. I. Pilyavsky, "Ivan Kuz'mich Korobov", *Arkhitekturnoye nasledstvo*, 4, Leningrad and Moscow, 1953, p. 42; also Vipper, p. 43.

40 A. N. Punin, "Pyotr I i Kristofer Ren. K voprosu o stilevykh istokakh petrovskogo barokko", in *Iskusstvo arkhitektury*, St Petersburg, 1995, pp. 34–42.

41 The Copenhagen Exchange was built by the architects Lorenz and Hans Steinwinkel.

42 Vlasov, 1996, p. 56; Vipper, 1978, pp. 168–69.

43 Iogansen, 1973, pp. 45–56.

44 Vlasov, 1996, p. 60.

45 Korol'kov, 1911, pp. 30–36.

46 G. I. Vzdornov, "Arkhitektor P'yetro Antonio Trezini", in Alekseyeva (ed.), 1973, pp. 20–30.

47 Vlasov, 1996, pp. 61–62.

48 V. S. Voinov, "Andreas Shlyuter – arkhitektor Petra Velikogo. (K voprosu o formirovanii stilya 'Petrovskoye barokko'.)", *Sovetskoye iskusstvoznaniye – 76/1*, Moscow, 1976; H. Ladendorf, *Der Bildhauer und Baumeister Andreas Schlüter*, Berlin, 1935.

49 Savarenskaya, Petrov and Shvidkovsky, 1989, pp. 78–79.

50 Vipper, 1978, p. 47.

51 RGADA (Kabinet Petra I), f. 9, otd. II, op. 4, yed. khr. 57, ll. 38–39.

52 Shilkov, 1960, p. 93.

53 A. Lipman, *Petrovskaya kunstkamera*, Moscow and Leningrad, 1945; see also *Palaty Sankt-Peterburgskoy Akademii nauk, Biblioteki i Kunstkamery*, St Petersburg, 1741. On the work of G. J. Mattarnovi, see also *Ermitazh. Istoriya i arkhitektura*, Leningrad, 1974, p. 24.

54 Now in the model collection of Nauchno-Issledovatel'skiy Muzey Rossiyskoy Akademii Khudozhestv (NIMAKh), St Petersburg.

55 V. V. Antonov and A. V. Kobak, *Svyatyni Sankt-Peterburga*, I, St Petersburg, 1994, pp. 32–34.

56 H. Mellon, *The Triumph of the Baroque*, Milan, 1988, pp. 582–84.

57 N. Kalyazina, "Arkhitektor Leblon v Rossii", in T. V. Alekseyeva (ed.), *Ot Srednevekov'ya k Novomu vremeni*, Moscow, 1984, pp. 94–124; V. Lossky, *J.-B.-A. Le Blond*, Prague, 1936; id., "L'Hôtel de Vendôme", *Gazette des Beaux-Arts*, 2, 1934, p. 30.

58 J.-B.-A. Le Blond, *La Théorie et le Pratique du Jardinage*, Paris, 1709.

59 Quoted by Shilkov, 1959, p. 144.

60 T. Dubyago, *Russkiye regulyarnyye sady i parki*, Leningrad, 1963, pp. 63–101; G. Bolotova, *Letniy sad*, Leningrad, 1981; N. Arkhipov and A. Raskin, *Petrodvorets*, Leningrad, 1968; *Arkhitekturnyye pamyatniki okrestnostey Leningrada*, Leningrad, 1983, pp. 322–34, 580–82. For Le Blond's designs, see *Arkhitekturnaya grafika Rossii. Pervaya polovina XVIII veka*, Leningrad, 1981, pp. 52–57.

61 Vipper, 1978, p. 49.

62 D. Rosh, "Risunki Nikolaya Pino, prednaznachennyye dlya Rossii", *Staryye gody*, May 1913, pp. 3–21; *Arkhitekturnaya grafika Rossii. Pervaya polovina XVIII veka*, Leningrad, 1981, pp. 120–25.

63 *IRI*, III, Moscow, 1912, p. 141; Vipper, 1978, p. 53.

64 G. G. Grimm, "Proyekty arkhitektora N. Miketti dlya Peterburga i yego okrestnostey v sobranii Ermitazha", *Soobshcheniya Gosudarstvennogo Ermitazha*, 1958, 13, pp. 212–24; V. Dolbin, "Tvorcheskaya zhizn' arkhitektora N. Miketti" (abstract of doctoral thesis), Leningrad, 1983 (complete text in the Sciences Library of the Russian Academy of Arts

[Nauchnaya biblioteka Rossiyskoy akademii khudozhestv], St Petersburg); K. Malinovsky, *Gli architetti italiani a San Peterburgo nel Setticento*, Milan, 1996, pp. 69–82.

65 See Shilkov, 1960; Arkhipov and Raskin, 1968.

66 E. Hempel, *Gaetano Chiaveri, der Architect der Katholischen Hofkirche zu Dresden*, Dresden, 1955; id., "Gaetano Chiaveri. Supplementi alle opere dell'architetto romano", *Palladio*, VII, Venice, 1957, pp. 172–78; V. F. Shilkov, "Dve raboty arkhitektora K'yaveri v Rossii", *Arkhitekturnoye nasledstvo*, 9, pp. 61–64; Malinovsky, 1996, pp. 71–78.

67 Shilkov, 1960, p. 113.

68 N. Kalyazina, L. Dorofeyeva and G. Mikhaylov, *Dvorets Menshikova*, Moscow, 1986.

69 P. N. Petrov, "Materialy dlya biografii grafa Rastrelli", *Zodchiy*, 5, 1876, p. 55; B. R. Vipper, "V.V. Rastrelli", in *IRI*, V, Moscow, 1960, p. 175.

70 Vipper, 1978, p. 52.

71 M. Lumiste, *Kadriogskiy dvorets*, Tallinn, 1976, pp. 5–8.

72 A. N. Voronikhina, *Peterburg i yego okrestnosti v chertezhakh i risunkakh arkhitektorov pervoy treti XVIII veka*, Leningrad, 1972, pp. 33–41.

73 Bodrova, 1978, pp. 41 ff.

74 I. E. Grabar', "Obucheniye russkikh zodchikh", in *IRI*, V, Moscow, 1960, pp. 118–19.

75 RGADA, f. 17, op. 1, yed. khr. 303, ll. 3–11.

76 Ibid.

77 Grabar', 1960, p. 118.

78 I. I. Golikov, *Dopolneniya k deyaniyam Petra Velikogo*, XIV, Moscow, 1794, p. 380.

79 Ibid., p. 381.

80 RGADA (Kabinet Petra I), f. 9, otd. II, op. 3, yed. khr. 81, l. 305.

81 Ibid., f. 17, op. 1, yed. khr. 303, l. 9.

82 *Sbornik Imperatorskogo russkogo istoricheskogo obshchestva* [IRIO], XCIV, St Petersburg, 1894, p. 161.

83 RGADA (Kabinet Petra I), f. 9, otd. II, op.3 yed.khr. 81, l. 246.

84 Ibid., f. 1, op. 1, yed. khr. 303, l. 10.

85 S. S. Bronshteyn, "K 250-letiyu so dnya rozhdeniya I. K. Korobova", *Arkhitektura i stroitel'stvo Leningrada*, 1950, 13, pp. 41–46; V. I. Pilyavsky, "Ivan Kuz'mich Korobov. Materialy k izucheniyu tvorchestva", *Arkhitekturnoye nasledstvo*, 4, Moscow and Leningrad, 1953, pp. 41–62.

86 P. N. Petrov, "Arkhitektor M. G. Zemstsov", *Zodchiy*, 8, 1877, pp. 70–73.

87 Id., "P. M. Yeropkin", *Zodchiy*, 5, 1878, pp. 54–55; V. Yeropkina, "Odin iz ptentsov Petra Velikogo", *Istoricheskiy vestnik*, 1, 1903, pp. 565–75; D. Ye. Arkin, "Russkiy traktat-kodeks XVIII veka", *Arkhitekturnyy arkhiv*, 1, Moscow, 1946, pp. 7–20.

88 N. A. Yevsina, *Arkhitekturnaya teoriya v Rossii pervoy poloviny XVIII veka*, Moscow, 1975, p. 82.

89 V. F. Shilkov, "Proekty planirovki Peterburga 1737–1740 godov", *Arkhitekturnoye nasledstvo*, 4,

Moscow and Leningrad, 1953, pp. 7–13; Savarenskaya, Petrov and Shvidkovsky, 1989, pp. 111–18.

90 In many depictions of early St Petersburg, especially the well-known engraved panorama by A. Zubov (1717), buildings can be seen which were referred to at the time as *mazankovyye*, or timber-framed. They were plastered to a greater extent than in Germany and France. See Lupov, 1957, pp. 47–49; Grabar' (ed.), *O russkoy arkhitekture*, Moscow, 1969, pp. 98–99.

91 *PSZRI,: Sobraniye pervoye*, VI, St Petersburg, 1848, no. 3799.

92 Ibid.

93 A. Matveyev, *Rastrelli*, Moscow, 1938, p. 16; Z. Batovsky, *Arkhitektor F.-B. Rastrelli o svoikh tvoreniyakh*, St Petersburg, 2000, p. 75.

94 I. E. Bondarenko, "Annengof", *Akademiya arkhitektury*, 1935, 6, pp. 74–81.

95 G. Kraft, *Podobnoye opisaniye ledyanomu domu, postroyennomu v Sankt-Peterburg*, St Petersburg, 1743, p. 3.

96 Ibid., p. 4.

97 *IRI*, III, p. 180.

98 P. N. Petrov, "Materialy dlya biografii grafa Rastrelli", *Zodchiy*, 5, 1876, pp. 55–56.

99 Ibid., p. 55.

100 *IRIO*, LXIX, 1872, p. 754.

101 Yu. M. Denisov and A. M. Petrov, *Zodchiy Rastrelli*, Leningrad, 1963, p. 192.

102 B. P. Vipper, "V. V. Rastrelli", *IRI*, V, 1963, p. 178.

103 Matveyev, p. 17; papers of N. P. Sobko in Otdel Rukopisey Rossiyskoy Natsional'noy Biblioteki (OR RNB), fasc. "Rastrelli".

104 Petrov, p. 56; V. Kurbatov, "Znacheniye grafa Bartolomeo Rastrelli v istorii russkogo zodchestva", *Zodchiy*, 45, 1907, pp. 461–63 and 47, pp. 477–83; A. N. Benya, *Tsarskoye selo v tsarstvovaniye imperatritsy Yelizavety Petrovny*, St Petersburg, 1910; G. K. Lukomsky, "Proyekty Rastrelli v venskoy Al'bertine", *Sredi kollektsionerov*, September-December 1924, pp. 51–53; V. Vipers, *Baroque Art in Latvia*, Riga, 1939; Z. Batowski, *Architect Rastrelli o swych pracach*, L'vov, 1939; G. N. Logvin, *Arkhitektura Andreyevskoy tserkvi v Kiyeve*, Kiev, 1957; Vipper, 1963, pp. 174–309.

105 Vipper, 1976, p. 77.

106 D. Ye. Arkin, *Rastrelli*, Moscow, 1954, p. 26.

107 Matveyev, 1938, pp. 103–29.

108 Ibid., p. 106.

109 Antonov and Kobak, 1994, p. 123.

110 Denisov and Petrov, 1963, pp. 170–71.

111 Mellon, 1999, p. 582.

112 Ibid., p. 583.

113 A. N. Petrov, "Izvestiya o zhizni i trudakh arkhitektora brigadirskogo ranga Savvy Chevakinskogo", *Severnaya pchela*, 287–88, 1833, pp. 1140–44; id., "Savva Chevakinsky", in Yu. S. Yaralov, *Zodchiye Sankt-Peterburga. XVIII vek*, St Petersburg, 1997.

114 S. Topil'sky, *Morskoy Bogoyavlenskiy sobor*, St Petersburg, 1871.

115 I. Ye. Zabelin, *Materialy dlya istorii, arkheologii i statistiki goroda Moskvy*, part II, Moscow, 1891, pp. 861–84; A. I. Mikhaylov, *Arkhitektor Dmitry Ukhtomsky i yego shkola*, Moscow, 1954, pp. 23–30.

116 A. I. Mikhaylov, "K istorii proyektirovaniya i stroitel'stva kolokol'ni Troitse-sergiyevoy lavry", *Arkhitekturnoye nasledstvo*, 1, Moscow, 1951; P. V. Sytin, *Istoriya planirovki i zastroyki Moskvy*, I, Moscow, 1950, pp. 233–87; Mikhaylov, 1954, pp. 30–35, 90–96, 128–36.

117 I. E. Grabar', "Shkola i 'komanda' knyazya D.V. Ukhtomskogo", *Arkhitektura*, 3–5, 1923; M. A. Il'yin, "Dmitry Vasil'yevich Ukhtomsky", in *Lyudi russkoy nauki*, II, Moscow and Leningrad, 1948, pp. 1127–35.

118 A. F. Krasheninnikov, "Karl Blank", in Yaralov (ed.), 1981, pp. 145–52.

119 Mikhaylov, 1954, pp. 137–54.

120 Ibid., p. 138.

v THE RUSSIAN ENLIGHTENMENT

1 D. A. Kyucharianis, *Khudozhestvennyye pamyatniki goroda Lomonosova*, Leningrad, 1985, pp. 46–62.

2 A. T. Bolotov, *Zhizn' i priklyucheniya Andreya Bolotova, opisannyye samim im dlya svoikh potomkov*, II, Moscow, 1933, pp. 104–05.

3 A. Brinkner, *Istoriya Yekateriny Vtoroy*, St Petersburg, 1885, p. 132.

4 Bolotov, 1933, p. 229.

5 D. O. Shvidkovsky, "Poet v prostranstve yekaterinskogo parka", in id. (ed.), *Charlz Kameron*, Moscow, 2001, pp. 286–94.

6 S. Shubinsky, "Domashnyy byt Yekateriny II", *Literaturnoye prilozheniye k "Nive"*, 2, 1900, p. 118.

7 D. O. Shvidkovsky, "Ideal'nyy gorod russkogo klassitsizma", in M. Libman (ed.), *Deti Didro i kul'tura yego epokhi*, Moscow, 1986, pp. 78–104.

8 N. A. Shil'der, *Imperator Aleksandr I*, I, St Petersburg, 1896, p. 486.

9 *IRIO*, XXIII (*Pis'ma Yekateriny II k Grimmu*), 1878, p. 99.

10 Ibid., p. 85.

11 Ibid., p. 157.

12 D. O. Shvidkovsky, "K voprosu o prosvetitel'skoy kontseptsii sredy v russkikh dvortsovo-parkovykh ansamblyakh epokhi Prosveshcheniya", in I. Danilova (ed.), *Vek Prosveshcheniya. Rossiya i Frantsiya*, Moscow, 1983, pp. 185–200; D. Shvidkovsky, "The System of Links between Russian and European Architecture during the Second Half of the XVIII century", in W. Zambien (ed.), *Europe des échanges: la culture architecturale*, Paris, 1992.

13 *IRI*, III, pp. 267–68.

14 Petnov P. N. (ed.), *Sbornik materialov dlya istorii*

15 V. K. Shuysky, "Zhan Batist Mishel' Vallen-Delamot", in Yu. S. Yaralov (ed.), *Zodchiye Sankt-Peterburga. XVIII vek*, St Petersburg, 1997, pp. 325–79; V. G. Lisovsky, *Akademiya khudozhestv*, St Petersburg, 1997.

16 *IRI*, III, pp. 272–73.

17 M. F. Korshunova, *Yuriy Fel'ten*, Leningrad, 1988.

18 *IRI*, III, p. 312.

19 D. A. Kyucharianis, *Antonio Rinal'di*, Leningrad, 1984; A. G. Raskin, *Gorod Lomonosov*, Leningrad, 1979.

20 Kyucharianis, 1985, pp. 84–152; Raskin, pp. 17, 27, 38, 41.

21 *IRIO*, XXIII, p. 119.

22 Ibid.

23 A. Ikonnikov, *Kitayskiy teatr i kitayshchina v Detskom sele*, Moscow and Leningrad, 1931; S. S. Bronshteyn, *Arkhitektura goroda Pushkina*, Leningrad, 1940, pp. 31–36; A. N. Petrov, *Gorod Pushkin*, Leningrad, 1977; M. F. Korshunova, *Arkhitektor Yuriy Fel'ten*, Leningrad, 1982, cat. nos 16, 19, 21; D. A. Kyucharianis, *Antonio Rinal'di*, Leningrad, 1979, pp. 103–05; D. O. Shvidkovsky, "Vostochnyye stili v arkhitekture russkogo klassitsizma", in N. Yevsina (ed.), *Russkiy klassitsizm*, Moscow, 1995, pp. 158–66; D. Shvidkovsky, "Orientalism in Russian Neo-Classical Architecture", in id., *The Empress and the Architect: British Architecture and Gardens at the Court of Catherine the Great*, New Haven, CT, and London, 1996, pp. 167–85; id., "Le mythe occidental de l'Orient dans l'architecture et les jardins russes de l'époque des Lumières", in S. Karp (ed.), *Le mythe Russe en Occident des Lumières*, Paris, 2001.

24 Shvidkovsky, 1983, p. 188.

25 Ye. A. Tartakovskaya, "Chesmenskiy dvorets", *Vremennik IZO*, Leningrad, 1928; Korshunova, 1988, pp. 70–78; D. Shvidkovsky, "Russian Gothic Revival", in id., 1996, pp. 185–225.

26 Korshunova, 1988, pp. 73–74.

27 Yekaterina Velikaya, *Sobraniye sochineniy*, XII, St Petersburg, 1892, pp. 583–84.

28 D. A. Kyucharianis and A. G. Raskin, *Gatchina. Khudozhestvennyye pamyatniki*, Leningrad, 1990, p. 12; S. Rozhdestvensky, *Stoletiye goroda Gatchiny*, I, St Petersburg, 1896, p. 3.

29 *IRI*, III, p. 302.

30 Kyucharianis and Raskin, 1990, p. 13.

31 D. A. Kyucharianis, *Antonio Rinal'di*, St Petersburg, 1994, p. 83.

32 Ibid., p. 84.

33 C. Campbell, *Vitruvius Britannicus*, I, London, 1712.

34 Kyucharianis, 1994, p. 86.

35 A. Cross, "British Gardeners, Russian Gardens", *Garden History*, 1991, 19/1, p. 15.

36 *IRIO*, XXIII, p. 238.

37 Kyucharianis, 1979, p. 161.

38 Cross, 1991, p. 16.

39 P. Mellon (ed.), *The Triumph of Baroque*, Milan, 1999, pp. 162, 170, 395.

40 *IRI*, III, p. 309.

41 D. A. Kyuchariants, "Antonio Rinal'di", in Yaralov (ed.), 1997, pp. 378–79.

42 L. Hautecoeur, *L'Architecture classique à Saint-Pétersbourg*, Paris, 1912; N. I. Romanov, "Zapadnyye uchitelya Bazhenova", *Akademiya arkhitektury*, 2, 1939, pp. 17–22; A. I. Mikhaylov, *Bazhenov*, Moscow, 1951, pp. 19–31; M. Mosser and D. Rabreau, *Charles de Wailly. Peintre, architecte dans l'Europe des Lumières*, Paris, 1979; M. Mosser and D. Rabro, *Sharl' de Vayi i russkiye arkhitektory*, Paris and Moscow, 1979; *Rossiya–Frantsiya. Vek Prosveshcheniya*, Moscow, 1989.

43 *IRI*, III, pp. 328–31.

44 V. N. Ivanov, "O modeli Kremlevskogo dvortsa V. I. Bazhenova", *Akademiya arkhitektury*, 2, 1937, pp. 22–30; Mikhaylov, 1951, pp. 49–111; I. Bondarenko, "Arkhitektor V. I. Bazhenov i yego proyekt Kremlevskogo dvortsa", *Akademiya arkhitektury*, 1–2, 1935, pp. 107–10; V. V. Zgura, *Problemy i pamyatniki, svyazannyye s V. I. Bazhenovym*, Moscow, 1929; V. Snegiryov, *Arkhitektor Bazhenov*, Moscow, 1937.

45 N. N. Belekhov and A. N. Petrov, *Starov*, Moscow, 1950, pp. 20–21; D. A. Kyuchariants, *Ivan Starov*, Leningrad, 1982, pp. 7–17.

46 Ibid., p. 18; T. F. Savarenskaya, F. A. Petrov and D. O. Shvidkovsky, *Istoriya gradostroitel'nogo iskusstva*, II, Moscow, 1989, pp. 139–46; V. Shilkov, "Raboty Kvasova i Starova po planirovke russkikh gorodov", *Arkhitekturnoye nasledstvo*, Moscow and Leningrad, 4, 1953.

47 Belekhov and Petrov, 1950, pp. 31–46; O. N. Lyubchenko, *Yest' v Bogoroditske park*, Tula, 1984; Bolotov, Moscow, III, 1933.

48 Belekhov and Petrov, 1950, pp. 67–81; S. G. Runkevich, *Aleksandro-Nevskaya lavra. 1713–1913*, St Petersburg, 1913.

49 W. Herrmann, *Laugier and Eighteenth-century French Theory*, London, 1985, pp. 68–90.

50 Belekhov and Petrov, 1950, pp. 81–103, 115–33.

51 D. Didrot, *Sobraniye sochineniy*, X, Moscow, 1947, p. 193.

52 Ibid., p. 192.

53 Ibid.

54 Ibid., p. 194.

55 Z. V. Zolotnitskaya, "Kremlevskiye stroyeniya i zodchestvo Moskvy", in I. Markova (ed.), *Yekaterina Velikaya i Moskva*, Moscow, 1997, pp. 107–09.

56 Ye. G. Gorokhova, "Ulozhennaya Komissiya", in ibid., pp. 107–09.

57 Hermann, 1985, pp. 68–90; F. Fiche, *La Théorie architecturale à l'Age Classique*, Paris, 1986.

58 A. F. Sumarokov, "Nadpis' na kolonne pri zakladke Bol'shogo Kremlevskogo dvortsa", in Mikhaylov, 1951, p. 87.

59 Ibid.

60 Bazhenov's plans are published in Mellon (ed.), 1999, cat. 189–99; Z. V. Zolotnitskaya and L. V. Saygina, *V. I. Bazhenov. Katalog chertezhey*, Moscow, 1988, pp. 21–25.

61 Yu. G. Klimenko, "Tvorchestvo arkhitektora N. Legrana", doctoral diss., MARKhI, 2000.

62 Didro, 1947, p. 191.

63 Yekaterina Velikaya, "Zapiski", in V. Kovalevsky (ed.), *Moskva v istorii i literature*, Moscow, 1912, pp. 166–67.

64 Mikhaylov, 1951, pp. 189–240; I. Ye. Zabelin, "Dom Moskovskogo publichnogo i Rumyantsevskogo muzeyev (byvshiy Pashkova)", *Russkiy arkhiv*, 6, 1904; Yu. Krivokurtsev, "Skhodstvo arkhitektury doma Pashkova [. . .] s frantsyzskoy arkhitekturoy XVIII veka", *Akademiya arkhitektury*, 2, 1937, p. 46.

65 Mikhaylov, 1951, pp. 189–93; Zgura, 1929, pp. 126, 154–56 ff.

66 A. I. Vlasyuk, A. A. Kaplun and A. A. Kiparisova, *Kazakov*, Moscow, 1957, pp. 126–83, 211–56; Ye. A. Beletskaya, *Arkhitekturnyye al'bomy M. F. Kazakova. Al'bomy partikulyarnykh stroyeniy. Zhilyye zdaniya Moskvy XVIII veka*, Moscow, 1956; A. A. Kaparisova, "Barochnyye otrazheniya v planirovkakh Kazakova", *Yezhegodnik Muzeya arkhitektury*, I, Moscow, 1937, pp. 69–79; A. M. Kharlamova, *"Zolotyye komnaty" Demidovykh v Moskve*, Moscow, 1955; N. L. Krasheninnikova, *Ansamb' Golitsynskoy bol'nitsy*, Moscow, 1955; I. A. Bondarenko (ed.), *Matvey Fyodorovich Kazakov i arkhitektura klassitsizma. Sb. statey*, Moscow, 1996.

67 A. M. Kharlamova, *Kolonnyy zal Doma Soyuzov* [formerly the premises of the Assembly of the Gentry], Moscow, 1955.

68 Vlasyuk, Kaplun and Kiparisova, 1957, pp. 31–64, 280–87.

69 *IRIO*, XXIII, p. 120; Ye. G. Gorokhova, "Prazdnovaniye Kyuchuk-Ka nardzhiskogo mira", in I. Markova (ed.), 1997, pp. 89–91; D. Shvidkovsky, "Russian Neo-Gothic in the Age of Classicism", in id., 1996, pp. 185–224.

70 K. N. Mineyeva, *Tsaritsyno*, Moscow, 1988.

71 Vlasyuk, Kaplun and Kiparisova, 1957, pp. 205–09.

72 Mikhaylov, 1951, pp. 172–73, 189–93; *Pamyatniki arkhitektury Moskovskoy oblasti*, I, Moscow, 1975, pp. 20–21; Ye. D. Zhuravskaya and N. G. Presnova, "Yekaterina II i podmos-kovnyye usad'by", in I. Markova (ed.), 1997, pp. 157–59; Zgura, 1929, pp. 126, 154–56 ff.

73 A. Cross, *By the Banks of the Neva*, Cambridge, 1997, pp. 283–84; B. B. Mikhaylov, "Sadovnik Frensis Rid v Tsaritsyne i Ostankine", *Arkhitektura SSSR*, 4, 1990, pp. 104–09.

74 *IRIO*, XXIII, p. 83.

75 Gosudarstvennyy Ermitazh, Otdel risunki, inv. no. 6860; V. Shevchenko, "Arkhitekturnyye proyekty dlya Rossii", in *Sharl'-Lui Klerisso, arkhitektor Yekateriny Velikoy. Risunki iz sobraniya Gosudarstvennogo Ermitazha*, St Petersburg, 1997, pp. 84–96.

76 Mosser and Rabreau, 1979, pp. 82–100.

77 Shevchenko, 1997, pp. 84–96.

78 *IRIO*, XXIII, p. 119.

79 Ibid., p. 13.

80 Ibid., p. 20.

81 Ibid., p. 156.

82 Ibid., p. 120.

83 Ibid., p. 157.

84 Ibid., p. 86.

85 Shvidkovsky, 1996, pp. 41–117; V. N. Taleporovsky, *Charl'z Kameron*, Moscow, 1939; M. G. Voronov and G. D. Khodasevich, *Ansamb' Kamerona v Pushkine*, Leningrad, 1982.

86 C. Cameron, *The Baths of the Romans*, London, 1772; V. V. Zubov, *Kommentariy k russkomu izdaniyu traktata Ch. Kamerona "Termy Rimlyan"*, Moscow, 1939.

87 A. V. Khrapovitsky, *Dnevnik*, St Petersburg, 1874, p. 85.

88 *Ruchnoy dorozhnik*, St Petersburg, 1802, p. 21.

89 Khrapovitsky, 1874, p. 244.

90 M. I. Pylyayev, *Zabytoye proshloye okresnostey Peterburga*, St Petersburg, 1889, p. 473.

91 Sh. de Lin', *Pis'ma*, Moscow, 1809, p. 108.

92 *Ukaz ob obrazovanii pri Tsarskom sele goroda Sofii. Otdel'nyy list*, St Petersburg, 1780; *Polnoye sobraniye zakonov Rossiskoy imperii. Sobraniye pervoye*, St Petersburg, 1848, XX, no. 14358.

93 T. Talbot Rice, *Charles Cameron*, exhib. cat., London, 1968, p. 15.

94 Shvidkovsky, 1983, pp. 185–200.

95 P. Goode (ed.), *The Oxford Companion to Gardens*, London, 1991, pp. 197–98.

96 D. Shvidkovsky, "Pavlovsk", in id., 1996, pp. 117–67.

97 V. N. Taleporovsky, *Pavlovskiy park*, Petrograd, 1927.

98 D. Shvidkovsky, "Pavlovsk", in id., 1996, pp. 126–33.

99 Taleporovsky, 1939; G. Loukomsky, *Charles Cameron*, London, 1943.

100 D. Shvidkovsky, "Adam Menelaws and William Hastie", in id., 1996, pp. 225–52; A. Cross, "Cameron's Scottish Workmen", *Scottish Slavonic Review*, Glasgow, spring 1988.

101 F. F. Vigel', *Zapiski*, I, Moscow, 1928, p. 181.

102 G. G. Grimm, *Kvarengi*, Leningrad, 1962; V. I. Pilyavsky, *Kvarengi*, Leningrad, 1981; V. Piliavsky, *Giacomo Quarenghi*, Bergamo, 1984; V. Zanella (ed.), *Giacomo Quarenghi. Architetto a Pietroburgo. Lettere e altri scritti*, Venice, 1988.

103 *IRI*, III, p. 351.

104 *Pamyatniki arkhitektury Leningrada*, 1971, p. 255.

105 O. I. Braytseva, M. V. Budylina and A. M. Kharlamova, *Arkhitektor N. A. L'vov*, Moscow, 1961; N. Glumov, *L'vov*, Moscow, 1980; V. Vereshchagin, "Putyevyye zametki N. A. L'vova po Italii v 1781 g.", *Staryye gody*, May 1909.

106 *Chetyre knigi Palladiyevoy arkhitektury. Kniga I*, St Petersburg, 1798.

107 Ibid., preface.

108 Belikhov and Petrov, 1950, pp. 81–103; B. A. Rozadeyev, *Smol'nyy; Tavricheskiy dvorets*, Moscow and Leningrad, 1958.

109 *Russkiy arkhiv*, 5, St Petersburg, 1887, p. 93.

110 Ibid., p. 94.

111 Ibid.

112 Cross, 1997, pp. 274–76.

113 S. S. Montefiore, *Prince of Princes: The Life of Potemkin*, London, 2000, pp. 467–70, 494–98.

114 Didro, p. 194.

115 V. A. Shkvarikov, *Planirovka gorodov Rossii XVIII i nachala XIX veka*, Moscow, 1939, pp. 64–139; Savarenskaya, Petrov and Shvidkovsky, II, pp. 137–60.

116 Rossiyskiy gosudarstvennyy voyennyy istoricheskiy arkhiv (RGVIA henceforth), f. 349, op. 3, 1718, l. 13.

117 *Senatskiy arkhiv v 15 tt.*, St Petersburg, 1888–1913, XIII, 1909, pp. 152–57.

118 Ibid., p. 159.

119 Ibid.

120 Ibid., p. 154.

121 Ibid.

122 Ibid., p. 157.

123 Ibid.

124 Ibid.

125 Ibid.

126 V. Gayshinets, "Arkhitektor Nikitin", doctoral diss., MARKhI, Moscow, 1987.

127 *Senatskiy arkhiv*, XIII, 1909, p. 157.

128 Ye. Beletskaya, N. Krasheninnikov, L. Chernozubova and I. Ern, *Obraztsovyye proyekty v zastroyke russkikh gorodov XVIII–XIX vekov*, Moscow, 1961.

129 P. Roosevelt, *Life on the Russian Country Estate*, New Haven, CT, 1995.

130 Bolotov, 1933, I, pp. 127–28.

131 Ibid., p. 133.

132 Ibid., p. 136.

133 Ibid.

134 Ibid., II, p. 187.

135 S. T. Aksakov, *Sobraniye sochineniy v 5 tt.*, I, Moscow, 1966, p. 508.

136 Ibid.

137 Ibid.

138 Ibid.

139 Ibid., p. 509.

140 Ibid.

141 Ibid., p. 510.

142 G.-L. Le Rouge, *Cahier des jardins anglo-chinois*, Paris, 1775–87; J. Grohmann, *Izdeenmagazin für Gartenkunst*, Leipzig, 1789–92.

143 "Saburovo", in V. I. Pluzhnikov (ed.), *Orlovskaya oblast'. Katalog pamyatnikov arkhitektury*, Moscow, 1986.

144 J.-F. Neufforge, *Receuil d'architecture*, Paris, 1762.

145 I. Ye. Putyanin, "Arkhitektura russkikh usadebnykh tserkvey v epokhu klassitsizma", abstract of doctoral diss., MARKhI, Moscow, 1998.

146 K. N. Mineyeva, *Tsaritsyno*, Moscow, 1988, p. 60.

147 O. A. Medvedkova, "Tsaritsynskaya Psevdogotika V. I. Bazhenova: opyt interpretatsii", in A. L. Batalov (ed.), *Ikonografiya arkhitektury*, Moscow, 1990, pp. 153–74.

148 V. K. Shuysky, *Vinchentso Brenna*, Leningrad, 1986, p. 22.

149 Ibid.

150 Ibid., p. 29.

151 Krannent Art Museum, Urbana, IL, 67-1-2, 485574.

152 S. Dixon, *Catherine the Great*, Harlow, 2001, p. 234.

153 C.-N. Ledoux, *L'Architecture considérée sous le rapport de l'art, des moeurs, et de la législation*, Paris, 1804, preface.

154 I. V. Linnik, "Dve opoznannyye kartiny Dzhuzeppe Kadesa [. . .]", in M. F. Korshunova (ed.), *Dzhakomo Kvarengi*, St Petersburg, 1994, pp. 43–46.

155 *Yekaterina Velikaya i Moskva*, exhib. cat., Moscow, 1997, p. 63.

156 A. Cross, *By the Banks of the Thames*, Newtonville, MA, 1980, pp. 65–68; D. Shvidkovsky, "A Grandmother's Garden for the Heir to the Imperial Throne", *Garden History*, 24/1, 1996, pp. 107–13.

157 Yekaterina Vtoraya, *Sochineniya*, Moscow, 1990, p. 126.

158 Ibid., p. 27.

159 Ibid.

160 S. Djunkovsky, *Alexandrova Datcha uveselitelny sad [. . .] velikogo Kniaza Alexanra Pavlovitcha*, Cracow, 1810.

161 Yekaterina Vtoraya, 1990, p. 130.

162 Belekhov and Petrov, 1950, p. 98.

163 Pérouse de Montelos, *Boullée*, Paris, 1994, pp. 102–04.

164 Belekhov and Petrov, 1950, p. 111.

165 E. F. Gollerbakh, "Kameron v Tsarskom sele", in N. Ye. Lansere (ed.), *Charl'z Kameron*, Petrograd, 1924, p. 40.

VI THE EUROPEAN CENTURY

1 J. Loudon, *The Encyclopaedia of Gardening*, London, 1828, p. 49.

2 D. F. Kobeko, *Tsesarevich Pavel Petrovich*, St Petersburg, 1882, pp. 168–74.

3 Ibid., p. 170.

4 N. E. Lansere, "Arkhitektura i sady Gatchiny: Gatchina pri Pavle Petroviche, tsesareviche i imperatore", *Staryye gody*, 1914, July–September, pp. 7–12.

5 F. A. Petrov (ed.), *Russkaya starina*, Moscow, 1992, p. 432.

6 Ibid., p. 435.

7 V. K. Shuysky, *Vinchentso Brenna*, Leningrad, 1986, pp. 21–120.

8 V. V. Puchkov and L. V. Khaykina, *Mikhaylovskiy*

zamok. Zamysel i voploshcheniye, St Petersburg, 2000.

9 F. F. Vigel', *Zapiski*, I, Moscow, 1928, p. 125.

10 D. O. Shvidkovsky, *Charl'z Kameron pri dvore Yekateriny*, Moscow, 2001, p. 176.

11 I. E. Grabar', "Ranniy aleksandrovskiy klassitsizm i yego frantsuzskiye istoki", in id., *O russkoy arkhitekture*, Moscow, 1969, pp. 284–310; J.-M. Pérouse de Montclos, *Les Prix de Rome*, Paris, 1984.

12 Vigel', 1928, p. 181.

13 G. D. Oshchepkov, *Arkhitektor Tomon*, Moscow, 1950; V. K. Shuysky, *Toma de Tomon*, Leningrad, 1981.

14 J.-D. Le Roy, *Les Ruines des plus beaux monuments de la Grèce, ouvrage divisé en deux parties, où l'on considère dans la première, ces monuments du côté de l'histoire, et dans la seconde, du côté de l'architecture*, Paris, 1758 (2nd ed., 1770).

15 Vigel', 1928, p. 182.

16 V. K. Shuysky, "Zhan Fransya Toma de Tomon", in B. M. Kirikov (ed.), *Zodchiye Sankt-Peterburga. XIX – nachalo XX veka*, St Petersburg, 1998, pp. 58–59.

17 M. S. Bunin, *Ansambl' Strelki Vasil'yevskogo ostrova*, Leningrad, 1956.

18 V. I. Pilyavsky, *Kvarengi*, Leningrad, 1978, pp. 145–46.

19 V. A. Panov, *Arkhitektor Voronikhin*, Moscow, 1937; G. G. Grimm, *Arkhitektor Voronikhin*, Moscow and Leningrad, 1963; V. G. Lisovsky, *Andrey Voronikhin*, Leningrad, 1971.

20 N. Ye. Lansere, "Zakharov i yego Admiralteystvo", *Staryye gody*, June 1911; G. G. Grimm, *Arkhitektor Andrey Zakharov: zhizn' i tvorchestvo*, Moscow, 1940; V. K. Shuysky, *Andrey Zakharov*, Leningrad, 1989 (St Petersburg, 1995).

21 O. Mandel'shtam, "Admiralteystvo", quoted in *Peterburg, Petrograd, Leningrad v russkoy poezii*, Leningrad, 1975, p. 203.

22 Vigel', 1928, pp. 177–79.

23 M. F. Korshunova, "Arkhitektor V. Geste (1755–1832)", *Trudy Gosudarstvennogo Ermitazha*, XVIII, Leningrad, 1977; A. Cross, "Charles Cameron's Scottish Workmen", *Scottish Slavonic Review*, Glasgow, 1988, p. 56; D. Shvidkovsky, *The Empress and the Architect: British Architecture and Gardens at the Court of Catherine the Great*, New Haven, CT, and London, 1996.

24 A. K. Andreyev, "Adam Menelas", *Problemy sinteza i arkhitektury*, 7, Leningrad, 1977; Shvidkovsky, 1996.

25 L. B. Aleksandrova, *Luidzhi Ruska*, Leningrad, 1990.

26 L. I. Ivanova-Vein (ed.), *Arkhitekturnyye shkoly Rossii*, Moscow, 2001; Yu. G. Klimenko, "Arkhitektor Nikolya Legran", doctoral diss., MARKhI, Moscow, 1999.

27 Ibid.

28 A. K. Andreyev, "Khudozhnik arkhitektury

akademik Ivan Alekseyevich Ivanov [. . .]", doctoral diss., Repin School of Painting, Sculpture and Architecture, Leningrad, 1991.

29 L. B. Aleksandrova, "Andrey Mikhaylov", in Kirikov (ed.), 1998, pp. 113–23.

30 M. P. Tubli, *Avraam Mel'nikov*, Leningrad, 1980.

31 P. V. Panukhin, "Arkhitektor Rodion Kazakov", doctoral diss., MARKhI, Moscow, 1987.

32 A. P. Sedov, *Yegotov*, Moscow, 1951.

33 Ye. I. Kirichenko, *Moskva. Pamyatniki arkhitektury XVIII – pervoy treti XIX vekov*, Moscow, 1975; M. V. Budylina, "Planirovka i zastroyka Moskvy posle pozhara 1812 g.", *Arkhitekturnoye nasledstvo*, 1, Moscow, 1951, pp. 135–74.

34 Z. K. Pokrovskaya, *Osip Bove*, Moscow, 1999; Z. V. Zolotnitskaya, *Arkhitektor Bove*, exhib. cat., Moscow, 1986.

35 Ye. A. Beletskaya and Z. K. Pokrovskaya, *D. I. Zhilyardi*, Moscow, 1980.

36 Ye. A. Beletskaya, *Arkhitektor A. G. Grigor'yev*, Moscow, 1976.

37 Ibid., p. 7.

38 Quoted from M. Z. Taranovskaya, *Karl Rossi*, Leningrad, 1980, p. 23.

39 Ibid.

40 V. I. Pilyavsky, *Stasov – arkhitektor*, Leningrad, 1963; id., *Zodchiy V. P. Stasov*, Leningrad, 1970; T. Ye. Tyzhnenko, *Vasily Stasov*, Leningrad, 1990.

41 G. A. Ol', *Aleksandr Bryullov*, Leningrad and Moscow, 1955 (Leningrad, 1983).

42 V. K. Shuysky, *Ogyust Monferran*, St Petersburg, 2001; A. L. Rotach and O. A. Chekanova, *Monferran*, Leningrad, 1979; N. P. Nikitin, *Ogyust Monferran*, Leningrad, 1939.

43 G. G. Grimm, *Ansambli Rossi*, Leningrad and Moscow, 1946; M. Z. Taranovskaya, *Karl Rossi: arkhitektor, gradostroitel', khudozhnik*, Leningrad, 1980.

44 Quoted from ibid., p. 124.

45 Ibid., p. 41.

46 Vigel', 1928, I, p. 182.

47 Ibid., II, p. 85.

48 Ibid.

49 T. Gotye, *Puteshestviye v Rossiyu*, Moscow, 1867, p. 180.

50 H. Giesberg, "Die Nikolaikirche in Potsdam", in *Karl Friedrich Schinkel*, Leipzig, 1980, pp. 167–75.

51 V. V. Antonov and A. V. Kobak, *Svyatyni Sankt-Peterburga*, I, St Petersburg, 1993, pp. 105–09; O. Monferran, *Sobornaya tserkov' Sv. Isaakiya Dalmatskogo*, St Petersburg, 1820.

52 O. A. Chekanova and A. L. Rotach, *Ogyust Monferran*, Leningrad, 1990, p. 94.

53 *Karl Friedrich Schinkel*, pp. 174, 188.

54 M. B. Pyotrovsky (ed.), *Zdaniya Ermitazha*, St Petersburg, 1998, p. 218.\

55 Ye. A. Beletskaya, N. L. Krasheninnikova, L. Ye. Chernozubova and I. V. Ern, *Obraztsovyye proyekty v zastroyke russkikh gorodov*, Moscow, 1961; L. Ye. Chernozubova, "Obraztsovyye proyekty planirovki zhilykh kvartalov i ploshchadey nachala XIX veka", *Arkhitektur-*

noye nasledstvo, XV, Moscow, 1963; S. S. Ozhegov, *Tipovoye i povtornoye stroitel'stvo v Rossii v XVIII–XIX vekakh*, Moscow, 1984.

56 T. F. Savarenskaya, D. O. Shvidkovsky and F. A. Petrov, *Istoriya gradostroitel'nogo iskusstva*, II, Moscow, 1989, pp. 142–51.

57 *Polnoye sobraniye zakonov Russkoy imperii* (henceforth *PSZRI*), *Sobraniye pervoye*, XXVII, 1830, pp. 1002–04.

58 *Sobraniye fasadov Vysochayshe aprobirovannykh dlya chastnykh stroyeniy v gorodakh Rossiyskoy imperii*, I–V, St Petersburg, 1809–12.

59 *PSZRI*, *Sobraniye pervoye*, XXX, 1851: prilozheniye no. 24061–a (see also general chronological index to *PSZRI*, I, 1851, p. 962).

60 Ozhegov, 1984, pp. 80–94.

61 Chernozubova, 1963.

62 Ozhegov, 1984, p. 81.

63 Korshunova, 1977; A. Schmidt, "William Hastie. Scottish Planner of Russian Cities", *Proceedings of the American Philosophical Society*, CXIV, 1970, pp. 226–43.

64 Shvidkovsky, 1966, pp. 225–52; Savarenskaya, Shvidkovsky and Petrov, 1989, pp. 160–70.

65 A. Youngson, *The Making of Classical Edinburgh*, Edinburgh, 1966, pp. 138–56.

66 M. Bogdanovich, *Graf Arakcheyev i voyennyye poseleniya*, St Petersburg, 1871.

67 Ozhegov, 1984, p. 106; V. V. Antonov, "Aleksandr Shtaubert", in Kirikov (ed.), 1998, pp. 203–11.

68 V. F. Fedoseyev, *Rukovodstvo k postroneniyu drevnikh domov [. . .] s prisovokupleniyem k onomu risunkov izyashchnykh sadovykh stroyeniy i domam po obraztsam zagorodnykh*, St Petersburg, 1831; A. Rudol'sky, *Domostroyeniye s planami, fasadami kamennykh i derevyannykh gorodskikh i sel'skikh zdaniy [. . .] raznykh sadovykh ukrasheniy [. . .] i mnogimi drugimi chertezhami*, St Petersburg, 1838; *Polnaya arkhitektura dlya gorodskikh i sel'skikh khozyayev*, Moscow, 1836; *Novyy portfel' dlya gorodskikh i sel'skikh khozyayev [. . .] na sta listakh*, Moscow, 1839.

69 *PSZRI*, *Sobraniye vtoroye*, XXVI, 1851, no. 24814; XXIV, 1854, no. 28422; XXXI, 1856, no. 30320.

70 G. K. Lukomsky, *Arkhitektura russkoy provintsii*, St Petersburg, 1912.

71 H. Colvin, "Gothic Survival and Gothic Revival", in id., *Essays in the History of English Architecture*, New Haven, CT, and London, 1999, pp. 217–44.

72 S. V. Klimenko, "Arkhitektor Ivan Michurin", doctoral diss., MARKhI, Moscow, 2002.

73 A. G. Boris, "Romanticheskaya tema v arkhitekture Moskvy rubezha XVIII i XIX vekov", doctoral diss., MARKhI, Moscow, 1990.

74 Ye. Borisova, A. Krasheninnikov, A. Petrov et al. (ed.), *Pamyatniki arkhitektury prigorodov Leningrada*, Leningrad, 1983, pp. 447–48.

75 V. Tenikhina, *Kottedzh*, Moscow, 1986;

A. N. Benua and N. Ye. Lansere, "Dvortsovoye stroitel'stvo imperatora Nikolaya", *Staryye gody*, July–September 1913.

76 Quoted from Ol', 1955, p. 30.

77 Pokrovskaya, 1999, pp. 118–20.

78 Ye. I. Kirichenko, "M. D. Bykovsky", in Yu. S. Yaralov (ed.), *Zodchiye Moskvy*, II, Moscow, 1981, pp. 268–69.

79 Ibid.

80 Ye. I. Kirichenko, *Mikhail Bykovsky*, Moscow, 1988.

81 Ye. A. Borisova, *Russkaya arkhitektura vtoroy poloviny XIX veka*, Moscow, 1979, pp. 102–19; Ye. Kirichenko, "Theoretical attitudes to architecture in Russia 1830–1910", *Architectural Association Quarterly*, XI/2, 1979, pp. 17–23; C. Cooke, "Russian Perspectives", *Architectural Design*, 3–4, 1980, pp. 60–63; T. A. Slavina, *Konstantin Ton*, Leningrad, 1989; E. Kirichenko, *Russian Design and the Fine Arts: 1750–1917*, New York, 1991; C. Cooke, "Precursors: Rationalism, Nationalism and the Schools", in id. (ed.), *Russian Avant-Garde: Theories of Art, Architecture and the City*, London, 1995, pp. 6–10; V. G. Lisovsky, *Natsional'nyy stil' v arkhitekture Rossii*, St Petersburg, 2000, pp. 53–167.

82 Ye. I. Kirichenko, *Khram Khrista Spasitelya*, Moscow, 1997.

83 Quoted from Slavina, 1989, p. 48.

84 Borisova, 1979, pp. 220–41; Ye. Borisova, "Breaking with Classicism: Historicism in 19th-Century Russia", *Architectural Design*, 3–4, 1980, pp. 17–23.

85 I. Ye. Zabelin, *Russkoye iskusstvo. Cherty samobytnosti v drevnerusskom zodchestve*, Moscow, 1900, p. 12.

86 Ye. R. Arenzon, "Pogodinskaya izba", *Pamyatniki Otechestva*, 2, 1983, pp. 144–47.

87 V. A. Gartman, *Obraztsy russkogo ornamenta*, St Petersburg, 1872.

88 Lisovsky, 2000, pp. 153–63; Ye. I. Kirichenko, "Arkhitektor I. P. Ropet", *Arkhitekturnoye nasledstvo*, XX, Moscow, 1972, pp. 85–93.

89 Borisova, 1979, pp. 245–46.

90 Ye. I. Kirichenko, *Zdaniye Istoricheskogo muzeya*, Moscow, 1984; E. I. Kirichenko, "The Historical Museum: A Moscow design competition 1875–83", *Architectural Design*, 7–8, 1987, pp. 24–26.

91 *Proyekty glavnogo fasada Verkhnykh torgovykh ryadov na Krasnoy ploshchadi v Moskve*, Moscow, 1889; Yu. Yaralov (ed.), "A. N. Pomerantsev", in id. (ed.), *Zodchiye Moskvy*, I, Moscow, 1978.

92 V. N. Listov, *Ippolit Monigetti*, Leningrad, 1976.

93 O. Morel and D. Shvidkovsky, *La Maison Igoumnoff*, Paris, 1994.

94 *Zodchiy*, 5, 1882, pp. 71–72.

95 A. Parland, *Khram Voskreseniya Khristova, sooruzhennyy na meste smertel'nogo porazhennogo v Boze pogibshego Imperatora Aleksandra II na Yekaterinskom kanale v Sankt-Peterburge*, St Petersburg, 1907.

96 F. M. Dostoyevsky, *The Diary of a Writer*, quot-

97 Ibid., p. 74.

98 *Zodchiy*, 1, 1872, p. 7.

99 T. A. Petrova, *Andrey Shtakenshneyder*, Leningrad, 1978.

100 T. Ye. Tyzhnenko, "Garal'd Bosse", in Kirikov (ed.), 1998, pp. 341–60.

101 V. G. Isachenko, "Aleksandr Rezanov", in ibid., pp. 360–69.

102 T. Ye. Tyzhnenko, *Maksimilian Mesmakher*, Leningrad, 1984.

103 T. I. Nikolayeva, *Viktor Shreter*, Leningrad, 1991.

104 D. Dol'gner, "Arkhitektor Lyudvig Bonshtedt i yego vklad v nemetsko-russkiye svyazi XIX stoletiya", in G. Yu. Sternin (ed.), *Vzaimosvyazi russkogo [. . .] iskusstva i nemetskoy khudozhestvennoy kul'tury*, Moscow, 1980.

105 D. S. Likhachev (ed.), *200 let sem'ye Benua v Rossii: Yubileynyy sbornik*, St Petersburg, 1994; V. G. Lisovsky and L. A. Yudina, "Zamechatel'nyy zodchiy i pedagog L. N. Benua", *Stroitel'stvo i arkhitektura Leningrada*, 2, 1979; V. Ruzhzhe, "Gradostroitel'nyye vzglyady arkhitektora L. N. Benua", *Arkhitekturnoye nasledstvo*, VII, Moscow, 1955.

106 *Zodchiy*, 6, 1906, p. 24.

107 Ibid.

108 Ibid.

109 Ye. A. Borisova and G. A. Sternin, *Russkiy modern*, Moscow, 1990.

110 N. V. Masalina, "Tserkov' v Abramtseve", in G. Yu. Sternin (ed.), *Iz istorii russkogo iskusstva vtoroy poloviny XIX – nachala XX veka*, Moscow, 1978, pp. 47–57; O. I. Arzumanova, *Musey-zapovevdnik "Abramtsevo"*, Moscow, 1988; Ye. A. Borisova, "Arkhitektura v tvorchestve khudozhnikov Abramtsevskgo kruzhka (u istokov 'neorusskogo stilya')", in G. Yu. Sternin (ed.), *Khudozhestvennyye protsessy v russkoy kul'ture vtoroy polovinoy XIX veka*, Moscow, 1984, pp. 137–82; G. N. Bocharov, "Deyatel'nost' khudozhnikov po vozrozhdeniyu russkogo narodnogo iskusstva. Abramtsevo i Talashkino", in G. Yu. Sternin (ed.), *Russkaya khudozhestvennaya kul'tura kontsa XIX – nachala XX veka*, II, Moscow, 1969, pp. 341–52; D. Z. Kogan, *Mamontovskiy kruzhok*, Moscow, 1970.

111 S. Makovsky, *Talashkino*, Moscow, 1905.

112 C. Cooke, "Shekhtel in Kelvingrove and Mackintosh in the Petrovka: Two Russo-Scottish exhibitions at the turn of the century", *Scottish Slavonic Review* (Glasgow), Spring 1988, pp. 177–205.

113 Ye. I. Kirichenko, *Fyodor Shekhtel'*, Moscow, 1973; id., *Shekhtel'*, Moscow, 2001; C. Cooke, "Fedor Osipovich Shekhtel: An architect and his clients in turn-of-the century Moscow", *AA Files*, 5, January 1984, pp. 3–30; id., "Fedor Shekhtel: Architect of Moscow's 'forgotten class'", in M. Raeburn (ed.), *Twilight of the Tsars: Russian Art at the Turn of the Century*, London, 1991, pp. 43–65.

114 Ye. I. Kirichenko, *Russkaya arkhitektura. 1830–1910s*, Moscow, 1978, pp. 320, 334.

115 Ibid., pp. 336–38.

116 G. A. Revzin, *Neoklassitsism v russkoy arkhitekture nachala veka*, Moscow, 1992.

117 D. O. Shvidkovsky and Ye. A. Shorban, *Osobnyaki Moskvy*, Moscow, 1997.

118 Yu. S. Yaralov, *Aleksandr Tamanyan*, Moscow, 1950.

119 G. D. Oshchepkov, *I. V. Zholtovsky*, Moscow, 1955.

120 Ye. A. Shorban, "Vichuga (Bonyachki)", in *Pamyatniki arkhitektury Ivanovskoy oblasti*, II, Moscow, 2000.

121 V. D. Bobrov and B. M. Kirikov, *Osobnyak Kseshinskogo (o A. I. Gogene)*, St Petersburg, 1996; V. G. Isachenko, "Tvorcheskoye naslediye P. Yu. Syuzora", *Leningradskaya panorama*, 10, 1985; B. M. Kirikov, "Obrazets stilya modern (o A. I. von Gogene)", *Stroitel'stvo i arkhitektura Leningrada*, 6, 1977.

122 V. G. Isachenko and G. A. Ol', *Fyodor Lidval'*, Leningrad, 1987.

VII THE SOVIET AND POST-SOVIET ERAS

1 C. Cooke, *The Russian Avant-Garde: Theories of Art, Architecture and the City*, London, 1995; id., *The Great Utopia: The Russian and Soviet Avant-Garde. 1915–1932*, New York, 1992; El Lissitzky, *An Architecture for World Revolution* [1930], Cambridge, MA and London, 1970; A. Kopp, *Ville et révolution: architecture et urbanisme soviétiques des années vingt*, Paris, 1967; V. E. Khazanova, *Sovetskaya arkhitektura pervykh let Oktyabrya*, Moscow, 1971; A. Senkevitch, *Soviet Architecture 1917–1962: A Bibliographical Guide*, Charlottesville, VA, 1974; S. O. Chan-Magomedov, *A. Vesnine et le constructivisme*, Paris, 1986; D. Elliot, *New Worlds: Russian Art and Society 1900–1937*, London, 1986; S. O. Chan-Magomedov, *Arkhitektura sovetskogo avangarda*, I, Moscow, 1996; II, Moscow, 2001.

2 N. N. Punin, *Tatlin*, Petrograd, 1921; S. O. Khan-Magomedov, *Zhivskul'ptarkh*, Moscow, 1993; id., *Psikhoanaliticheskiy metod N. Ladovskogo vo VKhUTEMASe-VKhUTEINe*, Moscow, 1993; id., *Propedevtika "Prostranstvo"*, Moscow, 1994; id., *Inkhuk i ranniy konstruktivizm*, Moscow, 1994; A. Strigalev and Yu. Kharten. *Tatlin. Retrospektiva*, Cologne and Moscow, 1994; S. O. Khan-Magomedov, *Pionery sovetskogo dizayna*, Moscow, 1996.

3 *Doma-kommuny. Materialy konkursov*, Leningrad, 1931; D. Ye. Arkin, *Iskusstvo bytovoy veshchi*, Moscow, 1932; M. Ya. Ginzburg, *Zhilishche*, Moscow, 1934; M. Bliznakov, "Soviet Housing during the Experimental Years 1918–1933", in W. Brumfield (ed.), *Russian Housing in the Modern Age: Design and Social History*, Cambridge, 1993, pp. 85–148.

4 *Moskovskoye arkhitekturnoye obshchestvo. Sbornik,*

5, Moscow, 1923; *Obshchestvo arkhitektorov-khudozhnikov. Yezhegodnik*, Leningrad, 12, 1927; 13, 1930; 14, 1935.

5 V. Stepanov, *Belogrud,* Leningrad, 1939; M. Minkus and N. Pekareva, *Fomin*, Moscow, 1953; V. G. Isachenko (ed.), *Zodchiye Peterburga XX veka*, St Petersburg, 2000.

6 O. Shvidkovsky (ed.), *Building in the USSR*, London, 1971; K. N. Afanasjev, *Ideen–Projekte–Bauten. Sowietische Architektur 1917 bis 1932*, Dresden, 1973; *Art into Life. Russian Constructivism 1914–1932*, New York, 1990; *Avantgarde I. Russisch-Sowietische Architektur*, exhib. cat., Stuttgart, 1991; *Avantgarde II. Sowietische Architektur*, exhib. cat., Stuttgart, 1993.

7 M.Ya. Ginzburg, *Stil' i epokha*, Moscow, 1924; S. O. Khan-Magomedov, *M. Ya. Ginzburg*, Moscow, 1972.

8 N. Ladovsky, "Osnovy postroyeniya teorii arkhitektury (pod znakom ratsionalisticheskoy estetiki)", *Izvestiya ASNOVA*, Moscow, 1926; V. Petrov, "ASNOVA za 8 let", *Sovetskaya arkhitektura*, 1–2, 1931; S. O. Khan-Magomedov, *Teoreticheskiye kontseptsii tvoricheskikh techeniy sovetskoy arkhitektury*, Moscow, 1974; id., *Nikolay Ladovsky*, Moscow, 1984.

9 P. Osipov, "OSA i ASNOVA", *Iskusstvo v massy*, 7, 1930; R. Khiger, "Obshchestvo sovremennykh arkhitektorov (OSA)", *Sovetskaya arkhitektura*, 8, 1969; V. E. Khazanova, *Sovetskaya arkhitektura pervoy pyatiletki. Problema goroda budushchego*, Moscow, 1980; S. O. Khan-Magomedov, *U istokov formirovaniya ASNOVA i OSA*, Moscow, 1994.

10 F. Yakovkin, "VOPRA i OSA", *Sovremennaya arkhitektura*, 5, 1929; V. Simbirtsev, "Vserossiyskoye obshchestvo proletarskikh arkhitektorov (VOPRA)", *Sovetskaya arkhitektura*, 18, 1969.

11 M. A. Il'yin, *Vesniny*, Moscow, 1960; A. Chinyakov, *Brat'ya Vesniny*, Moscow, 1970; P. Aleksandrov and S. Khan-Magomedov, *Ivan Leonidov*, Moscow, 1971; S. O. Khan-Magomedov, *Aleksandr Vesnin*, Moscow, 1983; A. Gozak and A. Leonidov, *Ivan Leonidov*, London, 1987.

12 F. Starr, *Melnikov: Solo Architect in a Mass Society*, Princeton, NJ, 1978; id., *Il padiglione di Melnikov a Parigi 1925*, Rome, 1979; S. O. Khan-Magomedov, *Konstantin Mel'nikov*, Moscow, 1990; I. V. Kokkinaki, "Mezhdunarodnaya zhizn' Konstantina Mel'nikova", *Arkhitektura SSSR*, 3, 1990; V. E. Khazanova, *Klubnaya zhizn' i arkhitektura kluba*, Moscow, 1994; I. V. Kokkinaki and A. A. Strigalev, *Mel'nikov*, Moscow, 1995; J. Pallasmaa and A. Gozak, *The Melnikov House, Moscow (1927–1929)*, London, 1996.

13 N. Sokolov, *Shchusev*, Moscow, 1952; K. N. Afanas'yev, A.V. *Shchusev*, Moscow, 1982.

14 A. Abramov, *Mavsoley Lenina*, Moscow, 1969; S. O. Khan-Magomedov, *Mavsoley Lenina (istoriya sozdaniya i arkhitektura)*, Moscow, 1972.

15 N. Dokuchayev, "Sovremennaya russkaya

arkhitektura i zapadnyye paralleli", *Sovetskoye iskusstvo*, 18, 1927; H. Schmidt, "Sowjetunion und Modernarchitektur", *Die Neue Stadt*, VI/VII, 1932, pp. 146–48; id., "Deutsche Architekten in der Sowjetunion", *Deutsche Architektur*, 10, 1967, n. 10; K. Junghanns, "Die Beziehungen zwischen deutschen und sowjetischen Architekten in den Jahren 1917–1933", *Wissenschaftliche Zeitschrift der Humboldt-Universität zu Berlin. Gesellschafts- und Sprachwissen-schaftliche Reihe*, Berlin, 1967, pp. 369–81; A. Chinyakov, "Le Korbyuz'ye i Vesniny", *Sovetskaya arkhitektura*, 18, 1969; I. V. Kokkinaki, "K voprosu o vzaimosvyazi sovetskikh i zarubezhnykh arkhitektorov v 1920–1930 gody", *Voprosy sovetskogo izobrazitel'nogo iskusstva i arkhitektury. Sbornik*, 3, Moscow, 1976; C. Borngraber, "Foreign Architects in the USSR: Bruno Taut and the brigades of Ernst May, Hannes Meyer and Hans Schmidt", *Architectural Association Quarterly*, 11/1, 1979, pp. 50–62; I.V. Kokkinaki, "Le Korbyuz'ye i sovetskaya Rossiya", *Arkhitektura SSSR*, 6, 1985; id., "Sovetsko-germanskiye arkhitekturnyye svyazi vo vtoroy polovine 1920-kh godakh", in G. Yu. Sternin (ed.), *Vzaimosvyazi russkogo i sovetskogo iskusstva i nemetskoy khudozhestvennoy kul'tury*, Moscow, 1989; W. Brumfield (ed.), *Reshaping Russian Architecture: Western technology, utopian dreams*, Cambridge, 1990; J.-L. Cohen, *Le Corbusier and the Mystique of the USSR*, Princeton, NJ, 1992.

16 B. Taut, *Die neue Baukunst in Europa und Amerika*, Stuttgart, 1929; E. Mendelsohn, *Russland, Europa, Amerika. Ein architektonischer Querschnitt*, Berlin, 1929.

17 Kokkinaki, 1985, p. 94.

18 A. V. Lunacharsky, "Predisloviye k russkomu perevodu stat'i Le Korbuiz'ye 'Ochi nevidyashchiye'", *Khudozhestvennyy trud*, 2, 1923, p. 7.

19 Konnikaki, 1985, p. 95.

20 I. G. Erenburg, "Vsemirnaya vystavka", *Ogonyok*, 15, p. 23.

21 Kokkinaki, 1985, p. 99.

22 Ibid., p. 99.

23 Chinyakov, 1969.

24 Le Korbyuz'ye, "Otvety na voprosy iz Moskvy", in V. Shkvarikov (ed.), *Planirovka goroda*, Moscow, 1933, pp. 186–87.

25 Kokkinaki, 1989, p. 116.

26 Letter from E. Mendelsohn, *Sovremennaya arkhitektura*, 3, 1927, p. 108; "O privlechenii inostrannykh spetsialistov k stroitel'stvu v SSSR", *Stroitel'naya promyshlennost'*, 12, 1925, pp. 823–24.

27 *Pervaya vystavka sovremennoy arkhitektury*, exhib. cat., Moscow, 1927; Ya. Tugenkhol'd, "K vystavke sovremennoy arkhitektury", *Izvestiya*, 12 June 1927; I. Kokkinaki, "The First Exhibition of Contemporary Architecture in Moscow", *Architectural Design*, 5/6, 1983, pp. 50–59.

28 Kokkinaki, 1989, p. 119.

29 Ibid., p. 122.

30 F. Whitford, *The Bauhaus*, London, 1984; Kh. Shedlikh, "Bauhaus i VKhUTEMAS. Obshchiye cherty pedagogicheskoy programmy", in Sternin (ed.), 1989; S. O. Chan-Magomedov, *Vkhutemas*, Paris, 1990; C. Cooke, *The Russian Avant-Garde. Theories of Art, Architecture and the City*, London, 1995; S. O. Khan-Magomedov, *VKhUTEMAS*, I, II, Moscow, 1996.

31 Shedlikh, 1989, p. 156.

32 K. Pyushel', "Gruppa Khannesa Mayera v Sovetskom Soyuze", in Sternin (ed.), 1989, pp. 157–60.

33 Ibid., p. 160.

34 A. Vesnin, "Tvorcheskiye puti sovetskoy arkhitektury i problemy arkhitekturnogo nasledstva", *Sovetskaya arkhitektura*, 3–4, 1933; I. A. Fomin, "Rekonstruktsiya klassiki. O stile nashey epokhi", *Sovetskoye iskusstvo*, 43, 1933; K. S. Alabyan, *Zadachi sovetskoy arkhitektury*, Moscow, 1937; N. Tret'yakov, *Georgy Gol'ts*, Moscow, 1969; V. Ye. Bykov, *Gol'ts*, Moscow, 1978; M. G. Barkhin, *Metod raboty zodchego: iz opyty sovetskoy arkhitektury, 1917–1957 gg.*, Moscow, 1981; A. Tarkhanov and S. Kavtaradze, *Stalinist Architecture*, London, 1992; C. Cooke, "Socialist Realist Architecture: Theory and Practice", in C. Brown and B. Taylor (eds), *The Art of the Soviets: Painting, Sculpture and Architecture in a One-Party State 1917–1992*, Manchester, 1993; H. Hudson, *Blueprints and Blood: The Stalinisation of Soviet Architecture*, Princeton, NJ, 1994; C. Cooke, "Beauty as a route to the 'radiant future': Responses of Soviet architecture", *Journal of Design History*, 2, 1997, pp. 137–60.

35 *General'nyy plan rekonstruktsii Moskvy*, Moscow, 1936.

36 *Arkhitektura kanala Volga-Moskva*, Moscow, 1939.

37 N. Ya. Kolli and S. M. Kravets, *Arkhitektura Moskovskogo metro*, Moscow, 1936; I. Kattsen, *Metro Moskvy*, Moscow, 1947; N. A. Pekareva, *Moskovskiy metropoliten*, Moscow, 1958.

38 [R. Byron and B. Lubetkin], "The Palace of Soviets, Moscow", *The Architectural Review*, May 1932; *Dvorets Sovetov. Vsesoyuznyy konkurs*, Moscow, 1933; *Pavil'yon SSSR na mezhdunarodnoy vystavke v Parizhe*, Moscow, 1938; *Arkhitektura Dvortsa Sovetov*, Moscow, 1939; A. Kopp, *L'Architecture de l'époque stalinienne*, Paris, 1971; I. Eygel', *Boris Iofan*, Moscow, 1978; A. Cunliffe, "The Competition for the Palace of Soviets in Moscow, 1931–33", *Architectural Association Quarterly*, 11/2, 1979, pp. 36–48.

39 A. F. Zhukov, *Arkhitektura Vsesoyuznoy sel'-skokhozyaystvennoy vystavki 1939 goda*, Moscow, 1939.

40 "Gradostroitel'stvo 1941–1954 gg.", in N. Baranov (ed.), *Vseobshchaya istoriya arkhitektury*, XII, Moscow, 1975, pp. 144–91.

41 V. K. Oltarzhevsky, *Stroitel'stvo vysotnykh zdaniy v Moskve*, Moscow, 1953; V. Ass and P.

Zinov'yev, *Arkhitektor Rudnev*, Moscow, 1956; N. P. Bylinkin and N. N. Stoyanov, *Vysotnyye zdaniya*, Moscow, 1958; J.-L. Cohen, *Scenes of the World to Come. European Architecture and the American Challenge*, Paris and New York, 1995, pp. 160–83; C. Cooke, "Manhattan in Moscow", *Domus*, September 2001, pp. 88–101.

42 N. P. Bylinkin, *Progressivnyye cherty v arkhitekture massovogo zhilishchnogo stroitel'stva po tipovym proyektam*, Moscow, 1957; A. A. Galaktionov, *Ratsionalisticheskiye priyomy zastroyki zhilykh kvartalov po tipovym proyektam*, Moscow, 1957; A. V. Ikonnikov, *Esteticheskiye problemy massovogo zhilogo stroitel'stva*, Leningrad, 1968; Yu. S. Yaralov (ed.), *Sovetskaya arkhitektura shestidesyatykh godov. Sbornik*, Moscow, 1972.

43 N. A. Pekareva (ed.), *Moskovskiy Dvorets pionerov*, Moscow, 1966; M. V. Posokhin, *Kremlevskiy Dvorets s'yezdov*, Moscow, 1971; id., *Perspektivy razvitiya Moskvy*, Moscow, 1973; G. A. Orlov and K. A. Dzerzhinsky, *Sovetskaya arkhitektura. Tvorcheskiye problemy*, Moscow, 1977.

44 O. A. Shvidkovsky, *Vzaimodeystviye iskusstv*, Moscow, 1978; V. P. Tolstoy, *Monumental'noye iskusstvo SSSR*, Moscow, 1979.

45 A. T. Polyansky, *Arkhitekturnoye tvorchestvo i standartnoye stroitel'stvo*, Moscow, 1971; B. R. Rubanenko (ed.), *Arkhitekturno-khudozhestvennyye voprosy industrial'nogo domostroyeniya*, Moscow, 1977; id. (ed.), *Zhilishchnoye stroitel'stvo v SSSR*, Moscow, 1976; N. P. Rozanov, *Krupnopanel'noye domostroyeniye*, Moscow, 1982; A. Ikonnikov (ed.), *Estetika massovogo domostroyeniya. Sbornik statey*, Moscow, 1984.

46 C. Cooke, "A Picnic by the Road or Work in Hand for the Future?", in *Nostalgia of Culture: Contemporary Soviet Visionary Architecture*, exhib. cat., London, 1988, pp. 12–25; H. Klotz (ed.), *Paper Architecture: New Project from the Soviet Union*, New York, 1990; G. Burrer (ed.), *A. Brodsky and I. Utkin. Palazzo Nero and Other Works*, Wellington, OH, 1992; A. Brodsky, *Raboty. 1991–2000*, Moscow, 2001.

47 D. Shvidkovsky, "Moscow in 1997. Power, Trade and the New Russians", *Architectural Association Files*, 2, 1997; D. Shvidkovsky," L'Architecture de Moscou", *Critique*, 1, Paris, 2000; G. I. Revsin, *Time for Change: Recent Developments in Russian Architecture*, exhib. cat., London, 2002.

48 V. V. Vanslov and Ye. V. Zaytsev (eds), *Khram Khrista Spasitelya v Moskve*, Moscow, 2000; L.V. Shirshova and I. V. Novik, *Khram Khrista Spasitelya v Moskve. Vossozdaniye skul'pturnogo i zhivopisnogo ubranstva*, Moscow, 2000.

49 *Pervaya kniga Moskovskogo arkhitekturnogo obshchestva* [this and the following each with a foreword by D. Shvidkovsky], Moscow, 1999; *Salon: 1995–2000*, Moscow, 2000; *Arkhiv 2000*, Moscow, 2000; *Arkhiv 2001*, Moscow, 2001; *Salon: 2000–2001*, Moscow, 2001.

Select Bibliography

Abechedarsky, L. S., *Belorussiya i Rossiya. Ocherki russko-belorusskikh svyazey vtoroy poloviny XVI–XVII vv.*, Minsk, 1978

Ackerman, J., "The Certosa of Pavia and the Renaissance in Milan", in *Distant Points: Essays in Theory and Renaissance Art and Architecture*, Cambridge, MA, 1991, pp. 278–87

Afanas'yev, K. N., *Postroyeniye arkhitekturnoy formy drevnerusskimi zodchimi*, Moscow, 1961

——, *A. V. Shchusev*, Moscow, 1978

Agafonov, S. O., "Nekotoryye ischeznuvshiye tipy drevenerusskikh derevyannykh postroyek", *Arkhitekturnoye nasledstvo*, 2, Moscow, 1952, pp. 173–86

——, "K voprosu ob otkrytykh vnutr' shatrakh v russkom derevyannom zodchestve", ibid., pp. 87–192

Agli, M., *San Michele. Splendore e degrado di un monumento*, Pavia, 1996

Alabyan, K. S., *Zadachi sovetskoy arkhitektury*, Moscow, 1937

Aleksandrov, P. A., and Chan-Magomedov, S. O., *Ivan Leonidov*, Moscow, 1971

Aleksandrova, L. B., *Luigi Ruska*, Leningrad, 1990

——, "Andrey Mikhaylov", in *Zodchiye Sankt-Peterburga. XIX–nachalo XX veka*, St Petersburg, 1998, pp. 113–23

Alekseyev, A. N., and Sternin, G.Yu. (eds), *Russkaya khudozhestvennaya kul'tura kontsa XIX–nachala XX veka, I–IV*, Moscow, 1969–80

Alekseyeva, S. B., "Arkhitektura i dekorativnaya plastika Zimnego dvortsa", in Alekseyeva, T.V. (ed.), *Russkoye iskusstvo barokko: materialy i issledovaniya*, Moscow, 1977, pp. 128–58

Alekseyeva, T.V., *Issledovaniya i nakhodki*, Moscow, 1976

——, "Franchesko-Bartolomeo Rastrelli i russkaya kul'tura", in id. (ed.), *Ot Srednevekov'ya k novomu vremeni*, Moscow, 1984, pp. 131–40

—— (ed.), *Russkoye iskusstvo XVIII veka: materialy i issledovaniya*, Moscow, 1968

—— (ed.), *Russkoye iskusstvo XVIII veka: materialy i issledovaniya*, Moscow, 1973

—— (ed.), *Russkoye iskusstvo pervoy chetverti XVIII veka: materialy i issledovaniya*, Moscow, 1974

—— (ed.), *Russkoye iskusstvo barokko: materialy i issledovaniya*, Moscow, 1977

—— (ed.), *Russkoye iskusstvo vtoroy poloviny XVIII–pervoy poloviny XIX veka: materialy i issledovaniya*, Moscow, 1979

—— (ed.), *Ot Srednevekov'ya k Novomu vremeni*, Moscow, 1984

Alferova, G. V., "K voprosu o stroitel'noy deyatel'nosti patriarkha Nikona", *Arkhitekturnoye nasledstvo*, 18, Moscow, 1969, pp. 30–44

——, "Issledovaniye i restavratsiya palat Averkiya Kirillova", in Shchenkov, A. S. (ed.), *Iz istorii restavratsii pamyatnikov kul'tury*, Moscow, 1974

——, "Ansambl' Krestnogo monastyrya na Kiy-ostrove", *Arkhitekturnoye nasledstvo*, 24, Moscow, 1976, pp. 83–93

——, "K voprosu o stroitel'stve gorodov v Moskovskom gosudarstve v XVI–XVII vv.", *Arkhitekturnoye nasledstvo*, 28, Moscow, 1980, pp. 20–28

Alpatov, M. V., "Khudozhestvennoye znacheniye Pavlovska", in *Yezhegodnik instituta istorii iskusstv*, Moscow, 1954

——, *Arkhitektura russkogo klassitsizma nachala XIX veka*, Moscow, 1961

——, *Andrey Rublev*, Moscow, 1972

——, "Iskusstvo Feofana Greka i ucheniye isikhastov", in *Vizantiyskiy vremennik*, 33, Moscow, 1972, pp. 190–02

——, *Feofan Grek*, Moscow, 1979

—— (ed.), *Uspenskiy sobor Moskovskogo Kremlya*, Moscow, 1971

Anderson, I., *Scotsmen in the Service of the Czars*, Edinburgh, 1970

Andreyev, A. K., "Adam Menelas", *Problemy sinteza iskusstv i arkhitektury*, 7, Leningrad, 1997, pp. 38–59

Andreyev, N., "Filofey and his epistle to Ivan Vasilyevich", *Slavonic and East European Review*, 38, 1959, pp. 1–31

Andreyeva, A., *Mestnik Bogiy na tsarskom trone: Khristianskaya tsivilizatsionnaya model' sakralizatsii vlasti v russkoy istorii*, Moscow, 2002

Angelini, P., Navone, N., and Pfister, A. (eds), *Architetti neoclassici italiani e ticinesi fra Neva e Moscova*, Milan, 2001

Anikst, M. A., and Turchin, V. S., *V okrestnostyakh Moskvy*, Moscow, 1979

Antonov, V. V., "Zhivopistsy-dekoratory Skotti v Rossii", in Alekseyeva, T. V. (ed.), *Russkoye iskusstvo vtoroy poloviny XVIII– pervoy poloviny XIX veka*, Moscow, 1979, pp. 69–107

Antsiferov, N. P., *Dusha Peterburga*, St Petersburg, 1922

Arenkova, Yu. I., "Arsenal v Kremle. Istoriya stroitel'stva", in Alekseyeva, T. V. (ed.), *Russkoye iskusstvo barokko: materialy i issledovaniya*, Moscow, 1977, pp. 43–54

—— and Mekhova, G. I., *Donskoy monastyr'*, Moscow, 1970

Arenzon, E. P., "Pogodinskaya izba", *Pamyatniki Otechestva*, 2, 1983, pp. 144–47

——, "'Abramtsevo' v Moskve: K istorii khudozhestvenno-keramicheskogo predpriyatiya S. I. Mamontova", *Muzey*, 10, Moscow, 1989, pp. 95–102

"Aristotele Fioravanti", *Arte Lombarda. Nuova serie*, 44–45, Milan, 1976 (special ed.)

Arkhipov, N. I., and Raskin, A. G., *Petrodvorets*, Leningrad and Moscow, 1961

——, *Bartolomeo Karlo Rastrelli*, Leningrad and Moscow, 1964

Arkhiv 2000, Moscow, 2000

Arkhiv 2001, Moscow, 2001

Arkhiv 2002–2003, Moscow, 2003

Arkin, D. E., *Rastrelli*, Moscow, 1954

—— (ed.), "Dolzhnost' arkhitekturnoy ekspeditsii. Traktat-kodeks 1737–1740", *Arkhitekturnyy arkhiv*, I, Moscow, 1946, pp. 7–108

Artamonov, M. I., *Istoriya khazar*, Leningrad, 1962

Arzumanova, O. I., *Muzey-zapovednik Abramtsevo*, Moscow, 1988

Aseyev, Yu. S., *Arkhitektura Kiyevskoy Rusi*, Kiev, 1969

——, *Arkhitektura drevnego Kiyeva*, Kiev, 1982

—— and Kharlamov, V. A., "Ob arkhitekture Uspenskogo sobora Pecherskogo monastyrya v Kiyeve (issledovaniya 1982 g.)", *Arkhitekturnoye nasledstvo*, 34, Moscow, 1986, pp. 209–14

Ass, B. Ye., and Zinovyev, P. P., *Arkhitektor Rudnev*, Moscow, 1956

Astaf'yeva-Dlugach, M. I., Volchok, Yu. P., and Zhuravlev, A. A., *Zodchiye Moskvy XX v.*, Moscow, 1988

Baldin, V. I., "Arkhitektura Troitskogo sobora Troitse-Sergiyevoy lavry", *Arkhitekturnoye nasledstvo*, 6, Moscow, 1956, pp. 21–56

——, *Zagorsk*, Moscow, 1974

——, *Arkhitekturnyy ansambl' Troitse-Sergiyevoy lavry*, Moscow, 1976, 1996

——, and Gerasimov, Yu. N., "Dukhovskaya tserkov' Troitse-Sergiyeva monastyrya", *Arkhitekturnoye nasledstvo*, 19, Moscow, 1972, pp. 53–65

Balog, G. P., Gladkova, Ye. S., Yemina, L. V. and Lemus, V. V., *Muzei i parki Pushkina*, Leningrad, 1969

Balogh, J., "Aristotele Fioravanti in Ungeria", *Arte Lombarda*, 44–45, Milan, 1976

Banige, V. S., *Kreml' Rostova Velikogo: XVI–XVII veka*, Moscow, 1976

Baranova, O. N., *Kuskovo: 18th-Century Russian Estate and the Museum of Ceramics*, Leningrad, 1983

Bardon Dandre, M.-F., *Costume des anciens Peuples*, 2 vols, Paris, 1772–74

Barkhin, M. G., *Metod raboty zodchego. Iz opyta sovetskoy arkhitektury. 1917–57*, Moscow, 1981

—— (ed.), *Mastera sovetskoy arkhitektury ob arkhitekture*, 2 vols, Moscow, 1975

Baron, S. H., "A Guide to Published and Unpublished Documents on Anglo-Russian Relations in the Sixteenth Century in British Archives", in id., *Muscovite Russia*, London, 1980

Bartenev, I. A., and Batazhkova, V. N., *Russkiy inter'yer XVIII–XIX veka*. Leningrad, 1977

——, *Russkiy inter'yer XIX veka*, Leningrad, 1984

Barteneva, M. I., *Nikolay Benua*, Leningrad, 1985

Batalov, A. L., "Chetyre pamyatnika arkhitektury Moskvy kontsa XVI veka", *Arkhitekturnoye nasledstvo*, 32, Moscow, 1984, pp. 47–53

——, "Sobor Voznesenskogo monastyrya v Moskovskom Kremle", *Pamyatniki kul'tury. Novyye otkrytiya*, X, Moscow, 1985, pp. 468–82

——, "Osobennosti 'ital'yanizmov' v moskovskom kamennom zodchestve rubezha XVI–XVII vekov", *Arkhitekturnoye nasledstvo*, 34, Moscow, 1986, pp. 238–45

——, "K interpretatsii arkhitektury sobora Pokrova na Rvu (O granitsakh ikonograficheskogo metoda)", in id. (ed.), *Ikonografiya arkhitektury*, Moscow, 1990, pp. 15–37

——, "Grob Gospoden' v zamysle Svyataya Svyatyh Borisa Godunova", in Batalov, A. L., and Lidov, A. M. (eds) *Iyerusalim v russkoy kul'ture*, Moscow, 1994, pp. 154–67

——, *Russkoye kamennoye zodchestvo epokhi Borisa Godunova*, Moscow, 1998

——, "Traditsiya stroitel'stva Uspenskikh khramov v XVI veke", in *Materialy konferentsii "Russkoye iskusstvo XVI veka"*, Moscow, 2000

——, "K voprosu o prisutstvii zapadnykh masterov v Moskve epokhi Ioanna Groznogo", paper read at conference *Lazarevskiye chteniya*, Moscow State University, 2001

——, and Bondarenko, I. A. (eds) *Restavratsiya i arkhitekturnaya arkheologiya. Novyye materialy i issledovaniya*, Moscow, 1991

——, and Lidov, A. M. (eds), *Iyerusalim v russkoy kul'ture*, Moscow, 1994

——, and Shvidkovsky, D. O., "Angliyskiy master pri dvore Ivana Groznogo", *Arkhiv arkhitektury*, I, Moscow, 1992, pp. 101–18

—— and Vyachanina, T. N., "Ob ideynom znachenii i interpretatsii iyerusalimskogo obraztsa v russkoy arkhitekture XVI–XVII vekov", *Arkhitekturnoye nasledstvo*, 36, Moscow, 1988, pp. 22–42

Bater, J. U., "The Industrialization of Moscow and St Petersburg", in Bater, J., and French, R. (eds) *Studies in Russian Historical Geography*, II, London, 1983, pp. 279–03

Batowski, Z., *Architect Rastrelli o swych pracach*, L'vov, 1939

——, *Arkhitektor Rastrelli o svoikh rabotakh*, St Petersburg, 2000

Bayburova, R. M., "Russkiy usadebnyy inter'yer epokhi klassitsizma. Planirovochnyye kompozitsii", in Vygolov, V. P., Vlasyuk, A. I., and Pluzhnikov, V. I. (eds), *Pamyatniki russkoy arkhitektury i monumental'nogo iskusstva*, Moscow, 1980, pp. 140–61

——, "Zal i gostinaya usadebnogo doma russkogo klassitsizma", in ibid., 1983, pp. 113–24

——, "Gorodskoy usadebnyy dom russkogo klassitsizma i frantsuzskiy klassitsicheskiy otel'", in ibid., 1985, pp. 116–26

Belanina, V. A., *Pavlovsk*. Moscow, 1987

Belavskaya, K. P., "Khudozhnik F. Viollet i yego raboty v Pavlovske", in *Pamyatniki kul'tury. Novyye otkrytiya*, Moscow, 1977, pp. 309–22

Belekhov, N. N. and Petrov, A. N., *Ivan Starov: materialy k izucheniyu tvorchestva*, Moscow, 1950

Beletskaya, Ye. A., *Arkhitekturnyye al'bomy M.F. Kazakova*, Moscow, 1956

——, "Iz istorii stroitel'stva doma Razumovskogo", *Arkhitekturnoye nasledstvo*, 9, Moscow, 1959, pp. 189–96

——, *Arkhitektor A. G. Grigor'yev*, Moscow, 1976

——, Krasheninnikova, N. L., Chernozubova, L.Ye. and Ern, I.V., *"Obraztsovyye" proyekty v zhiloy zastroyke russkikh gorodov XVIII–XIX vekov*, Moscow, 1961

—— and Pokrovskaya, Z.K., *D. Zhilyardi*, Moscow, 1980

Belova, O. V., *Slavyanskiy bestyariy: slovar' nazvaniy i simvolov*, Moscow, 2000

Beltrami, L., *Aristotele da Bologna*, Bologna, 1888, 1912

Benois, A. N., *Tsarskoye selo v tsarstvovaniye Yelizavety Petrovny*, St Petersburg, 1910

——, and Lansere, N.Ye., "Dvortsovoye stroitel'stvo imperatora Nikolaya I", *Staryye Gody*, July–September 1913

Bernardino Amico, *Trattato delle piante e imagini de sacri edificii di Terra Sante*, Florence, 1620; English ed.: *Plans of the Sacred Edifices of the Holy Land*, trans. Theofilius Bellorini and Eugene Hoade, with preface by Bellarmino Bagatti, London, 1953

Bernshtein, D. K., "O fenomene 'bumazhnoy arkhitektury' 1980-kh godov", in Azizyan, I.A. (ed.), *Teoriya arkhitektury*, I, Moscow, 1988, pp. 111–35

Betin, L. V., "Istoricheskiye osnovy drevnerusskogo vysokogo ikonostasa", in Lazarev, V. N. (ed.), *Drevnerusskoye iskusstvo.*

Khudozhestvennaya kul'tura Moskvy i prilezhashchikh k ney knyazhestv. XIV–XVI vv., V, Moscow, 1970, pp. 57–72

——, "Ob arkhitekturnoy kompozitsii drevnerusskikh vysokikh ikonostasov", in ibid., pp. 41–56

Bertotti-Scamozzi, O., *Le fabriche e i disegni di Andrea Palladio raccolti ed illustrati*, 4 vols, Vicenza, 1776–83

Bettini, S., "Alvise Lamberti da Montagnana. Un grande artisto veneto in Russia", *Le tre Venezie*, 7–12, 1944

Billington, J., *The Icon and the Axe. An Interpretive History of Russian Culture*, New York, 1966

Birnbaum, H., *Essays in Early Slavic Civilization*, Munich, 1981

Bliznakov, M., "The Realization of Utopia: Western Technology and Soviet Avant-Garde Architecture", in Brumfield, W. C. (ed.), *Reshaping Russian Architecture*, New York, 1991, pp. 145–75

Blondel, J.-F., *Discours sur la nécessité de l'étude de l'architecture*, Paris, 1754

——, *Cours d'architecture ou Traité de la décoration et construction des bâtiments*, 6 vols, Paris, 1771

Bobrinsky, A. A., *Reznoy kamen' v Rossii*, I: *Sobory Vladimirskoy oblasti XII–XIII stoletiy*, Moscow, 1916

Bobrov, V. D., and Kirikov, B. M., *Osobnyak Kshesinskoy (A. I. Gogena)*, St Petersburg, 1996

Bocharov, G. I., "Tsarskoye mesto Ivana Groznogo v Uspenskom sobore moskovskogo Kremlya", in Vygolov, V. P., et al., *Pamyatniki russkoy arkhitektury i monumental'nogo iskusstva*, Moscow, 1983, pp. 29–57

Bocharov, G. N., "Deyatelnost' khudozhnikov po vozrozhdeniyu russkogo narodnogo iskusstva. Abramtsevo i Talashkino", in Sternin, G.Yu. (ed.), *Russkaya khudozhestvennaya kul'tura kontsa XIX–nachala XX veka*, II, Moscow, 1969

——, and Vygolov, V.P., *Aleksandrovskaya Sloboda*, Moscow, 1970

——, *Vologda. Kirillov. Ferapontovo. Belozersk*, Moscow, 1979

——, *Sol'vychegodsk. Velikiy Ustug. Tot'ma*, Moscow, 1983

Bochkarev, V. N., *Moskovskoye gosudarstvo XV–XVII vekov po skazaniyam sovremennikov-inostrantsev*, St Petersburg, 1914

Bodrova, O. N., *Biblioteka Petra I. Ukazatel'-spravochnik*, Leningrad, 1978

Bogdanov, A., *Istoricheskoye, geograficheskoye i topograficheskoye opisaniye Sankt-Peterburga ot 1703 po 1751*, completed 1750, published with foreword by V. Rubanov, St Petersburg, 1779

Bogdanovich, M. I., *Graf Arakcheyev i voyennyye poseleniya*, St Petersburg, 1871

Bogoyavlensky, S. K., *O pushkarskom prikaze. Sbornik statey v chest' M. K. Lubavskogo*, Petrograd, 1917, pp. 384–85

Bolotov, A. T., *Zhizn' i priklucheniya Andreya Bolotova, opisannyye im samym dlya svoikh potomkov*, I–III, Moscow, 1933

Bolotova, G. R., *Letniy sad*, Leningrad, 1981

Bondarenko, I. A., "K voprosu ob ispol'zovanii mer dliny v drevnerusskom zodchestve", *Arkhitekturnoye nasledstvo*, 36, Moscow, 1988, pp. 54–63

——, "Svoye, chuzhoye i obshcheye v istorii arkhitektury", *Arkhitektura mira*, 2, Moscow, 1990, pp. 179–82

——, "Novoye voploshcheniye srednevekovogo ideala: k otsenke proyekta kremlyovskogo pereustroystva V. I. Bazhenova", *Arkhitekturnoye nasledstvo*, 40, Moscow, 1996, pp. 92–96

——, "O roli masterov-inozemtsev v traditsionnoy kul'ture Rusi", *Arkhitekturnoye nasledstvo*, 43, Moscow, 1999, pp. 179–82

—— (ed.), *Matvey Fyodorovich Kazakov i arkhitektura klassitsizma. Sbornik statey*, Moscow, 1996

Bondarenko, I. E., *Annengof. Akademiya arkhitektury*, 6, 1935, pp. 74–81

Borisova Ye. A., "Arkhitekturnoye obrazovaniye v Kantselyarii ot stroyenii vo vtoroy chetverti XVIII veka", *Yezhegodnik Instituta istorii iskusstv, Zhivopis' i arkhitektura*, Moscow, 1961, pp. 97–131

——, "Arkhitekturnyye ucheniki petrovskogo vremeni i ikh obucheniye v komandakh zodchikh-inostrantsev v Peterburge", in Alekseyeva, T.V. (ed.), *Russkoye iskusstvo pervoy chetverti XVIII veka*, Moscow, 1974, pp. 9–26

——, *Arkhitektura v tvorchestve khudozhnikov Abramtsevskogo kruzhka (u istokov neorusskogo stilya: khudozhestvennyye protsessi v russkoy kul'ture vtoroy poloviny XIX veka)*, Moscow, 1979, pp. 137–82

——, *Russkaya arkhitektura vtoroy poloviny XIX veka*, Moscow, 1979

—— and Kazhdan, T.P., *Russkaya arkhitektura kontsa XIX–nachala XX veka*, Moscow, 1971

—— and Sternin, G.Yu., *Russkiy modern*, Moscow, 1990

——, *Russkiy neoklassitsizm*, Moscow, 2002

Bowlt, J. (ed.), *Russian Art of the Avant-Garde: Theory and Criticism*, New York, 1976

Bozheryanov, I. N., *Nevskiy Prospekt: 1703–1903*, St Petersburg, 1903

Braudel, F., *Le Modèle Italien*, Paris, 1994

Braytseva, O. I., "Novyye konstruktivnyye priyomy v russkoy arkhitekture kontsa XVII–nachala XVIII veka", *Arkhitekturnoye nasledstvo*, 12, Moscow, 1960, pp. 133–52

——, "Nekotoryye osobennosti ordernykh kompozitsiy v russkoy arkhitekture rubezha XVII–XVIII vekov", *Arkhitekturnoye nasledstvo*, 18, Moscow, 1969, pp. 45–60

——, *Stroganovskiye postroyki rubezha XVI–XVIII vekov*, Moscow, 1977

——, "Novoye i traditsionnoye v khramovom zodchestve Moskvy kontsa XVII veka", *Arkhitekturnoye nasledstvo*, 26, Moscow, 1978, pp. 31–40

Braytseva, O. I., Budilina, M.V., and Kharlamova, A. M., *Arkhitektor N. A. L'vov*, Moscow, 1961

Brentani, A., *Antichi maestri d'arte e di scuola delle terre ticinesi: notizie e documenti*, 7 vols, Como, Lugano, 1963–73

Brinkner, A. K., *Istoriya Yekateriny Vtoroy*, St Petersburg, 1885

Brodsky, A. S., *Raboty, 1991–2000*, Moscow, 2001

—— and Utkin, I. M., ed. Burrer, G., *Palazzo Nero and Other Works*, Wellington, OH, 1992

Bronshteyn, S. S., *Arkhitektura goroda Pushkina*, Leningrad, 1939

——, "K 250-letiyu so dnya rozhdeniya I. K. Korobova", *Arkhitektura i stroitel'stvo Leningrada*, 13, 1950, pp. 41–46

Brumfield, W. C., *Gold in Azure: One Thousand Years of Russian Architecture*, Boston, MA, 1983

——, "Russia's Glorious Churches", *Historic Preservation*, February 1985, pp. 42–46

——, "The Decorative Arts in Russian Architecture: 1900–1907", *Journal of Decorative and Propaganda Arts*, 5, 1987, pp. 12–27

——, "Architecture and Urban Planning", in Cracraft, J. (ed.), *The Soviet Union Today: An Interpretive Guide*, Chicago, IL, 1988, pp. 164–74

——, "Anti-Modernism and the Neoclassical Revival in Russian Architecture, 1906–1916", *Journal of the Society of Architectural Historians*, 48, 1989, pp. 371–86

——, "Russian Perceptions of American Architecture, 1870–1917", in id. (ed. and intr.), *Reshaping Russian Architecture: Western Technology, Utopian Dreams*, New York, 1990, pp. 43–66

——, *The Origins of Modernism in Russian Architecture*, Berkeley, CA, and Oxford, 1991

——, *A History of Russian Architecture*, Cambridge and New York, 1993; rev. ed. 2004

——, *Lost Russia: Photographing the Ruins of Russian Architecture*, Durham, NC, and London, 1995

——, *Landmarks of Russian Architecture: A Photographic Survey*, Amsterdam, 1997

——, *Tot'ma: Arkhitekturnoye naslediye v fotografiyakh*, Moscow, 2005

——, *Vologodskiy al'bom: Arkhitekturnyye pamyatniki Vologodskoy oblasti. Svidetel'stvo v fotografiyakh*, Moscow, 2005

—— (ed.), *Reshaping Russian Architecture: Western Technology, Utopian Dreams*, Washington, D.C., and Cambridge, 1990

——, Anan'yich, B.V. and Petrov, Y. A., (eds), *Commerce in Russian Urban Culture, 1861–1914*, Washington, D.C., and Baltimore, MD, 2001

—— (eds), *Predprinimatel'stvo i gorodskaya kul'tura v Rossii. 1861–1914*, Moscow, 2002

Brumfield, W. C., and Ruble, B. A. (eds), *Russian Housing in the Modern Age: Design and Social History*, Washington, D.C., and Cambridge, 1993

—— (eds), *Zhilishche v Rossii: vek XX*, in *Arkhitektura i sotsial'naya istoriya*, Moscow, 2001

Brumfield, W. C., and Velimirovic, M. M. (eds), *Christianity and the Arts in Russia*, Cambridge and New York, 1991

Brunoff, N. I., "Due Cattedrali del Kremlino construite de italiani", *Architettura e arti decorative*, VI, fasc. III. Milan, 1926

Brunov, N. I., "K voprosu o tak nazyvayemom russkom barokko", in Nekrasov, A. I. (ed.), *Barokko v Rossii*, Moscow, 1926, pp. 43–55

——, "Model' iyerusalimskogo khrama, privezennaya v XVII veke v Rossiyu", *Soobshcheniya Rossiyskogo Palestinskogo obshchestva*, XXIX, Leningrad, 1926

——, "Sobor Savvino-Storozhevskogo monastyrya bliz Zvenigoroda", *Trudy etnografo-arkheologicheskogo muzeya MGU*, Moscow, 1926

—— "K voprosu o pervonachal'nom vide Sofii kiyevskoy", *Izvestiya Gosudarstvennoy akademii material'noy kul'tury*, V, Moscow, 1927

——, "K voprosu o rannemoskovskom zodchestve", *Trudy sektsii arkheologii RANION*, IV, Moscow, 1928, pp. 93–106

——, "Zur Frage des Ursprungs der Sophienkathedrale in Kiev", *Byzantinische Zeitschrift*, XXIX, 1929/30

——. "K voprosu o vostochnykh elementakh vizantiyskogo iskusstva", in *Trudy sektsii istorii iskusstv RANION*, IV, Moscow, 1930, pp. 21–29

——, "Kiyevskaya Sofiya drevneyshiy pamyatnik kamennoy arkhitektury", *Vizantiyskiy Vremennik*, 3, Moscow and Leningrad, 1950, pp. 164–78

——, "K voprosu o nekotorykh svyazyakh russkoy arkhitektury s zodchestvom yuzhnykh slavyan", *Arkhitekturnoye nasledstvo*, 2, Moscow, 1952, pp. 3–42

——, *Khram Vasiliya Blazhennogo v Moskve: Pokrovskiy Sobor*, Moscow, 1988

——, Vlasyuk, A. I., and Chinyakov, A. N., *Istoriya russkoy arkhitektury*, Moscow, 1956

Budylina, M.V., "Planirovka i zastroyka Moskvy posle pozhara 1812 goda", *Arkhitekturnoye nasledstvo*, 1, Moscow and Leningrad, 1951, pp. 135–74

——, "Arkhitekturnoye obrazovaniye v Kamennom prikaze (1775–82)", *Arkhitekturnoye nasledstvo*, 15, Moscow, 1963, pp. 111–20

Bulanin, D. M., "Maksim Grek i Vizantiyskaya literaturnaya traditsiya", doctoral diss., Leningrad, 1978

——, "Antichnyye traditsii v drevnerusskoy literature XI–XVI vv"., *Slavistische Beitrage* 278, Munich, 1991

Bulkin, V. A., Rapoport, P. A., and Shtender, G. M., "Ital'yanizmy v drevnerusskom zodchestve kontsa XV–XVI vekov", *Vestnik Leningradskogo gosudarstvennogo universiteta*, 20, Moscow, 1973, pp. 59–66

——, "O tserkvi Vozneseniya v Kolomenskom", in Kirpichnikov, A. N. (ed.), *Kul'tura srednevekovoy Rusi*, Leningrad, 1976, pp. 113–16

——, "Raskopki pamyatnikov arkhitektury v Polotske. 1976–1979 gg.", *Arkheologicheskiye otkrytiya 1976–1979 gg.*, Moscow, 1977–1980

Bunin, A. V. and Savarenskaya, T. F., *Istoriya gradostroitel'nogo iskusstva*, 2 vols, Moscow, 1979

Buryshkin, P. A., *Moskva kupecheskaya*, New York, 1954

Buseva-Davydova, I. L., "Ob istokakh kompozitsionnogo tipa 'vosmerik na chetverike' v russkoy arkhitekture kontsa XVII v.", *Arkhitekturnoye nasledstvo*, 33, Moscow, 1985, pp. 220–26

——, "Nekotoryye osobennosti prostranstvennoy organizatsii drevnerusskikh monastyrey", *Arkhitekturnoye nasledstvo*, 34, Moscow, 1986, pp. 201–07

——, "O roli zakazchika v organizatsii stroitel'nogo protsessa na Rusi v XVII veke", *Arkhitekturnoye nasledstvo*, 36, Moscow, 1988, pp. 43–53

——, "Ob izmenenii oblika i nazvaniya sobora Pokrova na Rvu", in id., *Arkhitekturnoye naslediye Moskvy*, Moscow, 1988, pp. 40–51

——, "Simvolika arkhitektury po drevnerusskim pismennym istochnikam XI–XVII vv.", in *Germenevtika drevnerusskoy literatury. Sbornik 2*, Moscow, 1989, pp. 279–308

——, "O kontseptsiyakh stilya russkogo iskusstva v otechestvennom iskusstvoznanii", in Komech, A. I. (ed.), *Problemy russkoy srednevekovoy khudozhestvennoy kul'tury*, Moscow, 1990, pp. 107–17

——, "O tak nazyvayemom obmirshenii russkogo iskusstva XVII v.", in *Lazarevskiye chteniya*, Moscow, 1990

——, "Zapadnyye vliyaniya v russkoy arkhitekture XVII v.", in Voronov, A.A. et al. (eds), *Problemy istorii arkhitektury*, part 2, Moscow, 1990, pp. 161–72

——, "K interpretatsii ideynogo zamysla Kolomenskogo dvortsa", in Smolina, N. A. (ed.), *Arkhitektura mira*, II, Moscow, 1993, pp. 28–31

——, "O narodnosti russkogo iskusstva XVII veka", *Filevskiye chteniya*, I, Moscow, 1993, pp. 190–206

——, "Arkhitekturnyye osobennosti khramov Rostovskoy mitropolii", in Komech, A. I. (ed.), *Iskusstvo Drevney Rusi: Problemy ikonografii*, Moscow, 1994, pp. 159–68

——, "Kategoriya prostranstva v russkom iskusstve XVII veka", in Yevsina, N. A. (ed.), *Barokko v Rossii*, Moscow, 1994, pp. 16–26

——, "Ob ideynom zamysle Novogo Iyerusalima patriarkha Nikona", in Lidov, A. M. (ed.), *Iyerusalim v russkoy kul'ture*, Moscow, 1994, pp. 174–81

——, "Dekor russkoy arkhitektury i problemy stylya", *Arkhitekturnoye nasledstvo*, 38, Moscow, 1995, pp. 39–49

——, "Evolyutsiya vnutrennego prostranstva russkikh khramov XVII v. (na primere tserkvi Troitsy v Nikitnikakh i Pokrova v Filyakh)", *Arkhitekturnoye nasledstvo*, 38, Moscow, 1995, pp. 265–81

——, "Zapadno-yevropeyskiye illustrirovannyye izdaniya v russkoy ku'lture XVII v.", in Likhachev, D. S. (ed.), *Kniga v prostranstve kul'tury*, Moscow, 1995, pp. 13–16

——, *Svyatyni i drevnosti Moskovskogo Kremlya*, Moscow, 1997

——, "Svoye i chuzhoye v russkoy kul'ture XVII veka", *Iskusstvoznaniye*, 2, 1998, pp. 279–80

——, "Tsar-zodchiy: legendy i deystvitel'nost'", in Bondarenko, I. A. (ed.), *Arkhitektura v istorii russkoy kul'tury. Vlast' i tvorchestvo*, IV, Moscow, 1999, pp. 79–168

——, "Ukrainskaya pravoslavnaya kul'tura kak universal'nyy medium", in *Istoriya religii v Ukraini*, part I, Kiev and L'vov, 1999, pp. 66–77

——, "Predstavleniye o simvolike khrama v kul'ture Drevney Rusi", *Arkhitekturnoye nasledstvo*, 44, Moscow, 2001, pp. 3–16

——, "Staroye i novoye kak kategorii russkogo iskusstva", *Iskusstvoznaniye*, 2, 2001, pp. 204–19

——, "Antichnost' v russkoy khudozhestvennoy kul'ture XVII v.", in, *Mir Kondakova*, Moscow, 2004, pp. 306–32

—— and Batalov, A. L., "O metodologii izucheniya simvoliki arkhitektury", in Voronov, A. A. (ed.), *Istoriya arkhitektury. Ob''yekt, predmet i metod issledovaniya*, Moscow, 1988, pp. 92–99

Busiri Vinci, A., "Lerudito della corte russa del Settecento, Ivan Ivanovitch Schuvalov ed i suoi rapporti con Roma", *L'Urbe*, 39, May–August 1976, pp. 39–46

Bussi, V., "Nota su Aloisio Caresano, architetto vercellese della seconda meta del XV secolo, morto forse in Russia nella prima meta del XVI secolo", *Arte Lombarda*, 44–45, 1976, pp. 237–48

Butikov, G.P., *Isaakiyevskiy sobor*, Leningrad, 1974

——, *Russian Iron Industry in the Eighteenth Century*, Newtonville, MA, 1986

—— and Khvostova, G. A., *Isaakiyevskiy sobor*, Leningrad, 1979

Buxton, R., *Russian Medieval Architecture, with an Account of the Transcaucasian Styles and their Influence in the West*, Cambridge, 1934

——, *The Wooden Churches of Eastern Europe: An Introductory Survey*, Cambridge, 1981

Bykov, V. Ye., *Gol'ts*, Moscow, 1978

Bylinkin, N. P., *Progressivnyye cherty v arkhitekture massovogo zhilogo stroitel'stva po tipovym proyektam*, Moscow, 1957

——, Kalmykova, V. N, Ryabushin, A. V., and Sergeyeva, G. V., *Istoriya sovetskoy arkhitektury (1917–1954)*, Moscow, 1985

——, and Stoyanov, N. N., *Vysotnyye zdaniya*, Moscow, 1958

——, and Ryabushin, A. V. (eds), *Sovremennaya sovetskaya arkhitektura, 1955–1980*, Moscow, 1985

Caffi, M., "Artisti lombardi del secolo XV: I Solari", in *Archivio storico Lombardo*, Milan, 1878, pp. 669–93

Calvi, G., "Guiniforte Solari", in *Notizie sulla vita e sulle opere dei principali architetti, scultori e pittori che fiorirono in Milano*, Milan, 1865, pp. 72–85

Cameron, C., *The Baths of the Romans*, London, 1772

Campbell, C., *Vitruvius Britannicus*, I, London, 1715

Carpeggiani, P., "Fioravanti al servizio di Ludovico Gonzaga", *Arte Lombarda*, 44–45, 1979, pp. 84–85

Castell, R., *The Villas of the Ancients Illustrated*, London, 1728

Cazzola, P., "Artisti italiani a Mosca", *Le vie del mondo*, 9, 1967, pp. 42–56

——, "I 'Mastri Frjazy' a Mosca sullo scorcio del quindicesimo secolo (dalle Cronache russe e da documenti di Archivi italiani)", *Arte Lombarda*, 44–45, 1976, pp. 157–72

——, "Mastri Frjazi di origine piemontese al Cremlino di Mosca", *Bolletino della Società piemontese di Belle Arti, Nuova serie*, XXX–XXXI, Turin, 1976–77, pp. 93–101

Ceschi, C., "Il periodo romano di Giacomo Quarenghi", *Saggi e Memorie di Storia dell'Arte*, 6, 1968, pp. 133–47

Chan-Magomedov, S. O., *Ginzburg*, Moscow, 1972

——, *Aleksandr Vesnin*, Moscow, 1983

——, *Nikolay Ladovsky*, Moscow, 1984

——, *A. Vesnine et le constructivisme*, Paris, 1986

——, *Aleksandr Vesnin and Russian Constructivism*, New York, 1986

——, *Pioneers of Soviet Architecture*, New York, 1987

——, *Il'ya Golosov*, Moscow, 1988

——, *Vkhutemas*, Paris, 1990

——, *Konstantin Mel'nikov*, Moscow, 1991

——, *Psikhoanaliticheskiy metod N. Ladovskogo vo VKhUTEMASe-VKhUTEINe*, Moscow, 1993

——, *Zhivskul'ptarch*, Moscow, 1993

——, *INKHUK i ranniy konstruktivizm*, Moscow, 1994

——, *Propedevtika "Prostranstvo"*, Moscow, 1994

——, *U istokov formirovaniya ASNOVA i OSA*, Moscow, 1994

——, *Pionery sovetskogo dizayna*, Moscow, 1996

——, *VKhUTEMAS*, I, II, Moscow, 1996

——, *Arkhitektura sovetskogo avangarda*, I, Moscow, 1996; II, Moscow, 2001

Chekalevsky, P. P., *Rassuzhdeniye o svobodnykh khudozhestvakh s opisaniyem nekotorykh proizvedeniy rossiyskikh khudozhnikov*, St Petersburg, 1792

Chernyavsky, M., *Tsar and People: Studies in Russian Myths*, New Haven, CT, 1961

——, "The Old Believers and the New Religion", *Slavic Review*, XXV/1, March 1966, pp. 1–39

—— (ed.), *The Structure of Russian History*, New York, 1970

Chernikhov, Ya., *Osnovy sovremennoy arkhitektury*, Leningrad, 1930

——, *Konstruktsiya arkhitekturnykh i mashinnykh form*, Leningrad, 1931

——, *Arkhitekturnyye fantazii*, Leningrad, 1933

Chernozubova, L. Ye., "Obraztsovyye proyekty planirovki zhilykh kvartalov i ploshchadey nachala XIX v.", *Arkhitekturnoye nasledstvo*, 15, Moscow, 1963, pp. 188–92

Chierici, S., *La Lombardia (Italia Romanica)*, I, Milan, 1991

Chinyakov, A. G., "Le Korbusier i Vesniny", *Sovetskaya arkhitektura*, 18, 1969

——, *Brat'ya Vesniny*, Moscow, 1970

Chvidkovsky, D. O., "L'Architecture de Moscou", *Critique*, 1, Paris, 2000

Clowes, E., Kassow, S., and West, J. (eds), *Between Tsar and People: Educated Society and the Quest for Public Identity in Late Imperial Russia*, Princeton, NJ, 1991

Cohen, J.-L., *Le Corbusier and the Mystique of the USSR*, Princeton, NJ, 1991

——, *Scenes of the World to Come. European Architecture and the American Challenge*, Paris and New York, 1995

Cole, A., *La Renaissance dans les cours italiennes*, Paris, 1988

Conant, K., *Carolingian and Romanesque Architecture*, Baltimore, MD, 1959

Cooke, C., "Form Is a Function: The Development of the Constructivist Architects' Design Method", in id. (ed.), *Russian Avant-Garde Art and Architecture*, London, 1983, pp. 34–49

——, "Shekhtel in Kelvingrove and Mackintosh on the Petrovka", *Scottish Slavonic Review*, 10, 1988, pp. 177–205

——, "A Picnic by the Roadside, or Work in Hand for the Future?", *Architectural Association Files*, 18, 1989, pp. 15–24

——, *Russian Avant-garde: Theories of Art, Architecture and the City*, London, 1995

—— (ed.), *Russian Avant-Garde Art and Architecture*, London, 1983

Cracraft, J., "Feofan Prokopovich", in Garrard, J. (ed.), *The Eighteenth Century in Russia*, Oxford, 1973, pp. 75–105

——, *The Petrine Revolution in Russian Architecture*, Chicago, IL, 1988

—— (ed.), *The Soviet Union Today: An Interpretive Guide*, Chicago, IL, 1988

Cross, A. G., *Russia Under Western Eyes*, London, 1971

——, *By the Banks of the Thames: Russians in Eighteenth-Century Britain*, Newtonville, MA, 1980

——, "Cameron's Scottish Workmen", *Scottish Slavonic Review*, Glasgow, spring 1988

——, "Catherine the Great and Whately's Observations on Modern Gardening", *Study Group on Eighteenth-Century Russia Newsletter*, 18, 1990, pp. 21–29

——, "British Gardeners, Russian Gardens", *Garden History*, 19/1, 1991

——, *By the Banks of the Neva: Chapters from the Lives and Careers of the British in Eighteenth-Century Russia*, Cambridge and New York, 1997

Cross, S., *The Russian Primary Chronicle*, Cambridge, 1930

Crummey, R., *The Formation of Muscovy 1304–1613*, London and New York, 1987

Cunliffe, A., "The Competition for the Palace of Soviets in Moscow, 1931–33", *Architectural Association Quarterly*, 2, 1979, pp. 36–48

Danilova, I. Ye., "Arkhitektura Uspenskogo sobora Aristoteliya F'yoravanti i printsipi postroyeniya i kompozitsii v proizvedeniyakh Dionisya", in id., *Iskusstvo Srednikh vekov i Vozrozhdeniya*, Moscow, 1984

Darkevich, V. P., "Romanskaya tserkovnaya utvar' iz Severo-vostochnoy Rusi", in Mongayt, A. N. (ed.), *Kul'tura drevney Rusi*, Moscow, 1966, pp. 61–70

Dedushenko, B. P., "K istorii ansamblya moskovskogo Vysoko-Petrovskogo monastyrya", in Lazarev, V. N. (ed.), *Drevnerusskoye iskusstvo XVII v.*, Moscow, 1964, pp. 253–71

Denisov, L. I., *Pravoslavnyye monastyri Rossiyskoy imperii*, Moscow, 1908

Denisov, Yu. M., "Usad'ba XVIII veka na Petergofskoy doroge", *Arkhitekturnoye nasledstvo*, 4, Moscow and Leningrad, 1953, pp. 148–54

——, "Ischeznuvshiye dvortsy", in Pilyavsky, V,. and Levinson-Lessing, V. F. (eds), *Ermitazh: Istoriya i arkhitektura zdaniya*, Leningrad, 1974, pp. 19–38

—— and Petrov, A. N., *Zodchiy Rastrelli: Materialy k izucheniyu tvorchestva*, Leningrad, 1963

Diderot, D., *Sobraniye sochineny*, X, Moscow, 1947

Dmitriyev, L. N., and Likhachev, D. S. (eds), *Pamyatniki literatury drevney Rusi. Konets XV–pervaya polovina XVI veka*, Moscow, 1984

Dmitriyeva, R. P., *Skazaniye o knyazyakh vladimirskikh*, Moscow, 1955

Dobrovol'skaya, E. D., *Yaroslavl'*, Moscow, 1968

Dokuchayev, N. V., "Sovremennaya russkaya arkhitektura i zapadnyye paralleli", *Sovetskoye iskusstvo*, 1927, 1, pp. 5–12; 2, pp. 5–15

Dolbin, V., *Dvorets Sovetov. Vsesouznyy konkurs*, Moscow, 1933

Dolgner, D., "Arkhitektor Ludvig Bonshtedt i yego vklad v nemetsko-russkiye svyazi XIX stoletiya", in Libman, M.Ya. (ed.), *Vzaimosvyazi russkogo iskusstva i nemetskoy khudozhestvennoy kul'tury*, Moscow, 1980

Dubyago, T. B., *Letniy sad*, Moscow and Leningrad, 1951

——, "Usad'by petrovskogo vremeni v okrestnostyakh Peterburga", *Arkhitekturnoye nasledstvo*, 4, Moscow and Leningrad, 1953, pp. 125–41

——, *Russkiye regulyarnyye sady i parki*, Leningrad, 1963

Dukes, P., *Catherine the Great and the Russian Nobility*, Cambridge, 1967

——, *Russia under Catherine the Great*, I: *Select Documents on Government and Society*, Newtonville, MA, 1978

——, *The Making of Russian Absolutism 1613–1801*, Moscow, 1979; London and New York, 1982

Dunayev, B. I., *Prepodobnyy Maksim Grek i grecheskaya ideya na Rusi v XVI veke*, Moscow, 1916

Elliott, D. (ed.), *Rodchenko and the Arts of Revolutionary Russia*, New York, 1979

Ernst, N. L., "Bakhchisarayskiy khanskiy dvorets i arkhitektor velikogo knyazya Ivana III Fryazin Aleviz Novyy", *Izvestiya tavricheskogo obshchestva istorii, arkheologii i etnografii*, II, Simferopol, 1928, pp. 39–55

Eygel', I. M., *Boris Iofan*, Moscow, 1978

Fedorov-Davydov, G., *Gorod Bulgar. Monumental'noye stroitel'stvo, arkhitektura, blagoustroystvo*, Moscow, 2001

Fedotova, T. P., "K probleme pyatiglaviya v arkhitekture barokko pervoy poloviny XVIII v.", in Alekseyeva, T.V. (ed.), *Russkoye iskusstvo barokko: materialy i issledovaniya*, Moscow, 1977, pp. 70–87

Fekhner, M.V., *Kolomna*, Moscow, 1966

——, *Kaluga. Borovsk*, Moscow, 1976

——, *Velikiye Bulgary. Kazan'. Sviyazhsk*, Moscow, 1978

Fennell, J., *The Emergence of Moscow 1304–1359*, Berkeley, CA, 1968

——, *The Crisis of Medieval Russia 1200–1304*, London and New York, 1985

Filarete (Antonio Averlino), trans. and ed. Spenser, J., *Treatise on Architecture*, 2 vols, New Haven, CT, and London, 1956

Filippini, F., "Le opere architettoniche di Aristotile Fioravanti in Bologna e in Russia", *Cronache d'Arte*, Reggio Emilia, II, fasc.3, 1925, pp. 101–20

Fisiolog Aleksandriyskoy redaktsii, trans. Smirnova, Ya., Moscow, 1998

Fletcher, G., ed. Pipes, R., and Fine, J., *Of the Russian Commonwealth*, Cambridge, MA, 1966

Florya, B. N., "Russkiye posol'stva v Italiyu i nachalo stroitel'stva Moskovskogo kremlya", *Gosudarstvennyye muzei Moskovskogo kremlya. Materialy i issledovaniya*, Moscow, 1980, pp. 12–18

Fomin, I. A., *Istoricheskaya vystavka arkhitektury*, St Petersburg, 1911

——, "Rekonstruktsiya klassiki. O stile nashey epokhi", *Sovetskoye iskusstvo*, 43, 1933

Frank, C., ed. Roettgen, S., "Plus il y en aura, mieux ce sera. Caterina II di Russia e Anton Rafael Mengs", in *Mengs. La scoperta del Neoclassico*, Venice, 2001, pp. 86–95

Friedrich, A., Heinrich, F,. and Holm, C., *Johann Heinrich Wilhelm Tischbein (1751–1829)*, St Petersburg, 2001

Galaktionov, A. A., *Ratsionalisticheskiye priemy zastroyki zhilykh kvartalov po tipovym proyektam*, Moscow, 1957

Gamel', I. Kh., *Anglichane v Rossii v XV–XVI vv.*, St Petersburg, 1869

Gan, A., *Konstruktivism*, Tver', 1922

Garrard, J. (ed.), *The Eighteenth Century in Russia,* Oxford, 1973

Gartman, V. A., *Obraztsy russkogo ornamenta*, St Petersburg, 1872

Gatova, T .A., "Iz istorii dekorativnoy skul'ptury Moskvy nachala XVIII v.", in Alekseyeva, T.V. (ed.), *Russkoye iskusstvo XVIII veka*, Moscow, 1973, pp. 31–44

——, "Giovanni Mario Fontana", in Yaralov, Yu.S. (ed.), *Zodchiye Moskvy*, Moscow, 1981, pp. 106–13

Gavrilov, S. A., "Tserkov' Vozneseniya v Kolomenskom. Issledovaniya 1972–1990 gg.", in Batalov, A. L., and Bondarenko, I. A. (eds), *Restavratsiya i arkhitekturnaya arkheologiya. Novyye materialy i issledovaniya*, Moscow, 1991, pp. 58–78

Gerchuk, U. Ya., *Vasily Ivanovich Bazhenov. Pis'ma. Poyasneniya k proyektam. Svidetel'stva sovremennikov. Biograficheskiye dokumenty*, Moscow, 2001

Ginzburg, M.Ya., *Stil' i epokha*, Moscow, 1924

——, *Zhilishche*, Moscow, 1934

Givov, V. M., and Uspensky, B. A., "Metamorfozy antichnogo yazychestva v istorii russkoy kul'tury XVII–XVIII vv.", in *Antichnost' v kul'ture i iskusstve posleduyushchikh vekov*, Moscow, 1984, pp. 204–85

Glezer, E. N., *Arkhitekturnyy ansambl' angliyskogo parka*, Leningrad, 1979

Glinka, V. M., Denisov, Yu. M., and Iogansen, M. V., *Ermitazh. Istoriya stroitel'stva i arkhitektury zdanii*, Leningrad, 1989

Glozman, I. M. (ed.), *Kuskovo. Ostankino. Arkhangel'skoye,* Moscow, 1976

Glumov, A. N., *L'vov*, Moscow, 1980

Gnedovsky, B. V., and Dobrovol'skaya, E.D., *Yaroslavl'. Tutayev. Moscow,* 1981

Godlevsky, N. N., "Planirovka kremlya Kolomny v XVI–XVII vv.", *Arkhitekturnoye nasledstvo*, 16, Moscow, 1967, pp. 19–28

——, "Planirovka i zastroyka Tul'skogo kremlya v XVI–XVII vv.", *Arkhitekturnoye nasledstvo*, 18, Moscow, 1969, pp. 25–29

Gogolitsyn, Yu. M. and Gogolitsyna, T. M., *Pamyatniki arkhitektury Leningradskoy oblasti*, Leningrad, 1987

Goldenberg, A. A., "Ideya Moskva Tretiy Rim v tsikle sochineniy XVI veka", *Trudy Otdela drevnerusskoy literatury*, XXXVII, Leningrad, 1983, pp. 139–49

Golikov, I. I., *Dopolneniya k Deyaniyam Petra Velikogo*, Moscow, 1790

——, *Sravneniye svoystv i del Konstantina Velikogo, pervogo iz rimskikh khristianskikh imperatorov, so svoystvami i delami Petra Velikogo*, Moscow, 1810

——, (ed.), *Pis'ma i bumagi Petra Velikogo. 1688–1701*, St Petersburg, 1787

Golitsyn, P. P., *Rod knyazey Golitsynikh*, I, St Petersburg, 1892

Golubinsky, Ye. Ye., *Prepodobnyy Sergiy Radonezhsky i sozdannaya im Troitskaya lavra*, Moscow, 1909

——, *Istoriya russkoy tserkvi*, I–III, Moscow, 1997–99

Gornostayev, F., "Ranneye zodchestvo Moskovskoy oblasti", in *IRI*, II, 1903

——, "Moskovskoye barokko", in *IRI*, III, 1911, pp. 417–68

——, *Dvortsy i tserkvi Uiga*, Moscow, 1914

Gorsey, J., *Zapiski o Rossii XVI–nachala XVII vv.*, Moscow, 1990

Gozak, A., and Leonidov, A., *Ivan Leonidov: The Complete Works*, New York, 1988

Gra, M. A., and Zhiromsky, B. B., *Kolomenskoye*, Moscow, 1971

Grabar', I. E., *Neizvestnyye i predpolagayemyye postroyki V. I. Bazhenova*, Moscow, 1951

——, "Russkaya arkhitektura pervoy poloviny XVIII v.", *Issledovaniya i materialy*, Moscow, 1954

——, "Moskovskaya arkhitektura nachala XVIII veka", in *IRI*, V, Moscow, 1960, pp. 40–62

——, "Ranniy aleksandrovskiy klassitsizm i yego frantsuzskiye istoki", in id., *O russkoy arkhitekture*, Moscow, 1969, pp. 284–310

—— (ed.), *Istoriya russkogo iskusstva*, 6 vols, Moscow, 1910–15

—— (ed.), *Istoriya russkogo iskusstva*, 13 vols, Moscow, 1953–64

Grashchenkov, V. N., "Dzhyakomo Kvarengi i venetsianskiy neoklassitsizm", *Sovetskoye iskusstvoznaniye*, 20, 1981, pp. 301–66

——, "Naslediye Palladio v arkhitekture russkogo klassitsizma", *Sovetskoye iskusstvoznaniye*, 2, 1981, pp. 201–34

Gray, C., *The Russian Experiment in Art, 1863–1922*, New York, 1986

Great Utopia: The Russian and Soviet Avant-garde, 1915–1932, New York, 1992

Grebenyuk, V. P., and Derzhavina, O.A., *Panegiricheskaya literatura Petrovskogo vremeni*, Moscow, 1979

Grech, A. N., "Dubrovitsy", *Podmoskovnyye muzei*, 4, Moscow and Leningrad, 1925, pp. 70–87

Grimm, G. G., *Arkhitektura perekrytii russkogo klassitsizma*, Leningrad, 1939

——, *Arkhitektor Andrean Zakharov*, Moscow, 1940

——, *Ansambli Rossi*, Leningrad and Moscow, 1946

——, "Kvarengi i Depre", *Soobshcheniya Gosudarstvennogo Ermitazha*, 14, 1958, pp. 23–34

——, "Proyekty arkhitektora N. Miketti dlya Peterburga i yego okrestnostey v sobranii Gosudarstvennogo Ermitazha", *Soobshcheniya Gosudarstvennogo Ermitazha*, Leningrad, 13, 1958, pp. 21–24

——, *Dzh. Kvarengi*, Leningrad, 1962

——, *Arkhitektor Voronikhin*, Leningrad, 1963

Grohmann, J., *Ideenmagazin für Gartenkunst*, Leipzig, 1789–92

Gualandi, M., *Aristotele Fioravanti, meccànico e ingegnere del secolo XV*, Bologna, 1870

Gudzy, N. A., "Maksim Grek i yego otnosheniye k epokhe italyanskogo Vozrozhdeniya", *Izvestiya kiyevskogo universiteta*, 7, 1911, pp. 1–19

Guillaume, J. (ed.), *L'Invention de la Renaissance. La réception des formes à l'antique au début de la Renaissance*, Paris, 2004

Gulyanitsky, N. F., "O maloissledovannoy storone tvorcheskogo metoda V. Rastrelli – gradostroitelya", *Arkhitekturnoye nasledstvo*, 21, Moscow, 1973, pp. 24–43

——, "O svoyeobrazii i preyemstvennykh svyazyakh ordernogo yazyka v russkoy arkhitekture", *Arkhitekturnoye nasledstvo*, 23, Moscow, 1975, pp. 14–29

——, "O kompozitsii zdanii v ansamblevoy zastroyki Moskvy perioda klassitsizma", *Arkhitekturnoye nasledstvo*, 24, Moscow, 1976, pp. 20–27

——, "Traditsii klassiki i cherty renessansa v arkhitekture Moskvy XV–XVII vv.", *Arkhitekturnoye nasledstvo*, 26, Moscow, 1978, pp. 13–30

——, "Gradostroitel'noye osobennosti Peterburga i cherty russkoy arkhitektury serediny XVIII v.", *Arkhitekturnoye nasledstvo*, 27, Moscow, 1979, pp. 12–21

——, "Tserkov' Pokrova v Medvedkove i russkoye zodchestvo XVI–XVII vv.", *Arkhitekturnoye nasledstvo*, 28, Moscow, 1980, pp. 52–64

——, "Cherty preyemstvennosti v kompozitsii tsentrov russkikh gorodov, pereplanirovannykh v XVIII v.", *Arkhitekturnoye nasledstvo*, 29, Moscow, 1981, pp. 3–17

——, "O vnutrennem prostranstve v kompozitsii ranne-moskovskikh khramov", *Arkhitekturnoye nasledstvo*, 33, Moscow, 1985, pp. 211–19

Guzanov, A. N., "Khudozhestvennyye kollektsii Pavlovskogo dvortsa i puteshestviye grafa i grafini Severnykh", in *Chastnoye kollektsionirovaniye v Rossii*, Moscow, 1995

Halle, F., *Die Bauplastik von Wladimir-Suzdal. Russische Romanik*, Berlin, 1929

Hamilton, G., *The Art and Architecture of Russia*, 2nd ed., Baltimore, MD, 1975

Haney, J., *From Italy to Muscovy: The Life and Works of Maxim the Greek*, Munich, 1973

Harris, J. Le Geay, *Piranesi and International Neo-classicism in Rome: Essays in the History of Architecture Presented to Rudolf Wittkower*, London, 1967, pp. 189–96

Harvey, J., *English Medieval Architects*, London, 1987

Hautecoeur, L., *L'Architecture classique à Saint-Pétersbourg*, Paris, 1912

Hayden, P., *Russian Parks and Gardens*, London, 2005

Hempel, E., *Gaetano Chiaveri, der Architect der Katholischen Hofkirche zu Dresden*, Dresden, 1955

——, *Gaetano Chiaveri. Supplementi alle opere dell'architetto romano. Palladio*, VII, Venice, 1957, pp. 172–78

Herberstein, S., *Notes upon Russia*, New York, 1963

——, *Zapiski o Moskovii*, Moscow, 1988

Herrmann, W., *Laugier and XVIII Century French Theory*, London, 1985

Higer, R., "Obshchestvo sovremennykh arkhitektorov (OSA)", *Sovetskaya arkhitektura*, 8, 1969

Hirschfeld, C. C. L., *Theorie der Gartenkunst*, 3 vols, Leipzig, 1779–80

Honour, H., *Neo-classicism*, Harmondsworth, 1968

Howard, J., *Christopher Galloway: Clockmaker, Architect and Engineer to Tsar Mikhail, the First Romanov*, Edinburgh, 1997

Hughes, L., "Belorussian craftsmen in late seventeenth-century Russia and their influence on Muscovite architecture", *Journal of Byelorussian Studies*, 3, 1976, pp. 332–33

——, "Western European Graphic Material as a Source for Moscow Baroque Architecture", *Slavonic and East European Review*, 55, London, 1977, pp. 433–43

——, "Moscow Baroque – A Controversial Style", *Transactions of the Association of Russian-American Scholars in the U.S.A.*, 15, 1982, pp. 69–93

——, *Sophia, Regent of Russia, 1657–1704*, New Haven, CT, and London, 1990

——, *Russia in the Age of Peter the Great*, New Haven, CT, and London, 1998

Ikonnikov, A. V., *Kitayskiy teatr i kitayshina v Detskom sele*, Moscow and Leningrad, 1931

——, *Yesteticheskiye problemy massovogo zhilogo stroitel'stva*, Leningrad, 1968

——, *Kamennaya letopis' Moskvy*, Moscow, 1978

——, *Arkhitektura Moskvy. XX vek*, Moscow, 1984

——, *Tysyacha let russkoy arkhitektury*, Moscow, 1990

——, and Stepanov, G. V., *Osnovy arkhitekturnoy kompozitsii*, Moscow, 1971

Il'yin, M. A., *Ivan Aleksandrovich Fomin*, Moscow, 1946

——, "Svyazi russkogo, ukrainskogo i belorusskogo iskusstva vo vtoroy polovine XVII v.", *Vestnik MGU. Seriya obshchestvennykh nauk*, 7, Moscow, 1954

——, *Zodchiy Yakov Bukhvostov*, Moscow, 1959

——, *Vesniny*, Moscow, 1960

——, "K voprosu o prirode arkhitekturnogo ubranstva 'moskovskogo barokko'", in Lazarev, V. N. (ed.), *Drevnerusskoye iskusstvo. XVII vek*, Moscow, 1964, pp. 232–35

——, "Nekotoryye predpolozheniya ob arkhitekture russkikh ikonostasov na rubezhe XIV–XV vv.", in Mongayt, A. N. (ed.), *Kul'tura drevney Rusi*, Moscow, 1966, pp. 79–88

——, "Pskovskiye zodchiye v Moskve v kontse XV veka", in Lazarev, V .N. (ed.), *Drevnerusskoye iskusstvo. Khudozhestvennaya kul'tura Pskova*, Moscow, 1968, pp. 189–96

——, "O palladianstve v tvorchestve Dzh. Kvarengi i N. L'vova", in Alekseyeva, T.V., *Russkoye iskusstvo XVIII–veka*, Moscow, 1973, pp. 103–08

——, *Podmoskov'ye*, Moscow, 1974

——, "Dekorativnyye reznyye poyasa rannemoskovskogo kamennogo zodchestva", in Popov, G. V. (ed.), *Drevnerusskoye iskusstvo. Zarubezhnyye svyazi*, Moscow, 1975, pp. 223–39

——, *Moskva. Pamyatniki arkhitektury XVIII-pervoy treti XIX veka*, Moscow, 1975

——, "K izucheniyu tserkvi Vozneseniya v Kolomenskom", in Podobedova, O. I. (ed.), *Drevnerusskoye iskusstvo. Problemy i interpretatsii*, Moscow, 1977, pp. 355–67

——, *Russkoye shatrovoye zodchestvo. Pamyatniki serediny XVI veka*, Moscow, 1980

Ioffe, I. I., "Russkiy Renessans", *Ucheniye zapiski Leningradskogo universiteta. Seriya filologicheskikh nauk*, 9, Leningrad, 1944

Iogansen, M. V., "Raboty D. Trezini po planirovke i zastroyke Strelki Vasil'yevskogo ostrova", in Alekseyeva, T. V. (ed.), *Russkoye iskusstvo XVIII v. Materialy i issledovaniya*, Moscow, 1973, pp. 45–55

——, *Mikhail Zemtsov*, Leningrad, 1975

——, "Zdaniye 'mazankovykh kollegiy' na Troitskoy ploshchadi Peterburga", in Alekseyeva, T. V. (ed.), *Ot Srednevekov'ya k Novomu vremeni*, Moscow, 1984, pp. 73–86

Ionisyan, O. M., "Osnovnyye etapy razvitiya galitskogo zodchestva", in Komech, A. I. (ed.), *Drevnerusskoye iskusstvo: khudozhestvennaya kul'tura X–pervoy poloviny XIII veka*, Moscow, 1998, pp. 41–58

——, "Romanskaya arkhitektura Lombardii i zodchestvo Vladimiro-Suzdal'skoy Rusi (k voprosu o proiskhozhdenii masterov Andreya Bogolubskogo)", *Materialy nauchnoy konferentsii pamyati M.A. Gukovskogo*, St Petersburg, 1998, pp. 25–29

Ioviy, P., *Kniga o moskovitskom posol'stve*, St Petersburg, 1908

Isachenko, V. G., "Tvorcheskoye naslediye P. U. Suzora", *Leningradskaya panorama*, 10, 1985

——, *Biograficheskiy slovar' arkhitektorov i stroiteley Sankt-Peterburga*, St Petersburg, 1997

——, Kirikov, B. M., and Fedorov, S. I. (eds), *Arkhitektory-stroiteli Peterburga-Petrograda nachala XX veka*, Leningrad, 1982

——, and Ol', G. A., *Fyodor Lidval'*, Leningrad, 1987

Ivanov, V. N., *Kostroma*, Moscow, 1978

Junghanns, K., "Die Beziehungen zwischen deutschen und sowjetischen Architekten in den Jahren 1917–1933", *Wissenschaftliche Zeitschrift der Humboldt-Universität zu Berlin. Gesellschafts- und Sprachwissenschaftliche Reihe*, Berlin, 1967, pp. 369–81

Kalyazina, N. V., "Lepnoy dekor v zhilom inter'yere Peterburga pervoy chetverti XVIII veka", in Alekseyeva, T. V. (ed.), *Russkoye iskusstvo pervoy chetverti XVIII veka*, Moscow, 1974, pp. 109–18

——, "Monumental'no-dekorativnaya zhivopis' v dvortsovom inter'yere pervoy chetverti XVIII veka (k probleme razvitiya stilya barokko v Rossii)", in Alekseyeva, T. V. (ed.), *Russkoye iskusstvo barokko. Materiali i issledovaniya*, Moscow, 1977, pp. 55–69

——, "Arkhitektor Leblon v Rossii (1716–1719)", in Alekseyeva, T. V. (ed.), *Ot Srednevekov'ya k novomu vremeni*, Moscow, 1984, pp. 94–123

——, Dorofeyeva, L. P,. and Mikhaylov, G. V., *Dvorets Menshikova*, Moscow, 1986

Kampfer, F., "La concezione teològica ed architettònica della cattedrale 'Vasilii Blazennyi' a Mosca", *Arte Lombarda*, 44–45, 1976, pp. 191–98

Kapterev, N. F., *Patriarkh Nikon i Tsar' Aleksey Mikhaylovich*, 2 vols, Moscow, 1909–12

Karger, M. K., "K voprosu ob ubranstve inter'yera v russkom zodchestve", *Trudy Vserossiyskoy akademii khudozhestv*, I, Moscow and Leningrad, 1947, pp. 15–50

——, *Arkheologicheskiye issledovaniya Drevnego Kiyeva*, Kiev, 1950

——, *Arkheologicheskiye issledovaniya Drevnego Kiyeva*, I, II, Moscow and Leningrad, 1961

——, *Drevniy Kiyev*, Moscow and Leningrad, 1962

——, *Novgorod: Architectural Monuments 11th–17th Centuries*, Leningrad, 1975

Karp, S. Ya., "Le questionnaire de Diderot adressé à Catherine II: quelques précisions", *Recherches sur Diderot et sur l'Encyclopédie*, 33, October 2001, pp. 9–61

Kartashov, A. V., *Ocherki po istorii russkoy tserkvi*, I–II, Moscow, 1991

Katzen, I. O., *Metro Moskvy*, Moscow, 1947

Kavelin, L., *Istoricheskoye opisaniye stavropigial'nogo Voskresenskogo, Novogo Iyerusalimskogo monastyrya*, Moscow, 1876

Kharlamova, A. M., *Zolotyye komnaty Demidovyh v Moskve*, Moscow, 1955

——, *Nikolay L'vov*, Moscow, 1961

Khazanova, V. E., *Iz istorii sovetskoy arkhitektury 1926–1932 gg.*, Moscow, 1970

——, *Sovetskaya arkhitektura pervykh let Oktyabrya*, Moscow, 1970

——, *Sovetskaya arkhitektura pervoy pyatiletki*, Moscow, 1980

——, *Klubnaya zhizn' i arkhitektura kluba*, Moscow, 1994

Kholostenko, N. V., "Neizvestnyye pamyatniki monumental'noy skul'ptury drevney Rusi (rel'yefy Borisoglebskogo sobora v Chernigove)", *Iskusstvo*, 3, 1951, pp. 84–91

——, "Issledovaniya Borisoglebskogo sobora v Chernigove", *Sovetskaya arkheologiya*, 2, 1967, pp. 188–210

——, "Uspenskiy sobor Pecherskogo monastyrya", in *Starodavnyy Kiyev*, pp. 107–70, Kiev, 1975

——, "Novy doslizheniya Ioanno-Predtechenskoy tserkvy ta rekonstruktsiya Uspenskogo soboru Kiyevo-Pecherskoy lavry", *Arkheologichny doslizheniya starodavnego Kiyevu*, Kiev, 1976

Khrapovitsky, A. V., *Dnevnik*, St Petersburg, 1874

Khrenov, N. A. (ed.), *Perekhodnye prozessy v russkoy khudozhestvennoy kul'ture. Novoye i noveyshiye vremya*, Moscow, 2003

Kilesso, S. K., *Kievo-Pecherskaya lavra*, Moscow, 1975

Kiparisova, A. A., "Barochnyye otrazheniya v planirovkakh Kazakova", *Yezhegodnik Muzeya arkhitektury*, I, Moscow, 1937, pp. 69–79

——, *Lefortovskiy dvorets v Moskve. Soobshcheniya instituta istorii i teorii arkhitektury*, 9, Moscow, 1948, pp. 45–54

——, "Stanovleniye nekotorykh tipov sooruzheniy moskovskogo klassitsizma v tvorchestve D.V. Ukhtomskogo", *Arkhitekturnoye nasledstvo*, 29, Moscow, 1981, pp. 33–40

——, and Koroleva, R., *Arkhitektor Dmitry Vasil'yevich Ukhtomsky. 1719–1774. Katalog*, Moscow, 1973

Kirichenko, Ye. I., "Dokhodnyye zhilyye doma Moskvy i Peterburga (1770–1830-e gg.)", *Arkhitekturnoye nasledstvo*, 14, Moscow, 1962, pp. 135–58

——, "O nekotorykh osobennostyakh evolyutsii gorodskikh mnogokvartirnykh domov vtoroy poloviny XIX–nachala XX vekov (Ot otdel'nogo doma k kompleksy)", *Arkhitekturnoye nasledstvo*, 15, Moscow, 1963, pp. 153–70

——, "Arkhitektor I. Ropet", *Arkhitekturnoye nasledstvo*, 20, Moscow, 1972, pp. 85–93

——, "Prostranstvennaya organizatsiya zhilykh kompleksov Moskvy i Peterburga v nachale XX v.", *Arkhitekturnoye nasledstvo*, 19, Moscow, 1972, pp. 118–36

——, *Fyodor Shekhtel'*, Moscow, 1973

——, "Arkhitektor V. O. Shervud i yego teoreticheskiye vozzreniya", *Arkhitekturnoye nasledstvo*, 22, Moscow, 1974, pp. 3–7

——, "Problema natsional'nogo stilya v arkhitekture Rossii 70-kh gg. XIX v.", *Arkhitekturnoye nasledstvo*, 25, Moscow, 1976, pp. 131–53

——, *Moskva na rubezhe dvukh stoletiy*, Moscow, 1977

——, *Russkaya arkhitektura, 1830–1910-kh godov*, Moscow, 1978

——, "Istorizm myshleniya i tip muzeynogo zdaniya v russkoy arkhitekture serediny i vtoroy poloviny XIX v.", in Sternin, G. Yu. (ed.), *Vzaimosvyaz' iskusstv v khudozhestvennom razvitii Rossii vtoroy poloviny XIX v.*, Moscow, 1982, pp. 135–42

——, *Zdaniye Istoricheskogo muzeya*, Moscow, 1984

——, *Arkhitekturnyye teorii XIX veka v Rossii*, Moscow, 1986

——, "The Historical Museum: A Moscow Design Competition, 1875–83", in Cooke, C. (ed.), *Uses of Tradition in Russian and Soviet Architecture*, London, 1987, pp. 24–26

——, *Mikhail Bykovsky*, Moscow, 1988

——, "Romantizm i istorizm v russkoy arkhitekture XIX veka (K voprosu o dvukh fazakh razvitiya eklektiki)", *Arkhitekturnoye nasledstvo*, 36, Moscow, 1988, pp. 130–55

——, *Khram Christa Spasitelya*, Moscow, 1997

——, *Fyodor Shekhtel'*, Moscow, 2001

Kirikov, B. M., "Mar'yan Mar'yanovich Peretyatkovich", *Stroitel'stvo i arkhitektura Leningrada*, 1, 1973, pp. 30–31

——, "Obrazets stilya modern (o A. I. fon Gogene)", *Stroitel'stvo i arkhitektura Leningrada*, 6, 1977

——, "Peterburgskiy modern", *Panorama iskusstv*, 10, Moscow, 1987, pp. 99–148

——, "Proobrazy kompozitsii Petropavlovskogo sobora", *Krayevedcheskiye zametki*, 2, St Petersburg, 1994, pp. 13–17

Kirillov, V. V., "Sibirskiy prikaz i yego rol' v organizovannom stroitel'stve gorodov na novykh zemlyakh", *Arkhitekturnoye nasledstvo*, 28, Moscow, 1980, pp. 13–19

Kirpichnikov, A. N., "Kreposti bastionnogo tipa v srednevekovoy Rossii", *Pamyatniki kul'tury. Novyye otkrytiya. Yezhegodnik. 1978*, Leningrad, 1979, pp. 471–99

Kivimae, J., "Peter Frjazin or Peter Hannibal? An Italian Architect in Late Medieval Russia and Livonia", *Settentrione. Rivista di studi italo-finlandeesi*, V, Turku, 1993, pp. 60–69

Kogan, D. Z., *Mamontovskiy kruzhok*, Moscow, 1970

Kokkinaki, I. V., "K voprosu o vzaimosvyazakh sovetskikh i zarubezhnykh arkhitektorov v 1920–1930-e gody", in Shmidt, I. M. (ed.), *Voprosy sovetskogo izobrazitel'nogo iskusstva i arkhitektury*, Moscow, 1976, pp. 350–82

——, "Le Corbusier i sovetskaya Rossiya", *Arkhitektura SSSR*, 6, 1985

——, "Sovetsko-germanskiye architekturnyye svyazi vo vtoroy polovine 1920-kh godov", in Sternin, G. Yu. (ed.), *Vzaimosvyazi russkogo i sovetskogo iskusstva i nemetskoy khudozhestvennoy kul'tury*, Moscow, 1989, pp. 119–28

——, "Mezhdunarodnaya zhizn' Konstantina Mel'nikova", *Arkhitektura SSSR*, 3, 1990

—— and Strigalev, A. A., *Mel'nikov*, Moscow, 1995

Kolli, N. Ya., and Aravets, S. M., *Arkhitektura Moskovskogo metro*, Moscow, 1936

Kolmakov, N. M., "Dom i familiya Stroganovykh", *Russkaya starina*, 53, 1887, pp. 575–602

Komashko, N. I., and Merzlutina, N. A., *Tserkov' Pokrova v Filyakh*, Moscow, 2003

Komech, A. I., "Postroyeniye vertikal'noy kompositsii Sofiyskogo sobora v Kiyeve", *Sovetskaya arkheologiya*, 3, 1968, pp. 232–38

——, "Rol' knyazheskogo zakaza v postroyenii Sofiyskogo sobora v Kiyeve", in Lazarev, V. N. (ed.), *Drevnerusskoye iskusstvo: khudozhestvennaya kul'tura domongol'skoy Rusi*, Moscow, 1971, pp. 50–64

——, "Spaso-Preobrazhenskiy sobor v Chernigove", in Popov, G. V. (ed.), *Drevnerusskoye iskusstvo: zarubezhnyye svyazi*, Moscow, 1975, pp. 9–26

——, "Rol' pridelov v formirovanii obshchey kompozitsii Sofiyskogo sobora v Novgorode", in Wagner, G. K., and Likhachev, D. S. (eds), *Srednevekovaya Rus'*, Moscow, 1976, pp. 147–55

——, "Dva napravleniya v novgorodskoy arkhitekture nachala XII veka", in Lazarev, V. N. (ed.), *Srednevekovoye iskusstvo. Rus'. Gruziya*, Moscow, 1978, pp. 56–62

——, *Drevnerusskoye zodchestvo kontsa X–nachala XII v.: vizantiyskoye naslediye i stanovleniye samostoyatel'nosti*, Moscow, 1987

——, and Pluzhnikov, V. I. (eds), *Pamyatniki arkhitektury Moskvy: Kreml', Kitay-gorod, Tsentral'nyye ploshchadi*, Moscow, 1983

Konapleva, M., *Teatralnyy zhivopisets Dzhyuseppe Valeriani*, Leningrad, 1948

Kopp, A., *Town and Revolution: Soviet Architecture and City Planning*, New York, 1970

——, *Architecture de l'époque stalinienne*, Paris, 1971

——, *Constructivist Architecture in the USSR*, New York, 1985

——, "Foreign Architects in the Soviet Union During the First Two Five-Year Plans", in Brumfield, W. C. (ed.), *Reshaping Russian Architecture: Western Technology, Utopian Dreams*, New York, 1991, pp. 176–214

Kopylova, S. V., *Kamennoye stroitel'stvo v Sibiri. Konets XVII–XVIII v.*, Novosibirsk, 1979

Korolev, E. V., "Skul'pturnoye ubranstvo Khrama Druzhby v Pavlovskom parke", in *Pamyatniki kul'tury. Novyye otkrytiya*, Moscow, 1987, pp. 236–43

Korol'kov, M. Ya., "Arkhitektory Treziny", *Staryye gody*, April 1911, pp. 17–36

Korshunova, M. F., "Arkhitektor W. Hastie (1755–1832)", *Trudy Gosudarstvennogo Ermitazha*, XVIII, Leningrad, 1977

——, *Giacomo Quarenghi*, Leningrad, 1977

——, *Arkhitektor Yury Fel'ten*, exhib. cat., Leningrad, 1982

——, *Yury Fel'ten*, Leningrad, 1988

——, *G. Quarenghi i N. L'vov. Zarubezhnyye khudozhniki i Rossiya*, St Petersburg, 1991, pp. 56–61

—— (ed.), *Giacomo Quarenghi*, St Petersburg, 1994

Korzukhina, V .F., "K rekonstruktsii Desyatinnoy tserkvi", *Sovetskaya arkheologiya*, 2, 1957, pp. 78–90

Kostochkin, V. V., *Gosudarev master Fyodor Kon'*, Moscow, 1964

——, *Krepostnoye zodchestvo drevney Rusi*, Moscow, 1969

——, "K voprosu o traditsiyakh i novatorstve v russkom zodchestve XVI–XVII vv.", *Arkhitekturnoye nasledstvo*, Moscow, 1979, pp. 29–37

Kovalenskaya, N. N., *Russkiy klassitsizm*, Moscow, 1964

Kovelman, G. M., *Tvorchestvo pochetnogo akademika inzhenera Vladimira Grigor'yevicha Shukhova*, Moscow, 1961

Kovrigina, V. A., *Nemetskaya sloboda Moskvy i yeyo zhiteli v kontse XVII–pervoy chetverti XVIII veka*, Moscow, 2000

Kozhin, N. A., "K genezisu russkoy lozhnoy gotiki", *Akademiya arkhitektury*, 1, Moscow, 1934, pp. 114–21

Kraft, G., *Podrobnoye opisaniye ledyanomu domu, postroyennomu v Sankt-Peterburge*, St Petersburg, 1743

Krasheninnikov, A. F., "Novyye dannye po istorii zdaniya Akademii khudozhestv", *Arkhitekturnoye nasledstvo*, 7, Moscow, 1955, pp. 125–39

——, "Lesnyye sklady na ostrove Novoy Gollandii v Peterburge", *Arkhitekturnoye nasledstvo*, 19, Moscow, 1972, pp. 96–101

——, "Nekotoryye osobennosti perelomnogo perioda mezhdu barokko i klassitsizmom v russkoy arkhitekture", in Alekseyeva, T. V. (ed.), *Russkoye iskusstvo XVIII v.: materialy i issledovaniya*, Moscow, 1973, pp. 97–102

——, "Karl Blank", in Yaralov, Yu. S. (ed.), *Zodchiye Moskvy*, Moscow, 1981, pp. 145–52

Krasheninnikova, N. L., *Ansambl' Golitsynskoy bol'nitsy*, Moscow, 1955

——, "Proyekty obraztsovykh zagorodnykh domov D. Trezini i zastroy-ka beregov Fontanki", *Arkhitekturnoye nasledstvo*, 7, Moscow, 1955, pp. 5–12

Krassovsky, M. V., "Tserkov' sela Dubrovitsy", *Izvestiya Imperatorskoy arkheologicheskoy komissii*, 34, St Petersburg, 1910, pp. 55–71

——, *Ocherk istorii moskovskogo perioda drevnerusskogo zodchestva*, Moscow, 1911

——, *Kurs istorii russkoy arkhitektury*, part 1: *Derevyannoye zodchestvo*, Petrograd, 1916

Krautheimer, R., *Early Christian and Byzantine Architecture*. Baltimore, MD, 1975

Kresal'ny, N., *Sofiyskiy zapovidnik u Kiyevi*, Kiev, 1960

Krivokurtsev, Yu. P., "Skhodstvo arkhitektury doma Pashkova s frantsuzskoy arkhitekturoy XVIII veka", *Akademiya arkhitektury*, 2, 1937, pp. 46–48

Kudryavtsev, A. I., and Shkoda, G. N., *Aleksandro-Nevskaya Lavra: Arkhitekturnyy ansambl' i pamyatniki Nekropoley*, Leningrad, 1986

Kunitskaya, Ye. R., "Menshikova bashnya", *Arkhitekturnoye nasledstvo*, 9, Leningrad and Moscow, 1959, pp. 157–68

Kurbatov, V. Ya., "Znacheniye grafa Bartolomeo Rastrelli v istorii russkogo zodchestva", *Zodchiy*, 1907, 45, pp. 461–63; 47, pp. 477–83

Kyuchariants, D. A., *Ivan Starov*, Leningrad, 1982

——, *Antonio Rinal'di*, Leningrad, 1976, 1984

——, *Khudozhestvennyye pamyatniki goroda Lomonosova*, Leningrad, 1985

——, and Raskin, A. G., *Gatchina. Khudozhestvennyye pamyatniki*, Leningrad, 1990

Ladendorf, H., *Der Bildhauer und Baumeister Andreas Schlüter*, Berlin, 1935

Ladovsky, N. A., "Osnovy postroyeniya teorii arkhitektury (pod znakom ratsionalisticheskoy estetiki)", *Izvestiya ASNOVA*, Moscow, 1926

Lansere, N. Ye., "Arkhitektura i sady Gatchiny. Gatchina pri Pavle Petro-viche, tsareviche i imperatore", *Staryye gody*, July–September 1914, pp. 7–12

—— (ed.), *Charles Cameron*, Petrograd, 1924

Lashkarev, P., *Kivoriy kak otlichitel'naya prinadlezhnost' altarya v drevney tserkvi*, Kiev, 1883

Latour, A., *Moscow: Architectural Heritage XIX–XX centuries*, Milan, 1996

——, (ed.), *Alexander Rodchenko, 1891–1956*, New York, 1987

Lavrentiy, archimandrit, *Kratkoye izvestiye o krestnom onezhskom Arkhangel'skoy yeparkhii monastyre*, Moscow, 1805

Lazarev, V. N., *Skul'ptura Vladimiro-Suzdal'skoy Rusi. Istoriya russkogo iskusstva*, in *IRI*, I, Moscow, 1953, pp. 408–23

——, "Le opere di Pietro Antonio Solari in Russia", *Arte e artisti dei Laghi Lombardi*, Como, 1959, pp. 424–41

——, *Mozaiki Sofii Kiyevskoy*, Moscow, 1960

——, *Feofan Grek i yego shkola*, Moscow, 1961

——, *Mikhaylovskiye mozaiki*, Moscow, 1966

——, "O rospisi Sofii Novgorodskoy", in Lazarev, V. N. (ed.), *Drevne-russkoye iskusstvo: khudozhestvennaya kul'tura Novgoroda*, Moscow, 1968, pp. 7–62

——, *Drevnerusskiye mozaiki i freski: XI–XV vv.*, Moscow, 1973

——, *Vizantiyskoye i drevnerusskoye iskusstvo*, Moscow, 1978

—— (ed.), *Drevnerusskoye iskusstvo: XV–nachala XVI vekov*, Moscow, 1963

—— (ed.), *Drevnerusskoye iskusstvo: XVII vek*, Moscow, 1964

—— (ed.), *Drevnerusskoye iskusstvo: khudozhestvennaya kul'tura Novgoroda*, Moscow, 1968

—— (ed.), *Drevnerusskoye iskusstvo: khudozhestvennaya kul'tura Pskova*, Moscow, 1968

—— (ed.), *Drevnerusskoye iskusstvo: khudozhestvennaya kul'tura Moskvy i prilezhashchikh k ney knyazhestv. XIV–XVI vv.*, Moscow, 1970

—— (ed.), *Drevnerusskoye iskusstvo: khudozhestvennaya kul'tura domon-gol'skoy Rusi*, Moscow, 1971

Lazzaroni, M., and Munoz, A., *Filarete, scultore e architetto del secolo XV*, Rome, 1908

Le Blond, J.-B.-A., *La Théorie et la Pratique du Jardinage*, Paris, 1709

Le Corbusier, *Otvety na voprosy iz Moskvy. Planirovka goroda*, Moscow, 1933, pp. 186–87

Le Rouge, G.-L., *Cahiers des jardins anglo-chinois*, Paris, 1775–87

Lem, I., *Teoreticheskiye i prakticheskiye predlozheniya o grazhdanskoy arkhitekture, s obyasneniyem pravil Vitruviya, Palladiya, Serliya, Vinoly, Blondelya i drugikh*, St Petersburg, 1792

——, *Nachertaniye drevnikh i nyneshnyago vremeni raznorodnykh zdaniy*, St Petersburg, 1802

Leonid, archimandrit, *Istoricheskoye opisaniye stavropigial'nogo, Novyy Yerusalim imenuyemogo monastyrya*, Moscow, 1876

——, "Akty Iverskogo Svyatoozerskogo monastyrya", *Russkaya istoriche-skaya biblioteka*, V, St Petersburg, 1878

Levinson-Lessing, V. F., "Pervoye puteshestviye Petra I za granitsu", in Komelova, G. N. (ed.), *Kul'tura i iskusstvo petrovskogo vremeni: pub-likatsii i issledovaniya*, Leningrad, 1977, pp. 5–36

Levykin, A. K., *Voinskiye tseremonii i regalii russkikh tsarey*, Moscow, 1997

Lidov, A. M., "Yerusalimskiy kuvukliy. O proiskhozhdenii lukovichnykh glav", in Batalov, A. L. (ed.), *Ikonografiya arkhitektury*, Moscow, 1990, pp. 57–68

——, "Obraz Nebesnogo Yerusalima v vostochno-khristianskoy ikono-grafii", in ibid, pp. 15–25

Likhachev, D. S., *Kul'tura Rusi vremeni Andreya Rubleva i Yepifaniya - Premudrogo (konets XIV–nachalo XV v.)*, Moscow and Leningrad, 1962

——, "Printsip ansamblya v drevnerusskoy estetike", in Mongayt, A. (ed.), *Kul'tura drevney Rusi*, Moscow, 1966, pp. 118–20

——, *Chelovek v literature drevney Rusi*, Moscow, 1970

——, *Poeziya sadov*, Leningrad, 1982

——, *Velikiy put'*, Moscow, 1987

Likhachev, N. P., *Istoricheskoye znacheniye italo-grecheskoy zhivopisi*, St Petersburg, 1911

Limonov, U., *Kul'turnyye svyazi Rossii s yevropeyskimi stranami v XV–XVII vekakh*, Moscow, 1978

Lipman, A., *Petrovskaya kunstkamera*, Moscow and Leningrad, 1945

Lisovsky, V. G., *Andrey Voronikhin*, Leningrad, 1971

——, *Akademiya khudozhestv*, Leningrad, 1972, 1997

——, *Natsionalnyy stil' v arkhitekture Rossii*, St Petersburg, 2000

Lissitzky, El, *Russia: An Architecture for a World Revolution*, trans. Eric Dluhosch, Cambridge, MA, 1970

Listov, V. N., *Ippolit Monighetti*, Leningrad, 1976

Lodder, C., "Constructivist Theater as a Laboratory for an Architectural Aesthetic", *Architectural Association Quarterly*, 2, 1979, pp. 24–35

——, *Russian Constructivism*. New Haven, CT, 1983

Lo Gatto, E., *Gli artisti italiani in Russia*, I–III, Milan, 1939–53

Logvin, G. N., *Chernigov, Novgorod-Seversky, Glukhov, Putivl'*, Moscow, 1965

——, *Sofiya Kiyevskaya*, Kiev, 1971

Loktev, V. I., "Rastrelli i problemy Barokko v arkhitekture", in Lipatov,

A., Rogov, A. and Sofronova, L. (eds), *Barokko v slavyanskikh kul'tu-rakh*, Moscow, 1982, pp. 299–315

Lossky, B., *J.-B.-A. Le Blond*, Prague, 1936

Lotman, Yu. M., "Problema vizantiyskogo vliyaniya na russkuyu kulturu v tipologicheskom osveshchenii", in id. (ed.), *Izbrannyye trudy v 3 tomakh*, I, Tallinn, 1992, pp. 234–45

Loudon, J. *The Encyclopaedia of Gardening*, London, 1828

Lubchenko, O. N., *Yest v Bogoroditske park*, Tula, 1984

Lukomsky, G. K., "O postroyke Novogo Peterburga", *Zodchiy*, 52, 1912, pp. 519–21

——, *Arkhitektura russkoy provintsii*, St Petersburg, 1912

——, "Novyy Peterburg (Mysli o sovremennom stroitel'stve)", *Apollon*, 2, 1913, pp. 25–27

——, *Vologda i yeyo starina*, St Petersburg, 1914

——, *Starinnyye usad'by Khar'kovskoy gubernii*, Petrograd, 1917

——, "Proyekty Rastrelli v venskoy Albertine", *Sredi kollektsionerov*, September-December 1924, pp. 51–53

——, *Charles Cameron*, London, 1943

Luk'yanov, N., "Moskovskiy Vospitatel'nyy dom i problemy russkogo klassitsizma", in Yeneyeva, N. (ed.), *Pamyatnik v kontekste kul'tury*, Moscow, 1991, pp. 53–62

Lumiste, M., *Kudryorzhskiy dvorets*, Tallin, 1976

Lunacharsky, A. V., "Predisloviye k russkomu perevodu stat'i Le Corbusier 'Ochi nevidyashchiye'", *Khudozhestvennyy trud*, 2, 1923

Luppov, S. P., *Istoriya stroitel'stva Peterburga v pervoy chetverti XVIII veka*, Moscow, 1957

——, "Neosushchestvlennyy proyekt petrovskogo vremeni stroitel'stva novoy stolitsy Rossii", *Trudy biblioteki AN SSSR*, III, Moscow and Leningrad, 1957

L'vov, N. A., "Putevye zametki N. A. L'vova po Italii (izdannyy V. A. Vereshchaginym)", *Staryye gody*, June 1909, pp. 276–82

——, ed. Lappo-Danilevsky, K. U., *Sochineniya*, Cologne, 1994

——, ed. Nikitina A. B., "Italyanskiy dnevnik 1781", *Pamyatniki kul'tura. Novyye otkrytiya*, Moscow, 1994, pp. 249–76

Makarevich, G. (ed.), *Pamyatniki arkhitektury Moskvy: Belyy Gorod*, Moscow, 1989

Makariy (Bulgakov), mitropolit, *Istoriya russkoy tserkvi*, I–XI, Moscow, 1994–2000

Makarov, V., "Andrey Bolotov i sadovoye iskusstvo v Rossii XVIII veka", *Sredi kollektsionerov*, 5–6, 1924, pp. 27–32

——, and Petrov, A. N., *Gatchina*, Leningrad, 1974

Makovsky, S., *Talashkino*, Moscow, 1905

Maksim Grek, *Tvoreniya*, 3 vols, Svyato-Troitskaya Sergeyeva Lavra, 1996

Maksimov, P. N., "K kharakteristike pamyatnikov moskovskogo zodch-estva XIV–XV vv.", *Materialy po arkheologii SSSR*, 12, Moscow, 1949

——, "Derevyannaya arkhitektura XVII veka", in *IRI*, IV, 1959, pp. 96ff.

——, "Zarubezhnyye svyazi v arkhitekture Novgoroda i Pskova XI–nachala XVI vekov", *Arkhitekturnoye nasledstvo*, 12, Moscow, 1960, pp. 23–44

——, "K voprosu ob avtorstve Blagoveshchenskogo sobora i Rizpolozhenskoy tserkvi v Moskovskom Kremle", *Arkhitekturnoye nasledstvo*, 16, Moscow, 1967, pp. 13–18

——, "O kompozitsionnom masterstve moskovskikh zodchikh nachala XV v.", *Arkhitekturnoye nasledstvo*, 21, Moscow, 1973, pp. 44–47

——, "Obshchenatsional'nyye i lokal'nyye osobennosti russkoy arkhitektury XII–XIV vv.", in Rybakov, B. A. et al. (eds), *Pol'sha i Rus'*, Moscow, 1974

——, "Sobor Spas-Andronikova monastyrya v Moskve", in Posokhin,

M.V. et al. (eds), *Arkhitekturnyye pamyatniki Moskvy XV–XVII vekov*, Moscow, 1977

Malaguzzi, V. F., "Solari, architetti e scultori Lombardi del XV secolo", *Italienische Forschungen*, I, Berlin, 1906

Malinin, V., *Starets Yelizarova monastyrya Filofey i yego poslaniya*, Kiev, 1901

Manfio, O. (ed.), *Omaggio a Pietro Ganzaga*, Feltre, 1986

Mango, C., *Byzantine Architecture*, New York, 1985

Marconi, P., Cipriani, A., and Valereani, E., *I desegni di architettura dell'Archivio Storico dell'Academia di San Luca*, 2 vols, Rome, 1974

Markina, I., (ed.), *Yekaterina Velikaya i Moskva*, exhib. cat., Moscow, 1997

Masalina, N., "Tserkov' v Abramtseve", in Borisova, Ye. A. (ed.), *Iz istorii russkogo iskusstva vtoroy poloviny XIX–nachala XX veka*, Moscow, 1978, pp. 47–58

Maslenitsin, S. I., *Kostroma*, Leningrad, 1968

Matveyev, A. A., *Rastrelli*. Moscow, 1938

Maykov, P. M., *Ivan Ivanovich Betskoy*, St Petersburg, 1904

Mazzi, G., "Indàgini archivistiche per Alvise Lamberti da Montagnana", *Arte Lombarda*, 44–45, 1976, pp. 96–101

McCormick, Th., *Charles-Louis Clérisseau and the Genesis of Neoclassicism*, Cambridge, 1990

Medvedev, I., *Vizantiyskiy gumanizm XIV–XV vekov*, St Petersburg, 1977

Medvedkova, O. A. "Tsaritsynskaya psevdogotika V. I. Bazhenova: opyt interpretatsii", in Batalov, A. L. (ed.), *Ikonografiya arkhitektury*, Moscow, 1990, pp. 153–73

——, "Tvorchestvo Voronikhina i romanticheskiye tendentsii v nachale XIX v.", in Voronov, A. A. (ed.), *Problemy istorii arkhitektury*, part II, Moscow, 1990, pp. 84–86

Mekhovsky, M., *Traktat o dvukh Sarmatyakh*, Moscow and Leningrad, 1936

Mendelsohn, E., *Russland, Europa, Amerika. Ein architektonischer Querschnitt*, Berlin, 1929

Merkelova, V. N., "K rekonstruktsii fasadov Arkhangel'skogo sobora", *Gosudarstvennyye muzei Moskovskogo Kremlya. Materialy i issledovanya*, III, Moscow, 1980, pp.76–86

Merzlutina, N. A., and Sedov, V. V., "Tema rakoviny v russkoy arkhitekture kontsa XVII veka (o sudbe znaka tzarskoy vlasty)", in Bondarenko, I. A. (ed.), *Arkhitektura v istorii russkoy kul'tury*, 4, Moscow, 1999, pp. 87–91

Meyendorff, J., *Byzantium and the Rise of Russia*, Cambridge, 1981

Mezentsev, V. I., "The Masonry Churches of Medieval Chernikhov", *Harvard Ukrainian Studies*, XI, 3–4, 1987, pp. 365–83

Mikhaylov, A. I., *Bazhenov*, Moscow, 1951

——, "Tvorchestvo Rastrelli i traditsii russkoy arkhitektury", *Arkhitekturnoye nasledstvo*, 1, Moscow and St Peterburg, 1951, pp. 62–66

——, *Arkhitektor D. V. Ukhtomsky i yego shkola*, Moscow, 1954

Mikhaylov, B. B., "Sadovnik Frensis Rid v Tsaritsyne i v Ostankine", *Arkhitektura SSSR*, 4, 1990, pp. 104–09

Mikhaylova, M. B., "K voprosu o meste ansamblya Kazanskogo sobora v yevropeyskoy arkhitekture", *Arkhitekturnoye nasledstvo*, 24, Moscow, 1976, pp. 41–50

——, "Tipy sooruzhenii antichnosti v arkhitekture russkogo klassitsizma", *Arkhitekturnoye nasledstvo*, 26, Moscow, 1978, pp. 4–5

——, "Russkiye arkhitektory pensionery v Italii (vtoraya polovina XVII–pervaya tret' XIX veka)", *Rossiya. Italiya. Vstrecha kul'tur*, IV, Moscow, 2000, pp. 84–97

Mikishat'yev, M. N., "Gollandiya i Rossiya: k voprosu ob ot-obrazhenii kontaktov", *Arkhitektura mira*, II, Moscow, 1993, pp. 31–37

Mil'chik, M. I., and Ushakov, Yu. S., *Derevyannaya arkhitektura russkogo severa*, Leningrad, 1981

Miller, D., "The Lubeckers Bartholomäus Ghotan and Nicolas Bulow in Novgorod and Moscow and the Problem of Early Western Influences on Russian Culture", *Viator*, 9, 1978, pp. 395–412

Millon, H. (ed.), *The Triumph of the Baroque: Architecture in Europe, 1600–1760*, Milan, 1999

Mineyeva, K. N., *Tsaritsyno*, Moscow, 1986

Minkus, M., and Pekareva, N. A., *Fomin*, Moscow, 1953

Monferran, A., *Sobornaya tserkov' Sv. Isaakiya Dalmatskogo*, St Petersburg, 1820

Montefiore, S. S., *Prince of Princes: The Life of Potemkin*, London, 2001

Morel, O., and Chvidkovsky, D., *La Maison Igoumnoff*, Paris, 1994

Morgan, E. D., and Coote, C. H., *Early Voyages and Travels to Russia and Persia*, London, 1886

Moskovskoye arkhitekturnoye obshchestvo. Sbornik, 1–5, Moscow, 1908–1923

Mosser, M., and Rabreau, D., *Charles de Wailly. Peintre, architecte dans l'Europe des Lumières*, Paris, 1979

Murano, M. T., *Scenografie di Pietro Gonzaga. Catalogo della mostra*, Vicenza, 1967

Musatov, A. A., and Shvidkovsky, D. O., "Predstavleniye o regulyarnosti v arkhitekture i zhizni russkogo goroda v pervoy chetverti XVIII veka", *Gorodskoye upravleniye*, 7, 1999, pp. 21–25

Nashchokina, M. V., "Venskiye motivy v arkhitekture Moskvy nachala XX veka", in Voronov, A. A. (ed.), *Voprosy istorii arkhitektury*, Moscow, 1990, pp. 94–109

Nekrasov, A. I., *Vizantiyskoye i russkoye iskusstvo*, Moscow, 1924

——, *Vozniknoveniye moskovskogo iskusstva*, Moscow, 1929

—— "Die neue Architektur und ihre Stellung in der tradizionellen russischen Baukunst", *Slavische Rundschau*, Prague, 1–2, 1929

——, "Problema proiskhozhdeniya drevnerusskikh stolpoobraznykh khramov", *Trudy kabineta istorii material'noy kul'tury*, 5, Moscow, 1930

——, *Drevnerusskoye zodchestvo*, Moscow, 1935

——, *Ocherki po istorii drevnerusskogo zodchestva XI–XVII vekov*, Moscow, 1936

—— (ed.), *Barokko v Rossii*, 1926

—— "O nachale barokko v russkoy arkhitekture XVIII veka", in ibid., pp. 56–78

Neufforge, J.-F., *Recueil d'architecture*, Paris, 1762

Nevolin, U. A., "Vliyaniye idei Moskva–Tretiy Rim na traditsii drevnerusskogo izobrazitel'nogo iskusstva", *Iskusstvo khristianskogo mira*, I, Moscow, 1996, pp. 71–84

Nickel, N. L., "Berufsmotive der sachsischen romanischen Bau-ornamentik zu den Schmuckmotiven der Vladimir-Suzdaler Architektur", in Smirnova, E. S. (ed.), *Dmitrovskiy sobor vo Vladimire. K 800-letiyu osnovaniya*, Moscow, 1997, pp. 81–92

Nikitin, N. P., *Monferran*, Leningrad, 1939

Nikolayev, Ye. V., *Klassicheskaya Moskva*, Moscow, 1975

Nikolayeva, T. I., *Viktor Shreter*, Leningrad, 1991

Nikulin, N. N., *Pis'ma I. F. Reyfensteyna. Problemy razvitiya zarubezhnogo iskusstva*, St Petersburg, 1996, pp. 32–34

Nikulina, N. I., *Nikolay L'vov*, Leningrad, 1971

—— and Yefimova, N. G. (ed.), *Karl Ivanovich Rossi. 1775–1849, Katalog chertezhey*, Leningrad, 1975

Nosov, N. G. (ed.), *Istoricheskiye svyazi Skandinavii i Rossii. IX–XX vv.*, Leningrad, 1970

Novikov, S. Ye., *Uglich: Pamyatniki arkhitektury i iskusstva*, Moscow, 1988

Obolensky, D., "Russia's Byzantine Heritage", in Cherniavsky, M. (ed.), *The Structure of Russian History*, New York, 1970

——, *Vizantiyskoye sodruzhestvo natsiy*, Moscow, 1988

Obshchestvo arkhitektorov-khudozhnikov. Yezhegodnik, Leningrad, 12, 1927; 13, 1930; 14, 1935

Ognev, B. A., "O pozakomarnykh pokrytiyakh", *Arkhitekturnoye nasledstvo*, 10, Moscow, 1958, pp. 43–58

——, "Variant rekonstruktsii Spasskogo sobora Spas-Andronikova Monastyrya", in Likhachev, D. S. et al. (eds), *Pamyatniki kul'tury. Issledovaniya i restavratsiya*, I, Moscow, 1959, pp. 72–82

Ol', G. A., *Alexandre Bryullov*, Leningrad, 1983

Oltarzhevsky, V. K., *Stroitel'stvo vysotnykh zdaniy v Moskve*, Moscow, 1953

Onians, J., "Filarete and the *qualità* architectural and social", *Arte Lombarda*, 18, 1973, pp. 96–114

Opolovnikov, A. V., *Russkiy Sever*, Moscow, 1977

——, *Russkoye derevyannoye zodchestvo*, Moscow, 1983

—— and Opolovnikova, Ye. A., *The Wooden Architecture of Russia*, New York, 1989

Oreshnikov, A. V., "Ornistotel', denezhnik Ivana III", *Staraya Moskva*, 2, Moscow, 1914, pp. 50–52

Orlov, G. A., and Dzerzhinsky, A. A., *Sovetskaya arkhitektura. Tvorcheskiye problemy*, Moscow, 1977

Oshchepkov, G. D., *Arkhitektor Tomon. Materialy k izucheniyu tvorchestva*, Moscow, 1950

——, *I. V. Zholtovsky*, Moscow, 1955

——, *Zdaniye tsentral'nogo voyenno-morskogo muzeya (b. Birzha) v Leningrade*, Leningrad, 1957

Osipov, P., *OSA i ASNOVA. Iskusstvo v massy*, 7, 1930

Ostroumov, I., *Istoriya Florentiyskogo sobora*, Moscow, 1847

Ostroumov, V., *Kazan': Ocherki po istorii goroda i yego arkhitekture*, Kazan', 1978

Ousterhaut, R., "Loca Sancta and the Architectural Response to Pilgrimage", in id. (ed.), *The Blessings of Pilgrimage*, Urbana, IL, and Chicago, IL, 1989

——, *Master Builders of Byzantium*, Princeton, NJ, 1999

——, "The Church of the Holy Sepulchre in Bologna, Italy", *Biblical Archeology Review*, 6, 2000, pp. 21–35

Ovchinnikova, Ye. S., *Tserkov' Troitsy v Nikitnikakh*, Moscow, 1970

Ovsyannikov, Yu. M., *Novodevichiy monastyr'*, Moscow, 1968

——, "Novyye materialy o zhizni i tvorchestve F.-B. Rastrelli", *Sovetskoye iskusstvoznaniye*, 79, part 1, Moscow, 1980, pp. 340–51

——, *Franchesko Bartolomeo Rastrelli*, Leningrad, 1982

——, *Domeniko Trezzini*, Leningrad, 1987

Ozhegov, S. S., *Tipovoye i povtornoye stroitel'stvo v Rossii XVIII–nachala XIX vekov*, Moscow, 1984

[Palladio, A.], *Chetyre knigi Palladiyevoy arkhitektury*, trans. and ed. L'vov, N. A., I, Moscow, 1789

Panchenko, A. M., *Russkaya kul'tura v kanun petrovskikh reform*, Leningrad, 1984

Panofsky, E., *Renaissance and Renascences in Western Art*, London and New York, 1960

Paoletti, P., *L'Architettura e la scultura del Rinascimento in Venezia*, II, Venice, 1893

Papernyi, V., *Kul'tura Dva*, Ann Arbor, MI, 1985

Parland, A., *Khram Voskreseniya Khristova, sooruzhennyy na meste smertel'no porazhennogo v Bozhe pogibshego Imperatora Aleksandra II na Yekaterininskom kanale v Sankt-Peterburge*, St Petersburg, 1907

Pavlinov, A. M., *Istoriya russkoy arkhitektury*, Moscow, 1894

Pekareva, N. A., *Moskovskiy metropoliten*, Moscow, 1958

Pérouse de Montclos, J.-M., *Les Prix de Rome*, Paris, 1984

——, *Boullée*, Paris, 1994

——, ed. Chvidkovsky, D. O., *Moscou. Patrimoine architectural*, Paris, 1997

Pervaya kniga Moskovskogo arkhitekturnogo obshchestva, Moscow, 1999

Pervukhin, N., *Tserkov' Il'yi Proroka v Yaroslavle*, Yaroslavl', 1915

——, *Tserkov' Bogoyavleniya v Yaroslavle*, Yaroslavl', 1916

Petrov, A. N., "S. Chevakinsky i peterburgskaya arkhitektura serediny XVIII veka", in Grabar', I. E. (ed.), *Russkaya arkhitektura pervoy poloviny XVIII v.*, Moscow, 1954, pp. 363–70

——, "Peterburgskiy zhiloy dom 30–40-kh godov XVIII stoletiya", *Yezhegodnik Instituta istorii iskusstv*, Moscow, 1960

——, *Zhivopis' i arkhitektura*, Moscow, 1961, pp. 132–57

——, *Pushkin. Dvortsy i parki*, Leningrad, 1969

——, *Gorod Pushkin. Dvortsy i parki*, Leningrad, 1977

——, Borisova, Ye. A., Naumenko, A. P., and Povelikhina, A. V., *Pamyatniki arkhitektury Leningrada*, Leningrad, 1972

——, Petrova, Ye. N., Raskin, A. G., Arkhipov, N. I., and Krasheninnikov, A. F., *Pamyatniki arkhitektury prigorodov Leningrada*, Leningrad, 1983

Petrov, P. N., "Materialy dlya biografii grafa Rastrelli", *Zodchiy*, 5, 1876, pp. 55–56

——, "Arkhitektor M. G. Zemtsov", *Zodchiy*, 8, 1877, pp. 70–73

——, "P. M. Yeropkin", *Zodchiy*, 5, 1878, pp. 54–55

Petrova, T. A., *Andrey Shtakenshneyder*, Leningrad, 1978

Pevsner, N., *An Outline of European Architecture*, Harmondsworth, 1963

Peyre, M.-J., *Oeuvres d'architecture*, Paris, 1765

Pilyavsky, V. I., "Ivan Kuz'mich Korobov", *Arkhitekturnoye nasledstvo*, 4, Moscow, 1953, pp. 41–62

——, *Stasov – Arkhitektor*, Leningrad, 1963

——, *Zodchiy Vasily Petrovich Stasov (1769–1848)*, Leningrad, 1970

——, "Proyekty triumfal'nykh sooruzheniy G. Kvarengi v Rossii", *Arkhitekturnoye nasledstvo*, 28, Moscow, 1980, pp. 71–79

——, *G. Kvarengi: Arkhitektor. Khudozhnik*, Leningrad, 1981

——, *Giacomo Quarenghi*, Bergamo, 1984

——, Tits, A. A., and Ushakov, Yu. S., *Istoriya russkoy arkhitektury*, Leningrad, 1984

Pirling, P., *Rossiya i papskiy prestol*, Moscow, 1912

Platonov, S. F., *Moskva i Zapad v XVI–XVII vv.*, Leningrad, 1925

Plukhanova, M. B., *Suzhety i simvoly Moskovskogo tsarstva*, St Petersburg, 1995

Pluzhnikov, V. I., "Sootnosheniye ob"yemnykh form v russkom kul'tovom zodchestve nachala XVIII veka", in Alekseyeva, T.V. (ed.), *Russkoye iskusstvo pervoy chetverti XVIII veka*, Moscow, 1974, pp. 81–108

——, "Rasprostraneniye zapadnogo dekora v petrovskom zodchestve", in Popov, G. V. (ed.), *Drevnerusskoye iskusstvo: Zarubezhnyye svyazi*, Moscow, 1975, pp. 362–70

——, "Organizatsiya fasada v arkhitekture russkogo barokko", in Alekseyeva, T. V. (ed.), *Russkoye iskusstvo barokko: materialy i issledovaniya*, Moscow, 1977, pp. 88–127

Podklyuchnikov, V. N., *Tri pamyatnika XVII stoletiya: Tserkov' v Fil'yakh, Tserko' v Uborakh, Tserkov' v Troitskom-Lykove*, Moscow, 1945

Podol'sky, R. P., "Petrovskiy dvorets na Iyauze", *Arkhitekturnoye nasledstvo*, 1, Moscow, 1951, pp. 14–55

——, "Ivan Korobov", *Sovetskaya arkhitektura*, 3, Moscow, 1952, pp. 10–16

Pod"yapol'skaya, Ye. N., *Pamyatniki arkhitektury Moskovskoy oblasti*, 2 vols, Moscow, 1975

Pod"yapol'sky, S. S., "Venetsianskiye istoki arkhitektury moskovskogo Arkhangel'skogo sobora", in Popov, G. V. (ed.), *Drevnerusskoye iskusstvo: Zarubezhnyye svyazi*, Moscow, 1975, pp. 252–79

——, "Arkhitektor Petrok Malyy", in Vygolov, V. P. et al. (eds), *Pamyatniki russkoy arkhitektury i monumental'nogo iskusstva. Stil', atributsii, datirovki*, Moscow, 1983, pp. 34–40

——, "K voprosu o svoyeobrazii arkhitektury Moskovskogo Uspenskogo sobora", in Smirnova, E. S. (ed.), *Uspenskiy sobor Moskovskogo Kremlya*, Moscow, 1985, pp. 24–51

——, "Deyatel'nost' ital'yanskikh masterov na Rusi i v drugikh stranakh Yevropy v kontse XV–nachale XVI vv.", *Sovetskoye iskusstvoznaniye*, 20, Moscow, 1986, pp. 84–118

——, "Novshestva v tekhnike moskovskogo kamennogo stroitel'stva kontsa XV–nachala XVI v.", in Voronov, A. A. (ed.), *Problemy istorii arkhitektury*, Moscow, 1990, pp. 141–45

——, "Ital'yanskiye stroitel'nyye mastera v Rossii v kontse XV–nachala XVI veka po dannym pis'mennykh istochnikov (opyt sostavleniya slovarya)", in Batalov, A. L., and Bondarenko, I. A. (eds), *Restavratsiya i arkhitekturnaya arkheologiya. Novyye materialy i issledovaniya*, I, Moscow, 1991, pp. 218–33

Pokrovskaya, Z. K., *Arkhitektor O. I. Bove (1784–1834)*, Moscow, 1964

——, *Osip Bove*, Moscow, 1999

Pokrovsky, N. V., "Iyerusalim ili Sion sobornoy riznitsy Novoyerusalimskogo monastyrya", *Vestnik istorii i arkheologii*, XXI, St Petersburg, 1911, pp. 23–27

Polenova, N. V., *Abramtsevo: vospominaniya*, Moscow, 1922

Polyansky, A. T., *Arkhitekturnoye tvorchestvo i standartnoye stroitel'stvo*, Moscow, 1971

Popaduk, S. S., *Teoriya neklassicheskikh arkhitekturnykh form russkoy arkhitekturnoy kul'tury XVII v.*, Moscow, 1998

Popov, G. V., "Dekoratsiya fasadov Dmitrovskogo sobora i kul'tura Vladimirskogo knyazhestva rubezha XII i XIII vv.", in Smirnova, E. S. (ed.), *Dmitrovskiy sobor vo Vladimire*, Moscow, 1997

—— (ed.), *Drevnerusskoye iskusstvo: Zarubezhnyye svyazi*, Moscow, 1975

Poppe, A., "Kompozycja Sofii Kijowskoi. W poszukiwaniu ukladu pierwotnogo", *Bioleten historii sztuki*, 30, 1968, pp. 1–29

——, "The Political Background to the Baptism of Rus': Byzantine-Russian Relations between 986–989", *Dumbarton Oaks Papers*, 30, Washington, DC, 1976, pp. 197–244

——, "The Building of the Church of St Sophia in Kiev", *Journal of Medieval History*, 7, Moscow, 1981, pp. 15–66

——, *The Rise of Christian Russia*, London, 1982

Posokhin, M. V., *Kremlyovskiy Dvorets s"yezdov*, Moscow, 1971

—— and Dyubek, D. A., "Eksperimental'nyy zhiloy rayon Chertanovo-Severnoye", *Znaniye*, 10, 1976

Possevino, A., *Moskoviya. Istoricheskiye svedeniya o Rossii*, Moscow, 1983

Preobrazhensky, M. T., *Pamyatniki drevnerusskogo zodchestva v predelakh Kaluzhskoy gubernii*, St Petersburg, 1891

Proskuryakova, T. S., "Planirovochnyye kompozitsii gorodov-krepostey Sibiri (vtoroy poloviny XVII v.–60-e gg. XVIII v.)", *Arkhitekturnoye nasledstvo*, 25, 1976, pp. 57–71

——, "O regulyarnosti v russkom gradostroitel'stve XVII–XVIII vv.", *Arkhitekturnoye nasledstvo*, 28, Moscow, 1980, pp. 37–46

Protasov, N. D., *Novshestva v moskovskom khramovom zodchestve kontsa XVII veka*, Sergiyev Posad, 1912

Puchkov, V. V., and Khaykina, L. V., *Mikhaylovskiy zamok. Zamysel i voploshcheniye*, St Petersburg, 2000

Punin, A. N., "Idei ratsionalizma v russkoy arkhitekture vtoroy poloviny XIX veka", *Arkhitektura SSSR*, 11, 1962, pp. 5–58

——, "Pochemu soshol so stseny klassitsizm?", *Stroitel'stvo i arkhitektura Leningrada*, 7, 1978, pp. 39–43

——, *Arkhitekturnyye pamyatniki Peterburga: vtoraya polovina XIX veka*, Leningrad, 1981

——, *Arkhitektura Peterburga serediny XIX veka*, Leningrad, 1990

——, "Pyotr I i Kristofer Ren. K voprosu o stilevykh istokakh petrovskogo barokko", *Iskusstvo arkhitektury*, St Petersburg, 1995, pp. 34–42

Punin, N. N., *Tatlin*, Petrograd, 1921

Purishev, I. B., *Pereslavl'-Zalessky*, Moscow, 1970

Pylyayev, M. I., *Zabytoye proshloye okrestnostey Peterburga*, St Petersburg, 1889

Pyotrovsky, M. B. (ed.), *Zdaniya Ermitazha*, St Petersburg, 1998

Pyushel, K., *Gruppa Khannesa Mayera v Sovetskom Soyuze. Vzaimosvyazi russkogo i sovetskogo iskusstva i nemetskoy khudozhestvennoy kul'tury*, Moscow, 1989, pp. 157–60

Quarenghi, G., *Edifices construits à Saint-Pétersbourg d'après les plans du Chevalier de Quarenghi et sous sa direction*, St Petersburg, 1810

——, ed. Zanella, V., *Architetto a Pietroburgo. Lettere e altri scritti*, Venice, 1988

Raam, V. V., *Arkhitekturnyye pamyatniki Estonii*, Leningrad, 1974

Rae, I., *Charles Cameron: Architect to the Court of Russia*, London, 1971

Ramelli, A. S., "Il Cremlino di Mosca, esempio di architettura militare", *Arte Lombarda*, 44–45, 1976, pp. 130–38

Rapoport, P. A., "Zodchiy Borisa Godunova", in Mongayt, A. N. (ed.), *Kul'tura drevney Rusi*, Moscow, 1966, pp. 215–21

——, "Russkaya arkhitektura na rubezhe XII i XIII veka", in id. (ed.), *Drevnerusskoye iskusstvo. Problemy i atributsii*, Moscow, 1977, pp. 12–29

——, *Zodchestvo drevney Rusi*, Leningrad, 1986

——, *Drevnerusskaya arkhitektura*, St Petersburg, 1993

Raskin, A. G., *Gorod Lomonosov: dvortsovo-parkovyye ansambli XVIII veka*, Leningrad, 1979

——, *Petrodvorets (Petergof)*, Leningrad, 1979

Reau, L., "Un grand architecte français en Russie: Vallin de La Mothe", *Architecture*, XXXV/12, pp. 173–80

Rempel', L., "K kharakteristike arkhitektury fashistskoy Italii", *Akademiya arkhitektury*, 1, 1935, pp. 50–61

Restle, M., "Bauplanung unter Mehmet II. Fatikh Filarete in Konstantinopel", *Pantheon*, XXXIX, 1981, pp. 361–67

Revsin, G. I., "Renessansnyye motivy v arkhitekture neoklassitsizma nachala XX veka", in Batalov, A. L. (ed.), *Ikonografiya arkhitektury*, Moscow, 1990, pp. 187–211

——, "Sad moderna i neoklassitsizma", in Voronov, A. A. (ed.), *Voprosy istorii arkhitektury*, Moscow, 1990, pp. 126–38

——, *Neoklassitsism v russkoy arkhitekture nachala XX veka*, Moscow, 1992

Revzina, Yu. Ye., "Nekotoryye ikonograficheskiye istochniki tsentricheskikh khramov XV veka v Italii", in Batalov, A. L. (ed.), *Ikonografiya arkhitektury*, Moscow, 1990, pp. 69–101

Rezvin, V. A., "Dom arkhitektora K. S. Mel'nikova", *Arkhitektura SSSR*, 1984, 4, pp. 84–85

Rice, T. Talbot, *Charles Cameron*, London, 1967

Robinson, J. M., "A Dazzling Adventurer: Charles Cameron - the Lost Early Years", *Apollo*, January 1992, pp. 31–35

Roche, D., "Perechen' russkikh i pol'skikh khudozhnikov, imena kotorykh znachatsya v spiskakh parizhskoy Akademii Zhivopisi i skul'ptury", *Staryye gody*, June 1909, pp. 306–15

Rogachevskaya, Ye. B., "Zapadnyy mir v Khozhdenii na Florentiyskiy sobor", *Germenevtika russkoy literatury*, 10, 2000, pp. 252–61

Rogovin, N. N., *Tserkov' Vozneseniya v Kolomenskom*, Moscow, 1941

Romanov, A. A., "Georgiyevskiy sobor v Yur'yeve-Pol'skom", *Izvestiya Arkheograficheskoy komissii*, 36, St Petersburg, 1908, pp. 70–96

——, "O formakh Uspenskogo sobora 1326 i 1472 gg.", *Materialy i issledovaniya po arkheologii SSSR*, Moscow, 1955

Romanov, N. I., "Zapadnyye uchitelya Bazhenova", *Akademiya arkhitektury*, 2, 1939, pp. 17–22

Romanyuk, S. K., "Vil'yam Val'kot (1874–1943)", *Stroitel'stvo i arkhitektura Moskvy*, 6, 1986, pp. 24–27

Roosevelt, P. R., "Tatiana's Garden: Noble Sensibilities and Estate Park Design in the Romantic Era", *Slavic Review*, 49, 1990, pp. 335–49

——, *Life at the Russian Country Estate*, New Haven, CT, 1995

Rosenblum, R., *Transformations in Late Eighteenth Century Art*, Princeton, NJ, 1967

Rotach, A. L., and Chekanova, O. A., *Monferran*, Leningrad, 1979

Rozanov, Ye. G., *Krupnopanel'noye domostroyeniye*, Moscow, 1983

Rozhdestvensky, S., *Stoletiye goroda Gatchiny*, Moscow, 1896

Rubanenko, B. R. (ed.), *Zhilishchnoye stroitel'stvo SSSR*, Moscow, 1976

—— (ed.), *Arkhitekturno-khudozhestvennyye voprosy industrial'nogo domostroyeniya*, Moscow, 1977

Ruble, B. A., "From Palace Square to Moscow Square: St Petersburg's Century-Long Retreat from Public Space", in Brumfield, W. C. (ed.), *Reshaping Russian Architecture: Western Technology, Utopian Dreams*, New York, 1990, pp. 10–42

——, "Moscow's Revolutionary Architecture and its Aftermath: A Critical Guide", in ibid., pp. 111–44

——, Brumfield, W. C., and Kopp, A., *Architecture and the New Urban Environment: Western Influences on Modernism in Russia and the USSR*, Washington, DC, 1988

Rudnev, L. V., "O formalizme i klassike", *Arkhitektura SSSR*, 11, 1954, pp. 30–32

Runkevich, S. G., *Aleksandro-Nevskaya Lavra, 1713–1913*, St Petersburg, 1913

Ruska, L., *Recueil des dessins de différents bâtiments construits à Saint-Pétersbourg et dans l'intérieur de l'Empire de la Russie*, St Petersburg, 1810

Rybakov, B. A., *Drevnosti Chernigova. Materialy i issledovaniya po arkheologii SSSR*, 11, Moscow and Leningrad, 1949

Rybina, Ye., *Inozemnyye dvory v Novgorode XII–XVII vv.*, Moscow, 1986

Sadov, A. I., *Vissarion Nikeyskiy*, St Petersburg, 1883

Salmon, F., "Charles Cameron and Domus Aurea: una pìccola esplorazione", *Architectural History*, 36, pp. 69–93

Salon: 1995–2000, Moscow, 2000

Salon: 2000–2001, Moscow, 2001

Samoylova, N., "Arkhitektor Viktor Aleksandrovich Vesnin", *Arkhitektura SSSR*, 4, 1982, pp. 32–40

Sapunov, B. V., "Antichnaya literatura v russkikh bibliotekakh XVII veka i Moskovskoye barokko", in id. (ed.), *Russkiye biblioteki i ikh chitateli*, Leningrad, 1983, pp. 70–80

Sarob"yanov, D. V., *Russkoye iskusstvo i zapad*, Moscow, 2004

Savarenskaya, T. F., Shvidkovsky, D. O., and Petrov, F., *Istoriya gradostroitel'nogo iskusstva. Pozdnyy feodalizm i kapitalizm*, Moscow, 1989

——, Shvidkovsky, D. O., Musatov, A. A. et al., *Arkhitekturnyye ansambly Moskvy XII–XIX vv.*, Moscow, 1997

Schmidt, A., "William Hastie, Scottish Planner of Russian Cities", *Proceedings of the American Philosophical Society*, 114, 1970, pp. 226–43

——, "The Restoration of Moscow after 1812", *Slavic Review*, 40, 1981, pp. 37–48

——, *The Architecture and Planning of Classical Moscow: A Cultural History*, Philadelphia, PA, 1989

Schmidt, H., "Deutsche Architekten in der Sowjetunion", *Deutsche Architektur*, 10, 1967

Sedov, A. P., *Yegotov*, Moscow, 1951

——, *Yaropolets*, Moscow, 1980

Sedov, V. V., "Tserkov' Nikoly na Lipne i novgorodskaya traditsiya XII veke vo vzaimosvyazi s romano-goticheskoy traditsiyey", in Komech, A. I. (ed.), *Drevnerusskoye iskusstvo: Rus', Vizantiya, Balkany. XIII vek*, St Petersburg, 1997, pp. 393–412

——, "Tri obraza Italii v russkoy arkhitekture", in Danilova, I. Ye. (ed.), *Rossiya–Italiya*, Moscow, 2005, pp. 351–67

Semenova, L. N., *Senatskiy arkhiv v 15 tomakh*, St Petersburg, 1888–1913

——, "Uchastiye shvedskikh masterovykh v stroitel'stve Peterburga (pervayya chetvert' XVIII v.)", in Nosov, N. I. (ed.), *Istoricheskiye svyazi Skandinavii i Rossii. IX–XX vv.*, Leningrad, 1970, pp. 269–81

Senkevitch, A., *Soviet Architecture 1917–1962: A Bibliographical Guide to Source Material*, Charlottesville, VA, 1974

Sergeyev, S. V., "Pamyatnik v khudozhestvennom kontekste: vospriyatiye usad'by Yekateriny II v Tsaritsyno v russkoy kul'ture pervoy treti XIX v.", in Voronov, A. A. (ed.), *Problemy istorii arkhitektury*, part II, Moscow, 1990, pp. 48–53

Sergeyeva-Kozina, T., "Kolomenskiy kreml'", *Arkhitekturnoye nasledstvo*, 2, Moscow, 1952, pp. 133–63

Shamurin, Yu., *Podmoskovnya*, Moscow, 1912

Shanin, T., *The Roots of Otherness: Russia's Turn of the Century*, 2 vols, New Haven, CT, 1986

Sharov, S. O., "Zaversheniya Spaso-Preobrazhenskogo sobora Solovetskogo monastyrya", *Arkhitekturnoye nasledstvo*, 34, 1986, 224–29

Shcherbatov, U. N, *Datskiy arkhiv. 1326–1690*, Moscow, 1893

——, "Kopengagenskiye akty, otnosyashiyesya do russkoy istorii", *Chteniya Obshchestva istorii i drevnostey rossiyskikh*, 4, St Petersburg, 1915

Shedlikh, Kh., "Bauhaus i VHUTEMAS. Obshchiye cherty pedagogicheskoy programmy", in Sternin, G. Yu. (ed.), *Vzaimosvyazi russkogo i sovetskogo iskusstva i nemetskoy khudozhestvennoy kul'tury*, Moscow, 1989

Shel'yapina, N. S., "K istorii izucheniya Uspenskogo sobora moskovskogo Kremlya", *Sovetskaya arkheologiya*, 1, 1972, pp. 200–14

Sherotsky, K. V., *Sofiyskiy sobor v Polotske. Zapiski otdeleniya russkoy i slavyanskoy arkheologii Russkogo arkheologicheskogo obshchestva*, I, St Petersburg, 1915, pp. 77–90

Shevchenko, V. G., *Arkhitekturnyye proyekty dlya Rossii. Sharl'-Lui Klerisso, arkhitektor Yekateriny Velikoy. Risunki iz sobraniya Gosudarstvennogo Ermitazha*, St Petersburg, 1997, pp. 84–96

—— and Cotte, S. (eds), *Charles-Louis Clérisseau*, Paris, 1995

Shil'der, N. A., *Imperator Alexandre I*, I–IV, St Petersburg, 1896

Shilkov, V. F., "Chetyre risunka Petra I po planirovke Petergofa", *Arkhitekturnoye nasledstvo*, 4, Moscow, 1953, pp. 35–40

——, "Proyekty planirovki Peterburga 1737–1740 godov", *Arkhitekturnoye nasledstvo*, 4, Moscow, 1953, pp. 7–13

——, "Arkhitektory-inostrantsy pri Petre I", in Grabar', I.E. (ed.), *Russkaya arkhitektura pervoy poloviny XVIII v.*, Moscow, 1954, pp. 118–67

——, "Russkiy perevod Vitruviya nachala XVIII veka", *Arkhitekturnoye nasledstvo*, 7, Moscow, 1955, pp. 89–92

——, "Dve raboty arkhitektora Kyaveri v Rossii", *Arkhitekturnoye nasledstvo*, 9, Moscow, 1959, pp. 61–64

Shirshova, L. V., and Novik, I. V., *Khram Khrista Spasitelya v Moskve. Vossozdaniye skul'pturnogo i zhivopisnogo ubranstva*, Moscow, 2000

Shirvinsky, S. V., "Venetsianizmy moskovskogo sobora", in *Sborniki Moskovskogo Merkuriya*, I, Moscow, 1917, pp. 191–04

Shorban, Ye. A., "Vichuga (Bonyachki)", *in Pamyatniki arkhitektury Ivanovskoy oblasti*, II, Moscow, 2000

Shreter, V. A., "K istorii Sankt-Peterburgskogo Obshchestva Arkhitektorov", *Zodchiy*, 5, 1984, pp. 35–37

Shtender, G. M., "K voprosu ob arkhitekture malykh form Sofii Novgorodskoy, in Lazarev, V. N. (ed.), *Drevnerusskoye iskusstvo: khudozhestvennaya kul'tura Novgoroda*, Moscow, 1968, pp. 83–107

——, "K voprosu o dekorativnykh osobennostyakh stroitel'noy tekhniki Sofii Novgorodskoy", in Kirpichnikov, A. N. (ed.), *Kul'tura Srednevekovoy Rusi*, Leningrad, 1974, pp. 202–12

——, "Pervonachal'nyy zamysel i posleduyushcheye izmeneniye galerey i lestnichnoy bashni novgorodskoy Sofii", in Rapoport, P. A. (ed.), *Drevnerusskoye iskusstvo: problemy i atributsii*, Moscow, 1977, pp. 34–37

——, "Issledovaniye galerey kiyevskogo Sofiyskogo sobora", *Stroitel'stvo i arkhitektura*, 7, 1980, pp. 25–29

——, "K voprosu o galereyakh Sofii Novgorodskoy", in Batalov, A. L., and Bondarenko, I. A. (eds), *Restavratsiya i issledovaniye pamyatnikov kul'tury*, II, Moscow, 1982

Shteyman, G. A., "Besstolpnyye pokrytiya v arkhitekture XVI–XVII vekov", *Arkhitekturnoye nasledstvo*, 14, Moscow, 1962, pp. 47–62

Shurygin, I., *Kazanskiy sobor*, Leningrad, 1987

Shuysky, V. K., *Toma de Tomon*, Leningrad, 1981

——, *Vinchentso Brenna*, Leningrad, 1986

——, *Andreyan Zakharov*, Leningrad, 1989

——, "Jan Batist Mishel Vallen Delamot", in *Zodchiye Sankt-Peterburga v XVIII vek*, St Petersburg, 1997, pp. 325–79

——, *Ogust Monferran*, St Petersburg, 2001

Shvidkovsky, D. O., "K voprosu o prosvetitel'skom kharaktere sredy v russkikh dvortsovo-parkovykh ansamblyakh epokhi Prosveshcheniya", in Libman, M. Ya. (ed.), *Vek Prosveshcheniya. Rossiya i Frantsiya*, Moscow, 1983, pp. 185–200

——, *Ideal'nyy gorod russkogo klassitsisma. Deni Didro i kul'tura yego epokhi*, Moscow, 1986

——, "The System of Links between Russian and European Architecture during the Second Half of the XVIII Century", in Zambien, W. (ed.), *L' Europe des échanges: la culture architecturale*, Paris, 1992

——, "'Vostochnyye stili' v arkhitekture russkogo klassitsizma", in Yevsina, N. A. (ed.) *Russkiy klassitsizm*, Moscow, 1995

——, *The Empress and the Architect: British Architecture and Gardens at the Court of Catherine the Great*, New Haven, CT, and London, 1996

——, "Moscow in 1997. Power, Trade and the New Russians", *Architectural Association Files*, 2, 1997

——, *Charles Cameron pri dvore Yekateriny II*, Moscow, 2001

——, "Le mythe occidental de l'Orient dans l'architecture et les jardins Russes de l'époque des Lumières", in Karp, S. Ya., et al. (eds), *Le mythe Russe en Occident des Lumières*, Paris, 2001

—— and Shorban, Ye. A., *Osobnyaki Moskvy*, Moscow, 1997

Shvidkovsky, O. A., *Vzaimodeystviye iskusstv*, Moscow, 1978

——, (ed.), *Building in the USSR, 1917–1932*, London, 1971

Simbirtsev, V. N., "Vserossiyskoye obshchestvo proletarskikh arkhitektorov (VOPRA)", *Sovetskaya arkhitektura*, 18, 1969

Sizov, Ye. S., "Novyye materialy po Arkhangel'skomu soboru moskovskogo kremlya", *Arkhitekturnoye nasledstvo*, 15, Moscow, 1963, pp. 176–77

Skrynnikov, R. G., *Tretiy Rim*, St Petersburg, 1994

Skrzhinskaya, Ye. K., *Barbaro i Kontarini o Rossii*, Leningrad, 1971

——, *Rus', Italiya i Vizantiya v Srednevekov'ye*, St Petersburg, 2000

Slavina, T. A., *Vladimir Shchuko*, Leningrad, 1978

——, *Issledovateli russkogo zodchestva: Russkaya istoriko-arkhitekturnaya nauka XVIII–nachala XX veka*, Leningrad, 1983

——, *Konstantin Ton*, Leningrad, 1989

Slovar' knizhnikov i knizhnosti Drevney Rusi. V 4 tomakh, 7 knigakh, Leningrad, 1987–2004

Smirnova, E. S. (ed.), "Uspenskiy sobor Moskovskogo Kremlya", *Materialy i issledovaniya*, Moscow, 1985

——, *Dmitrovskiy sobor vo Vladimire*, Moscow, 1997

Snegirev, V. L., *Aristotel' Fioravanti i perestroyka Moskovskogo Kremlya*, Moscow, 1935

——, *Pamyatnik arkhitektury khram Vasiliya Blazhennogo*, Moscow, 1953

——, *Zodchiy Bazhenov*, Moscow, 1962

Sobolev, N. N., "Proyekt rekonstruktsii pamyatnika arkhitektury – khrama Vasiliya Blazhennogo v Moskve", *Arkhitektura SSSR*, 2, 1977, pp. 42–48

Soboleva, L., *Issledovatel'skiye i restavratsionnyye raboty po tserkvi Preobrazheniya v usad'be Vyazemy. Teoriya i praktika restavratsionnykh rabot*, Moscow, 1972, pp. 84–98

Sokolov, M. N., *Misteriya sosedstva. K metamorfologii iskusstva Vozrozhdeniya*, Moscow, 1999

Spegal'sky, Yu. P., "K voprosu o vzaimovliyanii derevyannogo i kamennogo zodchestva v Drevney Rusi", *Arkhitekturnoye nasledstvo*, 19, Moscow, 1972, 66–75

——, *Pskov: Khudozhestvennyye pamyatniki*, Leningrad, 1972

Speransky, M. N., *Ocherki po istorii prikaza kamennykh del Moskovskogo gosudarstva*, Moscow, 1930

Starr, S. F., "The Revival and Schism of Urban Planning in Twentieth-Century Russia", in Hamm, M. (ed.), *The City in Russian History*, Lexington, KY, 1976, pp. 222–42

——, *Konstantin Mel'nikov: Solo Architect in Mass Society*, Princeton, NJ, 1978

——, "The Social Character of Stalinist Architecture", *Architectural Association Quarterly*, 2, 1979, pp. 49–55

Stepanov, V. G., *Belogrud*, Leningrad, 1939

Sternin, G. Yu., *Russkaya khudozhestvennaya kul'tura vtoroy poloviny XIX–nachala XX veka*, Moscow, 1984

Strazzullo, F., *Le lettere di Luigi Vanvitelli della Biblioteca Palatina di Caserta*, 3 vols, Galatina, 1976–77

Stremooukhoff, D., "Moscow the Third Rome: Sources of the Doctrine", *Speculum*, January 1953, pp. 84–101

Strigalev, A. A., and Kharten, Yu., *Tatlin. Retrospektiva*, Cologne and Moscow, 1994

Stuart, J., and Revett, N., *The Antiquities of Athens*, I, London, 1762

Sultanov, N. V., "Russkiye shatrovyye tserkvi i ikh sootnosheniye k gruzino-armyanskim piramidal'nym pokrytiyam", in *Trudy V Arkheologicheskogo s"ezda v Tiflise v 1881 g.*, Moscow, 1887, pp. 230–35

——, *Obraztsy drevnego zodchestva v miniatyurnykh izobrazheniyakh*, St Petersburg, 1891

Summerson, J., *Architecture in Britain, 1530–1830*, London, 1976

Suslov, V. V., *Tserkov' Vasiliya Blazhennogo v Moskve*, St Petersburg, 1912

Suzdaleva, T. N., *Trotsky*, Leningrad, 1991

Syrkina, F. Ya., *Pietro di Gottardo Gonzaga. Zhizn' i tvorchestvo, sochineniya*, Moscow, 1974

Sytina, T. M., "Russkoye arkhitekturnoye zakonodatel'stvo pervoy chetverti XVIII v.", *Arkhitekturnoye nasledstvo*, 18, Moscow, 1969, pp. 67–73

Taleporovsky, V. N., *Charl'z Kameron*, Moscow, 1939

——, *Kvarengi: materialy k izucheniyu tvorchestva*, Leningrad and Moscow, 1954

Tarabarina, U. V., "Pobeda nad korolevichem Vladislavom 1 oktyabrya 1618 goda i memorial'noye khramostroitel'stvo 1620-kh godov", in Batalov, A. L. (ed.), *Sakral'naya topografiya srednevekovogo goroda*, Moscow, 1998, pp. 100–08

——, "Russkaya arkhitektura pervoy treti XVII veka", doctoral diss., Moscow, 1999

Taranovskaya, M. Z., *Karl Rossi*, Leningrad, 1978

Tartakovskaya, Ye. A., "Chesmenskiy dvorets", *Vremennik ISO*, Leningrad, 1928

Tarunov, A. M., *Dubrovitsy*, Moscow, 1991

Taut, B., *Die neue Baukunst in Europa und Amerika*, Stuttgart, 1929

Tel'tevsky, P. A., "Velikiy Ustug", in Bykov, V. Ye. (ed.), *Arkhitektura i iskusstvo XVII–XIX vekov*, Moscow, 1977

Tenikhina, V., and Znamenov, V., *Kottedzh*, Leningrad, 1990

Tigler, P., *Die Architekturtheorie des Filarete*, Berlin, 1963

Tikhomirov, N. Ya., *Arkhitektura podmoskovnykh usadeb*, Moscow, 1955

Timofeyeva, T. P., "K utochneniyu daty Dmitrovskogo sobora", in Smirnova, E. S. (ed.), *Dmitrovskiy sobor vo Vladimire*, Moscow, 1997

Timofeyeva, Ye., "Pervonachal'nyy oblik Petropavlovskogo sobora", *Arkhitekturnoye nasledstvo*, 7, Moscow, 1955, pp. 93–108

Tits, A. A., *Russkoye kamennoye zhiloye zodchestvo XVII v.*, Moscow, 1966

——, "U istokov arkhitekturnogo chertezha", in Mongayt, A. N. (ed.), *Kul'tura drevney Rusi*, Moscow, 1966, pp. 268–71

——, *Zagadki drevnerusskogo chertezha*, Moscow, 1978

Tizhnenko, T. Ye., *Maksimilian Mesmakher*, Leningrad, 1984

——, *Vasily Stasov*, Leningrad, 1990

——, "Garald Bosse", in *Zodchiye Sankt-Peterburga. XIX–nachalo XX veka*, St Petersburg, 1998, pp. 341–60

Tolochko, P. P., *Drevniy Kiyev*, Kiev, 1982

Tolstaya, T. V., *Uspenskiy sobor Moskovskogo Kremlya*, Moscow, 1979

Tolstoy, U. V., *Pervyy sorok let snosheniy mezhdu Rossiyey i Angliyey (1553–1593 gg.)*, St Petersburg, 1875

Tolstoy, V. P., *Monumental'noye iskusstvo SSSR*, Moscow, 1979

Topil'sky, S., *Morskoy Bogoyavlenskiy sobor*, St Petersburg, 1871

Toropov, S. A., *Podmoskovnyye usad'by*, Moscow, 1947, 1977

Tret'yakov, N. N., *Georgy Gol'ts*, Moscow, 1969

Trubnikov, A., "Pervyye pensionery Imperatorskoy akademii khudozhestv", *Staryye gody*, April–June 1916, pp. 67–92

Tubly, M. P., *Avraam Mel'nikov*, Leningrad, 1980

Tugnoli-Pattaro, S., "Le opere bolognesi de Aristotele Fioravanti architetto e ingegnere", *Arte Lombarda*, 44–45, 1976, pp. 35–70

Tyadman, L. V., "Prostranstvo inter'yera v moskovskikh osobnyakakh pervoy poloviny XIX v.", in Vygolov, V. P. (ed.), *Pamyatniki russkoy arkhitektury i monumental'nogo iskusstva*, Moscow, 1980, pp. 162–81

——, "Razvitiye vnutrennego prostranstva domov-dvortsov 1700–1760-kh godov", in Alekseyeva, T. V. (ed.), *Ot Srednevekov'ya k novomu vremeni*, Moscow, 1984, pp. 180–210

Uspensky, B. A., *Izbrannyye trudy*, I: *Semiotika istorii. Semiotika kul'tury*, Moscow, 1996; II: *Yazyk i kul'tura*, Moscow, 1996

——, "Vospriyatiye istorii v Drevney Rusi i doktrina Moskva – Tretiy Rim", in ibid., I, pp. 83–123

——, *Tsar' i Patriarkh: kharizma vlasti i yeyo osmysleniye (Vizantiyskaya model' i yeyo russkoye pereosmysleniye)*, Moscow, 1998

Vagner [Wagner], G. K., "O proiskhozhdenii tsentricheskikh kompozitsiy v russkom zodchestve kontsa XVII veka", *Pamyatniki kul'tury*, 3, Moscow, 1961, pp. 123–33

——, "K voprosu o rekonstruktsii severnogo fasada Georgiyevskogo sobora v Iur'yeve-Pol'skom", *Arkhitekturnoye nasledstvo*, 14, Moscow, 1962, pp. 27–34

——, *Skul'ptura Vladimiro-Suzdal'skoy Rusi*, Moscow, 1964

——, *Skul'ptura drevney Rusi XII v.: Vladimir-Bogolyubovo*, Moscow, 1969

——, *Ryazan'*, Moscow, 1971

——, *Spaso-Andronikov monastyr'*, Moscow, 1972

——, *Belokamennaya rez'ba drevnego Suzdalya*, Moscow, 1975

——, "Ob otkrytii reznykh nadpisey sredi fasadnoy skul'ptury Dmitriyevskogo sobora vo Vladimire", *Sovetskaya arkheologiya*, 1, 1976, pp. 270–72

—— and Likhachev, D. S. (eds), *Srednevekovaya Rus'*, Moscow, 1976

Vashchenko, L. (ed.), *Arkheologiya Kiyeva*, Kiev, 1979

Vasil'yev, B. L., "Arkhitektory Neyelovy", *Arkhitekturnoye nasledstvo*, 4, Moscow, 1953, pp. 73–90

Venyaminov, B., "Arkhangel'skoye", *Mir iskusstva*, 2, 1904, pp. 31–40

Vereshchagin, V, "Putevyye zametki N. A. L'vova po Italii v 1781 g.", *Staryye gody*, May 1909

Vergunov, A., and Gorokhov, V., *Russkiye sady i parki*, Moscow, 1988

[Vignola, Giacomo Barozzi da], *Novyy Viniola, ili nachal'nyye grazhdanskoy arkhitektury nastavleniya, s obyasneniyem pravil o pyati chinakh ili orderakh onoy, po predpisaniyam Iakova Barochiya Vinioly*, Moscow, 1778

Viktorov, A. V., "Ermolin", in Yaralov, U. (ed.), *Zodchiye Moskvy XV–XIX vv.*, Moscow, 1981, pp. 34–41

Vipers [Vipper], B. R., *Baroque Art in Latvia*, Riga, 1939

Vipper, B. R., *Arkhitektura russkogo barokko*, Moscow, 1978

——, "Russkaya arkhitektura XVII v. i yeyo istoricheskoye mesto", in ibid., pp. 12–38

[Vitruvius], *Sokrashchennyy Vitruviy, ili sovershennyy arkhitektor*, trans. and ed. Kargavin, F., Moscow, 1789

Vityazeva, V. A., *Nevskiye ostrova*, Leningrad, 1986

——, *Kamennyy Ostrov*, Leningrad, 1991

Vlasov, V. G., *Arkhitektura Petrovskogo barokko*, St Petersburg, 1996

Vlasyuk, A. I., "Novyye issledovaniya arkhitektury Arkhangel'skogo sobora v Moskovskom kremle", *Arkhitekturnoye nasledstvo*, 2, Moscow and Leningrad, 1952, pp. 105–32

——, "Pervonachal'naya forma kupola tserkvi Pokrova na Nerli", *Arkhitekturnoye nasledstvo*, 2, Moscow and Leningrad, 1952, pp. 67–68

——, "O rabote zodchego Aleviza Novogo v Bakhchisaraye i v Moskovskom Kremle", *Arkhitekturnoye nasledstvo*, 10, Moscow, 1958, pp. 101–10

——, "K istorii proyektirovaniya i stroitel'stva zhilishch dlya rabochikh v kontse XIX v. v Rossii", *Arkhitekturnoye nasledstvo*, 15, Moscow, 1963, pp. 171–75

——, Kaplun, A. I., and Kiparisova, A. A., *Kazakov*, Moscow, 1957

Voinov, V. S., "Andreas Shlüter – arkhitektor Petra. (K voprosu o formirovanii stilya 'Petrovskoye barokko')", *Sovetskoye iskusstvoznaniye*, 1, 1976, pp. 367–77

Vorob'yev, A. V., and Smyslova, V. A., "O galereye Arkhangel'skogo sobora", *Arkhitekturnoye nasledstvo*, 15, Moscow, 1963, pp. 178–81

Voronikhina, A. N., *Peterburg i yego okrestnosti v chertezhakh i risunkakh arkhitektorov pervoy treti XVIII veka*, Leningrad, 1972

——, Kalyazina, N. V., Korshunova, M. F., and Petrova, T. A., *Arkhitekturnaya grafika Rossii: Pervaya polovina XVIII veka*, Leningrad, 1981

Voronin, N. N., "Zodchestvo Kiyevskoy Rusi", *IRI*, I, 1953, pp. 45–140

——, *Zodchestvo Severo-Vostochnoy Rusi XI–XV vekov*, I, II, Moscow, 1961, 1962

——, "Andrey Bogolyubsky i Luka Khrisoverg. (Iz istorii russko-vizantiyskikh otnosheniy XII veka)", in *Vizantiyskiy vremyannik*, XXI, Moscow, 1962, pp. 29–50

——, *Vladimir, Bogolyubovo, Suzdal', Yur'yev-Pol'skoy*, Moscow, 1971

——, *Yur'yev-Pol'skoy*, Moscow, 1985

—— and Kostochkin, V. V. (eds), *Troitse-Sergiyeva lavra. Khudozhestvennyye pamyatniki*, Moscow, 1968

—— and Rapoport, P. A., *Zodchestvo Smolenska, XV–XIII vv.*, Moscow, 1979

Voronov, M. G., and Khodosevich, G. D., *Ansambl' Kamerona v Pushkine*, Leningrad, 1982

Vyachanina, T. N., "O znachenii obraztsa v drevnerusskoy arkhitekture", *Arkhitekturnoye nasledstvo*, 32, Moscow, 1984, pp. 26–31

——, "Arkhangel'skiy sobor moskovskogo kremlya kak obrazets v russkom zodchestve XVI v.", *Arkhitekturnoye nasledstvo*, 34, Moscow, 1986, pp. 215–23

Vygolov, V. P., "Triumfal'nyye vorota 1721 g. I. P. Zarudnogo", *Arkhitekturnoye nasledstvo*, 12, Moscow, 1960, pp. 179–82

——, "O razvitii yarusnykh form v zodchestve kontsa XVII veka", in Lazarev, V. N. (ed.), *Drevnerusskoye iskusstvo: XVII vek*, Moscow, 1964, pp. 236–52

——, "Novoye o tvorchestve I. P. Zarudnogo", *Arkhitekturnoye nasledstvo*, 9, Moscow and Leningrad, 1968, pp. 157–68

——, *Arkhitektura Moskovskoy Rusi serediny XV veka*, Moscow, 1988

Vysotskaya, N. F., "Rol' belorussov v iskusstve Moskovskoy Rusi vtoroy poloviny XVII veka", *Filevskiye chteniya, tezisy*, Moscow, 2003, pp. 20–24

Vzdornov, G. I., "K voprosu ob arkhitekturnyh modelyakh XVII v.", *Soobshcheniya Zagorskogo gosudarstvennogo muzeya-zapovednika*, Zagorsk, 1960, pp. 191–95

——, "K arkhitekturnoy istorii Savvino-Storozhevskogo monastyrya", *Pamyatniki kul'tury. Issledovaniye i restavratsiya*, 13, Moscow, 1961

——, "Stroitel'stvo kolokol'ni Troitse-Sergiyevoy lavry (v svete novykh dannykh)", *Arkhitekturnoye nasledstvo*, 14, Moscow, 1962, pp. 152–84

——, "Arkhitektor Pietro Antonio Trezzini i yego postroyki", in Alekseyeva, T. V. (ed.), *Russkoye iskusstvo XVIII v.: materialy i issledovaniya*, Moscow, 1968, pp. 139–56

——, "Postroyki pskovskoy arteli zodchikh v Moskve. (Po letopisnoy stat'ye 1476 goda)", in Lazarev, V. N. (ed.), *Drevnerusskoye iskusstvo. Khudozhestvennaya kul'tura Pskova*, Moscow, 1968, pp. 174–88

——, "Zametki o pamyatnikakh russkoy arkhitektury kontsa XVII–nachala XVIII v.", in Alekseyeva, T. V. (ed.), *Russkoye iskusstvo XVIII veka. Materialy i issledovaniya*, Moscow, 1973, pp. 21–25

——, "K voprosu o postroykakh i lichnosti Aleviza Fryazina", in Rapoport, P. A. (ed.), *Drevnerusskoye iskusstvo. Issledovaniya i atributsii*, St Petersburg, 1997

Wagner, G. K., *see* Vagner, G. K.

Willan, T. S., *The Muscovy Company Merchants of 1555*, Manchester, 1953

——, *The Early History of the Muscovy Company*, Manchester, 1956

Wittkower, R., *Architectural Principles in the Age of Humanism*, New York, 1971

Yaralov, Yu. S., *Alexandre Tamanian*, Moscow, 1950

—— (ed.), *100 let obshchestvennykh arkhitekturnykh organizatsiy v SSSR, 1867–1967*, Moscow, 1967

—— (ed.), *Zodchiye Moskvy XV–XIX vv.*, Moscow, 1981

Yegorov, I., *The Architectural Planning of Saint Petersburg: Its Development in the 18th and 19th Centuries*, trans. E. Dluhosch, Athens, OH, 1969

Yekaterina Vtoraya, *Pis'ma k Grimmu. Imperatorskoye russkoye istoricheskoye obshchestvo. Sbornik*, XXIII, St Petersburg, 1878

——, *Zapiski Imperatritsy Yekateriny Vtoroy*, St Petersburg, 1907

Yelizarova, N. A., *Ostankino*, Moscow, 1966

Yeropkina, V. V., "Odin iz ptentsov Petra Velikogo", *Istoricheskiy vestnik*, 1, 1903, pp. 565–75

Yevangulova, O. S., *Dvortsovo-parkovyye ansambli Moskvy pervoy poloviny XVIII veka*, Moscow, 1969

——, "K probleme stilya v iskusstve petrovskogo vremeni", *Vestnik Moskovskogo universiteta*, 3, Moscow, 1974, pp. 67–84

Yevsina, N. A., *Arkhitekturnaya teoriya v Rossii XVIII v.*, Moscow, 1975

——, *Arkhitekturnaya teoriya v Rossii vtoroy poloviny XVIII–nachala XIX veka*, Moscow, 1985

Youngson, A., *The Making of Classical Edinburgh*, Edinburgh, 1966

Zabelin, I. Ye., *Russkoye iskusstvo: cherty samobytnosti v drevnerusskom zodchestve*, Moscow, 1900

——, *Istoriya goroda Moskvy*, Moscow, 1902

——, *Domashnyy byt russkikh tsarey v XVI i XVII stoletiyakh*, I, Moscow, 1990

Zabello, S. F., Ivanov, V. N., and Maksimov, P. N., *Russkoye derevyannoye zodchestvo*, Moscow, 1942

Zagaglia, B., *Un Libro di Pietro. Il Duomo di Modena*, Modena, 1988

Zanella, V. (ed.), *Giacomo Quarenghi architetto a San Pietroburgo. Lettere i altri scritti*, Venice, 1988

——, *Zapiski russkikh puteshestvennikov XVI–XVII vv.*, Moscow, 1988

Zapletin, N., "Dvorets Sovetov SSSR (po materialam konkursa)", *Sovetskaya arkhitektura*, 2–3, 1932, pp. 10–16

Zavarikhin, S. P., *Russkaya arkhitekturnaya kritika: seredina XVIII–nachalo XX vv.*, Leningrad, 1989

Zelenskaya, G., *Svyatyni Novogo Iyerusalima*, Moscow, 2002

Zemtsov, S. M., "Arkhitektory Moskvy vtoroy poloviny XV i pervoy poloviny XVI veka", in Yaralov, Yu. S. (ed.), *Zodchiye Moskvy XV–XIX vv.*, Moscow, 1981

——, and Glazychev, V. L., *Aristotel' F'yoravanti*, Moscow, 1985

Zgura, V. V., "Problema vozniknoveniya barokko v Rossii", in Nekrasov, A. I. (ed.), *Barokko v Rossii*, Moscow, 1926, pp. 13–42

——, *Problemy i pamyatniki, svyazannyye s V. I. Bazhenovym*, Moscow, 1928

Zhivov, V. M., and Uspensky, B. A., "Metamorfozy antichnogo yazy-
chestva v istorii russkoy kul'tury XVII–XVIII vv.", in Uspensky, B.
A. (ed.), *Antichnost' v kul'ture i iskusstve possleduyushchikh vekov*,
Moscow, 1984, pp. 204–85

Zhukov, A. F., *Arkhitektura Vsesouznoy sel'skokhozyaystvennoy vystavki 1953
goda*, Moscow, 1939

Zhuravlev, A. M., and Ikonnikov, A. V., *Arkhitektura Sovetskoy Rossii*,
Moscow, 1987

Zhuravleva, L., *Talashkino*, Moscow, 1989

Zolotnitskaya, Z. V., *Arkhitektor Bove*, exhib. cat., Moscow, 1986

—— and Saygina, L. V., in Gedor T. I. (ed.) *V. I. Bazhenov. Katalog
chertezhey*, Moscow, 1985

Zombe, S. A., "Proyekt plana Moskvy 1775 goda i yego gra-
dostroitel'noye znacheniye", *Yezhegodnik Instituta istorii iskusstv*,
Moscow, 1960, pp. 53–96

Zubov, V. P., *Kommentariy k russkomu izdaniyu traktata Ch. Kamerona
"Termy Rimlian"*, Moscow, 1939

Index

St Sophia, cathedral of, Kiev 17–22, *18–21*, 23
St Sophia cathedral, Novgorod 19, 20, 22, *22*, 23
St Sophia cathedral, Polotsk 19, 20, 22, 23
St Sophia, cathedral of, Tsarskoye Selo 259
St Sophia, cathedral of, Vologda 146, *146*
St Sophia, Trebizond 60
St Triphon, church of, Naprudnoye, Moscow 110–11, *111*
SS Boris and Gleb, church of, Kideksha 28, 29, *31*, 32
SS Boris and Gleb, monastery of, Chernigov 25
SS Cosma and Damian, church of, Moscow 249
SS Peter and Paul, cathedral and fortress of, St Petersburg 198, *198–99*
SS Peter and Paul, church of, Peterhof *334*, 335
SS Peter and Paul, church of, Smolensk 25
saints' images in sculpture 46, *47–49*, 56, 57
Samborsky, Andrey 260
San Abbondio, church of, Como 36, *38*
San Carlo alle Quattro Fontane, church of, Rome 207
San Giovanni Crisòstomo, Venice 104
San Michele, church of, Pavia 36, *38–39*, 43, 45, 90
San Zaccaria, church of, Venice 104, *107*
San'Abbondio, Como *38*
Santa Maria delle Grazie, Milan 91–92
Santa Maria Formosa, Venice 103–04
Santa Maria presso San Satiro, church of, Milan 96
Santo Stefano, Bologna 90
Saviour, cathedral of the, Andronikov monastery, Moscow 69–70, *71*, 110
Saviour, cathedral of the, Nizhny Novgorod 65
Saviour, church of the, Ubory 188
Saviour and Transfiguration, cathedral of the, Tver' 64
Saviour in the Wood, church of the, Kremlin, Moscow 97
Saviour and the Transfiguration, cathedral of the, Solovetsky Monastery 144
Saviour of the Transfiguration, church of the, Moscow 226
Saviour on Nereditsa, church of the, Novgorod 26
Saviour on the Bor, church of the, Moscow 65
Saviour-St Euphymios Monastery, Suzdal' 166
Saviour/Transfiguration, cathedral of the, Suzdal' 28
Saviour's Tower, Kremlin, Moscow 154, *155–56*, 157, 162
Savva, St 66
Scandinavia and North-eastern Rus' 26–27
Schädel, Gottfried 193, 202
Schäfler, Bella 368
Schignfoet, Simon 207
Schinkel, Karl Friedrich 317, 318, 324
Schlitte, Hans 148
Schlüter, Andreas 200–02, 203, 211
Schmidt, Hans 368
Schreiber, Vladimir 339
Schröter, Viktor 339
Schwertfeger, Thomas 203–04
Scotland
 Art Nouveau influence 343

and Catherine the Great's Revival of Antiquity 258–61
 masters from 125, 148, 154, 157
 urban planning model 321
sculpture
 antique relics in Kievan Rus' 16
 church of the Intercession on the Nerl' 34–36
 Mongol invasion and loss of 63
 and Romanesque style 60, 62
 St George's Cathedral reliefs 46–62, 65
 scarcity in architecture 60, 62
 Soviet monumental art 379
 Vladimir school 40–41, *42–43*
 see also ornament
Scuola di San Marco, Venice 99, 100–01, *108*
Second Coming and architecture 111–12, 117–18
Second World War 371
Select Council 132
Semyon of Suzdal' 83
Semyonov, Vladimir 351, 371
Senate building, Kremlin, Moscow 230, 248, *248*, 382
Senate and Synod building, St Petersburg 308, *309–10*
serf theatres *274*, 276
serfs: emancipation 271, 329, 336
Sergey of Radonezh, St 66
Serpukhov 65
Sforza, Francesco, duke of Milan 79, 80
Sforza, Galeazzo, duke of Milan 77–78
Sforzinda (ideal city) 129, *129*
Sharutin, Trefil 158
Shchedrin, Fyodor 299
Shcherbatov, Prince 351
Shchuko, Vladimir 369
Shchusev, Aleksey 362, 371
Shekhtel', Fyodor 343–49, *350*
Sheremetev, Count Nikolay: country estate 273, *273*
Sheremetev residence, St Petersburg 215
Sherwood, Vladimir 331
Shkin estate, Kolomna 279
Shopping Arcade, Kitay-Gorod, Moscow 262, *264*
shops 262, 331, 380
 see also Kitay-Gorod
Shtakenshneyder, Andrey 338–39
Shtaubert, Aleksandr 321
Shuvalov, Count Ivan 232
 Rastrelli's palace 215
Shuvalov family 211
Shuvalov Palace, St Petersburg 339
Shuysky, Prince Vasily 123
Sign of the Mother of God, church of the, Dubrovnitsy 186, *187–88*, 193
Silvestr (confessor to Ivan IV) 132
Simbirtsev, Vasily 370
Simmons, John 4
Skryabin, Aleksandr 340–41
skyscrapers in Moscow 371, 373
Slavophilism 326
Slavs 27, 28
slobody settlements 195

Small Hermitage, St Petersburg 233, *235*
Smolensk
 architectural school 2, 25–26
 cathedral of the Smolensk Icon of the Mother of God 145, *147*, 151
 as independent principality 25
 post-war restoration 358
 Romanesque ornament 25
Smolensk Icon of the Mother of God, cathedral of the, New Convent of the Virgin, Moscow 145, *147*, 151
Smol'ny Convent, cathedral of, St Petersburg *182*, 204, 211, 219–22, *221–23*, 240, 324
Smol'ny Institute, St Petersburg 262
social hierarchy
 and Peter the Great's urban planning 194, 195–96
 and replanning of St Petersburg 208, 209
 and urban planning under Catherine the Great 245–46, 269
Socialist Realism 369
Sofya Alekseyevna, Regent 183, 186
Solari, Boniforte 92
Solari, Giovanni 91
Solari, Guiniforte 91–92, 96
Solari, Pietro Antonio 91, 92, 93, 96
Solomoniya, wife of Vasily III 112
Solovetsky Monastery cathedral 144
Solunsky, Simeon 115, 117
Sophia (ideal city at Tsarskoye Selo) 259–60
Soufflot, Jacques-Germain 232, 241
Soviet Army Theatre, Moscow *see* Central Red Army Theatre
Soviet era
 architecture of 9, 357–79
 industrialized architecture 374, 376–79
 Russian Avant-Garde 358–68, 384
 Soviet Neoclassical Revival 9, 368–73, 376
 attitudes towards West and Western architecture 357, 358, 359, 362, 364, 366–68
 destruction of architectural heritage 357–58, 369, 380–81, 382
 ideology and interpretation of cathedral of St George ornamentation 56–57
 see also post-Soviet era architecture
Soviet pavilion
 Paris Exposition (1925) 362, 364
 Paris Exposition (1937) 370
Sparrow, Charles and John 239
Speer, Albert 370, 373
Speransky, Mikhail 296
stable buildings 253, 312, 335
Stalin, Josef 9, 357, 358, 368–73
Stanislavsky, Konstantin 344
Starov, Ivan Yegorovich 279, 311
 Alexander Nevsky Monastery cathedral 203, 241–42
 as chief architect under Catherine the Great 267–68, 270
 imperial palace at Pella 286–88
 Tauride Palace 265–66
Starozhilovo: von Derviz estate stables 335

Yeropkin, Pyotr 8, 184, 207, 208–09, *208*, 210, 225
Yevlashev, Andrey 225, 226
Yuri Dmitriyevich, Prince of Zvenigorod 66, 68
Yur'yev-Pol'sky
 cathedral of St George 5, *12*, 43, 44–62, *46–56*,
 58–61
 and Mongol invasion 63
Yushkov house, Moscow 248

Zabelin, Ivan 161, 330
Zaborsky, Pyotr 170
Zakharov, Andreyan 296, 298–301, 308, 340
 model planning designs 320
Zarudny, Ivan 193
Zemlyanoy Gorod, Moscow 245
Zemshchina 148
Zemtsov, Mikhail 203, 207, 212, 225
Zholtovsky, Ivan 351, 364, 368

Zhukov, Marshal Georgy: statue 381
Zodchiy (journal) 338, 341
Zosima, metropolitan of Russia 111–12
Zubov, Platon 234
Zuev club, Moscow *361*
Zvenigorod
 cathedral of the Dormition 66–68, *67–68*
 St Savva-Storozhevsky Monastery 66, 68, *69*, 166,
 167–68